MATISSE ON ART

THE DOCUMENTS OF TWENTIETH CENTURY ART

General Editor, Jack Flam
Founding Editor, Robert Motherwell

Other titles in the series available from University of California Press:

*German Expressionism: Documents from the End of the
Wilhelmine Empire to the Rise of National Socialism*
 Rose-Carol Washton Long
Memoirs of a Dada Drummer
 Richard Huelsenbeck
Art As Art: The Selected Writings of Ad Reinhardt
 Barbara Rose

Matisse

ON ART

JACK FLAM

UNIVERSITY OF CALIFORNIA PRESS

Berkeley · Los Angeles

University of California Press
Berkeley and Los Angeles, California

Library of Congress Cataloging-in-Publication Data

Matisse on art / [edited by] Jack D. Flam. — Rev. ed.

 p. cm.

Includes bibliographical references and index.

ISBN 0-520-20037-3 (cloth : alk. paper). — ISBN 0-520-20032-2
(pbk. : alk. paper)

 1. Matisse, Henri, 1869–1954—Aesthetics. 2. Art. I. Flam, Jack D.
II. Title.

ND553.M37A35 1995 95-7226

701—dc20 CIP

Printed in the United States of America

9 8 7 6 5 4 3 2 1

To my parents, and to my daughter Laura,
links in the chain . . .

Contents

List of Illustrations xi

Preface xv

Introduction: A Life in Words and Pictures 1

A Note on the Texts 25

1 Interview with Guillaume Apollinaire, 1907 27

2 Notes of a Painter, 1908 30

3 Statement on Photography, 1908 43

4 Sarah Stein's Notes, 1908 44

5 Interview with Charles Estienne, 1909 52

6 Interview with J. Sacs, 1910 56

7 Interview with Ernst Goldschmidt, 1911 60

8 Interview with Clara T. MacChesney, 1912 64

9 Visit by Robert Rey, 1913 70

10 Interview with Ragnar Hoppe, 1919 73

11 Interview with Jacques Guenne, 1925 78

12 Statement to Tériade: On Fauvism and Color, 1929 83

13 Statement to Tériade: On Travel, 1930 87

14 Statement to Tériade: Around a Retrospective, 1931 93

15 Interview with Gotthard Jedlicka, 1931 97

16	Interview with Pierre Courthion, 1931	104
17	Statement to Tériade: On Creativity, 1933	106
18	Interview with Dorothy Dudley, 1933	107
19	Letters to Alexander Romm, 1934	113
20	On Modernism and Tradition, 1935	118
21	Statements to Tériade: On the Purity of the Means, 1936	122
22	On Cézanne's "Three Bathers," 1936	124
23	Divagations, 1937	125
24	Henry de Montherlant: Listening to Matisse, 1938	127
25	Notes of a Painter on his Drawing, 1939	129
26	Interview with Francis Carco, 1941	132
27	On Transformations, 1942	142
28	Matisse's Radio Interviews, 1942	143
29	Conversations with Louis Aragon: On Signs, 1942	148
30	Interview with Marguette Bouvier, 1944	151
31	The Role and Modalities of Color, 1945	154
32	Observations on Painting, 1945	157
33	Interview with Léon Degand, 1945	159
34	Black is a Color, 1946	165
35	How I made my Books, 1946	166
36	Oceania, 1946	169
37	Jazz, 1947	169
38	Interview with André Marchand: The Eye, 1947	175

39 The Path of Color, 1947 177

40 Exactitude is not Truth, 1947 179

41 Letter to Henry Clifford, 1948 181

42 Interview with R. W. Howe, 1949 184

43 Henri Matisse Speaks to You, 1950 187

44 Interview with Georges Charbonnier, 1950 189

45 The Text: Preface to the Tokyo Exhibition, 1951 195

46 The Chapel of the Rosary, 1951 196

47 The Chapel of the Rosary:
 On the Murals and Windows, 1951 197

48 Statements to Tériade: Matisse Speaks, 1951 199

49 Testimonial, 1951 207

50 Interview with André Verdet, 1952 209

51 Looking at Life with the Eyes of a Child, 1953 217

52 Portraits, 1954 219

 Chronology 225

 Appendix (Selected French Texts: 2, 12, 21, 25, 31, 37, 49, 51) 237

 Notes 253

 Bibliography 305

 Index 315

Illustrations

FACING PAGE 28

1. Page from *L'Illustration*, 4 November 1905, with works shown at the Salon d'Automne.

FACING PAGE 29

2. *Le Bonheur de vivre*, 1905–1906. Oil on canvas, 175 × 241 cm. The Barnes Foundation, Merion, Pennsylvania.

3. *Standing Nude*, 1906–1907. Oil on canvas, 92.1 × 64.8 cm. Tate Gallery, London.

4. Photograph used by Matisse for *Standing Nude*.

FACING PAGE 44

5. Photograph of Michael and Sarah Stein, Matisse, Allan Stein, and Hans Purrmann in the Stein's apartment at 58, rue Madame, in 1907.

6. *The Red Madras Headdress*, 1907. Oil on canvas, 99.4 × 80.5 cm. The Barnes Foundation, Merion, Pennsylvania.

FACING PAGE 45

7. *Blue Nude*, 1907. Oil on canvas, 92.1 × 140.4 cm. The Baltimore Museum of Art. The Cone Collection, formed by Dr. Claribel Cone and Miss Etta Cone of Baltimore, Maryland.

8. *Harmony in Red*, 1908. Oil on canvas, 180 × 220 cm. The Hermitage Museum, St. Petersburg.

FACING PAGE 68

9. Photograph of Matisse's sculpture class, c. 1909.

10. Photograph of Matisse working on *Dance*, 1909.

FACING PAGE 69

11. *The Red Studio*, 1911. Oil on canvas, 181 × 219.1 cm. The Museum of Modern Art, New York. Mrs. Simon Guggenheim Fund.

12. Photograph of Matisse's House at Issy, c. 1911.

13. Photograph of Matisse's studio at Issy in 1911.

FACING PAGE 76

14. Photograph of Matisse with Renoir at Cagnes, 1918. Left to right: Matisse, Claude Renoir, Auguste Renoir, Pierre Renoir, Greta Prozor.

15. *Interior with a Violin*, 1918. Oil on canvas, 116 × 89 cm. Statens Museum for Kunst, Copenhagen. J. Rump Collection.

16. *Seated Odalisque*, 1922. Oil on canvas, 46.5 × 38.3 cm. The Barnes Foundation, Merion, Pennsylvania.

FACING PAGE 77

17. Photograph of Matisse in his studio at the Place Charles-Félix, Nice, working from a model dressed as an odalisque, c. 1926.

FACING PAGE 80

18. *The Dinner Table*, 1897. Oil on canvas, 100 × 131 cm. Private collection.

19. Paul Cézanne, *Three Bathers*, c. 1879–1882. Oil on canvas, 60.3 × 54.6 cm. Ville de Paris, Musée du Petit Palais, Paris.

FACING PAGE 81

20. *Portrait of Amélie Matisse*, 1913. Oil on canvas, 145 × 97 cm. The Hermitage Museum, St. Petersburg.

FACING PAGE 112

21. *Dance II*, 1910. Oil on canvas, 260 × 391 cm. The Hermitage Museum, St. Petersburg.

22. Photograph of a room dedicated to Matisse's work at Shchukin's home in Moscow, c. 1912.

FACING PAGE 113

23. *Nymph and Faun*, illustration from *Poésies de Stéphane Mallarmé*, 1932, p. 81.

24. *Dance* Mural, 1931–1933 (approximately 3.5 meters high × 13.84 meters wide) installed at the Barnes Foundation, Merion, Pennsylvania.

FACING PAGE 120

25. *Pink Nude*, 1935, and photographs of the painting in progress. Oil on canvas, 66 × 92.7 cm. The Baltimore Museum of Art. The Cone Collection, formed by Dr. Claribel Cone and Miss Etta Cone of Baltimore, Maryland.

25. *Pink Nude* in progress: State I, 3 May 1935.

FACING PAGE 121

25. *Pink Nude* in progress: State V, 20 May 1935.

25. *Pink Nude* in progress: State XXI, 16 October 1935.

FACING PAGE 168

26. Photograph of Matisse's studio at Cimiez with his *Theme and Variations* drawings on the wall, 1942.

27. *Oceania, the Sea*, 1946. Stencil on linen, 166 × 380 cm.

FACING PAGE 169

28. "The Tobogggan," Plate XX from *Jazz*, 1947. Pochoir on paper, 42.2 × 65.1 cm.

29. Photograph of the interior of the Chapel at Vence. Consecrated June 1951.

FACING PAGE 180

30. *Four Self-portrait Drawings*, 1939. Crayon on paper, each 36.8 × 26 cm.

FACING PAGE 181

31. *Model Reflected in a Mirror*, 1936. Pen and ink on paper, 45.1 × 56.8 cm. Private collection.

32. *Self Portrait*, 1937. Charcoal and estompe on paper, 47.3 × 39 cm. The Baltimore Museum of Art. The Cone Collection, formed by Dr. Claribel Cone and Miss Etta Cone of Baltimore, Maryland.

FACING PAGE 200

33. *La Desserte (copy after Jan Davidsz de Heem)*, 1893. Oil on canvas, 73 × 100 cm. Musée Matisse, Nice-Cimiez.

34. *Still Life after de Heem's "Desserte"*, 1915. Oil on canvas, 180.9 × 220.8 cm. The Museum of Modern Art, New York. Gift of Florene M. Schoenborn and Samuel A. Marx.

FACING PAGE 201

35. *The Moroccans*, 1916. Oil on canvas, 181.3 × 279.4 cm. The Museum of Modern Art, New York. Gift of Mr. and Mrs. Samuel A. Marx.

36. *Bathers by a River*, 1916. Oil on canvas, 261.8 × 391.4 cm. The Art Institute of Chicago. Charles H. and Mary F. S. Worcester Collection.

FACING PAGE 216

37. Photograph of a wall of Matisse's studio at the villa Le Rêve, Vence, c. 1947.

FACING PAGE 217

38. Photograph of Matisse in a wheelchair, working on a cutout. Hôtel Régina, Nice, 1952.

Preface

This book retains a favored place among my own works, not only because it was the first book I published, but also because it has been especially meaningful and useful to artists. Because Matisse was so undogmatic in his wisdom he speaks persuasively to artists working in many different ways and in many different mediums. In fact, I think that for Matisse the ideal audience for his writings was one composed mainly of artists and students. And because Matisse came out of the rich and lively painting culture of late nineteenth-century France, in which there was a strong sense of both continuity and community among artists—passed on not only by their works but also by their recorded remarks and writings—I believe that he would be pleased to see this community of artists extended beyond the borders of France and well beyond his own lifetime.

The manuscript for the first edition of this book was finished exactly twenty-five years ago, in 1970, although it was not published until three years later. Since so much time has passed between that publication and this revision, perhaps I should make a few remarks about the origins of this book and about my reasons for revising it so extensively now.

When, in the late 1960s, I first told people of my intention to compile a collection of Matisse's writings and interviews, they responded with a certain amount of skepticism. To some degree, this was because it was widely believed at the time that painting was "dead," and Matisse's aesthetics seemed hopelessly out of date. (Painting, of course, has remained vigorously and resiliently alive, and even in our present fractious artistic climate it is understood to fill a need within human experience that cannot be satisfied otherwise; and Matisse himself seems to have become ever more "up-to-date.")

But in large measure that skepticism also reflected the fact that at the time Matisse was considered by most to be a charming but rather superficial artist; aside from his seminal early essay, "Notes of a Painter," it was generally felt that he had little to *say* about art that would be meaningful to either artists or scholars. He seemed to have no particular theoretical or political program to articulate and no specific technique to advocate—no axes to grind. However, because I first had been drawn to Matisse primarily because of my own early training as a painter, rather

than from my later training as an art historian, these supposed shortcomings seemed to me virtues. My own early art training had been so similar to the one prescribed by Matisse that the terms in which he framed his ideas seemed somehow familiar to me—though I had never heard them expressed with quite such clarity or forcefulness. And so when this book was eventually published, I was especially pleased to hear from so many artists how much Matisse's writings meant to them. This is not, of course, to gainsay my being gratified by how useful this book has been to scholars and by its effect on Matisse studies generally.

People sometimes ask me if I don't get a bit tired of working on Matisse. My answer is that he is one of that relatively small number of artists who are truly inexhaustible. This sense of Matisse's specialness was recently reinforced in an unexpected way when I was completing the revision of this book and saw the large Poussin retrospective in Paris. There I was struck by what is perhaps the strongest parallel between Matisse and his great artistic forebear—other than their shared tendency to have powerful feelings be guided and compressed by the order and calm of form. I mean the extraordinary moral gravity that being an artist had for both of them, and the extraordinary courage they showed in sustaining such a high level of commitment and concentration over such a long period of time.

I also feel compelled to say that the circumstances surrounding the initial appearance of this book were not especially pleasant ones. For complicated reasons, publication of the book was delayed for three years. When it finally did appear I was not entirely pleased with its design and thus right from the beginning I looked forward to being able someday to bring out a volume that would be closer to my own idea of what such a book should be.

Now, almost twenty-five years later, Matisse studies have been so emphatically transformed that it seemed an appropriate time to update this book to include texts that have come to light since its first publication, and to update some of the documentary material. I must confess that when I began work on the revision I planned to make only minor changes, aside from the addition of new material. But as I began to review the book carefully, I realized that a good deal of other material also had to be changed. The translations, for example, have been reviewed and many of them revised, and important new scholarship is referred to in my introductions to the individual texts and in the footnotes.

Equally important, I now have a somewhat different view of how these texts should be edited. In the first edition, my main focus was on highlighting Matisse's own words. As a result, I often cut digressive remarks made by his various interviewers. I am now more sensitive to the historiographical value of those interviews and have included more of this interesting material.

The general introductory sections have also been radically changed. I have re-

placed the brief biographical sketch of Matisse's life with a more detailed chronology. The rather long section on Matisse's development as a painter has been eliminated; subsequent writings by myself and others have made it seem irrelevant in the present context, and I have chosen instead to concentrate more specifically on Matisse as a writer in my general Introduction.

The titles of paintings and sculptures by Matisse are here translated into English, and the book is also illustrated differently, with more emphasis given to photographs of the artist's working conditions. Since good color reproductions of his works, even of paintings that were virtually unknown in 1970, are now widely available, it seems superfluous to take up valuable space with pictures that are accessible elsewhere in studies such as Pierre Schneider's monumental *Matisse* (1984), in my own *Matisse: The Man and His Art, 1869–1918* (1986), and in John Elderfield's comprehensive *Henri Matisse: A Retrospective* (1992). The "Bibliography" below lists other recent well-illustrated works.

In the first edition of this book I acknowledged with gratitude the help of a number of people and institutions. Although I will not repeat them all here, I would like to reiterate my thanks to those people who provided crucial help with that version of the book.

In particular, I remain especially grateful for the kindness and good-hearted indulgence that Marguerite Matisse Duthuit showed toward an enthusiastic young American scholar who was so importunate with his questions about her father. I also want to reiterate my thanks to Laurie Schneider Adams, Henry Clifford, Danièle Giraudy, Susie Morgenstern, John Neff, and Pierre Schneider for having so generously shared their resources with me. And I want to repeat my special gratitude to Bonnie Burnham, whose dedication was invaluable to me in all phases of the preparation of the first edition of this book.

Over the past two-and-a-half decades, as I have pursued my study of Matisse, a number of people have been of enormous help to me. Although they are too many to mention here, I would like to thank those who were especially helpful with the revision of this book.

In particular I want to thank Claude and Barbara Duthuit for their crucial support, and also Maria-Gaetana Matisse and Paul Matisse for many kindnesses. The late Pierre Matisse, who always showed me such exemplary kindness and generosity, also provided me with a good deal of useful material that has been incorporated here as well as into my other writings about his father.

I also want to thank Sharon Dec for her unfailing helpfulness, Desirée Koslin for her timely translations of Danish and Swedish texts, and Charlene Woodcock, my editor at the University of California Press, for her enthusiastic support of this

project. My thanks also go to William H. Gerdts for generously sharing his knowledge of the American reception of Matisse, to Steven Harvey for making available
the manuscripts of Dorothy Dudley Harvey, to Francis Naumann for his good will
and generosity in making available documentary material, to William O'Reilly for
his helpful comments, and to Frank A. Trapp for making available to me the notes
from his 1950 interviews with Matisse.

Special thanks go to two friends who are also exemplary colleagues: John Elderfield and Dominique Fourcade, who have so generously shared their knowledge
and resources with me. Finally, I want to thank Denyse Montegut and Lisa Small
for their extensive help with the preparation of the final text.

~

This book is the first volume in the Documents of Twentieth Century Art series at
its new home at the University of California Press. The series is a continuation of
the one founded by Robert Motherwell in 1944, of which I have been co-editor
since 1979. The inclusion of this book in the series is especially gratifying. I first became acquainted with Robert Motherwell after he had reviewed *Matisse on Art* for
the *New York Times Book Review* and a friend suggested that we might enjoy knowing each other. From this developed our friendship and working relationship, during which he often remarked how much he regretted that Matisse's writings were
not in the Documents series. Now they are, and I believe that he would be as
pleased by this as I am.

Introduction:

A Life in Words and Pictures

Because Matisse is known as perhaps the most purely pictorial painter of his time, it is easy to overlook his involvement with words—both as a writer and a speaker. Virtually everyone who knew him remarked on his penchant for conversation. Fernande Olivier remembered the way he would "argue, assert and endeavor to persuade. He had an astonishing lucidity of mind: precise, concise and intelligent."[1] According to Leo Stein, Matisse was "capable of saying exactly what he meant when talking about art . . . a rare thing with painters."[2] In 1911 Ernst Goldschmidt (Text 7, below) described him as "an able writer, and a compelling speaker," and added "I have heard his enemies maintain that his fame is due solely to his eloquence."

Matisse's propensity to recount and explain is especially well reflected in the numerous interviews contained in this book. In his public statements he generally preferred to be represented by the spoken rather than written word and, as we shall see, he frequently used the interview as a stage for enunciating his ideas rather than as an informal encounter.

But when he did write, Matisse did so in a focused and lucid way. His prose, like his painting, is clear and concise. It also appears deceptively simple at first, though on closer scrutiny it resonates with complex overtones. He seems to have considered the artist's essay a distinct genre, a combination of autobiographical reminiscence and expository essay. This is perhaps why he makes relatively few literary references in his writings, which taken by themselves give the impression that his reading was fairly limited. In fact, the opposite is true. Throughout his life, Matisse read widely and deeply: poetry, essays, novels, philosophy, and theology. He had a solid classical education (he read both Greek and Latin) and his analytical turn of mind had been sharpened by his legal training. Pierre Matisse remembered his father literally being surrounded by books and noted that Matisse's profound respect for language was part of his concern for clarity of expression in general. This concern was so deep that in the early 1920s, Pierre Matisse was astonished to find his father reading a book on how to write clear French because he thought it would help him with his painting.[4]

And yet, despite his enthusiasm for explaining and clarifying, Matisse refused to consider himself a writer and even declared an aversion to expressing himself out-

side of his paintings. In talks with his students, in letters, and even in published statements he repeatedly said that verbalization about painting was at best futile, at worst harmful. When he sat down in 1908, at the age of thirty-nine, to write "Notes of a Painter" (Text 2), his first published essay about his art, he stated his misgivings in the first sentence: "A painter who addresses the public not just in order to present his works, but to reveal some of his ideas on the art of painting, exposes himself to several dangers. . . . I am fully aware that a painter's best spokesman is his work." Three years later, when Wassily Kandinsky asked him to contribute an essay to *The Blaue Reiter Almanac*, Matisse refused, saying that "one must be a writer to do something like that."[5]

One of Matisse's most persistent notions about the relationship between artists and words was that an artist should in effect render himself incapable of speaking so that he could better pursue his art. "A painter ought to have his tongue cut out," he told an American journalist in 1930, using an image that would become something of a leitmotif in later years.[6] "I used to say to my young students," he told a radio interviewer in 1942 (Text 28), "'You want to be a painter? First of all you must cut out your tongue because your decision has taken away from you the right to express yourself with anything but your brush.'" And in the first sentence of *Jazz* (Text 37), the most idiosyncratically personal of his published writings, he asks: "Why, after having written, 'He who wants to dedicate himself to painting should start by cutting out his tongue,' do I need to resort to a medium other than my own?" And yet he did resort to this other medium repeatedly, especially as he got older. Despite his disclaimers, he felt increasingly compelled to explain what he believed was important for an artist to know and to do.[7]

But this was only the tip of the iceberg. For Matisse was also a compulsive letter writer, and anyone who has studied his letters must be deeply impressed, even amazed, by the energy with which they were written. By this I mean not only the free-wheeling flow of his thoughts and his remarkable candor (in sharp distinction to his public utterances), but also his physical manner of writing: the way the handwriting tends to start out spaciously at the top of the page and become smaller as it moves toward the bottom, as if compressing itself in anticipation of the end of the sheet; the way the writing sometimes spills over and squeezes itself into the margins or turns a somersault and continues upside down on the top of the page. Even the punctuation is swept up in the onrush of thought—dashes and hyphens in place of periods at the ends of sentences and capital letters missing from the beginnings of what seem to be new sentences.

Moreover, the sheer bulk of the letters that Matisse wrote year after year to family, friends, and acquaintances makes us realize that he cannot have produced such a prodigious outpouring of letters—sometimes writing long missives to several people on the same day—unless he spent at least an hour at it on a daily basis. These

letters (which one hopes the Matisse family will someday allow to be collected and published) comprise an extraordinary human testament, a kind of counterpoint to the largely artistic concerns that Matisse wrote about in public forums. Taken together the letters form a stream-of-consciousness diary, made all the more interesting by the slightly different angles from which the same events are recounted to different people.[8] Like his paintings, the letters are part of his constant need to "discharge my emotion," as he sometimes phrased it.[9]

Matisse's public writings are a different matter. If they are only the tip of an iceberg, they are also comprised of a somewhat more clarified or purified substance. Moreover, these writings are relatively few. Prior to 1935, he composed only a single text for publication, the seminal "Notes of a Painter." (Most of the other numbered Texts in this book are interviews; and even some of the published "statements" are from letters that Matisse, for one reason or another, chose to make public.)

Matisse wrote about most of the mediums he worked in, often in a vividly descriptive way; although, curiously, he did not say much about his sculpture, which in many ways he considered a more private medium than his drawings. Many of the writings are either occasional or were meant to serve a specific purpose, whether to explain or justify what he was doing at a given time or to accompany an exhibition of his works. The first two Texts in this book, for example, Apollinaire's 1907 interview/essay and "Notes of a Painter," attempt not only to explain the rationale behind Matisse's art but also to bring him to the attention of his potential public. They are, in a broad sense, attempts to further his career. In fact, despite Matisse's rather asocial behavior, he was surprisingly open to interlocutors. As evidenced in the Texts below by Estienne, Sacs, Goldschmidt, MacChesney, and Rey, during his early years Matisse seems to have been quite willing to have people who were curious about him visit his studio.[10] This is not to say that Matisse was merely self-serving; like any true believer, he wanted to spread the faith. But, nonetheless, these early interviews indicate a desire to be noticed, to have his importance affirmed. This wish was probably intensified by historical circumstances. As Matisse came into his own as an artist around 1908, a number of other *avant-garde* movements began to emerge that were perceived as being in direct competition with him—especially the Cubism of Picasso and Braque.

Of these three eminent School of Paris painters of the first half of the century, Matisse was not only the earliest but also the most persistent—and the most conscientious—writer about art, and he was the only one of the three who seriously taught painting for a time.[11] Matisse had a good deal of the pedagogue about him and, lacking the *enfant terrible* stance of Picasso or the conscious mysticism of Braque, when he felt impelled to discuss his art went about it in the direct, orderly, and reasonable way in which he approached painting and life—the same manner that had earlier led his fellow students to call him "the professor." He retained many

of the basic bourgeois values that he had grown up with and had no desire to *épater le bourgeois*. If he did outrage his bourgeois public, it was not because he took special pleasure in it, but because he was too true to his inner values and too self-absorbed to accommodate or try to please that public.

Matisse's published statements on art frequently reflect the evolution of his art, for in most cases exploration of new means is followed rather than preceded by a written statement; the writings are in this sense reflective rather than exploratory. The painter speaks of results rather than of theoretical possibilities. In this way Matisse's writings differ quite sharply from the intense systematization and theoretical specificity found in contemporary artist-writers such as Kandinsky, Paul Klee, or Piet Mondrian. Unlike these men, Matisse spoke almost entirely from his own experience. He generally avoided metaphysics and philosophical speculation as well as complicated nomenclature or demonstrations of specific theories accompanied by pedagogical drawings, diagrams, or charts.[12] His writings are more pragmatic than philosophical or technical, and he is most comfortable, and at his best, when he talks about the actual activity of being an artist.

Although Matisse's writings and statements span almost half a century, they have a remarkable consistency, largely because he pursued many of the same goals throughout his life, working out different ways to achieve them. The major themes are self-expression, freedom from formulas, reliance on direct experience and intuition, the use of simple means, and an awareness of working within a tradition. The writings reflect his conviction that art is a means of projecting the self's encounter with the world through imagery, an activity grounded in contemplation that serves as a kind of private religion. The artist develops his art by developing himself.

Chronologically, Matisse's published statements can be divided into two distinct groups. Before 1929 there were relatively few written statements or interviews, while after 1929, and especially after 1940, Matisse was more readily inclined to discuss his art and career. In the first group, Matisse's statements repeat or elaborate the ideas in "Notes of a Painter." But around 1929, when he began an intense new exploration and re-evaluation of his pictorial means, Matisse seems to have felt a real need to discuss his work and to affirm the continued relevance of his art.

"Notes of a Painter" reflected Matisse's need to distance himself from both Academic and Impressionist aesthetics by emphasizing personal expression over representation of supposedly objective surface appearances. Instead of seeking to depict what he called the "succession of moments which constitutes the superficial existence of beings and things, and which is continually modifying and transforming them"—an aesthetic he associated with the Impressionists—Matisse stated his goal as that of searching for "a truer, more essential character, which the artist will seize so that he may give to reality a more lasting interpretation." Between 1908 and the

end of the First World War, in particular, he struggled with the creation of symbolically charged imagery in a complex, metaphysically suggestive space, and his paintings sometimes verged on pure abstraction.

Around 1918, exhausted by the demands of his austere new formulations,[13] and responding to the general "call to order" that pervaded French thought after the war, Matisse abandoned the path he had been following and returned to a more optical way of working that was closer to the Impressionists. Instead of sustaining the symbolic, abstract equivalences for light and space that he had explored between 1904 and 1917, he placed renewed emphasis on the description of objects and textures and on rendering the fleeting effects of light and atmosphere. "I felt that this was necessary for me right now," he told Ragnar Hoppe in one of his rare interviews from this period (Text 10). "It was quite simply a question of hygiene. If I had continued down the other road, which I knew so well, I would have ended up as a mannerist. One must always keep one's eye, one's feeling, fresh; one must follow one's instincts."

Matisse's change in style coincided with his move to Nice and with his renewed interest in the Impressionists, especially Renoir, whom he met shortly after he arrived there. (He had gone to see Monet at Giverny only a few months earlier.) Whereas in earlier years he had framed his ambitions largely in relation to Cézanne—whom he called "a sort of God of painting" (Text 11)—he now frequently cited Renoir as an important source of inspiration. After 1918, the art of Renoir served as a kind of foil to Cézanne's austerity. When in 1919 Matisse told Hoppe, "I want to depict the typical and the individual at the same time, a distillation of all I see and feel in a motif," he was referring to a duality in his ambitions that could be characterized in terms of the polarity between the art of Cézanne and that of Renoir.[14]

During the 1920s, in what is often referred to as his "Nice Period," Matisse published no essays and gave few interviews. And this, I believe, was because in an important sense he had backed away from the position he had so clearly articulated in "Notes of a Painter." In fact, he had retreated to precisely the sort of Impressionist-related approach that he had criticized in that essay. In relation to the highest ambitions he had stated for his art, the paintings of the so-called Nice Period were not verbally defensible except as a necessary detour, and for several years he remained silent about them.[15] During this time, his stature also declined sharply among *avant-garde* artists and critics.

Matisse's "retreat" lasted until around 1930, when he went through a severe painting crisis and began to seek new expressive means. The Barnes mural commission presented an opportunity for doing so, and by 1931 he was working toward a more synthetic, decorative kind of imagery. The five statements he made to the critic Tériade between 1929 and 1936 (Texts 12, 13, 14, 17, 21) reflect this change in

emphasis. After having been enthralled by the charms of southern light and sensuous surfaces for over a decade, Matisse was uneasy about the direction his work had taken. He seems to have felt that he had moved backwards since the bold and daring works of 1904 to 1917—an opinion shared not only by his adversaries but also by many of his supporters.[16]

In these statements to Tériade, and in his 1935 essay "On Modernism and Tradition" (Text 20), Matisse draws an implicit parallel between his Fauve works and what he was then seeking, emphasizing the use of strong colors, the clarification of his visual sensibility, and the "purification" of his means of expression. Though during the 1930s Matisse became more willing to discuss his art, he still spoke about it in fairly literal terms. Not until "Notes of a Painter on his Drawing" of 1939 (Text 25) does he seriously begin to elaborate on the symbolic aspect of his forms. While in the 1908 "Notes of a Painter" he had emphasized the process of how he arrived at his forms, in the later statement he emphasized the result, the creation of expressive plastic signs. This idea, which runs throughout the late writings, is reflected in Matisse's paintings of the late 1930s and early 1940s, in which he represents objects with condensed sign-like forms.

In 1941, Matisse underwent surgery for cancer and almost died after a long series of post-operative complications that included two pulmonary embolisms and a severe case of flu. After his recovery, he spoke of having been "reborn" and of enjoying an unprecedented freedom of mind. "I learned an important lesson from this long illness," he told Gotthard Jedlicka a decade later, "a lesson that has been shaping my life ever since. The doctors gave up on you, I told myself, because they were convinced that you were going to die soon. Therefore, the time that you live from now on is a gift from life itself—each year, each month, each day. So from now on, you will do only what pleases you, without thinking about what others expect and want from you. Everything that I did before this illness, before this operation, gives the feeling of too much effort; before this, I always lived with my belt tightened. Only what I created after the illness constitutes my real self: free, liberated."[17]

The most direct evidence of this new sense of freedom is seen in his works in cut and pasted paper, and many of the ideas he expresses in later statements parallel the development of the increasingly abstract imagery of his cutouts. Throughout the 1940s, as Matisse gave increasing attention and energy to the cutouts, he verbally repeated the theme of keeping one's instincts fresh through contact with nature and avoiding clichés. This principle was all the more important to him now that he was working more from memory and imagination than from direct optical experience. Although he had anticipated the possibility of such a shift in "Notes of a Painter," in which he spoke of the equal value of working both from nature and from imagination, in the early 1940s he saw working without a model as a clear sign of progress, as part of a gradual progression that he had been engaged in during most

of his career.[18] Yet he remained somewhat ambivalent when he wrote about this issue. In his last essay, "Portraits," (Text 52) he still insists on the value of working from nature and painting "portraits." To some degree, this insistence may simply be a reflection of his concern that younger artists not abandon nature. But it also can be seen as part of a larger strategy to rationalize an unresolvable conflict. For, although Matisse insisted throughout his career on painting what he saw, one of the marked characteristics of his works is that they represent things in a way that does not correspond to how most people actually see them.

This contradiction can be partially explained by the particular way in which Matisse thought about "seeing." He believed that it was crucial for an artist to avoid preconceptions when looking at things. Hence his notion of "Looking at Life with the Eyes of a Child" (Text 51), which to some degree echoed the ideal of the innocent eye espoused by the Impressionists. Unlike the Impressionists, however, Matisse emphasized the *imaginative* and even the *ethical* aspects of seeing, rather than simply the physical process. For him, imagination began in the eye and was inseparable from vision. And even more germane in the present context, Matisse's desire to avoid preconceptions reflected his own mistrust of words. For once an experience was named, some of the life went out of it, and it became less viable. Like "ready-made images," words could be "to the eye what prejudices are to the mind."

"The effort needed to see things without distortion," Matisse asserts in that same late text, "demands a kind of courage; and this courage is essential to the artist, who has to look at everything as though he were seeing it for the first time: he has to look at life as he did when he was a child and if he loses that faculty, he cannot express himself in an original, that is, a personal way." What Matisse sought in his paintings was a pre-verbal means of expression, innocent of and resistant to analytical thought. He believed that seeing is in itself a creative process, and that what an artist sees must be profoundly affected by what he thinks and feels about what he sees—providing that he has been able to keep his feelings and intellectual curiosity sufficiently alive. Ideas and feelings are discovered in the course of working, along with imagery. And if Matisse returns repeatedly to the same subjects, he is obliged to rediscover them and reinvent them pictorially, as both he and his subjects move through time. "I do not repudiate any of my paintings," he wrote in 1908, "but there is not one of them that I would not redo differently, if I had it to redo."

"Copying nature" in this context has a very particular meaning for Matisse. For while he repeatedly rails against "copying nature stupidly," as students were taught to do at the École des Beaux-Arts, he nonetheless insists that he paints what he sees. One might say that he regards his particular vision as privileged because he is able to see "everything as it really is" (Text 51). But as with Wallace Stevens's "Man with the Blue Guitar,"

Things as they are
Are changed upon the blue guitar.

But that is only part of the story. What is also involved here is Matisse's need to maintain a necessary fiction that lends objective authority to his pictures by insisting that we, the viewers, agree that he does see things "as they really are." This deflects us away from the artist, and away from certain aspects of the works themselves, and back to nature.

This Matisse seems to have desired very much. For example, he almost never discussed the specific symbolism in any of his works, and he gave surprisingly bland—not to say evasive—responses to inquiries about such symbolism.[19] Although he was deeply interested in philosophy and metaphysics, he denied any metaphysical content in his work and even had a major falling out with his son-in-law, Georges Duthuit, based partly on what he considered to be Duthuit's excessively expansive and intrusive interpretations of his work.[20] Matisse cultivated instead writers like Raymond Escholier and Gaston Diehl, who were content to confine themselves to descriptive accounts of his career that were nearly devoid of iconographical or psychological interpretation. Even Alfred Barr was caught up in this syndrome. Dependent as he was on Matisse and his family for much of the information that he collected for his landmark 1951 study of the artist, Barr was extremely discreet in his discussion of Matisse's life and equally cautious in his interpretation of Matisse's work.[21]

Matisse tried so hard to impose his will on discussions of his work that in effect he was asking for his interpreters' tongues to be cut out. And this brings us back to Matisse's use of this extraordinary formulation in relation to himself.

One of the most curious things about this statement is how little attention has been given to it, even though it is highly charged with psychological overtones. In this it is not unlike other aspects of Matisse's career that long went unquestioned because Matisse said they were so—such as his assertion that he painted Odalisques because he "had seen them in Morocco" (Texts 12, 48).

In fact, leaving aside for now the connotation of castration, the notion of the artist cutting out his tongue seems to be especially revealing of Matisse's attitude toward the relation between words and pictures—or in any case, toward words and *his* pictures. For words uncover what has been left unspoken in pictures—what perhaps cannot or should not be spoken—and direct our attention to what has escaped attention, perhaps even to what is *meant* to escape attention.

In fact, this is the way many of Matisse's best pictures are put together, in terms of shifting the viewer's attention from one part of the picture to another and of shifting the viewer's sense of what is most important.[22] In *Harmony in Red,* the nominal subject of the painting, a woman arranging flowers on a table, deflects us

from the deep subject, which is articulated by the play of the arabesques in relation to the flowers and landscape. In *The Red Studio*, the pictures on the wall deflect us from the drama of the statue of the woman being encircled by the plant on the table, and this vignette in turn deflects us from focusing too closely on the obvious symbolism of the clock or on the individual pictures within the picture. Matisse's paintings usually avoid a single "focal point" because they are organized in such a way that one thing always acts as a foil for something else. Wherever you look, you should also be looking somewhere else at the same time.

This is something that Matisse cannot point out in words, for it would make his pictures subservient to his verbal descriptions of them and focus our attention on certain aspects at the expense of others. Instead, Matisse uses words as another means of deflection—away from what is really happening in his paintings, away from the ways the subjects interact with how they are rendered, perhaps even away from the simple fact that people don't really look the way they do in his pictures. But most importantly, his words deflect us from drawing a logical conclusion from what he repeatedly tells us. For among the many paradoxes in Matisse's writings, the most striking of all is that although he insists that his works are based on self-expression, he wants us to believe that they tell us *nothing about himself*. It is as if he is saying that the artist should cut out his tongue in order to not give the game away—in order to not reveal that he is revealing himself.

Just how conscious of this Matisse may have been is hard to say; it is possible that he was able to hide this self-protective motive from himself entirely. That he was a shrewd observer of humanity was a commonplace among those who knew him. It was this knack for observation, in fact, that allowed him to be such a good mimic. But in relation to himself he seems to have had an extraordinary, even *willful*, imperviousness to self-exposure. One may be charmed by this, call him "pre-Freudian," or say that he was a nineteenth-century man. But however we rationalize it, this imperviousness to the implications of his imagery is quite extraordinary.

It is especially strong in relation to the way he expresses his sexuality, often with a disarming but apparently unconscious directness. (It seems indeed to have been unconscious, because if he became conscious of it he would most likely have been inhibited from expressing it at all.) In his 1918 *Self Portrait*, for example, the paintbrush he holds in his palette hand (set next to his meaty thumb) thrusts across his trousers like an erect phallus. Within the context of the total picture this is especially startling, given the way he represents himself, neatly dressed in suit and tie and engrossed in his work. In a number of his 1935–1937 line drawings, the artist's reflection in the mirror seems to be ravishing or physically dominating rather than merely drawing the nude model. And in his writings, he speaks of "discharging" or "releasing" his emotion in nearly sexual terms. And yet he seems to be blissfully unaware of all this. In cutting out his tongue, he has in effect put out his eyes. But this

"blindness" is not so much a way of avoiding the visual as it is a means of keeping the visual unattached from the verbal.[23] By consciously denying, even to himself, that his paintings could be acts of psychological self-exposure, he ensures that he can continue to express himself freely in them.

~

Schopenhauer said that "thoughts die the moment they are embodied by words"; to which Matisse might have added, they also lie.

In fact, it might be said that when artists write, they lie. Indeed, they have to lie; in part because (as Matisse himself was so well aware) what is essential is in their pictures and cannot really be expressed in words; and in part because being an artist is to some degree an act of self-invention. Certain truths either have no place in that invention or are dangerous to its sustenance.

Sometimes these misrepresentations are overt, but often they are acts of omission or abbreviation, as when Matisse exaggerates the amount of time he worked at an onerous job when he was impoverished (see Text 26), or when he glosses over the deep uncertainties of his student years, neglecting to mention that he failed the entrance examination to the École des Beaux-Arts. In fact, his constant insistence on the destructiveness of the teaching at the École des Beaux-Arts, even when the École no longer played an important role in French art, seems indicative of a deep and unresolved personal conflict.

Throughout his life Matisse retained more than a little of the conformist attitude of the *petite-bourgeoisie* from which he came, and whose values had been drummed into him as a child. Throughout much of his life he was torn between respect for authority and a need to rebel, between affirmation of tradition and a need to break with it, between being obliged to "copy nature" and being able to "express himself." If the École des Beaux-Arts played a large role in his personal mythology it is in no small measure because it came to stand for what he himself had escaped becoming and at all costs did not want to be drawn back into. It was a symbol of the small-minded, suffocating atmosphere of Bohain, of the narrowness of his own family's values, and perhaps even of the petty side of himself. But as much as he may have detested it, he was never completely free of it. Despite his position as a leader of the *avant-garde*, he felt compelled, even late in life, to advise young artists not to forget the importance of technical proficiency, of discipline, or of studying nature—traditional virtues that reflected his own training at the École des Beaux-Arts. The forces and influences that he had been subjected to in the earliest part of his training continued to make themselves felt throughout his life.[24]

The values of the École des Beaux-Arts also represented what Matisse would have become had he lived what he called "my normal life as a man."[25] They were the opposite of what, by heroic effort, he made himself into. Yet throughout most of his life he actively cultivated the inverse image of his inner, artist self. Instead he

chose to present himself as the "normal" man, the seemingly uncontroversial, reasonable man—"not involved in some extremist adventure," as Apollinaire put it (Text 1)—a man who behaved like a professor or physician. "Oh, do tell the American people that I am a normal man," Matisse tells the departing Clara MacChesney in 1912 (Text 8), apparently without irony, "that I am a devoted husband and father, that I have three fine children, that I go to the theatre, ride horseback, have a comfortable home, a fine garden that I love, flowers, etc., just like any man."

The invention of Matisse the artist meant to some degree reinventing Matisse the man, or in any case, shielding the artist with an effective mask so that he could concentrate on "speaking" through his paintings. The way in which he avoided discussing deep personal feelings became so much a part of his public persona, along with his highly developed sense of privacy and propriety, that he was frequently believed not to have any strong feelings. And although we know something about his personal conflicts because he spoke of them in letters to intimates, they are virtually absent from his public statements. Only once, in an interview that remained unpublished until after his death, did he drop his mask of calm acceptance, equilibrium, and unruffled goodwill. And then when he did so, he was unable at first to speak about his feelings except in the third person, only shifting back to the first person at the end of the statement, as if to acknowledge reluctantly that he was indeed speaking about himself. "If people knew what Matisse, supposedly the painter of happiness, had gone through, the anguish and tragedy he had to overcome to manage to capture that light which has never left him, if people knew all that, they would also realize that this happiness, this light, this dispassionate wisdom which seems to be mine, are sometimes well-deserved, given the severity of my trials."[26]

~

Another subtle strategy of deflection, one that is quite striking within the present context, is Matisse's use of other people to draw him out in interviews, which allowed him to set his ideas in a framework from which he could psychologically distance himself. In some cases, one could even say that the interviewer was a mask through which Matisse could speak without undue self-exposure. Among these masks one was especially effective, the mask named E. Tériade.

Starting in 1929 and lasting until nearly the end of his life, Matisse made a series of important statements to the Greek-born critic and editor who for several years acted as his principal spokesman.[27] These statements were especially well-timed to coincide with important moments in Matisse's career. In 1929, as Matisse began to move away from the naturalism that characterized his paintings of the 1920s, he prepared for this change with an extended statement to Tériade, which was published in an interview format along with four specific questions and answers (Text 12). A year later when Matisse returned from America, where he had been offered a commission to do a mural for the Barnes Foundation, he gave another "interview"

to Tériade, in which he discussed his recent travels and praised the Barnes Foundation (Text 13). In fact, this particular text was the product of three early-morning meetings between the two men, which occurred almost immediately after Matisse returned to Paris.[28] It seems that this text, and presumably others, was in a sense a construction, a collaborative effort in which the artist used the interviewer not only as someone who wrote down what he said, but also as someone who helped give form to his thoughts and ideas—performing that most accommodating of tasks by asking exactly the right questions and giving each response exactly the right weight and shape for the occasion at hand. In a 1931 interview with Tériade (Text 14), Matisse described his relationship to Cubism, coinciding with the showing of his largest Parisian retrospective. In 1933, Tériade included Matisse in a group of artists (including Braque, Picasso, Miró, and Dali) being asked about the "fundamental questions that entirely dominate modern painting" (Text 17). And in 1936, Tériade communicated two of Matisse's most important statements about Fauve painting and color, which helped relocate Matisse's relevance to contemporary painting in general (Text 21). At this time, the new image of Matisse was successfully launched and for fifteen years after the mask remained silent (though active behind the scenes). Then, in 1951, Tériade combined fresh interview material with excerpts from earlier texts and published "Matisse Speaks" (Text 48), to coincide with the artist's major American museum retrospective.

Although Tériade probably played some role in helping to formulate, or in any case to edit, these statements, that role is made transparent in some places and is given particular opacity in others. That is, Tériade is quite visible as the external agent who provides the occasion for posing questions to Matisse, hence relieving the artist of seeming to actually want or need to explain himself; Tériade rather than Matisse seems to be setting the agenda. But at the same time Tériade remains the supposedly neutral, apparently transparent medium for conveying Matisse's inner monologue. This makes it seem as if Matisse is just speaking his mind without any particular *motivation* for addressing the public. Tériade allows Matisse himself to remain neutral or disengaged. Moreover, in the statements made during the 1930s, Tériade acts as a screen for one of Matisse's glaring omissions, namely the important role Surrealism played in his thought and work during the last two decades of his life.

Matisse's distaste for the Surrealists is well known, as is evident in the disdainful reaction noted by Henry Russell Howe in 1949 (Text 42).[29] But in fact, during the two decades before 1949 Matisse had had a fruitful encounter with Surrealism—though one that was so complex and psychologically charged that he preferred to downplay or even ignore it. Matisse's acquaintance with André Breton, the most important member of the Surrealist movement, was famously problematical. In 1928 Breton singled out Matisse and Derain as "disheartened and disheartening old

lions," whom he characterized quite wickedly: "Leaving behind them the forest and the desert, which they do not even remember with nostalgia, they have entered the tiny arena of gratitude towards those who have broken them in and throw them their food. What surer testimony than a Derain *Nude* or yet another Matisse *Window* to the truth of Lautréamont's dictum that 'not all the water in the ocean would suffice to wash out one drop of intellectual blood'? So, will these men never stand on their own feet again? . . . I should like to discuss so total a loss at greater length. But what is the point? It is too late."[30]

At the time of Breton's devastating attack, he and Matisse had known each other for a few years and were acutely aware of how incompatible they were. Back in 1922, Man Ray had recounted how they argued "like two men who spoke different languages," and expressed his amused astonishment at how old-fashioned Matisse was.[31] Matisse, as might be expected, harbored no small amount of ill will toward Breton as a result of his criticism. But some twenty years later, in 1948, through the intermediary of Tériade, the two men began to see each other in a cordial, if somewhat cautious way. Tériade had asked Breton to write an essay about Matisse for a forthcoming issue of *Verve*, and this led the two former adversaries to become involved in a series of searching conversations in which they seemed to reach some sort of mutual understanding. Breton wrote the essay, which Matisse thought was "good," but it was never published "because the differences of opinion between the two men proved greater than the points on which they agreed."[32] Around this time Matisse told the Dominican monk, Brother Rayssiguier, who was working with him on the Vence chapel project, that Breton was "the father of Surrealism and also its gravedigger." Matisse added, "In fact, Lautréamont is the father. Nietzsche ruined them. They're the kind of people who force themselves to see things in a certain way. They create their own truth."[33] A few days later, Matisse wrote a letter to Rayssiguier in which he said of the Surrealists: "Their method is to get rid of everything right at the outset. I only throw away old clothes little by little. Forty or fifty years ago I began walking toward something which called to me . . . it was like being drawn through a dark forest to arrive at the present, but without ever knowing in advance where I was going."[34]

Understandably, Matisse saw the Surrealists as being in direct opposition to his own beliefs about what a work of art should be and do. Surrealist painting tended to be literary and sometimes banally illustrational and, since it depended more on poetic associations and implied narrative content than on direct visual experience, it deemphasized the autonomy of the individual work of art, which Matisse held to be sacrosanct. Moreover, the Surrealists' program must have to some degree scandalized the *bon bourgeois* within Matisse, who no doubt further faulted them for having devised elaborate theories in order to explain and justify what he considered a negligible form of art. And most especially, Surrealism was hell-bent on *exposure*,

on bringing out the repressed and suppressed, especially in relation to sexual matters. The Surrealists were dead set against exactly those boundaries of discretion and self-protection that were so essential to Matisse.

But all of this does not mean that Matisse could not learn from the Surrealists—even if he did so the way he threw away old clothes, "little by little."

Matisse was helped in this by having a number of friends who were associated, or had been associated, with Surrealism. Matisse knew both Man Ray (who did his daughter's marriage photographs) and Tristan Tzara (for whom Matisse illustrated two books, in 1939 and 1946).[35] Matisse and André Masson became close in 1932, shortly after Masson's falling out with the Surrealists, and the two men spent a good deal of time together, discussing the role of free association in the creation of art.[36] Louis Aragon, one of the founders of the Surrealist movement (though he, too, broke with them in 1932 when he joined the Communist party), became extremely close to Matisse at the beginning of World War II when they were neighbors in Nice. And in 1948, when Matisse was again in touch with Breton, he suggested that Brother Rayssiguier read Lautréamont, telling the priest, "When you've got into it, you'll want to carry on."[37]

Significantly, Tériade was also closely involved with the Surrealists. The journal *Minotaure*—which he edited (his title was "artistic director") and for which Matisse did a cover design in 1936—was so closely associated with the Surrealists that it is still frequently referred to as a "Surrealist periodical." (Breton himself was a regular contributor.) Matisse's revealing 1933 statement about creativity (Text 17) and his well-known 1936 statements about returning to the "purity of the means" (Text 21) both appeared in *Minotaure* articles written by Tériade. In his introduction to the issue of *Minotaure* in which Matisse's 1933 statement appeared, Tériade emphasized what he called "*the unity of differences*" in French artistic creation at the time, and stated his intention of showing "the new and true face of constantly changing thought." Matisse's 1936 statements were included in an article by Tériade entitled "Constance du fauvisme," in which Tériade emphasized a revival of the "fauve spirit" among painters like Matisse, Picasso, and Bonnard, and asserted that both their kind of painting and another kind of painting that had a "more poetic origin" (i.e., Surrealism) came from similar sources, and that despite their differences they would one day be seen as participating in the same enterprise.[38] Tériade's contextualization of Matisse's statement is clearly meant not only to relate him to his earlier, more abstract work, but also to relocate him in relation to the Parisian *avant-garde* of 1936.

Tériade, of course, was deeply sympathetic to Matisse's position. In fact, although he believed that Surrealism had a necessary and salutary role to play in the revival of French painting, he personally preferred painting that (like Matisse's) relied on the autonomy of its own internal formal means, on what he referred to as

"its own skin."[39] In June 1936, he published an article in *Minotaure* in which he located Surrealist painting in relation to the tradition that Matisse represented (Matisse's 1936 statement would appear in the next issue of *Minotaure*). In this article, Tériade framed Surrealism not so much as a reaction against the grand tradition of French painting but as "a salutary reaction against an overly elaborated, academic, and undeservedly successful materialism, into which, as the result of their imitators' errors and shortcomings, Picasso's guitars, Cézanne's apples, and Matisse's interiors were sunk." According to Tériade, Surrealist painting was a means of establishing a new relationship between painting and poetry and of liberating painting from academic dryness. He saw it as forming "an astonishing ensemble of propositions, of researches and realizations that were still located at the border between the precise and the unlimited, of the immediate and the imaginary. It has a kind of cruel light, a consciousness made pathetic by the despair that it contains, which digs around in the intermediate regions of reality and the marvelous world of the irrational in order to enrich life."[40]

Matisse's awareness of the Surrealists' thinking is reflected in several of his writings and statements of the 1930s. In his 1933 statement to Tériade and in "Notes of a Painter on his Drawing" of 1939 (Text 25) he gives new emphasis to the role of the unconscious. In "Divagations" of 1937 (Text 23), he refers to Leonardo da Vinci's discussion of finding images in the random spots and cracks on walls, a text that was crucial to the Surrealists.[41] And near the beginning of a series of 1941 interviews with Pierre Courthion, which were supposed to be published as a book, Matisse gave an unprecedented description of one of his own dreams, a nightmare he had when he was a student at the École des Beaux-Arts.[42] Dreams, of course, were a major preoccupation of the Surrealists, and the imagery of some of the late cutouts is based on incongruous, dream-like poetic subjects similar to those of the Surrealists. (One of the earliest and most striking examples of this is "The Dream of the White Elephant" in *Jazz*). The cutouts also employ floating biomorphic forms that may be related to those in the paintings of Masson and of Miró, with whom Matisse became acquainted in the late 1930s and whose work "intrigued" him.[43] And the oceanic and floral themes in some of Matisse's large cutouts, such as *Oceania, The Sea* (1946) and *Parakeet and Mermaid* (1952), may well have been partly inspired by the works of artists such as Max Ernst, Miró, or Masson—or even by Lautréamont's famous, adoring passage about the ocean in *Chants du Maldoror*. Moreover, the cutouts in general may be described in the terms that Tériade used to describe Surrealism in 1936, as "researches and realizations that were still located at the border between the precise and the unlimited, of the immediate and the imaginary."

While Matisse's awareness of Surrealism clearly seems to have stimulated his growing awareness of the role of the unconscious in his creative process during the 1930s, and helped him to develop a greater freedom of expression, at the same time

his response to Surrealism also seems to have contained a strong counterreaction. To some degree, Matisse used some of Surrealism's own weapons as means to critique it. This kind of response is evident both in his statements and his art. His 1933 statement to Tériade, for example, although acknowledging the important role of the unconscious in artistic creation, ends with an implied rebuttal to the Surrealists, whose program was associated with a number of negations—what Matisse later called "getting rid of everything at the outset." Matisse's assertion in the concluding paragraph of this statement, that "one does not put one's house in order by getting rid of what one does not have, because that only creates a void, and a void is neither order nor purity," seems to refer directly to the Surrealists. Similarly, although he used oceanic and floral themes in his late cutouts that recall some of the Surrealists' subjects, Matisse's compositions can also be seen as implicit critiques of the Surrealists' ominous treatment of those subjects.[44] Matisse eliminates what Tériade called the "cruel light" and "despair" of Surrealism. In place of the disquieting Surrealist nightmare, Matisse insists on evoking a different kind of dream—that of the "earthly paradise."

~

The Surrealists' semiotic concerns may also have helped effect a shift in Matisse's attitude toward the use of a concept that was crucial to the development of his later art—that of the pictorial sign.

Around 1908, Matisse's use of a literary word like "*signe*" seems to have followed in a general way such writers as Guillaume Apollinaire (Text 1), who used terms such as "*écritures plastiques*" when referring to pictures. Matisse himself used similar terms in "Notes of a Painter" (Text 2), in which "*écriture claire*" appears along with "*signe*."

In "Notes of a Painter," however, Matisse used the word "sign" in the sense of "mark" to describe the cumulative process of building up a picture in terms of a balancing of brushstrokes. This was related to his notion that each individual brushstroke could function as a discrete sign related to a distinct visual sensation, and that a picture could be constructed as an ensemble of such quasi-abstract individual marks, which created a surface syntax through which the image was perceived. This concept had come to Matisse from Neo-Impressionism and from Cézanne. The component parts of such a syntactical system are of course quite relative, as the individual strokes serve to indicate visual sensations whose semantic meaning can change radically with their context. (A stroke of red, for example, could be part of a house, a tree, or a face, depending on where in a picture it was placed.) It was not until much later, after his encounter with the Surrealists, that Matisse used the word "sign" to denote *fixed* signs that would not be so dependent on the context in which they were set, that would remain more or less constant no matter where they were placed.

The next time Matisse spoke of "signs" was in 1932 when he was in the middle of his work on the Barnes mural, in which his imagery was becoming simpler, flatter, more direct, and more sign-like. It was then that he told Tériade, in response to the upcoming centennial exhibition of Manet's work, that he especially valued the way Manet had simplified painting and had been "as direct as possible." He then went on to say, "A great painter is someone who finds personal and lasting signs that express in plastic terms the spirit of his vision."[45] Although the notion of "plastic signs" is also referred to in "Notes of a Painter on His Drawing" of 1939 (Text 25), Matisse did not develop it further until 1942 when he made his best-known statement about signs in a conversation with Louis Aragon (Text 29). Then he said that "the importance of an artist is to be measured by the number of new signs he has introduced into the language of art," and asserted that "it was absolutely necessary that I prepare, by the search for signs, for a new development in my life as a painter." His new notion of the "sign" was directly related to the renewal of his art.

Matisse explained to Aragon that even though his conception of signs was fluid, he saw the creation of signs as integral to the creation of a picture. Ideally, the artist would be constantly creating new signs for each and every single thing in each and every single work: "A sign for each thing. This marks a progress for the artist in the knowledge and expression of the world, a saving of time, the briefest possible indication of the character of a thing. The sign." This ideal is one that Matisse took very seriously, although it meant different things to him in his earlier and later work. It is part of the underlying dynamic behind the extraordinarily broad range of his imagery, and it is one of the reasons that he made so much of wanting to preserve his innocence and spoke of "looking at life with the eyes of a child."

In his early years, when he usually worked directly from nature, it meant looking at his subjects freshly each time he sat down to paint them. During the last decade or so of his life, when he worked mostly from memory and imagination, it meant keeping his "instincts fresh" so that he would not settle for signs that were ineffective or unoriginal—for signs that were too much like words. In the earlier paintings, the signs that Matisse employs are quite varied, not only in their shapes and inflections, or "écriture," but also in the complexity of the ways in which they signify. His signs are not merely signifiers of things, they are also visual embodiments of feelings and concepts that cannot ordinarily be seen with one's eyes. Forms are made to signify different kinds of things in a variety of different ways, even within a single painting. In *The Red Studio* of 1911, for example, the arabesque-like form of the nasturtium branch that wraps itself around the sculpture on the table in the foreground is not only a condensed graphic signifier for the tendril and leaves of a plant, but also, within the context of the whole picture, a sign for the passage of time—as a displaced symbol of duration that gains meaning from its relation to the clock at the center. Its significance does not stop there, for it also functions as a sign

of growth and vitality, as the only living thing in the room; and it does so not only because of what it physically *represents*, but also because its springy curvilinearity and its green color set it off against the planarity and dense redness of the rest of the picture. Similarly, in *The Piano Lesson* of 1916, the arabesques at the bottom of the window signify both a tangible thing (the wrought-iron grillwork) and also abstract ideas (growth and music).

In Matisse's later work, however, especially in the cutouts, his use of signs becomes more codified. During the late 1930s, especially in his drawings, Matisse had become acutely aware of the arbitrary nature of the linear signs that he was using to represent the objects before him. And as he began to work increasingly from memory rather than direct perception, he also became more aware of what it was that remained constant beneath the appearance of endless flux—another way of characterizing what in 1908 he had called "the essential character" of things, by which he could "give to reality a more lasting interpretation." His new and emphatic focus on this constancy allowed him to invent relatively fixed signs that functioned somewhat like words, as in the sign for the fig leaf that he speaks of in *Jazz* (Text 37), which "cries out: Fig tree." What keeps the cutout forms vital and original is not so much their individual shapes as how they are placed in relation to each other. "With signs," Matisse noted in a letter to Aragon, "one can compose freely and ornamentally."[46]

When Matisse worked on the cutouts, the cutting process took place away from the surface on which the forms would be placed, and the cut forms remained temporarily uncommitted to a specific place within the total picture. Moreover, the act of cutting comprised only part of the total procedure; the artist still had to set his forms within a context. This delay between the creation of a form and its placement within the total picture was important in two ways: it introduced an element of discontinuity that was retained in the pictures themselves and that impelled the artist to create signs which could signify independently of their specific contexts; and it forced the artist to keep the elements of his picture balanced in his mind even before he could actually see them together. In *Jazz* Matisse says that "cutting directly into vivid color reminds me of the direct carving of sculptors." This seems at first to be a rather odd analogy, especially since Matisse himself had done little direct carving. But one thing that the process of making the cutouts has in common with carving is that in both cases the artist must work toward a conception that he cannot yet fully see.

The spatial discontinuity of the cutouts also follows a new structural paradigm, that of the all-over surface effect, which is more rhythmic and more intensely decorative than any format Matisse had worked with before. (It is also more cacophonous, and seems in fact to evoke a new musical paradigm, closer to jazz than to the orchestral effects that Matisse had spoken of earlier.) In them, form is translated into a kind of sign language that is similar, in its abstractness, to written language.

The individual forms function as signs not only in the connotative but in the semiotic sense. They are parts of an abstract system in which the artist can save, reuse, and rearrange specific forms the way a poet reuses and recombines previously discarded words, phrases, or images. Their imagery occurs, like that of poetry, "in the mind."

And yet, the cutouts are of course quite unlike written language in a number of ways, most notably in their lack of narrative specificity and in the constant small variations that exist even between similar signs. "I cannot determine in advance signs that never change," Matisse explained to Maria Luz, for "that would be like writing: that would paralyse the freedom of my invention."

In the cutouts Matisse not only achieved a new balance between color and drawing, but also a new (and very Matissian) equilibrium between word and image.[47]

~

"To sum up," Matisse wrote in 1939, "I work *without theory*. I am conscious only of the forces I use, and I am driven by an idea that I really only grasp as it grows with the picture" (Text 25). But of course when an artist says that he works without theory, that statement is in itself a kind of theoretical position. In fact, one could say that Matisse's theory was that one should try to work without theory. This is not meant as a sophistry, for this was in fact Matisse's actual *program*. Throughout his life, he wrote of the activity of being an artist as part of an ongoing process of self-discovery rather than as the search for the truth of a single method or style. And this, he felt, made his life all the more difficult. "It makes for a life of torment . . . when an acute sensibility keeps you from leaning on a method for support," Matisse wrote to his friend André Rouveyre in 1941, echoing a sentiment he frequently expressed.[48]

The premium that Matisse put on avoiding a fixed method is especially evident when he is compared to other important artist-writers of his time. Matisse's writings are distinctly more hermetic than those of his contemporaries; they are more intensely self-referential, and they promote a program of self-discovery over all other concerns. And because of his nearly mystical belief in the process of self-expression, and in himself, his writings also have a distinctly fatalistic aspect. When the true and original self is found, the artist discovers how good he is, or isn't, as the case may be: "Either one has it or one hasn't," as he wrote in 1939 (Text 25). This extraordinary self-confidence sometimes produced an ironic reaction among those who knew him, as in the painter Auguste Bréal's comment that "Matisse cannot get over the fact that he is Matisse. He can hardly believe his luck."[49]

Matisse's extreme emphasis on self-expression is also very paradoxical in that it defines reality by describing one's own reactions to it, suggesting that an artist's production is the somewhat involuntary result of his temperament, from which it follows that the artist must simply believe that he has painted what he has seen, "even when he deviates from it in order better to express it" (Text 2). This creates a kind of circular relationship between the self and nature, and between expression and

copying, that results in a kind of theoretical impasse.[50] But it is not a paradox that Matisse wanted to resolve; rather, he absolutely needed to leave it unresolved and open in order to permit himself to act.

Although Matisse's preoccupation with originality of style is not of course unique to him among modern artists, what *is* remarkable is the degree to which he insists on giving this solipsistic enterprise priority over virtually everything else. Even his later comments about the invention of signs can be seen as a conceptual refinement of this notion of self-expression (see Text 29). For as Matisse states it, the artist must find his *own signs,* signs that are unique to himself, that are a manifestation of his own personality, through which his deeply subjective responses to the world can be given form. Matisse is quite explicit about this, pointing out that a true artist cannot use another artist's signs because the true artist's work must emanate from the true self.

Because of their extraordinary egocentricity, Matisse's writings stand apart from those of his contemporaries even when they address similar issues. For example, when the painters Albert Gleizes and Jean Metzinger published *Du Cubism* in 1912, they also criticized the Impressionists for having given "credit to the incompatibility of the intellectual faculties and artistic feeling." Gleizes and Metzinger then create a genealogy for Cubism in which Cézanne is seen as the founding father, and in which they establish the dominance of a single, commonly-shared pictorial language rather than an individualistically "ambiguous" form of expression. (This is reinforced by the very notion of joint authorship of such an essay—which implies both a social consensus and a certain "objectivity"—notions that were utterly foreign to Matisse's way of thinking.) For Gleizes and Metzinger, as for Matisse, Cézanne points the way, but he does so in an exclusionary fashion: "He who understands Cézanne, is close to Cubism. . . . In other words, at present, Cubism is painting itself."[51] (This appropriation of Cézanne would turn out to have a lasting effect on Matisse's critical fortunes. Especially after he settled in Nice, his own early Cézannism was largely forgotten; instead he would be more frequently associated with Gauguin, while the Cubists would be seen as the inheritors of Cézanne's mantle.) Like many other writers of the time, such as Olivier-Hourcade, Jacques Rivière, and André Salmon,[52] Gleizes and Metzinger propound an essentialist view of painting in which a single style or method is taken to represent a higher reality, and in which there is implicitly a "single truth" to be discovered in objects—a position that would have been anathema to Matisse (along with their attitudes about historical inevitability, which echoed Signac's similar dogmatism).

The social and political engagements of the Futurists were even farther from Matisse's concerns, even though a number of their stated goals, such as the representation of invisible forces and the evocation of different states of mind and temporal duration were issues that Matisse was also dealing with in his paintings at the

time. But Matisse confined these concerns to his paintings and did not write about them.[53] Similarly Fernand Léger's writings also tend to argue for modernism as a general social and aesthetic phenomenon, and, in comparison to Matisse, one is struck by their relative lack of self-reference.[54] Léger, like the Futurists, also describes images of the modern world, which should be reflected in art: "Present-day life, more fragmented and faster moving than life in previous eras, has had to accept as its means of expression an art of dynamic divisionism. . . ."[55] In "Notes of a Painter," Matisse also says that a work of art must reflect the time in which it is made. But unlike Léger, he does not bother to define, even in general terms, what the characteristics of that modernity are; he leaves that task entirely to his paintings. Nor does Matisse place his art overtly within the continuum of a recognizable social or technological history, as does Léger, who repeatedly describes those aspects of modern life that painting should address: "The view through the door of the railroad car or the automobile windshield in combination with the speed, has altered the habitual look of things."[56] In fact, the literal content of Matisse's writings is profoundly ahistorical. Just by reading him, it would be virtually impossible to reconstruct any of the social or political history of his time, or even to get a clear idea of what his world looked like. His conception of art is quite literally other-worldly.

~

Matisse certainly would have agreed with Goethe that "genuine works of art carry their own aesthetic theory implicit within them and suggest the standards according to which they are to be judged."[57] And although Matisse put a high value on words, he understood that he expressed himself most profoundly and uniquely with visual form, which was his own true "language." So that at the same time that he felt compelled to speak he also realized that what was truly original and profound about him, and what was so persuasively communicated by his paintings, he could not express with words. If his paintings are poetic in the best sense, his writings are for the most part matter-of-fact and, with the partial exception of *Jazz*, avoid lyricism or "literary" effects as much as they avoid polemical arguments, theoretical programs, or metaphysical speculations.

Matisse paid a price for his avoidance of an explicit theoretical program, which for a long time disassociated his art from many of the broader intellectual discourses of modern painting. For many years his lack of a theoretical program was mistaken for a lack of intellectual rigor, even for a lack of artistic ambition or significance. The Cubists' claim on Cézanne, for example, went unchallenged for decades because they appeared to have clearly articulated a theoretical relationship between their art and his. Matisse's relationship to Cézanne, though in fact at least equally strong, was generally overlooked, even though it was Matisse, more than any other artist of his time, who followed up on the implications of Cézanne's invention of a new kind of pictorial space. Similarly, because Matisse made no verbal

claims about the metaphysical ambitions or symbolic content of his paintings—and in fact discouraged such readings—his paintings were for a long time taken to be merely charming and superficial. Because people frequently look at paintings "with their ears" rather than their eyes, and because Matisse so resolutely refused to *tell* his viewers what his pictures were supposed to "mean," those pictures were long regarded with uncomfortable silence.

If Matisse hesitated to analyze his pictures in order not to upset his own inner equilibrium, he also understood the risks involved in verbally overdetermining a painting's meaning at its origin, which could close off the range of its meanings rather than open them up. "There are so many things in art, beginning with art itself, that one doesn't understand," he told Pierre Courthion in 1931 (Text 16). "A painter doesn't see everything that he has put into his painting. It is other people who find these treasures in it, one by one, and the richer a painting is in surprises of this sort, in treasures, the greater its author."

Matisse had seen how weak artists often fell back on verbal explanations as a compensation for the lack of real substance in their art. André Lhote, Albert Gleizes, and Jean Metzinger would have been vivid examples of painters whose work seemed to have been suffocated by excessive critical ruminations and theorizing. Hence in 1953, when he was asked what advice he would give to young painters, Matisse responded, "To draw a great deal and not to reflect too much." [58] But at the same time that Matisse wanted to remain silent, he also felt a deep need to reflect, to explain, and especially to address himself to the artists of the future. For all the times he said or thought "cut out your tongue," he nonetheless remained quite vocal. For the one thing that words could do that paintings could not, was to *warn* people—especially young artists—about excessive facility, about mannerisms, about the need to "possess nature." The thing that Matisse felt his writings could do better than his paintings was *to teach*. The writings allow Matisse to explain the hard work, the knowledge, and the discipline that were behind the easy-looking results. "I have always tried to hide my efforts and wanted my work to have the lightness and joyousness of a springtime that never lets anyone suspect the labors it has cost," he wrote to Henry Clifford in 1948 (Text 41). "So I am afraid that the young, seeing in my work only the appearance of facility and negligence in the drawing, will use this as an excuse for dispensing with certain efforts which I believe necessary."

The depth of Matisse's conflicted feelings about speaking, which are so closely related to his mixed feelings about teaching, are especially well seen in his experience with the series of nine interviews he did with Pierre Courthion in April and May of 1941, which were supposed to be gathered in a book titled *Entretiens*. At the time of the interviews, Matisse was recovering from the illness that had almost taken his life and was particularly receptive to talking about the past. At the beginning of the sixth interview, for example, when Courthion noted that Matisse had

begun to overcome his initial reticence he asked Matisse whether the interviews weren't a form of relaxation for him. Matisse responded that talking about his art "answered a necessity" and marked "an essential stage of life." He even remarked on how useful it would be to have the confidential reminiscences of artists like Delacroix, Corot, Renoir, and Cézanne.[59]

By June, however, Matisse was beginning to have second thoughts. In a letter to Rouveyre he expressed doubts about the project and said that he wanted the book to be called *Bavardages* ("Chats") rather than the more imposing *Entretiens* ("Interviews"), which he felt was too formal. (He also considered *Convalescence* or *Une Convalescence* as the title, indicating the therapeutic effect that those "chats" must have had.)[60] Shortly afterwards, Rouveyre read the manuscript and advised him not to publish it. Toward the end of August, Matisse thanked Rouveyre for dissuading him from allowing the interviews to be published and made a revealing statement about how he viewed his writing in relation to his art: "I understand completely that what I have written, or that which I was made to write, doesn't represent me morally and gives only a banal side of myself. Besides I don't have to look for a language other than the one that is natural to me."[61]

This goes right to the heart of the conflict embodied in Matisse's writings. He believed that the better part of himself was in his paintings and not in his writings. In this he was surely right. But he was a man of extraordinary richness and complexity, and even the "lesser" part of himself is extremely interesting, lucid, and inspiring. As we read his writings and statements, part of what is so stimulating about them comes from something outside themselves: our realization that *these* writings are related to *those* paintings; that the man who said *this*, made *that*. And this sense of tangible presence is constantly enhanced by the sense they convey of Matisse's intense commitment to the day-to-day process of creating art.

In his earliest public statement (Text 1), Matisse suggested this commitment with the disarming simplicity that truly great practitioners of an art sometimes possess, a simplicity that amounts to a kind of personal mysticism: "When difficulties stopped me in my work, I said to myself, 'I have colors, a canvas, and I must express myself with purity, even though I do it in the briefest manner by putting down, for instance, four or five spots of color or by drawing four or five lines which have a plastic expression.'" This statement, in one sense so abbreviated as to seem obvious,[62] is yet truly a summation of much of the thought behind Matisse's painting, for it expresses the two most powerful factors from which his art grew: an absolute belief in his own powers, and an absolute belief in painting itself. It is no exaggeration to say that Matisse conceived of himself as the high priest of a religion, and that despite any doubts that came up along the way, the basic and unassailable assumptions of his life lay in his refusal, one might say his inability, to doubt either his faith or his calling. "There is only one thing that counts in the long run," he

told an interviewer in 1952. "You have to abandon yourself to your work. You have to give yourself over entirely, without thoughts, especially without afterthoughts."[63]

Matisse, like Cézanne, stands apart from the schools and systems that were contemporary with him. While for many of his contemporaries the history of art was like a vast encyclopedia of forms that, through modification, could be transposed into new forms or recombined into new entities, for Matisse the history of art served mainly as an impetus to new modes of vision. Thus while many influences can be seen at work in his paintings, they rarely possess the conscious eclecticism of Derain, Braque, or Picasso. Instead Matisse drew from the past what he needed to organize his own sensations before nature. And therefore, unlike Picasso, who created a whole new language of forms and shapes—of new characters, as it were, in the world of painted imagery—Matisse arrived at a new formulation of pictorial space itself, with light energy articulated by color.[64] It was precisely the openness of his attitude and his extreme flexibility that allowed him repeatedly to revitalize himself from the same sources and to advance a notion of pictorial space that can be seen as no less than the discovery of a new reality for painting.

It is this, above all, that made Matisse so important nearly a century ago; and it is this, above all, that makes him so important today.

A Note on the Texts

In the following collection, Matisse's essential writings and statements have been arranged chronologically, with each basic Text given a number to facilitate cross-references. The date given for each Text is, as a rule, that of the time of actual writing—or in the case of interviews, the date of the actual interview—when known, if it differs from that of first publication. Each Text is preceded by a brief introduction and is annotated to explain certain points, to identify persons and circumstances not generally known, and to call attention to significant parallels with other statements by Matisse and other artists.

A word should be said about the range of the Texts included, since the present volume is both more and less than a collection of Matisse's complete writings. The Texts are meant to comprise the body of Matisse's significant statements on art regardless of the manner of presentation, whether they were statements written by the artist, statements transcribed by someone else, or interviews. The present collection includes all of Matisse's own significant writings and most of the transcribed statements and interviews. The criteria for selection were determined by a desire to represent Matisse's thoughts on art as fully and deeply as possible. All the Texts presented here were either published during Matisse's lifetime or were approved by him before his death. Taken together, then, they represent his formulation of the principles and ideas behind his art, as well as his observations on his career, on the various art movements that became prominent during his lifetime, and on some problems of the arts in general.

Within this context, only limited use has been made of the artist's general correspondence, the greater part of which is in any case not presently available for publication. Most of his letters to friends and relatives were concerned with daily affairs and problems, and those letters that deal with his art often repeat or echo public statements. The available letters have, however, been carefully examined and are quoted in the footnotes when they seem relevant to the issues being discussed; a similar use has been made of quotations from other sources, such as unpublished drafts of written texts and published variants of similar ideas.

In an attempt to ensure maximum consistency and accuracy, virtually all the foreign language Texts have been retranslated expressly for this book; and except for a

few cases indicated in the footnotes, all the translations are my own. Such diverse writers as George Moore and Vladimir Nabokov have argued that translations should sound like translations, a feeling that I share. In my translations, I have tried to preserve the original sense by closely following, whenever possible, the phrasing and wording of the originals. In many instances gallicisms have been retained in order to preserve some of the vividness of phrasing, although when necessary I have transposed person or tense to conform to more natural English usage.

For certain commonly used words that have cognates in English, I have generally used the cognate rather than a more commonly employed English equivalent. Thus when Matisse uses *accord*, for example, I often translate it as "accord" rather than as "harmony," and for *rapport* I frequently use "rapport" rather than "connection" or "relationship." Similarly, I generally retain "plastic" for *plastique*, which has no real English equivalent, and "drawing" for *dessin*, even when Matisse uses the word in a context where one might more normally use the English word "design," since there is no real equivalent in French for this particular distinction between "drawing" and "design." Especially problematical is the word *esprit*, which Matisse usually uses in the sense of "mind" but occasionally employs in a way that suggests more than just mental involvement; in those instances I have used the English "spirit," which better conveys this broader connotation.

Throughout most of this book words such as Fauve, Impressionism, and Neo-Impressionism are usually capitalized. But within the Texts themselves, exceptions are generally made in order to follow the usage in the original texts; whatever inconsistency this creates simply reflects that of the originals, which appeared in various kinds of publications over an extended period of time.

In order to provide readers with convenient access to the French originals of the most important texts, eight of them are given in an appendix.

1

Interview with Guillaume Apollinaire, 1907[1]

In December 1907 the poet and critic Guillaume Apollinaire published an essay based on recent conversations with Matisse. The direct quotations in this essay are Matisse's earliest published statements, and they set the stage for much of what he would say in the future.

While Apollinaire's style is lyrical ("When I came to you, Matisse, the crowd had looked at you and as it laughed you smiled"), Matisse's own statements are marked by the calm sobriety that was to characterize most of his writings and interviews.[2] Together, he and Apollinaire touch upon many of the themes that were to preoccupy Matisse in the coming years: his interest in purely pictorial expression rather than in literary or narrative content; his concern with self-expression, and the freeing of instinct; his desire to return to basic forms and processes; and his emphasis on reasonableness and an acute awareness of the past—particularly on his own position in relation to both the European and non-Western traditions. (The association of Matisse's name with various kinds of non-Western and "primitive" arts would persist throughout much of his life.)[3]

Most of what Matisse says here is fairly general; he gives little attention to specific theories of art, and concentrates instead on the process involved in becoming an artist, which he equates with self-discovery—as when he relates how he found his artistic personality by looking over his earliest works, and how he made an effort to develop it by relying on "instinct" and by returning always to "fundamentals." This emphasis upon fundamentals is of particular interest, for it is a point that Matisse was to return to again and again.

At this time Matisse was often accused of being overly eclectic, and especially of having been too much influenced by the art of Cézanne; thus, both courage and a certain defensiveness may be noted in his statement that he never avoided the influence of others. This anticipates Matisse's later statement of his belief that the act of creation is a synthesis of the individual's relationship to the art that has come before him and his own confrontation with nature.

INTERVIEW WITH GUILLAUME APOLLINAIRE

This is a tentative essay about an artist in whom are combined, I believe, the most tender qualities of France: the strength of her simplicity and the gentleness of her clarity.

There is no connection between painting and literature, and I am determined not to establish any confusion in this regard. The aim of Matisse is plastic expression in the same way that lyric expression is the aim of the poet.

When I came to you, Matisse, the crowd had looked at you and as it laughed you smiled.[4]

They saw a monster, there where a wonder was taking place.

I questioned you and your replies expressed the reasons behind the equilibrium of your sensible art.

<center>∼</center>

"I have worked," you told me "to enrich my mind by satisfying the diverse curiosities of my spirit, striving to know the different thoughts of ancient and modern masters of plastic art. And this study was also material, because I tried at the same time to understand their technique."

Then, having poured me some *rancio* liqueur you had brought back from Collioure, you tried to trace for me the vicissitudes of this perilous voyage of discovering your own personality. It proceeds from science to consciousness, that is to say to the complete forgetting of everything that is not in your own self. How difficult! Tact and taste are here the only policemen who can brush aside forever what should no longer be encountered along the way. Instinct offers no guide. It got lost and one is trying to find it.

"Then," you said, "I discovered myself by considering at first my earliest works. They rarely deceive. There I found something that was always the same and which at first glance I thought to be a monotonous repetition in my pictures. It was the manifestation of my personality, which appeared the same no matter what different states of mind I passed through."

Instinct was recovered. You finally subordinated your human consciousness to natural unconsciousness. But this took place at its own good time.

What an image for an artist: the omniscient and almighty gods, but subjected to destiny!

You told me: "I strove to develop this personality by counting above all on my instinct, and by frequently returning to fundamentals. When difficulties stopped me in my work I said to myself: 'I have colors, a canvas, and I must express myself with purity, even though I do it in the most summary way by setting down, for example, four or five spots of color, or by drawing four or five lines that have a plastic expression.'"

You have often been reproached for this summary expression, my dear Matisse, by those unaware that you have thereby accomplished one of the most difficult tasks: to give a plastic existence to your pictures without the aid of the object except as it arouses sensations.

The eloquence of your works comes above all from the combination of colors

HENRI MANGUIN. — La Sieste.

GEORGES ROUAULT. — Forains, Cabotins, Pitres.

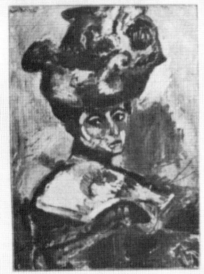

HENRI MATISSE. — Femme au chapeau.

ANDRÉ DERAIN. — Le séchage des voiles.

LOUIS VALTAT. — Marine.

HENRI MATISSE. — Fenêtre ouverte.

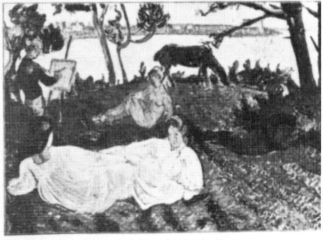

JEAN PUY. — Flânerie sous les pins.

1. The 4 November 1905 issue of *L'Illustration* published reproductions of works from the 1905 Salon d'Automne, where the term "fauve" was first coined. Two of Matisse's paintings are included: *The Woman with the Hat* (a portrait of Mme Matisse), and *Open Window, Collioure*.

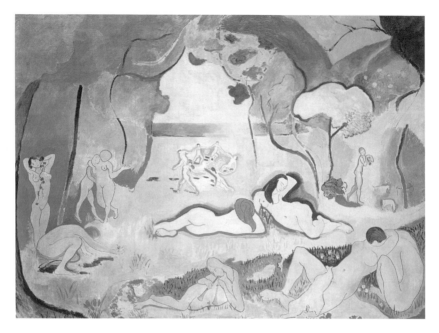

2. *Le Bonheur de vivre,* 1905–1906. This large, brightly colored pastoral scene, frequently referred to as "The Joy of Life," was one of Matisse's most famous and most frequently discussed early paintings.

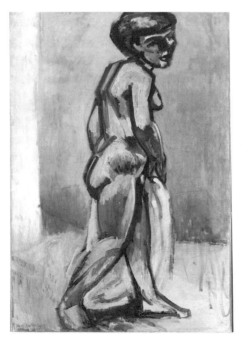

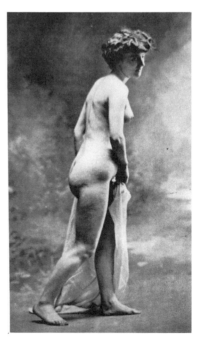

3. *Standing Nude,* 1906–1907. This painting was used as one of the illustrations for "Notes of a Painter" (Text 2).

4. Photograph used by Matisse for *Standing Nude.* Around this time, Matisse sometimes based his paintings on photographs rather than on live models, a practice he alluded to in 1908 (Text 3).

and lines. This is what constitutes the art of the painter and not, as some superficial thinkers still believe, the simple reproduction of the object.

～

Henri Matisse makes a scaffolding of his conceptions, he constructs his pictures by means of colors and lines until he gives life to his combinations, until they become logical and form a closed composition from which one cannot remove a single color or line without reducing the whole to a haphazard encounter of a few lines and a few colors.

To make order out of chaos, that is creation. And if the goal of the artist is to create, there must be an order for which instinct will be the measure.

To one who works in this way the influence of other personalities can do no harm. His certitudes are internal. They come from his sincerity and the doubts that bother him become the source of his curiosity.

"I have never avoided the influence of others," Matisse told me. "I would have considered this cowardice and a lack of sincerity toward myself. I believe that the personality of the artist develops and asserts itself through the struggles it has to go through when pitted against other personalities. If the fight is fatal and the personality succumbs, it is a matter of destiny."

As a result, all formal languages [*écritures plastiques*]: the hieratic Egyptians, the refined Greeks, the voluptuous Cambodians, the productions of the ancient Peruvians, the statuettes of African negroes proportioned to the passions that have inspired them, all may interest an artist and help him to develop his personality.[5] It is by incessantly having his art confront other artistic conceptions, and by not closing his mind to the arts related to the plastic arts, that Henri Matisse—whose personality is so rich that it might have developed in isolation—has attained the greatness and the confident conviction that distinguish him.

But, though curious to know the artistic capacities of all the human races, Henri Matisse remains above all devoted to the European sense of beauty.

Europeans, our heritage reaches from the gardens bathed by the Mediterranean to the solid seas of the north. There is where we find the nourishments that we love, and the spices from other parts of the world can at most serve us as seasonings. Further, Henri Matisse has above all pondered Giotto, Piero della Francesca, the Sienese primitives, and Duccio, less powerful in volume but more so in spirit. He then meditated upon Rembrandt. And, standing at this crossroad of painting, he looked at himself to find the path that his triumphant instinct should follow with confidence.

We are not in the presence of some extremist venture; the essence of Matisse's art is to be reasonable. Whether this reason is by turns passionate or tender, it expresses itself purely enough to be understood. The consciousness of this painter is the result of his knowledge of other artistic consciousnesses. He owes his plastic innovations to his own instinct or self-knowledge.

When we speak about nature we must not forget that we are part of it and that we must consider ourselves with as much curiosity and sincerity as when we study a tree, a sky, or an idea. For there is a rapport between us and the rest of the universe, we can discover it and then no longer try to go beyond it.

2

Notes of a Painter, 1908[1]

"Notes of a Painter," Matisse's first published essay, and one of the most important and influential artist's statements of the century, was written at a time when his work was extremely controversial and when he seems to have been opposed on the one hand to what he felt was the overly optical emphasis of the Impressionists, and on the other to what he considered the overly conceptual work of the emerging Cubists. This essay is an attempt by Matisse to state the basic tenets of his art and, by implication, to clear himself of some of the criticism levelled against him in both reactionary and avant-garde circles.[2] *La Grande Revue*, a leading literary journal, was a prestigious forum for Matisse's statement, recent issues having contained articles by such writers as André Gide, Raymond Poincaré, Léon Blum, and Charles Martel.

Matisse's essay was introduced by the painter and critic Georges Desvallières, who had solicited the article.[3] "The work of M. Matisse," Desvallières wrote, "arouses too much disdain, anger, and admiration for the *Grande Revue* to be content with the inevitably hasty evaluations offered thus far by the critics who have reviewed the various exhibitions in which his work could be studied." Desvallières noted that Matisse wished to have certain of his works illustrated "so that the public may compare what M. Matisse says, what he thinks, and what he actually does." All the works illustrated were of figures rather than of landscapes or still lifes, and all were quite austere and restrained in color, as if to emphasize Matisse's thoughtfulness and rationality.[4]

Desvallières' introductory paragraphs try to prepare his essentially literary readership for the intensely pictorial qualities of Matisse's works, noting that although

"our personal sense of good taste may sometimes be shocked by them . . . even then our artistic intelligence should not be indifferent to the discoveries made by this artist . . . he has in a sense liberated our eyes and broadened our understanding. . . ."[5]

The presentation of ideas in "Notes of a Painter" is quite methodical and seems to reflect Matisse's legal training. He begins the essay with a disclaimer, saying that the painter who addresses the public with words exposes himself to the danger of being literary. Yet he notes that other painters have written about their work, thereby associating himself directly with his contemporaries and indirectly with such illustrious names as Leonardo, Ingres, and Delacroix, who also wrote extensively.

When Matisse wrote this essay he was almost thirty-nine years old, and although he had not nearly exhausted the range of his stylistic development, much of his basic theoretical outlook was already formed. It would, with certain modifications, remain generally valid for the rest of his life and through a great number of stylistic changes. This has to do with a basic attitude expressed in "Notes of a Painter," in which he notes that his fundamental thoughts have not changed but instead have evolved, and that his modes of expression have followed his thoughts. It also has to do with the general nature of the ideas expressed: Matisse's essay is more reflective than technical. (Though in another sense it is above all pragmatic, in that he discusses specific goals for his own works rather than articulating a global program that sets forth a general theory of art.)

"Notes of a Painter" is a response both to Matisse's personal situation in 1908 and to the situation of French painting as he saw it. That year had marked a turning point in his career. By 1908, he was considered one of the most important living artists, even by those who disliked his work, and he was very much at the center of the Parisian art world. At the beginning of the year he opened a private school (attended mostly by foreigners), and his work attracted a small but serious group of collectors (most notably the Russian businessman Sergei Shchukin). He was also attracting serious critical notice in France and abroad, and at the 1908 Salon d'Automne he exhibited no less than eleven paintings, six drawings, and thirteen sculptures—a display that echoed previous Salon d'Automne retrospectives given to such modern masters as Cézanne, Renoir, and Gauguin. If this ambitious exhibition at the Salon was an implicit declaration of his status as a modern master, "Notes of a Painter" was a means of explicitly affirming that status.

Matisse's essay reflects an ongoing debate about painting at the time, the main issues of which were published in a survey by influential critic Charles Morice in 1905. The survey is of particular interest because it gives tangible evidence that *among artists* a paradigm shift was generally anticipated around 1905—the very year Matisse and Derain spent their "Fauve" summer together at Collioure.[6] Morice's survey was based on a questionnaire sent to a number of French artists the previous spring about the current state of French art. Among the fifty-seven respondents were Matisse's colleagues Charles Camoin, Georges Desvallières, Kees Van Dongen, Raoul Dufy, Pierre Girieud, René Piot, Jean Puy, Georges Rouault, and

Paul Signac. (It is not known whether or not Matisse was asked to participate; in any case he was not one of the respondents.)[7]

Morice asked the following five questions: (1) Do you feel that art today is tending to take new directions? (2) Is Impressionism finished? Can it renew itself? (3) Whistler, Gauguin, Fantin-Latour . . . what is the significance to us of these dead artists? What have they left us? (4) What opinion do you have of Cézanne? (5) Do you think that the artist should expect everything to come from nature, or should the artist only ask of nature the plastic means to realize the thought that is within him?

Significantly, a number of the artists who responded felt that art was in a moment of transition and might well take another direction; most of the artists felt that Impressionism already belonged to the past; and a number of the artists expressed a special enthusiasm for both Gauguin and Cézanne. Of particular interest is the general consensus that the artist must rely on his own feelings and ideas rather than upon nature as the basis for his art. Taken together, these elements indicate a desire for a more conceptual kind of art.[8]

A number of these issues are addressed in "Notes of a Painter," in which Matisse places his own painting in distinct contrast to Impressionism and emphasizes the primacy of personal expression over objective vision. In fact, one of the basic ideas in "Notes of a Painter," and of Matisse's whole theory of art, is his professed goal of "expression," which is inseparable from the painter's pictorial means, and which emphasizes the creation of intuitive symbolism through perceptual experience. As Roger Benjamin has shown, the term "Expressionism" had been used in France since at least 1901, when it was employed by the painter Julien-Auguste Hervé, and was understood as defining a position directly opposed to Impressionism and the Impressionist aesthetic.[9] Although for various reasons the term never caught on in France, there was "a semantically and philosophically consistent use for the term 'Expressionism' in France in 1901, in England in 1910 and in Sweden and Germany in 1911 . . . , and in France during the decade 1901–1910 Matisse was the emergent painter most strongly identifiable with the position, both in his work and in his 1908 article which rejects Impressionism and gives the classic account of the case for expression in art."[10] This was understood early on by Apollinaire, who wrote in 1913 that the terms *expressionnisme* and *expressionniste* came from one of the paintings Matisse used to illustrate "Notes of a Painter": *The Red Madras Headdress*, which was exhibited under the title *Tête d'expression* at the 1907 Salon d'Automne.[11]

In fact, "Notes of a Painter" seems to have had a defining influence on later conceptions of both Fauve and Expressionist painting, descriptions of which often follow quite closely the ideas expressed in Matisse's essay. In what was for a long time a standard book on the aesthetics of modern French painting, for example, Charles Gauss clearly echoes Matisse when he writes that the Fauves "cast the perceptual world into the background in favor of an intuited world. This intuition is a consciousness of life which is of the nature of a religious attitude. They make

no distinction between their consciousness of life and their manner of expressing it. The work of art is thus a sample of the feeling it expresses. It is the only rendition of that feeling in concrete form. The work of art is therefore a symbol in a special sense."[12]

Matisse's emphasis on intuition has much in common with Benedetto Croce's *Aesthetics* (1902) and Henri Bergson's *Creative Evolution* (1907). The broad concepts of Bergsonism were especially in the air at the time, and his ideas were current not only among artists and writers but also found their way, condensed, into the popular press (much as Matisse's own ideas, somewhat garbled, would later find their way into the *New York Times Magazine*).[13] Bergsonian Intuition offers an especially striking parallel with Matisse's thoughts. According to Bergson, Intuition—by the "sympathetic communication which it establishes between us and the rest of the living, by the expansion of our consciousness which it brings about, introduces us into life's own domain, which is reciprocal interpenetration, endlessly continued creation."[14] Matisse placed great importance on the possibility of expanded consciousness through "sympathetic communication" and "reciprocal interpenetration," so much so, that it may be described as his method. Matisse, conceiving of existence as flux, and perceiving happening in a fashion similar to Bergson's *durée*, wanted intuitively to evolve forms that would express the elusive "present" even as it was being eroded by the mutual interpenetration of past and future. It was precisely from "this succession of moments which constitutes the superficial existence of beings and things, and which is continually modifying and transforming them," that Matisse wanted to evolve forms which would express the "more essential character" of things, so that he might "give to reality a more lasting interpretation."

The goal of the process is to arrive at an absolute, which, paradoxically, has only relative validity: that is, for a given situation. Thus, Matisse, who could say that he would not repaint any picture in the same way, follows a process remarkably close to that outlined by Bergson in *Introduction to Metaphysics*:

> It follows that an absolute can be reached only by an *intuition*, whereas the rest [of our knowledge] arises out of analysis. We here call intuition the *sympathy* by which one transports oneself to the interior of an object in order to coincide with its unique and therefore ineffable quality.[15]

For Matisse the goal of this process was "that state of condensation of sensations which constitutes a picture." This idea, which is as important to the art of Matisse as *réalisation* was to the art of Cézanne,[16] also has affinities to Bergson:

> Now the image has at least this advantage, that it keeps us in the concrete. No image can replace the intuition of duration, but many diverse images, borrowed from very different orders of things, may, by the convergence of their action, direct the consciousness to the precise point where there is an intuition to be seized.[17]

This is also close to Matisse's idea of taking different routes to arrive at the same place (*réalisation* through *condensation*), and possibly explains why Matisse was not a painter of a small number of "masterpieces," but of numerous realizations of condensed and frozen duration, of multiple absolutes. It is in this special sense that Matisse's paintings become symbols; they are like a cinematographic record of the intuited perceptions of the duration of his lifetime, transformed into an almost Proustian ensemble of self-referring images.[18]

Another influence on Matisse's essay, even closer to home, was probably the writer and critic Mécislas Golberg, who seems to have had a strong effect on Matisse's thinking at this time. Golberg (1868–1907) was Matisse's exact contemporary and was close to a number of his friends and associates, especially the painter André Rouveyre. His book *La Morale des Lignes* ("The Moral Philosophy of Lines"),[19] published posthumously in early 1908, so clearly parallels some of Matisse's thinking in "Notes of a Painter" that Rouveyre has even asserted that Matisse's celebrated essay was actually "written by Golberg in close fraternal spirit with Matisse. No one knew this, no one was able to say this until now. . . . It was written in concomitance."[20]

Although Rouveyre's claim is not believable, Golberg, who had a strong effect on Apollinaire, Salmon, and Picasso,[21] may well have affected Matisse's thinking around this time. Golberg's discussion of drawing as "a search for the equilibrium necessary for life, for willpower in the constant disequilibrium of real life," as well as his reflections on mind and materialism, on the limitations of exactitude in representation, and most especially on the value of simplification and on the need for an essentialist "deformation" of representational norms, are closely related to Matisse's ideas:

> In art deformation is the basis of all expression, the more the personality becomes intense, the clearer also deformation becomes, the more it becomes individualized to attain the goal of supremely synthetic forms. . . .
> This deformation in simplification even becomes a necessity because of the more intense rhythm of life, of the greater emotiveness, of the more idealized and autonomous sensibility, which the introduction of those primitive hallucinatory elements that call themselves imaginative works prohibits!
> *The imagination completes the sensibility* of the real world; it renders the fact of life more dynamic, more expressive, but when the details appear, when the senses become simple indications of intellectuality, the imagination is no longer a complement of reality, but something abnormal, excessive and false.[22]

But as can be seen, although Golberg addresses some of the same issues that Matisse does, he does so in a different tone of voice and toward different ends. In

fact, the two men's writing styles are so different that it is nearly impossible to imagine them collaborating on a text together. Moreover, it is important to remember that although Matisse surely shared a number of intellectual concerns with his writer friends, the most important body of experience behind "Notes of a Painter" was his own experience as a painter. And although "Notes of a Painter" has a firm intellectual framework, the most important underlying elements of the essay have to do with the expression of ideas specifically in relation to pictorial problems. When Matisse discusses his placement of expressive spots of color, or the way he simplifies his drawing in order to express the essential characteristics of his model, or the way he changes the colors of an interior from green to red, he is referring to his direct and intense experience of painting, not only to a complex of abstract ideas. This is borne out by Matisse's statement that there are no new truths besides the discoveries within the formal configuration of a single painting. Seeking truth is as intuitive and relative a process as is individual perception, and "rules have no existence outside of individuals."

Even Matisse's discussions of abstract ideas are clearly based on his desire to articulate a means of practical action by which the art of painting could be transformed into something very different from what he had been taught at the École des Beaux-Arts, or even by the Neo-Impressionists. By abandoning the literal representation of objects and of movement, for example, and by avoiding anecdotal subject matter, Matisse hoped to achieve "a higher ideal of grandeur and beauty" and to raise decorative painting to the level of philosophy, to "give to reality a more lasting interpretation."

Unfortunately, these higher ambitions have for a long time been overshadowed by Matisse's statement, "What I dream of is an art of balance, of purity and serenity, devoid of troubling or depressing subject matter . . . a soothing, calming influence on the mind, something like a good armchair that provides relaxation from fatigue." This often-quoted sentence tends to give the impression that Matisse desired from painting merely relaxation or entertainment—in short that his ideals were somewhat superficial.[23] It is important to realize, however, that this statement is more an explanation, and perhaps defense, of his limited range of subject matter than an expression of simple-minded optimism. (Moreover, it is very likely that when he wrote this he had in mind his new patron, the Russian businessman Sergei Shchukin, whose recent life had been filled with tragedy and who sought consolation by what he called "living in" the pictures he acquired from Matisse.)[24] Matisse is not advocating an art of superficial decoration or entertainment, but stating his belief in art as a medium for the elevation of the spirit above and beyond, yet rooted in the experience of, everyday life.

Matisse's reliance on nature, so evident in his paintings, is very strongly stated in "Notes of a Painter." He emphasizes honesty and sincerity of perception to the degree that the painter should feel that he has painted only what he has seen: "And even when he departs from nature, he must do it with the conviction that it is only to interpret her more fully." Within Matisse's theoretical framework, nature is the

ultimate source of art, and the work of art is a synthesis of imagery perceived in nature and translated, by belief in the artist's own perceptions, into the final image. The act of painting is an act of belief, a synthesis (or "condensation") of sensations into perceptions, and of perceptions into significant form. Matisse is not dogmatic about his method for doing so. At the time he himself was working both from nature and from imagination, and he goes out of his way to state that, "Personally, I think neither of these methods must be preferred to the exclusion of the other. Both may be used in turn by the same individual, either because he needs contact with objects in order to receive sensations that will excite his creative faculty, or because his sensations are already organized."

Although Matisse dwells at great length on the general process of the creation of art through the temperament of the painter and by contact with nature, he discusses only to a limited degree the actual formal nature of paintings themselves. Indeed, unlike later painter-theorists such as Kandinsky, he says virtually nothing about the creation of space in painting, about the specific qualities of certain kinds of lines or colors, or about the relationship between the nature of painting and drawing. In the main, "Notes of a Painter" is concerned with subject matter and its function, and the relation of this to the artist himself. The only formal element that he discusses in specific terms is color.

The discussion of color is framed largely in terms of expression. Like Matisse's drawing, which is based on an aesthetic of condensation of meaning through essential lines, color is considered to be a reduction to essentials, the finding of an equivalence.[25] Matisse's search for color equivalence points to his desire not to reproduce direct optical sensation but rather to transfigure it, thus finding a configuration of form which, while it does not imitate nature, is an equivalence of the painter's perception of nature; all of which is accomplished through instinct rather than by the application of a set theory. This synthetic balancing of tones and hues is part of a conception in which the picture is not fragmented, but in which, right from the beginning, the painting is conceived as a total image rather than a conglomeration of vignettes. Consonant with this idea of total conception is Matisse's idea of clarity, the clarity that he so admired in Cézanne's paintings. Just as Cézanne's painting was woven into the fabric of Matisse's pictorial thought, so Cézanne's theories had also been absorbed and synthesized.

The main concerns of "Notes of a Painter" then, are those of expression, synthesis from nature, clarity, and color. In this essay Matisse states his faith in art as personal expression, his conception of which is not "imaginative" or literary, but based on the intuitive synthesis of sensations from nature. The artist, working toward an ideal, understood intuitively, is a person of extremely fine perceptions who is able to translate these perceptions into tangible form. The most important aspect of painting is not the imitation of nature, but the transfiguration of perceptions into an enduring image. This more lasting interpretation was to be achieved

by balancing the total structure of the picture rather than by dwelling on specific emotion: the drama of Matisse's painting, he implies, is to be found in form rather than specifically in subject matter. It is a drama of happening, not of events. The realization of a painting is achieved through synthesis of nature and the organization of visual ideas in a clear and lucid fashion. The process of painting has an almost religious significance because it involves a restructuring of time and space, a penetration into Reality itself.

NOTES OF A PAINTER

A painter who addresses the public not just in order to present his works, but to reveal some of his ideas on the art of painting, exposes himself to several dangers.

In the first place, knowing that many people like to think of painting as an appendage of literature and therefore want it to express not general ideas suited to pictorial means, but specifically literary ideas, I fear that the painter who ventures to invade the domain of the literary man will be looked at with astonishment. As a matter of fact, I am fully aware that a painter's best spokesman is his work.[26]

However, such painters as Signac, Desvallières, Denis, Blanche, Guérin and Bernard have written on such matters and been welcomed by various periodicals.[27] Personally, I shall simply try to state my feelings and aspirations as a painter without worrying about the writing.

But now I foresee the danger of appearing to contradict myself. I feel very strongly the tie between my earlier and my recent works. But I do not think exactly the way I thought yesterday. Or rather, my basic thought has not changed, but it has evolved, and my means of expression have followed. I do not repudiate any of my paintings but there is not one of them that I would not redo differently, if I had it to redo. My destination is always the same, but I work out a different route to get there.

Finally, if I mention the name of this or that artist it will doubtless be to point out how our manners differ, and it may seem that I am belittling his work. Thus I risk being accused of injustice towards painters whose aims and results I best understand, or whose accomplishments I most appreciate, whereas I will have used them as examples, not to establish my superiority over them, but to show more clearly, through what they have done, what I am attempting to do.[28]

~

What I am after, above all, is expression. Sometimes it has been conceded that I have a certain technical ability but that all the same my ambition is limited and does not go beyond the purely visual satisfaction that can be obtained from looking at a picture.[29] But the thought of a painter must not be considered as separate from his pictorial means, for the thought is worth no more than its expression by those

means, which must be more complete (and by complete I do not mean complicated) the deeper is his thought. I am unable to distinguish between the feeling I have about life and my way of translating it.[30]

Expression, for me, does not reside in passion bursting from a human face or manifested by violent movement. The entire arrangement of my picture is expressive: the place occupied by the figures, the empty spaces around them, the proportions, all of that has its share. Composition is the art of arranging in a decorative manner the diverse elements at the painter's command to express his feelings. In a picture every part will be visible and will play its appointed role, whether it be principal or secondary. Everything that is not useful in the picture is, it follows, harmful. A work of art must be harmonious in its entirety: any superfluous detail would replace some other essential detail in the mind of the spectator.

Composition, the aim of which should be expression, is modified according to the surface to be covered. If I take a sheet of paper of a given size, my drawing will have a necessary relationship to its format. I would not repeat this drawing on another sheet of different proportions, for example, rectangular instead of square. Nor should I be satisfied with a mere enlargement, had I to transfer the drawing to a sheet the same shape, but ten times larger. A drawing must have an expansive force which gives life to the things around it. An artist who wants to transpose a composition from one canvas to another larger one must conceive it anew in order to preserve its expression; he must alter its character and not just square it up onto the larger canvas.[31]

～

Both harmonies and dissonances of color can produce agreeable effects. Often, when I start to work, I record fresh and superficial sensations during the first session. A few years ago I was sometimes satisfied with the result. But today if I were satisfied with this, now that I think I can see further, my picture would have a vagueness in it: I should have recorded the fugitive sensations of a moment which could not completely define my feelings and which I should barely recognize the next day.[32]

I want to reach that state of condensation of sensations which constitutes a picture. I might be satisfied with a work done at one sitting, but I would soon tire of it; thus I prefer to rework it so that later I may recognize it as representative of my state of mind.[33] There was a time when I never left my paintings hanging on the wall because they reminded me of moments of over-excitement and I did not like to see them again when I was calm. Nowadays I try to put serenity into my pictures and re-work them as long as I have not succeeded in doing so.

Suppose I want to paint a woman's body: first of all, I imbue it with grace and charm, but I know that I must give it something more. I will condense the meaning

of this body by seeking its essential lines. The charm will be less apparent at first glance, but it must eventually emerge from the new image I have obtained, which will have a broader meaning, one more fully human. The charm will be less striking since it will not be the sole quality of the painting, but it will not exist less for its being contained within the general conception of my figure.[34]

~

Charm, lightness, freshness—such fleeting sensations. I have a canvas on which the colors are still fresh and I begin to work on it again. The tone will no doubt become duller. I will replace my original tone with one of greater density, an improvement, but less seductive to the eye.

The impressionist painters, especially Monet and Sisley, had delicate sensations, quite close to each other: as a result their canvases all look alike. The word impressionism perfectly characterizes their style, for they register fleeting impressions. It is not an appropriate designation for certain more recent painters who avoid the first impression, and consider it almost dishonest. A rapid rendering of a landscape represents only one moment of its existence [*durée*]. I prefer, by insisting upon its essential character, to risk losing charm in order to obtain greater stability.

Underlying this succession of moments which constitutes the superficial existence of beings and things, and which is continually modifying and transforming them, one can search for a truer, more essential character, which the artist will seize so that he may give to reality a more lasting interpretation. When we go into the seventeenth- and eighteenth-century sculpture rooms in the Louvre and look, for example, at a Puget, we can see that the expression is forced and exaggerated to the point of being disquieting. It is quite a different matter if we go to the Luxembourg; the attitude in which the sculptors catch their models is always the one in which the development of the limbs and tensions of the muscles will be shown to greatest advantage. And yet movement thus understood corresponds to nothing in nature: when we capture it by surprise in a snapshot, the resulting image reminds us of nothing that we have seen.[35] Movement seized while it is going on is meaningful to us only if we do not isolate the present sensation either from that which precedes it or that which follows it.

There are two ways of expressing things; one is to show them crudely, the other is to evoke them with art. By removing oneself from the literal *representation* of movement one attains greater beauty and grandeur. Look at an Egyptian statue: it looks rigid to us, yet we sense in it the image of a body capable of movement and which, despite its rigidity, is animated. The ancient Greeks too are calm: a man hurling a discus will be caught at the moment in which he gathers his strength; or at least, if he is shown in the most strained and precarious position implied by his action, the sculptor will have epitomized and condensed it so that equilibrium is

re-established, thereby suggesting the idea of duration. Movement is in itself unstable and is not suited to something durable like a statue, unless the artist is aware of the entire action of which he represents only a moment.[36]

~

It is necessary that I precisely define the character of the object or of the body that I wish to paint. To do so, I study my means very closely: if I put a black dot on a sheet of white paper, the dot will be visible no matter how far away I hold it: it is a clear notation [*écriture claire*]. But beside this dot I place another one, and then a third, and already there is confusion. In order for the first dot to maintain its value I must enlarge it as I add another mark [*signe*] to the paper.[37]

If upon a white canvas I set down some sensations of blue, of green, of red, each new stroke diminishes the importance of the preceding ones. Suppose I have to paint an interior: I have before me a cupboard; it gives me a sensation of vivid red, and I put down a red that satisfies me. A relation is established between this red and the white of the canvas. Let me put a green near the red, and make the floor yellow; and again there will be relationships between the green or yellow and the white of the canvas which will satisfy me. But these different tones mutually weaken one another. It is necessary that the diverse marks [*signes*] I use be balanced so that they do not destroy each other. To do this I must organize my ideas; the relationship between the tones must be such that it will sustain and not destroy them. A new combination of colors will succeed the first and render the totality of my representation. I am forced to transpose until finally my picture may seem completely changed when, after successive modifications, the red has succeeded the green as the dominant color.[38] It is not possible for me to copy nature in a servile way; I am forced to interpret nature and submit it to the spirit of the picture. From the relationships I have found in all the tones there must result a living harmony of colors, a harmony analogous to that of a musical composition.[39]

For me, all is in the conception. It is thus necessary to have a clear vision of the whole right from the beginning. I could mention a great sculptor who gives us some admirable pieces: but for him a composition is merely a grouping of fragments, which results in a confusion of expression.[40] Look instead at one of Cézanne's pictures: all is so well arranged that no matter at what distance you stand or how many figures are represented you will always be able to distinguish each figure clearly and to know which limb belongs to which body. If there is order and clarity in the picture, it means that from the outset this same order and clarity existed in the mind of the painter, or that the painter was conscious of their necessity. Limbs may cross and intertwine, but in the eyes of the spectator they will nevertheless remain attached to and help to articulate the right body: all confusion has disappeared.

~

The chief function of color should be to serve expression as well as possible. I put down my tones without a preconceived plan. If at first, and perhaps without my having been conscious of it, one tone has particularly seduced or caught me, more often than not when the picture is finished I will notice that I have respected this tone while I progressively altered and transformed all the others. The expressive aspect of colors imposes itself on me in a purely instinctive way. To paint an autumn landscape I will not try to remember what colors suit this season, I will be inspired only by the sensation that the season arouses in me: the icy purity of the sour blue sky will express the season just as well as the nuances of foliage. My sensation itself may vary, the autumn may be soft and warm like a continuation of summer, or quite cool with a cold sky and lemon-yellow trees that give a chilly impression and already announce winter.[41]

My choice of colors does not rest on any scientific theory; it is based on observation, on feeling, on the experience of my sensibility. Inspired by certain pages of Delacroix, an artist like Signac is preoccupied with complementary colors, and the theoretical knowledge of them will lead him to use a certain tone in a certain place. But I simply try to put down colors which render my sensation. There is an impelling proportion of tones that may lead me to change the shape of a figure or to transform my composition. Until I have achieved this proportion in all the parts of the composition, I strive towards it and keep on working. Then a moment comes when all the parts have found their definite relationships, and from then on it would be impossible for me to add a stroke to my picture without having to repaint it entirely.

In reality, I think that the very theory of complementary colors is not absolute. In studying the paintings of artists whose knowledge of colors depends upon instinct and feeling, and on a constant analogy with their sensations, one could define certain laws of color and so broaden the limits of color theory as it now defined.

~

What interests me most is neither still life nor landscape, but the human figure. It is that which best permits me to express my so-to-speak religious feeling towards life. I do not insist upon all the details of the face, on setting them down one-by-one with anatomical exactitude. If I have an Italian model who at first appearance suggests nothing but a purely animal existence, I nevertheless discover his essential qualities, I discover amid the lines of the face those which suggest the deep gravity that persists in every human being. A work of art must carry within itself its complete significance and impose that upon the beholder even before he recognizes the subject matter. When I see the Giotto frescoes at Padua I do not trouble myself to recognize which scene of the life of Christ I have before me, but I immediately under-

stand the feeling that emerges from it, for it is in the lines, the composition, the color. The title will only serve to confirm my impression.[42]

What I dream of is an art of balance, of purity and serenity, devoid of troubling or depressing subject matter, an art that could be for every mental worker, for the businessman as well as the man of letters, for example, a soothing, calming influence on the mind, something like a good armchair that provides relaxation from fatigue.[43]

Often a discussion arises as to the value of different processes, and their relationship to different temperaments. A distinction is made between painters who work directly from nature and those who work purely from imagination. Personally, I think neither of these methods must be preferred to the exclusion of the other. Both may be used in turn by the same individual, either because he needs contact with objects in order to receive sensations that will excite his creative faculty, or because his sensations are already organized. In either case he will be able to arrive at that totality which constitutes a picture. In any event, I think that one can judge the vitality and power of an artist who, after having received impressions directly from the spectacle of nature, is able to organize his sensations to continue his work in the same frame of mind on different days, and to develop these sensations; this power proves he is sufficiently master of himself to subject himself to discipline.[44]

The simplest means are those which best enable an artist to express himself. If he fears the banal he cannot avoid it by appearing strange, or going in for bizarre drawing and eccentric color. His means of expression must derive almost of necessity from his temperament. He must have the humility of mind to believe that he has painted only what he has seen. I like Chardin's way of expressing it: "I apply color until there is a resemblance." Or Cézanne's: "I want to secure a likeness." Or Rodin's: "Copy nature." Leonardo said: "He who can copy can create." Those who work in a preconceived style, deliberately turning their backs on nature, miss the truth. An artist must recognize, when he is reasoning, that his picture is an artifice; but when he is painting, he should feel that he has copied nature. And even when he departs from nature, he must do it with the conviction that it is only to interpret her more fully.[45]

Some may say that other views on painting were expected from a painter, and that I have only come out with platitudes. To this I shall reply that there are no new truths. The role of the artist, like that of the scholar, consists of seizing current truths often repeated to him, but which will take on new meaning for him and which he will make his own when he has grasped their deepest significance. If aviators had to explain to us the research that led to their leaving earth and rising in the air, they would merely confirm very elementary principles of physics neglected by less successful inventors.[46]

An artist always profits from information about himself, and I am glad to have

learned what is my weak point. M. Péladan in the *Revue Hébdomadaire* reproaches a certain number of painters, amongst whom I think I should place myself, for calling themselves "Fauves," and yet dressing like everyone else, so that they are no more noticeable than the floor-walkers in a department store.[47] Does genius count for so little? If it were only a question of myself that would set M. Péladan's mind at ease, tomorrow I would call myself Sar and dress like a necromancer.[48]

In the same article this excellent writer claims that I do not paint honestly, and I would be justifiably angry if he had not qualified his statement by saying, "I mean honestly with respect to the ideal and the rules."[49] The trouble is that he does not mention where these rules are. I am willing to have them exist, but were it possible to learn them what sublime artists we would have!

Rules have no existence outside of individuals: otherwise a good professor would be as great a genius as Racine. Any one of us is capable of repeating fine maxims, but few can also penetrate their meaning. I am ready to admit that from a study of the works of Raphael or Titian a more complete set of rules can be drawn than from the works of Manet or Renoir, but the rules followed by Manet and Renoir were those which suited their temperaments and I prefer the most minor of their paintings to all the work of those who are content to imitate the *Venus of Urbino* or the *Madonna of the Goldfinch*. These latter are of no value to anyone, for whether we want to or not, we belong to our time and we share in its opinions, its feelings, even its delusions. All artists bear the imprint of their time, but the great artists are those in whom this is most profoundly marked. Our epoch for instance is better represented by Courbet than by Flandrin, by Rodin better than by Frémiet. Whether we like it or not, however insistently we call ourselves exiles from it, between our period and ourselves an indissoluble bond is established, and M. Péladan himself cannot escape this. The aestheticians of the future may perhaps use his books as evidence if they get it in their heads to prove that no one of our time understood anything about the art of Leonardo da Vinci.

3

Statement on Photography, 1908[1]

In 1908 the critic George Besson solicited views on photography from several painters for Alfred Stieglitz's magazine *Camera Work*, with two questions: "Do you believe that by means of photography, works of art can be produced?" and "Do you approve of interpretations by means of photography, and the intervention of

the photographer by the different means at his disposal, to realize, according to his taste and his own personal style, his emotions?"

Although Matisse's statement may seem at first to relate directly to an aesthetic of photography ("documentary" as opposed to "contrived" or "studio"), he was actually almost exclusively concerned with using photography as yet another way of approaching the study of nature. In 1911 Matisse would tell a Russian interviewer, "In my view, the artist should not represent nature as it is in reality. We have photography for that." [2] Although he does not say so, for the past few years Matisse had used photographs to provide source materials for some of his figurative paintings and sculptures. [3]

STATEMENT ON PHOTOGRAPHY

Photography can provide the most precious documents existing and no one can contest its value from that point of view. If it is practiced by a man of taste, the photograph will have an appearance of art. But I believe that it is not of any importance in what style they have been produced; photographs will always be impressive because they show us nature, and all artists will find in them a world of sensations. The photographer must therefore intervene as little as possible, so as not to cause photography to lose the objective charm which it naturally possesses, notwithstanding its defects. By trying to add to it he may give the result the appearance of an echo of a different process. Photography should register and give us documents. [4]

4

Sarah Stein's Notes, 1908 [1]

Sarah Stein (Mrs. Michael Stein) was a close friend of Matisse and studied in his school, which she helped to organize during 1908. The school, partially financed by Michael Stein, opened in January 1908, at 56 rue de Sèvres, and was moved in the spring to the former Couvent du Sacré Coeur on the boulevard des Invalides. The class tapered off after Matisse left Paris in the spring of 1909, and was finally closed in the spring of 1911. Sarah Stein, who remained devoted to Matisse, took careful notes on Matisse's advice to the class and to individuals within the class, and these notes give some of the best insights into Matisse's teaching.

The program of study at Matisse's school was fairly traditional, consisting of drawing and painting from plaster casts and from the model, still-life, and modelling clay. At the height of his interest in the school, Matisse came every Saturday to give criticism, the usual practice of professors when he had himself been a student. The emphasis, according to the German painter Hans Purrmann, who served as

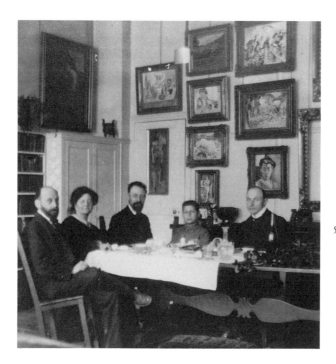

5. Michael and Sarah Stein, Matisse, Allan Stein, and Hans Purrmann in the Steins' apartment at 58, rue Madame, in 1907. The Steins were among Matisse's earliest serious collectors; Purrmann and Sarah Stein co-founded Matisse's school.

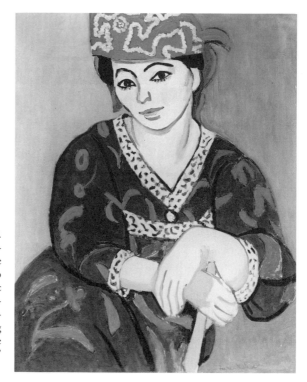

6. *The Red Madras Headdress*, 1907. This portrait of Mme Matisse, exhibited at the 1907 Salon d'Automne as *Tête d'expression*, was used to illustrate Matisse's first two public statements (Texts 1 and 2). For several years it was the most widely reproduced of his paintings. According to Apollinaire, it gave rise to the use of the word "expressionism."

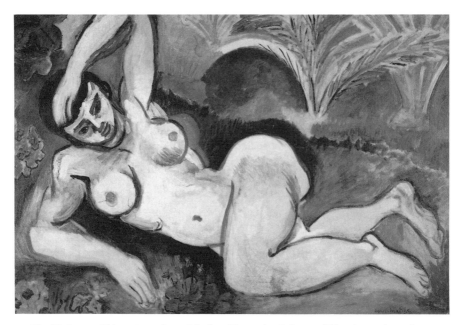

7. *Blue Nude*, 1907. This major early work had a wide-ranging influence. When it was shown in Chicago in 1913, students at the Art Institute held a protest meeting and burned an effigy of it.

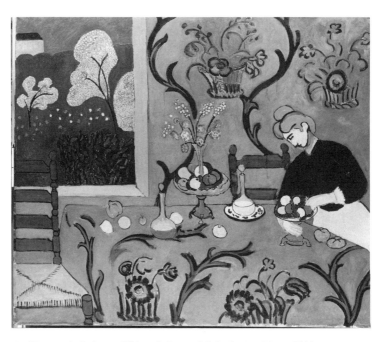

8. *Harmony in Red*, 1908. This variation on Matisse's 1897 *Dinner Table* was painted for the dining room of Sergei Shchukin's home in Moscow. It is alluded to in "Notes of a Painter" (Text 2), as a painting whose harmony was changed from green to red.

the *massier*, or student in charge of the studio, was on "adhering to nature and try-
ing to portray it with exactness." In fact, in his approach to the model, there are
some striking analogies with academic drawing practice of the 1890s.[2] Yet Matisse's
teaching also was tempered by his own breadth of understanding and was stimu-
lating and rigorous.

As Purrmann points out, students who came to the school in order to learn to
do "Matisses," or to "learn a wild new art there," were disappointed: "Most of the
students in the school, however, did not lose themselves for long in this direction
and Matisse patiently helped them to find themselves. Indeed, he generally tried
to remove some incorrect image or mannerism from each student's work. He
stripped down each student's work to its essentials and looked to see if he could
discover a personal style in it. He then took great pains to develop and advance
this personal style. Matisse urged us, in a wonderful way, toward the relevant. One
had to begin with the conventional rather than with the interesting, for the inter-
esting is generated as one leaves the conventional. 'You don't do yourself in when
you refer more to nature. To attempt to achieve a likeness, one must first submit
oneself totally to her influence. Then you can reach back, motivate nature, maybe
even make her more beautiful! You must first learn to walk firmly on the ground
before you start walking a tightrope.'" [3]

Matisse's advice to his students seems to have three basic aspects: advice on how
to perceive nature more fully, advice on how to go about constructing a picture,
and general advice about the purpose of the work of art, especially in relation to
nature. In helping his students to perceive more fully what was presented to their
eyes, Matisse used both analytic and synthetic methods. A good deal of his advice
has to do with the analysis of form; for example he speaks of an antique head as a
ball. In some cases, as in his discussion of the analysis of the model, he takes a
functional approach: "Remember the foot is a bridge, the pelvis fits into the thighs
to form an amphora." He stresses not only visual analysis but also what might be
called emphatic analysis, as when he advises the student himself to assume the
pose of the model, to find the key of the movement where the strain is felt.

Matisse also tried hard to imbue his students with a poetry of vision compara-
ble to his own, and was constantly suggesting visual metaphors to them—as when
he suggests that they see the resemblance between a woman's calf and a beautiful
vase form.

As might be expected, his advice on the construction of paintings clearly re-
flects his own methods; as in his own paintings, he stresses the importance of
order and of unity. This unity, he advises, should be above all a unity of color:
"Construct by relations of color; close and distant—equivalents of the relations
that you see upon the model." This idea of "equivalence," which is so important
to Matisse's own paintings, he also stresses for his students: "You are representing
the model, or any other subject, not copying it; there can be no color relations be-
tween it and your picture; it is the relation between the colors in your picture
which are the equivalent of the relation between the colors in your model that
must be considered."

In terms of the general aesthetic outlook that he tried to communicate to his students, Matisse's comments are very revealing. He notes, for example, that while in antique works fullness of form results in unity and repose, in the work of modern artists we often find "a passionate expression and realization of certain parts at the expense of others; hence, a lack of unity, consequent weakness, and a troubling of the spirit." This is quite close to part of "Notes of a Painter." He also remarks that the great periods of art concern themselves with the essentials of form, while decadent periods dwell on small details—a prejudice no doubt stemming from his implicit criticism of nineteenth-century academic French painting. When he advises his students to let the model awaken ideas and not simply to agree with a preconceived theory or effect, he is also echoing ideas stated in "Notes of a Painter."

Matisse's advice to his students offers a valuable insight into his own concerns and methods—and shows to what degree he tried to encourages his students' individuality while freeing them from the dead weight of preconceived theories and ideas. This was a pedagogical attitude that he may well have derived from his own teacher, Gustave Moreau, and which was at the core of his own, ongoing self-education.

SARAH STEIN'S NOTES

DRAWING

The antique, above all, will help you to realize the fullness of form. I see this torso as a single form first. Without this, none of your divisions, however characteristic, count. In the antique, all the parts have been equally considered. The result is unity, and repose of the spirit. In the moderns, we often find a passionate expression and realization of certain parts at the expense of others; hence, a lack of unity, consequent weakness, and a troubling of the spirit. This helmet, which has its movement, covers these locks of hair, which have their movement. Both were of equal importance to the artist and are perfectly realized. See it also as a decorative motive, an ornament—the scrolls of the shoulders covered by the circle of the head.

In the antique, the head is a ball upon which the features are delineated. These eyebrows are like the wings of a butterfly preparing for flight.

Remember that a foot is a bridge. Consider these feet in the ensemble. When the model has very slender legs they must show by their strength of construction that they can support the body. You never doubt that the tiny legs of a sparrow can support its body. This straight leg goes through the torso and meets the shoulder as it were at a right angle. The other leg, on which the model is also standing, curves out and down like a flying buttress of a cathedral, and does similar work. It is an academy rule that the shoulder of the leg upon which the body mainly is resting is always lower than the other.[4]

Arms are like rolls of clay, but the forearms are also like cords, for they can be twisted. These folded hands are lying there quietly like the hoop-handle of a basket that has been gradually lowered upon its body to a place of rest.

This pelvis fits into the thighs and suggests an amphora. Fit your parts into one another and build up your figure as a carpenter does a house. Everything must be constructed—built up of parts that make a unit: a tree like a human body, a human body like a cathedral.[5] To one's work one must bring knowledge, much contemplation of the model or other subject, and the imagination to enrich what one sees. Close your eyes and hold the vision, and then do the work with your own sensibility. If it be a model assume the pose of the model yourself; where the strain comes is the key of the movement.

You must not see the parts so prosaically that the resemblance of this calf to a beautiful vase-form, one line covering the other as it were, does not impress you. Nor should the fullness and olive-like quality of this extended upper arm escape you. I do not say that you should not exaggerate, but I do say that your exaggeration should be in accordance with the character of the model—not a meaningless exaggeration which only carries you away from the particular expression that you are seeking to establish.[6]

See from the first your proportions, and do not lose them. But proportions according to correct measurement are after all but very little unless confirmed by sentiment, and expressive of the particular physical character of the model. When the model is young, make your model young. Note the essential characteristics of the model carefully; they must exist in the complete work, otherwise you have lost your concept on the way.

The mechanics of construction is the establishment of the oppositions which create the equilibrium of the directions. It was in the decadent periods of art that the artist's chief interest lay in developing the small forms and details. In all great periods the essentials of form, the big masses and their relations, occupied him above all other considerations—as in the antique. He did not elaborate until that was established. Not that the antique does not show the sensibility of the artist which we sometimes attribute only to the moderns; it is there, but it is better controlled.

All things have their decided physical character—for instance a square and a rectangle. But an undecided, indefinite form can express neither one. Therefore exaggerate according to the definite character for expression. You may consider this Negro model as a cathedral, built up of parts which form a solid, noble, towering construction—and as a lobster, because of the shell-like, tense muscular parts which fit so accurately and evidently into one another, with joints only large enough to hold their bones. But from time to time it is very necessary for you to remember that he is a Negro and not lose him and yourself in your construction.

We have agreed that forearms, like cords, can be twisted. In this case much of the character of the pose is due to these forearms being tied tight in a knot, as it were, not loosely interlaced. Notice how high upon the chest they lie; this adds to the determination and nervous strength of the pose. Don't hesitate to make his head round, and let it outline itself against the background. It is round as a ball, and black.

One must always search for the desire of the line, where it wishes to enter or where to die away. Also always be sure of its source; this must be done from the model.[7] To feel a central line in the direction of the general movement of the body and build about that is a great aid. Depressions and contours may hurt the volume. If an egg be conceived as a form, a nick will not hurt it; but if as a contour, it certainly will suffer. In the same way an arm is always first of all a round form, whatever its shades of particular character.

Draw your large masses first. The lines between abdomen and thigh may have to be exaggerated to give decision to the form in an upright pose. The openings may be serviceable as correctives. Remember, a line cannot exist alone; it always brings a companion along. Do remember that one line does nothing; it is only in relation to another that it creates a volume. And do make the two together.

Give the round form of the parts, as in sculpture. Look for their volume and fullness. Their contours must do this. In speaking of a melon one uses both hands to express it by a gesture, and so both lines defining a form must determine it. Drawing is like an expressive gesture, but it has the advantage of permanency. A drawing is a sculpture, but it has the advantage that it can be viewed closely enough for one to detect suggestions of form that must be much more definitely expressed in a sculpture which must carry from a distance.[8]

One must never forget the constructive lines, axes of shoulders and pelvis; nor of legs, arms, neck, and head. This building up of the form gives its essential expression. Particular characteristics may always heighten the effect, but the construction must exist first.

No lines can go wild; every line must have its function. This one carries the torso up to the arm; note how it does it. All the lines must close around a center; otherwise your drawing cannot exist as a unit, for these fleeing lines carry the attention away—they do not arrest it.

With the circle of brows, shoulders, pelvis and feet one can almost entirely construct one's drawing, certainly indicate its character.

It is important to include the whole of the model in your drawing, to decide upon the place for the top of the head and base of the feet, and make your work remain within these limits. The value of this experience in the further study of composition is quite evident.

Do remember that a curved line is more easily and securely established in its

character by contrast with the straight one which so often accompanies it. The same may be said of the straight line. If you see all forms round they soon lose all character. The lines must play in harmony and return, as in music. You may flourish about and embroider, but you must return to your theme in order to establish the unity essential to a work of art.[9]

This foot resting upon the model stand makes a line as sharp and straight as a cut. Give this feature its importance. That slightly drooping bulge of flesh is just a trifle that may be added, but the line alone counts in the character of the pose. Remember that the foot encircles the lower leg and do not make it a silhouette, even in drawing the profile. The leg fits into the body at the ankle[?][10] and the heel comes up around the ankle.

Ingres said, "Never in drawing the head omit the ear." If I do not insist upon this I do remind you that the ear adds enormously to the character of the head, and that it is very important to express it carefully and fully, not to suggest it with a dab.[11]

A shaded drawing requires shading in the background to prevent its looking like a silhouette cut out and pasted on white paper.

SCULPTURE

The joints, like wrists, ankles, knees and elbows must show that they can support the limbs—especially when the limbs are supporting the body. And in cases of poses resting upon a special limb, arm or leg, the joint is better when exaggerated than underexpressed. Above all, one must be careful not to cut the limb at the joints, but to have the joints an inherent part of the limb. The neck must be heavy enough to support the head (in the case of a Negro statue where the head was large and the neck slender and the chin was resting upon the hands, which gave additional support to the head).

The model must not be made to agree with a preconceived theory or effect. It must impress you, awaken in you an emotion, which in turn you seek to express. You must forget all your theories, all your ideas before the subject. What part of these is really your own will be expressed in your expression of the emotion awakened in you by the subject.

It can only help you to realize before beginning that this model, for instance, had a large pelvis sloping up to rather narrow shoulders and down through the full thighs to the lower legs—suggesting an egg-like form beautiful in volume. The hair of the model describes a protecting curve and gives a repetition that is a completion.[12]

Your imagination is thus stimulated to help the plastic conception of the model before you begin. This leg, but for the accident of the curve of the calf, would describe a longer, slenderer ovoid form; and this latter form must be insisted upon, as in the antiques, to aid the unity of the figure.

Put in no holes that hurt the ensemble, as between thumb and fingers lying at the side. Express by masses in relation to one another, and large sweeps of line in interrelation. One must determine the characteristic form of the different parts of the body and the direction of the contours which will give this form. In a man standing erect all the parts must go in a direction to aid that sensation. The legs work up into the torso, which clasps down over them. It must have a spinal column. One can divide one's work by opposing lines (axes) which give the direction of the parts and thus build up the body in a manner that at once suggests its general character and movement.[13]

In addition to the sensations one derives from a drawing, a sculpture must invite us to handle it as an object; just so the sculptor must feel, in making it, the particular demands for volume and mass. The smaller the bit of sculpture, the more the essentials of form must exist.

PAINTING

When painting, first look long and well at your model or subject, and decide on your general color scheme. This must prevail.[14] In painting a landscape you choose it for certain beauties—spots of color, suggestions of composition. Close your eyes and visualize the picture; then go to work, always keeping these characteristics the important features of the picture. And you must at once indicate all that you would have in the complete work. All must be considered in interrelation during the process—nothing can be added.[15]

One must stop from time to time to consider the subject (model, landscape, etc.) in its ensemble. What you are aiming for, above all, is unity.

Order above all, in color. Put three or four touches of color that you have understood, upon the canvas; add another, if you can—if you can't set this canvas aside and begin again.

Construct by relations of color, close and distant—equivalents of the relations that you see upon the model.[16]

You are representing the model, or any other subject, not copying it; and there can be no color relations between it and your picture; it is the relation between the colors in your picture which are the equivalent of the relation between the colors in your model that must be considered.

I have always sought to copy the model; often very important considerations have prevented my doing so. In my studies I decided upon a background color and a general color for the model. Naturally these were tempered by demands of atmosphere, harmony of the background and model, and unity in the sculptural quality of the model.

Nature excites the imagination to representation. But one must add to this the

spirit of the landscape in order to help its pictorial quality. Your composition should indicate the more or less entire character of these trees, even though the exact number you have chosen would not accurately express the landscape.

In still life, painting consists in translating the relations of the objects of the subject by an understanding of the different qualities of colors and their interrelations.

When the eyes become tired and the rapports seem all wrong, just look at an object. "But this brass is yellow!" Frankly put a yellow ochre, for instance on a light spot, and start out from there freshly again to reconcile the various parts.

To copy the objects in a still life is nothing; one must render the emotion they awaken in him. The emotion of the ensemble, the interrelation of the objects, the specific character of every object—modified by its relation to the others—all interlaced like a cord or a serpent.

The tear-like quality of this slender, fat-bellied vase—the generous volume of this copper—must touch you. A still life is as difficult as an antique and the proportions of the various parts as important as the proportions of the head or the hands, for instance, of the antique.

CRITICISM (remarks addressed to individual students)

This manner of yours is a system, a thing of the hand, not of the spirit. Your figure seems bounded by wires. Surely Monet, who called all but the people who worked in dots and commas wire-draughtsmen, would not approve of you—and this time he would be right.

In this instance the dark young Italian model against a steel-gray muslin background suggests in your palette rose against blue. Choose two points: for instance, the darkest and lightest spot of the subject—in this case the model's black hair and the yellow straw of the stool. Consider every additional stroke in addition to these.

This black skirt and white underskirt find their equivalent—in your scheme—in ultramarine blue with dark cobalt violet (as black), and emerald green and white. Now the model is a pearly, opalescent color all over. I should take vermilion and white for this lower thigh, and for this calf—cooler but the same tone—garance and white. For this prominence of the back of the forearm, cool but very bright, white tinged with emerald green, which you do not see as any particular color now that it is placed.

Your black skirt and red blouse, on the model stand, become an emerald green (pure) and vermilion—not because green is the complementary of red, but because it is sufficiently far away from red to give the required rapport. The hair must also be emerald green, but this green appears quite different from the former.

You must make your color follow the form as your drawing does—therefore

your vermilion and white in this light should turn to garance and white in this cooler shadow. For this leg is round, not broken as by a corner.

Thick paint does not give light; you must have the proper color-combination. For instance, do not attempt to strengthen your forms with high lights. It is better to make the background in the proper relation to support them. You need red to make your blue and yellow count. But put it where it helps, not hurts—in the background, perhaps.[17]

In this sketch, commencing with the clash of the black hair, although your entire figure is in gradation from it, you must close your harmony with another chord— say the line of this foot.

There are many ways of painting. You seem to be falling between two stools, one considering color as warm and cool, the other, seeking light through the opposition of colors. Had you not better employ the former method alone? Then your blue background will require a warmer shadow; and this warm, black head against it, a warmer tone than this dark blue you have chosen. Your model stand will take a warmer lighter tone; it looks like pinkish, creamy silk in relation to the greenish wallpaper.

Cézanne used blue to make his yellow tell, but he used it with the discrimination, as he did in all other cases, that no one else has shown.

The Neo-Impressionists took different centers of light—for instance, a yellow and a green—put blue around the yellow, red around the green, and graded the blue into the red through purple, etc.

I express variety of illumination through an understanding of the differences in the values of colors, alone and in relation. In this still life, an understanding of cadmium green and white, emerald green and white, and garance and white, give three different tones which construct the various planes of the table—front, top, and the wall back of it. There is no shadow under this high light; this vase remains in the light, but the high light and the light beneath it must be in the proper color relation.

5

Interview with Charles Estienne, 1909[1]

In April 1909 the critic Charles Estienne published an interview with Matisse as part of a newspaper series on modern art. This interview paid Matisse the honor of making him the first of the fourteen leading artists and critics who were eventually included in the series (including Paul Signac, Odilon Redon, and Albert Besnard among artists; and Camille Mauclair and Louis Vauxcelles among critics).

It is of particular interest because it reflects some of Matisse's immediate concerns at the time, as well as his personal stature ("leader of a school"), that led him to speak of modern painting partly in terms of "we." Although Matisse dwells upon the general, synthetic aspects of modern painting in the plural, he changes to the first person singular when he begins to elaborate on the distinctiveness of his own attitude.

Most of this interview is based on ideas stated in "Notes of a Painter." Indeed, some passages are repeated almost verbatim, with only small changes in wording. This restatement of many of the ideas in "Notes of a Painter" less than four months after its publication gave Matisse the opportunity, in addressing himself to a larger if less sophisticated audience, to underline the most essential aspects of his approach—especially the process that he referred to as "that state of condensation of sensations which constitutes a picture."

It also gave him the opportunity to quietly drop his statement about a painting being like a good armchair, which he had already come to regret, and which he omits when he repeats that passage from "Notes of a Painter."

INTERVIEW WITH CHARLES ESTIENNE

It is with full impartiality that we institute here several interviews on the plastic arts and their current development, and more directly on painting, for it is in this domain of art that experiments seem the most daring and the most debatable.

A new spirit has begun to flow through all the arts during the past twenty years. We have had symbolism, after naturalism, for poetry and literature; we have lately heard talk of "music of the future" and this music has become, I believe, that of today; revolutionary ferment is now in painting.

We are not setting out to state our preferences here. We admit and quite understand that these new tendencies are provoking a resounding censure. Above all, what we are investigating, for the edification of the public, are the arguments, the motives, the vital explanations.

To ask about these, we went to M. Henri-Matisse, who is considered, one cannot ignore it, the leader of a school, and whose works are among those which have aroused the harshest criticism.

M. Henri-Matisse answered us with a readiness that well indicates that the motives he gives us are his customary ones. Hence, he did not express them by random conversation, as one might imagine. This painter, of whom it is too easily said that he mocks the world, has a thoughtful and curious conception of his art, which he has already stated, at the inducement of M. Georges Desvallières, in the *Grand Revue* following the last Salon d'Automne. "I related in *Notes of a Painter*," he said to me, "several of my ideas; but what I am going to say to you will be more explicit and more complete."

First of all, M. Matisse harbors no resentment toward the public for its incomprehension: never, according to him, is the artist entirely understood by the majority; nor even by the mean. Is he even by his peers? Formidable question! The poet like the musician, the sculptor like the painter, must undergo this almost total impossibility. But the quality of the work of art operates little by little, without the knowledge of men, and this influence obliges them one day to attest the truth.[2]

"We are leaving the realist movement," said M. Henri-Matisse. "It has amassed the raw materials. They are there. We must now begin the enormous job of organization.

"What did the realists do, and the impressionists? They copied nature. All their art has its roots in truth, in exactitude of representation. It is a completely objective art, an art of unfeeling, one might say, of recording for the pleasure of it. And yet, what complications are behind this apparent simplicity! Impressionist painting—and I know, having come from there—teems with *contradictory sensations*. It is a state of agitation.

"We want something else. We work toward serenity through simplification of ideas and of form. The ensemble is our only ideal. Details lessen the purity of the lines and harm the emotional intensity; we reject them.

"It is a question of learning—and perhaps relearning—a linear script [*une écriture qui est celle des lignes*]; then, probably after us, will come the literature."

(The reader should understand the word literature to mean a mode of pictorial illustration.)

"The painter no longer has to preoccupy himself with details," continues M. Henri-Matisse. "The photograph is there to render the multitude of details a hundred times better and more quickly. Plastic form will present emotion as directly as possible and by the simplest means.

"The object of painting is no longer narrative description, since that is in books.

"We have a higher conception of it.

"By it, the artist expresses his interior visions.

"I take from nature what I need, an expression sufficiently eloquent to suggest my thoughts. I painstakingly combine all effects, balancing them in rendering and in color, and I don't attain this condensation, to which everything contributes, even the size of the canvas, at the first try. It is a long process of reflection and amalgamation. Suppose I want to paint a woman's body: first of all I reflect her form in my mind, I imbue it with grace and charm; then I must give it something more. I will condense the meaning of this body by seeking its essential lines. The charm will be less apparent at first glance, but it must eventually emerge from the new image obtained, which will have a broader meaning, one more fully human. The charm will be less striking since it will no longer be the sole quality of the painting, but it

will not exist less for its being contained within the general conception of my figure."[3]

That is explicit, and this is no less so:

"A picture is a slow elaboration. A first sitting notes down fresh and superficial sensations. A few years ago I was sometimes satisfied with the result. But today if I were satisfied with this, now that I think I can see further, my picture would have a vagueness in it; I should have recorded rapid, momentary sensations which cannot completely define my feelings, and which I should barely recognize the next day. I want to reach that state of condensation which constitutes a picture. I might be satisfied with a work done at one sitting, but I would quickly tire of it; thus, I prefer to rework it so that later I may recognize it as representative of my state of mind. There was a time when I never left my paintings hanging on the wall because they reminded me of moments of over-excitement and I did not like to see them when I had become calm again. Nowadays I try to put serenity into my pictures and re-work them as long as I have not succeeded in doing so."[4]

Here Matisse sounds like Puvis de Chavannes; for him painting is an appeal to reflection, to serenity. It should be restful, and this feeling should be reached by the simplest possible means; three colors for a large panel of the dance: azure for the sky; pink for the figures; green for the hill where the muses dance.[5]

And how does he compose? I believe I understood it by an example he gave me:

"I have to decorate a staircase. It has three floors. I imagine a visitor coming in from the outside. The first floor invites him. One must summon up energy, give a feeling of lightness. My first panel represents the dance, that whirling round on top of the hill. On the second floor one is now within the house; in its silence I see a scene of music with engrossed participants; finally, the third floor is completely calm and I paint a scene of repose: some people reclining on the grass, chatting or daydreaming. I shall obtain this by the simplest and most reduced means; those which permit the painter pertinently to express all of his interior vision.[6]

"What I dream of," Matisse continues, "is an art of balance, of purity and serenity, devoid of troubling or depressing subject matter, an art that could be for every mental worker, for the businessman as well as the man of letters, for example, a soothing, calming influence on the mind, something that provides relaxation from fatigue and toil."[7]

This conception is logical and acceptable. To interpret this, the artist goes back beyond the Renaissance to the image-makers of the Middle Ages, ingenuous as well as ingenious, and farther in the past, to Hindu and Persian art. Is he on the right path, or does he err? Too many contingencies assail us on all sides to allow us to be certain about this. The testimony of time, of the works, will outweigh our present speculations.

6

Interview with J. Sacs, 1910[1]

The following interview was published in 1919 in the Catalan journal *Vell i nou* as the second half of a two-part article by the writer Felius Elies, using the pseudonym J. Sacs. Although the date of the interview is not made clear in *Vell i nou*, and its presentation implies that it had taken place only a short time before it was published, a number of internal references indicate a much earlier date—the autumn of 1910, shortly before Matisse himself embarked on a trip to Spain.

The evidence for the earlier date is as follows. Most persuasively, Matisse's large painting *Music*, which had been commissioned by Shchukin and was sent to Russia shortly after the closing of the 1910 Salon d'Automne, is still in Matisse's studio at the time of the interview. The series of *Jeannette* busts (which was completed by 1916) is said to be still in progress. And the discussion of the Druet photographs also suggests an earlier date; by 1919 Matisse would have been less enthusiastic about the Druet photographs, since the Bernheim-Jeune gallery had by then been photographing his work for several years.

Both parts of this article were meant to address what was characterized as Matisse's "Primitivism, Infantilism, Savagism." The first article compares Matisse's reputation with that of Picasso and discusses excerpts from critical texts about Matisse—dating from 1905 to 1919—written by Gustave Coquiot, Georges Bouche, André Gide, Michel Puy, André Salmon, Maurice Denis, André Lhote, and Roger Fry. This interview, which is unusual for its argumentative tone, provides interesting insights into Matisse's views on the differences between an urgent need to return to simplified forms and the artificiality of self-conscious primitivism.

INTERVIEW WITH J. SACS

If the art of Kees Van Dongen[2] were better known among our public I would say that it was a popularization of Mr. Matisse. In this way we could easily sum up the aesthetic ideas of the French painter. In effect, this able Dutch painter has captured Matisse's intention and has adopted it for the middling intelligence of what, in contrast with "the greater public," we could call "the greater elite" of the Parisian *connaisseur*, the plenteous modern *amateurisme* that in the French capital takes such an interest in and has such a passion for the art of the avant-garde.

It can already be seen from the samples of criticism that we published in issue 100 of VELL I NOU that what Mr. Matisse seeks is to extract from sensation itself all of its spectacular drama. From this point of view, it is clear that colorism must take on an enormous importance, though not an absolute one, as a large sector of French criticism maintains in regard to the Matissian oeuvre.

Taking off from this objective sensationalism, Van Dongen moves toward a subjective sensationalism that describes, in a certain sense, states of mind or moods—a sort of hyperesthetic poeticism expressed through forms and colors that have undergone a similar hyperesthesia, a hallucinatory and morbid quality similar to that of Odilon Redon. Except that here, in the case of Van Dongen, this subjective exaltation is less spontaneous and universal, it is astutely researched, and limited to the paroxysms of modern life.

In this way, Van Dongen makes himself interesting to that "greater elite" we were speaking of; in this way sensationalism, so difficult to explain in words and to convey visually, comes to be revealed and indeed to be vulgarized.

Is the art of Henri Matisse alien to this fraud of Baudelairism? In theory, it is, indeed; in practice it is, as well. Nevertheless, we wouldn't stick our necks out: we could not swear that Mr. Matisse has absolutely no faith, not even subconsciously, in the power of the extra-artistic suggestion that this bald sensationalism of his painting could have on the most refined public of Paris. Mr. Matisse may have realized, at some high point in his theorizing, that the practical result was frightfully arid, monstrously sterile. Then, well-versed in Parisian psychology, aware above all of the spirit of that Parisian world that celebrates new art, this artist may have said to himself: in the light of these results, I must step back, but my failure is so monstrously fruitless that it becomes grand and this grandiosity is not to be ignored. What art nowadays can make such an impression as this? Does this very monstrousness not show me with its grandeur the road to follow? And Mr. Matisse, hunting for sensations with bad aim, hunter without game, showed up on the boulevard dragging behind him a most terrifying beast: the sensation of unintelligence. So you thought he couldn't even catch a partridge? There he is, bringing down a megathere!

This is both impressive and disturbing—we say this to the great French artist as we stand with him before his enormous composition entitled *Music*, reproduced in issue 100 of VELL I NOU—but it seems visually insufficient.[3] Would a slight concession to classical volume not add intensity?

What for? If all the intensity I might want were not there, if it were not all there even latently, this canvas would not make the slightest impression, so fleeting and rudimentary are its visual elements. If the intensity is there, classical art cannot add anything to it. From classical art I have taken the technique of the *trompe l'oeil*, the sentimentalism, the poetry, the aesthetic conventions, all the intellectual artifice and all the technical tricks in order only and above all to observe and exalt sensation, which is the purest of things, the most impermeable to sophistication, the most innate and primordial, the most truly moving, if not to say the most thrilling thing of all.

So, shall we make a clean slate then of all the magnificent acquisitions of modern art?, we replied. Of course, responded Mr. Matisse. Can you not see what has come of all these magnificent acquisitions? Can you not see what admirable and fabulous point of skill has been reached all for the purpose of saying nothing? Nowadays there are painters and sculptors who have achieved a skill, a technical knowledge that amazes us, surely superior to Raphael's ability and to that of all the artists of the Renaissance, superior to the ability of the Greek sculptors—and all of this only to display an enormous emptiness, to say nothing but commonplaces. We are fed up with so much skill, we are irritated by it: the very same commonplaces said with less art would seem perhaps more bearable. What are we to do with all this fabulous production, growing day by day in quantity and perfection? Sensitive artists will be smothered by it . . .

But the fact is that these artists, so capable and so empty, who are superior in skill to Phidias and to Raphael, are not superior to them in spirit: perhaps it can be supposed that with greater skill the Greek and Renaissance artists would have been even more spiritual, would have intensified their art even further—we egged him on. Oh no! Oh, no! Mr. Matisse jumped up, ever more alert and vibrant. —To the contrary: it is precisely the excess of preciousness and virtuosity that attenuated the spirit of that classical art. That is why the art closest to the classicisms, pre-Raphaelism, Greek art from the end of the VI century B.C., archaic Hellenism, often has a greater strength of spiritual expression because these are arts that have managed to abstain from this polish, this technical perfection and other farragoes that sap what is essential to that artistic vision.

So, then, primitivism would be a rule, a point of departure, or indeed, nowadays, a good point of return, if you will . . . —No, that's not it, either, the innovator responded. We have already experienced primitivism; we have seen the puerile, hypocritical and ridiculous consequences it has produced. Primitivism is the offspring of a primitive state of spirit that cannot be generated anew, that cannot be refabricated artificially. What's more, primitivism was also fatally limited by its intellectualism: primitivism wanted to will the recreation of classical art, which is an admirable art, but one which has run dry, limited by logic, rules, etc.

Naturally, we replied, but then we have no alternative but to return to modern art—not to modern artifice as you seem captiously to synthesize it—but to good modern art, this living and subtle modern art, profound and intense, that is more concerned with spirit than with form, that almost ignores technical ability, that ignores it perhaps too much; this art that you yourself, Mr. Matisse, exhibit proudly and sensuously on the main wall of this your dear little salon. —Oh, indeed, Matisse replied, taking up the discussion again as he cast a loving smile upon a small Renoir—this nude is a gem: I wouldn't sell it for a fortune. —But it's fine for Renoir to do this, while other artists of talent and great sensitivity, with back-

grounds in the most diverse schools of speculation, technicism and common sense, open up and express themselves as best they can: the essential thing, in the long run, will always be talent. —I don't see it that way: I don't like, I don't feel any bond with scholastic conventions or with common sense; what moves me is pure sensation.

So, we insist, artistic expression, which appears conditioned by a proper dosage of sensation and intelligence, can be limited or go bad: according to whether sensation or intelligence dominates, or an equal dosage is applied of both, the work of art will be of X, Y, or Z nature; it will be what we call a realistic or a romantic work of art, or something in between—what many call classical—or sensationalist, or intellectualist, or clever, no? Then it would be evident that mere sensation is not a sufficient artistic device.

Matisse shook his head and smiled with terrible skepticism; finally he said: It seems to me that, like most people, you are too bound by aesthetic convention, and so it will be very difficult for you to adopt my point of view and understand me. My painting appeals to you, but not as it should.

I understand and admire you, I replied, because I see you as one of the strongest, most conscientious and intelligent exemplars of this tradition of artistic self-inspection, artistic didacticism and living aesthetics that is developing uninterruptedly in French art and in no other art in the world. But I fear that at the core of your theories is the same failure as in Cubism. I would say that even you yourself are aware of this; and it is this, this heroism of the Cubists, your heroism in wanting to know even if you make no profit from it, your heroism in investigating even to the point of the absurd— in order to see the evidence of the absurd—is what makes this aestheticist impulse of French art admirable and exemplary: the entire world, future history will have to give thanks to you eternally for this . . .

—Oh, I do not have the slightest intention of failing! I do not believe in all this heroism. I am certain I am on the right track; I know that I am right, the head of the *Fauves* quickly interrupted.

—But, for God's sake, what of Intelligence ? You neglect, you look down on Intelligence . . .

—Quite so.

—Then all that is left is Instinct . . .

—Ah, *Voilà!* . . . *Voilà!* It is precisely Instinct that fascinates me. I believe only in Instinct. It is the purest, most invulnerable thing, the true lifespring of artistic activity. As a result, not only do I seek instinctual ferment before the spectacle of the world but the most instinctive way of expressing it as well; often a Titanic task, because our conventional education and our conventional ancestralism weigh terribly on me. Often one of those apparently simple works of mine is preceded by long and copious labor; often behind one of these works a dozen more have been under-

going evolution, or, if you wish, involution, from objective vision to the sensation-
alist idea that engendered it.

And as he said this, Mr. Matisse was untying a large portfolio full of pho-
tographs and was showing us in beautiful proofs from chez Druet the process of
several of his works,[4] begun with utter obedience to the artistic canons of scholastic
classicism and transformed progressively by means of successive omissions and de-
formations until he had obtained a point more or less proximate to his instinctive
view of the object or animated being that he wanted to paint. And each one of that
series of photographs portrayed a state of that horrible process of intelligent strip-
ping-down till reaching, in the last one, the most frightful and repulsive spectacle of
the simply instinctive image that the artist—one must trust in his sincerity—had
been able to capture. And this process was manifest even in his works of sculpture.
In the spacious atelier in the country house on the road to Clamart where the
painter lives were scattered about several seriated molds of a bust of a woman in the
course of despiritualization; the last of these sculptural states is not yet the definitive
one and yet it already provoked a strange, unknown horror, something akin to the
image of the cadaver of reason, the decomposing corpse of Intelligence.[5]

It was past time for us to leave behind that feeling of disquiet, for us to go out
into the spacious and exuberant garden and stroll down the paths half hidden by
the autumn leaves, to write the epilogue at the foot of the fountain where we were
delighted, as if by an Elysian vision, by the spectacle of the snowy Greek statues
peeping out along the near and distant alder groves of many and diverse greens.

Then the evening chill brought us into the warm and classically French house,
so elegantly comfortable; when we took our leave of that family, so distinguished,
so well-looked-upon in the finest intellectuality of the most traditionally cultivated
Paris, it all seemed to be a dream, all this accumulation of intelligence appeared to
be a prehistoric evocation—so strong had been our impression of instinctuality and
barbarism in Mr. Matisse's workshop.

7

Interview with Ernst Goldschmidt, 1911[1]

Late in 1911 the Danish painter and art historian Ernst Goldschmidt interviewed
Matisse at Issy. This text is of particular interest because of its early date; at the
time, Matisse's public image was still in the course of being developed, and Gold-
schmidt's own comments are thus almost as revealing as Matisse's. This text also
contains an interesting discussion of the recently completed *Red Studio*, along

with a succinct account of Matisse's painting method and of the importance of his garden—and his especially deep sympathy for the inner force of living things.

INTERVIEW WITH ERNST GOLDSCHMIDT

The many harsh verdicts pronounced on contemporary French art by occasional viewers can be profitably attributed to an acquaintance gained through visits to the annual exhibitions. But to form an opinion about prominent French artists through the official Salons is a hopeless undertaking. This is partly because of the great quantities of artistic products displayed, in which the individual artist's work quite drowns, and partly because several of the best French artists do not bother to participate in such exhibitions, where the painters in fashion and their epigones have been given prominence. By being familiar with these Salons, anyone seems to have license to berate the lack of grandeur, seriousness, stature, unity, and of true Masters in the most recent French art.

The truth is, however, that in France throughout history there has never been a lack of any of these components, and that even after the 19th century's stellar period of French painting shining talent continues to be produced. Henri Matisse is without a doubt among the most important of the new generation. When he was young, he had students who helped spread his reputation. In Denmark his name became known through the circle of Norwegian students who exhibited some time ago in the Art Association [Kunstforeningen]. His school has since ceased to exist. His recent fame has made him rich and independent; he now practices only his own art. He is a sculptor, an able writer, and a compelling speaker; I have heard his enemies maintain that his fame is due solely to his eloquence. But he is at his most expressive with brush in hand. In the castle of an art-loving Russian prince, Matisse's paintings hang side by side with 18th century masters.[2]

During an evening in Rouen I joyfully accepted the offer made by Marquet, himself such an accomplished painter, to be introduced to Henri Matisse.[3] And one afternoon I undertook the short trip from Paris to Clamart, where Matisse lives.[4] He does not conform to the standard type of Montmartre artist; he was extremely well-dressed, carried himself with great composure, and during our conversations his white teeth flashed through his neat, full, reddish blond beard with winning smiles and convincing argument. His voice was handsome, sonorous and penetrating, pouring a charm over his arguments which gave even his banalities a memorable turn. And all the while that he was talking, he was showing his guest the large canvases in his spacious studio.

There were Nymphs dancing and resting, suspended in the ether,[5] the blueing sea, cheerful sea-side cliff-faces, a table with fruit, a corner of the house, a wall with a commode in front—such is the extent of his range of subjects. My attention was caught by a large painting depicting a few ordinary pieces of furniture ranged along

a red-brown wall.[6] The objects had about them a remarkable, visionary impact, and still appeared completely representational. The red wall occupied the largest surface; in one unvarying shade it was barely interrupted by the few objects depicted. But this large, uniformly colored flatness indeed had life, since the colors of the things in one inexplicable way or other made the wall come alive, and because the wall's color gave the objects a curious visionary strength. Each color in the painting was determined by and dependent on the others.

"You're looking for the red wall," Matisse said to me as I gazed at the objects depicted in the painting and mentally compared them to what I could see in the studio. "That wall simply doesn't exist. As you can see here, I painted the same furniture against a completely blue-gray studio wall. These are experiments, or studies if you will. I am not happy with them as paintings. Once I had discovered that red color, I put these studies in a corner, and that's where they'll stay. Where I got that red from I couldn't say. But in a little while we'll take a walk in the garden, and maybe then things will seem clearer to you. I find that all these things—flowers, furniture, the commode—become what they are for me only when I view them together with that red. I don't know why that is, and as for the question you're asking me, well, I might as well ask you the same thing.

"Take that landscape with the two female nudes, for example.[7] Fine, you find the figures weak but the landscape beautiful. You may be right, I don't know. But let me tell you how I painted them. You told me that a few months ago you visited Collioure, where I usually spend the winter. I find that part of France has a beauty perhaps less seductive but ultimately much richer than that of the other coast, the Riviera, whose landscapes everyone loves so much. In Collioure I take walks every day in the hills along the shore, and that's where I saw the landscape you find so beautiful. I found it impossible to paint. I made many attempts, but I found the paintings I produced to be trivial, they didn't say anything. There were many more paintings in what I was seeing than in what I was painting. This is the only one that came close to satisfying me, and the reason, I think, is precisely the two female figures, imperfect as they are in more than one respect. The color yellow came to me one day when I was trying, in vain, to paint those hills. So I painted the canvas over again, this time painting the whole of the landscape in relation to the yellow color I gave the nude bodies in the middle of the picture, and I think I can say that it is only because of that yellow that the landscape turned out such that you venture to call it a good painting. Here are a few sketches."

Matisse was right; I found in these sketches just the same landscape, the same colors, the same treatment as in the final painting, but it was only through the yellow color that it became an image. Matisse's view of nature and his consciousness of the objects first acquire artistic form through the one color, one movement, one ornament which combine and fuse in his interiorized observation, together with a

strong sense of the decoration of the pictorial surface. His "poems" on nature are never literary, they act purely and primarily through color, the specific and paradigmatic medium of the art of painting. He differentiates between the true and the ostensibly true colors, just as he distinguishes between the true and ostensibly true movement. Truth for him is not in the Impressionists' perceptions, no matter how vigorous and esteemed these may be. In his mind, a first impression enters into relationships with certain forms or colors procured from elsewhere, giving life and character to his pictures.

Any old cheat could surely create some 600 works out of these theories. Only a master makes a theory obvious. Matisse is a master. He shapes his art with large and complete means, there is no superfluous comment in it, no phrase without meaning. Each of his colors has its own mission. Redundancy hampers truth. He often speaks in his articles about form and line, although it is not these theories of his, but his colors, which constitute his art. One ought to be careful in general about applying the written ideas of modern French painters as fundamental to the consideration of their work. From his theories of form, Matisse created in a transitional period pictures that are constricted, without seeming value. But his colors themselves are the life of his pictures:

"Here is my garden. Apart from staying in Collioure, this is my favorite place to be. Isn't that flower bed more beautiful than the finest antique Persian rug? Look at the colors, how different each is from the next, yet how they blend together. Look how that very dark blue shades off into a bold, light color, clearer and more luminous than the sky itself and yet so intense and precise in its force. Or that cactus flower. It looks like it's made of silk and velvet—look how it shines like a burning coal against the grayish green background, like a spider web hanging above thick, dark green silk! Have you ever seen such gigantic violets?[8] In the spring, when all these shoots sprout from the earth and creep down the garden pathways like a lavishly decorated train, I'm going to watch how the seeds, spindly and pale, suck strength and color from the sun day by day. The big horticultural companies sometimes send me illustrated catalogues. If I see something that looks beautiful, I order seeds and plant it, first in my greenhouse and then in my garden. It is instructive to look at the difference between the crude reproductions in the gardening catalogue and the actual flower when it blossoms. In fact, compared to the colors here, my paintings aren't much better than those reproductions. The intensity of these colors, that texture, is unattainable. Sometimes I put flowers right alongside my paintings, and how poor and dull all my colors seem! In the last analysis, it is not at all white, it is not at all, finally, a well-defined color that can be painted. It suggests soft light on white—like the glimmer of sunset on eternal snows. Have you ever seen the peak of Canigou in spring, bathed in the evening sun's red reflection?"[9]

Matisse's house, a large villa next to his studio, is surrounded by the flower gar-

dens. The handsome interior walls are covered with paintings, but only one is by his hand. It is a sketch of a model from the period he studied in Carrière's school.[10] The others are works by Gauguin and Cézanne, by Marquet and his contemporaries, and by younger peers in French painting. Some woodcarvings brought back from the South Seas make up the main sculptural decoration of the house. Matisse speaks vividly about the paintings on display and their masters, about his study with Carrière. He seems to regard the little sketch on the wall with especial veneration. It is far different from his later pictures in the manner of painting and coloration. But under the softened form that came from Carrière's influence, one can trace the strongly personal color impulse, which only much later comes to the fore. Matisse describes his exhibitions abroad. We entertain the possibility of an exhibition in Denmark. He speaks then about Collioure, the small fishing community at the foot of the Pyrenees, and of the highest peak of this mountain range, Canigou, whose beauty is recited by the Catalan poets. In a captivating manner he describes known and unknown places, and speaks about certain events in the south of France, about the Mediterranean spring, about marvelous automobile trips near the Spanish border.

The eloquent gentleman sitting in front of me is far removed from the taciturn, people-shy inhabitant of Aix, or from the Barbizon painter who became one with the soil he painted.[11] And it is a long way from Henri Matisse's well-tended garden to the expanses of Cézanne's Provence, or to the forests of Fontainebleau. These three place-names evoke the three phases in the art of a new age. The road runs straight from Fontainebleau to Aix. It then curves in many convolutions, not always so easy to follow. One of the bends goes through Matisse's flower gardens and the fishing village at the foot of the Pyrenees.

8

Interview with Clara T. MacChesney, 1912[1]

The stir which greeted the New York Armory Show of modern art (17 February to 15 March 1913) is by now legendary. Matisse, who was well represented (by thirteen paintings, three drawings and a sculpture), was vehemently attacked by the conservatives. The *New York Times*, 23 February 1913, for example, said of him: "We may as well say in the first place that his pictures are ugly, that they are coarse, that they are narrow, that to us they are revolting in their inhumanity." And when the show moved to the Art Institute of Chicago, the art students at the Institute held a protest meeting and burned in effigy Matisse's *Blue Nude* of 1907.

A week before the New York show closed, the *New York Times Magazine* published the following interview with Matisse, by the American painter and writer Clara T. MacChesney. The article, which ran under the headline, "Famous French Artist, Whose Canvases Are One of the Features of the International Exhibition Here, Tells of His Theories and Work," was illustrated with four paintings: *The Red Madras Headdress* of 1907, which was the most frequently reproduced and discussed painting of the eight Matisses in the show; *The Red Studio*, 1911; *Goldfish and Sculpture*, 1912 (Museum of Modern Art, New York version); and *Nasturtiums "Dance" II* (Metropolitan Museum of Art, New York version).

The actual interview took place in June 1912. Despite the (often amusing) inaccuracies and confusions in MacChesney's reportage, her sometimes awkward translations from French, and her evident ignorance of modern art, the statements by Matisse appear to be authentic and fairly accurate. This interview is of enormous interest, as it reveals Matisse quite consciously addressing a lay audience (indeed an ignorant and antagonistic lay audience); and it also provides a description of Matisse's working arrangements at this time.

Matisse was never an *enfant terrible*; he was always anxious about being understood and accepted. Thus he is not daunted by the obtuseness of his interviewer and states quite directly, if somewhat simply, the aims and challenges of his art. It is interesting to note his stress on technical competence (the answer to the tired old question, "but can he draw?") and on his extensive preparation and training as an artist.

INTERVIEW WITH CLARA T. MacCHESNEY

In speaking of the different Post-Impressionists, it is always Matisse's name which heads the list. At first it was a name which to many suggested the most violent extremes in art; it was spoken of with bated breath, and even horror, or with the most uproarious ridicule. But time has converted many, even of our most conservative critics and art lovers, to his point of view. One says: "He is a recluse in revolt, a red radical, whose aim is not to overturn pomps, but to escape from them. He discards traditions, and seeks the elemental," and "he paints as a child might have painted in the dawn of art, seeing only the essentials in form and color."

Five of his canvases were placed before me by a Paris dealer last Summer,[2] and arranged in chronological order. The first was an ordinary still life, painted in an ordinary manner. The next two were landscapes, broader and looser in treatment, higher in key, showing decidedly the influence of the Impressionists. The last two I studied long and seriously, but I failed absolutely to discover what they expressed—still-life, landscapes, or portraits.

Thus it was with keen interest that I sought this much-ridiculed man, whose work is the common topic of many heated arguments today. After an hour's train ride and walk on a hot June day, I found M. Matisse in a suburb southwest of

Paris.[3] His home, the ordinary French villa, or country house, two-storied, set in a large and simple garden and inclosed [*sic*] by the usual high wall. A ring at the gate brought the gardener, who led me to the studio, built at one side, among trees, leading up to which were beds of flaming flowers. The studio, a good-sized square structure, was painted white, within and without, and had immense windows, (both in the roof and at the side,) thus giving a sense of out-of-doors and great heat.

A large and simple workroom it was, its walls and easels covered with his large, brilliant, and extraordinary canvases. M. Matisse himself was a great surprise, for I found not a long-haired, slovenly dressed, eccentric man, as I had imagined, but a fresh, healthy, robust blond gentleman, who looked even more German than French, and whose simple and unaffected cordiality put me directly at my ease. Two dogs lay at our feet, and, as I recall that hour, my main recollection is of a glare of light, stifling heat, principally caused by the immense glass windows, open doors, showing glimpses of flowers beyond, as brilliant and bright-hued as the walls within; and a white-bloused man chasing away the flies which buzzed around us as I questioned him.

"I began at the École des Beaux-Arts. When I opened my studio, years after, for some time I painted just like any one else. But things didn't go at all, and I was very unhappy. Then, little by little, I began to paint as I felt. One cannot do successful work which has much feeling unless one sees the subject very simply, and one must do this in order to express one's self as clearly as possible."

Striving to understand, and failing to admire, a huge, gaudy-hued canvas facing me, I asked: "Do you recognize harmony of color?"

Almost with indignation he replied: "I certainly do think of harmony of color, and of composition, too. Drawing is for me the art of being able to express myself with line. When an artist or student draws a nude figure with painstaking care, the result is drawing, and not emotion. A true artist cannot see color which is not harmonious. Otherwise it is a *moyen*, or recipe. An artist should express his feeling with the harmony or idea of color which he possesses naturally. He should not copy the walls, or objects on a table, but he should, above all, express a vision of color, the harmony of which corresponds to his feeling. And, above all, one must be honest with one's self."

"But just what is your theory on art?" I persisted.

"Well, take that table, for example," pointing to one near by, on which stood a jar of nasturtiums. "I do not literally paint that table, but the emotion it produces upon me."

After a pause full of intense thought on my part, I asked: "But if one hasn't always emotion. What then?"

"Do not paint," he quickly answered. "When I came in here to work this morn-

ing I had no emotion, so I took a horseback ride. When I returned I felt like painting, and had all the emotion I wanted."

"What was your art training?" I asked.

"I studied in the schools mornings, and I copied at the Louvre in the afternoons. This for ten years."

"What did you copy?" I asked curiously.

"I made a careful copy of 'La Chasse' ('The Hunt') by Carraccio [*sic*], which was bought by the Government for the Hotel de Ville, at Grenoble; and the 'Narcisse', by Poussin, which was also bought for the provinces. Chardin's large still-life of fish I worked at for six years and a half, and then left it unfinished.[4] In some cases I gave my emotional impressions, or personal translations, of the pictures, and these," he said sadly, "the French Government did not care to buy. It only wants a photographic copy.

"No, I never use pastels or water colors, and I only make studies from models, not to use in a picture—'mais pour me nourrir'—to strengthen my knowledge; and I never work from a previous sketch or study, but from memory. I now draw with feeling, and not anatomically. I know how to draw correctly, having studied form for so long.

"I always use a preliminary canvas the same size for a sketch as for a finished picture, and I always begin with color. With large canvases this is more fatiguing, but more logical. I may have the same sentiment I obtained in the first, but this lacks solidity, and decorative sense. I never retouch a sketch: I take a new canvas the same size, as I may change the composition somewhat. But I always strive to give the same feeling, while carrying it on further. A picture should, for me, always be decorative. While working I never try to think, only to feel."

As he talked he pointed to two canvases of equal size. The sketch hung on the wall at my left, and the finished canvas was on an easel before me. They represented nude figures in action, boldly, flatly, and simply laid in in broad sweeps of vivid local color, and I saw very little difference between the two.[5]

"Do you teach?" I asked.

"Yes, I have a class of sixty pupils, and I make them draw accurately, as a student always should do at the beginning. I do not encourage them to work as I do now."[6]

Yet I had heard he was not always successful in this respect.

"I like to model as much as to paint—I have no preference. If the search is the same when I tire of some medium, then I turn to the other—and I often make 'pour me nourrir,' a copy of an anatomical figure in clay."

"Tell me," I said, pointing to an extraordinary lumpy clay study of a nude woman with limbs of fearful length, "why—?"

He picked up a small Javanese statue with a head all out of proportion to the body.

"Is not that beautiful?"

"No," I said boldly. "I see no beauty when there is lack of proportion. To my mind no sculpture has ever equaled that of the Greeks, unless it be Michael Angelo's."[7]

"But there you are, back to the classic, the formal," he said triumphantly. "We of to-day are trying to express ourselves to-day—now—the twentieth century—and not to copy what the Greeks saw and felt in art over two thousand years ago. The Greek sculptors always followed a set, fixed form, and never showed any sentiment. The very early Greeks and the primitifs only worked from the basis of emotion, but this grew cold, and disappeared in the following centuries.[8] It makes no difference what are the proportions, if there is feeling. And if the sculptor who modeled this makes me think only of a dwarf, then he has failed to express the beauty which should overpower all lack of proportion, and this is only done through or by means of his emotions."

Yet I gazed unconvinced at the little figure of a dwarf from Java, for I failed to see anything of beauty.

"Above all," he said, struggling with the fly problem, "the great thing is to express one's self."

I thought of a celebrated canvas Matisse once produced of blue tomatoes. "Why blue?" he was asked. "Because I see them that way, and I cannot help it if no one else does," he replied.

"Besnard's work? It is full of feeling, but *sans naïveté*. Monet is very big. Cézanne seeks more the classic. Rafäelli [*sic*] I do not like at all.[9] Goya, A. Dürer, Rembrandt, Corot, Manet are my favorite masters.

"Yes, I often go to the Louvre," he replied, in answer to my question, asked rather perfunctorily.

"Whose work do I study the most? Chardin's," he answered, to my great surprise.

"Why?" I asked curiously, for there is not a trace of that great man's manner in Matisse's work.

"I go there to study his technique."

Audible silence.

His palette, lying near by, was a large one, and so chaotic and disorderly were the vivid colors on it, that a close resemblance could be traced to some of his pictures.

"I never mix much," he said. "I use small brushes and never more than twelve colors."

"Black?"

"Yes, I use it to cool the blue."

I pondered on this statement a few moments before asking him if he had traveled much.

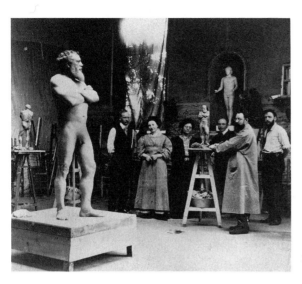

9. Matisse's sculpture class, c. 1909.

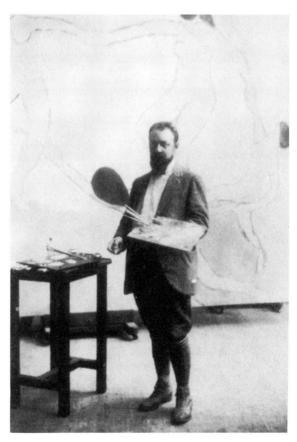

10. Matisse working on *Dance*, 1909.

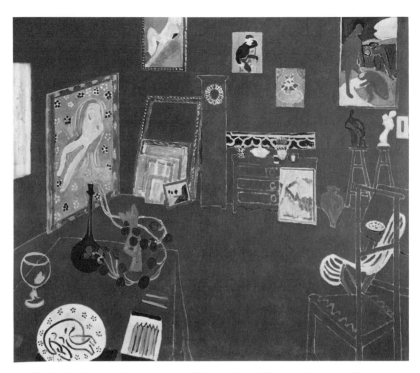

11. *The Red Studio*, 1911. Matisse discussed his invention of the red wall shortly after the painting was finished (Text 7).

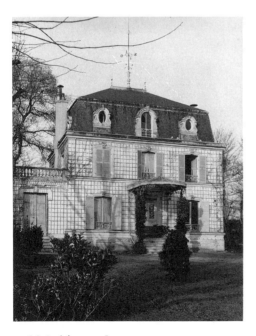

12. Matisse's house at Issy, c. 1911.

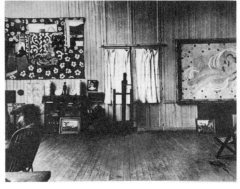

13. Matisse's studio at Issy in 1911.

"No, I've only made a trip or two to Germany, and lately to Tangiers in Morocco, and I've never been to America.

"No; I seldom paint portraits, and if I do only in a decorative manner. I can see them in no other way."

The few hanging on the wall were forceful, boldly, simply executed, and evidently done in stress of great emotion. An eye, in one canvas, was placed on the right cheek, and in another one-half of the face was drawn so unpleasantly to one side as to suggest a paralytic stroke.

One's ideas of the man and of his work are entirely opposed to each other: the latter abnormal to the last degree, and the man an ordinary, healthy individual, such as one meets by the dozen every day. On this point Matisse showed some emotion.

"Oh, do tell the American people that I am a normal man; that I am a devoted husband and father, that I have three fine children, that I go to the theatre, ride horseback, have a comfortable home, a fine garden that I love, flowers, etc., just like any man."

As if to bear out this description of himself, he showed me the salon in his perfectly normal house, to see a normal copy which he had made at the Louvre, and he bade me good-bye and invited me to call again like a perfectly normal gentleman.

As I walked down to the station in the blazing sun in the throes of a brain-storm from all I had seen and heard, Augustus John's opinion of Matisse stood out clear in my mind: "He has a big idea, but he cannot yet express it."

M. Matisse sells his canvases as fast as he can paint them, but, if the report is true, speculators buy the majority. He certainly has the courage of his convictions; his work is constructive, and not destructive; he has many followers, who, unlike him, are not expressing themselves, but are imitating him.[10] One critic maintains that his work acts like a sedative to a tired brain, or as an easy chair to a weary toiler home from his day's work.[11] But I am positive that I should not dare when weary, to sit for long in front of his "Cathedrals at Rouen."[12]

A facetious American asked: "Are these ruins?" for none of the pillars were perpendicular, but standing or falling at all angles to the horizon. She asked the reason of this apparent intemperance of the pillars and walls and was told: "Oh, we do not see as you do; we are perfectly free, and are bound by no rules, and we see as we please!"

9

Visit by Robert Rey, 1913[1]

In 1913, Robert Rey, then a young art student, became sufficiently intrigued and troubled by Matisse's paintings that he determined to meet the artist. According to his own later account, he (like others before him) came armed with a good deal of skepticism about Matisse's art; for at the time of his 1913 visit he considered realism "our daily bread."[2] Although there are few direct quotes by Matisse in Rey's account of his visit, the gist of their conversation can be gleaned from Rey's own remarks. The early date of this text, along with the description of Matisse's behavior and the unusually detailed descriptions of the works in his studio, make this a valuable document—in which Matisse speaks, as it were, through his silences.

VISIT BY ROBERT REY

The engraver Charles Bourgeat[3] had said to me: "Matisse is expecting you Sunday morning."

I was anxious to see the king of the savages, whose entry during the last Salon d'Automne had moved the hardy troop of innovators with a frisson that still endures.[4]

The train, across the suburbs blanketed with snow, thus brought us on this Sunday morning toward Clamart, where the great independent artist worked with fervor.

I went to this appointment as toward an initiation: in a few moments I would finally have the key to these enigmas that were the pictures and the statues of Matisse, the sense of these cephalic portraits, of these monstrously scoliotic figures, of these hallucinating colorings, in front of which I had seen so many "bourgeois" writhe and so many aesthetes become engrossed.

Soon we rang the doorbell: a large square garden, a large comfortable house, at the entry a cast of an antique sculpture, to which the snow had clung like the crown and collar of a swan; right from the vestibule, one is surrounded by savagery. Works by Redon, Gauguin, Cézanne, and African fetishes surround you and seem to follow you right up to the bright long room where Matisse receives us. Matisse! . . . One thought of him quite willingly as hairy and furry in the manner of the pure Idealists of the Commune, or still better cleanshaven, hermetic, and a bit greenish. How one forms one's ideas! Matisse is all smiles, he possesses essentially what one is used to calling an open face. He has high color, a reddish beard, it is true, but it is very disciplined, with large eyes whose gaze is made evasive by a proper pince-nez.

He is one of those artists about whom people fight without truce and without measure, some proclaim him the most gifted of our contemporaries and others call him the Prince of the Humbugs.[5]

I will not affirm Matisse's genius but on the contrary I have infinite respect for his good faith: while we were chatting, my disconcerted view stopped upon a large canvas very like those numerous culinary pictures of the Northern schools, of which there are so many in the Louvre. Handsomely patinated, sound in contour and in paint film, what was it doing here among the O'guttes[6] and the negro masks, this old "pompier" picture?

Matisse saw my surprise and modestly said: "That is mine, I did that some time ago; at the Louvre in fact."

But then—he is thus not among those about whom one can say their Mohicanism is their last hope, this man who keeps a full collection of technical gadgets and examples of the science of visual form.

A reflective student of Moreau, then of Carrière, he must have been a singular disciple if one is to believe the two studies of a male nude painted while he was in Carrière's studio and which flanked the window, these two males, swollen with prominent muscles, underlined by unexpected shadows.

"Finally, M. Matisse, what kind of perfection are you inclined toward? How can one define the aesthetic purpose for which you are striving in your endeavors?"

"Come to the studio."

And here we are, at the very end of the garden, in an immense studio, where canvases, some painted, others like the vertical walls of snow, hang in silence. Over there, in misty tones, heightened with blue reflections, there is a strange scene in which large personages can be made out sketched in large dark lines.[7] Here, gigantic and flat, a Moroccan, green, ardent, done with ochre and lake, the forehead stained with purple stripes.[8] On a chair, a nude, charming and supple in its unreal simplicity: and then some working models, some plaster proofs—diverse states—of a bust in which Matisse's manner is going to blossom forth under our eyes, in the manner of those Japanese flowers that a drop of water causes to blossom.[9] Here is the first state, it is a figure of a woman, quickly worked, but the notation detailed and knowing. Now the artist is going to apply himself to tightening up his working model, simplifying the detail, merging it in an "impressive" ensemble, as one sometimes dares to say. This is not yet enough; a third state comes into view: the hair is no longer represented except by abrupt masses, the profile is thinned, stretched, the small pedestal prolongs it without demarcation. But as in those poems of Maeterlinck, where amid the nebulous and disquieting unity of the discourse a concrete and definite word is pointed, so in this imprecise bust the lump of an eyebrow, the roll of a lip, sometimes clearly stand out. This is all at least very curious.

～

I swear to you here very softly, M. Matisse, that I could not follow you when you said to me "This profile, apparently unformed and rather horse-like, seen from here, from this angle, doesn't it suggest to you the idea of freshness and of youth?" I became

evasive. Certainly there is something there like enclosed life, an expression, yes, but confused and distant. This in good faith I saw, but I saw nothing else, without affirming moreover, and for so little, that there was not something else there to see.

I thought I understood that through this regression the artist sought above all the primitive state of sensibility "where the sin of art had never penetrated," according to the perfect phrase of Edmond Haraucourt.[10]

"Let's go back to the house," said Matisse. And carrying lithographs, drypoints, and the nude mentioned above, we left the frigid studio where the large Berber, the mysterious scene and the vast Neo-Assyrian bas-reliefs that Matisse cuts in enormous planks of plaster,[11] go back to sleep.

And, once again under the thrilling Cézannes, the encompassing Marquets, Matisse wanted to explain his inclination to me: of the two eternal conceptions of art he chose the second.

The first says: pursue nature, force it as at a race until you overtake it and then copy it in a servile way.

The other declares: photography couldn't be an art. The spark from which the work is born should not come from nature to the artist but, in the last analysis, from the artist toward the exterior world. In this case he will create, will be a poet and not a craftsman.

In short, and to say everything in a few words, should art be *subjective* or *objective*?[12] For Matisse it is without any doubt objective.[13] He notes an impression, a second, works it in his mind, refines it, makes it submit to this beginning of intellectual digestion that one could compare to the individual work of bees, and then projects it, thus crystallized, from the screen of his thought onto the screen of his canvas.

It is a little complicated, you say. Yes and no. It is evidently cerebral painting, a genre where many have seen the imminent death of painting itself.

But what prohibits simply shrugging off this art of Matisse, which for almost ten years has scandalized and attracted, is that an assiduous labor, the *labor improbus* of the ancients, presides over these productions.

Are these canvases infantile, amateurish and done at a single throw?

But not at all. The most dumbfounding, the most imbued with apparent babyishness, have been reworked twenty times, demolished and rebuilt in full consciousness, in full confidence. The most impromptu sketches represent, in fact, hours and days of effort.[14]

Why—you say—does this effort and this deformation always tend toward the most ugly? Alas, there we touch upon precisely the least likely point of the discussion. We see as "vile" that which Matisse sees as smooth, that which he has the right to see as exquisite. Didn't he find that bust with the nose of a tapir, where I discovered only inquietude and obtuse life, to radiate spring-like freshness? Which of us is

right? Neither, assuredly, and to reproach such an artist for creating ugliness comes from a simplistic and somewhat culpable dogmatism.

Actually, among these lithographs and wood engravings with enormous lines, the nude from a little while ago appeared calm and to have an attractive charm in its nuanced monochrome; in sum, were the surprise and the imprecations that arose from the color of Manet any more unjust than those that greet the chromatics of Matisse? What must happen to the public in order for a painter considered so dissident to be accepted by orthodox scholastics and be verbally venerated? That his name be known and that he be dead. Even the inaccessible Cézanne is, at that price, favorably admitted into our conversations. The extreme novelty cannot please the educated man who contemplates it, because he sees there the sign of an evolution that no longer depends on him, as an announcement of death. It is thus not without doing a bit of violence to his first impression that one can at least begin to approach the art of Matisse; and since we spoke casually in the long, clearly lighted room, I observed along the walls and on the mantelpiece those wooden statuettes from central Africa, of which Matisse has brought together several superb types; those ardently stylized heads with their intensely ingenuous expression, these knowing deformations done with care or duplicity, the caricatural and profound sense of a forehead that is too bulging, of a heavy eyebrow, of an acute cheekbone; and I thought I had grasped the true source of inspiration of this "difficult author."[15]

I was afraid of these hackneyed truisms which this sufficient lump of a girl wore me out with: "the critique of pure good sense." What had I learned? Nothing I swear; on this winter day I better perceived the artificial or spontaneous void that separates different souls: I hardly understood the painting of Matisse any better than upon my arrival.

And, undecided, charmed by the man, astonished, confusingly attracted by the work, I departed across the snowy suburb toward the Clamart train station.

10

Interview with Ragnar Hoppe, 1919[1]

In June of 1919, the Swedish art historian Ragnar Hoppe visited Matisse in his studio on the quai Saint Michel in Paris. Matisse was then spending most of the year in Nice and had only recently come north for the summer.

This interview came at a crucial time in Matisse's career, just as he was making a transition to the more atmospheric and naturalistic works of what is frequently characterized as his early "Nice Period." In it Matisse gives one of his most cogent

and absorbing accounts of what precipitated this change in style—an account made all the more valuable by its being so close in time to his actions. Matisse's discussion of wanting to keep his instincts fresh and to avoid mannerism is especially vivid in this context. Earlier he had used such arguments to justify his development of a more abstract way of painting; here he shows how the same inner compass could be used to effect a kind of reversal of polarity.

Along the way Matisse also gives Hoppe a fascinating account of the *White Plumes* paintings and drawings, and of *Interior with a Violin*, one of his finest and most important paintings of this period.

INTERVIEW WITH RAGNAR HOPPE

On a mild and cloudy day in June I had the honor of paying a visit to one of France's greatest living artists, Henri Matisse, who is well-known even in our country, not least as a teacher. The house in which Matisse lived, 19, Quai Saint-Michel, was old and almost a trifle sinister, and it was only with some effort that I could make out the door to the concierge's wretched dwelling in the gloomy entrance hallway, where I had been instructed to obtain further information. I knocked discreetly and of course disturbed the esteemed family of the concierge that had just assembled for a frugal lunch around the oilcloth-covered table with the obligatory soup in the center, the yardlong bread, and quite a supply of vin ordinaire. All responded in unison to my "*Bonjour, messieurs-dames*," with a "*Bonjour, monsieur*," and in response to my question as to where Mr. Matisse lived, I was informed that it was two flights up to the right. I already dreaded the thought of vainly having to ring the bells of two or three doors, since the French do not usually have nameplates or cards on them, but after I had managed to find my way up a rickety set of wooden stairs, I succeeded, to my indescribable joy, in finding a door on which there was a note with Matisse's name.

I rang. The master himself opened the door. We went through a couple of rooms with blinds lowered—the family was in the country—and then entered his studio, a middle-sized room with a low ceiling and rather bourgeois furnishings but a wonderful view of the quay, Notre-Dame, and the Saint-Michel bridge, with their swarms of pedestrians, cars, and buses. I was quite familiar with the view; Matisse had painted it many times. And I told him so. Yes, he answered, I never tire of it; for me it is always new, and just now it is more dear to me than ever before. The fact is, you see, that I was down by the Mediterranean for a couple of months, and that enables me to look again with fresh eyes at Paris, which is always Paris, that is, something indescribably glorious. To be sure, this little apartment here is inconvenient, but I have lived here for many years, I've grown attached to it, and I can't be without the view.

On the walls all around hung unframed studies held up by thumbtacks, most of

them by Matisse himself, but also a couple of paintings by Courbet and Cézanne. A few chairs of old-fashioned design, a pair of tables with a painter's paraphernalia, books, magazines, and heaps of drawings filled the rest of the room, which gave the impression more of joyful creation than of order. Matisse offered me a cigarette, and we sat down in two comfortable armchairs. I had not previously had the opportunity to study his features closely, since I had met him only fleetingly once before, but now I could observe him in peace and quiet. Matisse is now fifty years old, but he is still extremely talkative, and he spoke nearly uninterrupted, so I only once in a while needed to ask him a question or briefly answer one of his. He most resembles one of those French professors who usually give lectures to society audiences, and his eyeglasses, set in a face framed by a dark beard, contribute in no small measure to this impression of erudition. Like almost all Frenchmen, he gesticulated a great deal, and while talking he constantly illustrated his sentences with expressive hand movements. He is of average height but fairly sturdy and square of build. As elegantly dressed as an English gentleman, he was wearing a light-gray suit of the latest cut, and I noticed that the color of his neckerchief and his soft silk shirt had been chosen with great care and taste.

"Well, did you see my show at Bernheim's?" [2]

"No," I answered. "Unfortunately, it had closed by the time I arrived in Paris, so I could only see the paintings that had not been sold. But I did notice that you have now largely abandoned strong, very intense colors and that even your form seems softer and more impressionistic. May I ask you if there is a conscious idea or intent behind this style, which to me seems almost a return to an earlier stage?"

"Yes, you see, when you have achieved what you want in a certain area, when you have exploited the possibilities that lie in one direction, you must, when the time comes, change course, search for something new. For the time being, I am working predominantly in black and gray, with neutral, subdued tones, because I felt that this was necessary for me right now. It was quite simply a question of hygiene. If I had continued down the other road, which I knew so well, I would have ended up as a mannerist. One must always keep one's eye, one's feeling, fresh; one must follow one's instincts. Besides, I am seeking a new synthesis, and if you go down to the Triennale exhibition, you will find a composition there, a canvas from last summer, in which I have combined all that I've gained recently with what I knew and could do before. [3] My friends say it is my best painting, but in this case I do not share their opinion. I'm sure I have done better things, and I will do still better ones in the future; you may rely on it. But you must promise me, anyway, to go and look at that painting because I set great store by it. Yes, I am the happiest man in the world; I've always understood which way I should go, I have never for a moment strayed from it, and I see now that it leads to the goal, my goal. I have not made any mistakes, and I am proud and glad of that. I first worked as an impressionist, di-

rectly from nature; I later sought concentration and more intense expression both in line and color, and then, of course, I had to sacrifice other values to a certain degree, corporeality and spatial depth, the richness of detail.[4] Now I want to combine it all, and I believe I will be able to, in time. Look at that portrait over there, for example, the young lady with the ostrich feather in her hat.[5] The feather is put there as an ornament, decorative, but it also has a physical presence; you sort of feel its lightness, the soft, airy down, which moves with a breath of air. The material of the blouse is a fabric of a quite particular kind, the pattern has its own wondrous character. I want to depict the typical and the individual at the same time, a distillation of all I see and feel in a motif. Now, you may think, like so many others, that my paintings appear improvised, haphazardly and hurriedly composed. If you don't mind, I'll show you some drawings and studies so you may better understand how I work."

Matisse took out a huge portfolio with close to fifty drawings, all for the same lady's portrait. On the wall hung a couple of oil studies for the same canvas; the completed one was in a commercial gallery. "You see here," Matisse continued, "a whole series of drawings that I did for one single detail, the lace collar around the young lady's neck. The very first ones are worked out minutely, each mesh, yes, almost each thread; then I could simplify more and more, and in this last one, when I knew the lace as if by heart, I was able to translate it with a few quickly drawn lines into an ornament, an arabesque, without losing its character of being the lace, and of being that particular lace. And at the same time, it is a complete Matisse, isn't it? I worked the same way on the face, the hands, and all the other details, and of course I did a lot of movement and composition studies. There is a great deal of work but also a great deal of joy behind a painting like that. You can see for yourself how beautifully and composedly the hands rest in her lap. I didn't resolve the problem this well at once, believe me. But this is just the way that the hands should rest for their position to be in harmony with the bearing of the body and the expression of the face. It was only little by little that I realized this, but when I became fully aware of it, then I could also render this insight with lightning speed.

"Yes, that drawing is bad, but I keep it all the same, because I may be able to learn from it some day, just because I failed. One learns something every day; how could it be otherwise? For example, I have never been as conscious as now, recently, of the beauty of the color black, all that it can offer, both as a contrast and in itself.[6] When you see my interior from Nice, you'll understand some of that. If I had had the painting here, I should have liked to show it to you, but it will have to wait until another time."

"But Mr. Matisse," I said, "you don't have any actual works of art here. All I see on the walls are just studies for portraits or sketches made outdoors. Aren't you working on any larger things?"

14. Matisse with Renoir at Cagnes, 1918. Their meeting coincided with an important turning point in Matisse's life and art.

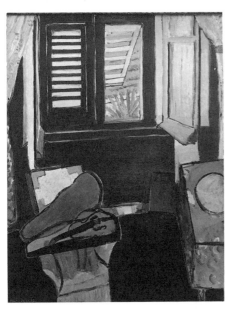

15. *Interior with a Violin*, 1918. In a 1919 interview (Text 10), Matisse discussed this as an important transitional work.

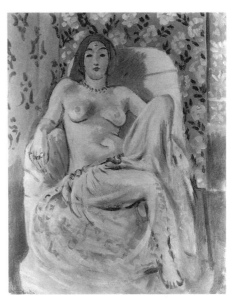

16. *Seated Odalisque*, 1922. During the early 1920s, Matisse's painting was infused with a new sensuality.

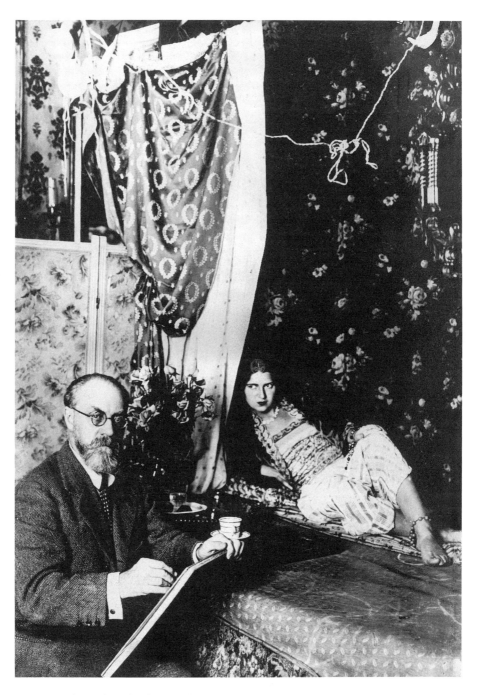

17. Matisse in his studio at the Place Charles-Félix, Nice, working from a model dressed as an odalisque, c. 1926.

"Yes, but I can't paint them in this small room here.[7] I need space around me, large dimensions, distance, and that's why I have built myself a studio out in my villa at Issy-les-Moulineaux, where I work on all my decorative projects. There, too, I have a glorious garden with lots of flowers, which for me are by far the best lessons in color composition. The flowers often give me impressions of color that are indelibly burnt onto my retina. Later, when I stand palette in hand before a composition and know only approximately which color I should apply, a memory like that may appear in my mind's eye, and come to my aid, give me a clue. In that way, I too become a naturalist, if you can call it being a naturalist to listen to one's memories and to the selective instinct that is so closely related to all creative talent.

"You are welcome to come out there some day, and you can just call me up here some afternoon; then we could travel there together. You see, I had a telephone installed in this little apartment just today." We chatted a while about the Parisian telephone service, which is well below the level of the Swedish one, and parted with a handshake and an *au revoir*.

A soft rain fell outside, all colors muted into the finest nuances of grey, and the blacks had a singular depth, a gentle strength, which made Matisse's statement about their special beauty become immediately relevant and vivid to me. On my way along the quay I passed the building in which the Triennale exhibition was taking place, so I took the opportunity to visit for a while. There was very little to see there except Matisse's three paintings, and the best of them was the one he had just discussed.

More than one of us who suddenly, on a hot, bright summer day have entered from the sunshine outside into a room with drawn curtains or partly closed shutters, have surely at first understood the dominant colors in that room as blacks, and at the same time have experienced a slight quiver of cold, a quiver instinctively associated with the color black. It was on such a theme, a sensation of this kind, that Matisse built his composition. A room with closed light grey shutters, through which one glimpses a strip of the sea suffused by the sun, is quite sufficient to suggest the heat outside. The walls in the room are completely, profoundly, coolly black, and on a table is a violin, warmly brown against the deep-blue lining of its case. On these objects falls a reflection of the sunlight through the shuttered window. The warm colors are vivid in the cold room, an impact of contrasts of the most concentrated kind, superbly calculated, theoretically elucidated, but based on a strong sensation.

I believe that this canvas truly provides the key to Matisse's artistry, because he is at once instinctive, sensual, and demonstrably theoretical, and if he himself possibly sets most store by the theoretical clarity of his work, it is nevertheless his refined, powerful sensuality which makes him into the artist that he is.

11

Interview with Jacques Guenne, 1925[1]

In 1925 the writer and critic Jacques Guenne published an interview with Matisse that consists mainly of reminiscences about his formative years. These reminiscences not only shed light upon Matisse's attitude toward his early training—a quarter of a century later—but also show his obsession with discipline and reliance on sensations after nature. This interview also contains one of Matisse's most striking observations about the significance and influence of Cézanne upon his own work. Since the end of 1917, when he had first met Renoir, Matisse's loyalties were in a sense divided between these two artists. If Cézanne had been his guiding light in the years between 1899 and 1917, beginning in 1918 the art of Renoir seemed more directly connected to the concerns of his own painting.[2] By the mid-1920s, however, Matisse was beginning a transition from the more naturalistic and sensual style that had characterized his work since 1918, to the more austere compositions of the late 1920s. It is especially interesting to see Matisse's renewed concern with Cézanne at this time.

INTERVIEW WITH JACQUES GUENNE

It was at Clamart, where Matisse usually spends several months, that I met him.

"I was a lawyer's clerk at Saint-Quentin," he said, "but even then other people's quarrels interested me much less than painting. One of my acquaintances, a friend of Bouguereau,[3] advised me to come to Paris and take lessons from a painter who had acquired such great notoriety at the École des Beaux-Arts. I used to go to the atelier of Bouguereau. The master taught relief in twenty lessons, the art of giving the human body noble academic bearing and the best way to scumble the depths. He contemplated my easel. 'You need to learn perspective,' he said. 'Erasure should be done with a good clean rag, or better yet, with a piece of tinder wood. You should seek advice from an older student.'[4]

"Another time, he reproached me more crossly for 'not knowing how to draw.' Tired of faithfully reproducing the contours of plaster casts, I went to Gabriel Ferrier,[5] who taught from live models. I did my utmost to depict the emotion that the sight of the female body gave me. The model had a pretty hand. I first painted the hand. How stupefied and indignant the professor was! Painting the hand before the model's face! 'But my poor friend,' he cried, 'you will never finish your canvas by the end of the week.' As I had barely sketched in the torso, he considered indeed that I would never have time to 'do the feet.' And one should be ready to 'do the feet' by Saturday, the day when the professor came around to correct us. I aban-

doned that studio.[6] Sometimes I went to Lille. I admired the works of Goya in the Museum.[7] I wanted to do something like that. It seemed to me that Goya had understood life well. Nevertheless I went back to the École des Beaux-Arts.

"I had been advised to go to the 'Antiques' where Gustave Moreau was teaching.[8] 'All you have to do,' I was told, 'is to rise when the professor walks by in order to be accepted as one of his students.' This time I had been better advised. What a charming master he was! He, at least, was capable of enthusiasm and even of being carried away. One day he would affirm his admiration for Raphael, another, for Veronese. One morning he arrived proclaiming that there was no greater master than Chardin. Moreau knew how to distinguish and how to show us who were the greatest painters, whereas Bouguereau invited us to admire Giulio Romano.[9]

"From that time dates my first still life,[10] you see it there, which I have preciously saved. I used to visit the Louvre. But Moreau told us: 'Don't be content with going to the museum, go out into the streets.' In effect it's there that I learned to draw. I went to the Petit Casino with Marquet, who was my co-disciple.[11] We were trying to draw the silhouettes of passers-by, to discipline our line. We were forcing ourselves to discover quickly what was characteristic in a gesture, in an attitude. Didn't Delacroix say: 'One should be able to draw a man falling from the sixth floor?'"[12]

Did you go to Impressionist shows?

"No, I only knew their works when the Caillebotte collection opened."[13]

Was Gustave Moreau aware of your efforts?

"Certainly. He told me: 'You are going to simplify painting.'"

Would that he had simplified his own!

"It was then that I made a copy of Chardin's *The Ray*.[14] Soon I joined a painter named Véry[15] and I left for Brittany with him. I then had only bistres and earth colors on my palette, whereas Véry had an Impressionist palette. Like him, I began to work from nature. And soon I was seduced by the brilliance of pure color. I returned from my trip with a passion for rainbow colors whereas Véry returned to Paris with a love for bitumen! Naturally colleagues and collectors marvelled at his new style.

"Then I did a *Desserte*.[16] And already I was no longer transposing in the transparent tones of the Louvre."

And what did Gustave Moreau think of that canvas?

"Moreau showed the same indulgence toward me as toward Marquet and Rouault.[17] To the professors who discovered what was already revolutionary in this attempt, he responded: 'Let it be; his decanters are solidly on the table and I could hang my hat on their stoppers. That's what is essential.' I exhibited this work at the Nationale.[18] It was the time when the public was generally terrified of germs. One had never seen so many cases of typhoid. The public found germs at the bottom of

my decanters![19] However, I had been raised to the level of Associate. What a fine civil service career opened before me! I deserve no praise, I assure you, for not having followed it. To tell the truth, it's my modest condition which I have to thank for my success. In effect, painting, even academic, was a poor provider at that time. I was going to be forced to take up another profession. I decided to take a year off, avoid all hindrances, and paint the way I wanted to. I worked only for myself.[20] I was saved. Soon the love of materials for their own sake came to me like a revelation. I felt a passion for color developing within me.

"At that moment the big Mohammedan exhibition was mounted.[21] And with what pleasure I also discovered Japanese woodcuts! What a lesson in purity, harmony, I received! To tell the truth, these woodcuts were mediocre reproductions, and yet I did not experience the same emotion when I saw the originals. Those no longer brought with them the newness of a revelation.[22]

"Slowly I discovered the secret of my art. It consists of a meditation on nature, on the expression of a dream which is always inspired by reality. With more involvement and regularity, I learned to push each study in a certain direction. Little by little the notion that painting is a means of expression asserted itself, and that one can express the same thing in several ways. '*Exactitude is not truth*,' Delacroix liked to say.[23] Notice that the classics went on re-doing the same painting and always differently. After a certain time, Cézanne always painted the same canvas of the *Bathers*. Although the master of Aix ceaselessly redid the same painting, don't we come upon a new Cézanne with the greatest curiosity? Apropos of this, I am very surprised that anyone can wonder whether the lesson of the painter of the *House of the Hanged Man* and the *Cardplayers* is good or bad. If you only knew the moral strength, the encouragement that his remarkable example gave me all my life![24] In moments of doubt, when I was still searching for myself, frightened sometimes by my discoveries, I thought: 'If Cézanne is right, I am right.' Because I knew that Cézanne had made no mistake. There are, you see, constructional laws in the work of Cézanne which are useful to a young painter. He had, among his great virtues, the merit of wanting the tones to be forces in a painting, giving the highest mission to his painting.

"We shouldn't be surprised that Cézanne hesitated so long and so constantly. For my part, each time I stand before my canvas, it seems that I am painting for the first time. There were so many possibilities in Cézanne that, more than anyone else, he had to organize his brain. Cézanne, you see, is a sort of god of painting. Dangerous, his influence? So what? Too bad for those without the strength to survive it. Not to be strong enough to withstand an influence without weakening is proof of impotence. I will repeat what I once said to Guillaume Apollinaire: '*For my part, I have never avoided the influence of others, I would have considered this cowardice and lack of sincerity toward myself.*' I believe that the artist's personality affirms itself by the

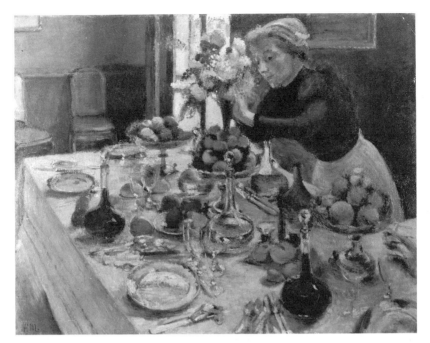

18. *The Dinner Table,* 1897. Matisse undertook this elaborate interior at the suggestion of his teacher, Gustave Moreau. It was his largest and most carefully planned canvas to date and one of the first to show the influence of Impressionism; he felt that it marked a turning point in his art (see Text 11).

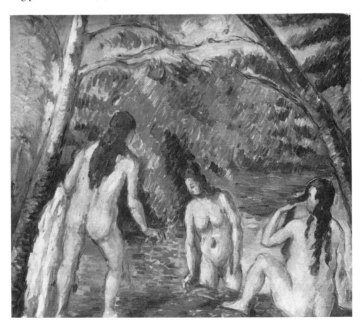

19. Paul Cézanne, *Three Bathers,* c. 1879–1882. Matisse bought this painting in 1899 and it served as an important source of inspiration: "it has sustained me morally in the critical moments of my venture as an artist; I have drawn from it my faith and my perseverance" (Text 22).

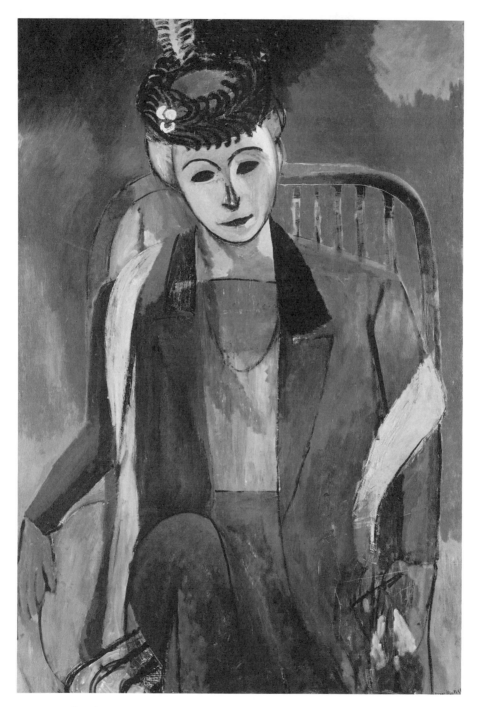

20. *Portrait of Amélie Matisse,* 1913. This severe portrait reflects Matisse's awareness of Cubist painting.

struggle he has survived. One would have to be very foolish not to notice the direction in which others work. I am amazed that some people can be so lacking in anxiety as to imagine that they have grasped the truth of their art on the first try. I have accepted influences but I think I have always known how to dominate them."

Matisse turned toward the wall where his latest works were hanging. And since I indicated two of them that differed only by the means of expression and the lighting:

"Yes," he told me, "I copy nature and I make myself even put the time of day in the painting. This one was painted in the morning, that one at the end of the afternoon; one with a model, the other without. I often told my students when I had a school: The ideal would be to have a studio with three floors. One would do a first study after the model on the first floor. From the second, one would come down more rarely. On the third, one would have learned to do without the model."

Can you tell me what reasons led you to open the school and then to close it?

"I thought it would be good for young artists to avoid the road I travelled myself. I thus took the initiative of opening a school in a convent on the rue de Sèvres, which I then moved near the Sacré Coeur convent, in a building where the Lycée Buffon now stands. Many students appeared. I forced myself to correct each one, taking into account the spirit in which his efforts were conceived. I especially took pains to inculcate in them a sense of tradition. Needless to say, many of my students were disappointed to see that a master with a reputation for being revolutionary could have repeated the words of Courbet to them: '*I have simply wished to assert the reasoned and independent feeling of my own individuality within a total knowledge of tradition.*' [25]

"The effort I made to penetrate the thinking of each one tired me out. I reached the point where I thought a student was heading in the wrong direction and he told me (revenge of my masters), 'That's the way I think.' The saddest part was that they could not conceive that I was depressed to see them 'doing Matisse.' Then I understood that I had to choose between being a painter and a teacher. I soon closed my school."

When you started out, what were the material conditions of life for a painter?

"We didn't have enough to buy a beer. Marquet lived in such poverty that one day I was obliged to reclaim the twenty francs a collector owed him because he needed the money so badly. I was personally obliged to work with Marquet on the decoration of the ceiling of the Grand-Palais.[26] Marquet did not have enough money to buy colors, especially the cadmiums, which were expensive. Consequently he painted in greys and perhaps this economic condition favored his style. At one point I thought of setting up a company of collectors run for my profit, as Van Gogh had proposed. One of my cousins agreed to be party to it on the condition that I do two 'views' of his property. Hunger was threatening us. And we

looked at what others were doing and decided to do the same in order to please the public. We couldn't. So much the better for us! The collectors said: 'We've got our eye on you,' which meant that, in a few years, they would take the risk of paying a hundred francs for one of our paintings."

Didn't you know the shop of Père Tanguy?[27]

"That shop in front of which people used to meet to make fun of Cézanne and Van Gogh? No! But I knew old Druet,[28] then a wine merchant on the place de l'Alma. Rodin ate there and made Druet take photos. Then Druet installed himself on the rue Matignon where he sold the Neo-Impressionists. He had a genius for making collectors enthusiastic, and thus performed a great service for painters. Ambroise Vollard did a bigger favor in taking the initiative in having canvases photographed.[29] This had considerable importance because without it others surely would have 'finished' all the Cézannes, as they used to add trees to all the Corots. Berthe Weill also helped painters a lot. 'Bring me a canvas,' she wrote us sometimes, 'I have a buyer.' And in fact it sometimes happened that a buyer introduced by her offered us twenty francs for a canvas, which was an honorable fee at the time.[30]

"For my part, I have never regretted this poverty. I was very embarrassed when my canvases began to get big prices. I could see myself condemned to a future of making nothing but masterpieces!"

What do you think of the works of the young?

"It's my turn to question you. Will you tell me where the young are?"

At recent exhibitions haven't you been included in purchase commissions by museums?

"In effect, I can in this case affirm to you that something has changed. One votes courageously within the Commissions and, if it is necessary, against the members of the Institute. In that way one prohibits the most academic daubers from entering the museums, even if one has not yet arrived at accepting the works that are the most audacious and worthy of interest."

～

We then spoke of the Exposition des Arts Décoratifs and I expressed my astonishment to see at the Bernheim [Gallery] pavilion the most beautiful canvases of Matisse imprisoned by grey frames that created the most dreadful effect, and that I disapproved of this determination to emphasize the modern at all costs:

"Only gold is appropriate for frames," Matisse responded. "One might say that the painters of today are afraid of light. How grey contemporary painting is! Many painters are preoccupied with researching the technique of fresco. As if the art of oil painting, which has value only for its transparencies, wasn't absolutely different from that of the fresco.

"A canvas painted with oil should be surrounded by a golden border and when the painting is good it is, you see, even much richer than the gold."

12

Statement to Tériade: On Fauvism and Color, 1929[1]

In 1929, before Matisse's Tahitian voyage, and again in 1930, a few months after it, Matisse's friend the writer and publisher E. Tériade recorded some statements by the artist. These two statements also were also used in a later, well-known "statement" prepared by Tériade, who became one of Matisse's most loyal and trusted friends and collaborators ("Matisse Speaks," Text 48, below).[2]

In the first statement, Matisse explains the differences between Neo-Impressionism and Fauvism, noting that the former is an essentially mechanical method of painting, and that the theoretical aspect of such painters as Seurat did not, in the last analysis, count nearly so much as the "human value" of their work, a line of thought quite in keeping with his earlier dictum that rules have no meaning outside of individuals. It is significant that Matisse recalls the artistic and moral victory that Fauvism represented to him, since this suggests the new crisis Matisse felt in his art at this time, which is reflected in such works as *Figure on an Ornamental Background* of 1925–26, *Woman with a Turban* of 1929–30, and *The Back IV* of 1930–31, which indicate his desire to achieve a renewed simplicity in his work. The parallel between this 1929 crisis and the earlier Fauve crisis is striking; both have to do with a calculated aesthetic and social risk (cf. the interview with Jacques Guenne, Text 11, above), and both are concerned with moving from observation of actual light and detail to construction with color "without differentiation of texture."

This statement also shows Matisse's retrospective state of mind at the time, and his lack of interest in contemporary movements, despite his preoccupation with seeking a new direction for his art. As he began to move forward, he continued to rely primarily on his inner resources and profound sense of history for both his formal ideas and his psychological equilibrium.

STATEMENT TO TÉRIADE: ON FAUVISM AND COLOR

[Matisse, about to leave Paris, speaks to Tériade:]

"I went to bed a little late last night. Let's speak to the point, because we have scarcely an hour. I am leaving right away for Nice. Paris tires me in winter—the noises, the movement, the events and fashions that one has to follow. When you are young, of course, it's all very good. You have to begin by entering the fray, adventuring in the bush.[3] But for me now, silence and isolation are useful. Only superficial painters need fear them. As for the movements and exhibitions, I have almost nothing to learn from them, and I don't want to let my thought stray from my work in progress. Look, during these few days that I spent in Paris, I went to see the boat

show the first day, and the second also, and every day since. Even today, I don't want to leave Paris without having given it a last glance. I adore boating. Look at the calluses I have on my hands." And Matisse showed us his bronzed palms, which bore the only sign of the sun in the grey room.

"How do you feel about the 'fauve' movement judged from the distance of today?" This question, asked a little bluntly, resounded too profoundly in Matisse for him to be able to answer it immediately, directly. Thus he began by going back to the sources, to the Neo-Impressionist period where his true work as a painter became evident, and I was given an admirable lesson on color, on the means by which the colored surface of the painting was divided according to Divisionist theories, on the reconstruction of white light, Chevreul's color wheel, diffusion, the breaking up of shadow by light, etc. This brought the painter to speak of himself and of his situation at that time.

"I showed Signac and Cross my first picture done according to these principles. The latter, noting that I had achieved contrasts as strong as the dominants, told me: 'That's good, but you won't stay with it long.'[4] Quite so.

"Neo-Impressionism, or rather that part called Divisionism, was the first systematization of the means of Impressionism, but a purely physical systematization; an often mechanical means corresponding only to a physical emotion. The breaking up of color led to the breaking up of form, of contour. Result: a jumpy surface. There is only a retinal sensation, but it destroys the calm of the surface and of the contour. Objects are differentiated only by the luminosity given them. Everything is treated in the same way. Ultimately, there is only a tactile vitality comparable to the 'vibrato' of the violin or voice. As Seurat's canvases become greyer with time, they lose whatever formulary aspect there was in the grouping of the colors and retain only their true values, those human values in painting which are today more profound than ever.[5]

"I didn't stay on this course but started painting in planes, seeking the quality of the picture by an accord of all the flat colors. I tried to replace the 'vibrato' with a more expressive and more direct harmony, a harmony whose simplicity and honesty would have given me quieter surfaces.

"Fauvism overthrew the tyranny of Divisionism. One can't live in a household that is too well kept, a house kept by country aunts.[6] One has to go off into the jungle to find simpler ways which won't stifle the spirit. The influence of Gauguin and Van Gogh were felt then, too. Here are the ideas of that time: Construction by colored surfaces. Search for intensity of color, subject matter being unimportant. Reaction against the diffusion of local tone in light. Light is not suppressed, but is expressed by a harmony of intensely colored surfaces. My picture *Music* was done with a fine blue for the sky, the bluest of blues (the surface was colored to satura-

tion, that is to the point where the blue, the idea of absolute blue, was entirely evident), green for the trees, and violent vermilion for the figures. With those three colors I had my luminous harmony, and also purity of color tone. To be noted: the color was proportioned to the form. Form was modified, according to the reaction of the adjacent areas of color. For expression comes from the colored surface that the spectator perceives as a whole."

And Matisse continues: "The painter releases his emotion by painting; but not without his conception having passed through a certain analytic state. The analysis happens within the painter. When the synthesis is immediate, it is schematic, without density, and the expression suffers.

"Fauvism did not content itself with the physical arrangement of the picture, as did Divisionism. It was thus the first effort towards an expressive synthesis. Compare El Greco and Velázquez.[7] With Velázquez, emotion is solely physical. It goes no further. Without the sensory pleasure, there is obviously nothing. But you can ask of painting a deeper feeling which touches the mind as well as the senses. On the other hand, purely intellectual painting is non-existent. You cannot even say that it goes no further, for it does not even begin. It remains locked up in the intention of the painter and is never realized."

What was the state of mind at the time of Fauvism?

"The state of mind was the defense of the painters against the Salons and the official painters. Nowadays, on the other hand, the Indépendants are the masters. To exist, you have to put on an 'Indépendant' arm band. That is the current madness of the moderns. One wants it; it isn't anymore. If more or less literary endeavors were born at that moment in painting, they were all confined to the literary coteries. The literary coteries were not aware of each other. There was no confusion between them. One didn't try to succeed through politics.[8] Sincerity was in favor."

Have we arrived at a new pictorial ideal?

"Some new means have been arrived at, or rather the means have been renewed. The retina tires of the same means. It demands surprises. For myself, since it is always necessary to advance and to seek new possibilities, I nowadays want a certain formal perfection, and I work by concentrating my means to give my painting this quality, which is perhaps external, but which is necessary at a given moment, of a well-executed, finished object. But this doesn't mean that it isn't necessary to mess up some canvas when you are young, that one shouldn't start at the beginning. The problems of a young man are very different, much more serious, and form the very basis of his work, before its components are fixed.

"At the time of the Fauves, what created the strict organization of our works was that the quantity of color was its quality. It had to be right from all points of view.

That is what was timely then. The people who saw painting from the outside were made uneasy by the schematic state of certain details. Hands, for example, Renoir painted progressively according to his feeling, sensation by sensation. We ourselves were preoccupied with the measure of the plastic ensemble, with its rhythm, with the unity of its movement. Thus we were accused of not knowing how to paint a hand or how to draw any other detail. Nothing could be more false. It was simply that the state of our pictorial problem did not permit us to go all the way to the perfection of details.

"The only thing one should ask of a painter is that he express his intentions clearly. His thought will profit from this. As for those who, preoccupied with the precious aspect of their works, begin with perfection, the spirit of the École [des Beaux-Arts] and of the Prix-de-Rome is with them. Without going so far as to encourage certain painters for whom the language no longer exists, I think that the young who will have something to say and who will go beyond the means along the way, will say it anyway."

Does your choice of Odalisques have any particular reasons behind it?

"I do Odalisques in order to do nudes. But how does one do the nude without it being artificial? And then, because I know that they exist. I was in Morocco. I have seen them.[9] Rembrandt did Biblical subjects with real Turkish materials from the bazaar, and his emotion was there. Tissot did the Life of Christ with all the documents possible, and even went to Jerusalem. But his work is false and has no life of its own.[10]

And the window? [11]

"My purpose is to render my emotion. This state of mind is created by the objects that surround me and that react in me: from the horizon to myself, myself included. For very often I put myself in the picture, and I am aware of what exists behind me. I express as naturally the space and the objects that are situated there, as if I had only the sea and the sky in front of me; that is to say, the simplest thing in the world. This is to make it understood that the unity realized in my picture, however complex it may be, is not difficult for me to obtain, because it comes to me naturally. I think only of rendering my emotion. Very often, the difficulty for an artist is that he doesn't realize the quality of his emotion and that his reason leads this emotion astray. He should use his reason only for control."

13

Statement to Tériade: On Travel, 1930[1]

Matisse had spent much of 1930 traveling. At the end of February he went to the United States—where he visited New York, Chicago, Las Vegas, Los Angeles and San Francisco—and a month later he left for the South Seas, where he visited Tahiti and a number of other islands. He returned to France at the end of July but came back to the United States in September to serve on the jury for the Carnegie International Exhibition. It was during this trip that Dr. Albert Barnes proposed that Matisse paint a mural for the main hall of the Barnes Foundation in Merion, Pennsylvania. Matisse returned to Paris in mid-October, and was interviewed by Tériade shortly after his arrival.[2]

The profound unrest that had moved Matisse to undertake his extensive voyages, and some of the effects that his travels had on him, are reflected in this interview with Tériade. One of the most interesting aspects of Matisse's remarks is his discussion of the tensions that provoked him to work, and their absence in Tahiti and presence again in New York. This desire to regain equilibrium in the face of tension was one of the most important psychological impulses behind his art.

This interview, which begins with Tériade's résumé of Matisse's travels, contains some of Matisse's most telling remarks about the South Seas and the United States, and an especially interesting reflection on the programs of the Barnes Foundation, for which he had just been commissioned to do a large mural.

STATEMENT TO TÉRIADE: ON TRAVEL

Nice-Le Havre. Le Havre-New York. From there to Chicago, Los Angeles, San Francisco. At San Francisco, embarkation on the "Tahiti," which sank three months later, for the island of the same name. A ten day crossing. A three month stay in Tahiti, including several weeks on a coral island called Apataki, across from Apakaka, and a few days at Fakarava.

Return on the "Ville-de-Verdun" to Marseille. The return voyage took nineteen days from Tahiti to Panama. Absolute solitude, neither land nor boats. On July 14th, Martinique. On the 16th, Guadeloupe. Circuit around Madeira, without a stop. Finally, arrival at Marseille after forty-six days at sea. In this way Matisse returned from the end of the earth at eighteen kilometers an hour.

He remained at Nice for a month and then left for Pittsburgh to sit on the Carnegie Prize jury.

I first asked Matisse questions about the need to travel, about the usefulness of travel for the painter, about his reactions before the new kinds of light and different

landscapes, finally about that role that such a tour of the earth has already played, or could play, in his work.

"If I may," Matisse says, "I should like to answer by an example taken from my work, which will put these questions into a tangible context.

"In my Nice studio, before my departure for Tahiti, I had worked several months on a painting without finishing it.[3] During my trip, even while strongly impressed by what I was seeing every day, I often thought of the work I had left unfinished. I might even say that I thought of it constantly. Returning to Nice for a month this summer, I went back to the painting and worked on it every day. Then I left again for America. And during the crossing I realized what I had to do—that is, the weakness in the construction of my painting and its possible resolution. I am anxious to go back to it today.

"This proves perhaps that my work is the binary of the life of my brain. Perhaps it is also the *idée fixe* of a foolish old world traveller who upon his return looks for a tobacco pouch he had mislaid before leaving.

"When you have worked for a long time in the same milieu, it is useful at a given moment to stop the usual mental routine and take a voyage that will let parts of the mind rest while other parts have free rein—especially those parts repressed by the will. This respite permits a withdrawal and consequently an examination of the past. You begin again with more certainty when the preoccupation of the first part of the trip, not having been destroyed by the numerous impressions of the new world you are plunged into, takes possession of the mind again.

"The mind of a man who is still developing can be intoxicated by places like Tahiti because his pleasures are confused (that is to say that when he has felt the voluptuous roundness of a Tahitian woman, he imagines that the sky is clearer). But when a man is formed, organized, with an ordered brain, he no longer makes these confusions and better knows the source of his euphoria, his expansion.

"Consequently, he doesn't risk interrupting the course of his own development. It is thus for the painter. A voyage made at the time when the mind is already formed has a usefulness different from that of a voyage made by a young man[4]—if you will grant that the artist can attain his complete development only on the soil where he is born.

"This is clearly applicable to artists for whom imagination plays an important role. As for the realists, if you take the word 'realism' in its narrow, objective sense, they can express themselves anywhere as long as their interior life does not change.

"Having worked forty years in European light and space, I always dreamed of other proportions that might be found in the other hemisphere. I was always conscious of another space in which the objects of my reveries evolved. I was seeking something other than real space. Whence my curiosity for the other hemisphere, or

a place where things could happen differently. (I might add, moreover, that I did not find it in Oceania.)

"In art, what is most important is the relationship between things. The attempts to possess the light and space in which I lived gave me the desire to see myself with a different space and light which would allow me to grasp more profoundly the space and light in which I do live—if only to become more conscious of them.

"That is why, when I was in Tahiti, I collected my thoughts to produce visions of Provence, in order to contrast them strongly with those of the Oceanic landscape."

Matisse concluded: "Most painters require direct contact with objects in order to feel that they exist, and they can only reproduce them under strictly physical conditions. They look for an exterior light to illuminate them internally. Whereas the artist or the poet possesses an interior light which transforms objects to make a new world of them—sensitive, organized, a living world which is in itself an infallible sign of divinity, a reflection of divinity.

"That is how you can explain the role of the reality created by art as opposed to objective reality—by its non-material essence."

Here are some remarks by Matisse about Tahiti:[5]

"Nature there is sumptuous, but not exalting, a familiar apartment-like sumptuousness, practically without surprises. You don't have an immediate reaction that makes you need to unwind by working.

"The light is lovely, but on a small scale, on trees that are not large and seem rather like house plants.

"I realized there that I had no pictorial reaction whatsoever, and that there was nothing to do but languish in the thick, cool shadows of the island mountains, or else at the 'Lotus,' the 'Lido,' or the 'Lafayette,' fashionable night-clubs no doubt open so that the Europeans will lose neither their inspiration nor the Dionysian habits of the Métropole.

"You are struck there by this ambiance which consists of doing nothing. Laziness is stronger than everything else. That is what lies behind the amiable amorality in the customs of the islanders, an amorality that becomes quite demoralizing after a short time. The Tahitians are like children. They have no sense of anything being prohibited, nor any notion of good and evil. Steal a bicycle? What for? Where would you go with it? Eventually, after riding around, it would have to be put back where it came from. Take the next fellow's wife? Nothing wrong with that. And if you are white, it's an honor for the family and its future descendants.

"The Tahitian girls retain their wild and uncultivated nature despite the delicate Parisian styles they wear. They go to a bar, they drink cocktails, and their only reading material is the seasonal catalogues from the Paris department stores.

"It is also true that everything there comes from far away, and very late. *L'Intran*

[*sigeant*] you read three months late. The newsreels at films are often four years behind the times. Thus this past summer I was able to admire the sumptuous reception of Amanoullah by the King of England, which, if it wasn't a burning current event, was at least ironically irreverent."

And Gauguin?

"Gauguin left as a rebel. That's what kept him in this ambiance which liquifies you, as is said there. His combative character, his sense of being crucified, preserved him from the general torpor. His wounded vanity kept him awake.

"There is no memory of him there. Except, on the part of the people who knew him, a regret that his paintings are so expensive nowadays. There is also a tiny 'rue Gauguin' just next to the Oceanic Phosphates Company, but the director of this company had never noticed it.

"Then there is his son who lives in Punaauia. Everyone calls him Gauguin. He has his father's heavy eyelids and hooked nose. A superb man in his thirties with powerful arms. He spends his nights engaged in *pêches miraculeuses*. Peculiar sign: he speaks no French. This is quite exceptional in Tahiti. Contrary to his father, his gentle character makes him very popular.

"In imitation of Gauguin, other painters live there and paint the beauties of the island with a heavy hand. They are generally encouraged by the inhabitants who thus hope to gain their turn. They all admire nature, but only at sunset: Sunset over Moorea. They paint nothing but that all their lives.

"It's true that the evening there is magnificent. Before the flamboyant sunset, the sky is blond, like honey. Then it turns blue with an infinite softness.

"On the other hand, at 6 o'clock in the morning, it is beautiful, too beautiful, ferociously beautiful. Weather so brilliant, so bright that you would think it was already noon. Then, I assure you, it is frightening. It is alarming to have the day begin with a dazzling sun that will not change until sunset. It is as if the light would be immobilized forever. It is as if life were frozen in a magnificent pose.

"Before I left, everyone said to me: *How lucky you are!* I answered: *I would love to be already on my way back.* Now I am!"

⌇

"The first time that I saw America," Matisse says, "I mean New York, at 7 o'clock in the evening, this gold and black block in the night, reflected in the water, I was in complete ecstacy. Someone near me on the boat said: *It's a spangled dress*, which helped me to arrive at my own image. New York seemed to me like a gold nugget.[6]

"Later, on the Fifth Avenue sidewalk, I was truly electrified, and I thought: Is it really worth the trouble to go so far (I was crossing America then to go to Tahiti) when I feel so full of energy here.

"The proportions of the street and the height of the buildings give a sensation of space. One breathes better there than in narrow old streets. One has an impression

of amplitude in which the order gives you a feeling of security. You can think very comfortably in a New York street, which has become practically impossible in our Parisian muddle.

"Obviously, I am not speaking of the side-streets, but rather of that American spirit which seems to be realized more and more freely in the heart of a city like New York.

"The skyscrapers are not at all what you would imagine from photographs. The sky begins after the tenth story, because the stonework is already eaten up by the light. The light and its reflections take the materiality from the building. Seen from the street, the skyscraper gives us the sensation of a gradation of tones from the base to the top. The gradation of a tone which evaporates in the sky, taking on the softness of the celestial matter with which it mixes, gives the passer-by a feeling of lightness that is completely unexpected by the European visitor. This lightening, which corresponds to a feeling of release, is quite beneficial in counterbalancing the overwhelming hyperactivity of the city.

"The modern buildings, mostly white, are often traversed from base to top with great brilliant aluminum moldings which render the proportions comprehensible at a glance, without distorting them, like a mirror of water. Thus we can associate this size with that which is already familiar to us, and the skyscraper fits into our scheme of palpable objects, with human proportions. This no doubt enlarges our space.

"At the Musée de Cluny, for example, you are confined by walls whose proportions were necessary in the Middle Ages. In the Renaissance chateau, one already breathes more freely. And so on. In the neighborhood of a skyscraper there is a clear feeling of liberty through the possession of a larger space.

"The space that I sought in Tahiti and did not find there, I found in New York.

"This is self-evident when you contemplate the city from the thirteenth or fourteenth floor of the Plaza Hotel for example, where you see Central Park before you, and, on each side, the skyscrapers of the grand avenues. It is a prodigious vision, but not inhuman like that of the high Swiss mountains, for example.

"As for Broadway at night, which is so greatly praised, it has no lasting interest. The Eiffel Tower illuminated is a much finer object. The Americans themselves admit it.

"On the other hand, when one sees New York from the river at the end of the day, all these great buildings of different heights are colored differently and present a ravishing spectacle in the Indian Summer sky. Until the end of November, there is a very pure, non-material light, a crystalline light, as opposed to the light of Oceania, which is pulpy and mellow like that of the Touraine, and which seems to caress what it touches.

"It is an exceedingly pictorial light, like the light of the Italian primitives."

Is there an American pictorial climate?

"Very much so, but one that has not been exploited yet. When the Americans have travelled sufficiently across the old world to perceive their own richness, they will be able to see their own country for what it is.

"And I am not only talking about the American physical climate, but the moral atmosphere itself. This tension, the constant dynamism, can be transformed, in the artist, into artistic activity by provoking a beneficial reaction in him."

How did the Americans come to our modern painting?

"Americans are interested in modern painting because of its immediate translation of feeling. It is more direct than previous painting. The materials used lose less of their natural side. It has much more to do with lines and colors in movement than with reproduction of a given object or person. Through it, Americans communicate more freely amongst themselves. It is more in rapport with the activity of their spirit. It does not tie them to a kind of identification of the conditions of the material life of the objects represented.

"When they are tired, their minds are not confronted by a 'void of action,' but they confront modern paintings and find, on another level, their own activity.

"Thus they relax.

"That is what I said twenty-five years ago in *La Grande Revue: Painting should be a calming influence for the mind tired by the working day of the contemporary man.*

"One of the most striking things in America is the Barnes collection,[7] which is exhibited in a spirit very beneficial for the formation of American artists. There the old master paintings are put beside the modern ones, a Douanier Rousseau next to a Primitive, and this bringing together helps students understand a lot of things that the academies don't teach.

"This collection presents the paintings in complete frankness, which is not frequent in America. The Barnes Foundation will doubtless manage to destroy the artificial and disreputable presentation of the other collections, where the pictures are hard to see—displayed hypocritically in the mysterious light of a temple or cathedral. According to the current American aesthetic, this presentation seeks to introduce a certain supposedly favorable mystery between the spectator and the work, but it is in the end only a great misunderstanding.

"In any case, the vogue for modern painting in America is certainly a preparation for a flowering of American art.

"Moreover, in other domains, the expression of the American energy is making itself felt, as in the cinema or in architecture, where they have given up imitating the Loire chateaux, without regret. Although some supreme vestiges still remain, little pieces surviving on the twenty-sixth floor of a building in the form of a hat, or

on Wall Street the cornices that crown a building create disturbing black bars which are disquieting to the passers-by.

"It will probably be said that I am flattering the Americans, just as they said a few years ago that I had grown a beard to please the Russians.[8] But there is every evidence, for someone with some awareness, that the new buildings are more satisfying to the mind than the poor assemblages of our diverse styles which they constructed in the past. There are still some examples of that on Fifth Avenue. Thus it is easy to compare.

"The great quality of modern America is in not clinging to its acquisitions. Over there, love of risk makes one destroy the results of the day with the hope that the next day will provide better.[9] America has the form and the spirit of a great range of experiences, which, for the artist, must be extremely agreeable."

And the Carnegie prize?[10]

"The purpose of the Carnegie is to show in America what is happening in European painting, and that without a feeling of judgment, without preference to one tendency rather than another. But what is slightly troubling is that the jury is constituted of artists whose tendencies are so irremediably different that the result has no significance.

"The European part of the jury is composed of three members: a Frenchman (always chosen from amongst the painters with the most advanced ideas), an Englishman (always a member of the Royal Academy in London), and a third person picked from one of the other European countries. This year, it was an Austrian. It is noteworthy that this third member should be, for preference, without marked leanings, the 'middling painter' par excellence, obviously to establish the desired equilibrium.

"This year the first prize was given to Picasso. The second to an American, Brook. The third to Dufresne."

14

Statement to Tériade: Around a Retrospective, 1931[1]

In 1931 Matisse had a large retrospective exhibition at the Galeries Georges Petit in Paris. This was the largest exhibition of his work that had yet been mounted in France and, coming as it did shortly after his sixtieth birthday, it drew a good deal of attention. Matisse's own retrospective mood at this milestone in his life is reflected in the predominantly autobiographical framework of his remarks.

This text is of especial interest because some twenty years later it provided the

basis for one of the most widely read interviews with Matisse, Tériade's "Matisse Speaks" of 1951 (Text 48). It is especially interesting to note that Matisse's remarks about Cubism, particularly his characterization of it as "a sort of descriptive realism," date from 1931 rather than 1951.

STATEMENT TO TÉRIADE: AROUND A RETROSPECTIVE

The large retrospective exhibition of the work of Matisse is going to be inaugurated Tuesday night at the Georges Petit Gallery. It will bring together one hundred and fifty paintings chosen from all of the artist's periods and one hundred drawings. European and American museums and collections have lent their best pieces. This exhibition is an artistic event. It is all the more so when it comes in the right conditions. Some of the best painters of the young generation are turning today toward Matisse to recognize the value of his contribution, especially with regard to the freeing of a spontaneous and synthetic vision of life. The work of Matisse, along with Cubism, constitutes a stage of what we consider today the kind of freedom that the young painters are seeking to realize entirely. We have spoken about this in the articles published here under the titles, "De la nature morte à la nature vive."

~

I had the opportunity recently to ask Matisse for some recollections about his beginnings.

"I arrived in Paris," he told me, "recommended by the only painter in Saint-Quentin, who was Paul-Louis Couturier,[2] a painter of chickens and the barnyard, a former student of Picot along with Bouguereau, of whom he spoke freely, and with Gustave Moreau, of whom he did not speak at all. I came to Paris recommended to Bouguereau by Couturier. I showed my early paintings to Bouguereau who declared to me that I did not know perspective. I found him in his studio, occupied with redoing, for the third time, his Salon success, *The Wasp's Nest*. It was of a young woman chased by amorous young men. He had near him his Salon picture, next to it a finished copy of the picture and, finally, on an easel, a blank canvas on which he was about to do a drawing after this copy. He was in the company of two friends: Truphème,[3] one of the prize-winners of the Salon des Artistes Français and Director of the École Municipale de Dessin du boulevard Montparnasse, and someone named Guignon, also an Artistes Français painter, and who painted only the olive trees of Menton.

"Bouguereau redid his picture literally for the third time. And his friends exclaimed: 'Oh! Monsieur, what a conscientious man you are, what a worker.' —'Ah yes!' Bouguereau replied, 'I am a worker, but art is difficult.'

"I saw the unconsciousness (unconsciousness since they were sincere) of these men who had been stamped by the Institute, and soon understood that I could get nothing from them."

Now here are some of Matisse's new memories about Fauvism and particularly about this period parallel to Cubism.

"It is said that it is I who gave Cubism its name. This isn't true.

"My master, Gustave Moreau, said that the mannerism of a kind of painting turned against it after a certain time, and that it is then that the qualities of a picture should be strong enough to render it bearable. This had put me on guard against all technique that was apparently extraordinary. The epithet 'fauve' was never accepted by the Fauves, it was always considered only a label given by the critics. It is Vauxcelles who invented the word. We showed at the Salon d'Automne. Derain, Manguin, Marquet, Puy were brought together in one of the large rooms, the little rotunda. Marque had placed a bust of an infant in the middle of this room. Vauxcelles came into this room and said: 'Well, Donatello among the wild beasts [*Tiens, Donatello au milieu des fauves*].'"[4]

"The Impressionist aesthetic appeared to us as inadequate as the technique of the Louvre and we wanted to go directly to our necessities of expression. The artist who is encumbered by all past and present techniques asks himself: 'What do I want?' This was the dominant anxiety of Fauvism: the artist departing from himself. If he makes only three touches of color they are the beginning of liberation from the emotion that he is gripped by.

"This state lasted a certain time, even a few years. Once you have come to be conscious of the quality of your desire you think of the object that you are making and you need to modify your technique in order to make yourself intelligible to others, to organize all the possibilities that you recognize in yourself. The man who has meditated about himself over a certain time re-enters life and senses the place that he can occupy. He can then act effectively."

"The pursuit of the plane among the Cubists is subjected to reality. For the lyric painter it is subjected to the imagination. It is the imagination which gives depth and space to the picture. The Cubist painters impose on the imagination of the spectator the rigorously exact space between one object and another. Under different appearances, Cubism is a sort of descriptive realism."

Matisse just interrupted, at Nice, his large work for the Barnes Foundation in Philadelphia [*sic*], an immense composition fifteen meters long and four meters high, *The Dance*, which will be placed in the main hall of the foundation, above three doors that give onto a magnificent garden. I asked him what he thought about it:

"I could have contented myself," he replied to me, "with my acquisitions of color harmonies, which have proved to be pleasurable, and with stirring or commu-

nicative arabesques. But I find myself standing before my work like a man who has never painted. I only know one thing, the place it must be part of, and the spirit of the milieu in which it should sing."

～

And since it has just been announced that Matisse has undertaken to illustrate the poems of Mallarmé in a large publication, I seized the occasion to ask him his ideas about illustrating poets.

"A work of art has a different meaning according to the epoch from whose viewpoint it is considered. Is it necessary to remain in our epoch and consider the work of art with our sensibility which is completely new today or rather to do research about the epoch in which it was created, relocate it in its epoch to see it with the other mediums (music, literature) and the parallel creations of that epoch, to know what it meant at its birth, what it provided then for its contemporaries? Obviously, to consider it from the viewpoint of its birth takes some of the pleasure away from its present life and its current action. A work of art provides to men of different periods a pleasure which comes from the communion between the work and the man who considers it. There is a relation between the quality of the work and the quality of mind of the person who considers it. The latter, in renouncing his own current quality in order to identify with the spiritual quality of the men of the epoch in which the work was created, diminishes himself and disturbs the plenitude of his pleasure, a little like someone who is driven by retrospective jealousy to seek out the past of the woman he loves.

"That is why artists have always sensed the necessity to dress up their themes, no matter which epoch they come from, with the attributes and the appearances of their own epoch. It was thus for the Renaissance. Rembrandt did biblical scenes with Turkish costumes and he lost nothing of the gravity nor of the human feeling of the Bible, whereas James Tissot, who actually lived in the holy places and found his inspiration in actual documents has only created anecdotal pictures without significance or evocative force.

"Poetry, when it represents a good poet, has no need of the declamatory art of a good reciter, or even the extraordinary qualities of a good composer, or the plastic virtues of a good painter. But it is agreeable to see a good poet inspire the imagination of another artist. This latter could create an equivalent. Then, so that the artist can really give himself to it entirely, he must be very careful to guard against following the text word for word; but, to the contrary he must work with his own sensibility enriched by his contact with the poet he is illustrating.

"I would love to be able to say simply, after having illustrated the poems of Mallarmé: 'This is what I have done after having read Mallarmé with pleasure.'"

15

Interview with Gotthard Jedlicka, 1931[1]

In the early summer of 1931, while Matisse's retrospective exhibition at the Galeries Georges Petit was still on view, the German art historian Gotthard Jedlicka arranged to see the exhibition with him. After a shaky start, Jedlicka, who had published a monograph on Matisse the previous year, manages to draw Matisse out on a number of subjects. Matisse's discussion of his recent trip to Tahiti is of particular interest here because of the way in which he anticipates his later use of Tahitian themes—after what he had seen there had had a chance, as he hoped, to "bear fruit only in memory" so that "something of all this will come into my paintings later on."

Matisse is especially eloquent in his defense of his return to a more naturalistic painting style during the 1920s, and in his discussion of how he tried to hide the enormous effort that went into his works. His remark that "What must be copied is the effort, not the result" clearly anticipates his later concern about how young artists would see his work (see Text 41, below).

This interview also contains one of Matisse's most interesting discussions of the role that drawing played within his work as a whole: "Drawing, after all, is concentrated painting," he asserts. "You paint when you draw, just as you draw when you paint." Yet he nonetheless reveals that he considers his paintings the most important part of his work, as when, after drawing in the evening, he feels that he is better prepared to go back to what he calls "my real work the next day."

INTERVIEW WITH GOTTHARD JEDLICKA

In a telephone conversation—not with me, but with intermediaries— Matisse had arranged that we would meet at nine o'clock in the morning at the hotel at the corner of Boulevard Raspail and Rue de Sèvres, where he has stayed over the past few years during his invariably brief visits to Paris.[2] In the hotel lobby I asked one of those little boys who seem to be worming their way through crowds even while daydreaming or leaning nonchalantly against a column, whether Mr. Matisse, with whom I had an appointment, was in the lobby. "Monsieur Matisse? Don't know him, monsieur," he said, raising his blond head and looking me straight in the eye. I grabbed the narrow leather band that held the boy's cap tightly under his chin and said, "Think about it! You really don't know Monsieur Matisse?" He did not budge, even after I let go of him, whereupon he shook his head emphatically, said "No, monsieur," and turned and walked away, his head tilted to one side, heading straight for the elevator to hold the door for a blond creature no taller and hardly older than himself.

The small airy anteroom where I stood swarmed with bellboys who had nothing to do. I went over to one of them and asked him the same question. Again the answer was quick: "Sorry, monsieur, but I don't know him!" I went to the big lounge and tried to find out if anyone was waiting for me. I had seen photographs of Matisse here and there. But I knew it would be hard to recognize him just from that. I sat for a while in one of those comfortable armchairs that are easier to sit down in than to get up out of and said to myself softly: All this is not a very good start. I watched the vaguely elegant clientele moving past each other in morning drowsiness, leafed through the glossy magazines about cars, sports, fashion, and travel, wondered why Matisse stayed at this hotel, and finally stood up to wait at the junction of the lobby and the hotel entrance.

But when I looked around for the last time, I noticed, right next to me, a gentleman who seemed to have been waiting there for some time, as if he had been waiting or looking for something in the same vague and somewhat impatient way that I was. He was peering at me through large horn-rimmed glasses, his gray-blue eyes sparkling with that mellow coolness so often typical of near-sighted but sharp-eyed people. Suddenly I realized that I had seen those eyes before, and the slanted light-colored eyebrows, the glasses, the flat nose. I made the connection at once: I had seen them in a pen-and-ink drawing on the cover of the German edition of a book that I had cared for so much.

"I was just about to go looking for you!" I said.

"You're the one?" he replied, decisively abandoning his impatience and extending his hand to me from such a short distance that I had trouble finding it. During all this time he focused his attention on the new situation with such presence of mind that, for a moment, I felt I could read on his forehead the calculation of how much time he meant to spend with me.

As we sat next to each other in an open-top taxi on that bright, warm summer morning, on the way to see his exhibition, I leaned slightly to the side so that I could observe Matisse inconspicuously. He was surprising in that there seemed to be so little surprising about him. I noticed this with perhaps unusual intensity because I had been anxious to discover that human warmth which, however inconspicuous, always creates a real relationship, which may be unconscious but nevertheless lasts beyond the moment, possibly even for years. The first thing that struck me about Matisse was that detached propriety I had encountered here and there and that is generally the mark of a survivor. It frankly compelled me to observe him with keen dispassion, as if this were the only way to establish a clear connection with his appearance. I therefore looked carefully at details that would have gone unnoticed in other situations. The painter was dressed in the comfortable clothes that disciplined men often permit themselves, just slightly too comfortable to be elegant. He wore a thin English coat, brownish, which looked to be new and that he

pulled together over his knees when he sat down to avoid sitting on the wrong pleat—a gesture that seemed most graceful and quite revealing, especially coming from him. Looking at his slightly drooping shoulders, I recognized that almost imperceptible deformity I have occasionally detected in other painters. It is as if the shoulders and back become slightly stunted under the tension of the arm's holding the brush and the posture of the observing eye. Oddly enough, this feature often gives older men a somewhat youthful appearance. His round beard, which bears a hint of its earlier reddish-brown and is carefully and closely trimmed, was tinged with gray, with clean, dry curls, darker and closer to its original color under the chin. His mustache was almost completely flecked with gray; it covered his sullen lips, pale and wrinkled, in which a now habitual effort could be read and which were now tightly closed. "He looks like a well-groomed notary!" I thought, for a moment even frightened by the thought—perhaps because it had come to me from a tolerably accurate knowledge of how his outward appearance had developed. But then I said to myself, "No, not really. He looks different, and his ordering clarity ranges over wider spheres."

I sensed that he was willing to discuss with me any issue concerning his painting—that he considered this a task to be attended to like any other. Since I felt self-confident, I managed a question that I meant purely to break the ice.

"Have you been traveling a lot lately?"

"Wait a minute . . . Yes, quite a bit, but for the most part not for pleasure. I went to the United States twice last year. Once I was invited to be a member of the Carnegie Foundation jury. The second time was to study, on the spot, the Barnes Foundation commission for a large mural: fifteen meters long and two meters high. I also made a long trip to Tahiti, for a rest, during which I saw a lot. I didn't take my brushes or canvas and I didn't paint a single picture.[3] I can't work during the constant surprises of a trip. I knew what would happen. The whole trip was a continuous surprise. Light and colors the like of which I had never seen. And I've lived in the South for many years now. Colors like that can bear fruit only in memory, once they've been compared to our colors. I hope something of all this will come into my paintings later on.[4] I am convinced that this is just what happened to Delacroix on his Moroccan trip. Ten years later those colors came out in his paintings."

He spoke in short sentences, occasionally interrupted by deep sighs when we got tied up in traffic. I knew all this was beside the point. Of course, what he was saying was new to me. But when I thought about it honestly, I realized that his words left me cold. I was already afraid that we would never manage to have a real conversation. What could I say to him, I wondered, to make him interrupt this polite report, and speak to me personally instead? So much depends on particular emotional vibrations. As we walked through the long gallery corridor and up the stairs to the exhibition, I felt that I would find a way to reach him, because finally I had

something to tell him. Slowing my pace so as to finish what I had to say before we got to the exhibition rooms, I said:

"Once I was concerned about how profound the influence of your work has been on other painters. At the same time, I had the impression that an entire generation shares a similar attitude toward you."

As I was speaking these words, we came to the anteroom, where three of Matisse's copies were exhibited: one of a work by David de Heem, one of a Ruysdael painting of a storm, one of Chardin's famous *Ray*. The little room looked very dark. As I had noticed in the preceding days, most visitors to the exhibit passed these paintings by without paying attention to them, because they did not consider them to be part of the Matisse exhibition.

"I am happy to hear what you say!" Matisse replied. "He who is truly talented does not lose his way. I have always learned and I am still learning even now. You can tell how I learned in my youth by looking at these copies, others of which I found in the Louvre archives, where they have been lying forgotten for decades. Even then it was said that they were not copies but paintings of my own. But it happened that way against my will. I think the exhibition has a fascinating effect if you look only at my later works. You can learn a lot from it—or nothing at all. What must be copied is the effort, not the accomplishment.⁵ That is what separates the real painter from the epigone."

He glanced at me as he said his, and from the look on his face I thought I could tell that he set great store by this formulation. We came to a small painting. I noticed that sentence by sentence, even word by word, he was expressing himself with precision.

"I have been asked why I do not exhibit my work in chronological order. Look at the exhibition. I wanted to show that earlier and later paintings not only belong together, but are alike in their essential substance. Their apparent great diversity actually refers back to the same experience. This painting was done in the Luxembourg Gardens.⁶ I remember it distinctly. Men, women and children were standing around the easel watching me paint. The adults were laughing; the children were imitating them. I was unhappy with the picture taking shape under my brush. I looked at the landscape stretching before me. Incontestably, I saw this rich variety of colors. I saw that red, some of which I later scratched off. It had been laid on too thickly. You have to understand, something like this can easily happen when you're too eager. I saw it at once and scratched off the excess. I had to do it that way. I had been so clumsy! I could feel that it was clumsy. But there is something else that I can see today just as clearly, in fact more clearly, than I did then: I achieved the effect I wanted. People have complained," he continued, looking around the gallery and pointing here and there to a picture or a part of a picture that he found particularly revealing, "People have charged that I don't paint the way I used to. Many

people consider my paintings from the Fauve period my best. But as far as their de-
cisive meaning to me is concerned, I see no difference between those paintings and
these. In those days I did what I felt within myself that I had to do. I am still doing
that today. Except that people seem to have noticed it more then. Today the situa-
tion is different. Then we were no longer satisfied with Impressionism. Its rich
techniques were dead for us. We knew we had other things to say. What we wanted
was not to paint like our predecessors, but to free ourselves. A couple of brush-
strokes innocent of traditional forms did more for this liberation than the prescrip-
tions of an entire Academy. But this does not mean that we had absorbed nothing!
You don't stay young forever. We matured during that time. And when you really
mature, that itself also proves that your youth was genuine. As I see it, I gradually
gained insight into what I was doing. Each painting through which I freed myself,
brought me closer to myself. I also tried to use what I learned about myself in this
way. You probably know that many of the paintings in this exhibition still belong to
me. They are works from various periods of my development. Art dealers have of-
fered me a lot of money for them. But I cannot part with them. I have to be able to
see where I've come from if I'm to get a feeling for where I'm going. When I look at
these paintings I can see it. But we were talking about other things. What I really
wanted then was to be understood. I could tell that I had a certain position to fill. I
wanted to fill it. That's why I opened a school. Which is to say that at the time I
didn't think so far ahead. Have you heard of it? I gave lessons for friends and stu-
dents at the Couvent des Oiseaux. I did it without pay just for the fun of teaching.
What I said seemed to mean something to many. It was such a great success that after
a few sessions I had several hundred students.[7] We had to change locations. I moved
the lessons to the Couvent du Sacré-Coeur. What I tried to do was to help others
find their own way. But that was exactly where I experienced great disappointment.

"Derain once said that my whole life was at stake in every picture I painted. I
don't think my paintings always give that impression. But one thing is true, to this
day, every time I start a new painting, I feel a terrible anxiety. Some of them may
seem brutal. Could it be otherwise? Anyone who paints has to make choices minute
by minute. How can you blame the painter if such decisions often seem impetuous?
Sometimes I have been lucky enough to finish a work quickly. You can see large pic-
tures here that I did in two hours—that odalisque, for example. But this is not al-
ways within my power. The opposite is more common . . . how often do we try to
create in a state of excitement! Usually this results in no more than a sketch. And a
sketch is not a painting. Does it surprise you that I, of all people, say such a thing? I
soon realized it. Only after the excitement has passed do we grasp its value and
meaning. To paint a good picture, just one good picture, you need an abundance of
exciting stimulations, which you have to examine soberly to see whether they are
suitable for painting. You have to admit, under these conditions, it is difficult to

paint a picture that gives an impression of having been created in an easy-going mood. I learned, early on, to abandon charm in the interest of character. Some have attributed this to some method. I think people see too much method in my works. I'm afraid they also overestimate the role of logic in them. My only method is work and observation. I work all the time: weekdays and Sundays, Christmas and New Year's day. But can you call that a method? I see too many things to be able to commit myself to just one. And you know, I have always seen everything just the way I painted it, even the things that have been interpreted as arbitrary, clever ornamentation. Not one single form have I invented, not even the ribs of this odalisque, which have so often been imitated. I have no interest whatever in inventing things and forms. It has often surprised me that people seem to find this so hard to understand. Painting is tremendously difficult enough without having to invent things; very often it resembles an intricate chess game. My students in particular have looked for my method, wanting to take it over. And when they found no such thing, they were disappointed and discouraged. I expended quite a lot of energy shaking them up again and again. I had no long-term success with any of them. They were not seeking their own paths, just an agreeable cliché. Almost all of them turned my search into mannerism and my form into gimmick. There was something else they also failed to understand. The techniques through which you paint can never be too simple. I have also striven for ever greater simplicity. But greater simplicity by no means excludes greater abundance. The simplest techniques free the eye for clarity of vision. In the long run, only the simple technique is convincing. But from time immemorial, it has taken courage to seek simplicity. I believe that it is the most difficult thing in the world. He who uses simple techniques must not be afraid to appear banal. How often have I told my students this? But this truth seemed too banal to them."

We walked past the drawings together.

"I draw a lot, and with an eye to detail," he said.

"Drawing also sharpens your sensitivity in painting. Drawing, after all, is concentrated painting. You paint when you draw, just as you draw when you paint. All the works on exhibit in these rooms and corridors, your see, represent only a small part of my work. There are various kinds of drawings. You see these detailed, almost painfully shaded black-and-white drawings? Homework, which I still assign myself even now. They have a particular meaning in my work. They precede, accompany, and follow my paintings—and by the dozens. Yet they have no clear-cut relation to the paintings themselves, because when I'm drawing I never think about the painting, which is really the indirect motive. I usually do the drawings in the evening, when it's too dark to paint. What I'm after in them is the effect of light and shadow, deliberately leaving color aside. This is very difficult and requires a different visual approach. On the other hand, it is a way of getting away from the painting that

would otherwise occupy my evenings and therefore gives me a really good rest. Naturally, many things relating to my painting occur to me during that time, things I have been looking for, perhaps without realizing it. When I go back to my real work the next day, I have subconsciously gained new ways of looking at things which will benefit the painting, even if only indirectly. But I see this only later and things are not always so simple . . . I have other drawings that cannot be forced. I think these are the most beautiful ones. You see these pen-and-ink drawings? They indicate the proportions through rhythm alone. I have done a series of similar lithographs. These are drawings I manage less frequently. They come out only in certain moods and states of excitement. They hardly ever have any connection with any planned painting. When I take pen in hand in a mood like that, I know from the outset that the drawing will not fail. I'm never wrong. I see the completed drawing clearly in front of me, my hand seems guided, I find it fantastically easy to draw it exactly as I see it. But unfortunately, this happens so rarely!"

He led me to a drawing of a reclining woman. It was hanging in a room so narrow it was almost a corridor. There are gestures that obviously denote the striving for an immediate goal. They look like periods at the end of sentences, even if the person concerned is unaware of them. Whoever knows how to read them will watch carefully for them. At the same time I noticed that Matisse was looking for a chance to summarize again what he had been saying, though without making it obvious. I had to smile when I realized that he was striving for order in his conversation just as in his paintings. He leaned forward slightly to examine the drawing by himself first, holding his eyes close to it and tracing one of his dark, chiseled curves with his head. When he straightened up, his face was flushed and his eyes, now almost blue, shone more sharply and brightly through his eyeglasses. Though his demeanor and expression told me everything, I gazed at Matisse with a polite inquisitive look.

"I told you that I work hard. There are times when I labor over a single sheet for hours on end. Here you see proof of that. One of my most recent drawings."

The drawing showed the flayed body of a woman, in which the strings of muscle were delineated with a throbbing tension. It reminded me of the construction drawings of Dürer and Leonardo and of Houdon's bronze of the flayed man. When I looked more carefully, I saw that the drawing was made up of two sheets.

"Can you believe that I sat over this drawing for more than two months? I worked on it for an hour and a half every evening—it was in winter. It consists, if you will, of hundreds of sketches superimposed one on top of the other. It was a preparation for a new painting that I'm working on now. The forms may look very deliberate to you. But as I told you before, I never invent anything, but always draw what I see . . . If you consider the drawing carefully, you will notice for example, how often I changed the position of the arm." He moved his hand, covered with

reddish-blond down that I now noticed for the first time, from one place to another, pointing with a thumbnail at the furrowed and erased lines here and there.

"And later I stuck another piece of paper on so I could continue the drawing. You see?"

He was quietly delighted that the tenacity of his way of drawing came through so clearly on that sheet. . . ."[8]

16

Interview with Pierre Courthion, 1931[1]

In this 1931 interview with the art historian and writer Pierre Courthion, Matisse makes some significant points in spite of the occasional resistance of his interviewer. Fresh from his visit to Tahiti, he mentions the state of mind that the South Seas had aroused in him and the way in which he had used the time to store impressions for later work. This process anticipates the method of working that he would develop more fully during the next decade: from memory rather than directly from nature.

This interview also gives good evidence of Matisse's keen awareness of the tradition in which he was working, and of the way in which he conceived his relationship to it.

INTERVIEW WITH PIERRE COURTHION

Matisse thinks slowly before speaking, and expresses himself with a striking precision. He has blue eyes, agate-colored, curiously attentive behind his tortoise-shell glasses. Dressed in sports clothes, his greying hair brushed back carelessly, he is seated in front of me with his legs crossed but his back very straight. He surrounds himself only with things that are necessary to him, putting out of his way everything that could distract him. He has only one canvas on the wall, the one he is working on at present, which is held up by drawing pins. When I tell him his painting reminds me of that of Velázquez he stops me: "When I saw his work in Madrid, to my eyes it was like ice! Velázquez isn't my painter: Goya, rather, or El Greco."[2]

Matisse likes that which is ablaze. Nevertheless, I expand on my comparison and he accepts it, saying: "Perhaps, but you must distinguish between *conception* and *result*. The conception of pure painting, in Velázquez's work, doesn't give a result that satisfies me."

"Delacroix, then," I said. "Although you don't grant the same importance to the imagination, to the subject."

"You see," continued Matisse, "we never realize sufficiently clearly that the old masters we admire would have produced very different works if they had lived in another century than their own. Delacroix in 1930 would not have been inspired by the same themes that occupied his mind in 1830."

I reminded Matisse that in 1908 he wrote: "What I dream of is an art of balance, of purity and serenity, devoid of troubling or depressing subject matter, an art that could be for every mental worker, for the businessman as well as the man of letters, for example, a soothing, calming influence on the mind, something like a good armchair that provides relaxation from fatigue."[3]

"It's true there is Chardin," I added, "but apart from these few relationships none of which is really direct, you are really so individualistic a painter that you are 'without a path.'"

"It depends on what you mean by that. Do you mean without being influenced and without having any influence on the future?"

"By no means: I mean that, for someone who tries to associate you with a tradition or a master, apart from the Mediterranean aspect which is your 'climate,' and the French ethos, which has rubbed off on you, you are an exception, and a rare, a very rare artist."

"I can't judge that. I don't know about that: but what's so astonishing about not understanding? There are so many things in art, beginning with art itself, that one doesn't understand. A painter doesn't see everything that he has put in his painting. It is other people who find these treasures in it, one by one, and the richer a painting is in surprises of this sort, in treasures, the greater its author. Each century seeks to nourish itself in works of art, and each century needs a particular kind of nourishment."

We started talking about the South Seas Islands and Matisse told me about his recent trip, recalling Tahiti, the small coral islands, the multi-colored fish, the broad, flat tones of the countryside. While visiting these islands, Matisse observed; he did not work with a paintbrush in his hand. To open his eyes! I believe that is the secret of a man like Matisse.

Matisse has widespread knowledge about everything. He never seems to be at a loss. I talked to him about his copies, done at the Louvre when he was young, some of which he found in storage in the museum, where they had lain hidden for a long time, since his difficult years.

"I owe my knowledge of the Louvre to Gustave Moreau: one didn't go there any more. He took us there, and taught us to see and to question the old masters."

"I saw your copies in your studio on boulevard Montparnasse. Can you tell me the order in which they were done?"

"I started with David De Heem's *Dessert*.[4] Then there was *The Ray*,[5] that I tried to paint schematically—Cézanne was the last.[6]

"Your copy of *The Ray* is the first work in which one can recognize your own style. It is clearly Chardin as seen by Matisse. Your *Dead Christ* after Philippe de Champaigne, seemed duller to me."[7]

"That's not surprising. I first had made a free copy of it; then, in the hope of a sale, I repainted it differently. I also made copies of [Raphael's] *Portrait of Baldassare Castiglione*, and of *The Storm* by Ruysdael."[8]

17

Statement to Tériade: On Creativity, 1933[1]

In a 1933 article Tériade published statements by a number of artists, including Matisse, in relation to "fundamental questions that entirely dominate modern painting," particularly "chance, spontaneity, the absence of the model."[2] Matisse once again professes his faith in the study of nature and in the enrichment of the self in order to achieve expression. He also repeats, more clearly, his earlier thoughts about how photography may be used to study nature (see Text 3, above). Of particular interest here are Matisse's remarks about the importance of preparatory studies, which "permit the painter to free his unconscious mind." This is an implicit description of the theme and variation method that underlay much of his work, and of how he conceived of drawing in relation to painting—subjects that he would return to in future writings and statements. It also indicates his growing awareness of the emphasis that the Surrealists had put on using the unconscious as a source of creativity. In fact, this text seems to reflect both Matisse's fascination with Surrealism at this time and his mistrust of it, which seems to be reflected in the concluding paragraph, where he speaks of "getting rid of what one does not have," which "only creates a void."

STATEMENT TO TÉRIADE: ON CREATIVITY

Photography has greatly disturbed the imagination, because one has seen things devoid of feeling. When I wanted to get rid of all influences that prevented me from seeing nature in a personal way, I copied photographs.[3]

We are encumbered by the sensibilities of the artists who have preceded us. Photography can rid us of previous imaginations. Photography has very clearly determined the distinction between painting as a translation of feelings and descriptive painting. The latter has become useless.

The things that are acquired consciously permit us to express ourselves unconsciously with a certain richness.

On the other hand, the unconscious enrichment of the artist is accomplished by all he sees and translates pictorially without thinking about it.

An acacia on Vésubie,[4] its movement, its svelte grace, led me perhaps to conceive the body of a dancing woman.

I never think, when looking at one of my canvases, of the sources of emotion that were able to motivate a certain face, object, or movement I see there.

The reverie of a man who has travelled is richer than that of a man who has never travelled. The daydreams of a cultivated mind and the daydreams of an uncultivated one have nothing in common but a certain state of passivity.

One gets into a state of creativity by conscious work. To prepare one's work is first to nourish one's feelings by studies that have a certain analogy with the picture, and it is through this that the choice of elements can be made. It is these studies that permit the painter to free his unconscious mind.

The harmony of all the elements of the picture that participate in a unity of feeling brought about by working on it imposes a spontaneous translation on the mind. This is what can be called the spontaneous translation of feeling, which comes not from a simple thing but from a complex thing, and which is simplified by the purification of the subject and of the mind of whoever translated it.

One does not put one's house in order by getting rid of what one does not have, because that only creates a void, and a void is neither order nor purity.

18

Interview with Dorothy Dudley, 1933[1]

In May of 1933, just before Matisse had the Barnes Mural crated for shipment, the American writer Dorothy Dudley came to his studio in Nice to see it; she also spoke to Matisse shortly after he returned from the United States, where he had

helped to install the mural. Dudley had known Matisse since 1925, when she had visited Matisse with her sister Katherine, who was a painter, and in his conversations with her Matisse is quite open and gives one of his most absorbing accounts of this project.[2] His comments about the way he had conceived of the mural as part of the architecture, and about the building itself, which had been designed by the French-born architect Paul Philippe Cret only a few years earlier, are particularly revealing; as is his explanation of the way he had planned for the greenery of the Barnes Foundation's garden to be visible through the glass doors beneath the mural, in order to complete their effect. (In fact, Barnes kept the glass doors covered, eliminating the effect of the greenery.)

The account that Matisse gives of the installation of the mural, and of Barnes' reaction to it are also of interest for what is omitted. Trying to put a good face on the situation, Matisse gives a rosy picture of his relationship with Barnes; whereas in fact the two men had argued violently while Matisse was in Merion and Barnes was somewhat disappointed by the mural itself.[3]

In the typescript of Dudley's article, she refers to the mural as a "painting" rather than a "fresco"; the wording was evidently changed by her editor. Other significant discrepancies between the published version and Dudley's typescript, which was cut in the editing process, are given in the notes, below.

INTERVIEW WITH DOROTHY DUDLEY

"Your canvas is the drama, isn't it, between yourself and nature—the nature you have selected to paint?" Henri Matisse said recently to a young painter. "That still life you have posed there, I know already how I would like to do it; those greens and pinks, those shapes—there are delicacies which engage me. But what use to tell you how I would do it? I feel it one way, you would feel it another. When you paint it you must have no preconceived idea; you must enter into it as into a virgin forest; you must place yourself in communion with nature, with that nature. You must make a communion. In the moment of painting you will think of no other artists, no other spectators; the others will not exist for you, only yourself and nature. Then the drama will result. You will attain with colors that quality which is not superficial, that atmosphere—how shall I explain it?—the way that in music various notes together make chords."[4]

Among collectors with a remarkable talent for selecting masterpieces is Albert Barnes. This self-made billionaire seems possessed by a passion to acquire great paintings, especially the moderns. What magnetic effect such collections in America may one day have on the eyes and souls of Americans is incalculable. (When I read this phrase to Matisse he looked ever so slightly cynical—that is, he laughed. But when I said, "Well, there might be such a thing as an influence even in the United States," he agreed seriously that there might be.)

To present his collection Dr. Barnes has had constructed a museum in Merion,

Pennsylvania, built of three boat-loads of stone carried from the center of France, the chateau country. It is the main gallery of this building which is decorated by the Matisse fresco, "La Danse," ordered to complete it. Immediately after the painting had been installed in May, the owner, expressing himself as delighted with his command, turned the key on it and went off to Europe.[5]

I am the one American reporter to have seen this latest work of Matisse. In April I asked of him an interview for an article I wanted to make, *The Painter in a Mechanical World*. Yes, he would give it to me, but not at once; he was occupied completing the Barnes decoration. Could I see it, and my sister who was a painter? Perhaps, if I would telephone again in about a week.

So the rendez-vous: Ten o'clock of a May morning; 8 rue Desiré Niel in Nice, a one-story studio of the kind built for moving picture companies.[6] A vast room, scrupulously swept, almost bare; along one wall occupying about two-thirds of it, the scaffolding which held the decoration. Matisse admitting us distantly, as impersonal as rock, really more so, and I remembered afterwards an aphorism of his: "What is not necessary is harmful!"[7] We had come to see the fresco, it was the fresco that dominated the moment and the place—so immediately engaging and powerful that it gave to this workroom the value of a severe temple or palace.[8]

Matisse indicated the alcove across the room from the decoration: "You will come in here, it is best to see the painting from here." Entering with us he showed us a blueprint of the Barnes museum, and then a plan of the room which his painting would complete. Then the elevation of the wall to be decorated: three French windows the length of it, six metres high, "through which one sees only the lawn, only green and flowers and bushes perhaps; one does not see the sky."[9] Above the doors three arched spaces reaching to the vaulted ceiling, so that the painting would be influenced by the triplicate shadow of the vaults. Then the elevation of the opposite wall where above the height of the windows were two balconies with arched doorways, to be hung with Arab or Indian embroideries, very beautiful, he said.

"And it is from these balconies," he explained, "that one will see the decoration fully as we see it now. From the floor of the gallery one will feel it rather than see it, as it gives the sense of sky above the green conveyed by the windows. Between them hang pictures, in this space *The Card Game* by Cézanne, in this Renoir's *Family*, here *The Models* by Seurat, beyond *Madame Cézanne in the Green Hat*, as well as several other canvases of the very first order. It is a room for paintings; to treat my decoration like another picture would be out of place. My aim has been to translate paint into architecture, to make of the fresco the equivalent of stone or cement. This, I think, is not often done any more. The mural painter today makes pictures, not murals."

I said, "What of Chavannes?"[10] . . . "He approaches it, yes, but does not arrive

perfectly in that sense. The walls of the Pantheon, for example, are of stone. Puvis' paintings are too soft in feeling to make the equivalent of that medium. If one had a diamond, say, one would set it in metal, not in rubber." [11]

With this scrupulous preface, we were at liberty to look at the painting: Eight giant figures against shafts of sky in a tremendous dance of goddesses. The flesh grey between black and white, like the walls of the room in Merion; the sky vivid cobalt blue and brilliant rose, which for a limpid narrow margin around the bodies deepens to a darker blue and rose; the grey of the flesh influenced against the blue toward orange, against the rose toward green. [12]

As one looked the dancers appeared to move in and out, as well as existing on a single plane. Matisse said: "Yes, but in reality the painting is made in flat tones without any gradation—a necessity of the fresco. It is the drawing, and the harmony and contrast of the colors, that form the volume, just as in music a number of notes form a harmony more or less rich and profound according to the talent of the musician who has assembled them."

I had never seen, I thought, a thing so simple and so calculated. His quick comment was: "'Calculated' is not the right word. For forty years I have worked without interruption; I have made studies and experiments. What I do now issues from the heart. All that I paint is produced that way. I feel it." [13] It was like saying that now precise calculation was with him a habit, and that only when calculation has become a habit can it be precise.

He went over to the fresco and pointed out how he had elevated the direction of the drawing to give height; and then turned to a table covered with photographs. They were pictures of the series of projects he had made, cut from colored papers, before he reached the conception which seemed to him architecturally just. [14] Each project was numbered; there were thirty of them, all of them beautiful. [15] The changes each time had been made away from the picture and toward the mural. And they had been made away from recumbency and toward ascension; away from the detail of what people are doing on the earth toward the ethereal areas of sky. So much so that the arches in the last project seemed actually to have changed measure and to be higher than they were wide. I spoke of this; his answer was:

"Yes, exactly, that was the problem, so that my decoration should not oppress the room, but rather should give more air and space to the pictures to be seen there. The arches were four metres wide and three and a half high. I saw that the surface to be decorated was extremely low, formed like a band. Therefore all my art, all my efforts consisted in changing apparently the proportions of this band. I arrived then, through the lines, through the colors, through energetic directions, at giving to the spectator the sensation of flight, of elevation, which makes him forget the actual proportions, much too short to crown the three glass doors—with the idea always of creating the sky for the garden one sees through the doors." [16]

"Then really your painting has corrected the architecture?" He admitted that this had seemed to him imperative; that if the proportions had been different he would not have developed this particular theme, but would have done something else with the surfaces. He emphasized the labors he had undergone to suit the decoration to the room. To this end he had purified and verified the drawing to the last fraction of an inch, so that it should always be supple and free, but never too fluent. For two years the work had occupied him; he had thought of nothing else. Now the final result pleased him. Tomorrow it would be packed and he would go to America to install it.

I asked if in other ways he liked the building for which the fresco was planned. His reply was evasive. There was light; paintings could be favorably seen there: "Nevertheless, I must say that when I have decorated a surface, it takes on a particular meaning, and that then the surface pleases me more than before." He said this as if it were a criterion of mastery to triumph over specifications and handicaps, whatever they were.

I asked if Barnes were a man with a really sensuous, sensitized eye. "He must be, or how else could he have made his collection?" "You know he has 340 Renoirs, more than any one possesses anywhere." There he paused as if the acquisition of so many canvases by that one painter were distinction enough. "And 80 Cézannes, very great canvases, and some fine examples of Seurat, which are rare, and a wonderful Greco. . . . " As he said over these names and numbers one caught from his voice the wealth and significance of the painted world. "Besides, he left me free to do what I wanted. He said, 'Paint whatever you like just as if you were painting for yourself.'"

Now it was time to go, and without knowing whether I could have the interview for which I had asked. . . . "But what do you want me to say? The painter should have nothing to say, his painting speaks for him." . . . For one thing, I said, I would like him to elaborate what he had told reporters about New York two years ago— that he could imagine no place more favorable to the painter. Yes, he remembered: "But why not? The New York light is exceptionally beautiful, and then those towers, those masses rearing themselves in the air, in that light which is like crystals . . ." I spoke of the light on the Riviera. "Yes, that too is very beautiful, but it is different. The atmosphere in New York is so dry, so crystalline, like no other . . . But you know a painter, especially a Frenchman, must be very careful. A Frenchman is supposed to talk too much. . . .

"They asked me so many questions—for example if the American painter should not stay at home. I said that New York ought to be an inspiration, that I liked your country. But perhaps New York pleased me because it was new to me, I was a visitor. After all it was educative to travel; even the French painter went to Italy to see the paintings of the past. Very likely your painters would need go to

Paris as a mere matter of education. But they wrote down that Matisse believed the American should stay at home! Why did they do that?"[17]

The talk turned on women painters. It was unfortunate for an artist to be born a woman, we thought. "Why", he asked. "She would be more distracted than a man; she would be more deflected by men than a man is by women." "Perhaps that was true in the old days," Matisse said, "when a woman was kept at home. But not today. Look at the women aviators, they are marvelous, as good as men." But aviation took less concentration than painting? "True, but perhaps it was a beginning. In time women might equal men in every sense; they might very well do so. A woman must merely lead a life devoted to painting; that is all that is necessary, provided she has the gift. That is what I have done. I have thought of nothing but my work. I have asked myself every day if I were doing what was essential to keep myself in condition to paint. All that is difficult. It means that one must remain calm, balanced, clear of distractions. One must make sacrifices. . . ."[18]

Would I write him on his return from America? Matisse asked. My article would be all the better then. He would tell me how they liked the decoration. They had apparently been waiting for it, asking if it were finished, or when would it be finished? "As if they were waiting for a god," he added. "Perhaps I ought to be frightened. After all I am not a god, I am only a man." Matisse said this lightly, yet almost reflectively, as if there might be uncertainty.[19]

In truth as one gave a last look at "The Dance," it would have been reasonable to contradict him. The fresco seemed to say that to a few painters, singularly so to Matisse, as to a few physicists who have devoted their lives to the nature of light, light has yielded secrets not known before. Perhaps then these men were gods or near to gods, being among the few who are more modern than the run of the moderns; since with them understanding penetrates invention.

Here spontaneity springs from a gravity due to years of intensive work nearly foreign to American life and architecture. Yet the painting would not accuse the hastier, less conscious American scene. It was a theorem in physics, in mathematics, so precisely solved that it would lend meaning and brilliance.[20]

Of the milieu Matisse would not be judge, except to agree: "You are still in a great hurry in your country, and for art leisure is necessary. It will come. You have some artists who are really gifted." As for his painting in relation to that milieu, he thought one might say this much: "In an age when one finds so rarely a collaboration between painters and architects, it is perhaps a good sign to see that one painter has submitted himself to an already existing architecture, so that a veritable collaboration will seem to have occurred."

True to his promise I saw Matisse on his return from the United States. Had his trip been successful? Had everything gone as he expected? "*J'étais ravi*," he said. "I reached Merion on a Friday and all was installed by Monday.[21] As soon as I saw the

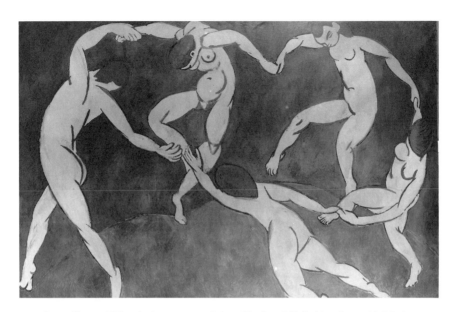

21. *Dance II,* 1910. This painting was commissioned by Sergei Shchukin, along with *Music.*

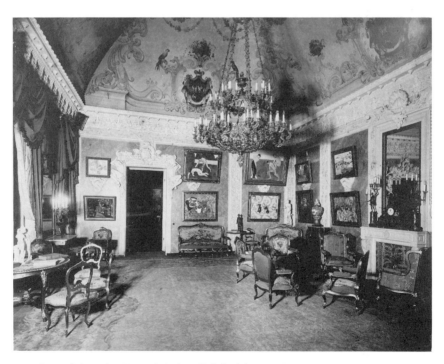

22. Room dedicated to Matisse's work at Shchukin's home in Moscow, c. 1912.

23. *Nymph and Faun*, illustration from *Poésies de Stéphane Mallarmé*, 1932. Matisse described the design problems this posed in "How I made my Books" (Text 35).

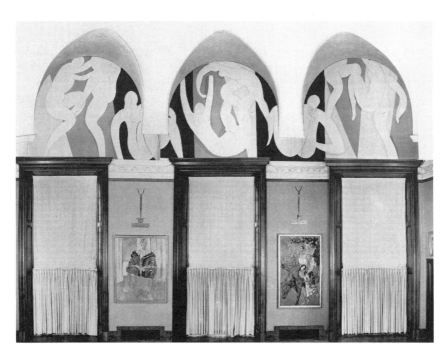

24. Matisse's *Dance* Mural, 1931–1933, installed at the Barnes Foundation, Merion, Pennsylvania.

decoration in place I felt that it was detached absolutely from myself, and that it took on a meaning quite different from what it had had in my studio, where it was only a painted canvas. There in the Barnes Foundation it became a rigid thing, heavy as stone, and one that seemed to have been spontaneously created at the same time with the building. . . .

"Barnes said, 'One would call the place a cathedral now. Your painting is like the rose window of a cathedral.'" Matisse showed me photographs taken from the balcony and from the door of the room. One of them from below made an oblique version of the dancers in one archway that amplified the roundness of the bodies: "And when one looks from this angle," he said, "one would say, too, it is like a song that mounts to the vaulted roof."

19

Letters to Alexander Romm, 1934[1]

In 1934 Matisse wrote several letters to the Soviet art critic Alexander Romm, who was writing a book about him,[2] and who had solicited information directly from the artist. Matisse's answers to Romm were the considered statements of an artist to his public, rather than personal letters, as is attested to by the content of the letters themselves and by Matisse's statement (20 June 1935) to the Director of the Museum of Modern Western Art in Moscow: "I have not written on painting since the War, as I did before in the *Grande Revue*, except to Mr. Romm."[3]

The letters are devoted mostly to discussion of Matisse's most recent works, especially the Barnes Murals and the *Dance* and *Music* panels that he had done for Shchukin in 1909–1910, and which had been confiscated by the State for the Museum of Modern Western Art in Moscow. These letters, which also reveal Matisse's precision and stubbornness, contain ideas that were repeated in his later statements about the Barnes mural.[4]

LETTERS TO ALEXANDER ROMM

Nice, 1 Place Charles Félix, 19 January 1934

Sir,

[The letter starts with topical matters and suggests illustrations for Romm's book.]
From these last years (1931–2 and 3), I am sending you the photo of an important work which I have just done for the Barnes Foundation (Philadelphia); it is a panel of 13 meters by 3.50 metres, placed above three entirely glazed doors six meters in height. The photo of the ensemble with the doors, made from different pho-

tographs assembled together, will give you an idea of it. The painting acts as a pediment to these three doors—like the elevated part of a cathedral porch—a pediment placed in shadow and yet required, in continuing the large mural surface broken by the three great luminous bays, to maintain itself in all its luminosity; consequently its plastic eloquence (a surface in shadow juxtaposed against a strongly lit bay without destroying the continuity of the surface) is the result of modern achievements regarding the properties of color. Perspective, as you can see for yourself, reduces the painted part, since it is in reality 3.50 meters tall, while the doors are 6 meters. I have added to these photos another of a view drawn by an architect, which gives the true proportions.

Apart from the fact that this work is the most important I have done these past three years, the subject too, analogous to one of my important works in Moscow (*The Dance*), will convey to you an interesting relationship between these two works. These panels are painted in flat colors. The areas between the doors are continued in the decoration of the black surfaces and give a unity of surface from the floor to the top of the vault: 6m + 3m.50 = 9m.50, which, together with the pendentives that press down on these black surfaces, gives the illusion of a monumental support for the vault.

The other colors: pink, blue, and the nudes of a uniformly pearl grey, form the whole musical harmony of the work. Their frank contrasts, their decided relationships, give an equivalent of the hardness of the stone, and of the sharpness of the ribs of the vault, and give the work a grand mural quality—a very important point since this panel is placed in the upper part of the large gallery of the Foundation, which is filled with easel paintings—it was logical clearly to differentiate my work of architectural painting.

I will indicate on the back of the photos the colors of the different sections. In spite of all these explanations, I think it will be impossible for you to get a clear enough idea of the work to be able to establish a close enough comparison with *The Dance* in Moscow, for the points of view are totally different. The Moscow panel still proceeds from the rules governing an easel painting (that is to say, a work which can hang anywhere), which is because I was unable to imagine these panels in place, only knowing the staircase where they were to hang from having gone up it a few times without knowing that I would have paintings there—at the time there was no question of decorating it.

The Merion panel was made especially for the place. In isolation I consider it only as an architectural fragment. It is really immovable, so much so that I foresee that these photos will be only of little interest to you in spite of my explanations.

You will find 2 or 3 photos representing two different versions of this same dance. That is because following an error in measurement of the two pendentives, which I had made 50 cm instead of 1 meter wide at the base, I had to start again

when my first panel was finished after a year of work.[5] I enclose with my letter this first version. The second is not a simple copy of the first; for, because these different pendentives required me to compose with architectural masses more than twice the size, I had to change my composition. I even produced a work with a different spirit: the first is warlike, the second Dionysian;[6] the colors, which are the same, have nonetheless changed; the quantities being different, their quality also changes: the colors are applied in a completely straightforward way so that it is their quantitative relations that produce their quality.

Since I am talking to you in such detail about my work, I should tell you that I did another large work of sixty etchings to illustrate the *Poésies de Mallarmé*.[7]

[Matisse lists the etching reproductions enclosed.]

I close hoping that you will excuse all this writing if it doesn't interest you. I live here in solitude and when I have the occasion to pour forth, I cannot resist. Please accept, Monsieur, with my thanks for all the trouble that you have gone to for me, my very best wishes.

<div align="center">Henri Matisse</div>

P.S. I couldn't procure other reproductions of etchings—these ones are rather soiled, but the balance and the proportion in relation to the page are scrupulously exact, for these two elements are essential.

<div align="center">~</div>

Nice, 14 February 1934

Dear Mr. Romm,

You tell me in your letter of 3 February that my Merion panel is a logical follow-up of the Moscow *Dance*, but that you see there a distinct difference: the human element is less pronounced—and this induces me to answer you that the object of the two works was not the same; the problem was different.

In architectural painting, which is the case in Merion, it seems to me that the human element has to be tempered, if not excluded. I, who let myself always be guided by my instinct (so much so that it manages to overcome my reason), had to avoid it, for it led me away from my architectural problem each time it appeared on my canvas. The expression of this painting should be associated with the severity of a volume of whitewashed stone, and an equally white, bare vault. Further, the spectator should not be arrested by this human character with which he would identify, and which by stopping him there would keep him apart from the great, harmonious, living and animated association of the architecture and the painting.

Didn't Raphael and Michelangelo, despite the abstraction resulting from all the richness of mind that they expended on their murals, weigh down their walls with the expression of this humanity, which constantly separates us from the ensemble,

notably in the *Last Judgement*? This human sentiment is possible in a picture—a picture is like a book—its interest does not overwhelm the spectator who must go in front of it; the place it will hang is not fixed in advance. It can change places without essentially modifying its place. The painter, then, has more freedom to enrich it.

Architectural painting depends absolutely on the place that has to receive it, and which it animates with a new life. Once it is placed there, it cannot be separated. It must give the space enclosed by the architecture the atmosphere of a wide and beautiful glade filled with sunlight, which encloses the spectator in a feeling of release in its rich profusion. In this case, it is the spectator who becomes the human element of the work.

You also say: "It seems to me that the Merion panels should produce an effect analogous to stained-glass windows in the semi-darkness of a nave." Yes, with the difference that my wall is penetrated by light at the foot, while in the nave it comes from above. My painted surface is quite opaque, and does not give any illusion of the transparency of a stained-glass window; rather it reflects light.

I should like to add that the glazed arches are wider than the solid parts, but that my vertical plan still takes precedence over all else. I will even add that by the action of my lines and my painted surfaces I have raised the arches of the vault, which were very oppressive and gave a crushing feeling.

You point out to me the difference between the Moscow *Dance* and the Merion panel (reminding you of '*La Joie de vivre*') and you wonder if the different character of the coloring is not the cause.

On this subject, I should tell you that the first panel made for Merion (which because of an accident in measurement had to be redone) and the final one are painted with exactly the same colors, the same manner of painting and that, nonetheless, they have a different character. The first decoration is a warlike dance and has a little of the frenzy of the Moscow panel. The feeling alone turned the same constructive elements into a different expression, by proportioning them differently—as in music, the seven notes, more or less altered, and the same tones express by their different combinations—an extraordinary variety of expression. That is all.

You may, as you ask, make use of passages of this letter and of the preceding one if you consider it worthwhile. I hope to have expressed myself clearly enough for that.

I congratulate the directors of the Russian B.[eaux] A.[rts] on their excellent idea to have public monuments decorated by their painters; that is where the great problem is, at present.

Please accept my thanks for the great interest that you take in my work, and also the expression of my highest regard.

Henri Matisse

P.S. I looked with interest at the book of embroideries that you sent me. I had already seen this work in Moscow in the National Museum of Art formed by the brother of Serge Ivanovitch Stschoukine; the reproductions in this book are very well done.

A friend brought me from Moscow, several years ago, a color reproduction of an *espagnole*,[8] in the Stschoukine collection. Could you tell me, if it is no trouble, whether there were other color reproductions made of my works in Moscow?

⌣

Nice, 17 March 1934

Dear Mr. Romm:

I said of a picture: its interest does not overwhelm the spectator who must go in front of it. It is an image. Like a book on the shelf of a bookcase, showing only the few words of its title, which needs, to give up its riches, the action of the reader who must take it up, open it, and shut himself away with it—similarly the picture enclosed in its frame and forming with other paintings an ensemble on the wall of an apartment or a museum, cannot be penetrated unless the attention of the viewer is concentrated especially on it. In both cases, to be appreciated, the object must be isolated from its milieu (contrary to architectural painting). It is this which made me write that the spectator must go "in front of"; I should have written "in search of" to be more precise.

[The letter concludes with topical matters.]

Henri Matisse

⌣

October 34

Dear Sir,

[The letter begins with topical matters.]

Regarding the information that you asked me for on my manner of painting—intense study of the model and rapid execution of the picture afterwards; this is quite right, but again the method of working depends very much on temperament. Delacroix said that after making all the studies that one feels are needed for a picture, it was necessary to buckle down to it exclaiming: "And now never mind about mistakes!" That is to say that it is necessary to let instinct speak. Regarding the transparency of colors, it is also a sort of instinct that guides your hand. When I undertook the Moscow *Dance* and *Music*, I had decided to put colors on flat and without shading. I knew that my musical harmony was represented by a green and a blue (representing the relation of the green pines to the blue sky of the Côte d'Azur) completed by a tone for the flesh of the figures. What seemed essential to me was the surface quantity of the colors. It seemed that these colors, applied by no

matter what medium, fresco, gouache, watercolor, colored material would give the spirit of my composition. I was quite astonished, when I saw the decorations in Moscow, to see that I had, in applying my colors, played a little game with the brush in varying the thickness of the color so that the white of the canvas acted more or less transparently and threw off a quite precious effect of moire silk.

To use the transparency of colors, to avoid mixing them, which renders them dull, use glazes, etc. (this is your own phrase). This is governed by the same principle. You can superimpose one color on another and employ it more or less thickly. Your taste and your instinct will tell you if the result is good. The two colors should act as one—the second should not have the look of a colored varnish, in other words the color modified by another should not look glassy. The painter who best used slightly thinned paint and glazes is Renoir—he painted with liquid: oil and turpentine (I suppose ⅔ poppy seed oil and ⅓ turpentine) quite fresh and not syrupy, oxidized by the air; for in this case the painting never dries; I knew of a Renoir of the Cagnes period, a figure of a woman representing a spring, which was still not dry twenty years after its execution.

Since I am speaking of the Moscow decoration, let me tell you that in the panel of *Music*, the owner had a little red painted on the second personage, a young flutist with crossed legs. He had a little red painted to hide the sex which was, however, indicated quite discreetly, it was there to finish the torso.[9] All that is needed is for a restorer to take a little liquid solvent like mineral spirits benzine, and rub this place a moment until the hidden lines appear.

20

On Modernism and Tradition, 1935[1]

Although Matisse had given interviews between 1908 and 1935, his own published writing within that period consisted only of a brief autobiographical note.[2] "On Modernism and Tradition," which was published in May 1935 in the London journal *The Studio*, was Matisse's first published essay since "Notes of a Painter." Unfortunately, the French original of this important text has been lost, and the English translation seems in places (noted below) to be somewhat inaccurate.[3] (Because of the unusual circumstances surrounding the publication of this text, the English original is here reproduced verbatim, retaining British spellings.)

In this essay, which was part of a series of articles in which artists and critics wrote on the art of the time, Matisse reminisces about his early training, especially the time he spent copying in the Louvre, and about his relationship to his contemporaries. He notes that while most of the latter were interested in the Impression-

ists and Post-Impressionists, he himself spent his time copying in the Louvre and submitting himself to the influence of such masters as Raphael, Poussin, and Chardin, because he wanted to see beyond the Impressionists' subtle gradations of tone: "In short, I wanted to understand myself." This emphasis upon the finding of oneself is a reiteration, here in autobiographical form, of Matisse's concept of painting as expression of universal feelings through the medium of the individual self.

In 1935 Matisse is just as concerned as he had been in "Notes of a Painter" with his notion of the picture as a total harmony (not unlike a musical composition) in which the configuration of form and space carries the expression. His image of the chess-board is particularly revealing and sheds light on his choice of subject matter. The constant repetition of similar—and sometimes the same—objects and situations in his painting may be seen to have the constancy of a chess-board, while the different configurations of form in which the situations are embodied may be compared to the different moves which make the appearance of the board change during the course of play. As the intentions of the players remain constant, so it might be said that Matisse's underlying intentions also remained constant, despite his changes in style.

The reasoning behind Matisse's synthesis of objects is succinctly stated here: significance is found not in copying nature but in the relation of the object to the artist's personality and to "his power to arrange his sensations and emotions."

Just as "Notes of a Painter" showed Matisse's relationship to tradition, here too he states that there has been no break in "the continuity of artistic progress from the early to the present day painters."[4] Matisse obviously sees himself as part of a long and rich tradition in which "only plastic form has a true value," and in which "a large part of the beauty of a picture arises from the struggle which an artist wages with his limited medium"—what Roger Fry called "The dual nature of painting, where we are forced to recognize at one and the same moment, a diversely colored surface and a three-dimensional world. . . ."[5] This struggle with the inherent tensions between the formal demands of the medium of painting and its representational function obsessed Matisse throughout his career.

In this essay Matisse once again discusses his continuity with the traditions of European painting, states his belief in painting as expression, and acknowledges his preference for bright, clear color. Although he alludes to color, line and subject matter, he avoids a specific discussion of space and the illusion of space, and of the relationship between painting and drawing.

ON MODERNISM AND TRADITION

It is undeniable that, during the last fifty years, every artistic effort of importance has been made in Paris. Elsewhere, artists are content to follow where others have led, but in Paris there is the enterprise and the courage necessary to all creative work which has made this city an artistic centre.

When I first began to paint, we did not disagree with our superiors and advanced our opinions slowly and cautiously. The Impressionists were the acknowledged leaders and the post-Impressionists followed in their footsteps. I didn't. We young painters strolled down the Rue Laffitte looking at the galleries in which their pictures were on view, and as we worked we thought of them. As for me, having left the Beaux Arts, I spent my time in the Louvre copying and submitting myself to the influence of such undoubted masters as Raphael, Poussin, Chardin and the Flemish. I felt that the methods of the Impressionists were not for me. I wanted to see beyond their subtle gradations of tone and continual experiments. In short, I wanted to understand myself. Coming out of the Louvre, crossing the Pont des Arts, I saw other subjects for my art.

"Well, what are you looking for?" Gustave Moreau, my master, asked me, one day.

"Something that is not in the Louvre," I answered, "but is there," pointing to the barges on the Seine.

"And do you think that the masters of the Louvre didn't see that?" he replied. In point of fact what I saw at the Louvre did not affect me directly. There I felt as though I were in a library containing works of the past and I wanted to create something out of my own experience, so I began to work alone.[6]

It was then that I met a tall, thin young man, who has since put on quite a respectable amount of flesh; this was Derain.[7] We lived together for some time at Collioure, where we worked unremittingly, urged by the same incentive. The methods of painting employed by our elders were not adequate to the true representation of our sensations, so we had to seek new methods. And, after all, this urge is felt by every generation. At that time, it is true, there was more scope than there is to-day, and tradition was rather out of favour by reason of having been so long respected.

The simplification of form to its fundamental geometrical shapes, as interpreted by Seurat, was the great innovation of that day. This new technique made a great impression on me. Painting had at last been reduced to a scientific formula; it was the secession from the empiricism of the preceding eras. I was so much intrigued by this extraordinary method that I studied post-Impressionism,[8] but actually I knew very well that achievement by these means was limited by too great adherence to strictly logical rules. Those around me knew of this feeling. Standing in front of a canvas that I had just finished, Cros [sic][9] said to me: "You won't stay with us long."

In the post-Impressionist picture, the subject is thrown into relief by a contrasting series of planes which always remains secondary. For me, the subject of a picture and its background have the same value, or, to put it more clearly, there is no principal feature, only the pattern is important. The picture is formed by the combination of surfaces, differently coloured, which results in the creation of an "expres-

25. *Pink Nude*, finished 31 October 1935. During the 1930s Matisse frequently had his paintings photographed in different stages of development. *Pink Nude* was worked on over a period of six months.

Pink Nude in progress: State I, 3 May 1935

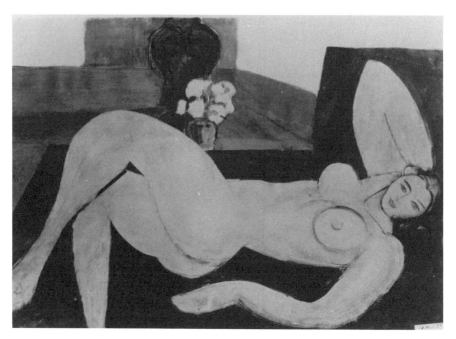

Pink Nude in progress: State V, 20 May 1935

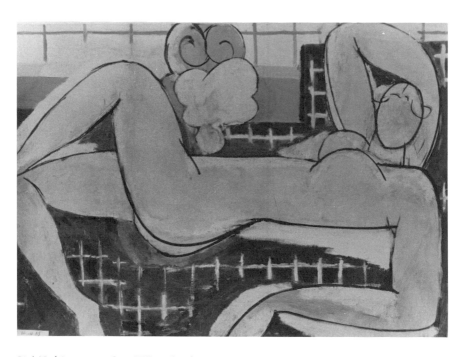

Pink Nude in progress: State XXI, 16 October 1935

sion." In the same way that in a musical harmony each note is a part of the whole, so I wished each colour to have a contributory value. A picture is the co-ordination of controlled rhythms, and it is thus that one can change a surface which appears red-green-blue-black for one which appears white-blue-red-green; it is the same picture, the same feeling presented differently, but the rhythms are changed. The difference between the two canvases is that of two aspects of a chessboard in the course of a game of chess.

The appearance of the board is continually changing in the course of play, but the intentions of the players who move the pawns remain constant.

I decided then to discard verisimilitude. It did not interest me to copy an object. Why should I paint the outside of an apple, however exactly? What possible interest could there be in copying an object which nature provides in unlimited quantities and which one can always conceive more beautiful. What is significant is the relation of the object to the artist, to his personality, and his power to arrange his sensations and emotions.[10]

I have a great love for bright, clear, pure colour, and I am always surprised to see lovely colours unnecessarily muddied and dimmed.

A great modern attainment is to have found the secret of expression by colour, to which has been added, with what is called Fauvisme and the movements which have followed it, expression by design;[11] contour, lines and their direction. In the main, tradition was carried forward by new mediums of expression and augmented as far as was possible in this direction.

It would be wrong to think that there has been a break in the continuity of artistic progress from the early to the present-day painters. In abandoning tradition the artist would have but a fleeting success, and his name would soon be forgotten.

To-day, it seems to me, that we live in a period of fermentation which promises to produce important and durable works. But, if I am not mistaken, only plastic form has a true value, and I have always believed that a large part of the beauty of a picture arises from the struggle which an artist wages with his limited medium.

One last comment on the name of that school of painting known as "Fauvisme," a word which was found so intriguing and which became the subject of many more or less apt witticisms. The phrase originated with the art critic Louis Vauxcelles who, on coming into one of the rooms of the Autumn Salon, where, among the canvases of that generation, a statue was on view executed by the sculptor Marque in the style of the Italian Renaissance, declared "Look, Donatello among the beasts."[12] This shows that one must not attach more than a relative importance to the qualifying characteristics which distinguish such and such a school, and which, in spite of their convenience, limit the life of a movement and militate against individual recognition.

21

Statements to Tériade: On the Purity of the Means, 1936[1]

In 1936 Matisse made two short statements to Tériade, which are particularly relevant to his own development at this point. From around 1929 to about 1933, Matisse had been undergoing a revision of his own values, as evidenced in his work and in his statements. The first of these two 1936 statements to Tériade is the boldest and the most straightforward appraisal of this change; and appearing as it did in the avant-garde review *Minotaure*, it amounted to a repositioning of Matisse in relation to the Parisian avant-garde.

In this text Matisse is concerned with a return to essentials, having apparently come to feel that during the early "Nice period" his paintings had become somewhat attenuated, perhaps too detailed, too relaxed, too low key, too much involved with the fleeting effects of light and atmosphere—not synthetic enough. Thus he calls for "beautiful blues, beautiful reds, beautiful yellows—matter to stir the sensual depths in men. This is the starting point of Fauvism: the courage to return to the purity of the means." Here Matisse is referring directly to the new boldness of his own imagery in the mid 1930s. Thus he can state: "In my last paintings I have united the acquisitions of the last twenty years to my essential core, to my very essence." The twenty-year period he refers to is roughly that between 1917 and 1936; thus the so-called Nice period is now recast as a time when he was regathering his forces, through the close analysis of optical effects, in order to strike out even more boldly in a more synthetic direction.

The second statement, which concerns relationships, anticipates Matisse's later exposition of his portrait painting method (Text 52, below), and bears witness to his consistency of method. It also provides a specific description of the fluid relationship Matisse maintained with his pictures while working on them, which is so vividly evident in photographs taken of them while still in progress.[2]

Shortly after this statement was first published, Matisse made some additions to it for Raymond Escholier's 1937 monograph; these are added here in brackets.

STATEMENTS TO TÉRIADE:
ON THE PURITY OF THE MEANS

When the means of expression have become so refined, so attenuated that their power of expression wears thin, it is necessary to return to the essential principles that made human language. These are, after all, the principles that "go back," that restore life, that give us life. Pictures that have become refinements, subtle degradations, dissolutions without energy, call for beautiful blues, beautiful reds, beautiful

yellows—materials to stir the sensual depths in men. This is the starting point of Fauvism: the courage to return to the purity of the means.

Our senses have an age of development which does not come from our immediate surroundings, but from a moment in civilization. We are born with the sensibility of a given period of civilization. And that counts far more than all we can learn about a period. The arts have a development that comes not only from the individual, but also from an accumulated strength, the civilization that precedes us. One can't do just anything. A gifted artist cannot do just anything at all. If he used only his talents, he would not exist. We are not the masters of our production. It is imposed on us.

In my latest paintings, I have united the acquisitions of the last twenty years to my essential core, to my very essence.

~

The reaction of each stage is as important as the subject. For this reaction comes from me and not from the subject. It is from the basis of my interpretation that I continually react until my work comes into harmony with me. As someone who writes a sentence, reworks it, makes new discoveries . . . At each stage, I reach a balance, a conclusion. At the next sitting, if I find that there is a weakness in the whole, I make my way back into the picture by means of the weakness—I re-enter through the breach—and I reconceive the whole. Thus everything becomes fluid again and as each element is only one of the component forces (as in an orchestration), the whole can be changed in appearance but the feeling sought still remains the same. A black could very well replace a blue, since basically the expression derives from the relationships. One is not bound to a blue, to a green or to a red [whose timbres can be introverted or replaced if the feeling so dictates].[3] You can change the relationships by modifying the quantity of the components without changing their nature. That is, the painting will still be composed of blue, yellow and green, in altered quantities. [A kilogram of green is greener than half a kilo. Gauguin attributes this saying to Cézanne in a visitor's book at the house of Marie Gloanec at Pont-Aven.][4] Or you can clarify the relationships that form the expression of a picture, replacing a blue with a black, as in an orchestra a trumpet may be replaced by an oboe. [It all depends on the feeling you're after.][5]

. . . At the final stage the painter finds himself freed and his emotion exists complete in his work. He himself, in any case, is relieved of it.[6]

22

On Cézanne's "Three Bathers," 1936[1]

In 1936 Matisse decided to give his Cézanne *Three Bathers* to the Museum of the City of Paris at the Petit Palais. He had purchased the painting from Vollard in 1899, and had kept it through intense financial difficulties (see Text 26, below).[2] His letter to Raymond Escholier, director of the museum, is a moving testament to his regard for Cézanne.

ON CÉZANNE'S "THREE BATHERS"

Nice, 10 November 1936

Yesterday I consigned to your shipper Cézanne's *Bathers*. I saw the picture carefully packed and it was supposed to leave that very evening for the Petit Palais.

Allow me to tell you that this picture is of the first importance in the work of Cézanne because it is a very dense, very complete realization of a composition that he carefully considered in several canvases which, though now in important collections, are only the studies that culminated in this work.

In the thirty-seven years I have owned this canvas, I have come to know it quite well, though not entirely, I hope; it has sustained me morally in the critical moments of my venture as an artist; I have drawn from it my faith and my perseverance; for this reason, allow me to request that it be placed so that it may be seen to its best advantage. For this it needs both light and adequate space. It is rich in color and surface, and seen at a distance it is possible to appreciate the sweep of its lines and the exceptional sobriety of its relationships.

I know that I do not have to tell you this, but nevertheless I think it is my duty to do so; please accept these remarks as the excusable testimony of my admiration for this work which has grown increasingly greater ever since I have owned it. Allow me to thank you for the care that you will give it, for I hand it over to you with complete confidence. . . .

Henri Matisse

23

Divagations, 1937[1]

Throughout his career, Matisse had been deeply concerned with the relationships between color and drawing. In the mid to late 1930s, when he was developing a flat, brightly-colored style of painting, the process of drawing took on a new relationship to that of painting. Line and color became somewhat separated—contrapuntal rather than integrally related processes.

Around this time, Matisse was moved to write two essays that are concerned primarily with drawing, "Divagations" and "Notes of a Painter on His Drawing."

Although the early critical battles seemed far in the past, recent political events had caused a new wave of reaction against much of modern painting, and Matisse's art was especially prone to criticism in Nazi Germany, where his art was considered "decadent" or "degenerate," and in the Soviet Union, where he was criticized for his "bourgeois aestheticism." Moreover, in the depth of the depression in America there was a tendency to distrust the visual opulence of Matisse's painting and its aloofness from social events.[2]

During this period Matisse was not only very much involved with drawing but was also quite aware of the appeal of his drawings even to persons who were not particularly enthusiastic about his painting.[3]

In "Divagations," Matisse reflects at length on the inscription at the École Nationale des Beaux-Arts of a saying of Ingres which reads, "Drawing is the probity of art." He uses this quotation as a springboard for his own reflections upon drawing and the teaching of drawing, and as a platform from which to vent his spleen against the academicians, whom he felt misunderstood "these facile words of Ingres, constantly repeated by pompous ignoramuses." In reflecting upon the importance that Ingres and Leonardo assigned to drawing, Matisse discusses the role of the artist as teacher.

Perhaps with some desire to justify the brevity of his own career as a teacher, Matisse regrets the sight of "genuine artists devoting a portion of their efforts to the aid of those who cannot find their way alone!"[4] Finally, he comes back to an attitude that underlies virtually all of his writings: "He who really has something to say is driven to it by the emotion that induces him to carry out his work in relation to his own qualities." Thus, while Matisse identifies himself with the "classical tradition" of painters, he expresses the attitude that if rules are made they must be broken, that while intensive training and endless study are necessary for the development of the artist, finally the artist must act on his own instincts. Matisse believed great art to be the product not of a didactic system, but of the contact between an individual sensibility and nature. Great art makes its own rules.

"Drawing is the probity of art." Many years ago I used to find myself frequently standing perplexed before this statement, graven above the signature of Ingres on the marble of the little monument dedicated to him in the vestibule of the drawing class called the "Cours Yvon" at the École Nationale des Beaux-Arts.

What exactly does this inscription mean? I readily agree that it is necessary first of all to draw, but what I do not understand is the word "probity." Can you hear Corot, Delacroix, Van Gogh, Renoir or Cézanne speaking like this? And yet I am not annoyed when Hokusai is called "the old man mad about drawing."

Are these facile words of Ingres, constantly repeated by pompous ignoramuses, to be linked with those contained in Leonardo da Vinci's manuscript recommending that lines of composition be sought in the cracks of old walls or indicating coarse tricks that are supposed to give expression to the likenesses of young girls? [5]

I think that Ingres and Leonardo, believing themselves obliged to teach their art, could only enter into communion with their pupils by giving them handy rules: —either to hold them to their work through the patient execution of a literal drawing of the object to be represented (I think of the tailor who, having botched the cut and hang of his suit, tries to get out of the scrape by fastening it to the body of the customer by means of numerous alterations which bind his victim and paralyze his movements); —or to remedy the poverty of their imagination through mechanical means of composition.

Similarly style, which is the result of the necessities of a given period and is determined by exigencies independent of the artist's will, cannot be taught.

Besides, I understood nothing of the drawing instruction given in this Cours Yvon, where, more than forty years ago, I was "corrected" by Gérôme, Bouguereau, Joseph Blanc, Bonnat, Lenepveu, etc., exacting but inept teachers; nor, with the passage of time, has any of this instruction come back to me. But would I have understood any more had these masters been genuine? I don't believe so. I once had the good fortune to receive Rodin's advice on the subject of my drawings, which had been shown him by a friend. Yet the advice he gave in no wise suited me, and on this occasion Rodin merely showed his petty side. [6] He could not do otherwise. For the best of what the old masters possess, that which is their *raison d'être*, is beyond their grasp. Having no understanding of it, they cannot teach it.

An atelier of students reminds me of Bruegel's *Parable of the Blind*, in which the teacher would be the first blind man who is leading the others.

Michel Bréal [7] used to say, "A professor is a man who teaches what he doesn't know" (quoted by his son Auguste).

How distressing it is to see genuine artists devoting a portion of their efforts to the aid of those who cannot find their way alone. They merely succeed in whittling

out so many white canes that will permit men who might also better use their activity to grope their way along to doing a useless piece of work.

He who really has something to say is driven to it by the emotion that induces him to carry out his work in relation to his own qualities.

Renoir was consequently right when he said: *The man who has turned his canvas to the wall for three months and still cannot discover what is lacking in it has no need to go on painting.*

24

Henry de Montherlant: Listening to Matisse, 1938[1]

In 1938, the well-known writer Henry de Montherlant published an interview with Matisse. Although this short piece is actually more of an essay than an interview, and the reader is in fact listening more to Montherlant than to Matisse, it gives valuable insights into Matisse's thoughts about the centrality of his work to his life.

MONTHERLANT: LISTENING TO MATISSE

Each winter, for the last two years, I have frequently seen Henri Matisse in Nice. He had been asked to illustrate a limited edition of *La Rose de Sable*. After a long hesitation, he finally decided against it: "It's a book in which everything has been said. There isn't room for anything in the margins." He had a copy of *Atala* on the table, which he pointed to: "That has no need to be completed either." [2]

Who was it that said: "I like women who have a past and men who have a future?" I like men who have a past and women who have a future. I like men who have lived a full life and accomplished much, and children who haven't as yet, but who are full of inspiration and promise. People of my own age are less interesting. I always feel as though I know more than they do. Barrès, who during his last agonizing five minutes of life must have been desolate at missing the pleasures of old age, spoke profoundly of the first signs of the twilight.[3] No one better understood Hugo's poems of old age, *Dieu, la fin de Satan*, unknown to the public.

Last winter, having caught influenza, Matisse thought he was going to die. It is important for a man, at least once in his life, to have believed he is about to die: parenthetically, this is one of the gifts war gives to man. I find it hard to believe that a creator of Matisse's calibre should have so early this "Moment of Oversight," with which D'Annunzio reproaches Barrès (the word, by the way, is Goethe's, apropos of whom I know not; we know that D'Annunzio was light-fingered). But finally he

took himself for lost, and such an idea is fruitful. While convalescing, he said several interesting things which pleased me, some of which I will relate here.

"I thought I was about to die. I was sure of it. It's not fair. I did all that I could not to become ill, but to no avail. No, it just isn't fair."

"Didn't your work and your memories prevent you from suffering? It always seemed to me that the artist, when faced with death, should be secretly smiling like the man whose safe is being robbed and knows that it is empty. What is valuable is elsewhere."

"Yes, but I should have liked to finish."

"I should have liked to *finish*." How well said! Constructed works. During the months I spent in Algiers, I could see from my window a tall block of flats being built. During the construction I wrote the eight hundred pages of *La Rose de Sable*. The house was taking form at the same time as my work. This parallel touched me. I said to myself: "Yes, it's just the same thing. This certainly is not mere chance." And I remember having written fifteen years ago in *Olympiques*: "If I die too soon, my work will have no roof."

Matisse continued: "I had formed in my mind a hierarchy of misfortunes, and I had found that the greatest misfortune for me would be to recover from my illness only to find that I had lost all will to work."

His apartment contains a large aviary, full of birds both rare and common. The first time I saw him last winter, he led me immediately to the aviary and gave a long dissertation on the birds. He spoke so long I began to worry: I remembered Goethe showing his medals to tiresome visitors, because he didn't have anything else to say to them. But I soon began to understand Matisse's child-like passion for his birds. He spoke of each like a real expert; some of his ideas went a bit beyond the realm of science, as when he said that European birds are brighter and more intelligent than those of exotic countries.

"Sometimes when I bought one of these birds I found it really very expensive . . . but when I thought I was done for, I said to my wife, see how right I was to buy these birds for my enjoyment! You must always do what gives you pleasure."

These were profound words, beyond their seeming ingenuousness. So much more profound than those idiots who say to you indignantly: "So, you think that man is born for happiness?" These stupid Westerners! "What have I done? I lived, I made myself happy," wrote Galliéni to Lyautey (and I believe that Lyautey would have written the same thing).[4] You really have to be a stupid Westerner not to experience a certain *grandeur* before such men who are reaching old age and, *having accomplished their work*, say: "And then, I made myself happy." For there is also the greatness of wisdom which is none other than that of intelligence.

Sometimes Matisse and I don't agree. As when he tells me he suffers from criticism, but praise does not give him pleasure (I'm just the opposite); or that it is the

truth of an artist that remains, not his legend; I don't see why posterity should be less frivolous than the contemporary world: the truth of the artist remains, but illuminated—and sometimes in the wrong light—by his legend. Or when he says that, like most of the artists I have met, he prefers working under uncomfortable conditions, and on works created with great difficulty, to work which "escapes from you, when it has barely been expressed, like a bird which flies off forever as soon as the cage is open." I, on the other hand, prefer those of my works that sprang into existence with an ease that was almost magic, because though I love my work, I prefer life to it, and the work that gave me trouble inspires a kind of grudge in me: it has taken too much time from my private life, which is more important to me. . . .[5]

Matisse often told me that the best thing the old masters have, their *raison d'être*, is beyond them, that they are not able to teach it and that they waste their time by trying. But they are able to teach, without meaning to, by informal conversation, about their work or their life.[6] And they can talk to their colleagues who practice a different art from theirs. Stendhal showed us Michelangelo going to the Coliseum to find inspiration for the Basilica of Saint Peter's: "A theater gives ideas for a church." There is unity in creation, and the writer learns from the painter as the cupola of Saint Peter's perhaps learned from the pagan circus.

25

Notes of a Painter on his Drawing, 1939[1]

In 1939, Matisse was persuaded to formulate a defense of his drawing for an issue of *Le Point* devoted to him and his work. The title of the resulting text, "Notes of a Painter on his Drawing," specifically alludes to his 1908 "Notes of a Painter," which is mentioned in the editor's introduction to Matisse's text.

In "Notes of a Painter on his Drawing," Matisse once again refers to his own education, which he felt made him cognizant of the different means of expression inherent in color and drawing. He discusses how he studied the old masters to find how they dealt with volume, line, contrasts and harmonies; and how he tried to synthesize his awareness of their work with his own observations from nature. Here he states quite explicitly his version of the method of classical training: to absorb the lessons of the masters and then to "forget" them in order to arrive at a means of personal expression.

Matisse's description of his own working method when drawing is very revealing; he not only describes his attitude toward the act of drawing, but also describes aspects of his attitude toward picture-making on the whole. In this essay Matisse also makes some important observations about the nature of his subject matter

and expresses views on space and line that are not found in his earlier writings. Discussing his interiors, he notes that his models are never to be conceived of as just props or "extras," and that while their expressiveness is usually not articulated by directly portrayed emotions, their "human content" is expressed by the total ensemble of his picture, by the creation of what he calls "plastic signs" [*signes plastiques*]. This sublimation of expression into the total ensemble of the painting is a clarification of the expression of similar values in "Notes of a Painter," and an important aspect of Matisse's method.

In this essay Matisse also discusses the creation of space, noting that his final line drawings always have a luminous space, and that the objects that constitute them have positions in different planes in space: "in perspective, *but in a perspective of feeling*, in suggested perspective." This notion of luminous space is a generalized equivalent of the ambiguous, intangible space that may also be seen in his paintings, and is most important to an understanding of his work.

Matisse felt that the human side of painting is the result of a mysterious, expressive quality which, if the painter himself is possessed of a good sensibility, comes through in the final painting. Thus it need not be overtly stated in the subject matter; the painter should instead construct his painting according to what he perceives, and the force of this expression will be evident as a by-product of the painter's own depth of humanity; not as something apart from—or only presented by—form, but rather as feeling that is embodied into the very fibre of form itself: "My plastic signs probably express their souls. . . ."

NOTES OF A PAINTER ON HIS DRAWING

My education consisted of making me aware of the different means of expression in color and drawing. My classical education naturally led me to study the Masters, and to assimilate them as much as possible while considering such things as volume, the arabesque, value contrasts and harmony, and to relate my reflections to my work from nature; until the day when I realized that for me it was necessary to forget the technique of the Masters, or rather to understand it in a completely personal manner. Isn't this the rule with every artist of classical training? Next came the knowledge and influence of the arts of the Orient.

~

My line drawing is the purest and most direct translation of my emotion. The simplification of the medium allows that. However, these drawings are more complete than they may appear to some people who confuse them with a kind of sketch. They generate light; seen on a dull day or in indirect light they contain, in addition to the flavor and sensitivity of the line, light and value differences that quite clearly correspond to color. These qualities are also evident to many in full light. They derive from the fact that the drawings are always preceded by studies made in a less rigorous medium than pure line, such as charcoal or stump drawing, which allows

me to consider simultaneously the character of the model, her human expression, the quality of surrounding light, the atmosphere and all that can only be expressed by drawing. And it is only when I feel that I am drained by the work, which may go on for several sessions, that my mind is cleared and I have the confidence to give free rein to my pen. Then I distinctly feel that my emotion is expressed by means of plastic writing. Once my emotive line has modelled the light of my white paper without destroying its precious whiteness, I can neither add nor take anything away. The page is written; no correction is possible. If it is not adequate, there is no alternative than to begin again, as if it were an acrobatic feat.[2] It contains, amalgamated according to my possibilities of synthesis, the different points of view that I could more or less assimilate through my preliminary study.[3]

The jewels or the arabesques never overwhelm my drawings from the model, because these jewels and arabesques form part of my orchestration.[4] Well placed, they suggest the form or the value accents necessary to the composition of the drawing. Here I recall a doctor who said to me: "When one looks at your drawings, one is astonished to see how well you know anatomy." For him, my drawings, in which movement was expressed by a logical rhythm of lines, suggested the play of muscles in action.

~

It is in order to liberate grace and character that I study so intently before making a pen drawing. I never impose violence on myself; to the contrary, I am like the dancer or tightrope walker who begins his day with several hours of numerous limbering exercises so that every part of his body obeys him, when in front of his public he wants to give expression to his emotions by a succession of slow or fast dance movements, or by an elegant pirouette.

(As regards perspective: my final line drawings always have their own luminous space, and the objects of which they are composed are on their different planes; thus, in perspective, *but in a perspective of feeling,* in suggested perspective.)

~

I have always considered drawing not as an exercise of particular dexterity, but above all as a means of expressing intimate feelings and descriptions of states of being, but a means deliberately simplified so as to give simplicity and spontaneity to the expression, which should speak without clumsiness, directly to the mind of the spectator.[5]

My models, human figures, are never just "extras" in an interior. They are the principal theme of my work. I depend absolutely on my model, whom I observe at liberty, and then I decide on the pose which best suits *her nature*. When I take a new model, it is from the unselfconscious attitudes she takes when she rests that I intuit the pose that will best suit her, and then I become the slave of that pose. I often keep those girls several years, until my interest is exhausted. My plastic signs

probably express their souls (a word I dislike), which interests me subconsciously, or what else is there?[6] Their forms are not always perfect, but they are always expressive. The emotional interest they inspire in me is not particularly apparent in the representation of their bodies, but often rather by the lines or the special values distributed over the whole canvas or paper and which form its orchestration, its architecture. But not everyone perceives this. It is perhaps sublimated voluptuousness, something that may not yet be perceptible to everyone.

~

It is said of me: "This charmer who takes pleasure in charming monsters."[7] I never thought of my creations as charmed or charming monsters. I replied to someone who said I didn't see women as I represented them: "If I met such women in the street, I should run away in terror." Above all, I do not create a woman, *I make a picture.*

~

In spite of the absence of cross-hatching, of shadows or of half-tones, I do not renounce the play of values, or modulations. I modulate with variations in the thickness of my line, and above all with the areas it delimits on the white paper. I modify the different parts of the white paper without touching them, but by how they relate to neighboring areas. This can be very well seen in the drawings of Rembrandt, Turner, and of colorists in general.[8]

To sum up, I work *without theory.* I am conscious only of the forces I use, and I am driven by an idea that I really only grasp as it grows with the picture. As Chardin used to say, "I add (or I take away, because I scrape out a lot) until it looks right."

Making a picture would seem as logical as building a house, if one proceeded on sound principles. One should not bother about the *human* side. Either one has it or one hasn't. If one has, it colors the work in spite of everything.

26

Interview with Francis Carco, 1941[1]

The French writer Francis Carco's recollection of his conversation with Matisse the year after the occupation of France is an interesting document for its attention to the small details of Matisse's working day during the early days of the war, and for the insights it offers into Matisse's rather selective recollections of the past. When the two men met in 1941, Matisse had just recently returned from Lyon, where he had undergone surgery for duodenal cancer. His recovery had been miraculous and his surprisingly open nostalgia may be in part due to these circumstances.

In Nice in 1941, I ran into Matisse under the arcades of the Place Massena. As usual he was looking well. He looked completely at peace with himself that day. Everything about him exuded harmony and honesty. His neat appearance, the brightness of his look, the assurance of his features and an undefinable air of youth and serenity struck me immediately.

"Come see me," he said, "I've been working hard."

That gave me enormous pleasure: it was so reassuring that at least one great artist refused to admit all was lost. Who else was thinking about painting then? He must have been the only one, and that seemed to be a good omen, because if each of us, in his own sphere, accomplished his allotted task, the machine could get going again and pull us out of the rut bad driving had put us in. The example, coming from such an exalted source, could only be the more inspiring. Matisse brought no vanity whatsoever to the situation. He had taken up his paint brushes again as did others their pen, their tools, and with the help of his love for work one could believe that the great miracle we had all been waiting for through the humiliating days before the Armistice was finally coming to pass.

That was not the first time that the painter had, so to speak, forced this to come about. Thanks to this faith in work, Matisse, who once struggled to ensure his material needs, had ended up by being hired by the Jambon studio where, in spite of his glasses and beard, he worked like a laborer.[2] His seriousness and courtesy have always stood him well, in all sorts of situations. At Jambon's everyone called him "doctor." And later, in Montmartre, "La Belle Fernande"[3] was to write of him as "the archetypal master."

His parents were grain merchants in the north; he arrived in Paris as a young man to study pharmacy, adds Gertrude Stein.[4] "He had set himself to copy the Poussins in the Louvre and became a painter scarcely without bothering about the consent of his family, who nevertheless continued to give him a small monthly allowance. At first he had a little success. And he got married . . . Then he had begun to come under the influence of Cézanne and then of Negro sculpture. From all this sprang the Matisse of the *Woman with the Hat*."[5]

That painting is the portrait of Mme Matisse and I remember the curious impression it made on me. I had not yet developed a taste for modern art. The discussions that it provoked at Max Jacob's on the rue Ravignan between Guillaume Apollinaire and Picasso, or at Frédé's during the long boisterous nights at the "Lapin Agile," had not yet convinced me.[6] Picasso never exhibited, on principle, and showed his works only to a small circle of the initiated few, so one had to be satisfied with the doctrinaire aphorisms that he tinged with humor to seduce his audience. Everything gravitated around these specifications. And I was wondering

if Picasso, in spite of his amazing powers of persuasion, didn't enjoy mystifying us more than painting, when the famous *Woman with the Hat* taught me more in an instant than all those paradoxes.

At last I was able to appreciate what my friends meant by a "portrait." Nothing about it was physically human. One had the impression that the artist had been more concerned with his own personality than with that of the model. I didn't know Mme Matisse at all but, according to Gertrude Stein, who bought the work without understanding why "it enraged everyone," she was a "big woman with a long face and a big, obstinate, hanging mouth."[7] Not a very flattering description, but I must agree that it corresponded pretty well to my own impression. However, this extraordinary work, whose lines might have been drawn on a wall in charcoal and yet were in balance with the cold tones that one might think had been applied with a stencil—this work had such a clear and deliberate air of premeditation that more than thirty years later I have not forgotten it.

"I painted this portrait at Issy-les-Moulineaux, "Matisse told me. "I went there in 1907 when I left the Couvent des Invalides. . . ."[8] A few years later, a trip to Morocco decided the direction of his talent. The painter returned to Paris and settled there on the quai Saint-Michel, in his old lodgings where he had so many times in the past descended the stairs early in the morning to take the bus "La Villette-Saint-Sulpice" to Jambon's to earn his and his family's livelihood at twenty-five sous an hour.

"It was hard work, but I had no choice. Jambon, who had obtained the commission for the decoration of the Trans-Siberian exposition at the Grand-Palais for the Expo, had taken us on, Marquet and myself, to paint the garlands. We worked bent double. We were all crimped up. What a job! I had never known more complete degradation. Among our companions, the sharp ones got themselves fired after two weeks so they could collect unemployment compensation. There were café waiters, delivery boys, a whole team of 'I-don't-give-a-damn' types whom the boss kept under his eye. Unfortunately the boss didn't like my looks. One day I was whistling and right away he called me: 'Hey there doctor, my word, you're having a good time!' I was so disgusted that I retorted: 'That's not what I'm here for!' Quick as a flash, that did it; I got my pay and the sack. I had to go and get signed on somewhere else."[9]

"But in the evening when you went home to the quai Saint-Michel, you had the consolation of admiring Cézanne's picture hanging in your studio?"[10]

"Of course," replied the painter, "I could have sold it . . . but I stood fast."

His face lit up with a smile.

"You must always stand fast, at all costs . . ."

"Yes," I said. "When you can."

"Whether you can or not, you hold on: that's the essential thing. When you're

out of will power you call on stubbornness, that's the trick. For big things as well as small, that suffices, almost always. I used always to be late. One evening I went to meet Marquet . . . and I waited. I cooled my heels for more than twenty minutes: no Marquet! The next day naturally, as soon as I saw him, I stopped him. 'What!' he replied. 'I waited for you too, but after fifteen minutes I left.' You know Marquet? He can't lie. Well, I told myself, since I always find a way to be late, I should one day be able to end up being on time!"

"Did you succeed?"

"All too well! And even now I poison everyone's existence with it, because by wanting to correct this fault, which is basically a female one, I have fallen into the opposite extreme: I arrive too early."

What is striking about Matisse when one knows him slightly, is the extreme interest he shows, in conversation, about trivia as well as about important matters. Under a nonchalant exterior, one that feels his keenness pierces the secret of things. Approximations don't attract him. The habit of reflection, of logic, of analysis, leads him to formulate each one of his thoughts or his impressions with all the clarity and rigor one could wish for.

~

Having taken up his invitation I was received in the big room on the left that he uses for a studio. Arranged in several rows, one above the other, a series of drawings executed after an initial study covered the walls.[11] You could read there, as in an open book, the succession of states and abbreviations by which the study was transformed into an arabesque and passed from volume to line, with the most subtle and sparse of scripts.

"That's what I call the cinema of my sensibility," he told me right away. "When my study is done, or rather my point of departure is established, then I let my pen run where it wills. There are all the steps which, from the form to the rhythm, permit me to watch my own reactions. I enjoy that: I don't know where I am going. I rely on my subconscious self and the proof of this is that if I am disturbed during the process I can no longer find the thread of it again."[12] After a while he said: "Basically I enjoy everything: I am never bored." Then inviting me with a nod: "Come," he added. "You will see how I am organized."

A second room, also on the left, had two cages full of birds.[13] Bengalis, cardinals, Japanese warblers fluttered the bright colors of their feathers, which the long black tail feathers of the widow-birds made even more brilliant. Fetishes and negro masks gave the room an exotic look; but since it only served as an antechamber to a conservatory where philodendra from Tahiti spread their huge leaves, we crossed it fairly quickly and found ourselves in a sort of jungle, which an ingenious sprinkling system maintained in its green and tropical state. On a marble platform gourds and

giant pumpkins composed, with Chinese statuettes, an ensemble of contrasts where the disproportion of the different elements permitted the artist to give free rein to his fantasy.

"Here we are in what I call my 'farm,'" Matisse informed me. "I putter here several hours a day, for these plants are a frightful bother to keep up. You have no idea! But as I take care of them, I learn their types, their weight, their flexibility, and that helps me in my drawings."

"In short, your return to the earth."

"Yes, of course . . . why not?"[14] And looking at me over his glasses, he said: "Do you understand now why I am never bored? For over fifty years I have not stopped working for an instant. From nine o'clock to noon, first sitting. I have lunch. Then I have a little nap and take up my brushes again at two in the afternoon until the evening. You won't believe me. On Sundays, I have to tell all sorts of tales to the models. I promise them that it's the last time I will ever beg them to come and pose on that day. Naturally I pay them double. Finally, when I sense that they are not convinced, I promise them a day off during the week. 'But Monsieur Matisse,' one of them answered me, 'this has been going on for months and I have never had one afternoon off.' Poor things! They don't understand. Nevertheless I can't sacrifice my Sundays for them merely because they have boyfriends. Put yourself in my place: when I was living in the Hôtel de la Mediterranée, the Battle of the Flowers[15] was almost a torture for me. All that music, the floats and the laughter on the Promenade! They were no longer with me, so I installed them by the window and painted them from behind. What could I do? I don't know how to improvise. In order for things to click I must recover the idea I had the previous day."

We returned to the studio. Matisse was speaking of his work and, recounting the thousand little difficulties he was running up against, he paused at times to scrutinize me and see if I was taking in what he said, then he continued explaining his methods in his rather hollow voice and that took me back to the time when we both had lived in the Hôtel de la Mediterranée by the sea. We had occupied neighboring rooms. One morning Matisse had come into my room.

"Well," he had asked me in the same velvety voice as he approached the bed. "What's wrong? Sick?"

I had the flu. Matisse took my pulse, and I understood from his serious air why his colleagues at Jambon's had called him the doctor.

"That's annoying," he said. "Yesterday I began a canvas at Cimiez and the car is waiting for me. But that's nothing. Just a minute."

He left the room and returned with several of his works, a hammer and some nails. In an instant the nails were in the wall, the pictures hung. Matisse gathered the folds of his cape around his shoulders.

"I'm off!" he said. "See you this evening. I'll come and see how you are. Stay in bed: don't do anything foolish. My paintings will keep you company."

I reminded him of this incident.

"A good old hotel, I must say!" he murmured. "And what lovely Italian-style ceilings! What tiles! They were wrong to tear the building down. I stayed there four years for the pleasure of painting nudes and figures in an old rococo salon. Do you remember the way the light came through the shutters? It came from below like footlights in a theater. Everything was fake, absurd, terrific, delicious. . . ."

We sat down.

"I was saying" he continued, offering me a cigarette, "that each day I need to recover my idea of the previous day. Even in the early days I was like that and I envied my comrades who could work anywhere. At Montmartre, Debray, the proprietor of the Moulin de la Galette,[16] used to invite all the painters to come and scribble at his place. Van Dongen was prodigious. He ran around after the dancers and drew them at the same time. Naturally I took advantage of the invitation too, but all I managed to do was learn the tune of the farandole,[17] which everyone used to roar out as soon as the orchestra played it:

> Let's pray to God for those who're nearly broke!
> Let's pray to God for those who've not a bean!

"Do you remember it? And later this tune helped me when I began my painting of *The Dance* that is in the Barnes Collection in New York.[18] I whistled it as I painted. I almost danced." A youthful expression passed across his face. "Those were good times!"

He must have read in my eyes that like him I had tasted the pleasures of those "good old days" and that I had no occasion to regret them either, because he continued: "I mean that we had painting in our blood then, that we would have fought for it. It's extraordinary, I was kicked out wherever I went and to use a model I was reduced to taking evening courses, in a Paris city school on the rue Etienne-Marcel. I slaved all day for my subsistence and was exhausted. My wife for her part had opened a little hat shop. But, however tired I was in the evening, nothing could have stopped me from getting to the rue Etienne-Marcel to work. One met strange fellows in that school. My neighbor, a sculptor, complained because he couldn't dig up a commission. Each evening he asked if we might not know a prominent man who had no statue in Paris. I looked with him: we boned up on a dictionary of famous men and finally discovered that Buffon fell into this category.[19] My sculptor, whom I took for an artist, leapt off to the Museum. He got round the Director who supported his request and got it accepted. Everything was going well. The fellow did a maquette, exhibited it at the Salon and, by way of thanking me for having

helped him in his research, offered to take me on as an assistant. Sculpture has always fascinated me. So I said to myself, in all good faith, that if I used the maquette as inspiration, I could do something. Ah là là! The fellow thought I was going mad because, having listened to my suggestions, he said to me: 'My dear fellow, out of the question! It's a matter of squaring the project up for enlargement. Otherwise I'll be out of pocket for it'!"

"Poor Buffon!"

"Yes. Rather. Luckily after a long search I also finished running to earth the academy where Carrière corrected the work of students.[20] It was on the rue de Rennes in a courtyard where a blockmaker's is now. Jean Puy, Derain, Laprade, Chabaud all belonged to this academy.[21] Chabaud, as he always used to, sweated away alone in his corner. The others used to show each other their sketches. Laprade's astounded everyone. 'Be careful! there's the thaw!'[22] I said looking at one of them. Laprade never forgave me for it. And yet, that is what it was, joking apart. As for the scribbling of those who were inspired by the patron's advice, that was really discouraging. You remember the remark Forain made in front of a canvas of children by Carrière: 'Someone was smoking in that room!' I couldn't stop myself saying: 'The stove is smoking. Open the windows!'[23] That wasn't really nasty. But once again I was kicked out. It was at that time that I became connected with Derain. He was on the eve of departure for Commercy to do his three years in the army and already he was painting magnificently. We had got to know each other in the Louvre where his copies bewildered the guards and visitors. Old Derain didn't get upset. When he came to join me at Collioure where I was spending the summer with my wife's family, he knew more about it than anyone. We worked together at Collioure, then exhibited the works that Vauxcelles baptized 'the Fauves.'"

"What a scandal!" Matisse rubbed his hands together. "Frankly, it was admirable. The name Fauves was perfectly suited to our feelings. Then, in 1905, I spent several months in Saint-Tropez where as yet only Signac and old Pegurier,[24] who was born in the region, were living. Cross lived at Le Lavandou. The others came later. Renoir, however, had settled at Cagnes and Lebasque at Le Cannet.[25] An agreeable painter, Lebasque. Marquet joined him in the Midi."

"But Marquet was much more your friend than his."

"Yes, true, but he got along very well with Lebasque. He was the most pleasant of the group, and got along well with everyone. At Marseilles, he had entrées into the strangest circles. For example, in the Bouterie quarter, the girls used to shout out as soon as they saw him passing by: 'There goes the *pintre.*'"[26]

Matisse was off. He felt such pleasure in recounting these anecdotes that I would have been rude to interrupt him. Like all loners, who first by shyness and then by defiance, stick to a certain subject but suddenly abandon themselves to memories of their old escapades, he went on speaking of Marquet with such warmth that he for-

got all about painting. He put such enthusiasm into his friendship for the "*pintre*" that you could feel how much he must have been captivated by him. They knew each other for a long time. They had worked, struggled and been successful together.

"At the time of the Expo, as they used to call the 1900 one, it was Marquet," went on my interlocutor, "who had the idea of finding a job which would allow us to live. We got a dozen addresses of decorators' studios out of the Bottin.[27] Marquet would apply for us to the boss. From street to street, we ended by being hired by Jambon, at the ends of the earth, near the Buttes-Chaumont. Marquet lived on the quai de la Tournelle and I on the quai Saint-Michel where we painted impressions of the Seine, each from our window.[28] I began by exhibiting at Vollard's who sold my first pictures to Olivier Sainsère. Then, one fine day, Vollard was convinced: for a thousand francs, he took five works from me among which were three large *desertes* which were not too bad. Then, at the amusing little Mlle Weill's place, Huc of the *Dépêche de Toulouse* bought one of twenty of my works for a hundred francs on Albert Sarraut's account.[29] At that time Mme Odilon Redon was offering the works of her husband for absurdly low prices. Druet had a bistro on the Place de l'Alma. Shortly after, he set himself up in the rue Duphot, and, since the Independents were organizing their exhibitions in the municipal greenhouses, Signac and Luce went to eat at his place. Rodin, who worked at a mason's in the rue de l'Université, crossed the river with them. Druet, besides his bistro, was interested in photography. He had set up a lighting system that delighted Rodin. Finally Druet opened an art gallery on the rue Matignon, and the first exhibition of Neo-Impressionists took place.

"Druet was a strange man. For fear that the artists would spend the money earned from the sale of their works too quickly, he gave it to them in small installments that never exceeded two hundred and fifty francs. The photography business he had started made more money than the pictures and one had to wait for better days. Moline, who was a dealer on the rue Laffitte, had a Neo-Impressionist show in his turn, but it had no success."

Matisse nodded: "Yes, those were the good old days, anyway!" he went on reflectively.

Perhaps he was remembering the long and splendid career in which, from the quai Saint-Michel to the Couvent des Invalides, then at Issy-les-Moulineaux, to Morocco, to l'Estaque, to Marseilles and from the Hôtel Beau-Rivage in Nice, to the Villa des Alliés, to the old Hôtel de la Mediterranée, to his apartment on the rue Charles-Félix, and the one he now lives in at Cimiez, he had "stood fast."[30] Frank Harris[31] (who had bravely fought for Oscar Wilde in London on his release from prison) had ceded him several rooms in the building on the rue Charles-Félix, and Matisse had hung the paintings of Cézanne and Gauguin there: the first, if we are to believe Gertrude Stein, bought with his wife's dowry and the second with her en-

gagement ring.[32] Harris, who loved painting, parted with these rooms out of admiration for Matisse, whom he spoke of as the most extraordinary Frenchman he had ever known, and I couldn't tell if the epithet did not hide some bitterness, so different were the two men. Twenty years later, Harris settled at Cimiez.

"Is it to be near Matisse?" I had asked him with irony.

Harris just smiled, then, since he had no real reason to exist without a noble cause, gave me a reading from his play on Joan of Arc. And Maeterlinck,[33] who didn't like him very much, concluded: "Naturally! Like all self-respecting Englishmen, he couldn't resist the pleasure of martyring her twice."

Evening fell. "You see," murmured Matisse suddenly, "when I think of the problems of the past, I wonder if they didn't stimulate in us the energy to conquer them. Life is short. Without problems, it would go by too quickly, and we would have made no progress. Thus" he said, putting a still-life under a good light, "I needed three months to finish this work. Once I would have hesitated less."

The painting is composed of a Persian vase and big shells from Oceania, arranged on a plane better defined by a simple opposition of tones than is clear at first glance.[34] In itself, each element was of little interest. It's their radiation, their harmony of values that give this work its richness, its power of orchestration.

"Isn't everything in the values?"

I almost quoted him the classic remark of Fromentin:[35] "A color does not exist in itself since it is, as one knows, modified by the influence of a neighboring color. Its quality comes from its surroundings." But Matisse got in ahead of me.

"Because one value on the right was out of place," he said, "everything got screwed up in my picture. Who would have thought it so important?"

This time I managed to get my quotation in, and I continued it, "But 'if from a Veronese, a Titian or a Rubens, you were to remove this perfect rapport of color values, you would be left with no harmony in the coloring, no strength, delicacy, or rarity.'"

The painter looked at me with approval. "People have taken years," he grumbled, "to realize just that. And yet it's right under your nose. When it's a matter of a friend's work, you see it right away: but in your own, you hesitate, stammer, because you can't reason any more: you have to feel."

"You have to love."

"Exactly! Basically it's as easy as pie. But we still don't have an overabundance of faculties to succeed where others fail."

I suppressed the compliment that was on the tip of my tongue for fear he would take it as trite flattery, since, even in the light of his works, Matisse has always been so straightforward that he avoids the particular for much wider issues. It's not that he's modest. He loves painting too much to make little of himself. He is also too much aware of his talent to be dazzled by words. This strength comes from his way

of life, away from rascals and cheats. He knows his limitations. Derain too has this same strength which is so rare a quality in most painters. But Derain goes out a lot and becomes infatuated with all sorts of people. I have met him several times in society where, in spite of his finesse, he would let himself fall into an agreement for a portrait which he later had no desire to paint. His frank temperament, his friendly, generous nature would often put him in absurd situations if he didn't cut it all suddenly short and disappear from Paris. "He's not a Fauve, he's a saint!" a Russian princess once remarked of him. Eight days later she rectified her statement, "Or rather, an eel."

And yet, when Zborowski died, Derain offered his widow several pictures in order to help her financially.[36] Madame Zborowska did not forget it. "And do you know?" she confessed without false shame, "he was the only one."

～

A question that I had promised myself to ask Matisse in the course of our interview was now troubling me. I wanted to ask how he could live in such isolation and still maintain such prestige in the eyes of his colleagues and collectors. Work is not the only thing; emulation also enters significantly into the life of an artist. Picasso, whom one runs into in the most humble galleries where youths hang their pictures, could have served as a pretext. He has always carefully kept himself up to date with contemporary developments and, time-consuming as this may often be, it maintains, in one who practices it, an intellectual curiosity which is of great importance.

Clemenceau, from the time I held the modest position of art critic on *L'Homme Libre*, had had this same avidity for learning.

"When you leave the paper," he said, catching me one evening between two doors, "do you go back to Montmartre?"

"Yes, Monsieur le Président."

"And in Montmartre, who will you go and see?"

"Poets and painters."

"Which painters?"

I mentioned Picasso, Valadon, Utrillo, Modigliani. The "Tiger" wrote down their names in a notebook.

"And the poets?"

"Guillaume Apollinaire, Salmon, Max Jacob, Jean Pellerin."

"And they are talented?"

"They are more than talented."

"Ah!" snorted Clemenceau. "Even if you are wrong, one must have faith. Never forget it!"

How to make Matisse realize that real youth consists in preserving this flame which still burned in the "Tiger" at seventy-three years of age? Especially how to talk to him of Picasso? He would have told me that Picasso only haunted the gal-

leries to improve all the prices. The old enmity that had only increased between them since Cubism might have disturbed the end of our conversation. In vain I told myself that with the passing of time and with his success Matisse probably no longer maintained the least bitterness toward his old rival; I was not at all sure of it. Gertrude Stein, who had introduced them to each other, affirms that they "became friends but that they were also enemies."[37]

Such incompatibility of temperament doesn't change easily. Besides it was not for me to get involved in the situation. And, though I wouldn't have minded hearing from Matisse himself what he thought of Picasso, or rather of this intellectual curiosity which he never ceases to manifest toward his art, I had no chance of finding out. The impression I had just received in front of the still-life that cost him three months of thought and effort had plunged me into a deep perplexity. I wanted to tell its author that certain research sometimes goes too far, that it by-passes its object, and through it one ends up with "an unknown masterpiece" about which Balzac reached his conclusions a long time ago.[38] But I restrained my desire.

Nevertheless, I told myself, the question is not without importance and if one but thinks about it, one might well wonder if artists don't go wrong in emphasizing difficulty alone. It is not a problem that will be solved by a handful of scholars. All art appeals first to the senses rather than to the mind. It is through the senses that art moves the masses just as much as it seduces the elite, and when one sees Picasso start from abstraction to reach the same contradictions as Matisse—but by a diametrically opposite route—one is tempted to fear that they will no longer be followed. There are limits that must not be passed. Beyond their boundaries, there is no longer, in effect, painter, poet or composer, but an artist in the supreme sense of the word; the artist in the pure state, given over without defense to the vertigo of the summit, of the Absolute.

"You were going to say?" enquired Matisse, who noticed my agitation.

I had nothing to say: his canvas spoke for me.

27

On Transformations, 1942[1]

This excerpt from a letter from Matisse to his son Pierre, one of two published in *First Papers on Surrealism*, and meant to give a sense of continuity during the uncertainty of the war, offers insight into Matisse's attitude toward his finished work in relation to his personality. The work Matisse refers to is *Red Still Life with a Magnolia*, 1941, in which he had painted a green marble table red. (See Text 51, below.)

This letter also offers a good example of Matisse's awareness at this time of the opposing demands of drawing and color, an issue that had already preoccupied him for several years and that became especially critical in the early 1940s, just before he began to concentrate on his paper cutouts. In January 1941 he had written at some length on this subject to Pierre Bonnard, saying that he was "paralyzed by something conventional that keeps me from expressing myself in painting as I would like. My drawing and my painting are separating. . . . a drawing by a colorist is not a painting. He must produce an equivalent in color. And that is what I'm not managing to attain."[2] That October he wrote to another artist friend, André Rouveyre, about his attempts to express himself in color, and spoke of what he called "The eternal conflict between drawing and color in the same individual."[3]

ON TRANSFORMATIONS

. . . to do in painting what I have done in drawing—return to painting without contradiction as in the dahlias—in the bouquet of flowers that you sent me a photograph of—and which needs the strong personality of the painter in order for the battle to leave interesting remains. When I attain unity, whatever it is that I do not destroy of myself is interesting enough—I am told that it is transformed, sublimated, but I'm not absolutely certain. I do not find myself there immediately, the painting is not a mirror reflecting what I experienced while creating it, but a powerful object, strong and expressive, which is as novel for me as for anyone else. When I paint a green marble table and finally have to make it red—I am not entirely satisfied, I need several months to recognize that I created a new object just as good as what I was unable to do and which will be replaced by another of the same type when the original which I did not paint as it looked in nature will have disappeared—the eternal question of the objective and the subjective.

28

Matisse's Radio Interviews, 1942[1]

Early in 1942 Matisse gave two interviews broadcast over the radio, transcripts of which were sent to Pierre Matisse in New York in a letter dated 13 March 1942; a note at the top of the letter indicates that the interviews were broadcast "about two months ago."[2] The first is general in scope, the second an attack on the French academic Beaux-Arts system in which Matisse suggested that the Prix de Rome be replaced by "travelling scholarships."

The first broadcast contains interesting answers to some fundamental questions,

including an important statement of the function of the window motif in Matisse's works.

In the second broadcast, Matisse not only rails against the teaching at the École des Beaux-Arts but also prescribes an alternative course of study that very much resembles his own training; for example, the creation of studios in which young artists "could be corrected by a master of their choice"—much as he himself had been by Gustave Moreau.

MATISSE'S RADIO INTERVIEWS

FIRST BROADCAST

As you know it is the painters who, by creating images, allow the objects and scenes of nature to be seen. Without them we could distinguish objects only by their different functions of utility or comfort. Each generation brings its new, characteristic representation.

Since the earliest times (from the cave artists to the modern painters), artists have enriched the common plastic vocabulary and each generation of man has seen through the eyes of the artists of the preceding generation.

Thus in my youth the coloring of chromos or the illustrations in popular books, which generally represented acceptable taste, was made against a dark background, because their creators were influenced by the painters of the preceding generation: notably those of the Romantic school.

Then the coloring of the chromos brightened and the colors of the Impressionist palette succeeded the harmonies of bistre.

Finally, after the rediscovery of the emotional and decorative properties of line and color by modern artists, we have seen our department stores invaded by materials decorated in medleys of color, without moderation, without meaning.

Then came the tonal scale of Marie Laurencin's palette, softly graduated, at the same time as the angular and linear decorations of the Cubist painters. These odd medleys of color and these lines were very irritating to those who knew what was going on and to the artists who had to employ these different means for the development of their form.

Finally all the eccentricities of commercial art were accepted (an extraordinary thing); the public was very flexible and the salesman would take them in by saying, when presenting things: "This is modern."

Today the exaggerations have quieted down, and the colors remain gay; nothing new asserts itself, however. This gaiety, which is a little relief for the pleasure of the eyes, is due to the vision of modern painters.

Why do you paint, M. Matisse?

Why, to translate my emotions, the feelings and the reactions of my sensibility through color and drawing,[3] which neither the most perfect camera, even in color, nor the cinema, can do.

From the point of view of entertainment and amusement the cinema has great advantages over painted pictures, which each represent only a single view. In the cinema a simple landscape documentary contains many different landscapes. People who like seascapes, if their first consideration is not to find the soul of the painter, can find complete satisfaction in front of the lifelike representations of the calm or tragically rough sea that the cinema gives them, and someone who loves images can have a collection of films representing views of the entire world, while a lover of paintings has but a few canvases, especially if they are of good quality.

As for portrait painters, they are outdone by good photographers, especially those who use anthropometry, who make complete likenesses. For a true lover who wants to keep the memory of one who has been the joy of his life will prefer a good photograph, which will aid his memory better than the interpretation of the departed's face by an artist, even a celebrated artist.

What then of the artists? Of what use are they?

They are useful because they can augment color and drawing through the richness of their imagination intensified by their emotion and their reflection on the beauties of nature, just as poets or musicians do.

Thus among painters the only ones we need are those who have the gift of translating their intimate feelings through color and drawing.

I used to say to my young students: "You want to be a painter? First of all you must cut out your tongue because your decision has taken away from you the right to express yourself with anything but your brush."

To express yourself, how do you go about it?

A study in depth permits my mind to take possession of the subject of my contemplation and to identify myself with it in the definitive execution of the canvas. The most elementary means suffice: some colors employed without mixing, other than with white or black, in order not to disturb their purity and their brilliance. It is only through their relationship that I express myself. As for drawing, I follow my inner feelings as closely as possible. Thus all the intellectual [*savante*] part of my work is secondary and very little evident.

When do you consider a work to be finished?

When it represents my emotion very precisely and when I feel that there is nothing more to be added. And once finished, the work stands on its own and the important thing is the next one, which absorbs all my interest.

Do you forget your works?

Never. Although working every day for fifty years, I have painted quite a few. Whenever someone speaks of one of my pictures, even an old one, in calling to mind some of its features, without being able to remember the year I did it, I see very precisely the state of mind I was in when I made it and all its colors, as well as its place in my total work.

Do you worry about the future of your works?

Since I am convinced that an artist can have no greater enemies than his bad paintings, I do not release a painting or a drawing until I have given it every possible effort; and if after that it still has life, I am happy as to the impression that it will make on the minds of those who see it.

Remember that the advantage that painting has over the theater is that future generations may repair the injustice of the generation in which the painting first appeared, while in the theater, if a play does not have immediate success it is buried for a very long time. The theater, as Debussy said, cannot allow itself glorious failures.

What do you remember of your teachers?

One only among them counts for me: Gustave Moreau, who turned out, among numerous students, some real artists.

The great quality of Gustave Moreau was that he considered that the minds of young students should undergo continuous development throughout their lives, and that he did not push them to satisfy the different scholastic tests which, even when artists have succeeded in the greatest competitions, leave them, at around thirty, with warped minds and an extremely limited sensibility and means; so that if they are not wealthy, they can only look for marriage to a well-to-do woman to help them follow their path in the world.

(The Wedding March from Lohengrin is played.)

Where does the charm of your paintings of open windows come from?

Probably from the fact that for me the space is one unity from the horizon right to the interior of my work room, and that the boat that is going past exists in the same space as the familiar objects around me; and the wall with the window does not create two different worlds. This is probably where the charm of these windows, which have quite naturally interested me, comes from.

Why does Nice hold you?

Because in order to paint my pictures I need to remain for several days in the same state of mind, and I do not find this in any atmosphere but that of the Côte d'Azur.

The northern lands, Paris in particular, once they have developed the mind of the artist through the intensity of their collective life and the richness of their museums, offer too unstable an atmosphere for work as I understand it.

Further, the richness and the silver clarity of the light of Nice, especially during the beautiful month of January, seem to me unique and indispensable to the mind of the plastic artist, especially if he is a painter.[4]

SECOND BROADCAST

Presentation:

I went to see Henri Matisse in his studio at Cimiez, where, a voluntary recluse among his birds and his tropical plants, he is illustrating "Les Amours" of Ronsard. And, speaking of the prime place that the independent French painters occupy throughout the world, I naturally was led to ask him the following question:

Do you think that the change of domicile might have an influence on the winners of the Rome competition, for the artistic climate is far from being the same in Rome and in Nice?

"Why do you want to speak about the Prix de Rome? Let it die in peace. The painters Manet, Degas, Claude Monet, Renoir, Cézanne have shown its uselessness. What artists who have won the Prix de Rome in the last 50 years can be compared to them? Albert Besnard? But he is a conventional painter who hid himself behind the palette of the Impressionists. The terrific Degas said: 'Besnard? But he's a pompier who catches fire [*Mais c'est un pompier qui prend feu*].'

"Not a single museum director, not a single foreign collector knows the name or even the existence of the Prix de Rome. Not a student who comes to France to study painting dreams of going to the École des Beaux-Arts. Their laureates are even neglected by postcards."

But, in your opinion, what are the causes of this deficiency?

"Without any doubt the teaching given at the École des Beaux-Arts, and of which the crowning and the goal are the Rome competition, is deadly for young artists . . . Because it pushes them toward the same cliché; they are taught, think of it, to do a head, a bust, hands, feet, in a limited amount of time, something that is 'monstrous' in artistic studies . . .[5] Because only technical proficiency counts . . . Because, stripped of their instinct and of their curiosity these poor artists are made 'cripples' forever at that time of life, from 15 to 25 years, which is the beginning of the road. In sum, this milieu of the Beaux-Arts-Prix-de-Rome is a mutual aid society from which nothing durable ever comes. I have seen painters return from Rome completely horrified because they suddenly realized their inability to express themselves sincerely.

"I repeat, the Rome competition should disappear, because it is basically sterile and even harmful, because it turns young artists away from their instinctive path. All the plastering over won't change anything—even if a notable independent artist, avid for honors, accepted the direction of it."

The direction of the Beaux-Arts then has never reached out a hand to the independent artists?

"The direction of the Beaux-Arts was always uninterested in the independent artists. And Monsieur Rougeon, then the Director of the Beaux-Arts, responded to the art critic Charles Morice, who asked him for a wall where Gauguin could execute a fresco: 'As long as I am Director of the Beaux-Arts, there will not be a centimeter of painting for Monsieur Gauguin.' It was also former Prix de Rome winners, members of the Institute, the head of which was Gérôme, who 'refused' half the Caillebotte bequest, which contained the most beautiful pictures by Manet, Cézanne, Renoir, and Pissarro."[6]

But finally, Monsieur Matisse, how can the state effectively involve itself with young artists?

"By creating free studios in which the young painters could be corrected by a master of their choice. On the other hand, instead of all the demands of the Prix de Rome and the support that the state gives to the Salons, couldn't one give 'travel scholarships' to artists who combined obvious gifts with a sound character, so they could go to study abroad 'freely,' in our colonies and even in France, wherever they felt it was possible to develop and enrich themselves. Won't this sort of thing, which seems to me very simple, come to pass one day?"[7]

29

Conversations with Louis Aragon: On Signs, 1942[1]

In 1943 Matisse's friend, the poet and novelist Louis Aragon, introduced Matisse's portfolio *Dessins: Thèmes et variations* with an essay "Matisse-en-France," which was based on numerous extended conversations with the artist. Aragon had great insight into Matisse and his work and vividly conveys the spirit of Matisse's actual manner of speech, drawing him out on a number of subjects that are central to his art. The following extract is one of Matisse's most revealing statements on the nature and importance of pictorial signs and on how he synthesized them.

Matisse's discussion of how new plastic signs eventually become part of the common plastic language is an interesting parallel to his similar, but distinctly less articulate comments to Charles Estienne almost thirty-five years earlier (Text 5, above). In fact, Matisse had begun to work in terms of a notion of plastic signs as early as 1906, but had moved in another direction during the early 1920s. In the early 1930s the "sign" aspect of his imagery became increasingly apparent; and as he began to prepare himself to abandon working directly from nature, Matisse seems to have developed a rather explicit theoretical basis for a feature of his art that had already preoccupied him for almost three decades.

Matisse's confession.

"To imitate the Chinese . . ." Matisse says. Here follows the painter's confession, which was not made all at once. I should like to retain the essence of it, I'm afraid of breaking its branches. If he admits that he labored for long years in quest of a theme, or rather of a formula, a sign for each thing, this can be connected with that other admission, the most disturbing one: "I have been working at my craft for a long time, and it's just as if up till now I had only been learning things, elaborating my means of expression."

Once again, what amazing modesty, what scrupulous conscientiousness he shows: that immense lifelong labor, those fifty years of work were merely the preparation of his craft. What is he trying to do? Matisse continues:

"I have shown you, haven't I, these drawings I have been doing lately, learning to represent a tree, or trees? As if I'd never seen or drawn a tree. I can see one from my window. I have to learn, patiently, how the mass of the tree is made, then the tree itself, the trunk, the branches, the leaves. First the symmetrical way the branches are disposed on a single plane. Then the way the branches turn and cross in front of the trunk . . . Don't misunderstand me: I don't mean that, seeing the tree through my window, I work at copying it. The tree is also the sum total of its effects upon me. There's no question of my drawing a tree that I see. I have before me an object that affects my mind not only as a tree but also in relation to all sorts of other feelings . . . I shan't get free of my emotion by copying the tree faithfully, or by drawing its leaves one by one in the common language . . . But only after identifying myself with it. I have to create an object that resembles the tree. The sign for the tree, and not the sign that other artists may have found for the tree: those painters, for instance, who learned to represent foliage by drawing 33, 33, 33, just as a doctor who's sounding you makes you repeat 99 . . . This is only the residuum of the expression of other artists. These others have invented their own sign . . . To reproduce that means reproducing something dead, the last stage of their own emotion . . ."

As he spoke to me I was thinking of Matisse's followers, of all those who imitate him clumsily or too cleverly, but who can see only, so to speak, his superficial gestures: they think they are starting from *his signs*, but they are in fact bound to fail because one can imitate a man's voice but not his emotion.

". . . and the residuum of another's expression can never be related to one's own feeling. For instance: Claude Lorrain and Poussin have ways of their own of drawing the leaves of a tree, they have invented their own way of expressing those leaves. So cleverly that people say they have drawn their trees leaf by leaf. It's just a manner of speaking: in fact they may have represented fifty leaves out of a total two thousand. But the way they place the sign that represents a leaf multiplies the leaves in

the spectator's mind so that he sees two thousand of them . . . They had their personal language. Other people have learned that language since then, so that I have to find signs that are related to the quality of my own invention. These will be new plastic signs, which in their turn will be absorbed into the common language if what I say by their means has any importance for other people . . ."

And very quickly Matisse adds a truth, his own truth, which sums it all up:

"The importance of an artist is to be measured by the number of new signs he has introduced into the plastic language . . ."

The Confession continued.

It was after confiding this concept of signs that he made a remark which takes us a long way from the trees: "It's just as if I were someone who is preparing to tackle large-scale composition."

"I don't understand . . ."

Those blue eyes. Matisse stretches out his arms, holding his hands in a curious position with the wrists half bent and the fingers slightly turned in, as though he wanted to show them to me in a foreshortened effect, which was to be the subject of his next sentence. "Look, look . . . Why do they say Delacroix never painted hands . . . that he only painted claws . . . like this? Because Delacroix was a painter of grand scale compositions. He had to finish off, at a certain place, the movement, the line, the curve, the arabesque that ran through his picture. He carried it to the end of his figure's arm and there he bent it over, he finished it off with a sign, you see, a sign! . . . always the same sign, the hand, made in the same way, not a particular hand but his hand, the claw . . . The painter who composes on the grand scale, carried away by the movement of his picture, cannot stop over details, paint each detail *as if it were a portrait*, portray a different hand each time. . . ."

"You said that you were going to, it's just as if you . . ."

"As if I were going to tackle large-scale composition. It's odd, isn't it? As if I had all my life ahead of me, or rather a whole other life . . . I don't know, but the quest for signs—I felt absolutely obliged to go on searching for signs in preparation for a new development in my life as painter . . . Perhaps after all I believe, without knowing it, in a future life . . . in some paradise where I shall paint frescoes . . ."

There's more laughter than ever in those blue eyes. On another occasion Matisse starts off once more from the *Chinese artist with the fine and limpid heart* to reconsider signs. This time his own hand describes not the claws in a Delacroix but a Burmese hand . . . "You know those Burmese statues with very long, flexible arms, rather like this . . . and ending in a hand that looks like a flower at the end of its stalk . . ." That's the Burmese sign for a hand. The sign may have a religious, priestly, liturgical character or simply an artistic one. A sign for each thing. This marks a progress for the artist in the knowledge and expression of the world, a saving

of time, the briefest possible indication of the character of a thing. The sign. "There are two sorts of artists," Matisse says, "some who on each occasion paint the portrait of a hand, a new hand each time, Corot for instance, and the others who paint the sign for a hand, like Delacroix. With signs you can compose freely and ornamentally . . . "

Thereupon he returns to his own example, the mouth shaped like a 3. He draws the series of hieroglyphs based on a specific model, whose mouth has a slightly thicker lower lip, both lips being fleshy and pressed close together: I see the figure 3 gradually appearing under his hand as a profile of that mouth, although it is seen from the front. "Why a 3 and not an 8? Because the mind can always imagine a line cutting the two parts of the 8 in the middle, whereas the 3 has to remain a whole . . ." On reflection, he adds: "There's also the fact that I have grown used to seeing objects in a certain light, like all the painters of my time. So in the 3 of the mouth there's one part in shadow and the other, the part that disappears, is swallowed up by the light."

30

Interview with Marguette Bouvier, 1944[1]

Marguette Bouvier's account of her visit to Matisse at Vence in October 1944 offers a candid glimpse of Matisse at home, when, weakened, he was forced to work in bed. The sense of his work room, the kinds of objects with which he surrounded himself, and especially his discussion of his student, offer interesting insights into Matisse's attitudes about his own art and about teaching art.

INTERVIEW WITH MARGUETTE BOUVIER

Vence . . . October 1944.

The pigeon caressed by Matisse flies from the foot of the bed to settle on the edge of the chair. It is a rare species, completely white; a cloud of powder makes a halo around it whenever it beats its wings.

Henri-Matisse has a passion for birds. He considers a bird cage as indispensable as a bed in a bedroom, and he collects hummingbirds, mirabilis, bengalis, and guittes or blue budgerigars. Congolese tapestries hang on the walls, panther skins, Persian rugs . . . Matisse and his legend reign over this unreal world.

Since 1918 the painter has lived in Nice. The evacuation measures before the American landings made it necessary for him to move to Vence. This was not an easy move because he brought his shells and Chinese porcelain, his *moucharaby*[2]

and his marble tables and all the strange objects with which he loves to surround himself. Thus he reconstructed, in his villa Le Rêve, this Matisse-atmosphere which he needs in order to live.

How many times I have surprised him in bed, a sweater over his pajamas, a board across his knees while he worked. He would be drawing, jotting illustration projects in the margins of Ronsard or Charles d'Orléans. In the room conceived for working while in bed, everything was easily reached without moving. Within arm's reach a revolving bookcase with dictionaries and classics. In the drawers an assortment of pencils, carefully arranged, erasers, paper, and naturally the telephone on his bedside table.[3] No one could be less bohemian than this artist who requires and studies his comforts like a *grand bourgeois*.

Matisse doesn't like to leave himself open to trouble. He has collected around his bed everything that pleases him. He has remade a world of his own taste in his bedroom.

Entering this room is a constant joy for me. Beyond the painter is the man, the man of a surprising intelligence and a dynamism that age has not touched.

On the wall facing him, under his eye, Matisse always hangs the paintings he is working on. Today there are seven paintings: a woman in a Russian blouse, a theme he his treated several times, still-lifes, and in the center the portrait of a girl seated at a table between two bouquets of flowers.[4] As I was looking at this very red, very blue, very striking canvas, Matisse said to me: "That's my little student who was the model.[5] Come tomorrow morning when I give her her lesson. We'll go together to where she's working, you'll meet her."

The next day he was waiting for me, wearing light gloves and holding a cane. Matisse was already known for his elegance among his peers, when at the beginning of the century, unknown and rich mainly in hope, he bought his first automobile on credit.

We left together, scaling the rocky path side by side, and soon came to the girl. She looked like a child of sixteen, though she was nineteen. Her easel was set up in front of an olive tree with three trunks which she was drawing.

Matisse took some charcoal and immediately underlined with a heavy line the essential parts, the architecture of the tree:

"One can always exaggerate in the direction of truth," he said.

The girl felt no shyness at being corrected by Matisse. The whole thing seemed simple to her. She said to him:

"That is difficult to express. There are two movements. What bothers me is that stump."

"Why don't you eliminate it?"

The question was a trap but the girl took care not to fall in.

"Because that would upset the balance."

"You see the empty spaces," replied the master, "they are very meaningful, it's they which will provide your balance."

All of Matisse was in that conversation. In three minutes, with clarity and without a single superfluous word, he transmitted the essential principles of his drawing to his student; *to exaggerate the truth* and to study at length *the importance of voids*.

As we continued our walk, Matisse told me how this student came to him out of the blue.

"She lives nearby, four kilometers from my villa. One fine day she decided to come to see me and arrived without ceremony at the house. My secretary wasn't in. She found her way in and without any preamble asked me:

" 'I brought you some drawings, do you want to see them?'

" 'What . . . What . . . ' I was stunned by such audacity. 'First of all, who are you? Who sent you?'

" 'No one, but I have some drawings to show you.'

" 'Whose drawings?'

" 'My drawings.'

" 'But I am not interested . . . Why didn't you telephone? Why didn't you have yourself announced?'

"She persisted with a child's pout:

" 'Excuse me, sir, this will only take two minutes. You only have to tell me if they are bad or good.'"

One can easily imagine the uneasiness of this little unknown girl, come to show her works to one of the greatest living painters, whom chance had given her as a neighbor.

" 'But where after all are your famous drawings?'

" 'On the road . . . yes, on the road, I left them in front of the gate in my cart.'

"This kid had loaded two large framed pencil drawings, and carted them from home to ask my opinion.

"I let myself be moved, I examined them and said what I thought. She continued:

" 'Do you think I could sell them? . . . for how much?'

" 'I have no idea. There you are going a little far. A minute ago it was only a matter of telling you what I thought of them. . . . Now you want a valuation.'

"She was so insistent that I kept the drawings to show them. The next day I gave her an address where she sold several of them. Since, she has come to pose for me. Each day she works near my windows and I give her advice."

He concluded:

"With her, it happened by itself. But you know, I accept no students . . . I made an exception for this child with the intention of leaving her to fate as soon as I had shown her the principles that can help her. For the moment I am going to put her on the double buckle diet."

"Double buckle? What do you mean?"

"It's very simple, you'll understand in a moment. After dividing the paper up and down with a vertical line and crosswise with a horizontal line, she has to draw the lines of the tree in relation to these two fundamental directions.

"In other words, the branches of the tree composed of oblique lines must always be drawn in relation to these two principal directions.

"In a drawing representing an object or a tree, a line or a curve must not be just any line or any curve, they must be architecturally constructed so that the whole forms a stable combination."[6]

\sim

A walk with Matisse is a real botany lesson.

He knows all sorts of things about the growth of fruit, the nature of the soil, which have nothing to do with painting. To say that he is interested in such diverse subjects reminds me that he plays no games. Matisse, at seventy-four years of age, has never touched a game of cards or chess or draughts. When, after too sustained an effort or during a convalescence, someone suggested that he play something for amusement, he refused, saying like Degas, "And what if it bores me to distract myself?"

31

The Role and Modalities of Color, 1945[1]

In 1945, the critic and art historian Gaston Diehl published a series of quotations and reflections by Matisse noted in the course of "recent conversations." These comprise one of Matisse's most detailed statements about the expressive possibilities and musical properties of color and its relationship to drawing. Matisse's observation about the increased use of bright colors in fashion and department stores is of especial interest. It indicates his awareness of how an important aspect of an original and vital expressive language can be co-opted and trivialized by commercial interests—a theme that he will return to in later statements.

THE ROLE AND MODALITIES OF COLOR

To say that color has once again become expressive is to write its history. For a long time color was only the complement of drawing. Raphael, Mantegna, or Dürer, like all Renaissance painters, constructed with drawing first and then added color.

On the other hand, the Italian Primitives and especially the Orientals had made color a means of expression. It was with some reason that Ingres was called an "un-

known Chinese in Paris," since he was the first to use bold colors, limiting them without distorting them.[2]

From Delacroix to Van Gogh and especially Gauguin, through the Impressionists, who cleared the way, and Cézanne, who gives the definitive impulse and introduces colored volumes, one can follow this rehabilitation of the role of color, and the restitution of its emotive power.

～

Colors have a beauty of their own which must be preserved, as one strives to preserve pure tones in music. It is a question of organization and construction that is sensitive to maintaining this beautiful freshness of color.

There was no lack of examples. We had not only painters, but also popular art and Japanese *crépons* which could be bought at the time.[3] Thus, Fauvism was for me the proof of the means of expression: to place side by side, assembled in an expressive and structural way, a blue, a red, a green. It was the result of a necessity within me, not a voluntary attitude arrived at by deduction or reasoning; it was something that only painting can do.

～

What counts most with color are relationships. Thanks to them and them alone a drawing can be intensely colored without there being any need for actual color.

No doubt there are a thousand different ways of working with color. But when one composes with it, like a musician with his harmonies, it is simply a question of emphasizing the contrasts.

Certainly music and color have nothing in common, but they follow parallel paths. Seven notes, with slight modifications are all that is needed to write any score. Why wouldn't it be the same for plastic art?

～

Color is never a question of quantity, but of choice.

At the beginning, the Russian Ballet, particularly *Scheherazade* by Bakst, overflowed with color.[4] Profusion without moderation. One might have said that it had been thrown from a bucket. The result was gay because of the material itself, not as the result of any organization. However, the ballets facilitated the employment of new means of expression through which they themselves greatly benefited.

An avalanche of color has no force. Color attains its full expression only when it is organized, when it corresponds to the emotional intensity of the artist.

With drawing, even if it is done with only one line, an infinite number of nuances can be given to each part that the line encloses. Proportion plays a fundamental role.

～

It is not possible to separate drawing and color. Since color is never applied haphazardly, from the moment there are limits, and especially proportions, there is a schism. It is there that the creativity and personality of the artist intervene.

Drawing also counts a great deal. It is the expression of the possession of objects. When you know an object thoroughly, you are able to encompass it with a contour that defines it entirely. Ingres said that the drawing is like a basket: you cannot remove a cane without making a hole.[5]

~

Everything, even color, can only be a creation. I first of all describe my feelings before arriving at their object. It is necessary then to recreate everything, the object as well as the color.

When the means employed by painters are taken up by fashion and by big department stores, they immediately lose their significance. They no longer command any power over the mind. Their influence only modifies the appearance of things; only the nuances are changed.

~

Color helps to express light, not the physical phenomenon, but the only light that really exists, that in the artist's brain.

Each age brings with it its own light, its particular feeling for space, as a definite need. Our civilization, even for those who have never been up in an airplane, has led to a new understanding of the sky, of the expanse of space. Today there is a demand for the total possession of this space.[6]

Awakened and supported by the divine, all elements will find themselves in nature. Isn't the Creator himself nature?

~

Called forth and nourished by matter, recreated by the mind, color can translate the essence of each thing and at the same time respond to the intensity of emotional shock. But drawing and color are only a suggestion. By illusion, they must provoke a feeling of the possession of things within the spectator. But it is only to the degree that the artist can induce this feeling in himself and convey his suggestion of it in his work and in the mind of the viewer. An old Chinese proverb says: "When you draw a tree, you must feel yourself gradually growing with it."

~

Color above all, and perhaps even more than drawing, is a means of liberation.

Liberation is the broadening of conventions, old methods being pushed aside by the contributions of the new generation. As drawing and color are means of expression, they are modified.

Hence the strangeness of new means of expression, because they relate to other things than what interested preceding generations.

~

Color, finally, is sumptuousness and display. Isn't it precisely the privilege of the artist to render precious, to ennoble the most humble subject?

32

Observations on Painting, 1945[1]

This essay, dated "Paris, 30 August 1945," is concerned with the development of young painters in relation to the past, and stresses both the importance of studying the old masters and the block that the past can sometimes be to the young artist.

Matisse suggests that the young painter can free himself from the spell of his immediate predecessors by seeking out kindred spirits and by finding new sources of inspiration in the work of other civilizations. Here, as in earlier statements, he generalizes directly from his own experience. He repeats that great painting is a product of the synthesis between study of the past and study of nature. In this way the painter can acquire the perception and enthusiasm for hard work that will enable him—through self-knowledge, which for Matisse was the single most important requisite—to produce significant art.

OBSERVATIONS ON PAINTING

I can still hear old Pissarro exclaiming at the Salon des Indépendants, in front of a very fine still-life by Cézanne representing a cut crystal water carafe in the style of Napoleon III, in a blue harmony: "It's like an Ingres."[2]

When my surprise passed, I found, and I still find, that he was right. Yet Cézanne spoke exclusively of Delacroix and of Poussin.[3]

Certain painters of my generation frequented the Masters of the Louvre, to whom they were led by Gustave Moreau, before they became aware of the Impressionists. It was only later that they began to go to the rue Laffitte or even more important, to Durand-Ruel's to see the celebrated *View of Toledo* and the *Road to Calvary* by El Greco, as well as some Goya portraits and *David and Saul* by Rembrandt.

It is remarkable that Cézanne, like Gustave Moreau, spoke of the Masters of the Louvre. At the time he was painting the portrait of Vollard, Cézanne spent his afternoons drawing at the Louvre. In the evenings, on his way home, he would pass through the rue Laffitte, and say to Vollard: "I think that tomorrow's sitting will be a good one, for I'm pleased with what I did this afternoon in the Louvre." These visits to the Louvre helped him to detach himself from his morning's work, for the artist always needs such a break in order to judge and to be in control of his previous day's work.[4]

At Durand-Ruel's gallery I saw two very beautiful still-lifes by Cézanne, biscuits and milk bottles and fruit in deep blue. My attention was drawn to them by old

Durand to whom I was showing some still-lifes I had painted. "Look at these Cézannes that I cannot sell," he said. "You should rather paint interiors with figures like this one or that one."

Then as now the road of painting seemed completely blocked to the younger generations; the Impressionists attracted all the attention.

Van Gogh and Gauguin were ignored. A wall had to be knocked down in order to get through.

The different currents in modern painting remind me of Ingres and Delacroix, who seemed so completely separate in their own time, so much so that their disciples would have fought in their defense if they had so desired. Yet today it is easy to see the similarities between them.

Both expressed themselves through the *arabesque* and through *color*. Ingres, because of his almost compartmentalized and distinct color, was called "a Chinese lost in Paris."[5] They forged the same links in the chain. Today only nuances prevent us from confusing them with each other.

Later it will be apparent that Gauguin and Van Gogh also lived at the same time: arabesques and color. The influence of Gauguin seems to have been more direct than that of Van Gogh. Gauguin himself seems to come straight out of Ingres.

The young painter who cannot free himself from the influence of the preceding generation is bound to be sunk.

In order to protect himself from the spell of the work of his immediate predecessors whom he admires, he can search for new sources of inspiration in the productions of diverse civilizations, according to his own affinities. Cézanne drew inspiration from Poussin. (To redo Poussin from nature.)

If he is sensitive, a painter cannot lose the contribution of the preceding generation, because it is part of him, despite himself. Yet it is necessary for him to disengage himself in order to produce in his own turn something new and freshly inspired.

"Challenge the influential master," said Cézanne.[6]

A young painter should realize that he does not have to invent everything, but should above all get things straight in his mind by reconciling the different points of view expressed in the beautiful works by which he is affected, and at the same time by directly questioning nature.

After he has become acquainted with his means of expression the painter should ask himself, "What do I want?" and proceed in his research, from the simple to the complex, to try to discover it.[7]

If he can preserve his sincerity toward his deep feeling without trickery or with-

out being too lenient with himself, his curiosity will not desert him and in his old age he will still have the same ardor for hard work and the necessity to learn that he had when young.

What could be better!

33

Interview with Léon Degand, 1945[1]

Early in the summer of 1945 Matisse came north to Paris for the first time since 1940. At the 1945 Salon d'Automne he was honored by a retrospective of thirty-seven works, most of them done during the War. Léon Degand took the occasion to interview Matisse in his studio on the boulevard Montparnasse, and the resulting text provides interesting insights on several matters. Matisse had never been a particularly open person, and in his later years he increasingly concealed himself behind a carefully constructed public image. The way that Degand's rather acerbic initial reaction to Matisse's self-control gives way to increasing admiration is instructive and—in contrast to the reverent tone of much of the writing about Matisse at this time—refreshing.

At the time of Degand's visit Matisse had on hand a series of "work-in-progress" photographs of the *Leda* panel that he had recently finished.[2] The ensuing discussion about Matisse's use of these photographs is especially detailed and informative.

INTERVIEW WITH LÉON DEGAND

Boulevard du Montparnasse. A building, an elevator in the cage of a stairway, an apartment door of no particular distinction. The door opens, and a face familiar to all who know Matisse's work greets me: his secretary and often his model.[3]

A large bright room where I am asked to wait. No smell of paint. Matisse only paints at Cimiez. Some lovely pieces of furniture. Some pictures on the wall, framed and unframed. A negro fetish. A Romanesque capital on the shaft of its column. Some books. An unstained parquet floor. At each side of an impeccably polished table, two firmly graceful chairs with light cushions. On the table, alone, a pencil sharpened with the greatest care. Everything, even the light, denotes a human presence that is careful about—no, in love with—order.

The "familiar face" reappears and we go into another room. Light, grace, order, steadiness, neatness accompany us here. I see again in an instant my trip from the door down in the street up to this room. It is here that *Monsieur Matisse* lives. There

is a concierge, noises of morning work and children in the staircase. I return to the room. In a light penumbra, here is *Matisse*. In bed, seated, supported by methodically piled cushions. At 11:00 in the morning? I apologize for perhaps having surprised a sick person in bed. But no. I shake a healthy hand, receive a lively look through spectacles that are stripped of vain ornamentation. Matisse is 75 years old.

"I worked part of the night," he explains to me.

I sit down. He connects without delay. "*Well?*" To a few introductory words he replies:

"Everything about me has been said in Raymond Escholier's book. I went over it myself."[4] I allude to the retrospective at the Salon d'Automne. "Moreover, my canvases speak for me. It is through them that I express myself."

Just as well that I had not come to enquire about biographical details.

One canvas, carrying the number XXXIII, not mentioned in the Salon d'Automne catalogue, had surprised and disturbed a number of visitors.

"The public is made to be confused," declared the Fauve. "Thanks to which it receives the shock that pushes it to reflect. That canvas was painted between 1910 and 1920 (he turns toward the "familiar face" who specifies, after a brief research: around 1918). "It is entitled *Window on the Garden*. It is a very beautiful picture."[5]

I wanted to get right to an important question. The works of Matisse breathe a spontaneity that was alluded to by a number of painters of the following generations and encouraged them, despite him, in the direction of the rapid sketch. By which they imagined they were sheltering the freshness of their inspiration from the drying dangers of prolonged work on a picture. They confuse spontaneity and facility.

"Spontaneity is not what I am looking for. Thus *The Dream* [1940] took me six months of work. The *Red Still Life with a Magnolia* [1941] also took six months. (The "familiar face" shows me a series of photographs representing the various moments in the realization of a representation of Leda on three panels. It is like a film. The first image dates to June 1944, the last to June 1945. All of that year was consecrated to this sole work.)

"Undoubtedly it is necessary to paint as one sings, without constraint. The acrobat executes his number with ease and an apparent facility. Let's not lose sight of the long preparatory work that permitted him to attain this result. It is the same with painting. The possession of the means should pass from the conscious to the unconscious through the work, and it is then that one is able to give the impression of spontaneity.

"Painting requires organization by very conscious, very concerted means, as in the other arts. Organization of forces—colors are forces—as in music, organization of tones. But let's not confuse painting and music. Their actions are only parallel. One wouldn't be able to translate Beethoven's symphonies into painting."

I had already discovered this reference to music in things Matisse had said. What are Matisse's relations to music? It is always curious to know what relationship an artist specialized in a certain form of art can maintain with other forms and what lessons he has learned from them.

"I like music very much," Matisse says to me.

When I ask for particulars, he indicates a little radio set at the head of his bed. Good music enchants him. Does he himself play?

"I played the violin when I was young (that is, until he was fifty years old, his secretary says). I played with some feeling. I wanted to acquire too rich a technique, and I killed my feeling. Now I prefer to listen to others."[6]

Exactly the opposite of what Matisse has achieved in his art, which is reserved, where the possession of his technique permits him, on the contrary to express his feeling. And there, luckily for us, he was not content with a passive attitude, neither for himself nor for we who do not paint.

"You mean that in music I prefer to have others do my work for me."

But we return to spontaneity and, in particular, to the psychological and moral conditions of the artist's work.

"I work from feeling. I have my conception in my head, and I want to realize it. I can, very often, reconceive it. (We take up the photos of the *Leda*.) But I know where I want it to end up. The photos taken in the course of the execution of the work permit me to know if the last conception conforms more to what I am after than the preceding ones, whether I have advanced or regressed."

"Aren't you afraid this technique of research will cut off your inspiration?"

"No. I have within me something to express, through plastic means. I work as long as that has not come out."

"This apparent spontaneity that you manage to retain in your paintings in spite of this constant work, was taken for facility by certain artists. They were pleased to see a lesson there . . ."

"I am not obliged to put guard-rails around me everywhere I go."

I cannot help finding Matisse's approach to painting, this obstinate construction, this extreme consciousness of a fine intellectualism, completely remote from any sort of facile naturalism. Matisse continues his rigorous utterance.

"At any rate, when one expresses a feeling, it is nothing as long as one has not found its perfect form."

"That demands a great consciousness of one's feeling, if one has it."

"Above all, that demands sincerity. I want to keep myself always in a high state of sincerity; for it is impossible to force inspiration."

"This sincerity assumes lucidity as well?"

"It is advisable first of all to acquire the habit of not lying, neither to others nor to yourself. That is where the drama of many contemporary artists is found. They

tell themselves: I am going to make concessions to the public and, when I have made enough money, I will work for myself. From that moment, they are lost. They behave like those women who decide to become streetwalkers until they have amassed a sum of money, then to marry. 'Virtue is like a match: it can only be used once,' Pagnol wrote in *Marius*.[7] It is the same for painters.

"Beware of concessions. And don't let yourself be impressed when someone says to you: 'What a beautiful painting! And you have rubbed out part of it!' What counts is not the quantity of canvases that one has done, but the organization of one's brain, the order that one puts into the mind, in view of the completion of what one has conceived."

Once again, we used the example of the *Leda*. The photographs are eloquent. At a given moment Matisse thought the work finished. Two days later, he changed it for the better. The feeling had not been exactly expressed by the architecture of the composition.

"This feeling is independent of a change in color. If a green is replaced by a red, the look of a painting can change, but not its feeling. Colors are forces, I said. They must be organized with a view to creating an expressive ensemble. The same as in orchestration, where one gives a part to an instrument which can also be assumed by another to reinforce the effect."

Matisse expresses himself in an unlabored way, with an exquisite vivacity in his words and thoughts, with clarity. From the portrait of him that begins to emerge, there is evident the animation of the sage who does not believe he has discovered wisdom in passivity. The order and the neatness of the apartment that surrounds me are just the natural expressions of this man who inhabits it. One only has to look at the colors and the drawings of Matisse in order to recognize in them other illustrations of this organization, this will to end up with clear order. On my chair at the foot of the bed, I have the physical feeling of being a participant in this living rational equilibrium. But the hands and the eyes of Matisse, as much as his voice, with a measure from which no intensity of expression is excluded, recall me to our conversation.

Shouldn't one worry about excess of feeling?

"Feeling is self-contained. You don't say to yourself: Look, today I am going to manufacture some feeling. No, it is a matter of something more authentic, more profound. Feeling is an enemy only when one doesn't know how to express it. And it is necessary to express it entirely. If you don't attempt to go to the limit, you only get approximations. An artist is an explorer. He should begin by seeking himself, seeing himself act. Then, not restraining himself. And above all, not being easily satisfied.

"In no case should the client be an obstacle to the pursuit of this purpose. Also watch out for the influence of wives. The priest and the doctor should never marry,

so as not to risk letting temporal considerations come before those of their professions. The same goes for the artist."

"That is what Julien Benda prescribed for the *clergyman*, so he could make judgments with complete independence. In sum, you advise a sort of religious celibacy." [8]

"Yes. There is everything to fear from the woman who plagues you by warning you of dangers or of what you are missing out on. It is also indispensable for the artist to reduce his existence to the minimum. Maillol understood that. 'I can live on a pickled herring a day,' he said. Simplify life. Don't allow in anything useless."

I admire this constant care to not let oneself be distracted from his course of action, even in the smallest details of life, this horror of wasted time.

"In an automobile, one shouldn't go faster than five kilometers an hour. Otherwise one no longer senses the trees" (said with the gesture of a feeling hand). "And for a long trip, better to take the train than a car. When I get into the train at Nice, I have all the leisure of thinking, of dreaming, of being by myself until Paris."

It doesn't displease me to hear such an indifference to the pleasures of driving.

"Have you done any cycling?"

"Yes. But one day I had an accident and I had to have my foot in a plaster cast. Gustave Moreau asked me what happened. I told him that I used a bicycle to go to the country to paint landscapes. He replied to me: people did fine landscapes before there were bicycles. I was convinced."

Will Matisse tell me what he thinks of our contemporaries? Which artist will he name?

I run up against complete refusal.

"Just because I don't agree with my neighbor doesn't mean that he's wrong. To each his own path."

The ritual question: What projects?

"God knows. God guides my hand. Certainly He doesn't speak directly to me; but I trust in Him."

I learn however that he just finished drawings, initial letters, and the complete composition of an edition of the *Lettres Portugaises*; some lithographs after which Pierre Reverdy wrote some texts (this time it is the poet who is the illustrator); some color illustrations for the poems of Charles d'Orléans, some black and white lithographs for the poems of Ronsard. [9]

For several years certain people, even some of the best, have been worrying that our period doesn't have a style of its own. They think they have discovered, in this claimed absence of style, a sign of decadence. What does one of the men who has had the most decisive influence on the style of his time think about this?

"They don't see the style of their time. They make me think of the man who wanted to paint a mountain. The more he climbed, the less he saw of it. One will

see later, all the paintings of our period will be of the same style. In spite of everything, Ingres and Delacroix are of the same period. The same for the eighteenth century. Style springs necessarily from the epoch. Undoubtedly there are styleless periods. But our period has a style that will be clearly marked. Liberty of artistic expression, which is the rule today, will not stop this. This freedom, granted, will only be valid if it is applied in the context of a tradition. Tradition does not mean habit. At any rate, it is not because we no longer dress as one did under Louis XIV or in 1900 that we have no style. We have things to say, and we say them according to the means forged by our epoch. Raphael today wouldn't paint as he did." [10]

"A current obsession is *wanting* a French art, as if French art were not necessarily the product of French artists."

"Obviously. Moderation is the characteristic of French art. It is found everywhere in France. In places that seem the most cosmopolitan one finds France. Someone said to me not long ago when I was abroad: 'How lucky you are to return to Paris where everything is so beautiful and so fine.' I responded: 'In returning to my home I am going to pass by the avenue de l'Opéra; I don't see what it can have that is particularly French; it seems to me that this character of the street is everywhere.' He insisted: 'Don't fool yourself; you will only notice it in leaving here.' This foreigner was right. In that avenue which appeared to have grown up a little haphazardly, all was well-placed. The shop signs were not too large and flashy and I could breathe an air of tranquillity there with which I was quite satisfied.

"But the French are not aware of their surroundings, for the same reason that you don't think about the jacket you're wearing when it gives you ease of movement."

"What do you think of the 'human element' that so completely occupies certain of our contemporaries?"

"These preoccupations are foreign to painting. When I had students I told them: you must begin by cutting off your tongue, for, starting today, you should express yourself only through plastic means. You must be what you are, and cultivate this. Don't wait for inspiration. It comes while one is working.

"The human element, what is it, after all? It is the faculty that certain beings have to identify with their setting, with the people around them, the flowers that they see, the landscapes in which they live. The colors of a picture, like the phrases of a symphony, don't need anecdote to give the spectator or the listener the feeling that the artist is a sensitive or generous being.

Subtle color relationships, exactly proportioned in a composition, devoid of every kind of anecdotal significance confirm, on the wall of the room, these words of the painter.

"People have still not given up reproaching your art for being extremely decorative, meaning that in the pejorative sense of *superficial*."

"Delacroix said: We are not understood, we are acknowledged. The decorative

for a work of art is an extremely precious thing. It is an essential quality. It is not pejorative to say that the paintings of an artist are decorative. All the French Primitives are decorative.

"The characteristic of modern art is to participate in our life. A painting in an interior spreads joy around it by the colors, which calm us. The colors obviously are not assembled haphazardly, but in an expressive way. A painting on a wall should be like a bouquet of flowers in an interior. These flowers are an expression, tender or lively. Or, the pleasure simply comes to us from a yellow or red surface, which accounts for the more tender expression of the flowers, like roses, violets, daisies, compared with the bright and purely decorative orange of marigolds."

There is a Matissian atmosphere which emanates from the man as well as the work, an atmosphere of fine and sensual intellectuality, serene and grave, devoid however of vain austerity. There is nothing profane or irrelevant.

In the course of the interview that one has perhaps just read, I saw Matisse in the middle of the day. A bright, early autumn light appeared to reinforce the brilliant light of the decor—very Matisse—where I came to meet him. I lived through my eyes. In this same room I saw Matisse that evening in artificial light, seated at a work table dressed in a long pale dressing gown, a light scarf on his shoulders, a checked cap tilted down over his eyes. Now the colors in the room are toned down. Matisse speaks and I prefer to listen only to the verbal equivalent of this philosophy of life that he has illustrated with so much happiness in his art. It is enchanting to perceive that Matisse has arrived there without forcing himself, without giving himself over to delirium, in consenting to be that which he felt himself to be, but not without caution. For, if he practices an art fitting to the emotion of the artist, it is an art that is controlled. There is not a single burst of color in one of his pictures that is not intimately related to all the other parts of the picture.

What happiness that France should also encompass this place in the world, healthy, aerated, relaxed, without languor, smiling and as if perfumed with a consciousness with which Matisse is identical, man and artist.

34

Black is a Color, 1946[1]

On the occasion of an exhibition entitled "Black is a Color" at the Gallery Maeght, Paris, in December 1946, Matisse made remarks on this theme that were recorded by M. Maeght. Matisse's use of black as a color is particularly interesting, since in one way or another it is to be found throughout his paintings, even in the

late cutouts, where it provides especially rich expression in such large compositions as *The Snail* and *The Sorrows of the King*. Matisse's musical allusion is not uncommon in his writings and surely not unexpected from a painter who, like Ingres, was a dedicated violinist.

BLACK IS A COLOR

The use of black as a color in the same way as the other colors—yellow, blue or red—is not a new thing.

The Orientals made use of black as a color, notably the Japanese in their prints. Closer to us, I recall a painting by Manet in which the velvet jacket of a young man with a straw hat is painted in a blunt and lucid black.[2]

In the portrait of Zacharie Astruc by Manet, a new velvet jacket is also expressed by a blunt luminous black.[3] Doesn't my painting of Moroccans use a grand black which is as luminous as the other colors in the painting?[4]

~

Before, when I didn't know what color to put down, I put down black. Black is a force: I used black as ballast to simplify the construction. Now I've given up blacks.[5]

~

Like all evolution, that of black in painting has been made in jumps and starts. But since the Impressionists it seems to have made continuous progress, taking a more and more important part in color orchestration, comparable to that of the double-bass as a solo instrument.

35

How I Made my Books, 1946[1]

"How I made my Books" is a specialized essay contributed to an anthology of statements by artist-illustrators. It is a literal account of Matisse's method of working, descriptive rather than theoretical, with the notable exception of the parallel drawn between making a painting and making a book.[2] This procedure from the broad conception to detail, and then through a process of distillation and reduction to essentials, seems to run throughout Matisse's writings.

HOW I MADE MY BOOKS

To start with my first book—the poems of Mallarmé.[3]

Etchings, done in an even, very thin line, without hatching, so that the printed page is left almost as white as it was before printing.

The drawing fills the entire page so that the page stays light, because the drawing is not massed towards the center, as usual, but spreads over the whole page.

The recto pages carrying the full-page illustrations were placed opposite facing verso pages that carry the text in 20-point Garamond italic. The problem was then to balance the two pages—one white, with the etching, the other comparatively black, with the type.

I obtained my result by modifying my arabesque in such a way that the spectator should be interested as much by the white page as by his expectation of reading the text.

I compare my two pages to two objects taken up by a juggler. Suppose that his white ball and black ball are like my two pages, the light one and the dark one, so different, yet face to face. In spite of the differences between the two objects, the art of the juggler makes a harmonious whole in the eyes of the spectator.

~

My second book: *Pasiphäe* by Montherlant.[4]

Linoleum engravings. A simple white line upon an absolutely black background. A simple line, without hatching.

Here the problem is the same as that of the "Mallarmé," except the two elements are reversed. How can I balance the black illustrating page against the comparatively white page of type? By composing with the arabesque of my drawing, but also by bringing the engraved page and the facing text page together so that they form a unit. Thus the engraved part and the printed part will strike the eye of the beholder at the same moment. A wide margin running all the way around both pages masses them together.

At this stage of the composition I had a definite feeling of the rather bleak character of this black and white book. A book, however, is generally like that. But in this case the large, almost entirely black page seemed a bit funereal. Then I thought of red initial letters. That pursuit caused me a lot of work; for after starting out with capitals that were pictorial, whimsical, the invention of a painter, I had to settle for a more severe and classical conception, more in accord with the elements already settled—the typography and engraving.

So then: Black, White, Red. —Not so bad . . .

Now for the cover. A blue came to my mind, a primary blue, a canvas blue, but with a white line engraved on it. As this cover has to remain in the slipcase or in a binding, I had to retain its "paper" character. I lightened the blue, without making it less blue, but through a woven effect—which came from the linoleum. Unknown to me, an attempt was made whereby the paper, saturated with blue ink, looked like leather. I rejected it immediately because it had lost the "paper" character I wanted it to have.

This book, because of the numerous difficulties in its design, took me ten months of effort, working all day and often at night.

~

My other books, notably *Visages*, the *Poésies de Ronsard*, the *Lettres portugaises*,[5] those in the process of publication, which are waiting their turn at press, though they differ in appearance, were all done according to the same principles, which are:

1st. Rapport with the literary character of the work;

2nd. Composition conditioned by the elements employed as well as by their decorative values: black, white, color, kind of engraving, typography. These elements are determined by the demands of harmony for the book as a whole and arise during the actual progress of the work. They are never decided upon before the work is undertaken, but develop coincidentally as inspiration and the direction of my pursuits indicate.

I do not distinguish between the construction of a book and that of a painting and I always proceed from the simple to the complex, yet I am always ready to reconceive in simplicity. Composing at first with two elements, I add a third insofar as it is needed to unite the first two by enriching the harmony—I almost wrote "musical."

I reveal my way of working without claiming that there are no others, but mine developed naturally, progressively.

~

I want to say a few words about lino engraving.

Linoleum shouldn't be chosen just as a cheap substitute for wood, as it gives the print a particular character, very different from that of wood, and for which it should be sought.[6]

I have often thought that this simple medium is comparable to the violin with its bow: a surface, a gouge—four taut strings and a swatch of hair.

The gouge, like the violin bow, is in direct rapport with the feelings of the engraver. And it is so true that the slightest distraction in the drawing of a line causes a slight involuntary pressure of the fingers on the gouge and has an adverse effect on the line. Likewise, a change in the pressure of the fingers that hold the bow of a violin is sufficient to change the character of the sound from soft to loud.

Lino engraving is a true medium predestined to be used by the painter-illustrator.

I have forgotten a valuable precept: put your work back on the block twenty times over and then, if necessary, begin over again until you are satisfied.

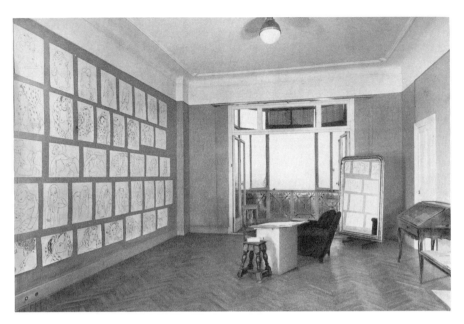

26. Matisse's studio at Cimiez with his *Themes and Variations* drawings on the wall, 1942. Matisse referred to this room as "the cinema of my sensibility" (Text 26).

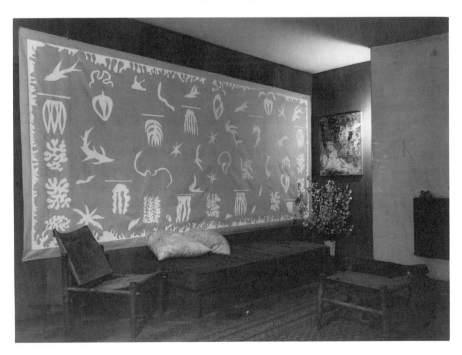

27. *Oceania, the Sea*, c. 1946. This tapestry is based on one of Matisse's first large cutout designs (see Text 36).

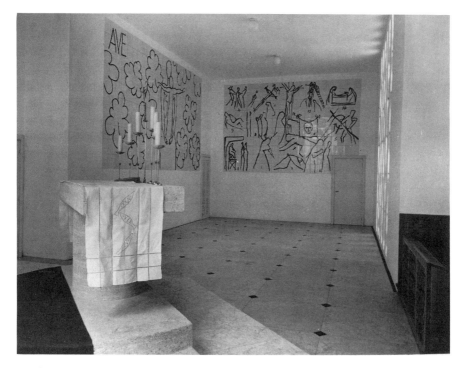

de contes
populaires
ou de voyage.
J'ai fait ces
pages d'écri-
tures pour
apaiser les
réactions,
simultanées

28. "The Toboggan," from *Jazz*, 1947 (Text 37). Matisse handwrote the text for this book, the only illustrated book for which he also composed his own text.

29. The interior of the Chapel at Vence, 1951. The ceramic tiles carry representations of the Virgin Mary and of the Stations of the Cross (see Texts 46, 47).

36

Oceania, 1946[1]

In 1946, Matisse created two compositions based on his recollections of his trip to the South Seas in 1930—*Oceania, the Sea* and *Oceania, the Sky*. Zika Ascher first approached Matisse about the possibility of designing a decorative commission for the London firm, A. Ascher, Inc., in 1946. Matisse neither refused nor agreed, but asked Ascher to visit him the next time he was in Paris. When Ascher saw Matisse a few months later, Matisse showed him the cut paper Oceania designs, which were pinned directly onto the walls of his work space. After surmounting a number of technical problems, the two compositions were eventually transferred and printed in silkscreen editions of thirty each.

This fragment of a 1946 letter about the project offers a nice insight into Matisse's version of the creation of forms from experience "recollected in tranquility"— which in the coming years was to become his principal way of working.

OCEANIA

This panel, printed on linen—white for the motifs and beige for the background—forms, together with a second panel, a wall tapestry composed during reveries that came fifteen years after a voyage to Oceania.[2]

From the first, the enchantments of the sky there, the sea, the fish, and the coral in the lagoons plunged me into the inaction of total ecstasy. The local tones of things hadn't changed, but their effect in the light of the Pacific gave me the same feeling as I had when I looked into a large golden chalice.

With my eyes wide open I absorbed everything as a sponge absorbs liquid.

It is only now that these wonders have returned to me, with tenderness and clarity, and have permitted me, with protracted pleasure, to execute these two panels.

37

Jazz, 1947[1]

Matisse began the cut and pasted designs for *Jazz* some time around 1943 and the book was published on 30 September 1947, as a folio of almost one hundred and fifty pages. The pictures of the book consist of some twenty colorful plates of pochoir prints executed after Matisse's original cut-paper compositions, using inks based on the same colors that he had used for the originals. The subjects of the

plates are taken largely from folklore, mythology, and the circus—a departure from Matisse's usual subject matter—with an accompanying text reproduced in Matisse's own large, sprawling handwriting. *Jazz* was in effect Matisse's first major public affirmation of his new cutout technique, and he was especially concerned about its reception.[2] Matisse worked on the text for *Jazz* in a number of notebooks, from which he used only parts of the projected text.[3] As published, the text is divided into sixteen sections, some of which are introduced by a title, others by an underlined opening phrase (printed here in italics).

In the introduction to the text Matisse notes that the holograph text is meant to "serve only as an accompaniment to my colors. . . . THEIR ROLE IS THUS PURELY SPECTACULAR." With typical modesty—(not to say indirection)—Matisse states that he can only offer some remarks, made in the course of his lifetime as a painter: "I ask of those who have the patience to read them, that indulgence which is generally accorded to the writings of painters." The introduction, then, serves as a modest and indirect way for the painter to introduce his desire to make some observations about the nature of art and about life itself. The device of saying that the writing is unimportant gives him freedom to ramble in the text and to be fanciful and metaphorical—and at times intensely personal—in contrast to the usually rather abstract or methodical explanations of his ideas.

In fact, the writing of this book was very important to Matisse; and though the pictures were mostly finished by 1944, he continued to work on the text until shortly before its publication in 1947. And while the handwritten text gives the impression of great spontaneity, it went through a number of different drafts and versions—as can be seen in a 1946 notebook that is usually referred to as "*Répertoire: 6.*"[4] Some of these variants are given in the annotations to the text below.

Although for many years most writers accepted Matisse's avowal that there was no particular relationship between plates and text, a subtle but firm relationship does exist. The illustrations themselves seem to have two major kinds of subjects: the isolated figures (the Clown, Icarus, Swimmer, etc.), which seem to be metaphors for the artist; and the double figures (Knife Thrower, Cowboy, Heart, etc.) which suggest a dialogue, in the manner of "artist and model."[5] The underlying theme of the *Jazz* plates thus seems to be art and artifice; and these themes find many parallels in the text. Further, despite the vivid colors of the plates and their circus themes, few of them are actually cheerful; several are among Matisse's most ominous images.[6]

There are also some wry juxtapositions, such as the placement of the falling "Icarus" at the end of the "Airplane" section. In a draft for this section, Matisse had written: "You find yourself in a completely white landscape, in radiant but not blinding light. The forms of the clouds seem to block the route. We come closer and then penetrate them in silent fog and diffused light. We emerge, the noise of the plane grows louder and once again we find ourselves abruptly in the bright, caressing light (a light not only bright but delectable). Isn't this what we need to help

us forget? An airplane trip can help us both to forget and to find the peace of mind that makes everything possible. What is surprising is the feeling of motionlessness and of great security. It seems impossible that we could fall."[7]

Not only is the subject matter of *Jazz* unusual for Matisse, but so is the feeling conveyed. It is quite likely that in *Jazz* Matisse was striving after the kind of meaningful cacophony found in Erik Satie's *Parade* of 1917, which he associated with the improvisatory nature of jazz music.[8]

The twenty plates and rambling text of *Jazz*, full of subtlety and innuendo, at once bold and gay and tragic (Satie had said of jazz that "it shouts its sorrows"), form one of Matisse's most interesting statements about his art—and in fact amount to a kind of artistic credo.

JAZZ

Notes

Why, after having written, "He who wants to dedicate himself to painting should start by cutting out his tongue," do I need to resort to a medium other than my own?[9] Because now I wish to present color plates in the most favorable conditions possible. To do so, I need to separate them by intervals of a different character. I decided that a handwritten text was most suitable for this purpose. The unusual size of the writing seems to me to provide the necessary decorative rapport with the character of the color plates. Thus these pages serve only as an accompaniment to my colors, as asters add to the composition of a bouquet of more important flowers. THEIR ROLE IS THUS PURELY SPECTACULAR.

What can I write? I certainly cannot fill these pages with the fables of La Fontaine, as I did when I was a solicitor's clerk, for "engrossed conclusions" that no one, not even the judge, ever reads; and which only serve to use up a quantity of official paper proportionate to the importance of the case.

I can only offer some remarks, notes made in the course of my lifetime as a painter. I ask that those who have the patience to read them do so with the indulgence generally accorded the writings of a painter.[10]

The Bouquet

During a walk in the garden I pick flower after flower, gathering them one after the other into the crook of my arm as I chance to pick them. Then I go into the house with the intention of painting them. After I have rearranged them in my own way, what a disappointment: all their charm is lost in this arrangement. What has happened?

The unconscious grouping made when my taste led me from flower to flower

has been replaced by a willful arrangement, the result of remembered bouquets long since dead, which have left in my memory the bygone charm with which I have burdened this new bouquet.

Renoir told me: "When I have arranged a bouquet in order to paint it, I go round to the side I had not seen."

~

The Airplane

A simple voyage by plane from Paris to London gives us a revelation of the world that our imagination cannot anticipate.[11] At the same time that the feeling of our new situation delights us, it confuses us with the memory of the cares and annoyances with which we let ourselves be troubled on that same earth that we catch sight of below us as we cross over holes in the plain of clouds that we are overlooking from an enchanted world which was there all the time. And when we are returned to our modest condition of walking, we will no longer feel the weight of the grey sky upon us because we will remember that beyond this wall of clouds, so easily crossed, there exists the splendor of the sun as well as the perception of limitless space in which for a moment we felt so free.

Shouldn't one have young people who have finished their studies make a long journey by plane.[12]

The character of a face in a drawing depends not upon its various proportions but upon a spiritual light that it reflects. So much so, that two drawings of the same face may represent the same character though drawn in different proportions. No leaf of a fig tree is identical to any other, each has a form of its own, but each one cries out: Fig tree.[13]

~

If I have confidence in my hand that draws, it is because as I was training it to serve me, I never allowed it to dominate my feeling. I very quickly sense, when it is paraphrasing something, if there is any disaccord between us: between my hand and the "je ne sais quoi" in myself that seems submissive to it.

The hand is only an extension of sensibility and intelligence. The more supple it is, the more obedient. The servant must not become the mistress.

~

Drawing with scissors

Cutting directly into vivid color reminds me of the direct carving of sculptors.

This book was conceived in that spirit.

~

My Curves are not mad

The plumb line in determining the vertical direction forms with its opposite, the horizontal, the draughtsman's points of the compass. Ingres used a plumb line.[14]

You see in his studies of standing figures this unerased line, which passes through the sternum and the inner ankle bone of the "leg that bears the weight."

Around this fictive line the "arabesque" develops. I have derived constant benefit from my use of the plumb line.

The vertical is in my mind. It helps me make precise the direction of my lines, and in my rapid drawings I never indicate a curve, for example that of a branch in a landscape, without being conscious of its relationship to the vertical.

My curves are not mad.

~

A new picture must be a unique thing, a birth bringing to the human spirit a new figure in the representation of the world. The artist must summon all his energy, his sincerity, and the greatest modesty in order to shatter the old clichés that come so easily to hand while working, which can suffocate the little flower that does not come, ever, in the way one expects.

~

A musician has said:
In art, truth and reality begin when you no longer understand anything you do or know and there remains in you an energy that is all the more strong for being balanced by opposition, compressed, condensed. Then you must present yourself with the greatest humility, completely blank, pure, candid, your brain seeming empty in the spiritual state of a communicant approaching the Lord's Table. You clearly must have all your accomplishments behind you, and have known how to keep your Instinct fresh.

~

Do I believe in God?
Yes, when I work. When I am submissive and modest, I sense myself helped immensely by someone who makes me do things that surpass myself. Still, I feel no gratitude toward *Him* because it is as if I were watching a conjurer whose tricks I cannot see through. I then find myself thwarted of the profit of the experience that should be the reward for my effort. I am ungrateful without remorse.[15]

~

Young painters, painters misunderstood or only lately understood—no hatred!
Hatred is a parasite that devours everything. One doesn't build upon hatred, but upon love. Emulation is necessary, but hatred . . .

Love, on the contrary, sustains the artist.

~

"Love is a great thing, a great goodness, which alone renders light that which is heavy and endures with an equal spirit that which is unequal. For it carries weights that would be a burden without it, and makes sweet and pleasant all that is bitter . . .

"Love wants to rise, not to be held down by anything base . . .

"Nothing is more gentle than love, nothing stronger, nothing higher, nothing wider, nothing more pleasant, nothing more complete, nothing better in heaven or on earth, because love is born of God and cannot rest other than in God, above all living beings. He who loves, flies, runs, and rejoices; he is free and nothing holds him back."

<div align="right">(Im. de J. C.)[16]</div>

~

Happiness.
Derive happiness from yourself, from a good day's work, from the clearing that it makes in the fog that surrounds us.[17] Think that all those who have *succeeded*, remembering the difficulties of their beginnings, exclaim with conviction: "*those were the good old days.*" For most of them: Success = Prison. And the artist must never be a *prisoner*. Prisoner? An artist must never be a prisoner of himself, prisoner of a style, prisoner of a reputation, prisoner of a success, etc . . . Didn't the Goncourt brothers write that Japanese artists of the great period changed their names several times during their lives. I like that: they wanted to protect their freedoms.[18]

Lagoons,
Wouldn't you be one of the seven wonders of the Paradise of painters?[19]

~

Happy are those who sing with all their heart, in the forthrightness of their heart.

~

Find joy in the sky, in the trees, in the flowers. There are flowers everywhere for those who want to see them.

~

Future life.
Wouldn't it be consoling and satisfying if all those who gave their lives to the development of their natural talents, for the profit of all, were to enjoy after their deaths a life of satisfactions in accord with their desires.[20] While those who live in narrow-minded selfishness . . .

~

Jazz
These images, in vivid and violent tones, have resulted from crystallizations of memories of the circus, of popular tales, or of travel. I have made these pages of writings to appease the simultaneous oppositions of my chromatic and rhythmic improvisations, pages forming a kind of "sonorous background" which carries them, which surrounds them and thus protects their distinctiveness.

I pay my respects to Angèle Lamotte and Tériade—their perseverance has sustained me in the creation of this book.[21]

38

Interview with André Marchand: The Eye, 1947[1]

Like the interviews by Montherlant and Bouvier, the painter André Marchand's recollection of his conversation with Matisse gives a charming insight into Matisse's candid views on painting. Matisse's remarks about wanting to start his life as an artist over again are particularly revealing. At this time he was in a sense doing just that with his paper cutouts, which—more obviously than any of his previous work—came from the mind's eye.

INTERVIEW WITH ANDRÉ MARCHAND: THE EYE

I arrive at the villa "Le Rêve." "You know," says Matisse, "I didn't invite you to come and see me the other day because I am often bothered by people who drop in unexpectedly. But I take the greatest delight in chatting, and that's why I called you this morning." I reply that I wouldn't want to disturb his peace and quiet for anything in the world. Then the conversation turns to the country: he asks if I find it beautiful. I tell him it is downright ugly, that all the buildings are dreadful, that the ruin of the countryside is the fault of the architects. Henri Matisse smiles, says to me: "But at Versailles, you can't paint, whereas here, in this disorder, it is the painter who must find order."

Some photos have just arrived from Paris. They are of landscapes, one of which Matisse painted forty years ago. "I was very young, you see, I thought it was no good, a bad job, not constructed, an unimportant sketch. Well, look at it in miniature there in the photo; everything is there, it has balance, the tree leaning slightly toward the right; look, here is an enlargement. Basically, after that, I only developed this idea further. You know, you have only one idea, you are born with it and all your life you develop your fixed idea, you make it breathe. I believe that in drawing I have been able to say something, I have worked a lot with that problem. Cézanne constructed his paintings, but the magic of color still remained to be found after him. Cézanne's paintings have a peculiar structure; reversed, looked at in a mirror for example, they often lose their balance."

Henri Matisse tells me he used to go to the Louvre. Chardin attracted him when he was young, but he realized that he couldn't paint like Chardin, that basically he had to harmonize yellow, blue, and red, and by this apparently abridged means he had to express himself completely. Everything had to be redone in order to attain life, and then there was the problem of black.

Matisse quotes Pissarro on the subject of Manet; Pissarro said to him one day, "Manet is stronger than us all, he made light with black" (this went against all the

Impressionist theories of the time).² While Henri Matisse speaks, outside the daylight is fading and the evening sky is turning pale green.

Matisse says to me: "Here is a country where light plays the leading role, color comes second; it's with color that you put down this light of course,³ but above all you must feel this light, have it within yourself; you can get there by means that seem completely paradoxical, but who cares? It's the result alone that counts. I went to Corsica one year,⁴ and it was by going to that marvelous country that I got to know the Mediterranean. I was quite dazed by it all; everything shines, everything is color and light.

"I met a Corsican painter one day who told me his country was abominable and seeing my work said: 'How strange what you're doing is; what is it of?' I told him it was a certain house and described it to him. 'Ah!' he said, 'I know the place well, I will go and see it tomorrow.' The next day he came to the place where I was working, stood in surprise in front of my canvas, looking at the subject, understanding nothing at all, and said: 'I like what you're doing there, but I can't find it anywhere in the subject.'"

Matisse continues: "There is a young girl who draws who comes to see me fairly often. I tell her: basically when you look at a subject you have only to copy it, right?"—Matisse smiles as he watches me. "Yes, it's not that you have only to copy it, but in the course of working, whether you are before a landscape, a person, a bunch of flowers—anything at all—along comes the struggle, the revolt, and it's at that moment that you exactly set down the chosen subject according to your own temperament; painters with nothing to say copy quite stupidly; they are boring and useless."

Adjusting a navy-blue cap on his head, Matisse adds: "Ah! what a fascinating occupation, it's strange how short life is: now I can see what I have to do, I would like to start over again, but a painter's life is never long enough, you leave your work in the middle; the essential thing is to say well what you have to say." Then suddenly he says:

"Do you know that a man has only one eye which sees and registers everything, this eye, like a superb camera which takes minute pictures, very sharp, tiny (Matisse shows me the size between his fingers, about three millimeters across) and with that picture man tells himself: 'This time I know the reality of things,' and he is calm for a moment. Then, slowly superimposing itself on the picture another eye makes its appearance, invisibly, which makes an entirely different picture for him.

"Then our man no longer sees clearly, a struggle begins between the first and the second eye, the fight is fierce, finally the second eye has the upper hand, takes over and that's the end of it. Now it has command of the situation, the second eye can then continue its work alone and elaborate its own picture according to the laws of interior vision. This very special eye is found here," says Matisse, pointing to his brain.⁵

39

The Path of Color, 1947[1]

"The Path of Color" is Matisse's account of how he came to the realization that "color exists in itself, possessing its own beauty." He notes the positive effect of having one's ideas and efforts confirmed by a tradition, especially a long-lived one. (Although he refers to the Fauve period, the same dynamic underlay his shift in style during the 1930s.) Matisse also sums up three important aspects of his use of color: the way that light is suggested through color; the musical effects that can be created with color organized in terms of the internal needs of a picture (rather than in terms of describing objects); and the relative simplicity of color technique—the use of a fairly limited palette to achieve complex coloristic effects.[2]

Instead of rendering light and atmosphere in scrupulous mimetic detail, Matisse notes again that "it is enough to invent signs. When you have a real feeling for nature you can create signs which are equivalents to both the artist and the spectator." In this way Matisse reaffirms his transition to the more overtly sign-like imagery of the cutouts.

The use of expressive colors is felt to be one of the basic elements of the modern mentality, a historical necessity, beyond choice. This kind of historical and personal fatalism is a persistent leitmotif in Matisse's thinking, as in his 1936 statement to Tériade that "we are not masters of our production. It is imposed on us," and his remark at the end of "Notes of a Painter on his Drawing," that "one should not bother about the human side. Either one has it or one hasn't." And in 1952, upon the opening of the museum dedicated to him in Le Cateau, Matisse recalled when he first realized his vocation as a painter: "I constantly felt aware of the importance of my decision, and despite the certitude that I had found my true path, one in which I was in my own element and not hemmed in as in my earlier life, still I was frightened, realizing that there was no turning back. So I plunged headlong into my work, following the principle that I had heard expressed all through my young life, which was 'Hurry up!' . . . Like my parents, I got on with my work as quickly as possible, driven on by something, I do not know what, by a force that I see today as being alien to my normal life as a man."[3]

Just as there is often no turning back for an individual, so there is sometimes no turning back for a whole tradition; and Matisse was acutely aware of this.

This statement parallels in many ways the ideas in "Role and Modalities of Color," Text 31, above.

THE PATH OF COLOR

Color exists in itself, has its own beauty. We were made to realize this by the Japanese *crépons* we bought for a few centimes on the rue de Seine.[4] I then understood

that one could work with expressive colors that are not necessarily descriptive colors. Of course, the originals were no doubt disappointing. But isn't eloquence even more powerful, more direct when the means are coarser? Van Gogh was also passionate about Japanese *crépons*.

Once my eye was unclogged, cleansed by the Japanese *crépons*, I was capable of really absorbing colors because of their emotive power. If I instinctively admired the Primitives in the Louvre and then Oriental art, in particular at the extraordinary exhibition at Munich,[5] it is because I found in them a new confirmation. Persian miniatures, for example, showed me the full possibility of my sensations. I could discover in nature how my sensations should come. By its properties this art suggests a larger and truly plastic space. That helped me to get away from intimate painting.

Revelation thus came to me from the Orient. It was later, before the icons in Moscow, that that art touched me and I understood Byzantine painting.[6] You surrender yourself that much better when you see your efforts confirmed by such an ancient tradition. It helps you jump over the ditch.

I had to get away from imitation, even of light. One can provoke light by the invention of flat planes, as one uses harmonies in music. I used color as a means of expressing my emotion and not as a transcription of nature. I use the simplest colors. I don't transform them myself, it is the relationships that take care of that. It is only a matter of enhancing the differences, of revealing them. Nothing prevents composing with a few colors, as in music that is built on only seven notes.

It is enough to invent signs. When you have a real feeling for nature, you can create signs that are equivalents for both the artist and the spectator.

In the early Russian ballets, Bakst threw around colors by the bucketful. It was magnificent but without expression. It is not quantity that counts, but choice and organization. The only advantage that comes out of it is that color henceforth has freedom everywhere, even in the department stores.

We have made this choice in spite of ourselves. It was inescapable, it was a matter of fate. That is why it so profoundly represents the spirit of a period. But there is no need to confine oneself to that; today one must continue and go further.

40

Exactitude is not Truth, 1947[1]

This essay was written in May 1947 for the catalogue of an exhibition of Matisse's drawings, organized in Liège by the Association pour le progrès intellectuel et artistique de la Wallonie, with the participation of the Galerie Maeght, Paris. The title phrase comes from a saying of Delacroix. The following year—at Matisse's request—an English translation of it was included in the catalogue for the Philadelphia Museum of Art's 1948 retrospective exhibition of his work.

In this essay Matisse notes that in painting and drawing, even in portraiture, conviction does not depend on "forms being copied exactly as they are in nature or on the patient assembling of exact details, but on the profound feeling of the artist before the objects that he has chosen, on which his attention is focussed, and whose spirit he has penetrated." He reiterates the image of the fig tree that he used in *Jazz*, and extends that image to other growing things, even people, concluding that everything has an inherent truth which must be distinguished from its surface appearance. And this is the only truth that matters; it is the essential truth of the objects depicted that makes a drawing or painting successful.

Matisse again emphasizes the importance of creating signs, and in describing the process by which he arrives at "signs" for objects, he also makes an unexpectedly revealing statement about his own character. Because he is speaking about drawings of himself, rather than directly about himself, he permits himself to be more candid than was his habit, noting that in the drawings "this ensemble of elements describes the same man, in terms of his character . . . in terms of the reserve he displays in relation to life which keeps him from uncontrolled surrender to it. . . . the same man, who always remains an attentive spectator of life and of himself."

EXACTITUDE IS NOT TRUTH

Among these drawings, which I have chosen with the greatest of care for this exhibition, are four drawings—portraits perhaps—done from my face as seen in a mirror. I should particularly like to call them to the visitors' attention.

These drawings sum up, in my opinion, observations that I have made for many years about the character of drawing, a character that does not depend on forms being copied exactly as they are in nature or on the patient assembling of exact details, but on the profound feeling of the artist before the objects that he has chosen, on which his attention is focussed, and whose spirit he has penetrated.

My conviction about these things crystallized when I realized for example that in

the leaves of a tree—of a fig tree particularly—the great difference of forms that exists among them does not keep them from sharing a common quality. Fig leaves, whatever their fantastic variations of form, always remain unmistakably fig leaves. I have made the same observation about other growing things: fruits, vegetables, etc.

Thus there exists an essential truth that must be disengaged from the outward appearance of the objects to be represented. This is the only truth that matters.

The four drawings in question are done from the same subject.

Yet each one of them is written with an apparent freedom of line, contour, and expression of volume.

Indeed, no one of these drawings can be superimposed upon another, because each has totally different contours.

In the four drawings in question the upper part of the face is similar, but the lower part is completely different: in No. 158 in the catalogue [top left][2] it is massive and square; in No. 159 [top right], it is elongated in relation to the upper part; in No. 160 [bottom, left] it terminates in a point, and in no. 161 [bottom, right] it bears no resemblance to the lower part of the face in any of the other drawings.

Nevertheless the different elements that make up these four drawings translate to the same extent the organic makeup of the person depicted. These elements, if they are not expressed by the same signs, are nonetheless still wedded together in each drawing by the same feeling: the way in which the nose is rooted in the face, in which the ear is screwed into the skull, the way in which the lower jaw is hung, the way in which the eyeglasses are set on the nose and ears, the tension of the gaze, its uniform density in all the drawings—even though the nuance of expression varies in each drawing.

It is quite clear that this ensemble of elements describes the same man, in terms of his character, his personality, his way of considering things, his reaction to life, and in terms of the reserve he displays in relation to life which keeps him from uncontrolled surrender to it. It is indeed the same man, who always remains an attentive spectator of life and of himself.

It is quite evident that the anatomical, organic inexactitude in these drawings has not harmed the expression of the intimate character and essential truth of the person, but on the contrary has served to express it.

Are these drawings portraits or not?

What is a portrait?

Isn't it a translation of the human sensibility of the person represented?

~

The only saying of Rembrandt's that we know is this: "I have never painted anything but portraits."

Is the portrait in the Louvre painted by Raphael and showing Joan of Aragon in a red velvet dress really what can be called a portrait?

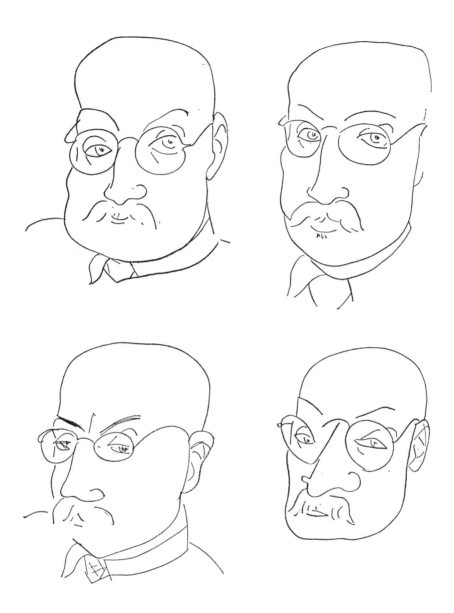

30. *Four Self-portrait Drawings*, 1939. Matisse discussed these drawings in "Exactitude is not Truth" (Text 40).

31. *Model Reflected in a Mirror*, 1936. During the late 1930s, Matisse placed new emphasis on drawing (see Text 25).

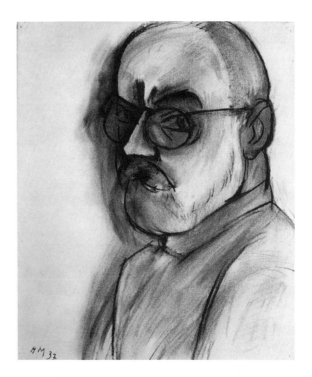

32. *Self Portrait*, 1937.

These drawings are so little the result of chance, that in each one it can be seen how, as the truth of the character is expressed, the same light bathes them all, and that the plastic quality of their different parts—face, background, transparency of the eyeglasses, as well as the feeling of material weight—all impossible to put into words but simply done, one can say, by dividing a piece of paper into compartments delimited by a simple line of almost equal thickness—all these things remain the same.

Each of these drawings, as I see it, has an individual invention that comes from the artist's penetration of his subject, going so far as to identify himself perfectly with his subject, so that its essential truth constitutes the drawing. It is not at all changed by the different conditions under which the drawing is made; on the contrary, the expression of this truth by the suppleness of its line and by its freedom lends itself to the demands of the composition; it is given nuance, even new life, by the turn of mind of the artist who expresses it.

Exactitude is not truth.

41

Letter to Henry Clifford, 1948[1]

Matisse considered his work to be a continuation of the grand tradition of French painting, and he was acutely aware of the influence that his predecessors had upon him. Especially in the later years of his life, he was also very much concerned about his own influence upon young artists. This letter to Henry Clifford, the director of the Philadelphia Museum of Art, was written upon the occasion of the 1948 retrospective exhibition of Matisse's work at the museum. In this letter, which he asked to have published in the catalogue, Matisse expresses this concern and makes some trenchant observations about the relationship of his own paintings to the young painters of the day.

As in many of his statements at this time, Matisse was preoccupied with comparisons between painting and drawing; his comment here that drawing is the domain of the Spirit while color is that of Sensuality, is one of his most definitive comparisons of color and drawing—and one which makes an interesting comparison with a slightly earlier, and rather unusual characterization of the differences between two arts, in which he asserted that "drawing is nonetheless the female and painting the male."[2]

Although Matisse states, "I do not claim to teach," this letter attempts to do precisely that. Disturbed by the possibility that young artists would not be aware

of the effort that had gone into his work, Matisse insists that only training as rigorous as his own, based upon careful observation of nature and diligent hard work, will allow the painter to achieve true mastery of his art. Asserting his belief in the capacities of the individual, he insists that the young artist must be gifted to begin with, and that this gift cannot be taught, only amplified, by appropriate study.

LETTER TO HENRY CLIFFORD

Vence, 14 February 1948

Dear Mr. Clifford:

I hope that my exhibition may be worthy of all the work it is giving you and by which I am deeply touched.

However, in view of the great impact it may have, given how much preparation has gone into it, I wonder whether its scope will not have a more or less unfortunate influence on young painters. How are they going to interpret the impression of apparent facility that they will get from a rapid, even superficial, viewing of my paintings and drawings?

I have always tried to hide my efforts and wanted my work to have the lightness and joyousness of a springtime that never lets anyone suspect the labors it has cost. So I am afraid that the young, seeing in my work only the appearance of facility and negligence in the drawing, will use this as an excuse for dispensing with certain efforts which I believe necessary.

The few exhibitions that I have had the opportunity of seeing during these last years make me fear that young painters may be avoiding the slow and painful preparation that is necessary for the training of any contemporary painter who claims to construct only with color.

This slow and painful work is indispensable. Indeed, if gardens were not dug over at the proper time, they would soon be good for nothing. Do we not first have to clear and then to prepare the soil each season?

The work of initial preparation, of renewing, is what I call "preparing the soil."

When an artist has not known how to prepare for his time of flowering, by work which bears little resemblance to the final result, he has a short future before him;[3] or when an artist who has "arrived" no longer feels it necessary to touch the earth from time to time, he ends up going around in circles, repeating himself until, by this very repetition, his curiosity is extinguished.

An artist must possess Nature. He must identify himself with her rhythm, by work that prepares for the mastery by which he will later be able to express himself in his own language.[4]

The future painter must be able to sense what is useful to his development—

drawing or even sculpture—everything that will let him become one with nature, identify himself with her, by penetrating the things (which is what I call nature) that arouse his emotion. But I believe that study by means of drawing is essential. If drawing belongs to the realm of the Spirit[5] and color to that of Sensuality, you must draw first to cultivate the Spirit and to be able to lead color through a spiritual path. That is what I would like to cry aloud, when I see the work of young people for whom painting is not an "Adventure," and whose only goal is their impending first exhibition, meant to start them on the road to fame.

It is only after years of preparation that the young artist should touch Color—Color as an intimate means of expression and not descriptive Color, of course. Then he can hope that all his images, even the very signs that he uses, will be in response to his feeling of love for things, a response that he may be confident about if he has been able to carry out his education with purity and without lying to himself. Then he will employ color with discernment. He will place it in accordance with a natural, unformulated and completely concealed drawing that will spring directly from his feeling; that which allowed Toulouse-Lautrec, at the end of his life, to exclaim, "At last, I no longer know how to draw."

The painter who is just beginning thinks that he is painting from the heart. The artist who has completed his development also thinks that he is painting from the heart. Only the latter is right, because his training and his discipline allow him to accept impulses from within, which he can in part control.

I do not claim to teach; I only want my exhibition not to suggest false interpretations to those who have their own way to make. I should like people to know that they cannot approach color as though they could just "walk in on it," that it is necessary to undergo a strict preparation to be worthy of it. But first of all, it is clear that one must have the "gift as a colorist," as a singer must have that of a voice. Without this gift one can get nowhere, and not everyone can declare like Correggio, "I too am a painter."[6] A colorist makes his presence known even in a simple charcoal drawing.

Dear Mr. Clifford, here my letter ends. I started it to let you know that I am aware of the trouble you are taking on my behalf at this time. I see that, obeying an inner necessity, I have expressed myself about drawing, color, and the importance of discipline in the education of an artist. If you think that all these reflections of mine can be of use to anyone, do whatever you think best with this letter. You may add it, if there is still time, to the explanatory part of your catalogue.

Please accept, Mr. Clifford, the expression of my feelings of deepest gratitude.

42

Interview with R. W. Howe, 1949[1]

In 1949 Matisse gave a brief interview to Russell Warren Howe which, despite the chattiness of Howe's reportage, is of interest. The statement that "to draw is to make an idea precise," for example, reinforces the impression that one gets from Matisse's paintings, that the idea is embedded in the drawing and the emotional or sensory impulse is carried for the most part by color. This comment is also consonant with Matisse's statement in the letter to Henry Clifford that drawing is in the domain of the spirit and color of sensuality.

Of especial interest is Matisse's (expected) criticism of the doctrinaire aspect of Cubism, so foreign to his own intuitive approach, and his disavowal of the influence of Gauguin, to whom he was so often compared, because of the superficial similarity between their works, especially their use of flat planes of color. In fact, Gauguin had played a more important role in Matisse's development than he was usually willing to acknowledge; and he had been more deeply disturbed by the rise of Cubism than he generally admitted in public.

Matisse's equivocal response to "non-objective" painting is also worth noting; only a few years later, his answers to André Verdet's questions on the subject will be quite specific and outspoken.

INTERVIEW WITH R. W. HOWE

Caravaggio, Velázquez, Turner, Van Gogh and many other artists have taught us to expect a physical link between a painter and his canvases, but Henri-Matisse in no way resembles his art. With his careful dress and manner and his neat apartment in the Boulevard Montparnasse, he is in magnificent contrast to his startling North African orientalism, to his fantasy-arabesques of figure and decoration, to the drenching reds and poster emerald-greens he found in the French Midi, or to the other myriad pure-tints which were on his palette when he returned from the South Seas. At seventy-nine, he is a discreet and simplicity-loving grandfather.

But the popular picture of Matisse, scientific craftsman, is inaccurate. M. René Huyghes [sic], curator of paintings at the Louvre, attributes to him an "exquisite and refined impassibility." When I told Matisse this, he nodded characteristically and said, "Look at the walls around you. You will see that what he says is not altogether true."

The walls he indicated were covered by large Indian ink drawings on figure-and-decoration themes, typified by a power of simplicity and gentle French lucidity, by an orchestration of line and arabesque which suggested at one and the same time concision and intensity, and which, transformed into color, would become an

art of independent harmonies, each supporting the other. The essential lesson of each was personal emotion, instinctiveness.

"How can one make art without passion?" asked Matisse. "Without passion, there is no art. The artist to a greater or lesser degree dominates himself, but it is passion which motivates his work."

Some critics have fixed Matisse's aim as the solidity which Cézanne spoke of. Others propose a classic dignity. When I asked him which was correct, he just said, "Look at what I'm doing now," and if the bold Matisse line of his latest work suggested Cézanne and solidity, the group of recent female head-portraits on one of his bedroom walls recalled equally the classic dignity of David (the current exhibition of whose works Matisse had just visited) and the more fluid dignity of Utamaro and Kuniyoshi.

The lasting quality of Matisse rests to a great extent in the drawing. "To draw is to make an idea precise. Drawing is the precision of thought. By it the feelings and the soul of the painter travel without difficulty into the spirit of he who looks on. A work without drawing is a house without a frame," he told me.

Of his method, Matisse speaks freely. For his figure-pieces, his favorite work, he does not always work from studio drawings. He often draws directly from model to canvas.

When I asked him if he believed in a methodical life, he gave a great wink of agreement, for that is one of his strongest principles. "One must work at set hours every day. One must work like a workman. Anyone who has done anything worthwhile has done that." Later he said, "All my life, I have worked all my waking day."

The master of color chuckles when you mention the conception of Paul Signac's theory that there were a fixed number of complementary tones, and ask him if this conception is absolute. "Assuredly not! Complementaries? There are some which have no name. One can create associations which are not red, not green, not blue. We do not need laws, we just assimilate each new discovery."

Too doctrinaire also is the mind-over-feeling attitude of many cubists. For Matisse, the mind effort is only partly dominant, and it is the instinct which creates. "For me, it is the sensation first, then the idea. I see a bouquet of flowers, it pleases me, I do something. If the cubist conceives an idea and then asks himself 'what sensation does that give me?'—well, I just don't understand that."

The art of Matisse was a courageous individualism, but he modestly describes it in another way— "I owe my art to all painters. When I was young, I worked in the Louvre, copying the old masters, learning their thought, their technique. In modern art, it is indubitably to Cézanne that I owe the most."

The architectural solidity and virility of Matisse is far from the color-shapes of the impressionist-born art of Gauguin, to whom the textbooks ascribe Matisse's chief inspiration. He says strongly, "The basis of Gauguin's work and mine is not

the same." For that reason, Matisse can do no more than "esteem" the impressionistic and Gauguinesque art of his old friend Pierre Bonnard.

His most iconoclastic opinion is on Delacroix, whose Journal is now the most-read book among French painters: perhaps because Matisse, in line with French tradition, finds a mysticism like Delacroix's too philosophical, too intellectual—too "literary," as French critics say—he thinks all this interest completely unjustified.[2]

I asked him: "What do you think of the abstract—do you believe that one should deduce one's abstractions from the forms of nature, or that one should create the form, outside of nature?"

Matisse replied, "There is always a measure of reality. The rest, I agree, is imagination. But there are no laws until the work is finished. One cannot make programs. Painting is a grave art: we have not yet all its spirit, all its reason; nor have we liberty, and that is what is needed most."

On the new painting, Matisse is non-committal. "I am not rightly placed to speak of the art of younger painters. I know better—I was falsely judged myself when I was a young man."[3] And at the mention of Surrealism, Matisse puts his chin out sharply—a gesture which is all a Frenchman needs to make in order to say, "That's a different kettle of fish." For the aesthetics which his genius does not span do not much interest him; he is a specialist. "I have no opinion on Surrealism. It is difficult, so difficult to judge the young. We all do that of which we are capable." I asked him what he would do if he were a young painter in this day and age. "I should be very thankful!" he smiled, adding, "but seriously, my life tells you what I should do. I should do what I have done. Now I am almost at the end of the journey, and I cannot know precisely what I would do if I were at the beginning. I am not exactly youthful, and one must have youth to see into the future. If I were young, I would do something, and when I had done it I should know then on what researches I should spend my life.

"To-day, everything is expensive for the painter—colors, materials, life itself. If I were a young painter, I should take a job with a salary, and then I would be independent and paint freely.

"My art would not suffer. If I did bad painting, if I decorated Christmas crackers, that would harm my art, but bank-clerking or loading a goods-train would be fine.

"Nietzsche said, 'All artists should learn a trade in order to be free.' One need only work three or four hours a day. Then one's painting can be sincere, and one need not worry about the tastes of others. Sometimes, I know, one must work as one can," he says, and then recalls the time when he and Marquet painted laurel leaves all over Jambon's theater in Paris for one-and-a-half francs an hour.

Unlike Vlaminck, Matisse is undismayed at the modern scene, and to the feelings of the new generation he says, "Anxiety? It is no worse to-day than it was for

the Romantics. One must dominate all that. One must be calm; and art should not be worrying or disturbing—it should be balanced, pure, tranquil, restful."

Matisse, in his simplicity, is yet too complex a character to capture in half-an-hour's conversation. I found him in bed after the ritual afternoon nap, dictated by feeble health. He was reading a book on architecture, and by his hand lay the Bible. His assistant was tracing some of his inkline drawings, in connection with his experiments, and the walls were lined with his work. He has a look of intense intelligence, and his rare smile is warm and candid. In his simplicity, he is strangely like his master, Cézanne. He is often wisely non-committal. He is specialized to his art, which is primarily instinctive, and he is no example of Baudelaire's theory that literature, music and painting were interrelated. The only scientific side of his nature seems to be his sure knowledge of anatomy, which lends itself to the discovery of new values, some structural, some less easy to define. He is conscious of his assured place in the history of art, but conscious too that he is of a different period to that of the new painting, and selflessly indifferent to a future that will probably see others going on ahead.

Henri-Matisse has brought all the great traditions of French painting onto a new path, where for many bitter, impoverished years he walked alone, ill and in debt and doubting himself; on that path he now rests, contented.

He has often been called the painter of luxury. One has only to think of the lives of the great Spanish masters to see that few things are more artistic than luxury. He is perhaps a fraction less aptly called the painter of exoticism, for there is little evidence in him of that element which is half of exoticism—fear that the world is destined to become uniform. But at all costs he has in him the other half—the desire for escape, a feeling for broad spaces: one of his parting remarks was, "If I were young, I'd make a tour of the world in a plane. I find that an extraordinary achievement. Why in a matter of hours, one can be in India, China, South Africa. Miraculous!"

43

Henri Matisse Speaks to You, 1950[1]

In March 1950, Matisse wrote a short essay for *Traits*, a small avant-garde periodical addressed largely to art students. Matisse's article, in keeping with the tenor of the periodical and of his own pedagogical concerns, is addressed to the aspiring artist. He once again encourages study of the art of the past while cautioning against the dangers of superficial imitation. This short statement is a good example of Matisse's acute awareness of the historical context within which every artist works, and of his own use of the past as a "library" of possibilities of perception.

For forty years, I lived with a large plaster cast of the Argive statue "Cleobis."[2]

This larger-than-lifesize figure with its rigid forms, and parallel limbs, in which one sees an Egyptian influence—how alive it is! with a life more condensed and more profound than that of Egyptian sculpture, and also more human. It marks the beginning of Greek feeling, from which we are descended.

For ten years, I walked around it in my garden. Placed in a corner of the lawn and surrounded by tree trunks, it looked beautiful.

When its head and shoulders had become partially disintegrated by the rains of many winters, I brought it into the studio so as not to lose it completely, and finally here we are now in Nice.

We have rarely been separated for more than forty years, and the great interest I have had in it has only increased.

Recently, during a night of insomnia, I caught myself unconsciously contemplating it from the hollow of my armchair. The perfect silence of the hour certainly helped our coming together. With each involuntary pause I made before this plaster statue, this revealer of so many treasures, its exceptional qualities once again impressed me. It did not reveal new beauties to me, but old discoveries asserted themselves with greater intensity and with more profundity than in our previous encounters.

Happy with this renewal of interest, I solemnly promised myself to commune with it again, charcoal in hand, not doubting the benefit that it would be able to give me through future revelations.

I understood then the great benefit that the artist's sensibility can draw from an encounter with an ancient, especially very ancient, work with which he feels affinities.

Didn't Cézanne encounter Poussin?

I remembered studies that I made before other ancient sculptures. These studies didn't produce agreeable drawings, but drawings that revealed intense efforts; not final results, it's true, but afterwards recognized as profitable.

I just had a visit from Le Corbusier, that distinguished and inventive mind, who has successfully realized his great architectural and decorative audacity. As we stopped before my Argive Adonis, he said to me, "Let me look at this marvel, I drew it a great deal ten years ago."[3]

Isn't this a little surprising, this confession of an artist who would seem to be only self-motivated?

All that I am relating has no other intent than to be read by some artist in formation (isn't one in formation all one's life?) who is searching for new sources of inspi-

ration in which he would be able to feel confident because his personality could draw freely upon those sources.

May I add that it is perilous to fall under the influence of the masters of my own epoch, because the language is too close to ours, and one risks taking the letter for the spirit. The masters of ancient civilizations had a language that was very full for them, but so different from ours that it prevents us from making too literal an imitation. Influenced by them, we are obliged to create a new language, for theirs refuses us a full development of ideas and very quickly closes its door on us.

Cézanne said: "Defy the influential master."

Cézanne did not need to fear the influence of Poussin, for he was sure not to adopt the externals of Poussin; whereas when he was touched by Courbet, as were the painters of his period, his technique was too strongly affected by Courbet, and Cézanne found his expression limited by Courbet's technique. Also, after that period, all this group of painters went to the other extreme: Courbet worked with black paint, and the Impressionists, at first his imitators, used all the colors of the rainbow.

WHEN ONE IMITATES A MASTER, THE TECHNIQUE OF THE MASTER STRANGLES THE IMITATOR AND FORMS ABOUT HIM A BARRIER THAT PARALYZES HIM. I COULD NOT REPEAT THIS TOO OFTEN.

44

Interview with Georges Charbonnier, 1950[1]

Georges Charbonnier's interview with Matisse, which covers a broad range of subjects in some depth, gives some interesting insights into Matisse's conscious and subconscious processes of synthesis. His discussions of the dance theme, of the chapel at Vence, and of why he sometimes painted blank faces are especially detailed. In speaking of the spiritual values of his painting he shows how far he was from thinking of his art as mere decoration.

INTERVIEW WITH GEORGES CHARBONNIER

GEORGES CHARBONNIER: Henri Matisse, you have made a number of mural compositions and, in them, you have used the theme of the dance several times. How did you compose these mural paintings?

HENRI MATISSE: I like dance very much. Dance is an extraordinary thing: life and rhythm. It's easy for me to live with dance. When I had to compose a dance for Moscow,[2] I had just been to the Moulin de la Galette on Sunday afternoon.

And I watched the dancing. I especially watched the farandole. Often, in the middle or at the end of a session there was a farandole. This farandole was very gay. The dancers hold each other by the hand, they run across the room, and they wind around the people who are milling about . . . it's all extremely gay. And all that to a bouncing tune. An atmosphere I knew very well. When I had a composition to do, I returned to the Moulin de la Galette to see the farandole again. Back at home I composed my dance on a canvas of four meters, singing the same tune I had heard at the Moulin de la Galette, so that the entire composition and all the dancers are in harmony and dance to the same rhythm.[3]

CHARBONNIER: Did the idea of using the theme of the dance exist before the mural painting, or is it rather the surface and form of the wall that suggested the theme to you?

MATISSE: No, it's not the wall, but because I particularly like dance; it's because I saw more in dance: expressive movements, rhythmic movements, music that I like. This dance was in me, I didn't need to warm myself up: I proceeded with elements that were already alive.

CHARBONNIER: Did you think from the beginning that movement would be used effectively in mural painting? It is said that the static characterizes easel painting whereas movement . . .

MATISSE: There are two ways of looking at things. You can conceive a dance in a static way. Is this dance only in the mind or in your body? Do you understand it by dancing with your limbs? The static is not an obstacle to the feeling of movement. It is a movement set at a level which does not carry along the bodies of the spectators, but simply their minds.[4]

CHARBONNIER: In the United States, you did another mural composition for the American, Barnes, using the theme of the dance.

MATISSE: I did a ceiling there with the same composition, but I adapted it to the circumstances. For example, there were what architects call "lunettes" in a vaulted ceiling.[5] And then I made my figures larger than life-size, larger than the surfaces could contain. Thus there is half a body coming down from above. Another is half-length. Over an area that was not very wide, only thirteen meters, I permitted the observer to see a much larger dance, because I used fragments.[6]

CHARBONNIER: Didn't any special difficulty arise from the fact that this wall painting is placed against the light?

MATISSE: This wall painting is indeed against the light, but in the end I profited from the situation. The mural is above three big doors, each five meters high, which give onto a garden. They are glass. The spaces between the doors are

about two meters wide. I made use of the contrast created by these spaces; I used them to create correspondences with the forms in the ceiling. I put blacks in the ceiling much darker than the grey of the spaces between the doors. Thus I displaced the contrast. Instead of making it between the bright doors and the spaces in between, I put it up in the ceiling so that my very strong contrast united the whole panel, doors and spaces.

CHARBONNIER: I believe you were led to use colors that were not violent because the very lively greens of the garden also impeded the composition of the painting?

MATISSE: The main point to observe was that this decoration was placed in an enormous room in which there were the finest Renoirs, the finest Cézannes, and remarkable Seurats. I could not, did not claim to, nor ought to have fought with these paintings. Being up above I had to use a range of sort of aerial colors, and I also had to avoid some colors, like green, it's true; but at the same time, I made big black contrasts corresponding to the spaces between the doors, and pink compartments, blue compartments, compartments of various colors so as to create a music of colors that was not very singular really, although my feeling was in harmony with the dance.[7]

CHARBONNIER: The dance theme—I am returning again to this point—wasn't it suggested to you by the form of the ceiling, more exactly by the necessity of using the whole surface of the ceiling, which led to representing some figures standing and others crouching?

MATISSE: Above all I had to give the impression of vastness in a limited space. That's why I used figures that are not always whole, so half of them is outside . . . If for example, I am filling a space three meters high, I make the figures a total height which, if fully represented, would have been six meters. I use a fragment and I lead the spectator by the rhythm, I lead him to follow the movement from the fragment he sees, so that he has a feeling of the totality.

The interesting thing is certainly—as in painting generally—to give the idea of immensity within a very limited surface.

That's what I did in the chapel at Vence. It's a convent chapel, and in spite of everything, it seems to me that I created an idea of vastness that touches the spirit and even the senses. The role of painting, I think, the role of all decorative painting, is to enlarge surfaces, to work so that one no longer senses the size of the wall.

CHARBONNIER: Why did you decorate the chapel at Vence?

MATISSE: Because, for a very long time, I wanted to synthesize my contribution. Then this opportunity came along. I was able, at the same time, to do architecture, stained-glass, large mural drawings on tile, and to unite all these elements, to fuse them into one perfect unity. I even designed a spire more than 12 meters

high for the chapel. And this spire—in wrought iron—which is more than 12 meters, doesn't crush the chapel but, on the contrary, gives it height. Because I made the spire—like a pencil drawing on a sheet of paper—in the air . . . When you see a cottage with smoke coming from the chimney at the end of the day, and watch the smoke that rises and rises, you get the impression that it never stops at all. That is something of the feeling I created with my spire.[8]

The same for the interior, for the altar: an officiant stands in front of the public. It was thus necessary to decorate the altar in a light manner so that the officiant could see his flock and the faithful could see the officiant. There is thus, in the elements, a lightness that meets this need. This lightness arouses feelings of release, of obstacles cleared, so that my chapel is not "Brothers, we must die." It is rather "Brothers, we must live!"[9]

CHARBONNIER: Do you think—I know that I am putting this clumsily—that there is such a thing as religious art?

MATISSE: All art worthy of the name is religious. Be it a creation of lines, or colors: if it is not religious, it doesn't exist. If it is not religious, it is only a matter of documentary art, anecdotal art . . . which is no longer art. Which has nothing to do with art. Which comes at a certain period in civilization to explain and demonstrate to people without any artistic upbringing the things that they could have noticed anyway without there being any need to tell them. The public is spiritually lazy. One must put a story-picture in front of their eyes which remains in their minds and even leads them a little farther . . . But that's a kind of art that we no longer need. That kind of art is out-dated.

CHARBONNIER: When you do a chapel, when you decorate it, you know that people are going to come in who will see the paintings, the decorations, who will find themselves in a certain environment and who will adopt a certain attitude. What do you seek to communicate to them? Do you feel a duty towards them? This duty, do you think you have it equally when you show only an easel painting stripped of religious ends, a mural painting that has only a decorative end?

MATISSE: I want the chapel visitors to experience a lightening of the spirit. So that, even without being believers, they sense a milieu of spiritual elevation, where thought is clarified, where feeling itself is lightened. The benefit of the visit will come into being easily without any need for it to be hammered home.

CHARBONNIER: This benefit, don't you dream of providing it equally for someone looking at a canvas?

MATISSE: That is obvious. A picture that didn't create that feeling wouldn't exist. A picture by Rembrandt, Fra Angelico, a picture by a good artist always inspires this feeling of escape and spiritual elevation. The fact that the picture is an easel painting won't let it escape this necessity. An easel painting, what is an

"easel painting"? It's a painting you hold in your hand, if you like. But this painting must nevertheless carry the spectator's mind much farther than a set-piece. I don't conceive of a painting without this quality. Otherwise, it's a reproduction. Today, thanks to photography, one can make such lovely reproductions, even in color, that the duty of the artist, the painter, is to provide more; what photography cannot give.

CHARBONNIER: The painting of Rembrandt, whom you have just mentioned, for example doesn't always communicate serenity. El Greco often communicates anxiety. Whereas, you have said, you have written—the passage has been quoted a hundred times— "I don't wish to disturb."

MATISSE: Yes indeed. I believe my role is to provide calm. Because I myself have need of peace.

Rembrandt's painting is obviously painting in depth. It is the painting of the North, of Holland, Flanders, which doesn't have the same atmosphere as ours in France or on the Mediterranean . . . the Mediterranean is quite close to Paris, after all.

El Greco is a tormented soul who exteriorizes his torment and puts it on canvas. This torment is certainly communicated to the spectator. But one could conceive that had El Greco dominated his torment and anxiety, he would have expressed it as Beethoven did in his last symphony.[10]

CHARBONNIER: Let's change the subject. You are a painter, but you are also a sculptor and, personally, there's a question I am always asking myself. Are the means of expression equivalent? Do certain things express themselves by choice in music, others in painting? Can you say certain things in painting and others in sculpture? And conversely, in painting and sculpture, can you say the same thing? Suppose one morning, a man begins to paint and not to sculpt—or vice-versa—it is probable that this choice cannot be put down to chance.

MATISSE: I myself have done sculpture as the complement of my studies. I did sculpture when I was tired of painting. For a change of medium. But I sculpted as a painter. I did not sculpt like a sculptor. Sculpture does not say what painting says. Painting does not say what music says. They are parallel ways, but you can't confuse them.[11]

CHARBONNIER: But is their course the same?

MATISSE: The horizon line is vast. It is made of innumerable points. As you go on walking, you go towards the horizon, but you go towards quite different points. In any case, art is the expression of man's soul. He uses what means he can: music, sculpture, painting . . . It's a personal affair, an affair of natural dispositions and talents.

CHARBONNIER: Let us restrict ourselves to the field of forms and colors. Can you

oppose painting and drawing? Alain has said that painting expresses the moment and drawing the instant . . . does that seem valid to you?[12]

MATISSE: Personally, I think painting and drawing say the same thing. A drawing is a painting made with reduced means. On a white surface, a sheet of paper, with pen and ink, you can, by creating certain contrasts, create volumes; by changing the quality of the paper you can give supple surfaces, bright surfaces, hard surfaces, without, however, using either shading or highlights . . . For me, a drawing is a painting made with reduced means, which can be totally absorbing, which can very well release the feelings of the artist just as much as the painter. But painting is obviously a thing that has more to it, that acts more strongly on the mind.

CHARBONNIER: Like all artists of real importance, you have thus done painting, drawing, sculpture, but you have also made illustrations. What sort of problem does illustration present? What is involved in illustrating a text?

MATISSE: Illustrating a text is not completing a text. If a writer needs an artist to explain what he has said, it's because the writer is inadequate. I have found writers to whom there was nothing to add: they had said everything.

The illustration of a book can also be an embellishment, an enrichment of the book by arabesques, in conformity with the writer's point of view. You can also produce illustrations by decorative means: fine paper, and so on. Illustration has its usefulness, but it doesn't add much to the essential literature. Writers have no need of painters to explain what they want to say. They should have enough resources of their own to express themselves.

CHARBONNIER: One last question, positively the last: how is it that in the work of a fairly large number of contemporary painters, the human face is becoming anonymous?

MATISSE: Are you saying that for my benefit? Because I don't put in eyes sometimes, or a mouth for my figures? . . . But that's because the face is anonymous. Because the expression is carried by the whole picture. Arms, legs, all the lines act like parts of an orchestra, a register, movements, different pitches. If you put in eyes, nose, mouth, it doesn't serve for much; on the contrary, doing so paralyzes the imagination of the spectator and obliges him to see a specific person, a certain resemblance, and so on; whereas if you paint lines, values, forces, the spectator's soul becomes involved in the maze of these multiple elements . . . and so, his imagination is freed from all limits.

45

The Text: Preface to the Tokyo Exhibition, 1951[1]

In 1951 Matisse had a large retrospective exhibition at the National Museum in Tokyo, for which he wrote a preface to the catalogue. As in the letter to Henry Clifford, Matisse states his concern that the students who see the exhibition be able to realize that "the principal interest of my works comes from careful observation and respect for nature." Matisse then goes on to reiterate the advice to young artists that he expressed in the letter to Henry Clifford, stating that without sincerity and the study of nature the artist can do nothing but float from one influence to another. Thus in the last years of his life, while his own works—especially the late cutouts—were becoming more and more abstract, Matisse felt impelled to advise the younger generation, who were producing painting that he admittedly did not understand, to study nature in order that they might realize that the source of his imagery was not in mere stylization, but in a conviction of sincerity before nature.

THE TEXT: PREFACE TO THE TOKYO EXHIBITION

After I had decided that my exhibition at the Maison de la Pensée Française in Paris[2] would be my last show of this kind, I nevertheless agreed to this important exhibition in Japan—Mr. Hazama had so clearly explained the interest it would have for the art students of his country.

Given the place that Japanese artists have accorded me until now, I thought it my duty to accept his proposition and so I collected for this exhibition paintings and drawings that show my activity retrospectively.

I hope that the students who see this show will perceive that the principal interest of my works comes from attentive and respectful observation of Nature as well as from the quality of feeling that Nature has inspired in me, rather than from a certain virtuosity which almost always comes from honest and constant work.

I cannot stress enough the absolute necessity for an artist to have perfect sincerity in his work, which alone can give him the great courage he needs in order to accept it in all modesty and humility.

Without this sincerity, for which I am making a great case, the artist can only drift from one influence to another, forgetting to find the terrain from which he must take his own individual characteristics.

Let the young artist not forget that the attraction of this terrain is directed to his heart and rarely fits in with the problems of existence.

He must, however, manage to reconcile the two without losing the fullness of his possibilities.

46

The Chapel of the Rosary, 1951[1]

Upon completion of the Chapel of the Rosary at Vence, Matisse wrote an intro-
duction to the picture book published about the chapel. His comments, which are
quite general, barely touch on the chapel itself, which is described in purely formal
terms. Instead he stresses the importance of the chapel as a summing up of his ca-
reer, as a unique contribution to posterity, and as a major synthesis of the tradi-
tions of which he is a part. He calls particular attention to his reaction against
École des Beaux-Arts teaching and to his study of the expressive qualities of form
and color—to his respect for "the purity of the means," which he saw as perhaps
his most important contribution to the plastic tradition, and which he felt to be so
fully realized in the chapel.

THE CHAPEL OF THE ROSARY

All my life I have been influenced by the opinion current at the time I first began to
paint, when it was permissible only to comply with observations made from nature,
when all that came from the imagination or from memory was called "bogus" and
worthless for the construction of a plastic work. The masters at the Beaux-Arts used
to say to their pupils: "Copy nature stupidly."

Throughout my entire career I have reacted against this opinion to which I
could not submit, and this struggle has been the source of the different changes
along my route, in the course of which I have searched for the possibilities of ex-
pression beyond the literal copy, such as divisionism and fauvism.

These rebellions led me to study separately each element of construction: draw-
ing, color, values, composition; to explore how these elements could be combined
into a synthesis without diminishing the eloquence of any one of them by the pres-
ence of the others, and to make constructions from these elements with their in-
trinsic qualities undiminished in combination; in other words, to respect the purity
of the means.

Each generation of artists views the production of the previous generation differ-
ently. The paintings of the impressionists, constructed with pure colors, made the
next generation see that those colors, if they can be used to describe objects or nat-
ural phenomena, contain within them, independently of the objects that they serve
to express, the power to affect the feelings of those who look at them.

Thus simple colors can act upon the inner feelings with more force, the simpler
they are. A blue, for example, accompanied by the brilliance of its complemen-

taries, acts upon the feelings like a sharp blow on a gong. The same with red and yellow; and the artist must be able to sound them when he needs to.

In the chapel my chief aim was to balance a surface of light and color against a solid wall with black drawing on a white background.

This chapel is for me the culmination of a lifetime of work, and the coming into flower of an enormous, sincere and difficult effort.

This is not a work that I chose, but rather a work for which I was chosen by fate, towards the end of the road that I am still continuing according to my researches; the chapel has afforded me the possibility of realizing them by uniting them.[2]

I foresee that this work will not be in vain and that it may remain the expression of a period in art, perhaps now outdated, though I do not believe so. It is impossible to be sure about this today, before the new movements have been realized.

Whatever errors this expression of human feeling may contain will fall away of their own accord, but there will remain a living part which will unite the past with the future of the plastic tradition.

I hope that this part, which I call my revelation, is expressed with sufficient power to be fertilizing and to return to its source.

47

The Chapel of the Rosary:
On the Murals and Windows, 1951[1]

Late in 1951 Matisse wrote a short statement on the Vence Chapel for the Christmas issue of *France Illustration*. In this essay Matisse elaborates on the emotional and symbolic significance of the main visual elements of the chapel: the three ceramic tile panels (Saint Dominic, the Virgin and Child, and especially the Stations of the Cross), and the stained-glass windows. This essay, which is descriptive in a manner reminiscent of "How I made my Books" (Text 35), provides one of Matisse's most detailed published discussions of a single work.

THE CHAPEL OF THE ROSARY:
ON THE MURALS AND WINDOWS

This chapel is for me the culmination of a lifetime of work.

The ceramics of the Chapel of the Rosary at Vence have produced reactions of such astonishment that I would like to try to dispel them.

These ceramic panels are composed of large squares of glazed white tile bearing

drawings in black outline that decorate them while still leaving them very light. The result is an ensemble of black on white in which the white dominates, with a density that forms a balance with the surface of the opposite wall, which is composed of stained glass windows that run from the floor to the ceiling, and which express, through their neighboring forms, an idea of foliage that is always of the same origin, coming from a tree characteristic of the region: the cactus with large oval, spine-covered stalks, which bears yellow and red flowers.

These stained-glass windows are composed of three carefully chosen colors of glass, which are: an ultramarine blue, a bottle green, and a lemon yellow, used together in each part of the stained-glass window. These colors are of quite ordinary quality; they exist as an artistic reality only by their harmony of quantities, which magnifies and spiritualizes them.

To the simplicity of these three constructive colors is added a differentiation of the surface of some of the pieces of glass. The yellow is roughened and so becomes only translucent while the blue and the green remain transparent, and thus completely limpid. This lack of transparency in the yellow stops the mind of the spectator and keeps it within the interior of the chapel, thus forming the foreground of a space that begins in the chapel and then passes through the blue and green to lose itself in the surrounding gardens. Thus when someone inside can look through the glass and see a person coming and going in the garden, only a meter away from the window, that person seems to belong to a completely separate world from that of the chapel.

I write of these windows—the spiritual expression of their color to me is indisputable—simply to establish the difference between the two long sides of the chapel, which, decorated differently, sustain themselves by their mutual opposition. From a space of bright shadowless sunlight that envelops our spirit on the left, we find, passing to the right, the tile walls. They are the visual equivalent of a large open book where the white pages carry the signs explaining the musical part composed by the stained-glass windows.

In sum, the ceramic tiles are the main spiritual part and explain the meaning of the monument. Thus they become, despite their apparent simplicity, the important point that should add to the contemplation we should experience; and I believe I should make this clear by insisting on the character of their composition.

In their execution the artist is revealed with complete freedom. Thus, having from the first foreseen these panels as illustrations of these large surfaces, during the execution he gave a different feeling to one of these three: that of the Stations of the Cross.

The panel of Saint Dominic and that of the Virgin and the Christ Child are on the same level of decorative spirit, and their serenity has a character of tranquil con-

templation that is proper to them, while that of the Stations of the Cross is animated by a different spirit. It is tempestuous. This marks the encounter of the artist with the great tragedy of Christ, which makes the impassioned spirit of the artist flow out over the chapel. Initially, having conceived it in the same spirit as that of the first two panels, he made it a procession of succeeding scenes.[2] But, finding himself gripped by the pathos of so profound a tragedy, he upset the order of his composition. The artist quite naturally became its principal actor; instead of reflecting the tragedy, he has experienced it and this is how he has expressed it. He is quite conscious of the agitation of spirit which this passage from the serene to the dramatic arouses in the spectator.[3] But isn't the Passion of Christ the most moving of these three subjects?

I would like to add to this text that I have included the black and white habits of the Sisters as one of the elements of the composition of the chapel; and, for the music, I preferred to the strident tones of the organ—which are enjoyable, but explosive—the sweetness of the voices of women, which with their Gregorian chant can become a part of the quivering colored light of the stained-glass windows.

48

Statements to Tériade: Matisse Speaks, 1951[1]

By 1951, Matisse and Tériade had been friends for over two decades and had worked together on a number of projects. In 1951, the two collaborated on "Matisse Speaks," Matisse's most extensive published autobiographical statement, which ranges throughout his entire career. Although "Matisse Speaks" was presented as a straightforward transcription by Tériade of an extended statement made by Matisse in July 1951, it is actually somewhat of a pastiche, put together to coincide with the large Matisse retrospective that opened at the Museum of Modern Art in November 1951. Though many of Matisse's remarks may have been transcribed in 1951, several parts of this text—for which there is no extant French original—appear to have been lifted from some of Tériade's previous interviews with Matisse, and it is never made clear what the exact source of each section is. (In particular, Tériade seems to have made use here of his 1929, 1930 and 1931 interviews with Matisse; see Texts 12, 13, 14, above.) Here, as in the original, most of the text is presented as if it were an extended quote, broken up by italicized subheadings.

Of particular interest are the passages that do seem to come from 1951, especially those in which Matisse refers to specific events and works that were apparently important enough to him to be vividly remembered many years later.

[Tériade begins with a brief outline of Matisse's career, then introduces his text as follows:]

We are still too close to this grand and dazzling career to make any new interpretations or see it in a wider reference. So it seems that today it is most profitable and important to secure the opinions of Matisse himself, his personal point of view, as of July, 1951, in his eighty-second year, on his own painting and on the different stages of his work over the last six decades. Here they are:

Beginnings, 1890–92

"I was an attorney's clerk, studying to be a lawyer, at St.-Quentin. Convalescing after an illness, I met somebody who copied chromos—sort of Swiss landscapes which in those days were sold in albums of reproductions. I bought a box of colors and began to copy them, too. Afterwards, every morning from seven to eight, before going to my studies, I used to go to the École Quentin Latour where I worked under draftsmen who designed textiles.[2] Once bitten by the demon of painting, I never wanted to give up. I begged my parents for, and finally got, permission to go to Paris to study painting seriously.

"The only painter in St.-Quentin was a man named Paul Louis [*sic*] Couturier, a painter of hens and poultry-yards. He had studied with Picot—one of Bouguereau's disciples—which he mentioned, and with Gustave Moreau, which he never mentioned. So I came to Paris with recommendations from Couturier to Bouguereau.

"I showed some of my first pictures to Bouguereau who told me that I didn't know perspective. He was in his studio, re-doing for the third time his successful Salon picture, *The Wasp's Nest* (it was a young woman pursued by lovers). The original Salon picture was nearby; next to it was a finished copy, and on the easel was a bare canvas on which he was drawing a copy of the copy. Two friends were with him: Truphème, one of the prize-winners of the Artistes Français group and director of the Municipal School of Drawing on the Boulevard Montparnasse, and a man named Guignon, another of the Artistes Français painters—he only painted olive trees at Menton. Bouguereau was literally re-making his picture for the third time. And his friends exclaimed: 'Oh, Monsieur Bouguereau! What a conscientious man you are; what a worker!' 'Ah, yes!' responded Bouguereau, 'I am a worker, but art is hard.'

I saw the unconsciousness (unconscious because they were sincere) of these men who were stamped by official art and the Institute, and soon understood that I could get nothing from them.[3]

"I went to the Académie Julian and signed up for the Prix de Rome competition at the École des Beaux-Arts. One of my friends persuaded me that there was noth-

33. *La Desserte* (copy after Jan Davidsz de Heem), 1893. This was one of the most important copies Matisse did in the Louvre during his student days.

34. *Still Life After de Heem's "Desserte"*, 1915. Matisse later did a variation on his copy of de Heem's *Dessert,* using what he called "the methods of modern construction" (Text 48).

35. *The Moroccans*, 1916.

36. *Bathers by a River*, 1916.
These paintings are among Matisse's largest, most austere, and most abstract, early works.
(See Text 48.)

ing to learn at the École de Rome and I began to work from my own experiences.[4] I was enormously helped in this by meeting Gustave Moreau, in whose studio I entered and where I met Dufy and Rouault. Moreau took an interest in my work. He was a cultivated man who stimulated his pupils to see all kinds of painting, while the other teachers were preoccupied with one period only, one style—of contemporary academicism—that is to say their own, the leftovers of all conventions.

Copies at the Louvre, 1894–96

"We used to make copies at the Louvre, somewhat to study the masters and live with them, somewhat because the Government bought copies. But they had to be executed with minute exactitude, according to the letter and not the spirit of the work. Thus the works most successful with the purchasing commission were those done by the mothers, wives and daughters of the museum guards. Our copies were only accepted out of charity, or sometimes when Roger-Marx pleaded our cause.[5] I would have liked to be literal, like the mothers, wives and daughters of the guards, but couldn't.

"What is believed to be boldness was only awkwardness. So liberty is really the impossibility of following the path which everyone usually takes and following the one which your talents make you take.

"Among the pictures I copied at that time, I remember the *Portrait of Baldassare Castiglione* by Raphael, Poussin's *Narcissus*, Annibale Carracci's *The Hunt*, the *Dead Christ* of Philippe de Champaigne. As for the *Still-life* by David de Heem, I began it again, some years later, with the methods of modern construction.[6]

"Around 1896 I was at the École des Beaux-Arts and roomed on the Quai St.-Michel. Next door was the painter Véry who was influenced by the Impressionists, especially Sisley. One summer we went to Brittany together, to Belle-Ile-en-Mer. Working next to him I noticed that he could get more luminosity from his primary colors than I could with my old-master palette. This was the first stage in my evolution, and I came back to Paris free of the Louvre's influence and heading towards color.

"The search for color did not come to me from studying paintings, but from the outside—that is from the revelation of light in nature.

Divisionism, 1904

"At St.-Tropez I met Signac and Cross, theoreticians of Divisionism. In their company I worked on my picture *The Terrace at St.-Tropez*—really the boathouse at Signac's house, which was called La Hune. I also painted the big composition, *Luxe, Calme et Volupté*—it is still in the Signac collection—a picture made of pure rainbow colors.[7] All the paintings of this school [Divisionism] had the same effect: a little pink, a little blue, a little green; a very limited palette with which I didn't feel

very comfortable. Cross told me that I wouldn't stick to this theory, but without telling me why. Later I understood. My dominant colors, which were supposed to be supported by contrasts, were eaten away by these contrasts, which I made as important as the dominants. This led me to painting with flat tones: it was Fauvism.

Fauvism, 1905–10

"Fauvism at first was a brief time when we thought it was necessary to exalt all colors together, sacrificing none of them. Later we went back to nuances, which gave us more supple elements than the flat, even tones.

"The Impressionists' aesthetic seemed just as insufficient to us as the technique of the Louvre, and we wanted to go directly to our needs for expression. The artist, encumbered with all the techniques of the past and present, asked himself: 'What do I want?' This was the dominating anxiety of Fauvism. If he starts from within himself, and makes just three spots of color, he finds the beginning of a release from such constraints.[8]

"This period lasted for some time, even some years. Once you have reached the point where you take cognizance of the quality of your desire, you begin to consider the object which you are making, and you need to modify your methods in order to become more intelligible to others, and to organize all the possibilities that you have recognized within yourself.

"The man who has meditated on himself for a certain length of time comes back to life sensing the position he can occupy. Then he can act effectively.

"My master, Gustave Moreau, used to say that the mannerisms of a style turn against it after a while, and then the picture's qualities must be strong enough to prevent failure. This alerted me against all apparently extraordinary techniques.

"The epithet 'Fauve' was never accepted by the Fauve painters; it was always considered just a tag issued by the critics. Vauxcelles invented the word. We were showing at the Salon d'Automne; Derain, Manguin, Marquet, Puy and some of the others were exhibiting together in one of the big galleries. The sculptor Marque showed an Italianate bust of a child in the center of this hall. Vauxcelles came in the room and said: 'Well, Donatello among the wild beasts!' ['*Tiens, Donatello au milieu des fauves*'].[9]

"A whole group worked along these lines: Vlaminck, Derain, Dufy, Friesz, Braque. Later, each member denied that part of Fauvism he felt to be excessive, each according to his personality, in order to find his own path.

Morocco

"The voyages to Morocco helped me accomplish this transition, and make contact with nature again better than did the application of a lively but somewhat limiting theory, Fauvism. I found the landscapes of Morocco just as they had been described

in the paintings of Delacroix and in Pierre Loti's novels. One morning in Tangiers I was riding in a meadow; the flowers came up to the horse's muzzle. I wondered where I had already had a similar experience—it was in reading one of Loti's descriptions in his book *Au Maroc.*

"*The Moroccans*[10] —I find it difficult to describe this painting of mine with words. It is the beginning of my expression with color, with blacks and their contrasts. They are reclining figures of Moroccans, on a terrace, with their watermelons and gourds.

The Academy, 1908

"This is what they called my 'academy.' Around 1908, some younger painters wanted help. At that time there was some empty space at the Convent des Oiseaux; we rented it for a studio where one could get together and work. I used to come by in the evenings, from time to time, to see what they were doing. I quickly realized that I had my own work to do, and was wasting too much of my energy. After each criticism I found myself faced with lambs, and I had to build them up constantly, every week, to make them into lions. So I wondered whether I was a painter or a teacher; I decided I was a painter and quickly abandoned the school. Purrmann (member of the Academy in Berlin and a professor there), Grunwald [Grünewald] (professor at Stockholm), and the Scandinavian Sorenson were among my pupils.

The Collectors

"Among the collectors who were interested in my work from the beginning, I must mention two Russians, Stchoukine and Morosoff. Stchoukine, a Moscow importer of Eastern textiles, was about fifty years old, a vegetarian, extremely sober. He spent four months of each year in Europe, traveling just about everywhere. He loved the profound and tranquil pleasures. In Paris his favorite pastime was visiting the Egyptian antiquities in the Louvre, where he discovered parallels to Cézanne's peasants. He thought the lions of Mycenae were the incontestable masterpieces of all art. One day he dropped by at the Quai St.-Michel to see my pictures. He noticed a still-life hanging on the wall and said: 'I buy it [*sic*], but I'll have to keep it at home for several days, and if I can bear it, and keep interested in it, I'll keep it.' I was lucky enough that he was able to bear this first ordeal easily, and that my still-life didn't fatigue him too much. So he came back and commissioned a series of large paintings to decorate the living room of his Moscow house—the old palace of the Troubetzkoy princes, built during the reign of Catherine II. After this he asked me to do two decorations for the palace staircase, and it was then I painted *Music* and *The Dance.*

"Morosoff, a Russian colossus, twenty years younger than Stchoukine, owned a factory employing three thousand workers and was married to a dancer. He had

commissioned decorations for his music room from Maurice Denis, who painted *The Loves of Psyche*. In the same room were six big Maillol sculptures. From me he bought, among other pictures, *Window at Tangiers, The Moroccans on the Terrace* and *The Gate of the Casbah*.[11] The paintings of both these collectors now belong to the Museum of Western Art in Moscow.

"When Morosoff went to Ambroise Vollard, he'd say: 'I want to see a very beautiful Cézanne.' Stchoukine, on the other hand, would ask to see all the Cézannes available and make his choice among them.

Cubism

"Braque had come back from the Midi with a landscape of a village by the seashore, seen from above. Thus there was a large background of sea and sky into which he had continued the village roofs, giving them the colors of the sky and water. I saw the picture in the studio of Picasso who discussed it with his friends. Back in Paris, Braque did a portrait of a woman on a chaise-longue in which the drawing and values were decomposed. Cubism is the descendant of Cézanne who used to say that everything is either cylindrical or cubical.[12] In those days we didn't feel imprisoned in uniforms, and a bit of boldness, found in a friend's picture, belonged to everybody.

"Cubism had a function in fighting against the deliquescence of Impressionism.

"The Cubists' investigation of the plane depended upon reality. In a lyric painter, it depends upon the imagination. It is the imagination that gives depth and space to a picture. The Cubists forced on the spectator's imagination a rigorously defined space between each object. From another viewpoint, Cubism is a kind of descriptive realism.[13]

Negro art

"I often visited Gertrude Stein in the Rue de Fleurus. On the way was a little antique shop. One day I noticed in its window a small Negro head carved in wood which reminded me of the huge red porphry [*sic*] heads in the Egyptian galleries of the Louvre. I felt that the methods of writing form were the same in the two civilizations, no matter how foreign they may be to each other in every other way. So I bought the head for a few francs and took it along to Gertrude Stein's. There I found Picasso, who was astonished by it. We discussed it at length, and that was the beginning of the interest we all have taken in Negro art—and we have shown it, to greater or lesser degrees, in our pictures.[14]

"It was a time of new acquisitions. Not knowing ourselves too well yet, we felt no need to protect ourselves from foreign influences, for they could only enrich us, and make us more demanding of our own means of expression.

"Fauvism, the exaltation of color; precision of drawing from Cubism; trips to the Louvre and exotic influences from the ethnographical museum at the old Troc-

adéro,[15] all shaped the landscape in which we were living, through which we were travelling, and out of which we all came. It was a time of artistic cosmogony.

The War, 1914–18

"Despite pressure from certain conventional quarters, the war did not influence the subject matter of painting, for we were no longer merely painting subjects. For those who could still work there was only a restriction of means, while for those who couldn't work there was only a gathering of desires which they were able to gratify when peace returned. From this period date two of my large works, the *Young Girls by the River* and *The Piano Lesson*.[16]

Nice

"I left L'Estaque because of the wind, and I had caught bronchitis there. I came to Nice to cure it, and it rained for a month. Finally I decided to leave. The next day the mistral chased the clouds away and it was beautiful. I decided not to leave Nice, and have stayed there practically the rest of my life.

"At first, in 1918, I lived at the Hôtel Beau-Rivage. Back the following winter, I went to the Hôtel de la Méditerranée where I spent every winter, from October to May, for five years. Then I took an apartment at 1 Place Charles Félix, on the top floor overlooking the market-place and the sea.[17]

"I worked at Nice as I would have worked anywhere.

"Windows have always interested me because they are a passageway between the exterior and the interior. As for odalisques, I had seen them in Morocco, and so was able to put them in my pictures back in France without playing make-believe.[18]

Some thoughts on painting

"A work of art has a different significance for each period in which it is examined. Should we stay in our own period and consider the work of art with the brand-new sensibility of today, or should we study the epoch in which it was made, put it back in its time and see it with the same means and in a context of parallel creations (literature, music) of its period in order to understand what it meant at its birth and what it brought to its contemporaries? Obviously some of the pleasure of its present existence and of its modern action will be lost when it is examined from the point of view of its birth. In each period, a work of art brings to man the pleasure that comes from communion between the work and the man looking at it. If the spectator renounces his own quality in order to identify himself with the spiritual quality of those who lived when the work of art was created, he impoverishes himself and disturbs the fullness of his pleasure—a bit like the man who searches, with retrospective jealousy, the past of the woman he loves.

"This is why artists have always felt the need of dressing their themes—picked from any and all periods—in the attributes and appearances of their own time. The

Renaissance painters did this; Rembrandt's biblical scenes are full of anachronisms, but he preserved the gravity and the humanity of the Bible, while James Tissot, who actually went to live in the holy places and found his inspiration from old documents, could only make anecdotal pictures, without sweep or evocative power." [19]

Return to bright color, 1936

Around 1936 there came a sort of renewal in Matisse's art. Colors shed their softness and returned to the naked and youthful violence of the Fauve period. The following is an excerpt from an interview I had with the artist at about that time. This statement seems to me to be of the utmost importance, not only for all of Matisse's work from that time until now, but it has also been a banner for a whole generation of younger paintings who seek to experience for themselves a certain movement which could be called "Neo-Fauvism":

"When means become so refined, so distilled and extenuated that their expressive power exhausts itself, one must go back to the essential principles which formed the human language. These are the principles which push upward, which recapture life and give us life. Pictures which are refinements, subtle degradations, delicacies without energy, need the beautiful blues, the beautiful reds, the beautiful yellows, the materials which stir man's basic sensuality. This was the springboard of Fauvism— the courage to find anew the purity of means." [20]

Travels

"I am too anti-picturesque for traveling to have given me much. I went quickly through Italy. I went to Spain. I even spent a winter in Seville. I went to Moscow at Stchoukine's invitation around 1910; [21] it seemed to me like a huge Asian village. I went to Tahiti in 1930.

"In Tahiti I could appreciate the light, light as pure matter, and the coral earth. It was both superb and boring. There are no worries in that land, and from our tenderest years we have our worries; they probably help keep us alive. There the weather is beautiful at sunrise and it does not change until night. Such immutable happiness is tiring.

"Coming back from Tahiti, I went through America. The first time I saw New York, at seven in the evening, its mass of black and gold was reflected in the water, and I was completely ravished. Near me someone on the boat was saying 'it's a spangled dress,' and this helped me to arrive at my own image: to me New York seemed like a gold nugget." [22]

Recent works, 1943–51

[Here there are no quotes from the artist, and Tériade concludes with a discussion of *Jazz* (which he had published) and of the chapel at Vence. Of the cutout technique, Tériade says "It was Matisse's genius that gave these colors life. He had invented

a new means of plastic expression, and this will surely be an important date in his career."

Of the Vence Chapel, Tériade remarks: "Matisse calls it his chef d'oeuvre. It can be termed a supreme endeavor by a painter who has always been involved with the problems of radiant color and light. In his designs for this chapel he sought the definitive solution in nature herself, and by utilizing the materials of nature—sun and transparency."]

49

Testimonial, 1951[1]

In 1952 Maria Luz published a series of remarks by Matisse, recalled from a 1951 interview, the text approved by Matisse.

In this text Matisse makes one of his clearest statements about the nature of his space, his objects, and his conception of drawing in relation to color, and he is more specific about these various elements than in most of his earlier writings. Just as his art at this time was becoming more and more severely distilled and abstract, so it seems that this essay presents ideas that have been presented before, but in a clearer, more distilled and more abstract way.

TESTIMONIAL

I can say nothing of my feeling about space that is not already expressed in my paintings. Nothing could be clearer than what you can see on this wall: this young woman whom I painted thirty years ago . . . this "bouquet of flowers". . . this "sleeping woman"[2] which date from these last few years, and behind you, this definitive plan of a stained-glass window made of colored paper cutouts.[3]

From the *Joie de vivre*—I was thirty-five then—to this cut-out—I am now eighty-two—I have remained the same; not in the way that my friends mean who want to compliment me, no matter what, on looking well, but because all this time I have searched for the same things, which I have perhaps realized by different means.

I had no other ambition when I did the Chapel. In a very restricted space, the width is five meters, I wanted to inscribe a spiritual space as I had done so far in paintings of fifty centimeters or one meter; that is, a space whose dimensions are not limited even by the existence of the objects represented.

You must not say that I recreated space starting from the object when I "discovered" the latter: I never left the object. The object is not interesting in itself. It's the environment that creates the object. Thus I have worked all my life before the same

objects, which gave me the force of reality by engaging my spirit towards everything that these objects had gone through for me and with me. A glass of water with a flower is different from a glass of water and a lemon. The object is an actor: a good actor can have a part in ten different plays; an object can play a different role in ten different pictures. The object is not taken alone, it evokes an ensemble of elements. You reminded me of the table I painted isolated in a garden?[4] . . . Well, it was representative of a whole open-air atmosphere in which I had lived.

The object must act powerfully on the imagination; the artist's feeling expressing itself through the object must make the object worthy of interest: it says only what it is made to say.

In a painted surface I render space visible to the sense of sight: I make of it a color limited by a drawing. When I use paint, I have the feeling of the quantity—surface of color which is necessary to me, and I modify its contour in order to determine my feeling clearly in a definitive way. (Let's call the first action "to paint" and the second "to draw.") In my case, to paint and to draw are one. I choose my quantity of colored surface and I make it conform to my feeling of the drawing, as the sculptor molds clay by modifying the ball which he first made and afterwards elicits his feeling from it.

Look at this stained-glass window again: here is a dugong—an easily recognizable fish, it is in the Larousse[5] —and, above, a sea animal in the form of algae. Around it, those are begonias.

This Chinese soldier on the mantelpiece is expressed by a color whose shape determines its degree of effectiveness.

This fellow—(*the artist turns it between his fingers*)—who is turquoise and aubergine as no soldier has ever been, would be destroyed if he were dressed in colors taken from material reality.[6] To invented colors whose "drawing" determines the contours, is added the artist's feeling to perfect the meaning of the object. Everything here is necessary. This brown spot, which represents the ground on which one imagines the figure, gives the turquoise and aubergine an atmospheric existence that their intensity could make them lose.

The painter chooses his color in the intensity and depth which suit him, as the musician chooses the timbre and intensity of his instruments. Color does not command drawing, it harmonizes with it.

"Vermilion doesn't do everything . . ." said Othon F[riesz] with bitterness.[7] Neither must color simply "clothe" the form: it must constitute it.

You ask me if my cutouts are an end of my researches? . . . My researches don't seem to me to be limited yet. The cutout is what I have now found to be the simplest and most direct way to express myself. One must study an object a long time to know what its sign is. Yet in a composition the object becomes a new sign that

helps to maintain the force of the whole. In a word, each work of art is a collection of signs invented during the picture's execution to suit the needs of their position. Taken out of the composition for which they were created, these signs have no further use.

This is why I have never tried to play chess, although it was suggested to me by friends who thought they knew me well. I told them: "I can't play with signs that never change. This Bishop, this King, this Queen, this Castle, mean nothing to me. But if you were to put little figures that look like so-and-so or such a one, people whose life we know, then I could play; but still inventing a meaning for each Pawn in the course of each game."

Thus the sign for which I forge an image has no value if it doesn't harmonize with other signs that I must determine in the course of my invention and that are completely peculiar to it. The sign is determined at the moment I use it and for the object with which it must participate. For this reason I cannot determine in advance signs that never change and that would be like writing: that would paralyse the freedom of my invention.

There is no break between my early pictures and my cutouts, except that with greater completeness and abstraction I have attained a form filtered to its essentials; and of the object that I used to present in the complexity of its space, I have kept only the sign that is sufficient to make the object exist in its own form and for the ensemble in which I conceived it.[8]

I have always sought to be understood and when I was taken to task by critics or colleagues, I thought they were right, assuming I had not been clear enough to be understood. This assumption allowed me to work my whole life without hatred and even without bitterness toward criticism, regardless of its source. I counted solely on the clarity of expression of my work to gain my ends. Hatred, rancor and the spirit of vengeance are useless baggage to the artist. His road is difficult enough and he should cleanse his soul of everything that could make it more so.

50

Interview with André Verdet, 1952[1]

In April and May 1952, the poet and essayist André Verdet interviewed Matisse at Cimiez. This extended interview, ranging over many subjects, is one of the most important late interviews with Matisse. Verdet's questions are well chosen—indeed, they seem to have been carefully planned with Matisse's aid. Matisse's an-

swers clarify and extend many of his previous ideas with great eloquence, such as the personal motivation behind his desire for balance and equilibrium, his choice of subject matter, and the process of creation.

Matisse also has a good deal to say about drawing, especially the arabesque, which he declares to be the most synthetic means of linear expression. Speaking of color, he emphasizes its relative nature, noting that the relationship between painting and drawing is that of the modification of color areas through drawing. As in the statement to Maria Luz (Text 49), he notes that the sensation of space is separate from the size of the actual work of art, be it a small canvas or the chapel at Vence, and that his works are projections of his sensations enlarged in a spiritual space. Matisse also elaborates upon the projection of imagery that he believes to be a synthesis of the self in relation to nature and states that his drawings and paintings are parts of himself: "Together they constitute Henri Matisse."

Matisse's feelings about the relationship between the abstractness of art and the importance of inspiration from nature are quite fully stated here. Current developments in America and Europe perplexed and disturbed him. This interview provides valuable insight into Matisse's understanding of abstraction; he himself at the time of this interview had created several works that might be called non-objective, such as *The Snail*. But his description of how he arrived at the final image in such works shows the great importance that the experience of the actual object had for him in the formulation of his imagery: the final image is an equivalence of some *thing*, however abstract or metaphorical its treatment. Whereas in his earlier paintings he abstracted directly from what he saw, in the cut-outs he abstracted more from what he *knew*: the same process of recollection that he described in relation to his Oceania tapestry (Text 36, above).

Matisse's antipathy to non-figurative art is not so much an objection to its theoretical basis (equivalence through non-figurative form) but a dislike of what he felt to be a loss of contact with nature. This, of course, is very closely related to his concern about the training of young painters, as expressed in the letter to Henry Clifford and in the preface to the 1951 Tokyo Exhibition catalogue (Texts 41 and 45, above).

INTERVIEW WITH ANDRÉ VERDET

Why are you in love with the arabesque?

Because it's the most synthetic way to express oneself in all one's aspects. You find it in the general outline of certain cave drawings. It is the impassioned impulse that swells these drawings.[2]

How do you find the arabesque?

Look at these blue women,[3] this parakeet, these fruits and leaves. These are paper cutouts and this is the arabesque. The arabesque is musically organized. It has its own timbre.

Can the arabesque have an important function for mural decoration?

It has a real function. There again it translates the totality of things with a sign. It makes all the phrases into a single phrase. And there again, it is the proportion of things that is the chief expression.

Does easel painting still have a future?

I think that one day easel painting will no longer exist because of changing customs. There will be mural painting.

Colors win you over more and more. A certain blue enters your soul. A certain red has an effect on your blood pressure. A certain color has a tonic effect. It's the concentration of timbres. A new era is opening.

Shouldn't a painting based on the arabesque be placed on the wall without a frame?

The arabesque is effective only when contained by the four sides of the picture. With this support, it has strength. When the four sides are part of the music, the work can be placed on the wall without a frame.

Are there many elements of oriental art in the art of the 10th, 11th, and 12th centuries, that is, Romanesque art?

Yes, there were many. These elements came through Constantinople and Venice, as did all imports from the East at the time. These elements were a good contribution. Such contributions, in general, are always good. The bad is very quickly rejected. The contributions transform, rejuvenate and enrich. They open up new avenues and also form links.

Do you agree with Cézanne that there is a green blue and a yellow blue?

I would simply say that color exists only through relationships, and that the painting calls forth the emotional relationship of color with drawing.[4]

⌒

Is the choice of the painted object determined in the first place by a sociological necessity or by a subconscious necessity of the artist?

First of all by a subconscious necessity. But then the sociological necessity intervenes and becomes operative.

A critic has claimed that the work of art is always made in advance. Do you think so?

A work of art is never made in advance, contrary to the ideas of Puvis de Chavannes, who claimed that one could never visualize the picture one wanted to paint too completely before starting. There is no separation between the thought and the creative act. They are completely one and the same.

Does the necessity to create the work of art begin to germinate when the individual realizes that something is missing?

It begins when the individual realizes his boredom or his solitude and has need of action to recover his equilibrium.

Does the work reflect the artist?

The work is the emanation, the projection of self. My drawings and my canvases are pieces of myself. Their totality constitutes Henri Matisse. The work represents, expresses, perpetuates. I could also say that my drawings and my canvases are my real children.

When the artist dies he is cut in two. There are lives of artists which are short. Raphael, Van Gogh, Gauguin, Seurat, for example. But these people expressed themselves completely. They died represented. And they haven't finished living.[5]

An artist must therefore force himself to express himself totally from the beginning. Thus, he will not grow old: if he is sincere, human and constructive, he will always find an echo in following generations.

Do you have faith, for the future, in the collective work of art?

Yes, I believe in the collective work of art for certain given subjects, certain functions, and on the condition of a certain discipline. Let someone take the initiative. Others will follow, bringing their personal contribution, if they respect their guiding spirit. They will remain freely obedient to a direction while maintaining their own emotive powers.

⌇

Do the paper cutouts represent your need for surprise?

No. There it's the paper-material that remains to be disciplined, to be given life, to be augmented. For me, it's a need for knowledge. Scissors can acquire more feeling for line than pencil or charcoal.[6]

Observe this big composition: foliage, fruit, scissors; a garden. The white intermediary is determined by the arabesque of the cutout colored paper which gives this *white-atmosphere* a rare and impalpable quality. This quality is that of contrast. Each particular group of colors has a particular atmosphere. It is what I will call the *expressive atmosphere.*[7]

⌇

With the completion of the Chapel of Vence, it was said you were reconciled with Catholicism?

Much has been said and written. A lot of stories were circulated, in Europe and in America. The work of art was nothing more than a pretext for gossip.[8]

First of all, sacred art demands a good moral hygiene. My only religion is the love of the work to be created, the love of creation, and great sincerity. I did the chapel with the sole intention of expressing myself *totally*. It gave me the opportunity to express myself in a totality of form and color. The work was a learning process for me. I set a game of equivalences in play there. I created an equilibrium between rough and precious materials. These things were reconciled and harmonized by the law of contrasts. Multiplication of planes became unity of plane.

And it is intentional that I repeat yet again that it's not by copying the object that I will be able to make it come alive in the spirit of the spectator, as I feel it, but rather by the single virtue of synthetic equivalence.

Let's return to Vence: red cannot be introduced into the chapel . . . However, this red exists and it exists by virtue of the contrast of the colors that are there. It exists by reaction in the mind of the observer.

I know you attach the greatest value to sincerity in a work of art . . .

Art is not a trick of invention. Art must always be measured to the actual emotion of the man. Without sincerity there is no authentic work. When I am questioned and I answer, I always see myself doing the thing or having done it. I can't contradict myself. I am sincere and this sincerity is my equilibrium.

I also think of Courbet: "A real masterpiece is something one must be able to begin again to prove one is not guided by whim or by chance." That is part of sincerity. As Rude said: "That which goes beyond my compass is my personality."

Abroad, notably in Scandinavia, people are very much amazed by the mediocrity of the teaching at the École des Beaux-Arts, and that such a backward institution can still exist in the 20th century . . .

Reactions are necessary. Summer needs the winter. At the École des Beaux-Arts one learns what not to do. It's an example of what to avoid. That's the way it is. The École des Beaux-Arts is an excuse for the Prix-de-Rome. It will die by itself.

Attendance at the École should be replaced by a long free stay at the zoological gardens. There, by continual observation, students would learn the secrets of embryonic life, of quiverings. Little by little, they would acquire this *fluid* that real artists eventually possess.

You see: break with habit and the conformist routine. One day Toulouse-Lautrec cried, "At last I don't know how to draw." That meant he had found his true line, his true drawing, his own draughtsman's language. This also meant that he had left the means used *to learn to draw.*

One must know how to maintain childhood's freshness upon contact with objects, to preserve its naiveté. One must be a child all one's life even while a man, take one's strength from the existence of objects—and not have imagination cut off by the existence of objects.[9]

~

Did your stay in Tahiti have a great influence on your work?

The stay in Tahiti was very profitable. I very much wanted to experience light on the other side of the Equator, to have contact with its trees and to penetrate what is there. Each light offers its own harmony. It's a different atmosphere. The light of the Pacific, of the Islands, is a deep golden goblet into which you look.

I remember that first of all, on my arrival, it was disappointing. And then, little

by little, it was beautiful, beautiful . . . it is beautiful! The leaves of the high co-
conut palms, blown back by the trade winds, made a silky sound. This sound of the
leaves could be heard along with the orchestral roar of the sea waves, waves that
broke over the reefs surrounding the island.

I used to bathe in the lagoon. I swam around the brilliant corals emphasized by
the sharp black accents of holothurians.[10] I would plunge my head into the water,
transparent above the absinthe bottom of the lagoon, my eyes wide open . . . and
then suddenly I would lift my head above the water and gaze at the luminous
whole. The contrasts . . .

Tahiti . . . The Islands . . . But the tranquil desert island doesn't exist. Our Eu-
ropean worries accompany us there. Indeed there were no cares on this island. The
Europeans were bored. They were comfortably waiting to retire in a stuffy torpor
and doing nothing to get out of the torpor, nothing to interest themselves or to de-
feat their boredom; they did not even think any more. Above them and all around
them, there was this wonderful light of the first day, all this splendor; but they didn't
see how good it was any more.

They had closed the factories and the natives wallowed in animal pleasures. A
beautiful country, asleep in the bright heat of the sun.

No, the tranquil desert island, the solitary paradise doesn't exist. One would be
quickly bored there because one would have no problems. The memory even of
Mozart would seem strange to you.

*I have often observed that even your canvases go beyond the limits of what is called easel
painting and that they contain the space of mural painting.*

The size of a canvas is of little importance. What I always want is to give the feel-
ing of space, as much in the smallest canvas as in the chapel at Vence. Everything
we see passes before the retina, is inscribed in a small chamber, then is amplified by
imagination. One must find the tone of the correct quantity and quality to make an
impression on the eye, the sense of smell, and the mind. To make someone fully
enjoy a jasmine plant for example. To find the quantity and quality of colors. Look
at this composition: a garden. Well now, this garden is the recollection of my sensa-
tions experienced in nature which I project forward, which I expand in space.

I just interrupted you when you were going to talk about linear decisions . . .

Yes, the decision of the line comes from the artist's profound conviction. That
paper cutout, the kind of volute acanthus that you can see on the wall up there, is a
stylized snail.[11] First of all I drew the snail from nature, holding it between two fin-
gers; drew and redrew. I became aware of an unfolding, I formed in my mind a pu-
rified sign for a shell. Then I took the scissors. It was important that "the end
should always be contained in the beginning." Further, I had to establish the con-
nection between the object observed and its observer.

I had placed that snail in the big composition of the *Garden*. But the musical movement of the whole combination was broken. So I removed the snail; I have put it aside now to wait for a different purpose.

I repeat once more: one must be sincere; the work of art only exists fully when it is charged with human emotion and is rendered with complete sincerity, and not by means of applying some pre-arranged program. This is why we can look at the pagan works of artists before the early Christian primitives without being disturbed. On the other hand we may find ourselves before certain works of the Renaissance made in rich, sumptuous, alluring materials, and be disturbed to see that a feeling which has the characteristics of Christianity has so much about it that is ostentation and fabrication. Yes, that comes from the bottom of my soul: fabricated for the rich. The artist sinks to the level of his patron. In pagan art, the artist is frank with himself, carnal, natural; his emotion is sincere. There is no ambiguity. In the equivocal situation of the Renaissance, too often the patron's satisfaction guides the artist. The artist's spirit is thus limited.[12]

⌣

I believe you knew Vollard well?

He had come from Reunion.[13] I don't know how he managed to approach Renoir. He nosed about everywhere. From time to time, in the evening, he used to visit him. Often, in order to work, Renoir was obliged to throw him out. One day he told him: "You should do something for Cézanne; believe me, he's a great artist."

Cézanne's exhibition took place. Almost everyone was against it. No one could believe it. They thought it dreadful. The bourgeois who know they understand nothing of art—they not only passed up Cézanne but also Renoir, Bonnard and many others; the bourgeois claimed that Cézanne's painting did not conform to the Greek canon of beauty. Only one critic, Geoffrey [*sic*] wrote a good favorable article.[14]

But this Vollard was a cunning fellow, a gambler, and he had a flair . . . for business. He succeeded in setting up a gallery on the rue Laffitte. Forain said of him then that he was the "tripe-seller" of the rue Laffitte.

Vollard had acquired a considerable number of Cézannes. They were everywhere; the walls were covered with them; there were even piles of them on the floor, one right next to another, leaning up against the wall. He had managed to buy them at a low price. Cézanne, moreover, had judged him: "Vollard is a 'slave-trader.'"

To show you what kind of fellow he was, here is a little story: Valtat was in the Midi and his works were beginning to be noticed by a few collectors.[15] Vollard, who was advised by Renoir, stopped by Valtat's house at Anthéor and after having counted some canvases in a pile against the wall, said to Valtat without turning them around: "That makes so much . . ." Of course Valtat accepted.

The exhibitions of young artists at the gallery on the rue Laffitte were no more

than a pretext to bring in well-known buyers. On the day of an opening, without respect for the artist's work, etchings by Cézanne, Renoir and others were soon brought out. Vollard had no consideration for the canvases of young artists.

To break even at the end of each month, he set out to visit all his clients at home with sumptuous books under his arms, which he had published and which he sold at a discount. He ate like a pig, digested slowly, grew sullen and seemed to fall asleep. Around four o'clock, upsy daisy! the call of the evening papers woke him up and off he dashed . . . Take the Dreyfus affair, well now! Vollard was violently anti-Dreyfus. He said all those fellows, Dreyfus and the Dreyfusards should be stuck away on an uninhabited island until they ate each other up.

Poor Gauguin! Vollard brought him to the end of his tether . . . Gauguin used to send him canvases and Vollard sent him small consignments of colors, little tubes of colors. Yes, Vollard acted shamefully toward Gauguin.

More than ten years ago, I met Vollard for the last time at Vittel. I reminded him of one of the old anecdotes he liked to bring out about female logic. Afterwards he said: "Monsieur Matisse is a very dangerous man because he has an excellent memory."

Your book Jazz *caused a considerable stir. Many consider it one of the turning-points in your constant evolution. What gave you the idea for this book, which was so well done?*

By drawing with scissors on sheets of paper colored in advance, one movement linking line with color, contour with surface. It simply occurred to me to unite them and Tériade made a book out of it. Yes, *Jazz* did cause a considerable stir and I felt that I should continue, because until then my work was weakened by a lack of coordination between the different elements functioning as global sensations. Sometimes a difficulty arose: when I united the lines, volumes, and colors everything melted, one thing destroying another. I had to start over again, to look to music and dance, to find equilibrium and avoid the conventional. A new departure, new exercises, discoveries. I can tell you in confidence that it's from the book *Jazz*, from my paper cutouts, that later my stained-glass windows were born.

It's not enough to place colors, however beautiful, one beside the other; colors must also react on one another. Otherwise, you have cacophony. *Jazz* is rhythm and meaning.

Nearly two years ago, the critic Charles Estienne published an anthology called Is Abstract Art Academic?[16] *Do you think that today's abstract art could lead to a dead-end?*

First of all, I will say that there is no single abstract art. All art is abstract in itself when it is the fundamental expression stripped of all anecdote. But let's not play on words . . . Nonfigurative art, then . . .

All the same, one can say that today if there is no longer any need for painting to give explanations in its physical make-up, yet the artist who is expressing the object

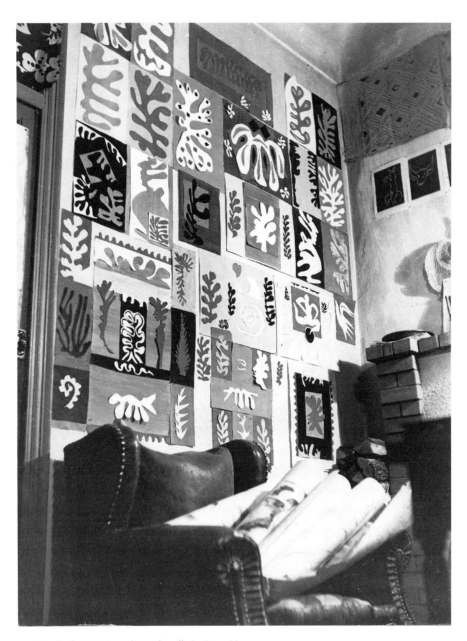

37. A wall of Matisse's studio at the villa Le Rêve, Vence, c. 1947.

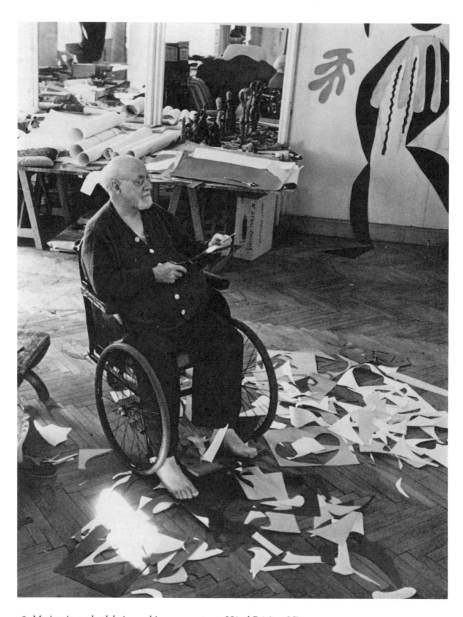

38. Matisse in a wheelchair, working on a cutout, Hôtel Régina, Nice, 1952.

by a synthesis, while seeming to depart from it, must nonetheless be able to explain this object himself to *himself*. He must necessarily end by forgetting it but, I repeat, deep *within himself* he must have a real memory of the object and of the reactions it produces in his mind. One starts off with an object. Sensation follows. One doesn't start from a void. Nothing is gratuitous. As for the so-called abstract painters of today, it seems to me that too many of them depart from a void. They are gratuitous, they have no power, no inspiration, no feeling, they defend a *non-existent* point of view: they imitate abstraction.

One doesn't find any expression in what is supposed to be the relationship of their colors. If they can't create relationships they can use all the colors in vain.

Rapport is the affinity between things, the common language; rapport is love, yes love.

Without rapport, without this love, there is no longer any criterion of observation and thus there is no longer any work of art.

51

Looking at Life with the Eyes of a Child, 1953[1]

In this essay Matisse notes that creation begins with vision, which is itself a creative operation. His affirmation that it is essential for the artist to look at everything as if he were seeing it for the first time, as though he were a child, recalls the Impressionist painters' belief in the importance of preserving a fresh and innocent vision—without which it would be impossible to express oneself in an original, personal way.

Matisse insists that the transposition of objects from the chaos of actual visual reality to the order and structure of a picture is achieved by infusing the picture with the same power and beauty that is found in nature. He concludes once again with the observation that the act of creation is the equivalent of an act of metaphysical love, and that love is at the root of all creation.

LOOKING AT LIFE WITH THE EYES OF A CHILD

To create is the artist's true function; where there is no creation there is no art. But it would be a mistake to ascribe this creative power to an inborn talent. In art, the genuine creator is not just a gifted being, but a man who has succeeded in arranging a complex of activities for their appointed end, of which the work of art is the outcome.

Thus, for the artist creation begins with vision. To see is itself a creative opera-

tion, which requires effort. Everything that we see in our daily life is more or less distorted by acquired habits, and this is perhaps more evident in an age like ours when cinema posters and magazines present us every day with a flood of ready-made images which are to the eye what prejudices are to the mind.

The effort needed to see things without distortion demands a kind of courage; and this courage is essential to the artist, who has to look at everything as though he were seeing it for the first time: he has to look at life as he did when he was a child and, if he loses that faculty, he cannot express himself in an original, that is, a personal way.

To take an example, I think that nothing is more difficult for a true painter than to paint a rose, since before he can do so, he has first to forget all the roses that were ever painted. I have often asked visitors who came to see me at Vence, "Have you seen the acanthus thistles by the side of the road?" No one had seen them; they would all have recognized the leaf of an acanthus on a Corinthian capital, but the memory of the capital prevented them from seeing the thistle in nature. The first step towards creation is to see everything as it really is, and that demands a constant effort. To create is to express what one has within oneself. Every creative effort comes from within. We have also to nourish our feeling, and we can do so only with materials derived from the world about us. Here is where working intervenes, the process whereby the artist incorporates and gradually assimilates the external world within himself, until the object of his drawing has become like a part of his own being, until he has it within him and can project it onto the canvas as his own creation.

When I paint a portrait, I come back again and again to my study, and every time it is a new portrait that I am painting: not one that I am improving, but a quite different one that I begin over again; and every time I extract from the same person a different being.

Often, in order to make my study more complete I have had recourse to photographs of the same person at different ages; the final portrait may show that person as younger or as appearing different from the way she did at the time of sitting, because that is the aspect which seemed to me the truest, the most revealing about her real personality.

The work of art is thus the culmination of a long process of development. The artist takes from his surroundings everything that can nourish his internal vision, either directly, as when the object he draws is to appear in his composition, or by analogy. In this way he puts himself into a state of creativity. He enriches himself internally with all the forms he has mastered and that he will one day set within a new rhythm.

It is in the expression of this rhythm that the artist's work will be really creative. To achieve it, he will have to sift rather than accumulate details, selecting in drawing, for example, from all possible combinations, the line that will be most fully expres-

sive and carry the most life; he will have to seek equivalences through which elements of nature are transposed into the realm of art.

In my *Still Life with a Magnolia* I painted a green marble table red; in another place I had to use black to suggest the reflection of the sun on the sea;[2] all these transpositions were not in the least a matter of chance or some kind of whim, but were the culmination of my previous researches, following which these colors seemed to me to be necessary, because of their relation to the rest of the composition, in order to render the impression I wanted. Colors and lines are forces, and the secret of creation lies in the play and balance of those forces.

In the chapel at Vence, which is the outcome of earlier researches of mine, I have tried to achieve that balance of forces; the blues, greens and yellows of the windows compose a light within the chapel, which is not strictly speaking any of the colors used, but is the living product of their harmony, their mutual relationships; this color-light was intended to play upon the white field embroidered with black of the wall facing the stained glass windows, on which the lines are purposely set wide apart. The contrast allows me to give the light its maximum vitality, to make it the essential element, that which colors, warms, and animates the whole structure, to which it is important to give an impression of boundless space despite its small dimensions. Throughout the chapel, there is not a single line, not a single detail that doesn't contribute to that impression.

It is in this sense, it seems to me, that art may be said to imitate nature: by the quality of life that creative work confers upon the work of art. The work will then appear as fertile and as possessed of this same inner vibration, of this same resplendent beauty, that we find in the products of nature.

Great love is needed to inspire and sustain this continuous striving towards truth, this concurrent generosity and profound laying bare that accompany the birth of any work of art. But isn't love at the origin of all creation?

52

Portraits, 1954[1]

For the folio *Portraits*, which consists of some ninety-three plates, Matisse wrote an introduction about portraiture, apparently at the request of the printer Fernand Mourlot,[2] in which he makes general comments on portraiture and describes his own process of creating portraits.

In portraiture, as in the rest of his paintings, Matisse notes his fidelity to original sensation and avoidance of schematization. He notes that when painting a

portrait a painter need not consciously inflect the work with his own style since it will bear his personal stamp anyway, once again stating his avoidance of both formula and exactitude in favor of personal expression.

He remarks that the process of producing a portrait requires a kind of rapport with the model, whose character is revealed gradually in progressive sittings, until the artist finally arrives at an image that is consonant with the essence of the model. Matisse's description of his working method while doing portraits applies, at least ideally, to the method of all of his painting. When at the end of the essay he compares his rapid drawings to medical diagnoses—revelations based on years of preparatory analysis—he once again underscores the value of informed intuition.

Matisse's discussion of portraiture and its application to his method of painting from life in this, his last published essay, is movingly reminiscent of the his affirmation in "Notes of a Painter" that like Chardin, Cézanne, Rodin and Leonardo, he felt that above all: "I want to secure a likeness."

PORTRAITS

The study of the portrait seems forgotten today. Yet it is an inexhaustible source of interest to anyone who has the gift or simply the curiosity.

One might think that the photographic portrait is adequate. For anthropometry, yes, but for an artist who seeks the true character of a face, it is otherwise: recording the model's features reveals feelings often unknown even to the very diviner who has brought them to light.[3] If it were necessary, the analysis of a physiognomist would almost be needed to attempt a clear explanation of them, for they synthesize and contain many things that the painter himself does not at first suspect.

True portraits, that is to say those in which the features as well as the feelings seem to come from the model, are rather rare. When I was young, I often went to the Musée Lécuyer at Saint-Quentin. There were a hundred or so pastel drawings by Quentin-Latour, done before starting his large formal portraits. I was touched by those agreeable faces, and then realized that each one of them was quite personal. I was surprised, as I left the Museum, by the variety of individual smiles on each of these mask-like countenances; though natural and charming on the whole, they had made such an impression on me that my own face was aching as if I had been smiling for hours. In the seventeenth century, Rembrandt, both with his brush and with his etching needle, made true portraits. My master Gustave Moreau said that before Rembrandt only grimaces had been painted, and Rembrandt himself declared that all of his work was nothing but portraits. I remember this saying, it appears to me true and profound.

The human face has always greatly interested me. I have indeed a rather remarkable memory for faces, even for those that I have seen only once. In looking at them I do not perform any psychological interpretation, but I am struck by their individ-

ual and profound expression. I don't need to put into words the interest that they arouse in me; they probably retain my attention through their expressive individuality and through an interest that is entirely of a plastic nature.

The driving force that leads me throughout the execution of a portrait depends on the initial shock of contemplating a face.

I have studied the representation of the face a good deal through pure drawing and so as not to give the result of my efforts the characteristics of my own personal style—as a portrait by Raphael is before everything a Raphael—around 1900 I endeavored to copy the face literally from photographs, which kept me within the limits of the visible features of a model. Since then I have sometimes taken up this way of working again. While following the impression produced on me by a face, I have tried not to stray from the anatomical structure.

I ended up discovering that the likeness of a portrait comes from the contrast that exists between the face of the model and other faces, in a word form its particular asymmetry. Each face has its own rhythm and it is this rhythm that creates the likeness. In the West the most characteristic portraits are found in Germany: Holbein, Dürer, and Lucas Cranach. They play with the asymmetry, the dissimilarities of faces, as opposed to the Southerners who usually tend to consolidate everything into a regular type, a symmetrical structure.

I believe, however, that the essential expression of a work depends almost entirely on the projection of the feeling of the artist in relation to his model rather than on the organic exactitude of the model.

The revelation of my life in the study of the portrait came to me in thinking of my mother. In a post office in Picardy, I was waiting for a telephone call. To pass the time I picked up a telegraph form lying on a table, and drew a woman's head on it with a pen. I drew without thinking of what I was doing, my pen going by itself, and I was surprised to recognize my mother's face with all its subtleties. My mother had a face with generous features, the highly distinctive traits of French Flanders.

I was still a pupil occupied with "traditional" drawing, anxious to believe in the rules of the school, remnants of the teaching of the masters who came before us: in a word, the dead part of tradition, in which all that was not actually observed in nature, all that derived from feeling or memory was scorned and condemned as "bogus." I was struck by the revelations of my pen, and I understood that the mind which is composing should keep a sort of virginity in relation to certain chosen elements and reject what comes to it by reasoning.[4]

Before the revelation at the post office, I used to begin my study by a kind of schematic indication, coolly conscious, showing the reasons for the interest that had sparked my interpretation of the model. But after this experience, the preliminary indication I have just mentioned was modified right from the very beginning. Having cleansed and emptied my mind of all preconceived ideas, I drew this prelim-

inary outline with a hand completely given over to my unconscious sensations, which sprang from the model. I was careful not to introduce any deliberate observation into this representation, or even to correct a physical error.

The almost unconscious transcription of the meaning of the model is the initial act of every work of art, particularly of a portrait. Following this, reason takes charge, holds things in check and makes it possible to have new ideas using the initial work as a springboard.

The conclusion of all this is: the art of portraiture is one of the most remarkable. It demands especial gifts of the artist, and the possibility of an almost total identification of the painter with his model. The painter should come to his model with no preconceived ideas. Everything should come to him in the same way that in a landscape all the scents of the countryside come to him: those of the earth, of the flowers linked with the play of clouds, of the movement of the trees and of the different sounds of the countryside.

I am able to speak only of my own experiences; I find myself before a person who interests me and, pencil or charcoal in my hand, I set down her appearance on the paper, more or less freely. This, in the course of a banal conversation during which I speak myself or listen without any spirit of opposition, which allows me to give free rein to my faculties of observation. At that moment, it wouldn't do to ask me a specific question, even a banal one such as "What time is it?" because my reverie, my meditation upon the model, would be broken, and the result of my work would be seriously compromised.[5]

After half-an-hour or an hour I am surprised to see an image that is a more or less precise likeness of the person with whom I am in contact gradually appear on my paper.

This image is revealed to me as though each stroke of charcoal erased from a mirror some of the mist which until then had prevented me from seeing it.

This generally is the meager result of a first sitting. It seems wise to me then to let one or two days intervene between this and the second sitting.

During this interval there occurs a kind of unconscious mental fermentation process. And thanks to this fermentation, in conformity with the impressions I received from my subject during the first sitting, I mentally reorganize my drawing with more certainty than there was in the result of the first contact.

When I look at my first attempt again it appears weak, without any accommodation; but within the haze of this uncertain image I can sense a structure of solid lines. This structure liberates my working imagination at the next sitting, in accordance with the inspiration that comes from it, along with what comes directly from the model. The model is no longer more to me than a particular theme from which flow the forces of lines or values that broaden my limited horizon.

This second sitting is analogous to having a fresh encounter with a sympathetic

person. The model ought to be relaxed and feel more confident with her observer; the latter is concealed behind a conversation that is not concerned with particularly interesting things, but on the contrary, plays on unimportant details. It seems to set up a current between the two that is independent of the increasingly commonplace words passing between them.

There generally appears, in accordance with the impressions of this sitting, a linear construction. The conclusions made during the first confrontation fade away to reveal the most important features, the living substance of the work.

The sittings continue in the same spirit, probably without these two people becoming substantially more informed about each other than on the first day. However, something has come into being, an interaction of feeling that makes each one sense the warmth of the other's heart, and the outcome of this will be the painted portrait or perhaps the possibility of expressing in a series of "rapid drawings" what has come to me from the model.

I have gained a deep knowledge of my subject. After prolonged work in charcoal, made up of studies that are more or less interrelated, flashes of insight appear, which while seeming more or less cursory are the expression of the intimate exchange between the artist and his model. Drawings that contain all the subtleties of observations made during the work arise from a fermentation within, like bubbles in a pond.

These drawings spring forth in one piece, constituted of elements without apparent coordination to the analysis that has preceded them; the multiplicity of the sensations expressed in each of them seems impossible to execute, so great is the speed with which they are all brought together. I am absolutely convinced that they represent the goal of my curiosity.

During a friendly visit, the surgeon, Professor L[eriche],[6] said to me, "I should like to know how you do your quick drawings." I answered that they were like the revelations resulting from an analysis but made without at first apparently knowing what subject I had to deal with: a kind of meditation.[7] He said to me: "That's exactly how I make my diagnoses. Someone asks me, Why did you say such and such? I answer: I have no idea, but I'm sure of it, and I mean it."

Chronology

1869
Henri-Émile-Benoît Matisse born 31 December at the home of his maternal grandparents in Le Cateau-Cambrésis in Picardy (Nord). His father, Émile-Hippolyte-Henri Matisse, a hardware and grain merchant, settles at nearby Bohain-en-Vermandois, where Henri will be raised, shortly after his birth. His mother, Anna Héloïse Gérard, described as "artistically inclined," paints china and makes hats.

1872
Birth of a brother, Émile-Auguste, on 9 July; he dies 4 April 1874.

1874
Birth of another brother, Auguste-Émile, on 19 June.

1882–87
Attends the Collège de Saint-Quentin and the Lycée Henri-Martin in Saint-Quentin. Is a dedicated amateur violinist.

1887–88
Spends a year studying law in Paris. In August passes first law examinations with honors as an *avoué* (solicitor or attorney, as opposed to an *avocat* or barrister or lawyer). Shortly afterward, returns to Picardy where he works as a law clerk in Saint-Quentin. He is overwhelmed by a sense of boredom and futility.

1889–1890
Attends early morning drawing classes at the municipal École Quentin de La Tour, which offers training in tapestry and textile design. His already frail health breaks down and he spends much of the year bedridden. He is exempted from military service in July 1889. Begins painting from "chromo" reproductions while convalescing from appendicitis. His first original picture, *Still Life With Books*, is painted in June 1890 and signed with his name in reverse: "Essitam, H. Juin 90." (He will later use "Essitam" as his cable address in Nice.) When he recovers, he returns to work at the law office and attends early morning classes at an art school in Saint-Quentin. There he benefits from a rigorous program in drawing and the attention of his teacher, Emmanuel Croizé.

1891
Decides to abandon law. Persuades his parents to let him study art and returns to Paris in October. Enrolls at the l'Académie Julian, where William Adolphe Bouguereau and Gabriel Ferrier teach, and begins preparation for the entrance examination to the École des Beaux-Arts.

1892
In February, he fails the entrance examination to the École des Beaux-Arts. Returns briefly to Picardy, where he is deeply impressed by Goya's *Youth* and *Old Age* in the Musée des Beaux-Arts at Lille. Moves to 19 quai Saint-Michel near Nôtre-Dame. Disillusioned with Bouguereau's teaching, he draws from plaster casts in the Cours Yvon at the École des Beaux-Arts and attracts the attention of Gustave

Moreau, who accepts him as a student. In Moreau's class he meets Georges Desvallières, André Rouveyre, Georges Rouault, Simon Bussy, Henri Evenepoël, and Henri Manguin. In October he registers at the École des Arts Decoratifs, where he takes courses in geometry, perspective, and composition. Meets Albert Marquet.

1893

Encouraged by Moreau, he begins to paint copies in the Louvre in April. Over the next decade he copies more than twenty-five works; these include some sixteenth- and seventeenth-century Italian, Dutch, and Spanish pictures, but most are French paintings from the seventeenth and eighteenth centuries, including works by Poussin, Watteau, Fragonard, and Chardin.

1894

Birth of his daughter, Marguerite Émilienne, to Caroline Joblaud, 3 September.

1895

Passes the entrance examination to the École des Beaux-Arts in March and is officially admitted into Moreau's class. Sees the centennial exhibition of Corot. Moves to the fifth floor of 19 quai Saint-Michel, which will be his residence until 1908. During the summer, makes a brief trip with the painter Émile Wéry to Belle-Ile in Brittany, where he begins to paint outdoors. Sees the important Cézanne exhibition at Ambroise Vollard's gallery, although it has no immediate effect on him; he is not yet "ready" to understand Cézanne.

1896

Exhibition at the Salon des Cent, organized by the symbolist journal *La Plume*, in April; this is the first recorded public exhibition of his work. Later that month he exhibits five paintings (two of which are sold) at the relatively conservative Salon de la Société Nationale des Beaux-Arts (Champs-de-Mars), of which he is elected an associate member after being nominated by its president, Pierre Puvis de Chavannes. Makes a second, more prolonged stay in Brittany (Belle-Ile), where he meets the Australian painter and collector John Russell. Paints landscapes and Dutch-inspired still lifes and interiors, such as *Breton Serving Girl*. Returns to Paris in October. Encouraged by Moreau to undertake a large composition, he begins work on *The Dinner Table*.

1897

Sees the Impressionist paintings from the Caillebotte bequest at the Musée du Luxembourg, where he is especially impressed by the works of Claude Monet. Exhibits *The Dinner Table*, his first Impressionist-inspired picture, at the Salon de la Société Nationale des Beaux-Arts. Makes the acquaintance of Camille Pissarro, who becomes a mentor. Makes a third summer trip to Belle-Ile, where he works in a freer manner that recalls Monet's paintings of similar motifs there. John Russell gives him two drawings by Van Gogh. Matisse legally recognizes his daughter, Marguerite. His relationship with her mother, Caroline Joblaud, ends later in the year.

1898

Marries Amélie-Noémi-Alexandrine Parayre (b. 1872) on 8 January. Honeymoons in London, where he studies Turner on Pissarro's advice. Goes to Ajaccio in Corsica, where he stays from February to August, except for a brief trip to Paris in June. In Corsica, he paints freely brushed landscapes and reads Paul Signac's *D'Eugène Delacroix au néo-impressionnisme*, which is published in the May–July issues of the *Revue Blanche*. Gustave Moreau dies on 18 April. In August Matisse and his pregnant wife go to Beauzelle and Fenouillet, near Toulouse, to be with her family.

1899–1900

Suffers extreme financial hardship, which will continue until 1904. His first son, Jean Gérard, is born in Toulouse on 10 January 1899. Matisse buys Cézanne's *Three Bathers* from Vollard, which he can ill afford, but which he holds onto through severe financial hardships; this painting will have a tremendous

and far-reaching influence on his thought and work (see Text 22). That same year Matisse also acquires Rodin's plaster bust of Henri de Rochefort, a painting of a boy's head by Gauguin, and a Van Gogh drawing. In February 1899 he and his family return to Paris and live at the quai Saint-Michel. He works briefly with Fernand Cormon, who has taken over Moreau's studio, but is asked to leave because he was already thirty. Begins to work in full-round sculpture; does a copy of Barye's *Jaguar Devouring a Hare*. In 1899 he exhibits for the last time at the conservative Salon de la Nationale. Studies at Eugène Carrière's studio, where he meets Jean Biette, André Derain, Jean Puy, Pierre Laprade, and Auguste Chabaud. Toward the end of 1899, Mme Matisse opens a milliner's shop. Matisse works with Marquet on decorative panels at the Grand Palais for the 1900 Paris Exposition.

In 1900 Matisse does his first etchings. Purchases two pastels by Odilon Redon. His second son, Pierre, is born on 13 June in Bohain. In the fall of 1900, Matisse attends evening sculpture classes at l'École d'Art Municipale and works at the studio of La Grande-Chaumière under Antoine Bourdelle. Draws from life at the Académie Colarossi. Remains in touch with friends from Moreau's studio, including Camoin and Manguin. Shows his drawings to Auguste Rodin.

1901–1903

Early in 1901, Matisse contracts severe bronchitis; his father takes him to Villars-sur-Ollon, Switzerland, to recuperate. Derain introduces Matisse to Maurice Vlaminck at a Van Gogh retrospective at the Bernheim-Jeune gallery. Exhibits at the Salon des Indépendants for the first time and is elected a *sociétaire*. His father, unhappy with the direction that Matisse's career is taking, discontinues his allowance. Matisse visits Derain and Vlaminck in Chatou and is impressed by their work.

In February 1902, he is in a group show at the Berthe Weill Gallery with five other painters from Moreau's studio. In April, Weill sells one of his paintings, the first sold by a dealer. Short of money, Matisse and his family spend the winter in Bohain.

In the spring of 1903, Matisse exhibits at the Salon des Indépendants. Sees the large exhibition of Islamic art at the Pavillon de Marsan. In the fall of 1903, he exhibits at the first Salon d'Automne. Mme Matisse, in poor health, gives up her millinery business. The family moves to Lesquielles-Saint-Germain for the rest of the year.

1904

Becomes friendly with Paul Signac. Copies Raphael's *Baldassare Castiglione*, his last recorded copy made at the Louvre. Sees the large exhibition of French Primitives at the Pavillon Marsan and the Bibliothèque Nationale. Has his first one-man show (45 paintings and 1 drawing) at Vollard's gallery, in June; the catalogue has a preface by Roger Marx. Summers at Saint-Tropez near Signac; is later joined by Henri-Edmond Cross. Begins studies for *Luxe, calme et volupté*. Sends thirteen canvases to the Salon d'Automne. He begins to hyphenate his name as Henri-Matisse, to distinguish himself from the painter Auguste Matisse.

1905

Visits Derain and Vlaminck at Chatou. Exhibits his Neo-Impressionistic painting *Luxe, calme et volupté* at the Salon des Indépendants, along with seven other works; it is purchased by Signac. Spends the summer with Derain in Collioure, where he begins to work on the boldly-brushed, brightly-colored canvases that will be called "*fauve* (wild beast)." Becomes friendly with the sculptor Aristide Maillol and sees the collection of Gauguin's South Sea pictures that were in the custody of Maillol's friend, Daniel de Monfreid.

Matisse exhibits at the Salon d'Automne with a group of young artists (including Derain, Manguin, Marquet, Puy, and Vlaminck) who create a scandal and are referred to as "*fauves*" by the art critic Louis Vauxcelles. Gertrude and Leo Stein purchase *The Woman with the Hat*. Members of the Stein family (Gertrude, Leo, Michael, and Sarah) become serious collectors of his paintings. He takes a studio in the Couvent des Oiseaux, 56 rue de Sévres, where he begins work on *Le Bonheur de vivre*, an imagined pastoral composition that will be his largest painting to date.

1906

Does first woodcuts and lithographs. Exhibits *Le Bonheur de vivre* (later usually referred to as the *La Joie de vivre*) at the Salon des Indépendants in March. Because of its size and brilliance of color, the painting (which is bought by Leo and Gertrude Stein) creates a furor among critics and conservative painters; it is also severely criticized by Signac, the vice-president of the Indépendants, who resents Matisse's disavowal of Neo-Impressionism. In March and April, Matisse also has his second one-man show, at the Druet Gallery. Meets Picasso at Gertrude Stein's apartment in April; probably meets Braque around the same time.

In the spring Matisse goes to Algeria and becomes interested in African art. Spends the summer at Collioure working in more mellow color harmonies. In the autumn he buys his first piece of African sculpture. Meets the Russian collector Sergei Shchukin, who has already purchased some of his works. Returns to Collioure in November.

1907

In January Matisse works on *Reclining Nude I* and *Blue Nude* at Collioure. Exhibits *Blue Nude* at the Salon des Indépendants. The painting is bought by Gertrude and Leo Stein, their last major Matisse purchase; Gertrude's loyalties shift to Picasso. The prestigious Bernheim-Jeune gallery makes its first recorded sale of a Matisse; the gallery will soon become his primary dealer. Matisse makes ceramic tiles and plates at the atelier of André Méthey in Asnières. During the summer, he goes to Italy with his wife. Visits the Steins at Fiesole near Florence, where he meets the American critic Walter Pach, who will become a supporter. Goes to Arezzo, Siena, Ravenna, Padua, and Venice; is especially impressed by the works of Giotto, Duccio, Piero della Francesca, Castagno, and Uccello. Spends the latter part of the summer in Collioure, where he paints *Le Luxe*. Exchanges paintings with Picasso. In December, Guillaume Apollinaire publishes his first article on Matisse, quoting him directly (Text 1). Sarah Stein and the German painter Hans Purrmann organize a school where Matisse will teach.

1908

The Académie Matisse opens in January at the Couvent des Oiseaux, 56 rue de Sèvres. In the three years of the school's existence, about 120 students, mostly foreigners, will attend. (Matisse is ridiculed by his critics for having students "from Massachusetts.") In the beginning, Matisse does not charge tuition, but he later does so in order to prevent students from coming to his studio simply because it is free. At this time, he begins work on an extended series of large, imagined figurative compositions, including *Bathers with a Turtle* and *The Game of Bowls*. In the spring, Matisse moves his home, studio, and school to the Hôtel Biron (the former Couvent des Oiseaux) at 33 Boulevard des Invalides. (Rodin takes rooms there in the fall; eventually the building will become the Musée Rodin.) In the spring he goes to Germany with Purrmann; visits Speyer, Munich, Nuremberg, Heidelberg. In April, he is given his first American exhibition at the 291 Gallery, New York. Shchukin introduces him to another Russian collector, Ivan Morosov. The two Russians soon beome the most important collectors of his work. (By 1913, Shchukin will own thirty-six of his paintings, Morosov eleven of them.) Matisse has an important showing at the Salon d'Automne (eleven paintings, including *Harmony in Red*, thirteen sculptures, and six drawings). Publishes "Notes of a Painter" (Text 2) in December. Late in December, he goes to Berlin with Hans Purrmann to prepare his exhibition at the Cassirer Gallery; but Cassirer refuses to hang all of his paintings, which receive hostile reviews. "Notes of a Painter" translated into German by Greta Moll.

1909

In January, exhibits at the second Salon of the Toison d'Or in Moscow. In March, Shchukin commissions *Dance* and *Music*. In April, Charles Estienne publishes an interview with Matisse (Text 5). The June issue of *Zolotoe runo/La Toison d'Or* (Moscow) is devoted to Matisse; it includes a Russian transla-

tion of "Notes of a Painter." On 1 July, Matisse leases a house at Issy-les-Moulineaux, a suburb south-west of Paris, and has a large studio built at edge of the garden (the house is on the Route de Clamart, hence the house is sometimes referred to as being in Clamart). Spends the summer in the south, at Cavalière, and moves to the house in the fall. Signs a three-year contract with the Bernheim-Jeune gallery, Paris. Finishes the first version of the large bas-relief *The Back*.

1910

In February–March, Matisse has a retrospective exhibition at the Bernheim-Jeune gallery (it includes sixty-five paintings and twenty-five drawings, ranging in date from 1893). Has a second exhibition at the 291 Gallery, in New York. Three Matisse drawings are donated to the Metropolitan Museum of Art, the first Matisse works to enter an American museum. At the end of the summer, he travels with Marquet and Purrmann to Munich to see a large exhibition of Islamic art, which makes a deep and lasting impression on him. Exhibits *Dance* and *Music* at the Salon d'Automne; they create a sensation and are violently attacked by the critics. Shchukin momentarily loses courage and declines to accept them; but changes his mind. Matisse's father dies in Bohain on 15 October. Exhausted, Matisse leaves for Spain in mid-November, where he stays until the following January; visits Seville, Granada, Cordoba, Madrid, Toledo.

1911

Matisse returns to France in January. In the spring he closes his school. Also in the spring, a large Cubist exhibition takes place in "Salle 41" at the Salon des Indépendants; Matisse's reputation among the avant-garde is in decline. Over the course of the year he will paint four very large and important decorative panels: *The Pink Studio*, *The Painter's Family*, *Interior with Aubergines*, and *The Red Studio*. Spends the summer at Collioure. In November, he travels to Russia (St. Petersburg and Moscow) at the invitation of Shchukin; he studies the icons there and is impressed by the foreignness of Russia (see Text 48). Back in Issy in December, he is interviewed by Ernst Goldschmidt (Text 7).

1912

In January Matisse goes to Morocco, where he paints mostly in Tangier until April. The Italian Futurists exhibit at Bernheim-Jeune. When Matisse returns to Issy, he works on paintings of goldfish and on the two versions of *Nasturtiums with "Dance."* The first exhibition of his sculpture is mounted in New York. In June, Clara MacChesney interviews him at Issy (Text 8). He studies the exhibition of Persian miniatures on view at the Musée des Arts Décoratifs from June to October. Christian Tetzen-Lund and Johannes Rump in Denmark begin to collect his works. Albert Barnes acquires his first two Matisses. Matisse returns to Morocco in the fall and spends the winter months in Tangier. Renews his contract with Bernheim-Jeune for another three years. Albert Gleizes and Jean Metzinger publish *Du Cubisme*.

1913

Returns from Tangier in the spring, visiting Ajaccio in Corsica and Menton en route. Apollinaire's *Les peintres cubistes* is published. Matisse exhibits his Moroccan paintings along with some of his sculptures at Bernheim-Jeune. Exhibits in the Berlin Sezession, and at the Armory Show in New York, Boston, and Chicago (seventeen works); *Blue Nude* and *Le Luxe* are burned in effigy by art students in Chicago. Spends the summer at Issy. Works on *The Back II*. Completes *Portrait of Mme Matisse* after more than a hundred sittings and sends it alone to the Salon d'Automne. Instead of traveling again that winter, he rents a studio at 19 quai Saint-Michel, below his old studio, which is now occupied by Marquet.

1914

Takes up etching. Works on lithographs. Paints *Portrait of Mlle Yvonne Landsberg* in the spring. Spends the summer at Issy. In July he has an exhibition at the Gurlitt gallery in Berlin. At his insistence, Michael and Sarah Stein lend nineteen paintings from their collection. World War I begins and the pictures cannot be returned to them. Soon after the start of the war, Matisse's mother and brother are be-

hind enemy lines in Le Cateau. Matisse tries to enlist for military service during the general mobilization but is rejected. In September, he goes to Collioure, where he becomes friendly with Juan Gris. Paints the somber *French Window at Collioure*. Returns to Paris in October. Visits Raymond Duchamp-Villon with Walter Pach.

1915

Has an exhibition in New York at the Montross gallery, his first full one-man show in the United States. Spends the winter painting at the quai Saint-Michel and at Issy, his works becoming increasingly austere and abstract. Makes a short visit to Arachon, near Bordeaux. In November he goes to Marseille with Marquet.

1916

Paints interiors and monumental compositions at the quai Saint-Michel and Issy, including *The Piano Lesson*, *The Moroccans*, and *Bathers by a River* (begun in 1909, at the same time as *Dance* and *Music*). Does *The Back III* and *Jeannette V*. Paints portraits of Michael and Sarah Stein. The Italian model Laurette begins to pose for him for what will be his first series of extended works from a single model.

1917

His paintings of Laurette, sometimes in exotic costumes, become more naturalistic and sensual. In May, with Marquet, Matisse visits the aged Monet at Giverny. In July, he and Marquet visit Chenonceaux, where Matisse does two small paintings of the chateau. Paints a number of landscapes around Trivaux. Signs a new three-year contract with Bernheim-Jeune. In December he goes to Marseille, then on to Nice by 20 December, where he stays at the Hôtel Beau-Rivage, 107 quai du Midi. On 31 December (Matisse's birthday) George Besson takes him to meet Renoir, who lives in Cagnes-sur-Mer.

1918

Paints at the Hôtel Beau-Rivage. Moves to an apartment at 107 quai du Midi, next door to the Beau-Rivage. In January–February he and Picasso have a two-person exhibition at Paul Guillaume's gallery in Paris. In May, Matisse moves to the Villa des Alliés and paints numerous landscapes in the surrounding countryside. In the early summer he goes to Issy, then on to Cherbourg to visit his son Pierre. Returns to Nice in the fall, where he takes rooms in the Hôtel de la Méditerranée et de la Côte d'Azur, on the Promenade des Anglais. Visits Pierre Bonnard at Antibes. The young model Antoinette Arnoux (or Arnoud) begins to pose for him. Apollinaire dies in Paris, 9 November. In the aftermath of the revolution in Russia, the Shchukin and Morosov collections are confiscated by the Soviet government.

1919

Matisse's paintings become increasingly naturalistic. He does the *White Plumes* series with Antoinette Arnoux. In May, exhibits at the Bernheim-Jeune gallery, his first one-man exhibition in Paris since 1913 and his first substantial exhibition of the Nice paintings. He comes to Paris in the spring. In May–June he is represented at the Triennial Exhibition of French art at the École des Beaux-Arts in Paris. Interviewed by Ragnar Hoppe about his change in style (Text 10). Exhibits with Maillol at the Leicester Galleries in London. Summers at Issy, where he paints *Tea*. In the fall he visits London, where he works on the decor and costumes for *Le Chant du Rossignol*, a ballet produced by Sergei Diaghilev and the Ballets Russes, with music by Igor Stravinsky and choreography by Léonide Massine. He uses cut paper for the costume designs. Takes a room at the Hôtel de la Méditerranée when he returns to Nice.

1920

Matisse's mother dies in Bohain on 25 January. He visits London again to work on *Le Chant du Rossignol*. Returns to Nice, to the Hôtel de la Méditerranée, in February, where he remains until June. Visits London for the Covent Garden performances of *Le Chant du Rossignol*. In July he goes to Etretat on the Normandy coast, where he paints motifs that had been painted by Monet. The first monograph on Matisse is published, with a text by Marcel Sembat and thirty black-and-white plates. He signs his

fourth three-year contract with Bernheim-Jeune. Returns to Nice in late September, his fourth season there, where he stays at the Hôtel de la Méditerranée until spring. In the fall, the model Henriette Darricarrère (b. 1901) begins to pose for him; she will be his most important model until 1927. In October–November, he has an exhibition of fifty-eight paintings at the Bernheim-Jeune gallery, all recent works from Etretat and Nice, except for five early works, including two 1890 paintings shown as *Mon premier tableau* and *Mon deuxième tableau*.

1921
Paints figures in landscapes near Nice. Returns to Nice in early September and rents an apartment on the third floor of 1 Place Charles-Félix, which he will keep until 1928.

1922
In February and March, he has an exhibition at Bernheim-Jeune of paintings done in Nice in 1921. Begins extended series of lithographs. The state purchases *Odalisque with Red Culottes* of 1921 for the Musée du Luxembourg, the first French museum purchase of a Matisse. He spends the summer at Etretat. Donates *Interior with Aubergines* to the museum in Grenoble. Paints a number of sensual reclining odalisques. Claribel and Etta Cone begin seriously to develop their Matisse collection. Albert Barnes begins major acquisitions of Matisse's work. Matisse returns to Nice in August. Marcel Sembat, an early and loyal supporter, dies on 5 September; his wife, the painter Georgette Agutte, commits suicide hours later. (The Sembat collection will be given to the Musée de Grenoble in 1923.)

1923
Paintings recently acquired by Barnes are exhibited in Paris at the Paul Guillaume gallery before being shipped to the United States. Matisse spends the summer in Issy. Renews his contract with Bernheim-Jeune for the last time, again for three years. Returns to Nice in the fall, where he paints richly decorative interiors, such as *Checker Game and Piano Music*. The collections of Shchukin and Morosov are combined in the Museum of Modern Western Art, Moscow. On 10 December Matisse's daughter Marguerite marries Georges Duthuit, a Byzantinist and writer on modern art.

1924
Exhibits at the Joseph Brummer galleries, New York, in February–March; Brummer, a former Académie Matisse student, writes the catalogue preface. Exhibition at the Bernheim-Jeune gallery in May. The largest retrospective of his work to date (87 paintings) is organized by Leo Swane for the Ny Carlsberg Glyptotek, Copenhagen; it subsequently travels to Stockholm and Oslo. His son Pierre goes to New York, where he works for the Dudensing galleries.

1925
Travels to Italy with his wife, Marguerite, and Georges Duthuit. Made a Chevalier of the Legion of Honor. Visits Amsterdam in August then remains in Nice until the end of the year. Does series of lithographs of odalisques that will be published as an album by Bernheim-Jeune in 1927. Begins *Large Seated Nude*, his first sculpture in years. Interview by Jacques Guenne (Text 11).

1926
Leases the fourth floor of 1 Place Charles-Félix in Nice, which will become his residence until 1938, retaining the third-floor apartment for a studio until 1928. Mme Matisse remains in Paris, in an apartment at 132 boulevard du Montparnasse.

1927
A Matisse retrospective exhibition is organized by Pierre Matisse at the Valentine Dudensing gallery, New York, including works ranging from 1890–1926. Matisse is awarded first prize at the Carnegie International Exhibition in Pittsburgh, for *Compote and Flowers* of 1924, a relatively conservative choice by the Carnegie jury; he had previously exhibited at the Carnegie exhibitions of 1921, 1924, 1925, and 1926. Henriette Darricarrère stops modeling for him.

1928

Mme Matisse joins her husband in the apartment at Place Charles-Félix in Nice. Matisse concentrates increasingly on prints, drawings, and sculpture.

1929

In January, interviewed by Tériade (Text 12). Does relatively little painting; in fact, he will do very few easel paintings until 1935. Works mostly on prints and sculptures. In May and June there is an exhibition of Paul Guillaume's personal collection at the Bernheim-Jeune gallery, which contains sixteen paintings and two sculptures by Matisse. Claribel Cone dies on 20 September. *Henri-Matisse*, a monograph by Florent Fels, is published.

1930

Matisse has a large one-man exhibition (two hundred sixty-five works, of which eighty-three are paintings) at the Thannhauser gallery in Berlin in February–March. Albert Skira commissions illustrations for Mallarmé's *Poésies*. Mme Matisse is bedridden with a spinal disorder. That spring, Matisse travels to Tahiti, stopping on the way in New York, Chicago, Los Angeles, and San Francisco. Stays in Tahiti with visits to other islands, from 29 March until mid-June. (Later he will tell his biographer Raymond Escholier, "I lived there three months, absorbed in my surroundings, with no other ideas than the newness of all I saw, overwhelmed, unconsciously storing up many things.") Returns via Panama, Martinique, and Guadeloupe, arriving at Marseille on 31 July. Interviewed by Tériade soon after his return (Text 13).

In the fall, Matisse returns to the United States to serve on the Carnegie jury (the first prize is given to Picasso). Visits the Barnes Foundation in Merion, Pennsylvania, and Etta Cone in Baltimore, Maryland. Albert Barnes proposes a mural commission for his foundation. Matisse accepts the Barnes commission and in December returns to the United States for the third time that year to work out details for the mural commission.

1931

Matisse returns to France in January. In June–July he has a retrospective exhibition in Paris at the Galeries Georges Petit (141 paintings). Interviewed by Tériade, Jedlicka, and Courthion (Texts 14, 15, 16). He also has one-man shows in Basel at the Kunsthalle (111 paintings), and in New York at the Museum of Modern Art (78 paintings). *Cahiers d'Art* publishes a special number on him, as does the journal *Les Chroniques du Jour*. He begins work on the large canvases for the Barnes mural, then takes the cure at Abano Bagni, near Venice. Studies Giotto's frescoes in Padua. When he returns to Nice, he begins to work on the mural with pieces of colored paper, which are pinned to the canvas in order to facilitate quick changes in the composition.

1932

In February when he is nearly finished with the Barnes mural he finds that the measurements are wrong. He decides to begin again. Publication in October of *Poésies de Stéphane Mallarmé*, with twenty-nine etchings by Matisse. Hires Lydia Delectorskaya (b. 1910) as a studio assistant for his work on the Barnes murals. There is an exhibition of his drawings at the Pierre Matisse gallery, New York, in November–December.

1933

Meets Barnes briefly in Mallorca, then again in Nice where Barnes sees the cut-paper composition for the mural for the first time. Finishes the mural in May. Is interviewed by Dorothy Dudley (Text 18). Goes to Merion in May to supervise the installation of the *Dance* mural at the Barnes Foundation. Exhausted, he returns to France to convalesce. Toward the end of the year, he reworks and finishes the so-called "first" version of the Barnes Mural. Makes a published statement to Tériade (Text 17).

1934

Pierre Matisse begins to organize a series of exhibitions of his father's works at his own gallery in New York. Matisse begins illustrations for an American edition of James Joyce's *Ulysses*, published in 1935. After some hesitation, Matisse contributes to *Testimony Against Gertrude Stein* (published early in 1935), in which he refutes statements she made about him in *The Autobiography of Alice B. Toklas* (published in 1933).

1935

In February, his former assistant Lydia Delectorskaya, hired the previous year to look after his convalescing wife, begins to pose for him. She will be his main model and companion for the rest of his life. He paints *Pink Nude, Blue Eyes, The Dream*; continues to use cut paper to make quick compositional revisions on his paintings. Enters into an agreement with the dealer Paul Rosenberg. Begins an extended sequence of virtuosic line drawings, which he will continue for the next several years. Visits Pierre Bonnard and maintains a correspondence with him. Does studies for a Beauvais tapestry, *Window at Tahiti*, in which he begins to use his Tahitian experiences in pictures. Writes "On Modernism and Tradition," his first published essay since 1908 (Text 20).

1936

Exhibits recent drawings at the Leicester gallery in London and twenty-seven recent paintings at the Paul Rosenberg gallery in Paris. The so-called "first" version of the Barnes mural *Dance* is purchased by the city of Paris through the efforts of Raymond Escholier, director of the Musée du Petit Palais. Matisse gives his Cézanne *Three Bathers* to the Musée du Petit Palais (see Text 22). An album of his drawings is published in a special issue of *Cahiers d'Art*. He begins to work in cut and pasted paper on maquettes for decorative projects. His painting becomes increasingly flatter, brighter, more highly patterned. Makes statements to Tériade about returning to the purity of Fauvism (Text 21).

1937

A special gallery is allotted to Matisse's works (61 paintings) at the Maîtres de l'Art Indépendant exhibition at the Petit Palais, Paris. Escholier's biographical monograph, *Henri Matisse* is published on 20 April. Matisse visits London in July. Is hospitalized in Paris in September. Returns to Nice in mid-October, where he will remain until June 1938. He is commissioned by the Ballets Russes de Monte Carlo to design scenery and costumes for *Le Rouge et le noir*, with choreography by Léonide Massine and music from Dmitri Shostakovich's First Symphony; his set designs are freely adapted from the imagery of the Barnes *Dance*. Publishes "Divagations" (Text 23).

1938

Seriously ill with influenza. Participates in a major exhibition with Picasso, Braque, and Laurens in Oslo. Exhibits his latest paintings at Paul Rosenberg's gallery. Does his first independent paper cutouts, a medium which he had previously used for maquettes for decorative projects. Spends the summer in Paris. In the fall, he moves to the Hôtel Régina in Cimiez, a suburb of Nice on a hill overlooking the city. Has one-man shows at the Paul Rosenberg gallery in Paris and the Pierre Matisse gallery in New York. Paints *Song*, a commissioned overmantel decoration for Nelson Rockefeller's apartment in New York. Continues his series of *Rumanian Blouse* drawings. Interviewed by Montherlant (Text 24).

1939

First performance of *Le Rouge et le noir* in Monte Carlo. Matisse works in the Hôtel Lutetia in Paris during the summer. Publishes "Notes of a Painter on his Drawing" (Text 25). In late August, he travels to Geneva to see an exhibition of paintings from Spain, but the imminent prospect of war forces him to return to France by 27 August. Germany invades Poland on 1 September; France declares war two days later. Matisse returns to Nice in October, where he stays at the Hôtel Régina. (Before leaving Paris, he has all of his works there stored in a vault at the Banque de France.)

1940

Goes to Paris in April to finalize his separation from Madame Matisse. Obtains a Brazilian visa and boat ticket, planning to leave on 8 June, but then changes his mind and decides to remain in France. (In September he will write to his son Pierre in New York: "When I saw everything in such a mess I had them reimburse my ticket. It seemed to me as if I would be deserting. If everyone who has any value leaves France, what remains of France?") Leaves Paris by train around 20 May, with Lydia Delectorskaya, just ahead of the invading German armies. Goes to Bordeaux in May, then to Ciboure. Paris falls to the Germans in June and France agrees to an armistice. The country is divided into an occupied zone in the north, and the "Vichy" regime in the south. Matisse returns to Nice via Carcasonne and Marseille. Corresponds with Picasso, Marquet, and Bonnard. Suffers worsening intestinal disorders and is diagnosed with a tumor.

1941

In January, he undergoes surgery for duodenal cancer at the Clinique du Parc in Lyon. Nearly dies of complications following surgery but eventually makes a strong recovery. Pierre Courthion begins a series of interviews on 5 April, with the plan that they will be made into an autobiographical book to be illustrated by Matisse and published by Skira in Geneva; the interviews continue after Matisse returns to Nice in May. He tells Courthion that "It's like a rebirth, and I now consider time in a completely different way than before the operation. Now I'm more balanced." Stenographic transcripts of the interviews are made, and the typescript is completed; but in October Matisse decides not to publish the interviews. Instead he agrees to illustrate Ronsard's poems for Skira (*Florilège des amours de Ronsard* will be published in 1948).

The operation and ensuing illness leave Matisse seriously affected; damage to the muscular wall of his abdomen causes him permanent weakness so that he is able to hold himself erect only for limited periods of time, and he becomes a semi-invalid, often painting and drawing in bed. He begins the "Thèmes et variations" drawings. Plans to illustrate *Pasiphäe* by Henry de Montherlant. Paints extremely bold still lifes, notably *Red Still Life with a Magnolia*. Interviewed by Carco (Text 26). Meets Louis Aragon and Elsa Triolet, who are living in Nice.

1942

Early in the year, Matisse gives two interviews that are broadcast on Vichy radio (Text 28). Louis Aragon visits him in Cimiez and undertakes to write the introduction for *Thèmes et variations* (see Text 29). Matisse exchanges paintings with Picasso. Gall bladder attacks keep him bedridden for more than two months and prevent him from working until mid-August. He works on illustrations for the *Poèmes* of Charles d'Orléans.

1943

Matisse remains in Nice at the Hôtel Régina until late June, working mainly in bed. His nurse, Monique Bourgeois, who models for him, will later become Sister Jacques of the Dominican Nuns at Vence and play an important role in the realization of the Vence chapel. In addition to painting and working on the Ronsard illustrations, he begins the paper cutouts that will eventually form the book *Jazz*, published in 1947. Following an air raid at Cimiez, he moves inland to the villa "Le Rêve" at Vence; this will remain his principal residence until 1949. Publication of *Dessins: Thèmes et variations* (see Text 29).

1944

Mme Matisse and Marguerite, both active in the Resistance, are arrested and sentenced to prison terms. Marguerite is almost deported, then imprisoned until the Allies' liberation of Paris in August. *Pasiphäe* is published in Paris in May. Matisse is commissioned to paint a triptych using the theme of *Leda and the Swan* for the Argentinean ambassador (see Text 33). Picasso arranges for Matisse to be represented at the

Salon d'Automne in celebration of the liberation (the exhibition includes Matisse's *Still Life with Oranges* of 1912, which Picasso owns). Matisse works on illustrations for *Les fleurs du mal* by Baudelaire.

1945

In January, Matisse is visited by his daughter Marguerite, who tells him about her imprisonment. Matisse stays in Paris from July to November; is given a retrospective exhibition (37 paintings) in the Salle d'Honneur of the Salon d'Automne. Matisse and Picasso have simultaneous one-man shows at the Victoria and Albert Museum, London; these exhibitions are later shown at the Palais des Beaux-Arts in Brussels (May 1946). Matisse returns to Vence in late November. He exhibits in Paris at the Galerie Maeght's inaugural exhibition. The French state acquires six Matisse paintings for the newly created Musée National d'Art Moderne, including *Le Luxe I* (1907), *The Painter in His Studio* (1916), and *Red Still Life with a Magnolia* (1941). Gaston Diehl publishes Matisse's "Role and Modalities of Color" (Text 31). Tériade publishes a special Matisse issue of Verve, "De la couleur," which contains color reproductions of his 1941–1944 paintings.

1946

Begins to paint a series of intensely colored interiors at Vence; these will be published in *Verve* in 1948, and will comprise his last sustained achievement as a painter. He is visited by Picasso and Françoise Gilot at Nice, the first of several visits made between 1946 and 1954. He appears in a documentary film by François Campaux, in which he is seen working and speaking about his pictures. Illustrates the *Lettres portugaises* by Marianna Alcaforado and *Visages* by Pierre Reverdy. Works on large-scale paper cutouts: *Oceania, the Sky*, and *Oceania, the Sea* (see Text 36).

1947

Matisse elevated to a Commander of the Legion of Honor. Pierre Bonnard dies on 23 January. Publication of *Les fleurs du mal*. Matisse returns to Vence in April, after an absence of ten months. He turns down a new contract with Paul Rosenberg because he plans to do little painting in the future; says he will concentrate instead on decorative projects. Albert Marquet dies on 13 June. Matisse goes to Paris in the early fall for the publication of *Jazz* (Text 37). In December, he receives a visit from Brother Rayssiguier, a Dominican novice, concerning possible decorations for a Dominican chapel in Vence. Publishes "The Path of Color" (Text 39).

1948

An exhibition of his works (93 paintings, 19 sculptures, and 86 drawings) is organized by Henry Clifford at the Philadelphia Museum of Art; the catalogue includes texts by Matisse (Texts 40, 41). Meets Brother Rayssiguier again in April. Spends the summer in Paris, returning to Vence in October. Designs a figure of St. Dominic for the church of Notre-Dame-de-Toute-Grace at Assy. Works on cutouts and on the designs for the Chapelle du Rosaire of the Dominican nuns in Vence (see Texts 46, 47). Publication of *Florilège des amours de Ronsard*.

1949

Returns to the Hôtel Régina in Nice, where he works on the Vence chapel project. Exhibits recent paintings and cutouts (for the first time) at the Pierre Matisse Gallery, New York. Paper cutouts and other recent works are exhibited at Musée National d'Art Moderne. Retrospective exhibition at Lucerne. The Cone collection is bequeathed to the Baltimore Museum of Art. The foundation stone of the Vence chapel is laid.

1950

Models for the Chapel of the Rosary are shown for the first time at an exhibition at the Maison de la Pensée Française in Paris (along with 51 sculptures, including the five *Jeannette* heads, shown together for the first time, and 15 drawings). Matisse works on large-scale paper cutouts. Wins the grand prize at

the 25th Venice Biennale, which he shares with the sculptor Henri Laurens. Publication of *Poèmes de Charles d'Orléans*. Interviewed for French radio by Georges Charbonnier (Text 41).

1951

The Chapel of the Rosary in Vence is consecrated on 25 June; Pierre Matisse represents his ailing father, who cannot attend. Matisse publishes two short essays about the chapel (Texts 46, 47). A major exhibition is mounted by the Museum of Modern Art, New York (144 works); it travels to Cleveland, Chicago, and San Francisco. Alfred Barr publishes *Matisse, His Art and His Public*. Tériade publishes "Matisse Speaks," an extensive autobiographical statement by Matisse (Text 48). Matisse does his last painting, *Woman in a Blue Gondoura Dress*. (He had completed no other paintings since 1948.) Works on paper cutouts and large brush drawings.

1952

Works on large cutouts, including the series of *Blue Nude* cutouts, *The Swimming Pool*, and *Memory of Oceania*, which is a kind of culmination of his South Seas imagery. Has exhibitions at Knokke-le-Zoute in Belgium and in Stockholm. The Musée Matisse is inaugurated at Le Cateau-Cambrésis on 8 November. Matisse gives extensive interviews to André Verdet (Text 50).

1953

Works on the mural-size cutout *Large Decoration with Masks* and other large works for ceramic tile commissions. The first exhibition given over entirely to Matisse's cutouts takes place at the Berggruen Gallery, Paris. Exhibitions of his sculptures are shown in London and New York. Three important paintings and related drawings are exhibited in Oslo and in three cities in the United States. "Looking at Life with the Eyes of a Child" is published (Text 51).

1954

An exhibition of his paintings is shown at the Paul Rosenberg Gallery, New York. Gaston Diehl's *Henri Matisse*, the most extensive French monograph, is published on 20 March. Simon Bussy dies on 20 May. Alberto Giacometti makes a dozen drawings of Matisse during visits to the Hôtel Régina between 20 May and 6 July, and again in September. André Derain dies on 8 September. Matisse's book *Portraits* (Text 52) is prepared for publication; it will appear posthumously, on 20 December. Matisse designs the rose window for the Union Church of Pocantico Hills, New York, which was commissioned by Nelson Rockefeller in memory of his mother. This is Matisse's last work.

Henri Matisse dies in Nice on 3 November. He is buried in the cemetery on the hilltop at Cimiez, in a plot of ground offered by the city of Nice.

Appendix:

Selected French Texts

Un peintre qui s'adresse au public, non plus pour lui présenter ses œuvres, mais pour lui dévoiler quelques-unes de ses idées sur l'art de peindre, s'expose à plusieurs dangers.

Tout d'abord, si je sais que beaucoup de personnes se plaisent à regarder la peinture comme une dépendance de la littérature, et à lui demander d'exprimer, non des idées générales qui conviennent à ses moyens, mais des idées spécifiquement littéraires, je crains qu'on ne voit pas sans étonnement le peintre se risquer à empiéter sur le domaine de l'homme de lettres; j'ai pleinement conscience, en effet, que la meilleure démonstration qu'il puisse donner de sa manière est celle qui résultera de ses toiles.

Pourtant, des artistes comme Signac, Desvallières, Denis, Blanche, Guérin, Bernard, ont écrit des pages auxquelles les revues ont fait accueil. Pour moi, je tenterai d'exposer simplement mes sentiments et mes désirs de peintre, sans y apporter de préoccupation d'écriture.

Mais un autre danger que j'entrevois maintenant, c'est d'avoir l'air de me contredire. Je sens très fortement le lien qui unit mes toiles les plus récentes à celles que j'ai peintes autrefois. Cependant, je ne pense pas exactement ce que je pensais hier. Ou plutôt, le fond de ma pensée n'a pas changé, mais ma pensée a évolué et mes moyens d'expression l'ont suivie. Je ne répudie aucune de mes toiles, et il n'en est pas une que je ne refasse autrement, si j'avais à la refaire. Je tends toujours vers le même but, mais je calcule différemment ma route pour y aboutir.

Enfin, s'il m'arrive de citer le nom de tel ou tel artiste, ce sera sans doute pour faire ressortir ce que sa manière a de contraire à la mienne, et on en conclura que je fais peu de cas de ses œuvres. Ainsi je risquerais d'être taxé d'injustice à l'égard des peintres dont, peut-être, je comprends le mieux la recherche, ou dont je goûte le plus pleinement les réalisations, alors que j'aurai pris leur exemple, non pour m'attribuer aucune supériorité sur eux, mais pour marquer plus clairement, en montrant ce qu'ils ont fait, ce que je tente de mon côté.

~

Ce que je poursuis par-dessus tout, c'est l'expression. Quelquefois, on m'a concédé une certaine science, tout en déclarant que mon ambition était bornée et n'allait pas au-delà de la satisfaction d'ordre purement visuel que peut procurer la vue d'un tableau. Mais la pensée d'un peintre ne doit pas être considérée en dehors de ses moyens, car elle ne vaut qu'autant qu'elle est servie par des moyens qui doivent être d'autant plus complets (et, par complets, je n'entends pas compliqués) que sa pensée est plus profonde. Je ne puis pas distinguer entre le sentiment que j'ai de la vie et la façon dont je le traduis.

L'expression, pour moi, ne réside pas dans la passion qui éclatera sur un visage ou qui s'affirmera par un mouvement violent. Elle est dans toute la disposition de mon tableau: la place qu'occupent les corps, les vides qui sont autour d'eux, les proportions, tout cela y a sa part. La composition est l'art d'arranger de manière décorative les divers éléments dont le peintre dispose pour exprimer ses sentiments. Dans un tableau, chaque partie sera visible et viendra jouer le rôle qui lui revient, principal ou secondaire. Tout ce qui n'a pas d'utilité dans le tableau est, par là même, nuisible. Une œuvre comporte

une harmonie d'ensemble: tout détail superflu prendrait, dans l'esprit du spectateur, la place d'un autre détail essentiel.

La composition, qui doit viser à l'expression, se modifie avec la surface à couvrir. Si je prends une feuille de papier d'une dimension donnée, j'y tracerai un dessin qui aura un rapport nécessaire avec son format. Je ne répéterais pas ce même dessin sur une autre feuille dont les proportions seraient différentes, qui par exemple serait rectangulaire au lieu d'être carrée. Mais je ne me contenterais pas de l'agrandir si je devais le reporter sur une feuille de forme semblable, mais dix fois plus grande. Le dessin doit avoir une force d'expansion qui vivifie les choses qui l'entourent. L'artiste qui veut reporter une composition d'une toile sur une toile plus grande doit, pour en conserver l'expression, la concevoir à nouveau, la modifier dans ses apparences, et non pas simplement la mettre au carreau.

~

On peut obtenir par les couleurs, en s'appuyant sur leur parenté ou sur leurs contrastes, des effets pleins d'agrément. Souvent, quand je me mets au travail, dans une première séance je note des sensations fraîches et superficielles. Il y a quelques années, ce résultat parfois me suffisait. Si je m'en contentais aujourd'hui, alors que je pense voir plus loin, il resterait un vague dans mon tableau: j'aurais enregistré les sensations fugitives d'un moment qui ne me définiraient pas entièrement, et que je reconnaîtrais à peine le lendemain.

Je veux arriver à cet état de condensation des sensations qui fait le tableau. Je pourrais me contenter d'une œuvre de premier jet, mais elle me lasserait de suite, et je préfère la retoucher pour pouvoir la reconnaître plus tard comme une représentation de mon esprit. A une autre époque, je ne laissais pas mes toiles accrochées au mur, parce qu'elles me rappelaient des moments de surexcitation, et je n'aimais pas à les revoir étant calme. Aujourd'hui, j'essaie d'y mettre du calme, et je les reprends tant que je n'ai pas abouti.

J'ai à peindre un corps de femme: d'abord, je lui donne de la grâce, un charme, et il s'agit de lui donner quelque chose de plus. Je vais condenser la signification de ce corps, en recherchant ses lignes essentielles. Le charme sera moins apparent au premier regard, mais il devra se dégager à la longue de la nouvelle image que j'aurai obtenue, et qui aura une signification plus large, plus pleinement humaine. Le charme en sera moins saillant, n'en étant pas toute la caractéristique, mais il n'en existera pas moins, contenu dans la conception générale de ma figure.

~

Le charme, la légèreté, la fraîcheur, autant de sensations fugaces. J'ai une toile aux teintes fraîches et je la reprends. Le ton va sans doute s'alourdir. Au ton que j'avais en succédera un autre qui, ayant plus de densité, le remplacera avantageusement, quoique moins séduisant pour l'œil.

Les peintres impressionnistes, Monet, Sisley, en particulier, ont des sensations fines, peu distantes les unes des autres: il en résulte que leurs toiles se ressemblent toutes. Le mot impressionnisme convient parfaitement à leur manière, car ils rendent des impressions fugitives. Il ne peut subsister pour désigner certains peintres plus récents qui évitent la première impression et la regardent presque comme mensongère. Une traduction rapide du paysage ne donne de lui qu'un moment de sa durée. Je préfère, en insistant sur son caractère, m'exposer à perdre le charme et obtenir plus de stabilité.

Sous cette succession de moments qui compose l'existence superficielle des êtres et des choses, et qui les revêt d'apparences changeantes, tôt disparues, on peut rechercher un caractère plus vrai, plus essentiel, auquel l'artiste s'attachera pour donner de la réalité une interprétation plus durable. Quand nous entrons dans les salles de la sculpture du XVIIᵉ ou du XVIIIᵉ siècles, au Louvre, et que nous regardons, par exemple, un Puget, nous constatons que l'expression est forcée et s'exagère au point d'inquiéter. C'est encore bien autre chose si nous allons au Luxembourg: l'attitude dans laquelle les sculpteurs prennent le modèle est toujours celle qui comporte le plus grand développement des membres, la tension la plus forte des muscles. Mais le mouvement ainsi compris ne correspond à rien dans la nature: quand nous le surprenons au moyen d'un instantané, l'image qui en résulte ne nous rappelle rien que

nous ayons vu. Le mouvement saisi dans son action n'a de sens pour nous que si nous n'isolons pas la sensation présente de celle qui la précède, ni de celle qui la suit.

Il y a deux façons d'exprimer les choses: l'une est de les montrer brutalement, l'autre de les évoquer avec art. En s'éloignant de la *représentation* littérale du mouvement, on aboutit à plus de beauté et plus de grandeur. Regardons une statue égyptienne: elle nous paraît raide; nous sentons pourtant en elle l'image d'un corps doué de mouvement et qui, malgré sa raideur, est animé. Les Antiques Grecs sont calmes, eux aussi: un homme qui lance un disque sera pris au moment où il se ramasse sur lui-même, ou du moins, s'il est dans la position la plus forcée et la plus précaire que comporte son geste, le sculpteur l'aura résumée dans un raccourci qui aura rétabli l'équilibre et réveillé l'idée de la durée. Le mouvement est, par lui-même, instable, et ne convient pas à quelque chose de durable comme une statue, à moins que l'artiste ait eu conscience de l'action entière dont il ne représente qu'un moment.

<center>〰</center>

Il est nécessaire que je précise le caractère de l'objet ou du corps que je veux peindre. Pour y arriver, j'étudie mes moyens d'une manière très serrée: si je marque d'un point noir une feuille blanche, aussi loin que j'écarte la feuille, le point restera visible: c'est une écriture claire. Mais à côté de ce point, j'en ajoute un autre, puis un troisième, et déjà, il y a confusion. Pour qu'il garde sa valeur, il faut que je le grossisse au fur et à mesure que j'ajoute un autre signe sur le papier.

Si, sur une toile blanche, je disperse des sensations de bleu, de vert, de rouge, à mesure que j'ajoute des touches, chacune de celles que j'ai posées antérieurement perd de son importance. J'ai à peindre un intérieur: j'ai devant moi une armoire, elle me donne une sensation de rouge bien vivant, et je pose un rouge qui me satisfait. Un rapport s'établit de ce rouge au blanc de la toile. Que je pose à côté un vert, que je rende le parquet par un jaune, et il y aura encore, entre ce vert ou ce jaune et le blanc de la toile des rapports qui me satisferont. Mais ces différents tons se diminuent mutuellement. Il faut que les signes divers que j'emploie soient équilibrés de telle sorte qu'ils ne se détruisent pas les uns les autres. Pour cela, je dois mettre de l'ordre dans mes idées: la relation entre les tons s'établira de telle sorte qu'elle les soutiendra au lieu de les abattre. Une nouvelle combinaison de couleurs succédera à la première et donnera la totalité de ma représentation. Je suis obligé de transposer, et c'est pour cela qu'on se figure que mon tableau a totalement changé lorsque, après des modifications successives, le rouge y a remplacé le vert comme dominante. Il ne m'est pas possible de copier servilement la nature, que je suis forcé d'interpréter et de soumettre à l'esprit du tableau. Tous mes rapports de tons trouvés, il doit en résulter un accord de couleurs vivant, une harmonie analogue à celle d'une composition musicale.

Pour moi, tout est dans la conception. Il est donc nécessaire d'avoir, dès le début, une vision nette de l'ensemble. Je pourrais citer un très grand sculpteur qui nous donne des morceaux admirables: mais, pour lui, une composition n'est qu'un groupement de morceaux, et il en résulte de la confusion dans l'expression. Regardez au contraire un tableau de Cézanne: tout y est si bien combiné qu'à n'importe quelle distance, et quel que soit le nombre des personnages, vous distinguerez nettement les corps et comprendrez auquel d'entre eux tel ou tel membre va se raccorder. S'il y a dans le tableau beaucoup d'ordre, beaucoup de clarté, c'est que, dès le début, cet ordre et cette clarté existaient dans l'esprit du peintre, ou que le peintre avait conscience de leur nécessité. Des membres peuvent se croiser, se mélanger, chacun cependant reste toujours, pour le spectateur, rattaché au même corps et participe à l'idée du corps: toute confusion a disparu.

<center>〰</center>

La tendance dominante de la couleur doit être de servir le mieux possible l'expression. Je pose mes tons sans parti pris. Si au premier abord, et peut-être sans que j'en aie eu conscience, un ton m'a séduit ou arrêté, je m'apercevrai le plus souvent, une fois mon tableau fini, que j'ai respecté ce ton, alors que j'ai progressivement modifié et transformé tous les autres. Le côté expressif des couleurs s'impose à moi de façon purement instinctive. Pour rendre un paysage d'automne, je n'essaierai pas de me rappeler quelles teintes conviennent à cette saison, je m'inspirerai seulement de la sensation qu'elle me procure: la

pureté glacée du ciel, qui est d'un bleu aigre, exprimera la saison tout aussi bien que le nuancement des feuillages. Ma sensation elle-même peut varier: l'automne peut être doux et chaud comme un prolongement de l'été, ou au contraire frais avec un ciel froid et des arbres jaune citron qui donnent une impression de froid et déjà annoncent l'hiver.

Le choix de mes couleurs ne repose sur aucune théorie scientifique: il est basé sur l'observation, sur le sentiment, sur l'expérience de ma sensibilité. S'inspirant de certaines pages de Delacroix, un artiste comme Signac se préoccupe des complémentaires, et leur connaissance théorique le portera à employer, ici ou là, tel ou tel ton. Pour moi, je cherche simplement à poser des couleurs qui rendent ma sensation. Il y a une proportion nécessaire des tons qui peut m'amener à modifier la forme d'une figure ou à transformer ma composition. Tant que je ne l'ai pas obtenue pour toutes les parties, je la cherche et je poursuis mon travail. Puis, il arrive un moment où toutes les parties ont trouvé leurs rapports définitifs, et dès lors, il me serait impossible de rien retoucher à mon tableau sans le refaire entièrement.

En réalité, j'estime que la théorie même des complémentaires n'est pas absolue. En étudiant les tableaux des peintres dont la connaissance des couleurs repose sur l'instinct et le sentiment, sur une analogie constante de leurs sensations, on pourrait préciser sur certains points les lois de la couleur, reculer les bornes de la théorie des couleurs telle qu'elle est actuellement admise.

∼

Ce qui m'intéresse le plus, ce n'est ni la nature morte, ni le paysage, c'est la figure. C'est elle qui me permet le mieux d'exprimer le sentiment pour ainsi dire religieux que je possède de la vie. Je ne m'attache pas à détailler tous les traits du visage, à les rendre un à un dans leur exactitude anatomique. Si j'ai un modèle italien, dont le premier aspect ne suggère que l'idée d'une existence purement animale, je découvre cependant chez lui des traits essentiels, je pénètre, parmi les lignes de son visage, celles qui traduisent ce caractère de haute gravité qui persiste dans tout être humain. Une œuvre doit porter en elle-même sa signification entière et l'imposer au spectateur avant même qu'il en connaisse le sujet. Quand je vois les fresques de Giotto à Padoue, je ne m'inquiète pas de savoir quelle scène de la vie du Christ j'ai devant les yeux, mais de suite, je comprends le sentiment qui s'en dégage, car il est dans les lignes, dans la composition, dans la couleur, et le titre ne fera que confirmer mon impression.

Ce que je rêve, c'est un art d'équilibre, de pureté, de tranquillité, sans sujet inquiétant ou préoccupant, qui soit, pour tout travailleur cérébral, pour l'homme d'affaires aussi bien que pour l'artiste des lettres, par exemple, un lénifiant, un calmant cérébral, quelque chose d'analogue à un bon fauteuil qui le délasse de ses fatigues physiques.

On discute souvent sur la valeur des différents procédés, sur leurs rapports avec les divers tempéraments. On aime à faire une distinction entre les peintres qui travaillent directement d'après nature, et ceux qui travaillent purement d'imagination. Pour moi, je ne crois pas qu'il faille prôner l'une de ces deux méthodes de travail à l'exclusion de l'autre. Il arrive que toutes deux soient employées tour à tour par le même individu, soit qu'il ait besoin de la présence des objets pour recevoir des sensations et par là même surexciter sa faculté créatrice, soit que ses sensations se soient déjà classées, et dans les deux cas, il pourra parvenir à cet ensemble qui constitue le tableau. Cependant, je crois qu'on peut juger de la vitalité et de la puissance d'un artiste, lorsque impressionné directement par le spectacle de la nature il est capable d'organiser ses sensations et même de revenir à plusieurs fois et à des jours différents dans un même état d'esprit, de les continuer: un tel pouvoir implique un homme assez maître de lui pour s'imposer une discipline.

Les moyens les plus simples sont ceux qui permettent le mieux au peintre de s'exprimer. S'il a peur de la banalité, il ne l'évitera pas en se représentant par un extérieur étrange, en donnant dans les bizarreries du dessin ou les excentricités de la couleur. Ses moyens doivent dériver presque nécessairement de son tempérament. Il doit avoir cette simplicité d'esprit qui le portera à croire qu'il a peint seulement ce qu'il a vu. J'aime ce mot de Chardin: «Je mets de la couleur jusqu'à ce que ce soit ressemblant». Cet autre de Cézanne: «Je veux faire l'image» et aussi celui de Rodin: «Copiez la nature». Vinci

disait: «Qui sait copier sait faire». Les gens qui font du style de parti pris et s'écartent volontairement de la nature sont à côté de la vérité. Un artiste doit se rendre compte, quand il raisonne, que son tableau est factice, mais quand il peint, il doit avoir ce sentiment qu'il a copié la nature. Et même quand il s'en est écarté, il doit lui rester cette conviction que ce n'a été que pour la rendre plus complètement.

<div align="center">~</div>

On me dira peut-être qu'il était permis d'attendre d'un peintre d'autres vues sur la peinture, et qu'en somme je n'ai sorti que des lieux communs. A cela, je répondrai qu'il n'est pas de vérités nouvelles. Le rôle de l'artiste, comme celui du savant, se base à saisir des vérités courantes qui lui ont été souvent redites, mais qui prendront pour lui une nouveauté, et qu'il fera siennes le jour où il aura pressenti leur sens profond. Si les aviateurs avaient à exposer leurs recherches, à nous expliquer comment ils ont pu quitter la terre et s'élancer dans l'espace, ils nous donneraient simplement la confirmation de principes de physique très élémentaires que les inventeurs moins heureux ont négligés.

Un artiste gagne toujours à être renseigné sur son propre compte, et je me félicite d'avoir appris quel était mon point faible. M. Peladan, dans la *Revue Hebdomadaire*, reproche à un certain nombre de peintres, parmi lesquels je crois bien devoir me ranger, de se faire appeler les «Fauves» et de s'habiller comme tout le monde, de telle sorte que leur prestance n'est pas au-dessus de celle des chefs de rayons des grands magasins. Le génie tient-il à si peu de chose? S'il ne s'agit que de moi, que M. Peladan se rassure: demain, je me fais appeler Sar et je m'habille en nécromant.

Dans le même article, l'excellent écrivain prétend que je ne peins pas honnêtement, et j'aurais le droit de me fâcher, s'il ne prenait soin de compléter sa pensée par une définition restrictive: «Honnête-ment, j'entends dans le respect de l'idéal et des règles.» Le malheur est qu'il ne nous dit pas où sont ces règles. Je veux bien qu'elles existent, mais s'il était possible de les apprendre, que d'artistes sublimes nous aurions!

Les règles n'ont pas d'existence en dehors des individus: sinon aucun professeur ne le céderait en génie à Racine. N'importe qui d'entre nous est capable de redire de belles sentences, mais bien peu de ceux qui les auront dites, en auront pénétré le sens. Qu'il se dégage un ensemble de règles plus complet d'une œuvre de Raphaël ou de Titien que d'une de Manet ou de Renoir, je suis prêt à l'admettre, mais les règles qu'on trouvera chez Manet ou chez Renoir sont celles qui convenaient à leur nature et je préfère la moindre de leurs peintures à toutes celles des peintres qui se sont contentés de démarquer la *Vénus au petit chien* ou la *Vierge au Chardonneret*. Ces derniers ne donneront le change à personne, car bon gré mal gré, nous appartenons à notre temps et nous partageons ses opinions, ses sentiments et même ses erreurs. Tous les artistes portent l'empreinte de leur époque, mais les grands artistes sont ceux en qui elle est marquée le plus profondément. Celle où nous sommes, Courbet la représente mieux que Flandrin, Rodin mieux que Frémiet. Que nous le voulions ou non, et quelque insistance que nous mettions à nous y dire exilés, il s'établit entre elle et nous une solidarité à laquelle M. Peladan lui-même ne saurait échapper. Car c'est peut-être ses livres que les esthéticiens de l'avenir prendront comme exemple, quand ils se mettront en tête de prouver que personne de nos jours n'a rien compris à l'art de Léonard de Vinci.

<div align="center">

TEXT 12

From ENTRETIEN AVEC TÉRIADE, 1929

</div>

Le Néo-Impressionnisme, ou plutôt cette partie qu'on appela le Divisionnisme fut la première mise en ordre des moyens de l'Impressionnisme, mais une mise en ordre purement physique; moyen souvent mécanique qui ne correspond qu'à une émotion physique. Le morcellement de la couleur y amena le morcellement de la forme, du contour. Résultat: une surface sautillante. Il n'y a qu'une sensation ré-tinienne mais qui détruit la tranquillité de la surface et du contour. Les objets ne se différencient que

par la luminosité qu'on leur donne. Tout est traité de la même façon. Il n'y a, en fin de compte, qu'une animation tactile comparable au «vibrato» du violon ou de la voix. Les toiles de Seurat devenant plus grises avec le temps perdirent ce qu'il y avait de formulaire dans l'agencement de leurs couleurs et ne gardèrent que leurs valeurs authentiques, ces valeurs humaines de la peinture qui ne sont aujourd'hui que plus profondes.

Je ne suis pas resté dans cette voie et je peignis par aplats en cherchant la qualité du tableau par un accord de toutes les couleurs plates. J'ai essayé de remplacer le «vibrato» par un accord plus expressif, plus direct, un accord dont la simplicité et la sincérité m'auraient procuré des surfaces plus tranquilles.

Le Fauvisme secoua la tyrannie du Divisionnisme. On ne peut pas vivre dans un ménage trop bien fait, un ménage de tantes de province. Alors on part dans la brousse; pour se faire des moyens plus simples qui n'étouffent pas l'esprit. Il y a aussi, à ce moment, l'influence de Gauguin et de Van Gogh. Voici les idées d'alors: construction par surfaces colorées. Recherche d'intensité dans la couleur, la matière étant indifférente. Réaction contre la diffusion du ton local dans la lumière. La lumière n'est pas supprimée mais elle se trouve exprimée par un accord des surfaces colorées intensément. Mon tableau *La Musique* était fait avec un beau bleu pour le ciel, le plus bleu des bleus (la surface était colorée à saturation, c'est-à-dire jusqu'au point où le bleu, l'idée du bleu absolu, apparaissait entièrement), le vert des arbres et le vermillon vibrant des corps. J'avais, avec ces trois couleurs, mon accord lumineux, et aussi la pureté dans la teinte. Signe particulier, la couleur était proportionnée à la forme. La forme se modifiait selon les réactions des voisinages colorés. Car l'expression vient de la surface colorée que le spectateur saisit dans son entier.

. . . Le peintre se décharge de son émotion en peignant; mais non sans que sa conception ait traversé certain état analytique. L'analyse se fait chez le peintre. Quand la synthèse est immédiate, elle est schématique, sans densité, et l'expression s'appauvrit.

Le Fauvisme ne se contenta pas de l'ordonnance physique du tableau comme le Divisionnisme. Il fut aussi la première recherche d'une synthèse expressive. Comparez Greco et Vélasquez. Chez le second l'émotion est uniquement physique. Elle ne va pas plus loin. Sans la volupté il n'y a rien, évidemment. Mais on peut demander à la peinture une émotion plus profonde et qui touche l'esprit aussi bien que les sens. Par contre, une peinture purement intellectuelle est inexistante. On ne peut même pas dire qu'elle ne va pas plus loin car elle ne commence pas. Elle reste enfermée dans l'intention du peintre et ne se réalise jamais.»

TEXT 21
PROPOS RAPPORTÉS PAR TÉRIADE, 1936

Quand les moyens se sont tellement affinés, tellement amenuisés que leur pouvoir d'expression s'épuise, il faut revenir aux principes essentiels qui ont formé le langage humain. Ce sont, alors, les principes qui «remontent», qui reprennent vie, qui nous donnent la vie. Les tableaux qui sont des raffinements, des dégradations subtiles, des fondus sans énergie, appellent des beaux bleus, des beaux rouges, des beaux jaunes, des matières qui remuent le fond sensuel des hommes. C'est le point de départ du fauvisme: le courage de retrouver la pureté des moyens.

Nos sens ont un âge de développement qui ne vient pas de l'ambiance immédiate, mais d'un moment de la civilisation. Nous naissons avec la sensibilité d'une époque de civilisation. Et cela compte beaucoup plus que tout ce que nous pourrons apprendre d'une époque. Les arts ont un développement qui ne vient pas seulement de l'individu, mais aussi de toute une force acquise, la civilisation qui nous précède. On ne peut pas faire n'importe quoi. Un artiste doué ne peut pas faire quoi que ce soit. S'il n'employait que ses dons, il n'existerait pas. Nous ne sommes pas maîtres de notre production. Elle nous est imposée.

Dans mes dernières peintures j'ai rattaché des acquisitions de ces vingt dernières années à mon fond essentiel, à mon essence même.

~

La réaction d'une étape est aussi importante que le sujet. Car cette réaction part de moi et non du sujet. C'est à partir de mon interprétation que je réagis continuellement jusqu'à ce que mon travail se trouve en accord avec moi. Comme quelqu'un qui fait sa phrase, il retravaille, il redécouvre . . . A chaque étape, j'ai un équilibre, une conclusion. A la séance suivante, si je trouve qu'il y a une faiblesse dans mon ensemble, je me réintroduis dans mon tableau par cette faiblesse—je rentre par la brèche—et je reconçois le tout. Si bien que tout reprend du mouvement et comme chacun des éléments n'est qu'une partie des forces (comme dans une orchestration), tout peut être changé en apparence, le sentiment poursuivi restant toujours le même. Un noir peut très bien remplacer un bleu puisqu'au fond l'expression vient des rapports. On n'est pas esclave d'un bleu, d'un vert ou d'un rouge. Vous pouvez changer les rapports en modifiant la quantité des éléments sans changer leur nature. C'est-à-dire, le tableau sera toujours fait avec un bleu, un jaune et un vert dont on modifie les quantités. Ou bien vous pouvez préciser les rapports qui constituent l'expression du tableau en remplaçant le bleu par un noir, comme à l'orchestre l'on remplacera une trompette par un hautbois.

. . . . A la dernière étape le peintre se trouve libéré et son émotion existe entière dans son œuvre. Lui-même, en tout cas, en est déchargé.

TEXT 25
NOTES D'UN PEINTRE SUR SON DESSIN, 1939

Mon éducation a consisté à me rendre compte des différents moyens d'expression de la couleur et du dessin. Mon éducation classique m'a naturellement porté à étudier les Maîtres, à les assimiler autant que possible en considérant, soit le volume, soit l'arabesque, soit les contrastes, soit l'harmonie et à rapporter mes réflexions dans mon travail d'après nature, jusqu'au jour où je me suis rendu compte qu'il m'était nécessaire d'oublier le métier des Maîtres ou plutôt de le comprendre, d'une manière toute personnelle. N'est-ce pas la règle de tout artiste de formation classique? Ensuite vint la connaissance et l'influence des arts de l'Orient.

Mon dessin au trait est la traduction directe et la plus pure de mon émotion. La simplification du moyen permet cela. Cependant, ces dessins sont plus complets qu'ils peuvent paraître à certains qui les assimileraient à une sorte de croquis. Ils sont générateurs de lumière; regardés dans un jour réduit ou bien dans un éclairage indirect, ils contiennent, en plus de la saveur et de la sensibilité de la ligne, la lumière et les différences de valeurs correspondant à la couleur, d'une façon évidente. Ces qualités sont aussi visibles en pleine lumière, pour beaucoup. Elles viennent de ce que ces dessins sont toujours précédés d'études faites avec un moyen moins rigoureux que le trait, le fusain par exemple ou l'estompe, qui permet de considérer simultanément le caractère du modèle, son expression humaine, la qualité de la lumière qui l'entoure, son ambiance et tout ce qu'on ne peut exprimer que par le dessin. Et c'est seulement lorsque j'ai la sensation d'être épuisé par ce travail, qui peut durer plusieurs séances que, l'esprit clarifié, je puis laisser aller ma plume avec confiance. J'ai alors le sentiment évident que mon émotion s'exprime par le moyen de l'écriture plastique. Aussitôt que mon trait ému a modelé la lumière de ma feuille blanche, sans en enlever sa qualité de blancheur attendrissante, je ne puis plus rien lui ajouter, ni rien en reprendre. La page est écrite; aucune correction n'est possible. Il n'y a plus qu'à recommencer si elle est insuffisante comme s'il s'agissait d'une acrobatie. Il contient, amalgamés selon mes possibilités de synthèse, les différents points de vue que j'ai pu, plus ou moins, assimiler par mon étude préliminaire.

Les bijoux ou les arabesques ne surchargent jamais mes dessins, d'après le modèle, car ces bijoux et

arabesques font partie de mon orchestration. Bien placés, ils suggèrent la forme ou l'accent de valeurs nécessaires à la composition du dessin. Ici, me revient la réflexion d'un médecin me disant: «Lorsqu'on regarde vos dessins, on est étonné de voir comme vous connaissez bien l'anatomie». Pour lui, mes dessins, dont le mouvement était exprimé par un rythme logique de lignes, lui avaient suggéré le jeu des muscles en action.

C'est pour libérer la grâce, le naturel que j'étudie tellement avant de faire un dessin à la plume. Je ne m'impose jamais violence; au contraire; je suis le danseur ou l'équilibriste qui commence sa journée par plusieurs heures de nombreux exercices d'assouplissement, de façon à ce que toutes les parties de son corps lui obéissent lorsque, devant son public, il veut traduire ses émotions par une succession de mouvements de danse, lents ou vifs ou par une pirouette élégante.

(A propos de perspective: mes dessins définitifs au trait ont toujours leur espace lumineux et les objets qui les constituent sont à leurs différents plans; donc en perspective, *mais en perspective de sentiment*, en perspective suggérée.)

J'ai tenu toujours le dessin, non comme un exercice d'adresse particulière, mais avant tout, comme un moyen d'expression de sentiments intimes et des descriptions d'état d'âme, mais, moyens simplifiés pour donner plus de simplicité, de spontanéité à l'expression qui doit aller sans lourdeur à l'esprit du spectateur.

Mes modèles, figures humaines, ne sont jamais des *figurantes* dans un intérieur. Elles sont le thème principal de mon travail. Je dépends absolument de mon modèle que j'observe en liberté, et c'est ensuite que je me décide pour lui fixer la pose qui correspond le plus *à son naturel*. Quand je prends un nouveau modèle, c'est dans son abandon au repose que je devine la pose qui lui convient et dont je me rends esclave. Je garde ces jeunes filles souvent plusieurs années, jusqu'à épuisement d'intérêt. Mes signes plastiques expriment probablement leur état d'âme (mot que je n'aime pas) auquel je m'intéresse inconsciemment ou bien alors à quoi? Leurs formes ne sont pas toujours parfaites, mais elles sont toujours expressives. L'intérêt émotif qu'elles m'inspirent ne se voit pas spécialement sur la représentation de leur corps, mais souvent par des lignes ou des valeurs spéciales qui sont répandues sur toute la toile ou sur le papier et en forment son orchestration, son architecture. Mais tout le monde ne s'en aperçoit pas. C'est peut-être de la volupté sublimée, ce qui n'est peut-être pas encore perceptible pour tout le monde.

On dit de moi: «Ce charmeur qui se plaît à charmer des monstres». Je n'ai jamais cru que mes créations étaient des monstres charmés, ou charmants. J'ai répondu à quelqu'un qui disait que je ne voyais pas les femmes comme je les représentais: «Si j'en rencontrais de pareilles dans la rue, je me sauverais épouvanté». Avant tout, je ne crée pas une femme, *je fais un tableau*.

Malgré l'absence de traits entrecroisés, d'ombres ou de demi-teintes, je ne m'interdis pas le jeu des valeurs, les modulations. Je module avec mon trait plus ou moins épais, et surtout par les surfaces qu'il délimite sur mon papier blanc. Je modifie des différentes parties de mon papier blanc, sans y toucher, mais par des voisinages. On voit ça très bien dans les dessins de Rembrandt, de Turner et d'une façon générale, dans ceux des coloristes.

En résumé, je travaille *sans théorie*. J'ai seulement conscience des forces que j'emploie et je vais, poussé par une idée que je ne connais vraiment qu'au fur et à mesure qu'elle se développe par la marche du tableau. Comme disait Chardin: «J'en remets (ou j'en retire, car je gratte beaucoup) jusqu'à ce que ça fasse bien».

Faire un tableau paraîtrait aussi logique que de construire une maison si on marchait avec de bons principes. Le côté *humain*, on ne doit pas s'en occuper. On l'a ou on ne l'a pas. Si on l'a, il colore l'œuvre malgré tout.

TEXT 31
RÔLE ET MODALITÉS DE LA COULEUR, 1945

Dire que la couleur est redevenue expressive, c'est faire son histoire. Pendant longtemps, elle ne fut qu'un complément du dessin. Raphaël, Mantegna ou Dürer, comme tous les peintres de la Renaissance, construisent par le dessin et ajoutent ensuite la couleur locale.

Au contraire, les Primitifs Italiens et surtout les Orientaux avaient fait de la couleur un moyen d'expression. L'on eut quelque raison de baptiser Ingres, un chinois ignoré à Paris, puisque le premier il va utiliser les couleurs franches, les limiter sans les dénaturer.

De Delacroix à Van Gogh et principalement Gauguin en passant par les Impressionnistes qui font du déblaiement et par Cézanne qui donne l'impulsion définitive et introduit les volumes colorés, on peut suivre cette réhabilitation du rôle de la couleur, la restitution de son pouvoir émotif.

~

Les couleurs ont une beauté propre qu'il s'agit de préserver comme en musique on cherche à conserver les timbres. Question d'organisation, de construction, susceptibles de ne pas altérer cette belle fraîcheur de la couleur.

Les exemples ne manquaient pas. Nous avions devant nous, non seulement des peintres, mais aussi l'art populaire, et les crépons japonais que l'on vendait alors. Le fauvisme fut ainsi pour moi l'épreuve des moyens: placer côte à côte, assembler d'une façon expressive et constructive un bleu, un rouge, un vert. C'était le résultat d'une nécessité qui se faisait jour en moi et non d'une attitude volontaire, une déduction ou un raisonnement, dont la peinture n'a que faire.

~

Ce qui compte le plus dans la couleur, ce sont les rapports. Grâce à eux et à eux seuls un dessin peut être intensément coloré sans qu'il soit besoin d'y mettre de la couleur.

Sans doute, il existe mille façons de travailler la couleur, mais quand on la compose, comme le musicien avec ses harmonies, il s'agit simplement de faire valoir des différences.

Certes la musique et la couleur n'ont rien de commun, mais elles suivent des voies parallèles. Sept notes, avec de légères modifications, suffisent à écrire n'importe quelle partition. Pourquoi n'en serait-il pas de même pour la plastique.

~

La couleur n'est jamais une question de quantité mais de choix.

A leurs débuts, les ballets russes, et particulièrement Schéhérazade de Bakst, regorgeaient de couleur. Profusion sans mesure. On eut dit qu'elle avait été jetée au baquet. L'ensemble était gai par la matière, non par l'organisation. Cependant, les ballets ont facilité l'emploi des moyens nouveaux dont ils ont eux-mêmes très largement bénéficié.

Une avalanche de couleurs reste sans force. La couleur n'atteint sa pleine expression que lorsqu'elle est organisée, lorsqu'elle correspond à l'intensité de l'émotion de l'artiste.

Dans le dessin, même formé d'un seul trait, on peut donner une infinité de nuances à chaque partie qu'il enclôt. La proportion joue un rôle primordial.

~

Il n'est pas possible de séparer dessin et couleur. Puisque celle-ci n'est jamais appliquée à l'aventure, du moment qu'il y a des limites et surtout des proportions, il y a scission. C'est là où intervient la création et la personnalité du peintre.

Le dessin compte beaucoup aussi. C'est l'expression de la possession des objets. Quand vous connaissez à fond un objet, vous pouvez le cerner par un trait extérieur qui le définira entièrement. Ingres disait à ce propos que le dessin est comme un panier, dont on ne peut enlever un osier sans faire un trou.

~

Tout, même la couleur, ne peut être qu'une création. Je décris d'abord mon sentiment avant d'en arriver à l'objet. Il faut alors tout recréer, aussi bien l'objet que la couleur.

Que les moyens employés par les peintres soient happés par la mode, par les grands magasins, ils perdent aussitôt leur signification. Ils ne disposent plus d'aucun pouvoir sur l'esprit. Leur influence ne fait que modifier l'apparence des choses; on change seulement de nuances.

〜

La couleur contribue à exprimer la lumière, non pas le phénomène physique mais la seule lumière qui existe en fait, celle du cerveau de l'artiste.

Chaque époque apporte avec elle sa lumière propre, son sentiment particulier de l'espace, comme un besoin. Notre civilisation, même pour ceux qui n'ont jamais fait d'avion, a amené une nouvelle compréhension du ciel, de l'étendue, de l'espace. On en vient aujourd'hui à exiger une possession totale de cet espace.

Suscités et soutenus par le divin tous les éléments se retrouveront dans la nature. Le créateur n'est-il pas lui-même la nature.

〜

Appelée et nourrie par la matière, recréée par l'esprit, la couleur pourra traduire l'essence de chaque chose et répondre en même temps à l'intensité du choc émotif. Mais dessin et couleur ne sont qu'une suggestion. Par illusion ils doivent provoquer chez le spectateur la possession des choses. Mais c'est dans la mesure où l'artiste est capable de se suggestionner et de faire passer sa suggestion dans son œuvre et dans l'esprit du spectateur. Un vieux proverbe chinois ne dit-il pas: quand on dessine un arbre on doit, au fur et à mesure, sentir qu'on s'élève.

〜

La couleur surtout et peut-être plus encore que le dessin est une libération.

La libération, c'est l'élargissement des conventions, les moyens anciens repoussés par les apports de la génération nouvelle. Comme le dessin et la couleur sont des moyens d'expression, ils sont modifiés.

D'où l'étrangeté des moyens nouveaux puisqu'ils se rapportent à autre chose que ce qui intéressait les générations précédentes.

〜

La couleur enfin est somptuosité et réclame. N'est-ce pas justement le privilège de l'artiste de rendre précieux, d'ennoblir le plus humble sujet.

TEXT 37
JAZZ, 1947

Notes
Pourquoi après avoir écrit: «Qui veut se donner à la peinture doit commencer par se faire couper la langue», ai-je besoin d'employer d'autres moyens que ceux qui me sont propres? Cette fois j'ai à présenter des planches de couleur dans des conditions qui leur soient les plus favorables. Pour cela, je dois les séparer par des intervalles d'un caractère différent. J'ai jugé que l'écriture manuscrite convenait le mieux à cet usage. La dimension exceptionnelle de l'écriture me semble obligatoire pour être en rapport décoratif avec le caractère des planches de couleur. Ces pages ne servent donc que d'accompagnement à mes couleurs comme des asters aident dans la composition d'un bouquet de fleurs d'une plus grande importance.

LEUR RÔLE EST DONC PUREMENT SPECTACULAIRE.

Que puis-je écrire? Je ne puis pourtant pas remplir ces pages avec des fables de La Fontaine, comme je le faisais, lorsque j'étais clerc d'avoué, pour les «conclusions grossoyées», que personne ne lit jamais, même pas le juge, et qui ne se font que pour user une quantité de papier timbré en rapport avec l'importance du procès.

Il ne me reste donc qu'à rapporter des remarques, des notes prises au cours de mon existence de peintre. Je demande pour elles, à ceux qui auront la patience de les lire, l'indulgence que l'on accorde en général aux écrits des peintres.

~

Le Bouquet

Dans une promenade au jardin je cueille fleur après fleur pour les masser dans le creux de mon bras l'une après l'autre au hasard de la cueillette. Je rentre à la maison avec l'idée de peindre ces fleurs. Après en avoir fait un arrangement à ma façon quelle déception: tout leur charme est perdu dans cet arrangement. Qu'est-il donc arrivé?

L'assemblage inconscient fait pendant la cueillette avec le goût qui m'a fait aller d'une fleur à l'autre est remplacé par un arrangement volontaire sorti de réminiscences de bouquets morts depuis longtemps, qui ont laissé dans mon souvenir leur charme d'alors dont j'ai chargé ce nouveau bouquet.

Renoir m'a dit: «Quand j'ai arrangé un bouquet pour le peindre, je m'arrête sur le côté que je n'avais pas prévu.»

~

L'Avion

Un simple voyage de Paris à Londres en avion nous donne une révélation du monde que notre imagination ne pouvait nous faire pressentir. En même temps que le sentiment de notre nouvelle situation nous ravit, il nous rend confus par le souvenir de soucis et d'ennuis par lesquels nous nous sommes laissés troubler, sur cette terre que nous apercevons au-dessous de nous, à travers les trous de la plaine de nuages que nous dominons, pendant qu'il existait un milieu enchanteur dans lequel nous sommes. Et lorsque nous serons revenus à notre modeste condition de piéton, nous ne sentirons plus le poids du ciel gris peser sur nous, car nous nous souviendrons que derrière ce mur facile à traverser, il existe la splendeur du soleil ainsi que la perception de l'espace illimité dans lequel nous nous sommes sentis un moment si libres.

Ne devrait-on pas faire accomplir un grand voyage en avion aux jeunes gens ayant terminé leurs études.

Le caractère d'un visage dessiné ne dépend pas de ses diverses proportions mais d'une lumière spirituelle qu'il reflète. Si bien que deux dessins du même visage peuvent représenter le même caractère bien que les proportions des visages de ces deux dessins soient différentes. Dans un figuier aucune feuille n'est pareille à une autre; elles sont toutes différentes de forme; cependant chacune crie: Figuier.

~

Si j'ai confiance en ma main qui dessine, c'est que pendant que je l'habituais à me servir, je me suis efforcé à ne jamais lui laisser prendre le pas sur mon sentiment. Je sens très bien, lorsqu'elle paraphrase, s'il y a désaccord entre nous deux: entre elle et le je ne sais quoi en moi qui paraît lui être soumis.

La main n'est que le prolongement de la sensibilité et de l'intelligence. Plus elle est souple, plus elle est obéissante. Il ne faut pas que la servante devienne maîtresse.

~

Dessiner avec des ciseaux

Découper à vif dans la couleur me rappelle la taille directe des sculpteurs.

Ce livre a été conçu dans cet esprit.

~

Mes courbes ne sont pas folles

Le fil à plomb en déterminant la direction verticale forme avec son opposée, l'horizontale, la Boussole

du dessinateur. Ingres se servait du fil à plomb. Voyez dans ses dessins d'études de figures debout cette ligne non effacée qui passe par le sternum et la malléole interne de la «jambe qui porte».

Autour de cette ligne fictive évolue «l'arabesque». J'ai tiré de l'usage que j'ai fait du fil à plomb un bénéfice constant. La verticale est dans mon esprit. Elle m'aide à préciser la direction des lignes, et dans mes dessins rapides, je n'indique pas une courbe, par exemple celle d'une branche dans un paysage, sans avoir conscience de son rapport avec la verticale.

Mes courbes ne sont pas folles.

~

Un nouveau tableau doit être une chose unique, une naissance apportant une figure nouvelle dans la représentation du monde à travers l'esprit humain. L'artiste doit apporter toute son énergie, sa sincérité et la modestie la plus grande pour écarter pendant son travail les vieux clichés qui viennent si facilement à sa main et peuvent étouffer la petite fleur qui ne vient, elle, jamais telle qu'on l'attend.

~

Un musicien a dit:

En art la vérité, le réel commence quand on ne comprend plus rien à ce qu'on fait, à ce qu'on sait, et qu'il reste en vous une énergie d'autant plus forte qu'elle est contrariée, compressée, comprimée. Il faut alors se présenter avec la plus grande humilité, tout blanc, tout pur, candide, le cerveau semblant vide, dans un état d'esprit analogue à celui du communiant approchant de la Sainte Table. Il faut évidemment avoir tout son acquis derrière soi et avoir su garder la fraîcheur de l'Instinct.

~

Si je crois en Dieu?

Oui, quand je travaille. Quand je suis soumis et modeste, je me sens tellement aidé par quelqu'un qui me fait faire des choses qui me surpassent. Pourtant je ne me sens envers lui aucune reconnaissance car c'est comme si je me trouvais devant un prestidigitateur dont je ne puis percer les tours. Je me trouve alors frustré du bénéfice de l'expérience qui devait être la récompense de mon effort. Je suis ingrat sans remord.

~

Jeunes peintres, peintres incompris ou tardivement compris—pas de Haine! La haine est un parasite qui dévore tout. On ne construit pas dans la haine mais dans l'amour. L'émulation est nécessaire, mais la haine . . .

L'amour au contraire soutient l'artiste.

~

«C'est une grande chose que l'amour, un bien tout à fait grand, qui seul rend léger ce qui est pesant et endure d'une âme égale ce qui est inégal. Car il porte le poids sans qu'il soit un fardeau et rend doux et savoureux tout ce qui est amer . . .

«L'amour veut être en haut et n'être retenu par rien de bas . . .

«Rien n'est plus doux que l'amour, rien n'est plus fort, rien n'est plus haut, rien n'est plus large, rien de plus aimable, rien de plus plein, rien de meilleur au ciel et sur la terre, parce que l'amour est né de Dieu, et ne peut se reposer sinon en Dieu, au-dessus de toutes les créatures. Celui qui aime vole, court et se réjouit; il est libre et rien ne le retient».

(Im. de J.C.)

~

Bonheur.

Tirer le bonheur de soi-même, d'une bonne journée de travail, de l'éclaircie qu'elle a pu apporter dans le brouillard qui nous entoure. Penser que tous ceux qui sont *arrivés*, en se souvenant des difficultés de leurs débuts, s'écrient avec conviction: «*C'était le bon temps*». Car pour la plupart: Arrivée = Prison, et

l'artiste ne doit jamais être *prisonnier*. Prisonnier? Un artiste ne doit jamais être: prisonnier de lui-même, prisonnier d'une manière, prisonnier d'une réputation, prisonnier d'un succès, etc . . . Les Goncourt n'ont-ils pas écrit que les artistes japonais de la grande époque changeaient de nom plusieurs fois dans leur vie. J'aime ça: ils voulaient sauvegarder leurs libertés.

Lagons,
Ne seriez-vous pas une des sept merveilles du Paradis des peintres?

～

Heureux ceux qui chantent de tout leur cœur, dans la droiture de leur cœur.

～

Trouver la joie dans le ciel, dans les arbres, dans les fleurs. Il y a des fleurs partout pour qui veut bien les voir.

～

La vie future.
Ne serait-il pas consolant, satisfaisant que tous ceux qui ont donné leur vie au développement de leurs dons naturels, au profit de tous, jouissent après leur mort, d'une vie de satisfactions en accord avec leur désir. Tandis que ceux qui ont vécu en étroits égoïstes . . .

～

Jazz
Ces images aux timbres vifs et violents sont venues de cristallisations de souvenirs du cirque, de contes populaires ou de voyage. J'ai fait ces pages d'écritures pour apaiser les réactions simultanées de mes improvisations chromatiques et rythmées, pages formant comme un «fond sonore» qui les porte, les entoure et protège ainsi leurs particularités.

Je rends ici hommage à Angèle Lamotte et à Tériade, leur persévérance m'a soutenu dans la réalisation de ce livre.

TEXT 49
TÉMOIGNAGES, 1951

Je ne pourrais rien dire de mon sentiment de l'espace qui ne soit déjà exprimé dans mes tableaux. Rien ne serait plus clair que ce que vous pouvez voir sur ce mur: cette jeune femme que j'ai peinte il y a trente ans . . . ce «bouquet de fleurs» . . . cette «femme endormie» qui datent seulement de ces dernières années et, derrière vous, ce plan définitif d'un vitrail constitué en papiers de couleur découpés.

De «La joie de vivre»—j'avais trente-cinq ans—à ce découpage—j'en ai quatre-vingt-deux—je suis resté le même: non comme l'entendent mes amis qui veulent à toute force me complimenter sur ma mine, mais parce que, tout ce temps, j'ai cherché les mêmes choses, que j'ai peut-être réalisées avec des moyens différents.

Je n'ai pas eu d'autre ambition lorsque j'ai fait la Chapelle. Dans un espace très restreint, puisque la largeur est de cinq mètres, j'ai voulu inscrire, comme je l'avais fait jusqu'ici dans des tableaux de cinquante centimètres ou de un mètre, un espace spirituel, c'est-à-dire un espace aux dimensions que l'existence même des objets représentés ne limite pas.

Il ne faut pas me dire que j'ai recréé l'espace à partir de l'objet quand j'ai «découvert» celui-ci: je n'ai jamais quitté l'objet. L'objet n'est pas tellement intéressant par lui-même. C'est le milieu qui crée l'objet. C'est ainsi que j'ai travaillé toute ma vie devant les mêmes objets qui me donnaient la force de la réalité

en engageant mon esprit vers tout ce que ces objets avaient traversé pour moi et avec moi. Un verre d'eau avec une fleur est une chose différente d'un verre d'eau avec un citron. L'objet est un acteur: un bon acteur peut jouer dans dix pièces différentes, un objet peut jouer dans dix tableaux différents un rôle différent. On ne le prend pas seul, il évoque un ensemble d'éléments. Vous me rappelez ce guéridon que j'ai peint isolé dans un jardin? . . . Eh bien, il était représentatif de toute une ambiance de plein air dans laquelle j'avais vécu.

Il faut que l'objet agisse puissamment sur l'imagination, il faut que le sentiment de l'artiste s'exprimant par lui le rende digne d'intérêt: il ne dit que ce qu'on lui fait dire.

Dans une surface peinte je rends l'espace au sens de la vue: j'en fais une couleur limitée par un dessin. Quand je me sers de la peinture, j'ai le sentiment de la quantité—surface de couleur qui m'est nécessaire et je modifie son contour pour préciser mon sentiment de manière définitive. (Appelons la première action «peindre» et la seconde «dessiner»). Dans mon cas, peindre et dessiner ne font qu'un. Je choisis ma quantité de surface colorée et je la rends conforme à mon sentiment du dessin comme le sculpteur pétrit la glaise en modifiant la boule qu'il a faite tout d'abord, l'étirant d'après son sentiment.

Regardez encore ce vitrail: voici un dugong—un poisson très reconnaissable, il est dans le Larousse—et, au-dessus, un animal marin en forme d'algue. Autour ce sont des fleurs de bégonia.

Ce soldat chinois sur la cheminée est exprimé par une couleur dont le dessin détermine la quantité agissante.

Celui-ci—(*l'artiste le tourne entre ses doigts*)—qui est couleur de turquoise et d'aubergine comme jamais soldat ne le fut, serait détruit s'il était vêtu de couleurs prises dans la réalité matérielle. Des couleurs inventées dont le «dessin» détermine les contours, à cela vient s'ajouter le sentiment de l'artiste pour parfaire la signification de l'objet. Tout ici est nécessaire. Cette tache brune, qui figure le terrain sur lequel on imagine le personnage, rend aux couleurs turquoise et aubergine une existence aérienne que leur intensité pourrait leur faire perdre.

Le peintre choisit sa couleur dans l'intensité et la profondeur qui lui conviennent comme le musicien choisit le timbre et l'intensité de ses instruments. La couleur ne commande pas le dessin, elle s'accorde à lui.

«Le vermillon ne fait pas tout . . .» disait Othon F . . . avec aigreur. Il ne faut pas non plus que la couleur «habille» simplement la forme: elle doit la constituer.

Vous me demandez si mes découpages sont un aboutissement de mes recherches? . . . Mes recherches ne me paraissent pas encore limitées. Le découpage est ce que j'ai trouvé aujourd'hui de plus simple, de plus direct pour m'exprimer. Il faut étudier longtemps un objet pour savoir quel est son signe. Encore que dans une composition l'objet devienne un signe nouveau qui fait partie de l'ensemble en gardant sa force. En un mot, chaque œuvre est un ensemble de signes inventés pendant l'exécution et pour le besoin de l'endroit. Sortis de la composition pour laquelle ils ont été créés, ces signes n'ont plus aucune action.

C'est ainsi que je n'ai jamais essayé de jouer aux échecs bien que ce jeu m'ait été signalé par des amis qui pensaient bien me connaître. Je leur ai répondu: —«Je ne peux jouer avec des signes qui ne changent jamais. Ce Fou, ce Roi, cette Dame, cette Tour . . . ne me disent rien. Mais si vous mettiez des figurines à la ressemblance d'Un Tel, d'un Autre, et d'Autres encore, de gens dont nous connaissons la vie, là, je pourrais jouer mais en inventant un signe pour chaque pion au cours de chaque partie».

Donc le signe pour lequel je forge une image n'a aucune valeur s'il ne chante pas avec d'autres signes que je dois déterminer au cours de mon invention et qui sont tout à fait particuliers à cette invention. Le signe est déterminé dans le moment que je l'emploie et pour l'objet auquel il doit participer. C'est pourquoi je ne peux à l'avance déterminer des signes qui ne changent jamais et qui seraient comme une écriture: ceci paralyserait la liberté de mon invention.

Il n'y a pas de rupture entre mes anciens tableaux et mes découpages, seulement, avec plus d'absolu, plus d'abstraction, j'ai atteint une forme décantée jusqu'à l'essentiel et j'ai conservé de l'objet que je

présentais autrefois dans la complexité de son espace, le signe qui suffit et qui est nécessaire à le faire exister dans sa forme propre et pour l'ensemble dans lequel je l'ai conçu.

J'ai toujours cherché à être compris et, lorsque j'étais chahuté par les critiques ou par les confrères, je leur donnais raison estimant que je n'avais pas été assez clair pour être compris. Ce sentiment m'a permis de travailler toute ma vie sans haine et même sans amertume pour les critiques, d'où qu'elles viennent, ne comptant que sur la clarté de l'expression de mon œuvre pour arriver à mon but. La haine, la rancœur, et l'esprit de vengeance font partie d'un bagage dont l'artiste ne peut pas se charger. Sa route est assez difficile pour qu'il expurge son esprit de tout ce qui pourrait l'alourdir.

TEXT 51
IL FAUT REGARDER TOUTE LA VIE AVEC
DES YEUX D'ENFANTS, 1953

Créer, c'est le propre de l'artiste; —où il n'y a pas création, l'art n'existe pas. Mais on se tromperait si l'on attribuait ce pouvoir créateur à un don inné. En matière d'art, le créateur authentique n'est pas seulement un être doué, c'est un homme qui a su ordonner en vue de leur fin tout un faisceau d'activités, dont l'œuvre d'art est le résultat.

C'est ainsi que pour l'artiste, la création commence à la vision. Voir, c'est déjà une opération créatrice, et qui exige un effort. Tout ce que nous voyons, dans la vie courante, subit plus ou moins la déformation qu'engendrent les habitudes acquises, et le fait est peut-être plus sensible en une époque comme la nôtre, où cinéma, publicité et magazines nous imposent quotidiennement un flot d'images toutes faites, qui sont un peu, dans l'ordre de la vision, ce qu'est le préjugé dans l'ordre de l'intelligence.

L'effort nécessaire pour s'en dégager exige une sorte de courage; et ce courage est indispensable à l'artiste qui doit voir toutes choses comme s'il les voyait pour la première fois: il faut voir toute la vie comme lorsqu'on était enfant; et la perte de cette possibilité vous enlève celle de vous exprimer de façon originale, c'est-à-dire personnelle.

Pour prendre un exemple, je pense que rien n'est plus difficile à un vrai peintre que de peindre une rose, parce que, pour le faire, il lui faut d'abord oublier toutes les roses peintes. Aux visiteurs qui venaient me voir à Vence, j'ai souvent posé la question: «Avez-vous vu les acanthes, sur le talus qui borde la route?». Personne ne les avait vues; tous auraient reconnu la feuille d'acanthe sur un chapiteau corinthien, mais au naturel le souvenir du chapiteau empêchait de voir l'acanthe. C'est un premier pas vers la création, que de voir chaque chose dans sa vérité, et cela suppose un effort continu. Créer, c'est exprimer ce que l'on a en soi. Tout effort authentique de création est intérieur. Encore faut-il nourrir son sentiment, ce qui se fait à l'aide des éléments que l'on tire du monde extérieur. Ici intervient le travail, par lequel l'artiste s'incorpore, s'assimile par degrés le monde extérieur, jusqu'à ce que l'objet qu'il dessine soit devenu comme une part de lui-même, jusqu'à ce qu'il l'ait en lui et qu'il puisse le projeter sur la toile comme sa propre création.

Lorsque je peins un portrait, je prends et je reprends mon étude, et c'est chaque fois un nouveau portrait que je fais: non pas le même que je corrige, mais bien un autre portrait que je recommence; et c'est chaque fois un être différent que je tire d'une même personnalité.

Il m'est arrivé, souvent, pour épuiser plus complètement mon étude, de m'inspirer des photographies d'une même personne à des âges différents: le portrait définitif pourra la représenter plus jeune, ou sous un aspect autre que celui qu'elle offre au moment où elle pose, parce que c'est cet aspect qui m'aura paru le plus vrai, le plus révélateur de sa personnalité réelle.

L'œuvre d'art est ainsi l'aboutissement d'un long travail d'élaboration. L'artiste puise autour de lui tout ce qui est capable d'alimenter sa vision intérieure, directement, lorsque l'objet qu'il dessine doit

figurer dans sa composition, ou par analogie. Il se met ainsi en état de créer. Il s'enrichit intérieurement de toutes les formes dont il se rend maître, et qu'il ordonnera quelque jour selon un rythme nouveau.

C'est dans l'expression de ce rythme que l'activité de l'artiste sera réellement créatrice; il lui faudra, pour y parvenir, tendre au dépouillement plutôt qu'à l'accumulation des détails, choisir, par exemple, dans le dessin, entre toutes les combinaisons possibles, la ligne qui se révélera pleinement expressive, et comme porteuse de vie; rechercher ces équivalences par lesquelles les données de la nature se trouvent transposées dans le domaine propre de l'art.

Dans la *Nature morte au magnolia*, j'ai rendu par du rouge une table de marbre vert; ailleurs, il m'a fallu une tache noire pour évoquer le miroitement du soleil sur la mer; toutes ces transpositions n'étaient nullement l'effet du hasard ou d'on ne sait quelle fantaisie, mais bien l'aboutissement d'une série de recherches, à la suite desquelles ces teintes m'apparaissaient comme nécessaires, étant donné leur rapport avec le reste de la composition, pour rendre l'impression voulue. Les couleurs, les lignes sont des forces, et dans le jeu de ces forces, dans leur équilibre, réside le secret de la création.

Dans la chapelle de Vence, qui est l'aboutissement de mes recherches antérieures, j'ai tenté de réaliser cet équilibre de forces, les bleus, les verts, les jaunes des vitraux composent à l'intérieur une lumière qui n'est à proprement parler aucune des couleurs employées, mais le vivant produit de leur harmonie, de leurs rapports réciproques; cette couleur-lumière était destinée à jouer sur le champ blanc, brodé de noir, du mur qui fait face aux vitraux, et sur lequel les lignes sont volontairement très espacées. Le contraste me permet de donner à la lumière toute sa valeur de vie, d'en faire l'élément essentiel, celui qui colore, réchauffe, anime au sens propre cet ensemble dans lequel il importe de donner une impression d'espace illimité en dépit de ses dimensions réduites. Dans toute cette chapelle, il n'y a pas une ligne, pas un détail qui ne concoure à donner cette impression.

C'est en ce sens, il me semble, que l'on peut dire que l'art imite la nature: par le caractère de vie que confère à l'œuvre d'art un travail créateur. Alors l'œuvre apparaîtra aussi féconde, et douée de ce même frémissement intérieur, de cette même beauté resplendissante, que possèdent aussi les œuvres de la nature.

Il y faut un grand amour, capable d'inspirer et de soutenir cet effort continu vers la vérité, cette générosité tout ensemble et ce dépouillement profond qu'implique la genèse de toute œuvre d'art. Mais l'amour n'est-il pas à l'origine de toute création?

Notes

The notes to the Texts by Matisse are treated as a single unit with regard to repeated citations; that is, the first time a publication is cited, a full reference is given, while subsequent references are abbreviated to only the last name of the author and the year of publication, as in Barr 1951. (Exceptions are made only for the initial documentation of the individual Texts themselves.)

INTRODUCTION

1. Fernande Olivier, *Picasso et ses amis*, Paris, 1933; trans. Jane Miller, *Picasso and His Friends*, New York, 1965, p. 88. Olivier was Picasso's mistress from 1906 to 1912.
2. Leo Stein, *Appreciation: Painting, Poetry and Prose*, New York, 1947, p. 159.
3. See Jane Simone Bussy, "A Great Man," *Burlington Magazine*, CXXVIII, 995 (Feb. 1986), pp. 80–4. This article is a slightly abridged version of a lecture that Bussy gave at the Bloomsbury "Memoirs Club," probably in the autumn of 1947. The late Lawrence Gowing generously made a typescript of the complete lecture availableto me.
4. Pierre Matisse, interview with the author, New York, 4 March 1989. Only a fraction of the breadth of Matisse's reading is reflected in the writers that he chose to illustrate, but they too make up an impressive list: Mallarmé, Baudelaire, Ronsard, and Charles d'Orléans; and also Louis Aragon, René Char, Colette, James Joyce, Henry de Montherlant, Pierre Reverdy, and Tristan Tzara among his contemporaries.
5. See Klaus Lankheit, ed., *The Blaue Reiter Almanac*, New York, 1974, p. 18.
6. "Study Art in America," *The Literary Digest*, 18 October 1930. This appears to be Matisse's first published use of this phrase.
7. For an excellent discussion of Matisse's need to have the "slow and painful preparation" that underlay his work be made apparent to young artists, see John Elderfield, "Drawings at an Exhibition," in Queensland Art Gallery, *Matisse*, eds. Caroline Turner and Roger Benjamin, Brisbane, Australia, 1995.
8. This must be part of what interested Matisse about Joyce's *Ulysses*, for which he did a suite of illustrations in 1934, supposedly after having merely skimmed through the book. But even if he didn't actually read the whole book carefully before he did the illustrations for it, the very idea of Joyce's book must have fascinated him. For Joyce in a sense had translated into a literary form, into a public utterance, what for many years Matisse had been attempting to do privately in his letters. This perhaps also explains the dynamic nature of Matisse's illustrations for *Ulysses*, for which he devised an unusual format: each full-page illustration is overlaid with three or four smaller images printed on colored paper, which contain preliminary versions of the larger final illustration; we thus see not only the image but also how it came into being. Even though the subjects of Matisse's illustrations are taken from Homer's *Odyssey* rather than from Joyce's narrative, the spirit of those illustrations parallels Joyce's text.
9. For a revealing discussion of the sexual connotations of this phrase, see Yve-Alain Bois, "L'Aveugle-

ment," in *Henri Matisse, 1904–1917*, Paris, 1993; trans. in "On Matisse: The Blinding," *October*, 68 (Spring 1994), pp. 63–64.

10. A number of artists and writers mention such visits in passing. When Matisse went to Russia in 1911 at the invitation of his patron, Sergei Shchukin, he made a sincere effort to be cooperative with Russian art writers and journalists (see Albert Kostenevich and Natalya Semyonova, *Collecting Matisse*, Paris, 1993). Matisse received visitors quite openly throughout most of his life; and several of the later texts in this book also resulted from such encounters.

11. "Notes of a Painter" preceded by a considerable amount of time published statements by Braque and Picasso. Although Braque's earliest interview (1908) was published in 1910 (in Gelett Burgess, "The Wild Men of Paris," *Architectural Record*, May 1910, pp. 400–414), his writings were not published until later ("Pensées et réflections sur la peinture," *Nord-Sud*, December 1917, pp. 3–5). Picasso's first published theoretical statement ("Picasso Speaks," *The Arts*, May 1923, pp. 315–326) came even later. Further, while Braque's writings on art are aphoristic, and sometimes obscure, and Picasso's bombastic, Matisse usually uses the expository form, as in "Notes of a Painter."

12. In Kandinsky's most important early essay, *On the Spiritual in Art* of 1911–1912, he speaks in general terms about spiritual renewal, "modern-day science," and specific modern artists, and discusses in detail the specific symbolic meanings and psychological effects of colors. All of this is in distinct contrast to Matisse's writings, even when there are certain common underlying thematic concerns. Kandinsky, for example, discusses music in synesthetic terms, comparing colors to sounds, while Matisse generally uses music to establish structural analogies. (Only rarely does Matisse use musical analogies synesthetically, as when he compares a blue to the sound of a gong in Text 46.)

Kandinsky also emphasizes self-expression in his writings, but he casts it in a firmer theoretical framework, as in his categorical discussion of how "internal necessity" arises "from three mystical sources" and is "composed of three mystical necessities." (Wassily Kandinsky, *On the Spiritual in Art*, 2nd ed., 1912; in Kenneth C. Lindsay and Peter Vergo, eds., *Kandinsky: Complete Writings on Art*, vol. I, Boston, 1982, p. 173.) This is quite different from Matisse's reliance on pure intuition and supreme confidence in the self, as if that self were an ahistorical entity that largely transcended time and place.

Kandinsky's later utopian writings, such as his essays on the reform of art schools, show a degree of social concern that is quite outside the realm of Matisse's concerns. So are the specific meditations and analyses of forms and lines found in Kandinsky's Bauhaus writings, such as *Point and Line to Plane* (1926) or in Paul Klee's *Pedagogical Sketch Books* (1925). The close analyses of the specific physiological effects of line, color, and shape, and the social and metaphysical implications in these texts are completely outside the range of Matisse's expressed concerns. (See Paul Klee, *Pädagogisches Skizzenbuch*, 1925; trans. Sibyl Moholy-Nagy, *Pedagogical Sketchbook*, New York, 1953. See also Klee's *On Modern Art*, written in 1924 and first published in 1945; translated in Robert L. Herbert, *Modern Artists on Art*, Englewood-Cliffs, 1964, pp. 74–91.)

The same could also be said of Mondrian's metaphysical speculations and frequently dogmatic assertions about the relationships between plastic form and reality, especially his emphasis on immutable laws. (See "Plastic Art and Pure Plastic Art," 1936; in Piet Mondrian, *The New Art—The New Life: The Collected Writings of Piet Mondrian*, Harry Holtzman and Martin S. James, eds., Boston, 1986, pp. 292–293.)

13. Matisse's difficulties during the earlier period are reflected in his correspondence. In April 1913 he wrote to Charles Camoin, "The truth is that Painting is very deceptive," expressing his dissatisfaction with the portrait of his wife that he was working on. In an important letter of autumn 1914 he wrote to Camoin at some length discussing his evaluation of Seurat and Delacroix in relation to himself, also noting that his own realizations were more elusive than they had been ten years before. And on 2 May 1918, he wrote to Camoin: "Contour gives grand style (as soon as one proceeds by half-tones one is closer to truth but less grand). Don't you find that that is seeing things a

little superficially, and that one can use contour and a semblance of grand style, and half-tones and real grand style? Which is the grander style, that of Gauguin or of Corot? I believe that style comes from the order and the elevation of the mind of the artist. That order is acquired or developed or even completely intuitive, perhaps the consequence of order. But if it is the result of taking a position it never results in more than half-tone. This is said without pretension."

14. See Dominique Fourcade, "Autres propos de Matisse," *Macula*, 1, 1976, pp. 103–106, for an excellent discussion of the significance of Cézanne and Renoir to Matisse. Toward the end of Matisse's life, when he was asked, "What was the greatest single influence on your art—Giotto? Fra Angelico? Byzantine mosaics? Persian miniatures?" He replied, "All these and, above all, Cézanne." And when he was asked, "Which painter has exerted the most influence on you?" he replied with a single word: "Cézanne." ("Matisse Answers Twenty Questions," *Look*, XVII, 17, 25 August 1953, p. 71.)

15. In recent years there has been a general reconsideration of Matisse's work during the 1920s, and a tendency to see it as having a seamless continuity with his earlier and later work. But although Matisse produced a number of marvelous pictures during that time, and the experience of those paintings was crucial to his being able to maintain his vitality until the end of his life, most of the early Nice pictures represent a backing away from his own expressed ambitions for painting. That he had the courage to take that route, in the face of his own stated goals, is admirable, and also typical of his desire to remain free of programmatic restraints. But, questions of quality aside, within the present context those works must be seen as being atypical by his own definition.

16. Around 1930 the relative diminution of the quality and ambition of Matisse's work during the 1920s was a persistent theme in much of the writing about him. In 1929 even Tériade wrote that "we are far from pretending that Matisse today is working to perfect his canvases. . . . Thus we will simply say that Matisse is struggling today constantly to maintain the vigor of his legendary flexibility, the youth of his line, the vitality of his color. . . . He is working to maintain his freedom." (E. Tériade, "L'Actualité de Matisse," *Cahiers d'Art*, IV, 7, 1929, p. 286.) In a review of Matisse's retrospective exhibition at the Thannhauser gallery early in 1930, Fritz Neugass wrote that the artist himself "recognized that he has reached a standstill in his art, for he asks critics to judge him only on the entirety of his works, according to the great curve of his development." (Fritz Neugass, "Henri Matisse: Pour son soixantième anniversaire," *Cahier de Belgique*, 3, March 1930, p. 100; trans. Jack Flam in *Matisse, A Retrospective*, New York, 1988, p. 244.) And in a thoughtful analysis of Matisse's career as a whole, André Levinson severely criticized Matisse's paintings of the 1920s and asserted that his historical importance lay in his early works, not his recent ones: "I am quite certain that the exquisite mannerist of the *Odalisques* would never have been able to turn the art of his age upside down, and to so enrich and guide it." (André Levinson, "Les Soixante ans de Henri Matisse," *L'Art Vivant*, VI, 121, January 1930, p. 27; trans. Flam, 1988, pp. 243–244.)

17. Gotthard Jedlicka, "Begegnung mit Henri Matisse," in *Die Matisse Kapelle in Vence*, Frankfurt, 1955, p. 90. The interview took place in March 1952. Matisse continued: "In the past, I wanted to understand everything, whatever I painted, drew, modeled; I wanted to understand it so I could explain it, to myself and to others.

"I was twisted and inhibited by my willpower. I also believed only in whatever I had wrested out of myself through the complete use of my willpower. I thought my work was significant in relation to the degree of effort it had cost me; I equated the degree of my self-fulfillment to the degree of effort it involved. This is a fallacy! It is a great fallacy. Maybe one that every artist has to believe in at first in order for him to make progress.

"But the time during which an artist fulfills himself only through great effort has to be followed by a time in which he reaches his goal without any such effort; the period of hard preparation has to give way to a period of harvest. Maybe it is good if the young artist overestimates the extent to which his willpower shapes him; but it certainly is good if the aged and mature artist, while working, trusts the power of grace.

"There is only one thing that counts in the long run: you have to abandon yourself to your work. You have to give yourself over entirely, without thoughts, especially without afterthoughts. Only then does your work contain you totally. You also have to forget completely that the work you have created—whether it has really been seen or experienced or not—will always be judged by others."

18. In March 1942, at the beginning of his use of cutouts as an independent medium, Matisse wrote to Aragon, "I consider I have made some progress when I note in my work an increasingly evident independence from the support of the model. I should like to do without it completely one day— I don't expect to, because I haven't adequately trained myself to remember forms. Shall I still need forms? It's more a question of triumphing over one's dizziness during flight. I know well enough how a human body is made. A flower—if I don't find it in my memory I shall make it up." (Louis Aragon, *Henri Matisse: A Novel*, New York, 1972, vol. 1, p. 235.)

Even in the middle of the Nice Period, Matisse was already contemplating freedom from working directly from the model. In his 1925 interview with Jacques Guenne (Text 11), he discusses making a gradual progression away from working from the model, in terms of a studio that would have three floors: the first would be used to study from the model, the second for working partly without the model, and "on the third, one would have learned to do without the model."

19. Matisse's terse and generally less than helpful responses to the questionnaires that Alfred Barr sent to him around 1950 provide excellent examples of this. Especially revealing are the answers he gave to the fourth question Barr posed about a number of specific paintings: "Does the subject have a special personal or symbolic signification?" Matisse either ignored this question or evaded it with responses like "study of light," "relations of colors," "study of atmosphere and intimacy."

20. See Georges Duthuit, *Écrits sur Matisse*, ed. Rémi Labrusse, Paris, 1992, pp. 15–16.

21. Alfred H. Barr, Jr., *Matisse, His Art and His Public*, New York, 1951.

22. See Bois 1994 for a most interesting discussion of this aspect of Matisse's work.

23. I disagree here with both John Elderfield, *Henri Matisse: A Retrospective*, New York, 1992, pp. 33–48, and Bois 1994, who believe that Matisse was "mistrustful" of visual sensations.

24. See for example, Text 41, below. A detailed and documented discussion of this was included in the introduction to the first edition of this book. Although I believe it is no longer necessary to repeat that material here, it bears mentioning that Matisse's early training with academic painters had a curious effect upon his career. Although he expressed an active and long-lived contempt for it, his whole career was nonetheless affected by what he retained from it; and to some degree he was as powerless to do away completely with its influence on him as a child is to avoid the influence of a despised parent. Matisse did not become a truly independent painter until 1900, when he was thirty years old and had been subjected to traditional methods for a full decade. Moreover, he exhibited only at the conservative salons until the spring of 1901, when he first showed at the Salon des Indépendants. From his academic training he obtained a great respect for the necessity of technical proficiency and a belief in the study of nature as a means of arriving at truth, which doubtless contributed to the streak of conservatism that ran through his later thought. At the same time it also gave him the confidence and proficiency that would serve as a source of liberation from the very tradition that had nurtured him.

25. In 1952, upon the opening of the Musée Matisse in Le Cateau, the town where he was born, Matisse sent a written message in which he recalled how he felt when he decided to become an artist: "Despite the certitude that I had found my true path, one in which I was in my own element and not hemmed in as in my earlier life, still I was frightened, realizing that there was no turning back. . . . I got on with my work as quickly as possible, driven on by something, I do not know what, by a force that I see today as being alien to my normal life as a man." (Reprinted in Raymond Escholier, *Matisse ce vivant*, Paris, 1956, p. 18.) In 1941 Matisse told Pierre Courthion that when he discovered painting he had found a way to take charge of his own life and no longer felt that he had to do "what others wanted me to do."

26. The obliqueness of the first person usage is even more apparent in the French: *"Si les gens savaient ce que Matisse, dit le peintre de bonheur, a vécu et surmonté d'angoisses et de drames pour arriver à capter cette lumière qui ne la quitte plus, si les gens savaient cela ils apprendraient du même coup que ce bonheur, cette lumière, cette sagesse sereine qui, apparemment est devenue mienne, se méritent parfois dans la dureté des épreuves."* (André Verdet, *Entretiens notes et écrits sur la peinture: Braque, Léger, Matisse, Picasso*, Paris, 1978, p. 132.) Although this interview took place around 1951, it was not published until twenty-four years after Matisse's death.

27. Tériade was born Efstratios Eleftheriades, in 1897 on the Greek island of Lesbos. He came to France at the age of eighteen and established himself as an intelligent and energetic young writer and editor at Christian Zervos's influential *Cahiers d'Art*. He was subsequently involved with the periodicals *L'Intransigeant, Minotaure, Bête noir,* and *Verve,* and later became a leading publisher of artists' books, including Matisse's *Jazz.* For details of his activities, see Centre National d'Art Contemporain, *Hommage à Tériade*, Paris, 1973.

28. This is noted in Matisse's personal agenda; for the context, see Jack Flam, *Matisse: The Dance*, Washington, D.C., 1993, pp. 18–22.

29. Significantly, in the same interview Matisse also plays down the influence of Gauguin on his work. Gauguin, like the Surrealists, was associated with the "dark" side of existence, which Matisse was determined to keep at bay.

30. André Breton, *Le Surréalisme et la peinture*, rev. ed., Paris, 1965; translated by Simon Watson Taylor in *Surrealism and Painting*, New York, 1972, p. 9. My interest in Matisse's relationship to Surrealism was rekindled by a seminar report on the subject given by Asher Miller in my Matisse seminar at the Graduate Center of the City University of New York in the fall of 1992.

31. In a 7 October 1922 letter to Tristan Tzara, Man Ray noted their hopeless incompatibility: "Breton was here this morning, also Matisse, they argued for an hour, it was amusing: like two men who spoke different languages. It was astonishing. A man, like Matisse, who spoke of the necessity of drawing a hand like a hand and not like cigar ends. Then I did a portrait of Matisse where he looks like a grand master, but he wasn't satisfied and wanted something more amusing, I did a second one with a smile but he's a very charming man." Tristan Tzara Dossier, Bibliothèque Littéraire Jacques Doucet, Universités de Paris. My thanks to Francis Naumann for calling this letter to my attention and making it available to me.

32. Pierre Schneider, *Matisse*, New York, 1984, p. 674. Parenthetically, one wonders whether by 1948 Matisse hadn't come to understand that Breton's harsh evaluation of his Nice paintings in 1928 had had some justification. One also wonders whether Matisse's insistence in *Jazz* (Text 37, below) that the artist must be free of hatred might not make reference to his feelings about Breton in particular, as well as perhaps alluding to the general situation of divisiveness in France after the war.

33. In conversation, 10 November 1948; as cited in Schneider 1984, p. 674.

34. Matisse to Rayssiguier, 13 November 1948; as cited in Schneider 1984, p. 674.

35. Tristan Tzara, *Midis gagnés: poèmes*, Paris, 1939 (rev. ed. 1948); *Le signe de vie*, Paris, 1946.

36. André Masson, "Conversations avec Henri Matisse, *Critique*, 324, May 1974, pp. 393–9.

37. Schneider 1984, p. 711, n. 53.

38. Tériade, "Constance du fauvisme," *Minotaure II*, 9 (15 October 1936), p. 2.

39. See Bernard Anthonioz, "Le jardin sur la mer," in *Hommage à Tériade*, p. ix.

40. E. Tériade, "La peinture surréaliste," *Minotaure II*, 8 (15 June 1936), p. 5.

41. See Max Ernst, "10 August 1925," in *Au-delà de la peinture*, 1936, first published in the Max Ernst issue of *Cahiers d'Art*, 1937; trans. Patrick Waldberg, Surrealism, London, 1978, p. 96. See also Breton, *Genèse et perspective artistiques du Surréalisme* (1941); trans. in Breton 1972, pp. 74–76; also Michel Carrouges, *André Breton and the Basic Concepts of Surrealism,* trans. Maura Prendergast, University, Alabama, 1974, pp. 78–81.

42. Pierre Courthion, "Typescript of Nine Unpublished Interviews with Henri Matisse," 1941, p. 12. Getty Center for the History of Art and the Humanities, Santa Monica, California.

43. Pierre Matisse, whose gallery represented Miró, remembered that although in a sense his father didn't understand Miró's art, it interested him. Matisse said that he was "intrigued" by Miró, because his canvases were so tightly put together that if you took one spot away from one of them, the whole thing collapsed. The work of Mondrian, by contrast, Matisse respected but did not care for. Pierre Matisse, interview with the author, New York, 4 March 1989.

44. Matisse's increased interest in the art of the South Seas at this time may also reflect the Surrealists' preference for the "spirit-haunted" art of Oceania over the more "classical" sculpture of Africa; although the intensely decorative character of Oceanian art would have been its main appeal, Matisse also became increasingly interested in African textiles at this time.

45. E. Tériade, "Édouard Manet vu par Henri Matisse," *L'Intransigeant*, 25 February 1932, p. 5.

46. Matisse to Aragon, 16 February 1942. Part of the letter is reproduced in Aragon 1972, I, p. 150, fig. 83.

47. In his introductory essay to Matisse's album of drawings, *Dessins: Thèmes et variations*, Paris, 1943, pp. 9–10, Aragon noted that Matisse's true palette was a palette of objects, which was like "a poet's palette of words." Although the objects in the "Thèmes et variations" drawings were still rendered within the complexity and amplitude of their surrounding space, the relativity with which they moved around in that space already suggested to Aragon that they could be taken out of that space and condensed into more static and singular kinds of signs.

48. Matisse, letter to André Rouveyre, 6 October 1941.

49. Jane Simone Bussy, "A Great Man," *The Burlington Magazine*, CXVIII, 995 (Feb. 1986), p. 81.

50. Richard Shiff has framed this dilemma in terms of an interesting question: "Matisse seems unable to decide the central question: Does an artist actively control his own enterprise?" Shiff sees Matisse as wanting to establish three conflicting claims: to find his inner self, to express nature, and to actively create images of self and nature. Shiff speaks of Matisse being caught in a "theoretical morass into which he was drawn, or perhaps drew himself." (Shiff's remark that Matisse "perhaps drew himself" into this morass is an astute one, for Matisse seems precisely to have wanted to leave this question unresolved and open, and not resolve the *theoretical* question.) Shiff further notes that "for Matisse the demands of self-expression and originality seem to determine an unstable technique that must remain responsive to unpredictable developments. Such technique may never be 'mastered' because it continues to evolve, and it can be imitated by others only at their risk of assuming an alien identity or of fixing in place what must always move onward." Richard Shiff, *Cézanne and the End of Impressionism: a Study of the Theory, Technique, and Critical Evaluation of Modern Art*, Chicago and London, 1984, pp. 62–63.

51. Gleizes and Metzinger, *Du Cubisme*, 1912; trans. in Herbert 1964, pp. 3–4.

52. For examples of texts by these authors see Edward Fry, *Cubism*, New York and Toronto, 1966, pp. 14–90.

53. Marinetti's "Founding Manifesto of Futurism," published in the French newspaper *Le Figaro* in 1909, for example, employs violent images of extreme modernity that make Matisse's references to Greek sculpture and even to aviation in "Notes of a Painter" seem rather tame. Marinetti's essay is full of hyperbolic imagery ("A racing car whose hood is adorned with great pipes, like serpents of explosive breath . . . is more beautiful than the *Victory of Samothrace*"); bellicosity ("We will glorify war—the world's only hygiene"); and anti-traditionalism ("We will destroy the museums, libraries, academies of every kind, will fight moralism, feminism, every opportunistic or utilitarian cowardice").

 Marinetti's declaration that art "can be nothing but violence, cruelty, and injustice" is echoed in the 1910 collaborative essay, "Manifesto of the Futurist Painters," in which five artists outline a bombastic eight-point program that Matisse might well have considered a bizarre distortion of some of his own concerns. For while he might have been cautiously sympathetic to their desire to destroy "pedantry and academic formalism," to "invalidate all kinds of imitation," and elevate "all attempts at originality, however daring, however violent," and even to "regard art critics as useless

and dangerous," he would doubtless have been alarmed by their equally passionate desire to "sweep the whole field of art clean of all themes and subjects which have been used in the past," and to glorify the present world, "splendidly transformed by victorious Science."

Another of the Futurists artists' collaborative essays, "The Exhibitors to the Public" of 1912, which was published in French by Matisse's own gallery, not only proposed a working method that was the exact opposite of his, but promoted a historically specific model of reality, what they called "an absolutely modern sensation," without which "there can be no modern painting." When Matisse, by contrast, speaks of a painter being by necessity of his time, he does not define in words what that time looks or feels like; he leaves that definition entirely to his pictures.

For translations of these texts, see Umbro Apollonio, ed., *Futurist Manifestos*, New York, 1973, pp. 19–50.

54. Léger's earlier writings are preoccupied with abstract and impersonal formal definitions and with social relationships that Matisse ignores in his own writings. See for example, Léger's "The Origins of Painting and Its Representational Value" of 1913, in which Léger, like Matisse, insists that the "*realistic* value of a work of art is completely independent of any imitative character," but focuses his discussion on "the simultaneous ordering of three great plastic components: Lines, Forms, and Colors." Fernand Léger, *Functions of Painting*, ed. Edward F. Fry, New York, 1973, pp. 3–4.

55. Léger 1973, p. 8.

56. Léger, "Contemporary Achievements in Painting," 1914; trans. in Léger 1973, p. 11. In Léger's early writings he, like Matisse, was concerned with the rejection of Impressionism and the inherent limitations of Neo-Impressionism, which he characterized as a "mediocre formula." Instead he emphasized the importance of Cézanne as "the only one of the impressionists to lay his finger on the deeper meaning of plastic life because of his sensitivity to the contrasts of forms." (Léger, 1973, p. 17.) In later years, moreover, Léger was deeply involved with the aesthetics of the machine, which he once again set within a generalized vision of modernity: *"Modern man lives more and more in a preponderantly geometric order."* ("The Machine Aesthetic: the Manufactured Object, the Artisan, and the Artist," 1924; in Léger, 1973, p. 52. In this essay, p. 56, Léger goes on to criticize artists like Matisse for their "carelessness and lack of discipline.") In 1931, in distinct contrast to Matisse, Léger defended abstract art as "the most important, the most interesting of the different past trends that have developed during the last twenty-five years. It is definitely not an experimental curiosity. . . . " (Léger, "Abstract Art," 1931; in Léger, 1973. p. 83.)

57. Goethe letter to Cotta, 14 November 1808; as cited in Ludwig Curtius and Hermann J. Weigand, eds., *Goethe: Wisdom and Experience*, New York, 1949, p. 245.

58. *Look*, August 1953, p. 73.

59. Courthion 1941, p. 62.

60. Henri Matisse to André Rouveyre, 4 June 1941. This and other letters written to Rouveyre around this time indicate that Matisse had corrected (*rectifié*) the typescript himself; and that several of the "questions" posed by Courthion were added later to conform to Courthion's idea of making the text read in a more lively or flowing way (2 July 1941).

61. Matisse to André Rouveyre, 22 August 1941.

62. Matisse insisted that one should not undervalue self-evident truths. "You are going to think that I am saying nothing but banalities," he told Dorothy Dudley in 1925, "but one has to have the courage to say the banal." Dorothy Dudley, "Interview with Matisse, May 1925," typescript, p. 4. My thanks to Steven Harvey for making this text available to me.

63. Jedlicka 1955, p. 90.

64. That Picasso was aware of this difference, too, can be seen from the conversations about Matisse's use of color recorded by Françoise Gilot. Picasso was especially impressed by the way Matisse made color "breathe," hence his remark that "Matisse has such good lungs." As for himself, he said, "I don't use that language. I use the language of construction, and in a fairly traditional man-

ner, the manner of painters like Tintoretto or El Greco who . . . once their painting was about finished would add transparent glazes of red or blue to brighten it up and make it stand out more. The fact that in one of my paintings there is a certain spot of red isn't the essential part of the painting. The painting was done independently of that. You could take the red away and there would always be the painting; but with Matisse it is unthinkable that one could suppress a spot of red, however small, without having the painting immediately fall apart." Françoise Gilot and Carlton Lake, *Life with Picasso*, New York-Toronto-London, 1964, p. 271.

TEXT 1

1. Guillaume Apollinaire, "Henri Matisse," *La Phalange*, 11, 18 (December 1907), pp. 481–485. Apollinaire (1880–1918) would soon emerge as one of the leading poets and critics of the period. According to a note at the end of the essay, it was also scheduled to be published in the forthcoming *Cahiers de Mécislas Golberg*, but Golberg's death precluded that. Four of Matisse's paintings were reproduced along with the article: *Self Portrait*, 1906; *The Red Madras Headdress*, 1907; *La coiffure*, 1907; *Le luxe, I*, 1907.

2. Fernande Olivier, in *Picasso et ses amis*, Paris, 1933, p. 107, notes that whenever Matisse began to talk about painting he chose his words deliberately. Leo Stein, in *Appreciation: Painting, Poetry and Prose*, New York, 1947, p. 152, speaking of this period recalls: "Matisse was really intelligent. He was also witty, and capable of saying exactly what he meant when talking about art. This is a rare thing with painters. . . ." And George L. K. Morris, recalling a 1931 meeting with Matisse ("A Brief Encounter with Matisse," *Life*, XIX, 9, 28 August 1970, p. 44), noted: "As soon as Matisse speaks about art his voice becomes gentle and distinct, he talks very slowly."

3. By 1908, Matisse had acquired a small but substantial collection that consisted of some twenty pieces of African and Oceanic sculpture. See Daniel-Henry Kahnweiler, *Juan Gris: His Life and Work*, London, 1947, p. 74, n.2.

4. The crowd did indeed laugh; but Matisse was too intent on being understood to smile very much about it. He was stung by the reaction of the howling, jeering crowds at the 1905 Salon d'Automne and advised his wife not to attend, in order to spare her feelings. Gelett Burgess's account of a 1908 Salon gives a fair idea of how violent public reaction could be: "I had scarcely entered the Salon des Indépendants when I heard shrieks of laughter coming from an adjoining wing. I hurried along from room to room under the huge canvas roof, crunching the gravel underfoot as I went, until I came upon a party of well-dressed Parisians in a paroxysm of merriment, gazing, through weeping eyes, at a picture. Even in my haste I had noticed other spectators lurching hysterically in and out of the galleries; I had caught sight of paintings that had made me gasp. But here I stopped in amazement. It was a thing to startle even Paris. . . . Suddenly I had entered a new world, a universe of ugliness." Gelett Burgess, "The Wild Men of Paris," *The Architectural Record*, May 1910, p. 401.

5. Two years later, in "Medallion of a Fauve," Apollinaire would write of Matisse: "This fauve is a man of refinement. He likes to surround himself with ancient and modern works of art, with precious materials, with those sculptures where the negroes of Guinea, of Senegal, and of Gabon have represented with a rare purity their most frightening passions." Guillaume Apollinaire, *Chroniques d'art, 1903–1918*, ed. L. C. Breunig, Paris, 1960, p. 65.

TEXT 2

1. Henri Matisse, "Notes d'un peintre," *La Grande Revue*, II, 24 (25 December 1908), pp. 731–745. Within a year of its first publication, "Notes d'un peintre" was translated into Russian and German: *Toison d'Or (Zolotye Runo)*, 6, 1909; *Kunst und Künstler*, VII, 1909, pp. 335–347. The first English translation, however, apparently was that of Margaret Scolari Barr, first published in New York, Museum of Modern Art, *Henri-Matisse Retrospective Exhibition*, New York, 1931, pp. 29–36,

to which subheadings were added "for the convenience of the reader." This translation, with the subheadings, was reprinted in Alfred H. Barr, Jr., *Matisse, His Art and His Public*, New York, 1951, pp. 119–123.

2. Though it now seems odd, Matisse's early Fauve works were themselves criticized for being applications of theory. André Gide ("Promenade au Salon d'Automne," *Gazette des Beaux-Arts*, XXXIV, December 1905, pp. 476–485) noted that *The Woman with the Hat*, the scandal of the 1905 Salon, was not madness but "the result of theories." In Maurice Denis's review of the 1905 Salon d'Automne, he criticizes Matisse for lack of individual emotion, and for painting a kind of excessively theoretical "dialectic." (*L'Ermitage*, 15 November 1905; reprinted in Maurice Denis, *Théories, 1890–1910*, 4th ed., Paris, 1920, pp. 203–210.) Leo Stein (*Appreciation: Painting, Poetry and Prose*, New York, 1947, p. 161) relates that Matisse rebuffed Denis in front of one of Matisse's own paintings. But at the same time, by the end of 1908 Matisse was beginning to lose his dominant position among the Parisian avant-garde to Picasso and Braque. For a stimulating discussion of the context within which Matisse's essay appeared, see Roger Benjamin, *Matisse's "Notes of a Painter": Criticism, Theory, and Context, 1891–1908*, Ann Arbor, 1987. Other especially interesting discussions of Matisse's essay and its context can be found in Catherine C. Bock, *Henri Matisse and Neo-Impressionism*, Ann Arbor, 1981, pp. 100–108; Richard Shiff, *Cézanne and the End of Impressionism: A Study of the Theory, Technique, and Critical Evaluation of Modern Art*, Chicago and London, 1984, pp. 55–64; Yve-Alain Bois, "Matisse and 'Arche-drawing,'" in *Painting as Model*, Cambridge, Mass., and London, 1990, pp. 54–63.

3. Georges-Olivier Desvallières (1861–1950), like Matisse a former student of Gustave Moreau, was chief art critic for the *Grande Revue*, which was owned by his patron, Jacques Rouché.

4. The following paintings were reproduced: *Girl Reading*, 1906; *Standing Nude*, 1906–1907; *Seated Nude*, 1908; *Portrait of Greta Moll*, 1908; *Black and Gold Nude*, 1908; *The Game of Bowls*, 1908. All, of course, were reproduced in black and white. *The Game of Bowls* is the most "advanced" of the works represented and is the only "imagined" and only multi-figure scene.

5. Desvallières's introduction is worth citing in full:

"The work of M. Matisse arouses too much disdain, anger, and admiration for the *Grande Revue* to be content with the inevitably hasty evaluations offered thus far by the critics who have reviewed the various exhibitions in which his work could be studied.

"It was felt that the best exponent of these works would be their author himself. He was kind enough to offer us the remarks that follow, and we requested that he accompany these notes with some reproductions of his paintings and drawings so that the public may compare what M. Matisse says, what he thinks, and what he actually does.

"It must be acknowledged, after reading these notes and examining the drawings, that whatever reservations one may have about this artist, his efforts have aided the development of our techniques of plastic expression; and not by mystifying innovations, but simply by relying on the instinctive discoveries of medieval artists, of the Hindus, and of Oriental decorators.

"Like our ancestors, the Romanesque craftsmen who distorted their figures in accordance with the need for balance between the architecture and the personages who had to be depicted within it, Matisse takes full account of the rectangle formed by the paper on which he draws.

"If the drawing reproduced on page 734, for example [*Standing Nude*, 1906–1907, actually a painting], is not thought an accurate depiction of the idea we may have of a woman in that position, it is nevertheless not untrue to that idea; for the size of the head is just what it must be, given the volume of the foot and the slenderness of the bust, these various parts of the body having been carefully drawn so that the white spaces between the edge of the paper and the lines of the figure form an expressive ornamentation. In short, the architecture that Matisse creates with these disproportionate fragments is a solid one in which all the proportions are correct, even though the figure depicted does not give an impression of nature as it is commonly seen. In his treatment of

the colors of objects and people he has also made use of the relationships of color found in Persian carpets, and has achieved this through a method in which the contributions of modern science are not very distant; indeed, perhaps they are not sufficiently distant, which sometimes causes him to fall into paradox.

"Our personal sense of good taste may sometimes be shocked by them, but even then our artistic intelligence should not be indifferent to the discoveries made by this artist; for thanks to them, he has freed us from innumerable pedestrian habits of the hand, he has in a sense liberated our eyes and broadened our understanding of drawing, and no one can produce sound work today without studying the contributions of this school."

6. See Charles Morice, "Enquête sur les tendances actuelles des arts plastiques," *Mercure de France*, LVI–LVII, (1 and 15 August, 1 September 1905), pp. 346–359, 538–555, 61–85.

7. Morice had expressed mixed feelings in his published opinions about Matisse's art; hence it is equally likely that he had chosen not to invite Matisse to participate, or that Matisse had refused to do so. Shiff 1984, pp. 251, n. 11, believes that Desvallières answered Morice's questions "as one would imagine Matisse might have done." See Morice 1905, p. 352.

8. For an interesting and thorough analysis of the various responses to the questionnaire, see Niamh O'Laoghaire, *The Influence of Van Gogh on Matisse, Derain and Vlaminck, 1898–1908*, Unpublished Ph.D. dissertation, University of Toronto; 1991, pp. 163–164, 476–490.

9. Benjamin 1987, pp. 210–211.

10. Benjamin 1987, p. 212. See also Marit Werenskiold, *The Concept of Expressionism, Origin and Metamorphoses*, Oslo, 1984.

11. See Guillaume Apollinaire, "Je crois que l'avenir . . . ," 1913; unpublished text, in Pierre Caizergues and Michel Décaudin, eds., *Apollinaire, Oeuvres en prose complètes*, vol. II, Paris, 1991, pp. 508, 1595–1596. Apollinaire writes "nom d'expressionnisme qui lui a été donné en Allemagne convient bien à ce mouvement. *Expressionnisme* et *expressionniste*, ces appellations venant de la *tête d'expression* exposée par Henri Matisse au Salon d'Automne de 1907. . . ." My thanks to Dominique Fourcade for calling this text to my attention.

12. Charles Edward Gauss, *The Aesthetic Theories of French Artists from Realism to Surrealism*, Baltimore, 1949, p. 63.

13. See Text 8, below. For a discussion of parallels between Croce and Matisse, see Gauss 1949, p. 64.

14. Henri Bergson, *L'Évolution créatrice*, Paris, 1907; trans., *Creative Evolution*, New York, 1911, pp. 177–178. Hereafter cited as Bergson 1907.

15. As cited in Roger Shattuck, *The Banquet Years*, revised ed., London, 1969, p. 327.

16. The artist must penetrate apparent reality to arrive at a deeper Reality, what Kurt Badt has called "the One which is permanent in the changing world." (See Kurt Badt, *The Art of Cézanne*, Berkeley and Los Angeles, 1965, p. 217.) The possibility of realizing this goal is based on being able to attain an intuition of truth within one's direct experience of the world (the motif), and then to give that truth tangible articulation in the work of art. The problem is complicated, in that while Reality is constant, or rather has a constant duration, its manifestations and the *means for perceiving them*, are not. Hence Pissarro's acute observation that Cézanne painted the same painting all his life; in other words, Cézanne was striving for the same realization all his life. (See Barr 1951, p. 38, where this is taken literally to mean his "Bathers.") The *réalisation* of which Cézanne speaks is an articulation of his penetration into this Reality, for which Cézanne depended upon the sensations he could receive from the Provençal landscape, by which he might realize the underlying structure or truth behind the material manifestation and construct accordingly.

The process of *réalisation* then, moves by intuition from the motif to the work: paintings are the condensed, material results of perceptions of reality based on visual sensations modified by intuition. Matisse's process follows a similar path. The main difference between Cézanne and Matisse on this point is that Cézanne's sensations were received and articulated in detail, while Matisse

sought a *Gestalt* perception. Whereas Cézanne worked toward the whole in parts, achieving real-
ization by adjusting the parts to form a "realized" totality, Matisse tended to start with the whole
and adjust the parts until the totality was "realized" by adjustment and balancing of parts. Thus
the notion of being able "to reconceive in simplicity."

 For a stimulating discussion of Cézanne's notion of realization, see Badt 1965, pp. 195–228.

17. Cited in Shattuck 1969, p. 342.

18. In 1941 Matisse, speaking to Francis Carco, referred to his studio as the cinema of his sensibility
(See Text 26, below.) This idea also seems quite Bergsonian: "To reduce things to Ideas is there-
fore to resolve becoming into its principal moments, each of these being, moreover, by the hy-
pothesis, screened from the laws of time and, as it were, plucked out of eternity. That is to say that
we end in the philosophy of Ideas when we apply the cinematographical mechanism of the intel-
lect to the analysis of the real." Bergson 1907, p. 315.

19. Mécislas Golberg, *La Morale des Lignes*, Paris, 1908. An errata sheet states that a copy of the book
was shown to Golberg a few hours before his death; hence, although it was published officially in
1908, it was printed at the end of 1907. The publisher was Librairie Léon Vanier (A. Messein, Suc-
cesseur), whose address was 19 quai Saint-Michel, the same building where Matisse had lived for
well over a decade. Around the same time, Matisse had one of his paintings reproduced in *Le
Dernièr Cahier de Mécislas Golberg*, Paris, 1908, following p. 180 (the *View of Collioure* now in the
Gelman collection, usually dated 1908, but now firmly datable to the summer of 1907, as it is
listed as having been shown in the 1907 Salon d'Automne). As noted in Text 1, n. 1, above, Apolli-
naire's 1907 interview with Matisse was supposed to have been published in a subsequent issue of
Cahiers de Mécislas Golberg, but Golberg's death precluded that.

20. See Pierre Aubéry, *Anarchiste et décadent: Mécislas Golberg, 1868–1907, biographie intellectuelle
suivie de fragments inédits de son Journal*, Paris, 1978, p. 104. This information was given to Aubéry
in a letter from Rouveyre, dated 9 June 1962, written shortly before his death. The original French
reads as follows: *"le célèbre article de Matisse a été écrit par Golberg en étroite fraternité d'esprit avec
Matisse. Personne ne l'a su, personne n'a pu dire jusqu'ici. C'est significatif, en 1908, après La Morale
des lignes de 1907. C'était écrit en concomitance."* Rouveyre's letter was of course written several
years after Matisse had died and he was therefore not able to dispute its astonishing claim. More-
over, as early as 1922 Rouveyre had written about Golberg's influence on the Parisian avant-garde;
he had then averred that many of Apollinaire's best known ideas had come from Golberg, but did
not mention Matisse's "Notes of a Painter." (See André Rouveyre, "Souvenirs de mon commerce.
Dans la contagion de Mécislas Golberg," *Mercure de France*, 15 April 1922; as cited in Aubéry 1978,
p. 104.) Although it might be argued that Rouveyre, who was a close friend of Matisse's, did not
mention this supposed fact until after Matisse's death out of respect and friendship, it seems more
likely that over the years Rouveyre's memory became somewhat distorted. Of particular interest
in this context is the fact that the philosophical argument in *La Moral des Lignes* centers on Rou-
veyre's (rather mediocre) drawings, with which it is profusely illustrated, and which it takes to be
exemplary. Seen from our present perspective, Golberg's fabrication of such an impressive theo-
retical edifice around such slight works of art reminds us of the extraordinary disproportion be-
tween the artistic importance of Constantin Guys and Baudelaire's citation of his work in his re-
markable essay "The Painter of Modern Life." Rouveyre's confusion regarding Golberg's putative
co-authorship of "Notes of a Painter" may thus have something to do with the relative disappoint-
ment of his own career as an artist. Moreover, on the evidence of Golberg's writings it is not at all
clear that his understanding of pictorial form went much beyond a certain conceptual facility.

 Furthermore, Golberg died a full year before the publication of Matisse's essay. Thus, although
Golberg may have helped to clarify or even inspire certain aspects of Matisse's thinking, it is very
unlikely that he would actually have collaborated with Matisse on "Notes of a Painter." Aubéry
himself is skeptical about Rouveyre's claim (pp. 104–107), as are most subsequent writers on the

subject. See also, Xavier Deryng, "Guillaume Apollinaire et Mécislas Golberg: la critique côté cour, côté jardin," in Paris-Musées, *Apollinaire, critique d'art*, Paris, 1993, pp. 202–213.

21. John Richardson, *A Life of Picasso: Volume I, 1881–1906*, New York, 1991, pp. 423–424.

22. Golberg 1908, pp. 52–53. Elsewhere in the book (p. 27), Golberg writes that "deformation is the very principle of human creation, our *anima Dei!*"

23. For a good summation of this attitude, see Alison Hilton ("Matisse in Moscow," *Art Journal*, XXIX, 2, Winter 1969–1970, p. 166), who writes as follows of Matisse's position in "Notes of a Painter": "He believed in a purely decorative and hedonistic art. Accordingly, he stripped his paintings of all the disturbing or boring sides of life, and gave full play to what is festive, as in the early *Joy of Life*. A painting should contain nothing exciting or excessive, and, above all, no message." See also Janet Flanner (as Genêt), *The New Yorker*, 30 May 1970, p. 86; and Denys Sutton, "Matisse Magic Again," *Financial Times*, 3 June 1970, who describes Matisse as a painter "who is so easy on the eye and who is in no way profound."

24. See Beverly Kean, *All the Empty Palaces: The Merchant Patrons of Modern Art in Pre-Revolutionary Russia*, New York, 1983, p. 184.

25. It is interesting in this context to note Greta Moll's account of the portrait Matisse painted of her (1908) and which was illustrated in "Notes of a Painter." She noted, "I found it very interesting to watch how always when he altered one color he felt forced to change the whole color scheme." (Barr 1951, p. 129.)

26. Cf. Cézanne (letter to Camoin, 28 January 1902): "I have little to tell you; indeed one says more and perhaps better things about painting when facing the motif than when discussing purely speculative theories—in which as often as not one loses oneself." (John Rewald, ed., *Paul Cézanne, Letters*, London, 1941, p. 218.)

27. Paul Signac (1863–1935); Georges Desvallières (1861–1951); Maurice Denis (1870–1943); Jacques-Émile Blanche (1861–1942); Charles Guérin (1875–1939); Émile Bernard (1868–1941). Matisse cites mostly his contemporaries and painters older than himself, rather than the younger painters such as Braque (1882–1963) and Derain (1880–1954), or Marquet (1875–1947) with whom he had in fact been more closely allied. The painters Matisse names might be considered as the more "respectable" element of the avant-garde at the time, and also represent a group of men who had some reputation as writers and theorists. (Bernard had in fact recently written on Cézanne in "Souvenirs sur Paul Cézanne et lettres inédites," *Mercure de France*, 1 and 15 October 1907.)

28. The reference is most pointedly to Signac, although Matisse obviously did not want his criticism of the Impressionists or Rodin to be taken as a slur on their work.

29. Ironically, a criticism still made.

30. Cf. Bergson 1907, p. 145, where a similar idea is set out in more detail.

31. Matisse would return to this point several times. Speaking of the 1931–1933 Barnes Murals, he told Raymond Escholier: "Perhaps it would be important to indicate that the composition of the panel arose from a struggle between the artist and the fifty-two square meters of surface of which his spirit had to take possession, and not the modern procedure of the compositions' projection on the surface, multiplied to the size required and traced. A man looking for an airplane with a searchlight does not explore the vastness of the sky in the same way as an aviator." Raymond Escholier, *Matisse, ce vivant*, Paris, 1956, p. 129. Nonetheless, Matisse did sometimes square up small compositions onto larger canvases: he did so for *Luxe, calme et volupté* (1904–1905) and for *Le Bonheur de vivre* (1905–1906), among others.

32. Cf. Cézanne (letter to Bernard, 12 May 1904): "I am progressing very slowly, for nature reveals herself to me in very complex forms; and the progress needed is incessant. One must see one's model correctly and experience it in the right way; and furthermore express oneself forcibly and with distinction." Rewald 1941, p. 235.

33. Cf. Matisse, "A Cézanne is a moment of the artist while a Sisley is a moment of nature." (Barr 1951, p. 38.)

34. This discussion appears to be directly related to the nudes that were reproduced along with Matisse's essay. Compare Braque, in 1908: "I couldn't portray a woman in all her natural loveliness. . . . I haven't the skill. No one has. I must, therefore, create a new sort of beauty, the beauty that appears to me in terms of volume, of line, of mass, of weight, and through that beauty interpret my subjective impression. Nature is a mere pretext for decorative composition, plus sentiment. It suggests emotion, and I translate that emotion into art. I want to expose the Absolute, and not merely the factitious woman." Burgess 1910, p. 405.

35. Matisse here makes a fine distinction between various levels of reality. The movement captured by a snapshot, although it actually has happened, is so far away from absolute Reality (so superficial a moment), that it is without meaning, not "seen," even though the image may have passed imperceptibly across the retina. "Seen" (*ayons vu*) is meant here in the sense of "perceived."

36. Thus (in Bergsonian terms) the image can "direct the consciousness to the precise point where there is an intuition to be seized."

37. Matisse uses the word "sign" here to designate a "mark" rather than a sign in the semiotic sense. It is interesting to note, however, his preference in this passage for words like *écriture* and *signe*, which are usually associated with writing.

38. Here Matisse seems to be directly describing some of the process involved in the recent repainting of *Harmony in Red* (finished in the fall of 1908), which had been begun as a predominately blue-green composition and was transformed into a predominately red one. See Jack Flam, *Matisse: The Man and His Art, 1869–1918*, Ithaca and London, 1986, pp. 227–232.

39. Cf. Bergson 1907, pp. 156–157, and especially, "the intellect is characterized by the unlimited power of decomposing according to any law and of recomposing into any system."

40. The reference is to Auguste Rodin (1840–1917), who at the time was also Matisse's neighbor at the Hôtel Biron.

41. Here Matisse is almost certainly describing *The Forest at Fontainbleau*, which is often misdated to 1909.

42. Matisse had just been to Italy during the summer of 1907.

43. As noted above, this famous passage, often used to trivialize Matisse's art, has brought much criticism down on Matisse since it was written, and for decades affected the way his works were seen. He was cast as the perpetual optimist, the "painter of the good armchair." It is important to note, however, that Matisse is not describing his pictures here, but is speaking instead of a rather abstract aspiration for his art.

44. A criterion that Matisse no doubt got, at least in part, from Cézanne.

45. Cf. Braque (1917): "One must not imitate what one wishes to create." (Cited in Edward F. Fry, *Cubism*, New York-Toronto, 1966, p. 147.) Also Picasso (1923): "We all know that Art is not truth. Art is a lie that makes us realize truth. . . . The artist must know how to convince others of the truthfulness of his lies." (Fry 1966, pp. 165–166.)

46. On the importance of early experiences of aviation on French thought at this time, see Robert Wohl, *A Passion for Wings: Aviation and the Western Imagination, 1908–1918*, New Haven and London, 1994.

47. Mérodack Joséphin Péladan, novelist and critic, was the founder of a mystic order of Catholic Rosicrucians. In the 1890s he had invented his own symbolic system in relation to which he conceived of himself as a prophet who would renovate art through mystical aesthetic ideas based on Dante and Leonardo (hence Matisse's reference at the end of this essay). The article referred to is "Le Salon d'Automne et ses Retrospectives—Greco et Monticelli," *La Revue Hébdomadaire*, 42 (17 October 1908), pp. 360–378. In this article Péladan (pp. 360–361) wrote: "The created being,

like the Creator, in His image . . . is not restricted to historical costume. A manner of dress results from a manner of thought. The form manifests its basis; it is born of incessant work, of a growth from within and without. . . . Each year it becomes more difficult to speak of these people who have called themselves *les fauves* in the press. They are curious to see beside their canvases. Correct, rather elegant, one would take them for department store floor-walkers. Ignorant and lazy, they try to offer the public colorlessness and formlessness." Péladan's review of the 1908 Salon d'Automne makes an interesting contrast with that of Georges Desvallières ("L'art finlandais au Salon d'Automne," *La Grande Revue*, 25 November 1908, pp. 397ff, in which Desvallières speaks of the purely plastic means of the Fauves).

48. Péladan wrote under the name of "Sar."

49. Péladan (*Revue Hébdomadaire*, p. 373) had written: "The public, insensible to the difficult effort toward beauty, wants only antics. A clown makes the fortune of a circus, and thousands of artists imitate Chocolat; only it is the canvas that receives the kicks in the face in color. Truth, the most despairing of the Muses, terrible Truth would say: 'Suppose that M. Matisse painted honestly; wouldn't he be nearly unknown; he shows off as at the fair, and the public knows him.' By honestly, I mean with respect to the ideal and the rules. . . .'"

TEXT 3

1. "George Besson Conducts Interviews on Pictorial Photography," *Camera Work*, No. 24, October 1908, p. 22. Besson (b. 1882) wrote extensively on modern art. He later became quite friendly with Matisse, who painted two small portraits of him in late 1917 and early 1918.

2. M. V. Shevlyakov, "With Matisse," *Rannieie Utro*, 246 (26 October 1911); as cited in Albert Kostenevich and Natalya Semyonova, *Collecting Matisse*, Paris, 1993, p. 47. See also Matisse's 1933 statement to Tériade, and his comments on the use of photographs in *Portraits* (Texts 17 and 52).

3. See Flam 1986, pp. 183–185, 341–342.

4. Cf. Gustave Moreau, "Photographic truth is merely a source of information." Ragnar von Holten, *L'Art fantastique de Gustave Moreau*, Paris, 1960, p. 3.

TEXT 4

1. We are indebted to Professor John Dodds for permission to use his transcription of Sarah Stein's manuscript, which is published here with the headings that were later added by Barr. For a history of Matisse's school, see Barr 1951, pp. 116–118; Flam 1986, pp. 221–223. On the Steins and Matisse, see *Four Americans in Paris: The Collection of Gertrude Stein and her Family*, New York, 1970, especially pp. 35–50. For other first-hand accounts of Matisse's school see: Hans Purrmann, "Aus der Werkstatt Henri Matisses," *Kunst und Künstler*, XX, 5 (February 1922), pp. 167–176; Isaac Grünewald, *Matisse och Expressionismen*, Stockholm, 1944; Leo Swane, *Henri Matisse*, Stockholm, 1944; in the mid-1930s, Matisse also gave a brief account of the opening of the school to Escholier (Raymond Escholier, *Henri Matisse*, Paris, 1937, pp. 92–97). Escholier 1956, pp. 80–81, publishes Pierre Dubreuil's version of Matisse's teaching, close to that of Sarah Stein:

"The human body is an architectural structure of forms which fit into one another and support one another, like a building in which every part is necessary to the whole: if one part is out of place, the whole collapses. . . . If you are not sure, take measurements, they are crutches to lean on before you can walk. Construct your figures so that they stand, always use your plumb-line. Think of the hard lines of the stretcher or the frame, they affect the lines of your subject. . . . All human shapes are convex, there are no concave lines. . . . Paint on the white canvas. If you place a tone on a surface already colored, without reference to your subject, you sound a discord from the start which will hinder you all the way. One tone is just a color; two tones are a chord, which is life. A color exists only in relation to its neighbor. . . . Determine your impression from the beginning, and hold to that impression. Feeling counts above everything."

2. For example, the use of the plumb line. For some very interesting parallels see F. Goupil, *Manuel général de la peinture à l'huile*, Paris, 1877, pp. 158–166, which enumerated ten procedural steps: perceive, be attentive, compare, reason, retain, abstract, combine and order, analyze, generalize, imagine or invent.

3. Purrmann 1922, pp. 169–170.

4. Matisse's indirect way of getting this Beaux-Arts information across is interesting and amusing. He himself was not unaware of the irony of his position as a teacher, which he noted in his 1925 interview with Jacques Guenne (Text 11, below).

5. The specific imagery here seems to be inspired by the structure of Cézanne's paintings, particularly the Cézanne *Three Bathers* that Matisse owned. Although the image is a fanciful one, Matisse himself often used such metaphorical structures, as in the obviously tree-like structure of *The Serpentine*, 1909, or in the architectural structure of works like the *Back II* of 1913 and the *Portrait of Mlle Yvonne Landsberg* of 1914.

6. Such subtle ambiguities of shape recur throughout Matisse's work. Sometimes, as in *The Italian Woman* of 1916, which is in the shape of an amphora, the main compositional motif of the work is such a compound image.

7. Note the complete, almost mystical, fusing of the impulses inherent in the model and those received by the painter.

8. This provides some clue to Matisse's concept of his sculpture in relation to his two-dimensional works. In many cases his sculptures seem to be the results of self-imposed disciplines that would force him to "definitely express" formal constructions that are illusory in painting or drawing. See Jack D. Flam, "Matisse's *Backs* and the Development of his Painting," *Art Journal*, XXX, 4 (Summer 1971), pp. 352–361.

9. A vivid description of the linear substructure of Matisse's paintings between 1907 and 1917.

10. The correct reading should probably be: "The leg fits into the foot at the ankle. . . ."

11. Matisse here, as in other places (Cf. Note 4, above), seems to want to convey useful academic studio advice, without seeming didactic. Thus he suggests the general principle without making it a rule.

12. Also a common compositional feature in Matisse's paintings of that period: *Girl Reading*, 1906; both versions of *Le Luxe*, 1907; *Bathers with a Turtle*, 1908. Though this feature persists in Matisse's paintings through about 1918, it is less common after that.

13. This is especially vivid in the four sculptural reliefs of *The Back*.

14. According to Hans Purrmann, who ran Matisse's studio, Matisse said he could paint a still-life, for example, "with three or also with six colors. Whatever he chose, he would have to choose beforehand. Previously, he searched about in his paintbox for the colors that appeared correct to him in relationship to that which he wanted to reproduce. Now he determines his palette beforehand, and in this way he finds the equations that make up the life of a picture. Matisse pointed to a house as he spoke. 'Do you see the color of the foundation, of the molding, of the wall and the shutters? That forms a unity, a similar unity to that which a picture needs. Earlier, I went about the same work with a new color concept every day. That, however, cost me many desperate hours.'" Purrmann 1922, p. 170.

15. In his class, Matisse elaborated similar ideas in a number of ways: "A picture is like a game of cards. One must keep in mind from the beginning what one hopes to have in the end. Everything must be portrayed by itself as a whole from the very beginning." Purrmann 1922, p. 170.

16. According to Purrmann, "Perhaps Matisse had only one weakness. If he found a picture appealing in its colors, he was overcome by this charm and could hardly stop expressing his approval." Purrmann 1922, p. 170.

17. Cf. Purrmann: "In the confusion of conventions, Matisse always searched for pure means and spoke directly and freely. Therein lies his advantage. He put the observer directly in front of a freshness of expression. 'One must arrange things in a large and clear way in order to use three or

four contrasts correctly. It is between these contrasts that the further action of the colors comes into play. Painting is nothing but the observation of the relationship of one color to another. One must see an ensemble. Nature presents itself to me in this manner. It is even so in the case of Corot, where one must admit that he paints every object in its own local color.' . . . He once said to me in front of my work, 'To create light, use compatible tones that don't cause any disruption and preserve the unity. If you like, you could paint the shadows with contrasts but never apply contrasting colors on a round object, where you want unity. The shapes can also be brought out through the use of deeper colors, but never through the application of light.' He differentiates between cold and warm tones, but to create light out of the opposition of colors was to him a subject in itself." Purrmann 1922, p. 172.

TEXT 5

1. Charles Estienne, "Des tendances de la peinture moderne: Entretien avec M. Henri-Matisse," *Les Nouvelles*, 12 April 1909, p. 4. Starting with the catalogue of the 1904 Salon d'Automne Matisse began to use the hyphenated "Henri-Matisse" employed here by Estienne in order to avoid confusion with the well-known marine painter Auguste Matisse. After the latter died in 1931 Matisse generally dropped the hyphen.

2. Some twenty-five years later Matisse, speaking of the same problem, was to say: "The great mass of people who seem to have been touched by painting in the Middle Ages were not interested in the plastic and graphic qualities of the paint and the painter's work. They were interested in the story he had to tell because there were not other available ways for them to learn the story. . . . Today, no one need look at a picture, unless he is interested in painting. . . .

 "When a painting is finished, it's like a new born child, and the artist himself must have time for understanding. How, then, do you expect an amateur to understand that which the artist does not yet comprehend?" ("Matisse Speaks," *Art News*, XXXI, 36, 3 June 1933, p. 8.)

 Some forty years later, Matisse, answering a questionnaire about art and the public, wrote:

 "Art cannot be hampered by the dead weight of the public. But today there is no rupture between art and public. I experienced such a rupture in my youth. I resisted without compromising, and the public came to terms all the same. Does the rupture between art and public result from a severance between art and reality? I keep my feet on the ground, true enough, and the public can always find their way into my work. But when I began, there was no way in. When the artist is gifted, people come to him as to a living spring." (*Transition Forty-Nine*, 5, 1949, p. 118.)

3. This passage is an almost exact repetition of a passage in "Notes of a Painter," but with a few changes in wording. (See Text 2, above).

4. This paragraph also repeats part of "Notes of a Painter," with small changes in wording.

5. A reference to the first version of *The Dance* (1909; Museum of Modern Art, New York), which Matisse had recently done as a compositional study for a proposed commission.

6. The staircase referred to is that of Sergei Shchukin, the Russian collector who had just recently (31 March 1909) confirmed an order for two large panels (*Dance* and *Music*) to decorate his stairway. The project, which had been in the air for a while, was understandably on Matisse's mind at the time. This commission represented not only the opportunity for two of his largest works, but also the considerable sum of 27,000 francs.

 This interview affirms that Matisse conceived of the Shchukin commission in terms of three rather than two panels. The third panel that Matisse mentions here is *Bathers by a River* (1909–1916), which is the same size as the two Shchukin paintings, and which was begun around the same time as the others but not finished until several years later. For details, see Flam 1986, pp. 254–258, 365–371, 414–419.

 Matisse's conception here is quite in keeping with the procedure for decorative arts as outlined by such writers as Henry Havard, *La décoration*, Paris, 1892[?]; he chooses subjects that avoid in-

tense emotion and that have clearly legible but non-illusionistic imagery; he conceives of his pictures in terms of their ultimate destination and thinks in terms of emblematic abstract ideas. (See Havard, pp. 2–35.)

7. In this passage, which again parallels "Notes of a Painter," the reference to the "good armchair" is omitted.

TEXT 6

1. J. Sacs, "Enric Matisse," *Vell i nou*, 1 November 1919. The first part of this article was published in the 1 October issue of *Vell i nou*. Although Catalan writers usually gave the names of French artists in French, this text employs the Catalan translation of his name: "Enric." For the sake of clarity, I have retained "Henri." My thanks to John Elderfield for making this text available to me.

2. The Fauve painter Kees Van Dongen (1877–1934), who painted in a highly dramatic way.

3. As noted above, this painting was sent to Shchukin in Russia after the Salon d'Automne of 1910; if it was in Matisse's studio at the time of this interview, then the interview must be dated to the autumn of 1910—evidently just before Matisse left for Spain in mid-November.

4. Antoine Druet (b. 1857), the owner of the Galerie Druet, instituted the practice of photographing the works of artists, and established an important archive. Matisse's works were usually photographed when they were finished, but sometimes Druet photographed them while in progress, hence documenting their evolution. *Music*, for example, was photographed at least three times; see Flam 1986, pp. 287–288.

5. The reference is to the series of *Jeannette* busts; from Sacs's remarks, it would seem that at least three, perhaps even four of the busts were in Matisse's studio at the time. The complete series of five was finished in 1916.

TEXT 7

1. Ernst Goldschmidt, "Strejtog i Kunsten: Henry Matisse," *Politiken*, 24 December 1911. Translated by Desirée Koslin. Goldschmidt (1879–1959) wrote extensively on French art.

2. The reference is to Sergei Shchukin's palatial home in Moscow, which Matisse had just visited.

3. The painter Albert Marquet (1875–1947) was one of Matisse's closest friends at the time.

4. Matisse's villa was actually in Issy-les-Moulineaux, a few miles southwest of Paris. The address was 42 (later 92) route de Clamart, and a number of writers referred to it as being in Clamart.

5. Probably the first version of *Dance* (1909) and an early state of *Bathers by a River* (1909–1916).

6. *The Red Studio*, 1911.

7. Probably *The Reverie* (present whereabouts unknown, Druet negative no. 3714) that is represented at the lower right of *The Red Studio*.

8. Such giant violets were used to decorate the background and painted frame of *Interior with Eggplants*, painted that summer at Collioure.

9. Canigou is a granite peak in the eastern Pyrenees; only fifty kilometers from the sea, it rises to an altitude of some 10,000 feet.

10. Matisse studied with Eugène Carrière (1849–1906) when he returned to Paris from the south in 1899. See Text 26, below.

11. The painter from Aix is Cézanne; the reference to the Barbizon painter appears to be a general one.

TEXT 8

1. Clara T. MacChesney, "A Talk with Matisse, Leader of Post-Impressionists," *New York Times Magazine*, 9 March 1913; © 1913 by The New York Times Company. Reprinted by permission. Clara Taggart MacChesney (1860–1928) studied at the San Francisco School of Design and at the Colarossi Academy, Paris. She interviewed Matisse in June 1912; the article was published shortly before the Armory Show closed in New York.

2. The Bernheim-Jeune Gallery.

3. Matisse's house at Issy-les-Moulineaux, a suburb of Paris.

4. Matisse's copy of Chardin's *The Ray* is now in the Musée Matisse in Le Cateau.

5. MacChesney is referring to the two versions of *Nasturtiums with "Dance"*; note her reference to the "jar of nasturtiums," above.

6. Matisse's school had in fact closed in 1911.

7. Cf. Burgess 1910, p. 401, regarding Matisse and his colleagues: "What did it all mean? The drawing was crude past all belief: the color was as atrocious as the subject. Had a new era of art begun? Was ugliness to supersede beauty, technique give way to naiveté, and vibrant, discordant color, a very patchwork of horrid hues, take the place of subtle, studied nuances of tonality? Was nothing sacred, not even beauty?"

8. The grouping together of archaic and primitive arts here is indicative of Matisse's interest in arts based on expressive and conceptual forms rather on naturalist imitation of nature.

9. Paul Albert Besnard (1849–1934) and Jean-François Raffaëlli (1850–1924), successful popular painters in the "modern style" who combined the look of modernism with an essentially traditional outlook, probably would have represented to MacChesney "acceptable modernity." Degas once said of Besnard that he "has stolen our wings." (Albert Boime, *The Academy and French Painting in the Nineteenth Century*, London, 1971, p. 17); and in one of his 1942 radio interviews (below), Matisse would say of Besnard: "Albert Besnard? But he is a conventional painter who is hiding behind the palette of the Impressionists. The terrific Degas said: 'Besnard? *Mais c'est un pompier qui prend feu.*'"

10. Cf. Burgess 1910, p. 403: "Matisse himself, serious, plaintive, a conscientious experimenter, whose works are but studies in expression, who is concerned at present with but the working out of the theory of simplicity, denies all responsibility for the excesses of his unwelcome disciples. Poor, patient Matisse, breaking his way through this jungle of art, sees his followers go whooping off in vagrom paths to right and left. He hears his own speculative words distorted, misinterpreted, inciting innumerable vagaries."

11. The statement is of course paraphrased from Matisse's own "Notes of a Painter."

12. Here MacChesney seems to be confusing Matisse with Monet; or perhaps with Robert Delaunay.

TEXT 9

1. Robert Rey, "Une heure chez Matisse," *L'Opinion*, VII, 2 (10 January 1914), pp. 59–60. Rey, who was born in 1888, represents the generation immediately following Matisse's.

2. Robert Rey, "Souvenirs d'un étudiant," *Chroniques du jour*, 2, 9 (April 1931), pp. 4–5. In this article, Rey refers to his 1913 visit to Matisse's studio as an event that he later came to regard as a turning point in his own attitudes toward art.

3. Matisse did a portrait etching of Bourgeat in 1914.

4. Matisse had sent only one painting, his 1913 *Portrait of Madame Matisse*, which had created a stir among the avant-garde. See Flam 1986, pp. 371–373.

5. Probably a reference to the satirical article by Raymond Dorgelès, "Le Prince des Fauves," *Fantasio*, V, 105 (1 December 1910), pp. 299–300.

6. The meaning of this word is unclear. It is possibly a misprint of "Agutte" and refers to the paintings of Georgette Agutte, who was married to Matisse's friend Marcel Sembat.

7. Probably *Bathers by a River*, 1909–1916.

8. *Seated Riffian*, 1913.

9. The reference is to the series of *Jeannette* busts, begun in 1910, of which Matisse eventually did five versions; not all of them had yet been completed and Rey notes only three.

10. Edmond Haraucourt (1856–1941), poet associated with the Parnassian aftermath.

11. The bas-reliefs are the large *Backs*, of which Matisse had then completed two.

12. This question was a dominant one throughout the first decade of the century. In the spring of 1905, when Charles Morice sent a questionnaire to a number of artists about the current state of French art, one of the five questions had been: "What is your opinion about the following: Should the artist expect all to come from nature, or should the artist demand of nature the plastic means to realize all that is within the self?" The majority of the responding artists felt that the artist should rely more on himself than on nature. See Charles Morice, "Enquête sur les tendances actuelles des arts plastiques," *Mercure de France*, LVI–LVII, (1 and 15 August, 1 September 1905), pp. 346–359, 538–555, 61–85.

13. Rey employs a curious reversal of terms here, calling the Matisse's emphasis on internal motivation "objective" rather than "subjective."

14. Throughout his life, Matisse would call attention to the enormous effort that went into his apparently effortless works.

15. Matisse's enthusiasm for and study of African art had been frequently noted since Apollinaire's 1907 interview. According to the American painter Max Weber, who studied with Matisse in 1908, Matisse also used African sculpture in his teaching: "Matisse was very proud of his small but very choice collection of African Negro sculpture, and this was before Negro sculpture overwhelmed, if not conquered, the art of the continent. He would take a figurine in his hands, and point out to us the authentic and instinctive sculpturesque qualities, such as the marvelous workmanship, the unique sense of proportion, the supple palpitating fullness of form and equilibrium in them." Max Weber, lecture at the Museum of Modern Art, New York, 22 October 1951; handwritten manuscript, p. 14. Archives of American Art, New York.

Only a year or so later, Charles H. Caffin, who had visited Matisse in his studio, remarked that "some wooden figures carved by African natives," along with "some fragments of Egyptian sculpture are almost the only objects, besides pictures, in his studio. As he passes his hand over the wooden figures, he utters one word, 'Simplification.' Meanwhile, it does not escape me that the incised lines and the treatment of the planes in these figures, bear a close analogy to his own method of drawing and modeling; and I note that his figures have a feeling of quiet self-contained bulk, corresponding to the old African carver's expression in wood." Charles H. Caffin, "Matisse and Isadora Duncan," *Camera Work*, no. 25, January 1909, p. 18.

TEXT 10

1. Ragnar Hoppe, "På visit hos Matiss," in *Städer och Konstnärer, resebrev och essäer om Konst*, Stockholm, 1931, pp. 193–191. Translated by Desirée Koslin. Although the essay is dated 1920 in Hoppe's book (whose title translates as "Cities and Artists, Travel Correspondence and Essays on Art"), the reference to Matisse's painting in the Triennale exhibition places it in the previous June; the essay was probably published in serial form in 1920. Knut Ragnar Johan Hoppe (b. 1885) wrote extensively on French painting.

2. Matisse's first large post-war exhibitions at the Bernheim-Jeune gallery, "Oeuvres récentes de Henri-Matisse," was on view from 2 to 16 May 1919 and consisted mostly of recent paintings. This was the first time Matisse had shown a large group of the works painted in Nice, which plainly marked a departure from his earlier way of working.

3. *Interior with a Violin*, 1918.

4. More than thirty years later, around 1951, Matisse described this period in his career to André Verdet: "I was coming out of long, wearying years of effort, after many inner conflicts, during which I had given the best of myself to bring those researches to the point of achieving what I

hoped would be an unprecedented creation. Besides that, I had been powerfully held by the requirements of important mural and monumental compositions. After beginning with some exuberance, my painting had evolved toward decantation and simplicity. A synthesis both pictorial and moral, governed always by laws of harmony, held strict dominion over my work. A will to rhythmic abstraction was battling with my natural, innate desire for rich, warm, generous colors and forms, in which the arabesque strove to establish its supremacy. From this duality issued works that, overcoming my inner constraints, were realized in the union of contrasts. . . .

"With the Odalisques, I don't renounce what I had recently gained, those plastic advances you speak of, but I return to a more profound resonance, I again accept a certain kind of model and once again I take possession of a space where the air circulates freely again. In them was posed this problem for me: to attune and balance pure colors and half-tones so as to assure the painting's harmony and rhythmic unity against the possible danger of chromatic shrillness. . . ." André Verdet, *Entretiens, notes et écrits sur la peinture: Braque, Léger, Matisse, Picasso*, Paris, 1978, pp. 124–125. See also Text 48, n. 18, below.

5. *The White Plumes*, 1919. Directly below, Matisse refers to the suite of drawings that he did of the same model wearing the same hat.

6. Cf. "Black is a Color," 1946; Text 34, below.

7. In fact, for the next few years Matisse would be working on a smaller scale than he had previously.

TEXT II

1. Jacques Guenne, "Entretien avec Henri Matisse," *L'Art vivant*, 18 (15 September 1925), pp. 1–6; this interview was also incorporated into the chapter on Matisse in Guenne's *Portraits d'artistes*, Paris, 1925, pp. 205–219.

2. In 1918, Matisse wrote a brief text about Renoir for the catalogue of *Den Franske Utstilling*, Copenhagen, 1918, p. 12:

"The work of Renoir, after that of Cézanne, whose great influence has been manifested among artists, saves us from whatever drying effect there is in pure abstraction. The rules that one might deduce in considering the work of these two masters appear to be more difficult to discover in the work of Renoir, who hides his efforts better. Whereas the continuous tension of the mind of Cézanne, his lack of self-confidence, prevent him from giving himself to us entirely even though he shows the evidence of his corrections, from which are easily (too easily) deduced rules that have a mathematical precision.

"The mind of Renoir, through his modesty as well as his confidence in life, once the effort is made, allowed him to reveal himself with all the generosity he was provided with, stripped of its reconsiderations.

"This aspect of his work makes us see an artist upon whom the greatest gifts were bestowed, and who has had the gratitude to respect them."

Matisse was inspired by his acquaintance with Renoir, who though suffering from painful arthritis, continued to work to the end of his life. For an excellent discussion of Matisse's feelings about Renoir, see Dominique Fourcade, "Autres propos de Henri Matisse," *Macula*, 1, 1976, pp. 103–104.

3. The acquaintance referred to here is Philibert-Léon Couturier, whom Matisse later characterized as a "painter of hens and poultry-yards" (Text 48, below). Adolphe William Bouguereau (1825–1905) was one of the most popular and "successful" nineteenth-century academic painters. For an amusing account of Matisse's introduction to Bouguereau's studio, see "Matisse Speaks," 1951 (Text 48, below).

4. Matisse told Escholier (1937, p. 30) a slightly different version of the story, noting that

Bouguereau said to him: "You are erasing your charcoal with your finger. That denotes a careless man; take a rag or a piece of tinder wood. Draw the plaster casts hanging on the studio walls. Show your work to an older student: he will advise you. . . . You have to understand perspective. . . . But first you must learn how to hold a pencil. You'll never know how to draw."

5. Gabriel Ferrier (1847–1914) and Bouguereau alternately taught the class at the Académie Julian.

6. For Matisse's elaboration of this story, see Escholier 1937, pp. 30–31.

7. It was later recounted that he was encouraged to go on painting by Goya's *Youth and Age* at the Lille Museum, of which he thought, "I would like to be able to do that [*Ça, je pourrais le faire*]." (Barr 1951, p. 3, note to p. 15A.)

8. Gustave Moreau (1826–1898) had at this time recently been appointed a professor at the École des Beaux-Arts. The "Antiques" refers to the Cours Yvon at the École des Beaux-Arts where students drew from casts.

9. Giulio Romano (1499–1546), the Mannerist painter and follower of Raphael.

10. Painted in June 1890. Illustrated in *Cahiers d'Art*, no. 5–6 (1931), p. 230.

11. The Petit Casino was a cabaret on the Passage Jouffroy.

12. Delacroix's statement reported by Baudelaire was: "If you are not skilful enough to sketch a man falling out of a window, during the time it takes him to get from the fifth story to the ground, you will never be able to produce monumental work." (Marius Vachon, *Pour devenir un artiste*, Paris, n.d., p. 134.) Marquet is supposed to have added the postscript: "Yes, and make it a recognizable likeness, too!" (Barr 1951, p. 38.)

13. But later Matisse informed Alfred Barr that he had seen the Impressionists at Durand-Ruel's and at Vollard's before 1897. (Barr 1951, p. 16, n. 4.) Caillebotte bequeathed his collection of Impressionist paintings to the Luxembourg Museum.

14. The Matisse copy, which he worked on for several years (1894–1900), is in the Musée Matisse at Le Cateau.

15. The landscape painter Émile Véry, or Wéry (1868–1935), with whom Matisse went to Brittany in 1896.

16. *The Dinner Table*, 1897.

17. The painter Georges Rouault (1871–1958), who was one of Moreau's favorite students.

18. The Salon de la Société Nationale des Beaux-Arts of 1897. Matisse had been made an Associate in 1896, thus the painting had to be hung; but it was hung badly.

19. This story had evidently been told earlier to Georges Desvallières. (Barr 1951, p. 35, n. 1.)

20. In 1898–1899, when Matisse worked in Corsica, and at Fenouillet near Toulouse, close to where his wife's family lived.

21. The reference is to the Islamic art exhibition at the Pavilion de Marsan of the Louvre in 1903.

22. See Texts 31 and 39, below. In May of 1925, Matisse discussed Japanese prints and Islamic art in a long-unpublished interview with Dorothy Dudley. (My thanks to Steven Harvey for making the typescript of this interview available to me; it has heretofore been published only in a limited edition, in Gallery Schlesinger, *Ghosts & Live Wires*, New York, 1990, n.p.) Speaking of charcoal drawings, Matisse said to Dudley, "You have never seen a woman with black shadows on her body? No it's an exaggeration. There are several ways of expressing form. I am expressing it there by the modeling. That makes that source of exaggeration. There is also the way of the Japanese, where they express form by contours and by the juxtaposition of several tones, flat in color. People say that the effect is flat but this is not true, because they thought always in the round, in spatial quality, while working. Gauguin worked in this fashion."

"But can't one employ the two methods at the same time?"

"But yes certainly. We have to now that we know the two, we have to conciliate them.

That has been one of my battles. Gauguin and other painters of his time used almost entirely the method of the Japanese and the Persians. Now that we begin to master the problem a little we are returning more in thought to our own art, the art of Europe—Byzantine or Greek."

"Then," my sister queried, "the people are stupid who use the word 'representation' as a word of scorn? For example they said that Gauguin, Rodin, the Japanese—it's only representation. They scorn them."

"Oh only some little painters or poor little sculptors in Montmartre, the others don't scorn them. Gauguin went to Tahiti, he painted the savages with a Persian brain. Therefore now one feels a quality of exteriority in his pictures. But that is not to say that Gauguin was not an enormous force. And Rodin—he wanted to do everything by himself. So one finds him outside of the sculptural tradition, that which has a relation to architecture, like that Cambodian sculpture on the mantelpiece. For that reason Rodin himself when he looked at the work of Maillol said that his whole life had been in vain. Maillol never goes outside of the form. But that does not mean one can scorn Rodin. He was enormous!"

"The greatest since Michelangelo?" my sister asked.

"Perhaps."

"What do you think of Brancusi?"

"I don't see him—those casseroles. What do they mean? I don't know. I see nothing there. People talk about him a great deal, they admire him but of what use are they these casseroles?" (Pointing to the brasses on the mantel.) "These Persian bronzes they are of some use. You can put boiling water in one of them, coffee in another. But the Brancusi casseroles, I don't see them."

". . . . Well for myself I admired them," I said.

"Then so much the better for Brancusi."

23. More than two decades later, Matisse would write an essay with this title. See Text 40, below. Matisse offered an interesting insight into this process in his 1925 conversation with Dorothy Dudley and her sister: "You must look within yourself, you must ask yourself, what is it in nature I love so much I want to paint it. You must choose that. Then you must study it closely. You must follow nature closely, closely. You can't follow it too faithfully. And you must not be in a hurry. You must not say, I would like to be the style too, at once. To do that is to jump off the balcony because you would like to fly. There will have to be many battles. Then if truly there is something in nature you truly love, you will find the way to express it like all of us."

24. See Text 22, below. Hans Purrmann (1922, p. 172) wrote that Matisse had "unlimited love" for Cézanne.

25. Cf. Courbet, "I maintain that art is completely individual, and is for each artist nothing but the talent issuing from his own inspiration and his own studies of tradition." Pierre Courthion, ed., *Courbet raconté par lui-même et par ses amis*, Geneva, 1950, II, p. 205.

26. For the Exposition Universelle of 1900.

27. Père (Julien) Tanguy (1825–1894), the color dealer who early helped and exhibited the Impressionists, and was painted by Van Gogh.

28. Antoine Druet (b. 1857), who subsequently opened the Galerie Druet, established an important photographic archive of artists' works.

29. Ambroise Vollard (1868–1939), the famous shrewd dealer, was the largest early dealer in Cézannes, and gave Matisse his first one-man show in June 1904. It was actually Druet who instituted the practice of photographing the oeuvre of painters, the so-called "Druet Process."

30. Berthe Weill (1865–1951), the courageous gallery owner, the first to show Picasso in Paris (in 1900), also first exhibited Matisse, with five other Moreau pupils, in February 1902. Matisse later told Escholier (1956, p. 55) that while Weill and Druet had been as useful as any dealer is to a beginner, they could offer no security.

1. E. Tériade, "Visite à Henri Matisse," *L'Intransigeant*, 14 and 22 January 1929; partially reprinted as "Propos de Henri Matisse à Tériade," *Verve*, IV, 13, December 1945, p. 56. Used by permission of the author.

2. E. Tériade was the pseudonym for the Greece-born writer Efstratios Eleftherides (b. 1897). He was involved with several reviews that published works by and about Matisse, including *Cahiers d'Art*, *L'Intransigeant*, *Minotaure*, and *Verve*. He also published some of Matisse's illustrated books, most notably *Jazz* (1947).

3. Matisse mentioned this need to be away from the city on other occasions—cf. Text 28, below.

4. Henri Edmond Cross (1856–1910) was at Saint-Tropez with Matisse in 1904. See also Texts 20 and 48, below.

5. Matisse is indirectly referring to his earlier battle with the Neo-Impressionists. During the Fauve years, Signac was so angry at Matisse for abandoning his camp that he picked a fight with him at the café where the exhibitors and jurors met after the opening of the 1906 Indépendants (Georges Duthuit, *The Fauvist Painters*, New York, 1950, p. 61). In this statement Matisse implies that Seurat is a great painter almost despite, rather than because of, his theories (an attitude that has gained a good deal of support in recent years). The emphasis is once again on human values—just what Matisse had been accused of lacking in 1905–1906.

 In autumn 1914, Matisse wrote a letter to Camoin, regarding Seurat: "I know that Seurat is completely the opposite of a romantic, which I am; but with a good portion of the scientific, of the rationalist, which creates the struggle from which I sometimes emerge the victor, but exhausted." In the same letter, Matisse goes on to say: "Delacroix's composition is more entirely created, while that of Seurat employs matter organized scientifically, reproducing, presenting to our eyes objects constructed by scientific means rather than by signs coming from feeling. As a result there is in his works a positivism, a slightly inert stability coming from his composition, which is not the result of a creation of the mind but of a juxtaposition of objects. It is necessary to cross this barrier to re-feel light, colored and soft, and pure, the noblest pleasure. Delacroix's imagination, brought to bear on a subject, remains anecdotal, which is a shame; this relates to the quality of his mind, for Rembrandt in the same conditions is noble. A word that I never can say in front of a picture by Delacroix. . . . I am happy with my picture that returns me to the middle of all these movements of my mind." See Danièle Giraudy, "Correspondence Henri Matisse-Charles Camoin," *Revue de l'Art*, 12 (Summer 1971), pp. 7–34.

6. Perhaps an amusing reference to his relatives in Bohain and Le Cateau. See Escholier 1956, p. 98.

7. Cf. Texts 16 and 50, below.

8. Although Matisse refers here to "art politics," he also felt that there was no relationship between art and any kind of politics. "I keep myself outside of politics as much as possible," he told Yves Bridault ("J'ai passé un mauvais quart d'heure avec Matisse," *Arts*, 371, 7–13 August 1952, p. 1). "The mission of the artist is important enough for him to preoccupy himself only with his art. . . . I know. Delacroix did some pictures in 1848. Revolutions can sometimes serve a purpose, but it is necessary despite everything to remain outside of politics. One can have liberal ideas, but the artist hasn't the right to lose any of the precious time that he has for his self-expression."

9. In a conversation with André Verdet, around 1951, Matisse was more elaborate, and somewhat more straightforward, in relation to this matter. When Verdet asked him if there was any part of his work that had been misunderstood by critics, Matisse singled out the odalisques, asking: "Did I paint too many Odalisques, was I carried away by excessive enthusiasm in the happiness of creating those pictures, a happiness that swept me along like a warm ocean ground swell? I still don't know. . . . I had to catch my breath, to relax and forget my worries, far from Paris. The Odalisques were the fruits of a happy nostalgia, of a lovely, lively dream and of the almost ecstatic, en-

chanted experience of those days and nights, in the incantation of the Moroccan climate. I felt an irresistible need to express that ecstasy, that divine nonchalance, in corresponding colored rhythms, the rhythms of sunny and lavish figures and colors. . . ." Verdet 1978, p. 124. See also Text 48, n. 18, below.

10. James Tissot (1836–1902), a painter of fashionable scenes from everyday life, who had painted a well-known series of pictures based on Biblical themes. Cf. Text 48, below. In 1949 Matisse used Tissot as an example of someone not able to connect with the underlying significance of experience. Speaking of his own 1912–1913 experiences in Morocco, Matisse told Father Couturier that "The first time I saw the desert I had seen *nothing* (only the flat sand with a black dot on the horizon, which was Touggourt), because I was obsessed with the imaginings of my childhood. . . . It is like the Christ of Tissot: he represented Him in an Arabian way because he had gone to see the Arabs in Palestine. But that amounts to nothing at all, it is not Christ at all: Christ is what all the centuries have made of him; though in reality Christ however was exactly like that Arab that Tissot had seen . . . but that amounts to *nothing*." (Marie-Alain Couturier, *Se garder libre: Journal (1947–1954)*, Paris, 1962, p. 93.)

11. Cf. Texts 28 and 48, below.

TEXT 13

1. "Entretien avec Tériade," *L'Intransigeant*, 20 and 27 October 1930. Used by permission of the author.
2. According to Matisse's pocket diary, he was interviewed by Tériade on 15, 17, and 22 October. Matisse Archives, Paris. For details on the circumstances of his trips see Jack Flam, *Matisse: The Dance*, Washington, D.C., 1993.
3. *Woman in Yellow*, which was begun in 1929 and not finished until 1931.
4. Cf. the "Airplane" section of *Jazz* (Text 37, below).
5. For other discussions of Matisse's voyage to Tahiti, see Texts 16, 36, 37, 48, 50, below.
6. Cf. Text 48, below.
7. Barnes, who owned many of Matisse's paintings, had just commissioned Matisse to do a mural for the Barnes Foundation (see Texts 18, 19 and 44, below).
8. Many of Matisse's earliest collectors and patrons had been Russians and Americans.
9. This idea had great appeal to Matisse. See Text 33, below.
10. Matisse had himself won the Carnegie prize in 1927 (see p. 231, below).

TEXT 14

1. E. Tériade, "Autour d'une rétrospective, Henri-Matisse parle . . ." *L'Intransigeant*, 16 June 1931.
2. Actually Philibert-Léon Couturier (1823–1901), a student of the history and genre painter François Picot (1786–1868).
3. Auguste Joseph Truphème (1836–1898).
4. In his published version, Vauxcelles ("Le Salon d'Automne," *Gil Blas*, 17 October 1905) wrote, "*au milieu de l'orgie de tons purs: Donatello chez les fauves.*" In 1925 Matisse, speaking of artists' relationships to the past, had told Dorothy Dudley, "Yes and today if an artist does not try to do what someone of great power has done, they say it is no good. Every one must imitate the genius to be considered. And yet perhaps there is a tradition coming today—the Cubists." Dudley replied, "But the Cubists have broken too much with the past. And they are dogmatic. . . ." To which Matisse responded, "Perhaps that is true."

TEXT 15

1. Gotthard Jedlicka, "Begegnung mit Matisse," *Begegnungen: Künstler Novellen*, Basel, 1933, pp. 102–126. Jedlicka (1889–1965) wrote extensively on French art.

2. The luxurious Hotel Lutetia.

3. Although he painted no finished pictures in Tahiti, Matisse did at least one small oil sketch while he was there. See *Matisse et Tahiti*, Cahiers Henri Matisse No. 1, Musée Matisse, Nice, 1986, p. 69; also pp. 53–54, 66–75, for related drawings and photographs.

4. This is an especially interesting observation, given the extensive use that Matisse would later make of themes inspired by the South Seas, especially in his paper cutouts.

5. This is cited in French by Jedlicka: "*Ce qu'il faut imiter, c'est l'effort et non pas la réussite.*" Matisse would later voice similar concerns in his 1948 letter to Henry Clifford, Text 41 below.

6. Number 10 in the exhibition catalogue, Galeries Georges Petit, *Henri-Matisse, 16 juin–25 juillet 1931*, Paris, 1931.

7. Matisse exaggerates the size of the school; although he initially charged no tuition fee, eventually he did so in order to discourage students from coming to work in his atelier simply because it was free.

8. Jedlicka's concluding remarks are devoted to how he spent the rest of the day in Paris.

TEXT 16

1. Pierre Courthion, "Rencontre avec Matisse," *Les Nouvelles littéraires*, 27 June 1931, p. 1; translated by permission of the author. The Swiss-born Courthion (1902–1988) was a museologist and film director as well as the author of numerous books about modern art, including two important books on Matisse (published in 1934 and 1942), and an important series of nine unpublished interviews, done in the spring of 1941, when Matisse was recovering from surgery.

2. Matisse had been able to see works by Goya and El Greco at Durand-Ruel's gallery during the 1890s, including the latter's *View of Toledo*.

3. From "Notes of a Painter."

4. Matisse also did a more abstract variation on this still-life in 1915.

5. By Chardin; copied 1894–1900.

6. Matisse does not mean that he literally copied Cézanne, but rather that he did so in spirit. Cf. Cézanne's *Gulf of Marseille seen from L'Estaque*, c. 1885 and Matisse's *View of Saint-Tropez*, 1904; or various still-lifes done around the same time. This influence, especially from Matisse's own Cézanne *Three Bathers*, may be seen in *The Back IV*, 1930–31, and in the Barnes Murals.

7. Copied c. 1895.

8. The Raphael was copied in 1904, the Ruysdael in 1894.

TEXT 17

1. E. Tériade, "Émancipation de la peinture," *Minotaure*, I, 3–4, 1933, pp. 9–20 (the Matisse statement appears on p. 10). Reprinted in *Verve*, IV, 13 (December 1945), p. 20 (where it is misdated to 1934). Used by permission of Albert Skira.

2. The other artists were Georges Braque, Pablo Picasso, Borès, Joan Miró, André Beaudin, and Salvador Dali.

3. In 1943, Matisse told Aragon: "To get away from the individuality of the artist who relegates to the second level the intimate character inherent in the thing in question like Raphael, Renoir, etc., who seem to have always painted from the same woman . . . I copied . . . photographs, forcing myself to make the greatest resemblance possible; an image with as good a likeness as possible. I thus limited the field of possible evolutions from my imagination. It was still an error, but what a lot of things I learned from it!" Louis Aragon, "Matisse-en-France," in Henri Matisse, *Dessins: thèmes et variations*, Paris, 1943, p. 36; (hereafter cited as Aragon 1943).

4. The river that rises in the Alpes Maritimes and enters the sea at Nice.

TEXT 18

1. Dorothy Dudley, "The Matisse Fresco in Merion, Pennsylvania," *Hound and Horn*, VIII, 2 (January–March 1934), pp. 298–303. Dorothy Dudley Harvey was a Chicago-born writer and poet who published a biography of Theodore Dreiser. She and her sisters, Caroline, Katherine, and Helen were active in literature, dance, and fine arts on both sides of the Atlantic. My thanks to Steven Harvey for making this material available to me. For more on the Dudley sisters, see essays by Steven Harvey, Sidney Geist and Edward R. Burns, in Gallery Schlesinger 1990.

2. Dorothy and Katherine Dudley had gone to see Matisse in May 1925 to ask his advice about Katherine's paintings. Dorothy Dudley's account of that visit is published in Gallery Schlesinger 1990, n.p.

3. For details, see Flam 1993. When Frank A. Trapp interviewed Matisse in February 1950, the artist told him that he found Barnes most curious in the way he represented at the same time "the best and the worst" (*le meilleur et le pire*). My thanks to Frank A. Trapp for making his interview notes available to me.

4. Here the following additional paragraphs appear in Dudley's typescript: "The decoration which Matisse has just completed for the Barnes museum, dramatizes the essence of nature, the phenomenon itself; the communion is complete and lonely. Yet it has its relation to incident of time and place, to the needs of a Philadelphia art patron, and in that sense is an American event. Only patriotic inflationists can pretend that the United States is yet a milieu to create masters in painting, but it is not indiscreet to say, and this mural is new evidence, that the soil to produce paintings is as fertile with us as elsewhere. Superb collections increasingly lend wealth and meaning to the country. And what magnetic effect these may one day have on Protestant but hopeful eyes and souls is incalculable. (Curiously and perhaps happily Americans still suffer from eagerness, who after three hundred years are not cured of inexperience.)

 "Already there has come to exist among the skyscrapers a narrow plane of life synthetically Matissian, Picassian, Derainian, Brancusian, where these artists could scarcely go without encountering disciples, in the pictures, in the decoration, even in traits of mind. And so seductive, for example, through the Matisse lens have become Mediterranean colors and shapes—the balcony railings, the curtains, the fruit, the shutters, the Moroccan screen, the striped trousers of the Odalisque—that it would not be fantastic to trace back to him a recent current of travel—the deflection of numerous American tourists from their Lake country, the midnight sun, their Breton plage, to the Côte d'Azur.

 "Such in relation to anonymous needs is the involuntary power of a master who has dedicated his life to the nature of light. His discoveries have in turn printed themselves more coarsely perhaps, but palpably on the retina of the spectator's eye. Spending an hour in a gallery of Matisse canvases or with a book of his drawings, afterwards one finds printed on the memory intense images; one is sharply imbued with the miracle of light, and the wistful evanescence of the people and objects lighted, of the series turned together at any one moment into being. Color chords break in the mind; the closed eyes tastes [sic] the sun.

 "Matisse is one of the several moderns of today, heirs to those of yesterday, who appear to have actually changed the vision—as if a new continent had been sighted, a new lay of land, unembarrassed by tradition, Catholic or Protestant. To Americans, who have not yet stylized their own new continent, he is or in theory he might be like a guide to brilliance."

5. Here Dudley adds: "Thus the critics, who had long been waiting for this event, were deprived of their fun, either as disciples or as heretics. '*La Danse*,' unseen by human being, unless by a caretaker, was given back for a Pennsylvania summer into the keeping of nature—the terrestial hum and silence of days and nights. The drama of the work of art presented to its audience was post-

poned, perhaps even interrupted, what with the waning of art journals and the momentary fever for economic programs."

Matisse had been especially vexed by Barnes's unwillingness to allow visitors to see his work. In the typescript of Dudley's essay, she writes of Barnes that "he is known as reluctant to share these with the public. A reasonable reluctance, he leads one to believe: too many people would call out of idle curiosity; and besides when he used to welcome visitors he was persecuted as seeking to corrupt American youth with modern French art. One can believe this, since what more candid revelations, and what more experienced, in any thirty years of painting than the canvases from that sidereal center of art, Paris! And what public in those years more fearful of aesthetic truth than ours!"

6. The space was actually a garage.

7. In the typescript Dudley describes their arrival somewhat differently, "Matisse admitting us distantly, holding back a fiercely barking Schnauzer. Along one wall, occupying about two-thirds of it, the scaffolding which held the decoration. A workman, expressionless, standing always in the background near the entrance."

8. The typescript here reads: "'Are you afraid of dogs?' he asked. I said no, though had he asked, were we afraid of him, the answer would have been more difficult. In a room, however, which held so fine an understanding no one ought to be afraid. Besides there was something harmonious, like wine if it were not like honey, in the voice of Matisse, to contradict impersonality. Releasing his hold on the dog, who with a final scroll of barks accepted us, he indicated the alcove across the room from the decoration."

9. Actually, as Matisse later found to his regret, the glass panes of the doors were covered and so the greenery of the garden—which formed an integral part of his conception—could not be seen. He later tried, unsuccessfully, to have Barnes uncover the glass so the green of garden would be seen.

10. The mural painter Pierre Puvis de Chavannes (1824–1898), whose monumental decorative style employed fresco-like colors and simplified forms. Matisse, who was frequently compared to Puvis, was rather antipathetic to the earlier artist's soft, somewhat anemic idealization of antiquity.

11. The typescript reads here: "With this preface made as swiftly and accurately as a skillful surgeon or engineer might relate for students the exigencies of any one problem to the principles of his science, we were at liberty to look at the painting.

"Two giant figures in each archway, a third introduced from one into the adjacent archway: eight figures against shafts of sky in a tremendous dance of goddesses."

12. Here the typescript reads: "The flesh gray, between black and white, like the walls of the room in Merion; the sky vivid cobalt blue and brilliant rose, which for a limpid narrow margin around the bodies deepens to a darker blue and rose; the gray of the flesh influenced against the blue toward orange, against the rose toward the green. A sense of infinite modulation with only these five tones—these and the black of the drawing which, with an economy made credible by Matisse, designs the dancers. The one short line, indicating the bend of the torso of the middle lower figure, a marvel of thrift, makes the center of this geometry, to which are impeccably related the ovals of heads, the circles of breasts, the verticals of spines, the intersecting ellipses and angles of thighs, knees, ankles, shoulders and arms. A rhythmic geometry inviting to strength and elegance, if human beings knew how.

"As we looked we were reminded of the processions one sees in the Northern lights in America—the figures moved in and out as well as existing on a single plane. Matisse asked if the Northern lights were clouds? We said no, they were only on clear nights. He seemed for a moment arrested that his painting recalled a majestic phenomenon of nature, happening in our skies not his."

13. Matisse's response here is a good example of what high store he set upon the issue of his working instinctively and with spontaneous sincerity. His response may also have been an implicit rejoinder to

Barnes's feeling that the mural was in fact overly calculated in its effect. See Flam 1993, pp. 63–64.

14. Matisse had used pieces of colored paper to work out the composition of the mural without having to become involved in constant repainting. This technique anticipates that of his late cutouts.

15. These are photographs that Matisse had taken of the work while it was in progress. For reproductions of them, see Flam 1993.

16. Here the typescript reads: "Then really your painting has corrected the architecture? He admitted that this had seemed to him imperative; that if the proportions had been different he would not have developed this theme, but would have done something else with the surfaces. He emphasized the labor he had undergone in the one aim of suiting the decoration to the room. To this end he had purified and verified the drawing to the last fraction of an inch, so that it should always be supple and free, but never too fluent.

"For two years the work occupied him; he had thought of nothing else. Now the final result pleased him. Tomorrow it would be packed and he would go to America to install it. And now that it was complete the final result was so logical that one could imagine people who would find it a mere preliminary, and others to whom it would give a key to life. This dance made by flat tone and a minimum of line, both in itself and in the background it dictated, produced a sense of strength, of economy and precision, which made the equivalent of divinity—that is of the very movement of life, its victory over its disintegration. To a canvas fourteen by three and a half meters Matisse had conveyed the amazing simplicity of many of his drawings, where a minimum of line presents the maximum of reality.

"He spoke of his recent illustrations for Mallarmé: 'Do they remind you of this painting? Some people have said so.' It was true, the mural had the same intricate elimination. The faun for example, departing from his afternoon, described the line of ecstasy violently, concisely, as these dancers did flight in space."

17. Matisse had given a number of interviews to journalists while he was in America. Fairly typical of these is an interview published in *The Literary Digest*, 18 October 1930, in which he stated that the American artist had no particular need to go to Paris in order to learn his metier: "He can learn it in New York as well as anywhere in the world. Better, in some respects. Nearly all modern art is over here, most of all the good modern paintings. There are very few in Paris. . . . An American artist should learn his metier, develop his ability and work in America. Consider how much fresher are the subjects for a painter in this country, the scenery, the architecture, the people. Let him go to Paris for occasional visits of not more than a few months, if he wants to. But an American artist should express America."

The American painter George L. K. Morris, however, who met Matisse on a French train, has recorded the following: "I reply that I'm returning to New York in two months. 'That's a very good idea,' Matisse chimes in. 'Artists should stay in their own countries.' . . . I start a defense of my European trip. . . . The gentleness that had characterized Matisse's voice is now gone abruptly. 'Poussin and El Greco have been dead 300 years and you consider them in your procedure!' He ends up: 'The only hope for American art is for the painters there to stay home; they have a new untried country with beautiful skies and beautiful women—what more do you need?'" George L. K. Morris, "A Brief Encounter with Matisse," *Life*, LXIX, 9 (28 August 1970), p. 44.

Matisse's feeling that artists might better stay in their own country did not originate with his trip to America. In 1924 he told the Danish artist Finn Hoffmann, "I do not see it as an unconditionally good thing that so many foreign artists come to Paris." Finn Hoffmann, "Hos Henri Matisse," *Buen*, no. 2 (December 1924), p. 6.

Here Dudley has her own interpretation, which was cut in the published version: "Out of jealousy, we imagined. American painters used to flattery at home, naturally got little or none in Paris. Their defense was to return and decree that it was healthier for their art at home. Whistler,

for example, who attained quality, had none of that jealousy. 'But today we have no painters of the very first order.'

"'Oh, I think you have some who are really gifted,' Matisse insisted . . . 'But you are still in a great hurry in your country and for art, leisure is necessary. It will come.'"

18. At this point, Dudley notes in the typescript: "There was a knock at the door. A chauffeur reminded him of an appointment. Matisse looked at his watch, yes he was late; would I write him on his return from America? The article would be all the better then."

19. And indeed, as he wrote to his son Pierre, he was actually quite uncertain—even anxious—about how Barnes would react to the mural. See Flam 1993, pp. 59–60.

20. This section ends somewhat differently in the typescript, with an extended reflection on the differences between American and European life in which Dudley notes: "Sometimes undoubtedly the canvases of Matisse, exported to America, generate exotic values, which accuse our exemplary houses of emptiness. We are tantalized by a nostalgia for sophistication, to reconstruct in British-Jewish-America something of the flavor and wit, even the arrogance of the seasoned life, modern within ancient, which Matisse and other Parisians have had to dramatize.

"But in this panel, brilliance is attained without accessories. Its spontaneity springs from a gravity due to years of work and concentration almost foreign to American life, and therefore to modern life, first invented by Americans. Yet the *La Danse* was a problem in mathematics, in physics, so precisely resolved, that it would not accuse its hastier, less conscious milieu. It would illumine, not deride the American scene."

21. In fact, Matisse and Barnes had argued so violently during the installation that Matisse had become ill over it. Moreover, Barnes had made it clear that he was less than fully satisfied with the mural, despite the two men's public expressions of mutual admiration for the mural and for each other. See Flam 1993, pp. 60–62.

TEXT 19

1. The French originals of these letters are published in *Matiss. Zivopis, skul'ptura, grafika, pisma*, Leningrad, 1969, pp. 130–133. Two of the letters about the Barnes Murals were first published in *Iskusstvo*, 4, 1934, pp. 199–203. In French sources, Romm's name is spelled "Alexandre," but in the English version of his book, his name is given as "Alexander."

2. Alexander Romm, *Henri Matisse*, Moscow, 1935; English trans. from the Russian by Chen I-Wan, *Henri-Matisse*, Ogiz-Isogiz, 1937; new edition, "translated by Jack Chen," *Matisse, A Social Critique*, New York, 1947.

3. *Matiss*, Leningrad, 1969, p. 134.

4. See for example: Gaston Diehl, "Matisse: A la recherche d'un art mural," Paris, *Les Arts et les lettres*, no. 20 (19 April 1946), pp. 1, 3; also Text 44, below.

5. In fact, Matisse worked on the first version from 1931 to early 1932; he stopped work on it when he discovered the error in the measurements. He then began another work on a second set of canvases, which was finished in April 1933 and installed at Merion the following month. Then he went back to the "first" composition and finished it (on a third set of canvases) at the end of 1933. Hence the mural now at Merion (which Matisse refers to as the "second" version, was actually finished *before* the so-called "first" version, now at the Musée d'Art Moderne de la Ville de Paris. For a detailed discussion of the entire project, see Flam 1993.

6. Here as elsewhere, Matisse calls the Paris version the first version, and the Merion version the second version, even though the Paris version was finished *after* the Merion version had been installed. This was probably in part because he wanted Barnes to feel that he had the "final" version, and in part because he thought of them in terms of the order in which they were started.

7. *Poésies de Stéphane Mallarmé*, published by Skira in Lausanne, in October 1932.

8. Probably Matisse's *Spanish Woman with Tambourine* of 1909.

9. Shchukin, fearing a scandal, was uneasy about having such a large painting of nudes in his house, and had asked Matisse to paint out the boy flutist's sex, which Matisse refused to do (Barr 1951, p. 134). Shchukin then had it done when the painting was delivered. Matisse's request to Romm went unheeded, since as late as 1979 the painting still had a spot of red over the boy's sex.

TEXT 20

1. Henri Matisse, "On Modernism and Tradition," *The Studio*, IX, 50 (May 1935), pp. 236–239. This text was originally published in English; the original French text has been lost. The article ran under the following headline: "Continuing the series of articles, in which eminent critics and artists examine the meaning and trend of art to-day, the famous French painter, whose work has caused so much controversy, gives a personal expression of his artistic beliefs and development." Given the importance of the text, it is most curious that the text was not published in French around the same time; especially since a number of French periodicals would have welcomed it. The text reads more like a gathering of previous quotes than like an independent essay, and it would not be surprising to someday find that it was translated or adapted from previously gathered quotes, of the sort collected elsewhere by Tériade.

2. *Formes*, I, (January 1930), p. 11. The "Notice biographique" reads as follows:

 a) Born at Cateau-Cambrésis, December 31, 1869. Student at the École de Droit in 1887. Then, in 1892, I entered the École des Beaux-Arts, Gustave Moreau's studio. Worked at the Louvre copying Poussin, Raphael, Chardin, David de Heem, Philippe de Champaigne, etc. First public exhibition at the Société Nationale des Beaux-Arts in the Champ de Mars, 1894.

 Study excursions in Brittany and on the Mediterranean coast. Druet exhibition in 1904. Public opinion at that time was against the "fauves." Our tendencies were slowly accepted. Repeated exhibitions of painting, sculpture, and prints. Work uninterrupted up to the present with travels to Spain, Italy, Germany, Russia, Algeria and England.

 b) At first my painting kept to the dark range of the masters that I studied at the Louvre. Then my palette became brighter. Influence of the Impressionists, of the Neo-Impressionists, of Cézanne and of the Orientals. My pictures are set up through combinations of spots and arabesques. (Municipal Gallery of Moscow, Tescenlund [*sic*] Collection, Copenhagen, and Marcel Sembat Collection, Paris, for this period.)

 About 1914, these works which were above all of a decorative character began to make way for an expression that was more hollowed out, established by planes, in depth, for a kind of painting that was intimate, which is the painting of the current period.

 c) Extremely regular work, every day, from morning till evening.

 d) Some books and articles have been written about my work. They will, perhaps, provide you with information as to the relationship between my painting and the contemporary spirit. They include, amongst others, *H. Matisse*, published by La Nouvelle Revue Française; *H. Matisse*, published by Crès, and *Henri-Matisse* by Fels published by the "Chroniques du Jour". [Respectively: Marcel Sembat, *Matisse et son œuvre*, 1920; Elie Faure, Jules Romains, Charles Vildrac, and Léon Werth, *Henri-Matisse*, 1920 (rev. ed., 1923); Florent Fels, *Henri-Matisse*, 1929.

3. For an illuminating discussion of this text, see Yve-Alain Bois, "Matisse and 'Arche-drawing,'" in *Painting as Model*, Cambridge (Massachusetts) and London, pp. 3–64.

4. Cf. Cézanne (letter to Roger-Marx, 23 January 1905): "To my mind one should not substitute oneself for the past, one has merely to add a new link." Rewald 1941, p. 248.

5. Roger Fry, "Henri Matisse," *Cahiers d'Art*, VI, 5–6, 1931, p. 63.

6. Cf. Cézanne (letter to Émile Bernard, 1905): "The Louvre is the book in which we learn to read." (Rewald 1941, p. 250.) "Go to the Louvre. But after having seen the great masters who repose

there, we must hasten out and by contact with nature revive in us the instincts and sensations of art that dwell within us." (Cézanne to Camoin, 13 September 1903, in Rewald 1941, p. 230.)

7. André Derain (1880–1954), whom Matisse had met at Carrière's studio in 1901. It was at Collioure in the summer of 1905 that Matisse and Derain painted their first so-called Fauve canvases. This is one of the rare published references that Matisse makes to Derain.

8. Actually, Neo-Impressionism.

9. Henri-Édmond Cross (1856–1910) with whom Matisse worked at St.-Tropez during the summer of 1904.

10. Bois 1990 (p. 263, n. 19) notes that in the original French Matisse may well have written "organize (*organiser*)" rather than "arrange" here, echoing Cézanne's familiar phrase.

11. The word in French was most likely *dessin*, which should be translated as "drawing" rather than "design." The semicolon also seems to be an error, and this phrase should more properly read, "expression by drawing: contour, lines and their direction."

12. The incident took place at the 1905 Salon d'Automne, and the word was then used by Vauxcelles in his review of the Salon. See Text 14, n. 4, above. Vauxcelles himself credited Matisse with helping to coin the term. See Barr 1951, p. 56.

TEXT 21

1. E. Tériade, "Constance du fauvisme," *Minotaure*, II, 9 (15 October 1936), p. 3. Used by permission of Albert Skira.

2. For numerous reproductions of such photographs, see Delectorskaya 1988.

3. As noted above, the same statement is published by Escholier (1937, pp. 168–173; see also Escholier 1956, pp. 134–135), with some changes in wording that were no doubt suggested by Matisse, who carefully reviewed and corrected Escholier's manuscript.

4. This additional sentence also appears in Escholier's version (1937, p. 168; 1956, pp. 134–135). The phrase first appears in an 1867 short story by Duranty, "Le Peintre Marsabiel," who later incorporated a modified version of it into another story. As Yve-Alain Bois has noted in an interesting discussion of this matter (Bois 1990, pp. 37–39), it involved a caricature of Cézanne, whence Gauguin made the association with the older painter.

5. This sentence also appears in the Escholier version.

6. This sentence is omitted from the Escholier version.

TEXT 22

1. First published in Escholier 1937, pp. 17–18; reprinted in Escholier 1956, p. 50.

2. For accounts of Matisse's purchase of the painting, see Barr 1951, pp. 38–40; Flam 1986, pp. 66–73.

TEXT 23

1. Henri Matisse, "Divagations," *Verve*, I, 1 (December 1937), pp. 80–84.

2. See Barr 1951, pp. 222–223.

3. The American painter Stuart Purser, for example, recalls that when he visited Matisse in 1938, Matisse was pleased when Purser expressed not only his own enthusiasm for Matisse's drawings, but that of his students and colleagues. Purser has noted that Matisse seemed to feel at this time that his drawing had the widest appeal of all his work. (Communicated orally by Stuart Purser in 1969.)

4. See interview with Jacques Guenne (Text 11, above) for Matisse's account of his own experience as a teacher.

5. The reference is to the well-known passage in Leonardo's notebooks. (See for example Elizabeth G. Holt, *A Documentary History of Art*, Garden City, N.Y., 1957, vol. 1, p. 283.) This passage, which was cited by both André Breton and Max Ernst, had become an important point of refer-

ence for the Surrealists' method of free association. Matisse's mention of it in this context seems to be a gibe at the Surrealists.

6. Matisse had brought Rodin some drawings in 1900, and was apparently rebuffed by the master. Maurice Denis relates that Rodin told Matisse: "Fuss over it, fuss over it. When you have fussed over it two weeks more, come back and show it to me again." (André Gide, *Journal*, New York, 1947, vol. 1, p. 174.)

 Matisse gave Escholier (1956, pp. 161–162) his own version of the story as follows: "I was taken to Rodin's studio in the rue de l'Université, by one of his pupils who wanted to show my drawings to his master. Rodin, who received me kindly, was only moderately interested. He told me I had facility of hand, which wasn't true. He advised me to do 'fussy' drawings and to show them to him. I never went back. In order to understand my direction, I figured I had need of someone's help to arrive at the right kind of detailed drawings. For, proceeding from the simple to the complex (but it's the simple which is difficult to explain), when I had mastered the details, I would have finished my work: that of understanding myself. My work-discipline was already the reverse of Rodin's. But I did not realize it then, for I was quite modest, and each day brought its revelation.

 "I could not understand how Rodin could work on his Saint John, cutting off the hand and holding it on a peg; he worked on the details holding it in his left hand, it seems, anyhow keeping it detached from the whole, then replacing it on the end of the arm; then he tried to find its direction in accord with his general movement.

 "Already, for myself I could only envisage the general architecture, replacing explanatory details by a living and suggestive synthesis."

7. Michel Bréal (1832–1915), a well-known philologist and semantic scholar.

TEXT 24

1. Henry de Montherlant, "En écoutant Matisse," *L'Art et les Artistes*, XXXIII, 189 (July 1938), pp. 336–339. Translated by permission of Henry de Montherlant's Executor. Montherlant (1896–1972), a well-known novelist, dramatist, and essayist posed for Matisse in 1937. See Janine C. Huppert, "Montherlant vu par Matisse," *Beaux-Arts*, 243 (August 1937).

2. Though Matisse declined to illustrate both of these books, he later did illustrate a limited edition of Montherlant's *Pasiphäe* for Fabiani, published in 1944. Matisse repeats his ideas on the role of illustration in his 1950 interview with Georges Charbonnier (Text 44, below).

3. The novelist Maurice Barrès (1862–1923), who described Hugo's magnificent funeral in a chapter of *Les déracinés* (1897).

4. Louis Lyautey (1854–1934), General, later Maréchal de France and writer, served in the colonies in Indochina and Madagascar with General Joseph Galliéni (1849–1916).

5. Matisse, on the other hand, was to note that from the time he chose a career as an artist he was pushed on "by I do not know what, a force that I see today is quite alien to my normal life as a man." (Escholier 1956, p. 18.)

6. Matisse had also just expressed this idea in "Divagations." He was doubtless aware that an artist's writings and statements could be quite relevant to other artists. He himself was keenly aware of the effect that statements by other artists (Cézanne, et al) had on his own thought.

TEXT 25

1. Henri Matisse, "Notes d'un peintre sur son dessin," *Le Point*, no. 21 (July 1939), pp. 104–110. This essay seems in part to have been inspired by Matisse's desire to refute some of the points made in Claude Roger-Marx's recent essay, "Les dessins d'Henri Matisse," in his *Matisse*, Paris, 1938, n.p.

2. When Matisse was compared to the famous juggler, Rastelli, around 1930, he replied: "No, rather I am an acrobat." (Escholier 1956, p. 145.) Matisse later did compare himself to a juggler ("How I Made My Books," Text 35, below).

3. In 1943, Matisse told Aragon: "I do not paint things, I paint only the difference between things. . . . Consider . . . in the same series of drawings, the dress or the fabric . . . you will find that in each drawing they have the same quality as in the whole series. And thus with other elements. There is, then, in these series, a descriptive part of the objects that remains unchanged from one drawing to the next. . . . Even if I feel like adding a few little embellishments to it! Only the expression of the model has changed." Aragon 1943, p. 37.

4. The jewels are the necklaces and bracelets that Matisse often depicted in his prints and drawings around this time. See, for example, William S. Lieberman, *Matisse: 50 Years of His Graphic Art*, New York, 1956, pp. 114–117.

5. Cf. Matisse: "Isn't a drawing a synthesis, the culmination of a series of sensations retained and reassembled by the brain and let loose by one last feeling, so that I execute the drawing almost with the irresponsibility of a medium?" Aragon 1943, p. 34.

6. Roger-Marx 1938, n.p., had written of Matisse's drawings: "These young women, adapted to the decor devised to harbor them and decked out in accessories not of their own choosing are . . . nothing but a pretext for him to assert himself. . . . it is in the volumes or in tonal relationships that he is interested, and never in the soul."

7. Roger-Marx 1938, n.p., had written of "the invincible gifts of this sorcerer—who often charms monsters. . . ."

8. This was a recurring idea in Matisse's discussion of drawing. See for example Gaston Diehl, "Henri Matisse le méditerranéen nous dit," *Comoedia*, 7 February 1942, p. 1: "The drawing should generate light. . . . To modify the diverse parts of the white paper, it suffices to play the neighboring areas against each other."

TEXT 26

1. Francis Carco, "Conversation avec Matisse," in *L'ami des peintres*, Paris, 1953, pp. 219–238. Originally published in *Die Kunst-Zeitung*, Zurich, 8 (August 1943), the interview dates from 1941. © Editions Gallimard 1953: translated by permission. Carco (born François Carcopino, 1886–1958) was a poet and novelist. Matisse had contributed a print as an illustration for Carco's *Tableaux de Paris*, Paris, 1927.

2. In 1900 Matisse and Marquet had taken jobs at the theatrical scenery atelier of Jambon, near the Butte-Chaumont.

3. Fernande Olivier, Picasso's former mistress, and author of *Picasso et ses amis*, Paris, 1933.

4. Matisse actually had studied law, not pharmacy. This was one of the many inaccuracies that Matisse refuted in *Testimony Against Gertrude Stein, Transition Pamphlet* no. 1, Supplement to *Transition*, no. 23 (1934–1935), The Hague, 1935, p. 4: "I was not studying pharmacy but law. I was not interested in painting at that time. It was during a period of convalescence after an attack of appendicitis, when I was living with my family, that a neighbor suggested painting as a means of passing the time, and it was then that I first began to paint. I was for several years a clerk in a lawyer's office before I decided to take up painting seriously."

5. Cf. Gertrude Stein, *The Autobiography of Alice B. Toklas*, New York, 1955, p. 36; first published 1933, hereafter cited as Stein 1933.

6. Max Jacob and Picasso at that time lived at 13, rue Ravignan in the building known as "Le Bateau-Lavoir." Frédé, the proprietor of the "Lapin Agile" cabaret, was a well-known local character.

7. Cf. Stein 1933, p. 37: "She was a very straight dark woman with a long face and a firm loosely hung mouth like a horse. She had an abundance of dark hair. They had with them a daughter of Matisse . . . and Madame Matisse, as she once explained in her melodramatic simple way, did more than her duty by this child because having read in her youth a novel in which the heroine had done so and been consequently much loved all her life, had decided her to do so." In *Testimony Against Gertrude Stein*, Matisse responded (p. 3): "Madame Matisse was a very lovely Toulousaine,

erect, with a good carriage and the possessor of beautiful dark hair, that grew charmingly, especially at the nape of the neck. She had a pretty throat and very handsome shoulders. She gave the impression, despite the fact that she was timid and reserved, of a person of great kindness, force and gentleness. She was generous and incapable of calculation in her gestures of kindness. She characterizes the story of the novel having to do with a case of adoption similar to that in my family as pure invention."

8. *The Woman with the Hat* was of course painted in 1905. Matisse did not move to Issy until 1909, so there may be some confusion here with the *Portrait of Madame Matisse* of 1913.

9. Matisse seems to have romanticized this story somewhat; see Flam 1986, pp. 78–79, 88.

10. The Cézanne *Three Bathers* that Matisse had bought from Vollard in 1899. Despite his poverty at the time, he held on to the painting, which he gave to the Musée du Petit Palais in 1936. (See Text 22, above.)

11. For a photograph of this room, see fig. 26; also Louis Aragon, *Henri Matisse, Roman*, Paris, 1971, vol. I, p. 59; (English trans. by Jean Stewart, *Henri Matisse: A Novel*, New York and London, 1972).

12. He is speaking about the 1941 "Thèmes et variations" drawings. Compare Lydia Delectorskaya's first hand account in Staatsgalerie Stuttgart, *Henri Matisse, Zeichnungen und Gouaches Découpées*, Stuttgart, 1993, pp. 133–136.

13. In a letter to Marquet, dated 3 March 1942 (Private Collection, Paris), Matisse recounts that he lost two-thirds of his birds because of lack of food for them, the result of the general scarcity during the war.

14. In 1947 Matisse, speaking of abstract painting, remarked to Raymond Escholier: "Starting as I do from direct contact with nature, I have never wanted to be confined inside a doctrine whose laws would prevent me from getting health and strength through contact with the earth; like Antaeus." (Escholier 1956, p. 95.) Matisse discussed this relationship with Gaston Diehl ("Les nourritures terrestres de Matisse," *XXe Siècle*, 2, 18, October 1945, p. 1): "If it were only a matter of arranging some flowers, for example, in a vase, in order to make a motif for drawing or painting, art would be quite an easy thing. In reality there is a much more important question to resolve. This spectacle creates a shock in my mind. It is that which I have to represent, that which comes forth from myself.

"I turn to nature to find the essence of each thing. The means we use are beautiful in themselves, it is quite useless to add to them, and nature is herself beauty and richness. It is a question of choice. But it is always necessary to choose and to compose in order to express oneself. In that way one molds the brain of the spectator."

15. A street festival on the Promenade des Anglais in Nice.

16. A popular music hall in Montmartre, depicted notably in a famous pair of 1876 paintings by Renoir.

17. A French dance.

18. The Barnes collection is actually in Merion, Pennsylvania. The reference here may not be to the Barnes *Dance* of 1931–33, but to the 1909 *Dance*, now in the collection of the Museum of Modern Art, New York, which in 1941 was in the collection of Walter P. Chrysler. (Cf. Text 44, below).

19. Georges Louis Leclerc Buffon (1707–1778), the famous naturalist and director of the Jardin du Roi, who wrote extensive works on plants and animals. Matisse's memory of the incident is perhaps somewhat confused. The archives of the Museum National d'Histoire Naturelle reveal that the statue of Buffon in the Jardin des Plantes was executed by Jean-Marius-Siméon Carlus (1852–1930), a student of Falguière and Mercié. The Buffon statue was done for the 1907 bicentennial anniversary of Buffon's birth. In 1903 Carlus did a bust of the museum director, Edmund Perrier, which evidently led to the Buffon commission. It is therefore possibly the bust of Perrier that Matisse remembers being executed, not the statue of Buffon.

20. The painter Eugène Carrière (1849–1906), who painted in a soft-edged monochromatic manner.

21. Jean Puy (1876–1960), Pierre Laprade (1875–1932), Auguste-Elisée Chabaud (1882–1955).

22. The original is *"Attention! V'là l'dégel!* Idiomatically, the phrase also connotes a loss of innocence. In this context, Matisse is chiding Laprade for acquiring a glib facility, which resembled that of Carrière's soft (melted) forms.

23. Jean-Louis Forain (1852–1931) was an academic painter and a critic. The allusion is to the hazy forms in Carrière's paintings.

24. Auguste Pegurier (1856–1936). Actually, Matisse was in Saint-Tropez in 1904 and in Collioure in 1905.

25. The painter Henri Lebasque (1865–1937) had left Paris in 1900 for reasons of health. Matisse later (1917–18) visited Renoir at Cagnes.

26. *Pintre*, a variant of *pinter*, "to tipple," a pun on *peintre*, "painter."

27. *Annuaire Almanach du commerce et de l'industrie (Didot-Bottin)*, the commercial directory found in French post offices and cafés.

28. Both painters did numerous pictures of these views.

29. Berthe Weill owned the first private gallery to exhibit Matisse (February 1902). Albert Sarraut (1872–1962), an acquaintance of several Paris School personages, was a well-known politician and connoisseur, and author of many pieces on modern art.

30. For a detailed chronology of Matisse's early years in Nice, see Jack Cowart, "The Place of Silvered Light: An Expanded, Illustrated Chronology of Matisse in the South of France, 1916–1932," in Jack Cowart and Dominique Fourcade, *Henri Matisse, The Early Years in Nice, 1916–1930*, Washington, D.C. and New York, 1986, pp. 15–46.

31. Frank Harris (1854–1931), the novelist, dramatist, biographer, and bon vivant, who had written an essay about Matisse and Renoir.

32. Stein 1933, p. 37: "Matisse had at this time a small Cézanne. . . . The Cézanne had been bought with his wife's marriage portion. . . . The Cézanne was a picture of bathers and a tent. . . ." Matisse denied this statement in *Testimony Against Gertrude Stein* (p. 4): "With regard to the purchase of the Cézanne: there was no tent in the picture, it was a Cézanne with three women bathers and several trees. It was very much worked over so that there was no possibility of mistaking it. The story of its purchase with my wife's dot is invented."

33. Maurice Mæterlinck (1862–1949), Belgian poet, dramatist, and essayist who lived mostly in France.

34. *Red Still Life with a Magnolia*, 1941.

35. Eugène Fromentin (1820–1876), painter, novelist, and author of a classic treatise on seventeenth-century Dutch and Flemish painting.

36. Leopold Zborowski (1889–1932).

37. Cf. Stein 1933, p. 64, who states that when they first met they "became friends but they were enemies. Now they are neither friends nor enemies. At that time they were both." Françoise Gilot and Carlton Lake, *Life with Picasso*, New York-Toronto-London, 1964 note their lasting rivalry (pp. 99–100), as well as their mutual respect (pp. 261–264).

38. A reference to Balzac's short story "Le chef-d'œuvre inconnu," in which the painter Frenhofer secretly labors to produce a perfect painting; after ten years of work on the canvas, he shows it to two young painters who find it incomprehensible. Kurt Badt (*The Art of Cézanne*, Berkeley and Los Angeles, 1965, pp. 202–205) relates the story to the whole problem of "realization" that has confronted modern painting since the nineteenth century. For an excellent discussion of this, see Dore Ashton, *A Fable of Modern Art*, New York, 1980.

TEXT 27

1. *First Papers on Surrealism*, New York, 1942, pp. [25–26]. The letter is dated 7 June 1942; another letter, dated 18 September 1940, discusses the evolution of Matisse's painting *The Dream*, of 1940.

2. Matisse to Pierre Bonnard, 13 January 1940. The letter is worth quoting at length:

"Your letter has found me knocked out this morning, completely discouraged. . . . For I am paralyzed by something conventional that keeps me from expressing myself in painting as I would like. My drawing and my painting are separating.

"My drawing suits me, for it renders my specific feelings. But my painting is hampered by new conventions of flat planes through which I should express myself completely, with local tones only, without shading, without modelling, which should react with one another to suggest light, spiritual space. This hardly goes along with my spontaneity, which makes me discard a great deal of work in a minute, because I reconceive my picture several times in the course of its execution without really knowing where I am going, relying on my instinct. I have found a way of drawing which, after the preliminary work, has a spontaneity that relieves me entirely of what I feel, but this method is exclusively for me, as artist and spectator. But a drawing by a colorist is not a painting. He must produce an equivalent in color. And that is what I'm not managing to attain." ("Correspondence Matisse-Bonnard, 1925–1946," *La Nouvelle Revue Française*, XVIII, 211, 1 July 1970, p. 92.)

3. Matisse to André Rouveyre, 6 October 1941. This whole passage from this letter offers valuable insights into Matisse's state of mind at this time: "It makes for a life of torment when someone with my acute sensibility depends on a method, or rather when an acute sensibility keeps you from leaning on a method for support. I'm completely overwhelmed—and I remember that my whole life has been like this—a moment of despair followed by a happy instant of revelation that allows me to make something that surpasses reasoning and leaves me distraught before a new undertaking. So far as I can see, it will always be like this for me, I keep looking for the Ariadne's thread that should logically conduct me to being able to express myself in terms of what I have that is exceptional, with means (colors) that are richer than line drawing, with which I articulate what I am moved by in nature, in the sympathy that I create between the objects that surround me, around which I live and in which I am able to place my feelings of tenderness, without having to suffer from it, as in life. . . .

"I just received the article by [André] Lhote. . . . This intelligent article interests me, even though I learn absolute nothing about myself from it. The eternal conflict between drawing and color in the same individual, that is what he doesn't say, luckily because he also leaves some hope. I work in order not to lose this hope."

TEXT 28

1. This text is translated from a French transcript very kindly made available to me by Pierre Schneider.

2. Excerpts from both broadcasts were first published in Barr 1951, pp. 562–563. The first broadcast probably dates to mid-January 1942 (the 13 March transcript says it appeared "about two months ago").

3. The French sentence reads as follows: *"Mais pour traduire mes émotions, les sentiments et les réactions de ma sensibilité par la couleur et le dessin. . . ."* Before the French transcript came to light, Dominique Fourcade, translating back into French from Barr's English translation, understood the problem of the English word "design" here and reconstructed this as *"en termes de couleur et de forme."* (See Dominique Fourcade, ed., *Matisse: Écrits et propos sur l'art*, Paris, 1972, p. 189, n. 49). See Bois 1990, pp. 3–4, on the inappropriateness of the word "design" to Matisse's work, and p. 262, n. 2, for his comments on Fourcade's reconstruction.

4. In 1918 Matisse had written in a letter to Camoin (23 May 1918): "What a lovely place Nice is! What light, soft and tender despite its brilliance." And in 1943, he told Aragon: "Nice . . . why Nice? In my art I have tried to create a crystalline state for the mind: this necessary limpidity I have found in several places in the world, in New York, in Oceania, in Nice. If I had painted in the north as thirty years ago, my painting would have been different: there would have been mists, greys, gradations of color through perspective. In New York the painters say, 'we can't paint

here, with this sky made of zinc!' In fact, it is admirable. Everything becomes clear-cut, crystalline, precise, limpid. Nice, in this way, has helped me. You must understand that what I paint are objects thought of in plastic terms: if I close my eyes, I see the objects better than with my eyes open, free of accidental detail; that is what I paint. . . ." Aragon 1943, p. 32.

5. Matisse had painful memories of just such an experience in Gabriel Ferrier's studio; see Text 11.

6. Gérôme had played an instrumental role in having part of the Caillebotte bequest refused.

7. In a 1946 notebook called *Répertoire: 6,* in which Matisse wrote drafts of the text for his book *Jazz,* he wrote the following: "I was once asked what the role of the State should be in encouraging the Fine Arts—aid to young artists. My reply was: the suppression of schools with appointed teachers to be replaced by free studio-workshops in which the young artists could receive criticism by masters of their own choosing. The student would first of all be accepted by a committee of well-known figures in the art world, and then receive a grant from the State which would have a right of ownership over his work, the best part going to form museums of contemporary artists.

"I ended (by saying) that the best of them would be found among those who were unrecognized and had grown up 'the hard way.'

"I added it would be necessary to give all those applying to become artists a good hiding and that at the next attempt they would get a double ration. Those who came back a third time would unquestionably be destined to become artists or madmen.

"August 6, 1946. After visiting the exhibition of modern artists at the Luxembourg." Quoted in Pierre Schneider, *Matisse,* Paris, 1984, p. 710, n. 33. (English trans. by Michael Taylor and Bridget Strevens Romer, *Matisse,* New York and London, 1984; translation modified.)

TEXT 29

1. Louis Aragon, "Matisse-en-France," in Henri Matisse, *Dessins: Thèmes et variations,* Paris, 1943, pp. 25–28. Reprinted in Louis Aragon, *Henri Matisse: A Novel* (translated by Jean Stewart), London-New York, 1972, with valuable additional comments added by Aragon. Translation © Collins and Harcourt Brace Jovanovich. Translation slightly modified; in addition to some changes in wording, I follow the first publication's punctuation and use of italics. Aragon (1897–1982), one of the founders of Surrealism in literature, broke with that movement when he joined the Communist party. During the war he was a member of the Resistance movement.

TEXT 30

1. Marguette Bouvier, "Henri-Matisse chez lui," *Labyrinthe,* 1 (15 October 1944), pp. 1–3. Used by permission of Albert Skira.

2. A Moorish carved and inlaid screen.

3. The American art historian Frank A. Trapp remembers that when he visited Matisse in 1950, the artist used his bedside phone to conduct business. My thanks to Professor Trapp for making available to me the notes made during his visit.

4. These paintings (*Woman Sleeping; Annélies with Tulips and Anemones,* etc.) are illustrated in Bouvier's article.

5. The girl named Annélies appears in a photograph with Matisse on p. 2 of Bouvier's article.

6. Cf. Matisse's advice to his students about the use of the plumb line; also Aragon, Text 29, above, on the rendering of trees, and *Jazz,* Text 37, below: "My curves are not mad."

TEXT 31

1. Henri Matisse, "Rôle et modalités de la couleur," in Gaston Diehl, *Problèmes de la peinture,* Lyons, 1945, pp. 237–240.

2. Escholier 1956, p. 97, notes that the young Victor Hugo first connected Chinese art with Ingres in *Conversation Littéraire,* 1819, while speaking of the Ingres *Odalisque.*

3. *Crépons:* Brightly colored Japanese prints on crêpe paper. In a letter to André Rouveyre (15 Febru-

ary 1942) Matisse made an interesting observation on these *crépons*: "I knew and profited from the Japanese through reproductions, the poor prints bought on the rue de Seine in the boxes carried by the print merchants. Bonnard told me the same thing, and added that when he had seen the originals he found them a bit disappointing. That is explained by the patina and the discoloration of the old prints. Perhaps if we had only had the originals to look at, we would not have been as impressed as by the reprints."

4. Léon Bakst had done the settings for Diaghilev's production of *Scheherazade*. For more on Bakst's designs see Deborah Howard, "A Sumptuous Revival: Bakst's Designs for Diaghilev's Sleeping Princess," *Apollo*, XCI, 98 (April 1970), pp. 301–308.

5. Cf. Matisse's October 1945 statement:

"Drawing is possession. The feeling of the object, coming from the artist's heart, must be seized in both arms so that nothing can escape when he renders the image of it.

"A Chinese professor said to his pupil: When you draw a tree you should have the feeling that you are growing with it.

"Ingres also said: A drawing should be like the weave of a basket from which you cannot remove one reed without making a hole in it.

"What counts most in a picture is the drawing and the composition."

6. Matisse had been deeply impressed by a flight he had made from London to Paris in 1937. See his remarks in *Jazz*, 1947 (Text 37, below).

TEXT 32

1. Henri Matisse (Observations on Painting, untitled), *Verve*, IV, 13 (December 1945), pp. 9–10; translated as "Observations on Painting," by Douglas Cooper, *Horizon*, XIII, 75 (March 1946), pp. 185–187. Retranslated here using Cooper's title.

2. Probably *Still Life with a Peppermint Bottle* (National Gallery of Art, Washington).

3. Matisse clarifies this with his comparison of Ingres and Delacroix, below.

4. Cf. Matisse, *Portraits*, Text 52, below.

5. Cf. Text 31, above.

6. Cf. Cézanne (letter to Camoin, 9 December 1904): "Whoever the master is whom you prefer, this must only be a directive for you. Otherwise you will never be anything but an imitator." Rewald 1941, p. 241.

7. Cf., Matisse's account of his own experience around 1905, in "Matisse Speaks" (1951; Text 48, below): " 'What do I want?' That was the dominant anxiety of fauvism."

TEXT 33

1. Léon Degand, "Matisse à Paris," *Les Lettres françaises*, 6 (October 1945), pp. 1, 4. Translated by permission of *Les Lettres françaises*.

2. The panel was commissioned by an Argentine diplomat in Paris. Although begun in 1944, it was not finished until 1947. (See Barr 1951, pp. 269–270, 493; Schneider 1984, pp. 140, 151, 308.) At the time of Degand's visit, the panel was provisionally "finished."

3. Lydia Delectorskaya (b. 1910), who had been modeling for Matisse since 1934.

4. Raymond Escholier, *Matisse, ce vivant*, Paris, 1937. Although Matisse had read and made corrections on the manuscript for this book, it nonetheless contains a number of factual errors.

5. The painting is evidently *The Yellow Curtain* of 1915.

6. There is an interesting parallel here with Matisse's mistrust of an overly virtuosic painting technique.

7. Marcel Pagnol (1895–1974), whose popular novels about life in Marseille were also made into films.

8. Julien Benda (1867–1956), essayist and critic known for his rigorous views of literature and intellectual life.

9. Marianna Alcaforado, *Les Lettres Portugaises*, Paris, Tériade, 1946; Pierre Reverdy, *Visages*, Paris,

Editions du Chêne, 1946; *Florilège des Amours de Ronsard*, Paris, Albert Skira, 1948; *Poèmes de Charles d'Orléans*, Paris, Tériade, 1950.

10. Cf. the similar sentiments expressed at the end of "Notes of a Painter," Text 2, above.

TEXT 34

1. Henri Matisse, "Témoignages de peintres: Le noir est une couleur," in Galerie Maeght, *Derrière le miroir*, Paris, December 1946, pp. 2, 6, 7.

2. The painting is the *Luncheon in the Studio*, 1868. The man in the black coat is Léon Koëlla, Manet's illegitimate son.

3. *Portrait of Zacharie Astruc*, 1864.

4. *The Moroccans*, 1916.

5. Matisse does not mean that he had given up the use of black, but that he no longer used it merely for linear construction as in his earlier works. Actually, at this time Matisse was making great use of black as a chromatic element rather than as an element of linear construction. This particular sentence was written a year earlier, for the December 1945 "Exposition didactique" at the Galerie Maeght.

TEXT 35

1. Henri Matisse, "Comment j'ai fait mes livres," in *Anthologie du livre illustré par les peintres et sculpteurs de l'école de Paris*, Geneva, 1946, pp. 21–24. For a complete catalogue of Matisse's illustrated books see Claude Duthuit with Françoise Garnaud, *Henri Matisse: catalogue raisonné des ouvrages illustrés*, introduction by Jean Guichard-Meili, Paris, 1987.

2. Matisse discussed his outlook on book illustration with Escholier (1956, p. 153): "I agree with your distinction between the illustrated and the decorated book. A book should not need completion by an imitative illustration. Painter and writer should work together, without confusion, on parallel lines. The drawing should be a plastic equivalent of the poem. I wouldn't say first violin and second violin, but a concerted whole."

3. Matisse's book, *Poésies de Stéphane Mallarmé*, Lausanne, 1932, was published by Skira in October 1932. It is interesting to note that Matisse does not consider books illustrated by drawings not specifically done for them (such as Reverdy's *Les Jockeys camouflés* of 1918) or even designs not related to the text (such as his 1935 illustrations for Joyce's *Ulysses*), as his "illustrated books," but instead confines the term to books that were the result of close collaboration between him and the publisher. The history of the Mallarmé book is given by Barr 1951, pp. 244–246.

4. Henry de Montherlant, *Pasiphaë: Chant de Minos (Les Crétois)*, Paris, 1944. Matisse spoke of this book to Gaston Diehl, "Matisse, illustrateur et maître d'oeuvre," *Comoedia*, 132 (22 January 1944), p. 1: "The important thing is to create its substance. One lives with it in order to understand its demands, its possibilities. Little by little one ventures forward, one perfects the harmonies. These, in their turn, will permit me to color my blacks like my whites, to animate my surfaces and therefore to give the image the interior rhythm that corresponds to the expression of the author."

5. Pierre Reverdy, *Visages*, Paris, 1946; *Florilège des Amours de Ronsard*, Paris, 1948; Marianna Alcaforado, *Les Lettres portugaises*, Paris, 1946. Matisse also gave an interesting account of the Ronsard illustrations to Marguette Bouvier, "Henri Matisse illustre Ronsard," *Comoedia*, 80 (9 January 1943), pp. 1, 6.

6. Speaking of these linoleum cuts, Matisse told Gaston Diehl ("Avec Matisse le classique," *Comoedia*, 102, 12 June 1943, p. 6): "Three elements are in play: the linoleum, the gouge, and the *bonhomme*. It suffices to arrive at a harmony between them, that is to express oneself according to the materials, to live with them. Gustave Moreau loved to repeat 'The more imperfect the means, the more the sensibility manifests itself.' And didn't Cézanne also say: 'It is necessary to work with coarse means'? Here, to do things with such simple means, but at the same time in a very delicate manner, it is necessary to feel deeply, the sensation must burst forth definitively and totally."

TEXT 36

1. Henri Matisse, "Océanie, tenture murale," *Labyrinthe*, II, 3 (December 1946), pp. 22–23. The compositions are reproduced along with the text.

2. Matisse wrote extensively about his experiences in the South Seas and beginning with these works frequently treated Oceanic themes and motifs in his art. See Jack Cowart, Jack D. Flam, Dominique Fourcade, and John Hallmark Neff, *Henri Matisse Paper Cut-Outs*, St. Louis and Detroit, 1977, pp. 124–131; hereafter cited as St. Louis and Detroit 1977.

TEXT 37

1. Henri Matisse, *Jazz*, Paris, 1947. The book was published by Tériade on 30 September 1947. The plates were executed by Edmond Vaivel after the *découpages* of Matisse, using the same colors. The cover and manuscript pages were printed by Draeger Frères. The edition consisted of 250 numbered copies (and twenty copies, numbered I–XX, *hors commerce*) on vellum. All were signed by the artist. In addition 100 albums of plates only were printed.

2. Initially, Matisse was somewhat disappointed by the way the printing of the plates in the book turned out. On 25 December 1947 he wrote to his friend André Rouveyre: "But I know that these things should remain as they are, originals, quite simply gouaches."

3. For variants, see Schneider 1984, pp. 659–669.

4. See Schneider 1984, p. 659–669.

5. Of particular relevance here are the following remarks in *Répertoire: 6*: "I say to my model, 'Imagine a very pleasant story and follow its unfolding. Do I dare admit that in this way I create the cinematography of my model's private feelings? In my work I am as unobtrusive as a cameraman who is standing at the front of a train and who films the various aspects of an unknown countryside." Schneider 1984, p. 666.

6. In an interview with André Verdet around 1952, Matisse responded to a question about whether he had done the *Jazz* cutouts to amuse himself: "Amusement that is neither facile, nor superficial, nor frivolous. Some, critics or colleagues, will say: 'Old Matisse, nearing the end of life, is having fun cutting up paper. He is not wearing his age well, falling into a second childhood.' That won't make me happy, of course, but this kind of thing doesn't make me feel angry or bitter either. On the contrary, I try to understand good or bad reactions, to analyze criticisms wherever they come from, to analyze them in relation to what I'm doing.

"Well, I had a lot of fun cutting up my paper. But with the utmost seriousness, balancing all the weight of my past experience, the weight of an entire life devoted to incessant effort, with highs and lows, successes and failures, failures that I considered inevitable but intolerable and that I had to counteract as quickly as possible.

"What I was trying to do with these paper cutouts was to rediscover, through unusual technical means, the lovely days of line and color, to wring out of them the resonance and concurrence of a new freshness.

". . . . But at that time, I was unaware of inner light, mental—or, if you prefer, moral—light. Today I see that light every day. Natural light, the light that comes to us from outside, from the sky, merges with it. My light now commands a more concentrated power of crystallization. It is not so much that my sensations have gone through a slight metamorphosis, but that their condensation occurs in a more unusual way, and I try to sublimate as much as possible. . . .

"But here it is not a brush winding and gliding on canvas, but scissors cutting through stiff paper and color. The procedural conditions are completely different. The shape of the figure springs from the action of the scissors, which give it the motion of organic life. This tool, you see, does not modulate; it does not brush *onto*, but cuts *into*—a point that should be emphasized, for it makes the criteria of observation completely different. The new tool gives the artist who knows

how to use it greater authority in dealing with shapes. The product is different. My cutouts, I would hope, retain the sovereignty of the line that characterizes my drawing. My hand's great experience has had free play in handling the tool. But not all the benefits of this new technique ought to be ascribed to my old drawing habits. My paper cutouts also owe something to a technical procedure that comes from statuary. Have you read the book *Jazz*? Reread the preface. In it I wrote something like this: that cutting directly in color, directly with scissors, reminds me of the direct cut of the sculptor.

"The mediating line between pure color and myself as its creator is traced in the wake of the tool, in the instantaneousness of the cutting.

". . . . scissors can be as sensitive to line as pencil, pen, or charcoal—maybe even more sensitive. To me, sensitivity often lies in the instantaneousness of the gesture; a freshness always carefully protected from what might elegantly sink into routine. . . .

"The cutouts are not a new departure but a conclusion. They arose as if from a spring, without trial and error. They were a long time in the making, developing in secret. Perhaps they had already beckoned to me. For me the paper cutouts represent a creation parallel to oil painting. They must not be seen in any way as an indictment of painting.

". . . . I create only with concern to draw closer to the absolute, with greater abstraction. I pursue the essential wherever it leads. Previously I presented the object in the complexity of its space. Today all I see in it is the auspicious sign, the bare minimum necessary to its existence in that form and in the context in which I place it.

". . . . Hell, you know, is so close to Heaven, and Heaven so close to Hell. I sometimes try hard to believe that spring and summer, the beautiful seasons that I love so dearly, and the light that floods them, radiate and shine on the imaginary Elysian Fields that I enjoy conjuring up in my dreams, not for reassurance, but for fun. If people knew what Matisse, supposedly the painter of happiness, had gone through, the anguish and tragedy he had to overcome to manage to capture that light which has never left him, if people knew all that, they would also realize that this happiness, this light, this dispassionate wisdom which seems to be mine, are sometimes well-deserved, given the severity of my trials." Verdet 1978, pp. 130–132.

7. From *Répertoire: 6*; Schneider 1984, p. 660.

8. For a detailed discussion of this, see Flam, "Jazz," in St. Louis and Detroit 1977, pp. 37–47.

9. Matisse had been saying this at least since 1930, when he told an American interviewer that "a painter ought to have his tongue cut out." ("Study Art in America," *The Literary Digest*, 18 October 1930.)

10. One draft of the introduction, written in *Répertoire: 6*, entitled "Little Triflings [*Petits Riens*]" reads as follows:

"Little triflings?

"So why take the trouble to write them out?

"Because my colored pages must be padded, as though they were cushioned by pages of handwritten text of a certain format. This is what my publisher asked me for. But what about typography? No, the sample we did of it was not too successful.

"So why these little triflings? Because a weighty text would not go with my color schemes which do not make any claims for themselves other than that of using the fine colors of the trade, without spoiling their purity. What joy it is, just to look inside the packet of a kilo's worth of blue pigment, a packet of yellow, of green or red ochre, of black even. Well that is what I wanted to see transferred to paper, associated with simple things. Diverse memories. Most fitting for colors of such modest aims would be some children's tale or the writings of an artist, his thoughts, philosophical ideas even. . . . People are very tolerant of hobbies [*violons d'Ingres*] especially when they leave something to be desired. It's a consolation for the envious and makes for a good laugh with friends. That is why I have filled the pages separating my color plates with things of no impor-

tance—which may or may not be read—but which will be seen, and that is all I want. Like a kind of packing between my colors—like wood shavings.

"The publisher is a very gifted man, who has a great influence on artists, especially when his passionate love for a book is so great that it becomes part of his life.

"That is why I'm inclined to think, without being fully convinced, that the writing I have drawn out will be taken as it should be taken." As cited in Schneider 1984, p. 710, n. 31.

11. Matisse had made just such a revealing voyage in 1937, from London to Paris, which he described to his friend Simon Bussy: "We went up to an altitude of 3,000 meters and cruised at 240 km an hour. The plane was motionless and didn't seem to be getting anywhere. What is annoying about planes is that you seem to be going along at 10 km an hour. We left Croydon at 10:30 A.M. and at 12:30 I was having lunch at home—in fine fettle." Letter of 12 July 1937, as cited in Schneider 1984, p. 660.

In *Répertoire: 6* Matisse noted, "Everything is so clean, so pure, so simple in an airplane. Flying above the clouds we glimpse the earth we left only a short time before, its cities, and countryside in miniature. We say to ourselves, that is where there is so little love, where people tear each other apart, where they live in envy and jealousy. It's as if we are no longer part of all that, we are far away from it into this immense landscape, completely white, in the nearly motionless air. What a refuge! This is where we should come when we need to be uplifted." Schneider 1984, p. 660.

12. Regarding the lack of the expected question mark: here as elsewhere in this handwritten text, punctuation is made to accommodate the spacing of the text on the page.

13. This section is a condensed version of two of the themes that appear in "Exactitude is Not Truth," Text 40, below.

14. So did Matisse; he also passed this advice on to his students in 1908 (see "Sarah Stein's Notes," Text 4, above).

15. A variation on this in *Répertoire: 6* reads as follows: "I am guided like a medium pure and simple. If my pride gets in the way, my work does not go very well and after a few oaths I come round and give in to it again and things improve since my mind is set at rest by my own powerlessness when I feel the divine pilot is not with me." Schneider 1984, p. 710, n. 35.

16. This passage is inspired by Thomas à Kempis's *Imitation of Jesus Christ*, which Matisse kept at his bedside at this time and frequently meditated on. In *Répertoire: 6* he quoted à Kempis: "The soul needs two things to raise it above earthly things: simplicity and purity." This is followed by another quote, taken from "Page X, Baumann's preface": "The inner conflict will only stop when our trial on this earth has reached its end." Schneider 1984, p. 709, n. 6.

17. In a draft in *Répertoire: 6* Matisse wrote: "The life of a painter is so terribly hard in the beginning, and even throughout, so hard that one often wonders what kind of divine aid enables him to continue along his way in the midst of public and even critical incomprehension.

"A great mental discipline is required. A painter I know actually set the troubles of an artist's life in an order of importance, and the lack of money was not at the top of the list. Illness counted, but above all, the list ended up with *distaste for work*, considered to be the greatest disaster." Schneider, p. 710, n. 36.

18. Matisse noted in *Répertoire: 6*: "God has put the antidote near the poison. Always look for the antidote." Schneider 1984, p. 710, n. 34.

19. Cf. Matisse's recollection of the lagoons in Tahiti in "Oceania," Text 36, above; and "Interview with André Verdet," Text 50, below. Three of the plates in *Jazz* (XVII–XIX) are titled "Lagoon."

20. Cf. Matisse to Aragon (Text 29, above): "Perhaps after all I believe, without knowing it, in a future life . . . in some paradise where I shall paint frescoes. . . ."

21. Angèle Lamotte, Tériade's collaborator on *Verve*, had died early in 1945.

1. André Marchand, "L'Œil," in Jacques Kober, ed., *Henri Matisse*, Paris: Pierre à Feu (Maeght), 1947, pp. 51–53. Translation by permission of the publisher. Marchand (b. 1907), a somewhat eclectic painter, was active in Paris after World War II.

2. Matisse spoke of Manet at length in an interview with Tériade shortly before the large 1932 Manet centennial retrospective ("Édouard Manet vu par Henri Matisse," *L'Intransigeant*, 25 January 1932, p. 5):

 "Manet is the first painter to have made an immediate translation of his sensations and thus given free rein to instinct.

 "He was the first to act *through his reflexes* and thus to simplify the painter's technique.

 ～

 "To do this he had to discard all that he had acquired through education and keep only what came from himself. An example of this simplification of technique: instead of carrying out what was often quite long preparatory work in order to obtain a transparent tone, he applied his colors all at the same time, and with correct and precise relationships he achieved the equivalent of this transparency.

 ～

 "Manet was as direct as possible. He abandoned old subjects which could have got in the way of the simplicity of his technique and only expressed what had an immediate effect on his senses. His romantic nature attracted him to Spanish subjects. So, instead of repeating yet again the legend of Orpheus torn apart by the Maenads (as done by Michelangelo), he painted *The Death of the Toreador*. (This is one of the finest of Manet's pictures. I saw it in the Widener collection in Philadelphia surrounded by a magnificent collection of works of art of all periods, among them Rembrandts and Rubens, and I marvelled at the magisterial way it equalled the others.)

 "It only goes to show that while one can change one's means instantaneously, feeling has a continuity that may sometimes evolve, but only gradually.

 ～

 "*Olympia* belongs to Manet's period of transition. While certain aspects of this famous picture contain indications of the future, it nevertheless remains very close to the traditional painting of the old school. It is not, moreover, perhaps for this very reason, one of his best paintings.

 "Manet was open to all influences at once. At the end of his life he was even openly influenced by Claude Monet. A victim of his own sincerity, he was himself conscious of it. Among his paintings there is a *Garden on the Outskirts of Paris* done in separate brushstrokes resembling a Monet or a Sisley. This picture has neither the depth of color usual with Manet nor the finesse of a Monet. When Monet mixed tones, the color was never disturbed or dirtied. With his own means Manet also obtained limpid color. In this landscape attempt the color, being frankly neither one thing nor the other, looks quite mediocre.

 ～

 "A great painter is someone who finds personal and lasting signs to express in a plastic way the object of his vision. Manet found his own signs."

3. Cf. Cézanne (letter to Émile Bernard, 23 December 1904): "An optical impression is produced on our organs of sight which makes us classify as *light*, half-tone or quarter-tone the surfaces represented by color sensations. (So that light does not exist for the painter.)" Rewald 1941, p. 243.

4. Matisse went to Corsica in 1898, shortly after his marriage.

5. A succinct account of the difference between Matisse's paintings and his cutouts.

TEXT 39

1. Henri Matisse, "Le chemin de la couleur: Propos de Henri Matisse," *Art Présent*, 2, 1947, p. 23.
2. See C. R. Morse, "Matisse's Palette," *Art Digest*, VII, 15 (February 1933), p. 26; also the diagrams coordinating Matisse's palette to his paintings in the special "De la Couleur" issue of *Verve*, IV, 13, 1945.
3. Escholier 1956, p. 18.
4. The *crépons* were brightly colored Japanese prints on crêpe paper. See "Role and Modalities of Color," Text 31, above.
5. There were two important exhibitions of Islamic art that Matisse saw during his formative years. The first was in Paris in 1903; the second in Munich in 1910. Since the 1903 exhibition would appear to be more relevant to the period Matisse is discussing here, he may have later conflated their effect in his mind.
6. When Matisse was in Moscow in 1911, he gave an interviewer his impressions of the city: "The Kremlin, certain corners of Moscow, the relics of ancient art—these are all of a rare beauty. I especially liked the decoration of the Iverskaya Chapel and the old icons.

 "The icons are a supremely interesting example of primitive painting. Such a wealth of pure color, such spontaneity of expression I have never seen anywhere else. This is Moscow's finest heritage. People should come here to study, for one should seek inspiration from the primitives.

 "An understanding of color, simplicity—it's all in the primitives. The modern artist has to add his own sense of balance in order to create a lofty work of art." *Protiv Techeniya*, 8, 32 (5–18 November 1911); as cited in Kostenevich and Semyonova, 1993, p. 52.

TEXT 40

1. First published as "L'exactitude n'est pas la vérité," in *Henri Matisse: Dessins*, Paris, 1947. First translated into English for the Philadelphia Museum of Art exhibition catalogue, *Henri Matisse: Retrospective*, Philadelphia, 1948, pp. 33–34. The present translation has been done from the transcript of the French original at the Philadelphia Museum of Art, which is dated "Vence, May 1947."
2. The numbers referred to here are those of the Philadelphia Museum of Art catalogue; bracketed descriptions refer to the relative positions in our own illustrations.

TEXT 41

1. Henri Matisse, "Letter from Matisse to Henry Clifford," in Philadelphia Museum of Art, *Henri Matisse*, Philadelphia, 1948, pp. 15–16. The present text is translated from a copy of the original letter, which was very kindly sent to me by Henry Clifford. The French version of the letter published in *Henri Matisse: Les grandes gouaches découpées* (Paris, 1961), is not a true copy, but rather a translation into French of the English version published in the Philadelphia catalogue. The (inconsistent) capitalization of certain words, such as Color and Spirit, follow the original transcript of Matisse's letter. It is interesting to note that, contrary to edited versions of the letter, Matisse actually suggested that the letter be published in "the explanatory part" of the Philadelphia catalogue. For an excellent discussion of this text and of Matisse's interest in drawing at this time, see John Elderfield, "Drawings at an Exhibition," in Queensland Art Gallery, *Matisse*, ed. Caroline Turner and Roger Benjamin, Brisbane, 1995.
2. This appears in a 1940 letter to the Rumanian painter Théodore Pallady. Matisse makes the comparison after asking Pallady why he was doing only drawings but no paintings. Cited in Fourcade 1972, pp. 200–201, n. 62. See Elderfield's interesting interpretation of this unusual characterization of the difference between the two arts: "Drawing is female because (like women and slaves, its privileged subject) it is to be hidden away, 'completely concealed.' " (Elderfield 1995, n. 54.)

3. Ironically, there is a striking similarity between certain parts of Matisse's letter and some of Bouguereau's remarks in an address to the Institut de France in 1885, in which he stresses the importance of studying to acquire technical skill, for ". . . can greater misery be conceived than that experienced by the artist who feels the fulfillment of his dream compromised by the impotence of his execution?" (Linda Nochlin, ed., *Realism and Tradition in Art, 1848–1900*, Englewood Cliffs, 1966, p. 10.)

4. Cf. Cézanne (letter to Émile Bernard, 25 July 1904): "To achieve progress nature alone counts, and the eye is trained through contact with her." Rewald 1941, p. 239.

5. Matisse uses the word "*Esprit*" here, which could also be translated as "mind." But since he refers directly below to being able to lead color "through a spiritual path [*dans une voie spirituelle*]," I have translated "*Esprit*" as "Spirit."

6. Correggio's statement, "*Anch'io son pittore*," is supposed to have been uttered by the artist before Raphael's painting of *St. Cecilia* in Bologna.

TEXT 42

1. Russell Warren Howe, "Half-an-Hour With Matisse," *Apollo*, XLIX (February 1949), p. 29.

2. Matisse nevertheless had a great deal of regard for Delacroix, especially as a draftsman. (But see also Text 12, note 5.)

3. A gracious way of implying that he disapproves. Matisse reportedly enlarged on this in a conversation with Picasso around this time. Having received some catalogues with reproductions of American Abstract-Expressionist paintings, he noted: "I have the impression that I'm incapable of judging painting like that for the simple reason that one is always unable to judge fairly what follows one's own work. One can judge what has happened before and what comes along at the same time. And even among those who follow, when a painter hasn't completely forgotten me, I understand him a little bit, even though he goes beyond me. But when he gets to the point where he no longer makes any reference to what for me is painting, I can no longer understand him. I can't judge him either. It's completely over my head." Matisse then went on to say that Renoir had felt the same way about him. Gilot and Lake 1964, pp. 268–269.

TEXT 43

1. "Henri Matisse vous parle," *Traits*, 8 (March 1950), p. 5.

2. The plaster cast, presently at the Musée Matisse in Nice-Cimiez, is of an Argive Greek kouros. The original, which is identified as Cleobis by an inscription, is in the Museum at Delphi.

3. One of Le Corbusier's drawings of the statue is reproduced in *Traits* on the page facing Matisse's article.

TEXT 44

1. Georges Charbonnier, "Entretien avec Henri Matisse," *Le Monologue du peintre*, vol. II, Paris, 1960, pp. 7–16 © Editions Julliard 1960. This interview was recorded on tape in August 1950 and broadcast on French radio in January 1951.

2. The Shchukin painting of the *Dance*, begun in 1909 and finished in 1910.

3. This is an expansion of the same story that Matisse told Carco in 1941 (see Text 26). Georges Duthuit and Edward Steichen, however, have suggested folk origins for the dance theme. See Barr 1951, p. 135; Flam 1993, pp. 23–25.

4. Cf. "Notes of a Painter," above, where Matisse also discusses repose and movement in works of art.

5. The mural is actually on the wall, not the ceiling. Matisse's reference to the "ceiling" emphasizes the lifting effect that he wanted the mural to have. It might also be a subconscious reference to Michelangelo's paintings on the ceiling of the Sistine Chapel.

6. See Matisse's letter to Romm (14 February 1934), Text 19, above.

7. In 1946, Matisse told Gaston Diehl: "I had conceived this *Dance* long before, and had put it in the *Joie de vivre*, then in my first big dance composition. This time, however, when I wanted to make sketches on three canvases of one meter, I couldn't get it. Finally, I took three canvases of five metres, the very dimensions of the panels, and one day, armed with charcoal on the end of a bamboo stick, I set out to draw the whole thing at one go. It was in me like a rhythm that carried me along. I had the surface in my head. But once the drawing was finished, when I came to color it, I had to change all the pre-arranged forms. I had to fill the whole thing, and give a whole that would remain architectural. On the other hand, I had to stay in strict conjunction with the masonry, so that the lines would hold their own against the enormous, projecting blocks of the down-curving arches, and even more important, so that the lines would follow across them with sufficient vitality to harmonize with each other. To compose with all that and to obtain something alive and singing, I could only proceed by groping my way and continually modifying my compartments of colors and blacks." Gaston Diehl, *Henri Matisse*, Paris, 1954, p. 85. Cf. Diehl, "A la recherche d'un art mural," *Les Arts, les lettres*, 19 April 1946.

8. Matisse spent a lot of effort on the design of this spire. In 1950 he told D. W. Buchanan that the spire was being changed because it looked "too fragile," and would harmonize better with a heavier base. See Donald W. Buchanan, "Interview in Montparnasse," *Canadian Art*, VIII, 2 (1950–1951), pp. 61–65.

9. Barr 1951, p. 281, recounts that when the poet Louis Aragon, a Communist, visited Matisse shortly after the first model of the chapel had been constructed, Aragon said of the model: "Very pretty—very gay—in fact, when we take over we'll turn it into a dance hall." Matisse replied: "Oh no, you won't. I've already taken precautions. I have a formal agreement with the town of Vence that if the nuns are expropriated the Chapel will become a museum, a *monument historique!*"

10. Or, it is implied, like late Matisse. Matisse always kept his torment veiled from the outside world, and this reference to El Greco is an interesting statement of his evident belief that one's "torment" could be sublimated and produce imagery like his own.

11. In 1941, Matisse told Pierre Courthion: "I took up sculpture because what interested me in painting was a clarification of my ideas. I changed my method, and worked in clay in order to have a rest from painting, in which I had done absolutely all that I could for the time being. That is to say that it was done for the purpose of organization, to put order into my feelings and to find a style to suit me. When I found it in sculpture, it helped me in my painting. It was always in view of a complete possession of my mind, a sort of hierarchy of all my sensations that I kept working in the hope of finding an ultimate conclusion." Pierre Courthion, Nine Unpublished Interviews with Matisse, 1941, typescript, p. 66. Getty Center for the History of Art and the Humanities, Archives of the History of Art, Santa Monica, California. See also the extended discussion of this in Jack Flam, "La Sculpture de Matisse," *Les Cahiers du Musée National d'Art Moderne*, 30 (Winter 1989), pp. 23–40.

12. Alain was the pseudonym of the French philosopher Émile-Auguste Chartier (1868–1951).

TEXT 45

1. Henri Matisse, "Le Texte," in Tokyo National Museum, *Henri Matisse*, Tokyo, 1951, p. [2].

2. In 1950, at which the maquettes for the Vence Chapel and several of his sculptures had been shown for the first time.

TEXT 46

1. Henri Matisse, "La Chapelle du Rosaire," in *Chapelle du Rosaire des Dominicaines de Vence*, Vence, 1951.

2. In his letter to Bishop Rémond for the consecration of the chapel, Matisse said of it: "This work has taken me four years of exclusive and assiduous labor and it represents the result of my entire

active life. I consider it, despite its imperfections, to be my masterpiece . . . an effort which issues from a life consecrated to the search for truth." (*L'Art sacré*, 11–12, 1951, pp. [2–3].) Matisse scrupulously avoids religious references in both these texts.

TEXT 47

1. Henri Matisse, "Chapelle du rosaire des Dominicaines de Vence," *France Illustration*, 320 (1 December 1951), pp. [561–570]; reprinted as "La Chapelle de Vence, aboutissement d'une vie," *XXe Siècle*, special number, "Hommage à Henri Matisse" (1970), pp. 71–73.

2. The early studies for the Stations of the Cross were also more literally descriptive than the final, expressive ones. See Barr 1951, pp. 520–521.

3. The Stations of the Cross panel is in fact one of Matisse's most violent departures from the art "devoid of troubling or depressing subject matter" that he had stated as his goal in "Notes of a Painter" and had reaffirmed throughout his career.

TEXT 48

1. E. Tériade, "Matisse Speaks," *Art News Annual*, 21, 1952, pp. 40–71. Reproduced by permission of *Art News*. This was originally published in English from a now-lost French text; the variations in wording between the present text and the 1929–1931 texts that seem to form its basis may be attributable to differences in translation, as the earlier texts have been translated for this volume directly from their French originals.

2. At Saint-Quentin Matisse had worked under Emmanuel Croizé at the École Quentin-Latour, primarily a school for textile and tapestry designers.

3. The above paragraphs are based on Tériade's 1931 interview (Text 14).

4. See Escholier 1937, pp. 30–31, for an elaboration.

5. The critic Roger Marx (1859–1913) had defended the Louvre copies of Matisse and other Moreau students and pleaded their case before the Purchase Committee. Marx later (winter 1901–02) introduced Matisse to Berthe Weill.

6. Matisse refers here to the 1915 variation on his 1893–1895 copy of the De Heem painting.

7. The first painting is now in the Isabella Stewart Gardner Museum, Boston; the second is now in the Musée d'Orsay, Paris.

8. The mention of the three spots of color recalls "Notes of a Painter," Text 2, above.

9. The preceding two paragraphs are taken from Tériade's 1931 interview (Text 14, above). For Vauxcelles' precise words, see Text 14, n. 4, above.

10. Matisse's large painting of 1916, now in the Museum of Modern Art, New York.

11. The so-called "Moroccan Triptych" of 1912–1913, now in the Pushkin Museum, Moscow, and the *Arab Café*, now in the State Hermitage Museum, St. Petersburg.

12. In fact, Cézanne mentioned only spheres, cylinders, and cones.

13. This paragraph is the same as part of Tériade's 1931 interview (Text 14). In a 1952 interview with André Verdet, Matisse elaborated on his reactions to Cubism in the years before World War I:

 "A difficult watershed for me was the period of Cubism's triumph. At my age, one can own up to one's past anguish, all the more because death does not cause me as much anguish as the physical suffering that sometimes leads to it. I was virtually alone in not participating in the others' experiment, Cubism, in not joining the direction that was acquiring more and more followers and whose prestige was becoming increasingly widespread. . . .

 "I was entrenched in my pursuits: experimentation, liberalization, problems of color, color-as-energy, color-as-light. Cubism certainly interested me, but it did not speak to my deeply sensory nature, to the great lover that I am of line, of the arabesque, those bearers of life. . . . For me to turn toward Cubism would have been to go counter to my artistic conceptions. . . .

 "[Cubism] brushed against me, exactly. It was written about some of my compositions of the

period that they were para-cubist. At the time, Picasso and I frequently exchanged ideas. We used to go for walks together. . . .

"Shortly before the war, in '12 or '13. Our differences were amicable. Sometimes our points of view strangely met. Picasso and I were in one another's confidence. We mutually gave one another a great deal in those exchanges. We cared passionately about our respective technical problems. There is no question that we each benefited from the other. I think that, ultimately, there was a reciprocal interpenetration between our different paths. This was, it must be emphasized, this was at a time when one or another's discoveries were offered generously to all, a time of artistic fraternity. Look, when I think of Cubism, it is the coupled faces of Braque and Picasso that appear, along with their joint works." Verdet 1978, pp. 127–128.

14. In 1941 Matisse gave Pierre Courthion this account of his early encounter with African sculpture: "I came to it directly. I often used to pass through the rue de Rennes in front of a curio shop called 'Le Père Sauvage,' and I saw a variety of things in the display case. There was a whole corner of little wooden statues of negro origin. I was astonished to see how they were conceived from the point of view of sculptural language; how it was close to the Egyptians. That is to say that compared to European sculpture, which always took its point of departure from musculature and started from the description of the object, these negro statues were made in terms of their material, according to invented planes and proportions.

"I often used to look at them, stopping each time I went past, without any intention of buying one, and then one fine day I went in and I bought one for fifty francs.

"I went to Gertrude Stein's home on the rue de Fleurus. I showed her the statue, then Picasso arrived. We chatted. It was then that Picasso became aware of African sculpture. That's why Gertrude Stein speaks of it." Courthion 1941, p. 54. See also Jack Flam, "Matisse and the Fauves," in William Rubin, ed., *"Primitivism" in 20th Century Art: Affinity of the Tribal and the Modern,* vol. I, New York, 1984, pp. 211–239.

15. Now the Musée de l'Homme.

16. *Bathers by a River,* 1909–1916, and the *Piano Lesson,* 1916, are two of Matisse's most monumental and austere early works.

17. For a detailed chronology of Matisse's early years in Nice, see Jack Cowart, "The Place of Silvered Light: An Expanded, Illustrated Chronology of Matisse in the South of France, 1916–1932," in Jack Cowart and Dominique Fourcade, *Henri Matisse, The Early Years in Nice, 1916–1930,* Washington, D.C., and New York, 1986, pp. 15–46.

18. Around 1951, Matisse was a bit more candid in discussing this subject with André Verdet: "But there were so many reproaches even when I did the long series of Odalisques! You are giving me the opportunity to offer yet another explanation of this subject, for the charges some people made against me then stuck for a long time, and I still suffered from distant repercussions of them much later. . . . No one who creates is blameless. Did I paint too many Odalisques, was I carried away by excessive enthusiasm in the happiness of creating those pictures, a happiness that swept me along like a warm ocean ground swell? I still don't know. . . . What I could not accept was that, in chiding me for a certain profusion of these pictures, people felt entitled to describe them with words like "exoticism" and "orientalism," used in the pejorative sense, as if my natural bent, my predilection for the arts of the Orient, might have drifted, given the plastic use I was making of some of their elements, might have drifted into mannerism, facile decorativeness, or even a questionable rococo!

"Morocco had excited all my senses. . . . The intoxication of the sun long held me in its spell. I was coming out of long, wearying years of effort, after many inner conflicts, during which I had given the best of myself to bring those researches to the point of achieving what I hoped would be an unprecedented creation. Besides that, I had been powerfully held by the requirements of important mural and monumental compositions. After beginning with some exuberance, my paint-

ing had evolved toward decantation and simplicity. A synthesis both pictorial and moral, governed always by laws of harmony, held strict dominion over my work. A will to rhythmic abstraction was battling with my natural, innate desire for rich, warm, generous colors and forms, in which the arabesque strove to establish its supremacy. From this duality issued works that, overcoming my inner constraints, were realized in the union of contrasts. . . .

"I had to catch my breath, to relax and forget my worries, far from Paris. The Odalisques were the fruits of a happy nostalgia, of a lovely, lively dream and of the almost ecstatic, enchanted experience of those days and nights, in the incantation of the Moroccan climate. I felt an irresistible need to express that ecstasy, that divine nonchalance, in corresponding colored rhythms, the rhythms of sunny and lavish figures and colors. . . .

"The Odalisques formed a whole, large in number. No doubt, not all the paintings were one hundred percent successful. I would be the first to agree that there may be hesitations or inadequacies in this or that painting. But I deplore the epithet some people unfortunately saw fit to hurl in characterizing this period that was so fruitful for me. You can find flaws in some of the paintings of the Odalisques series, but not the flaw that the word 'mannerism' designates to you and me. With the Odalisques, I don't renounce what I had recently gained, those plastic advances you speak of, but I return to a more profound resonance, I again accept a certain kind of model and once again I take possession of a space where the air circulates freely again. In them was posed this problem for me: to attune and balance pure colors and half-tones so as to assure the painting's harmony and rhythmic unity against the possible danger of chromatic shrillness. . . .

"I was still pursuing my goal, the shining independence of color, but pursuing it by other means. For instance, the components of the paintings compress the empty spaces, the "holes." The tapestry motifs play a role that is equal to the female nude, the central figure that reigns supreme in the interiors. These elements are active, they are not simply dropped there as something extra in a supporting, purely decorative, role. . . .

"Look at these Odalisques carefully: the sun's brightness reigns in a triumphal blaze, appropriating colors and forms. Now, the oriental decors of the interiors, all the hangings and rugs, the lavish costumes, the sensuality of heavy, slumbering flesh, the blissful torpor of faces awaiting pleasure, this whole ceremony of siesta brought to maximum intensity in the arabesque and the color must not deceive us: I have always rejected anecdote for its own sake. In this ambience of languid relaxation, beneath the sun-drenched torpor that bathes things and people, a great tension smolders, a specifically pictorial tension that arises from the interplay and mutual relations of the various elements. I eased those tensions so that an impression of happy calm could emerge from these paintings, a more or less amiable serenity in the balance of deliberately massed riches. . . .

"[It was] a tranquil period of transition that marked the beginning of another adventure, in the course of which the painting's rhythmic syntax will be completely changed, by the inversion of the relations between forms, figures, and background." Verdet 1978, pp. 123–126.

19. The two paragraphs above are based on Tériade's 1931 interview (Text 14, above).
20. See Text 21, above, which is translated rather differently.
21. Actually in the fall of 1911.
22. This passage is based on Tériade's 1930 interview with Matisse (Text 13, above). Actually, Matisse first passed through New York on his way to Tahiti.

TEXT 49

1. Maria Luz, "Témoignages: Henri Matisse," *XXe Siècle*, n.s. 2 (January 1952), pp. 55–57. Used by permission of *XXe Siècle*.
2. *The Dream* of 1940, which had been repainted several times, seems to have been a favorite of Matisse's.
3. The work referred to is *Chinese Fish*, 1951.

4. *The Pink Marble Table*, 1917.

5. The dugong is a sea-dwelling mammal; there is a line drawing of it in the *Nouveau Larousse illustré*, the popular French encyclopedia.

6. The figure referred to is not part of one of Matisse's compositions, but one of the several Chinese ceramic figures he owned.

7. The painter Othon Friesz (1879–1949), of whom Matisse had a low opinion. In 1935 he had written to Camoin describing a Friesz exhibition, which he called "shabby." (Escholier 1956, p. 237.)

8. An excellent description of an essential difference between the conception of things in even his latest paintings and the cutouts.

TEXT 50

1. André Verdet, "Entretiens avec Henri Matisse," in *Prestiges de Matisse*, Paris, 1952, pp. 37–76. Verdet published other interviews with Matisse, done between 1948 and 1951, in *Entretiens notes et écrits sur la peinture: Braque, Léger, Matisse, Picasso*, Paris, 1978, pp. 113–132; important passages from some of these are cited as Verdet 1978 in notes to other texts in the present book. Verdet (b. 1913) gained Matisse's confidence and elicited some of his most interesting later statements about his art and career.

2. "*Elle est l'élan passionnel qui gonfle ses dessins.*" Pun on *élan* which means "moose" or "elk" as well as "impulse" or "enthusiasm." Cf. Gustave Moreau (*Cahier IV*, p. 23, as cited in Ragnar van Holten, *Gustave Moreau*, Paris, 1960): "Art is dead when, in composition, the reasonable combination of the mind and good sense come to replace, in the artist, the almost purely plastic imaginative conception—in a word, the love of the arabesque."

3. The reference is to the cutouts Matisse was then working on: the series of blue female figures, *Parakeet and Mermaid*, and other decorative panels.

4. A revealing example of Matisse's concern with *Gestalt* impressions, as opposed to Cézanne's concern with detailed analysis of visual sensations.

5. Cf. Matisse (in a radio interview, 1942, Text 28, above): "An artist has no greater enemies than his bad paintings."

6. Cf. Matisse's comment to Verdet, around 1951: "scissors can be as sensitive to line as pencil, pen, or charcoal—maybe even more sensitive. To me, sensitivity often lies in the instantaneousness of the gesture; a freshness always carefully protected from what might elegantly sink into routine. . . ." (Verdet 1978, p. 131.) Cf. also Gotthard Jedlicka's record of his meeting with Matisse in March 1952, in which he noted that as Matisse talked his hands were in motion and "executed invisible cutouts in the air." Noticing Jedlicka's attention to this, Matisse said: "A pair of scissors is a marvelous instrument . . . and the paper I use for my cutouts is marvelous. . . . Almost like cardboard, a paper that resists the striking of the scissors." Gotthard Jedlicka, "Begegnung mit Henri Matisse," in *Die Matisse Kapelle in Vence*, Frankfurt, 1955, p. 85.

7. The reference is probably to *Vegetables*, 1951 (signed 1952). See Pierre Reverdy and Georges Duthuit, *The Last Works of Henri Matisse*, New York, 1958, p. 20.

8. Matisse's chapel had indeed roused a good deal of speculation about his return to Catholicism. On 25 June 1951, the day of the consecration of the Vence Chapel, a Reuters dispatch stated untruthfully that Matisse had "sent a message to the Bishop declaring that building the chapel had renewed his faith in God," and that Matisse had told the Bishop, "I started this work four years ago, and as a result I know now I believe in God." (Barr 1951, p. 287.) The 15 July issue of *La Vie catholique illustrée* published the story of the chapel under the headline " 'EVERY TIME I WORK I BELIEVE IN GOD,' " a misleading transposition of Matisse's somewhat less than religious statement in *Jazz* (Text 37, above). The attempt to align Matisse with the Church is also reflected in a curious little book composed of a few short quotations from Matisse (*Propos de Matisse: propos notés par le père Couturier*, 1956, unpaginated, printed in an edition limited to 35 copies) in which

Matisse is quoted as having said: "I told Picasso: yes, I pray, and you too, and you know it very well: when all goes badly, we throw ourselves into prayer to recover the climate of our first communion. And you do it, you too. Don't say no" (March 1949); "One is led, one doesn't lead. I am only a servant." "Death is not at all final, it is a door that opens" (March 1952).

9. A recurrent theme in Matisse's later statements, reflecting his freedom from working directly from nature in the imagery of the cutouts. See also Text 51, below.

10. Trepang, or sea cucumber.

11. The composition is reproduced in color in the Verdet book, following p. 64.

12. Matisse, recalling his 1907 visit to Italy, told Escholier, around the same time as the Verdet interview: "In front of the primitives of Sienna, I thought 'Here I am in Italy, the Italy of the primitives which I loved. When, in Venice, I came to the great Titian, Veronese, those wrongly termed Renaissance masters, I saw in them superb fabrics created for the rich, by those great sensuous artists of more physical than spiritual value.'" (Escholier 1956, p. 86.)

13. La Réunion (Reunion Island), east of Madagascar.

14. Gustave Geffroy defended Cézanne in *Le Journal*, 16 November 1895. He also sat for an excellent portrait by Cézanne. His review of Matisse's *Woman with the Hat* at the 1905 Salon d'Automne had been unfavorable. In Matisse's 1912 interview with Clara MacChesney, Matisse had himself confronted this bourgeois misunderstanding of both modern and Antique art (see Text 8).

15. The painter Louis Valtat (1869–1952), who was associated with the Fauves.

16. Charles Estienne, *L'Art abstrait, est-il un académisme?*, Paris, 1950. Estienne had interviewed Matisse back in 1909 (Text 5, above).

TEXT 51

1. Henri Matisse, "Il faut regarder toute la vie avec des yeux d'enfants," *Le Courrier de L'U.N.E.S.C.O*, VI, 10 (October 1953); based on an interview by Régine Pernoud. Translated shortly afterward as "Looking at Life with the Eyes of a Child," *Art News and Review*, London, 6 February 1954, p. 3, with Vence twice misprinted as "Venice." Retranslated here.

2. This occurs in some works done during Matisse's early years in Nice, from around 1919 to 1922; for example, *Open Window*, 1921.

TEXT 52

1. Henri Matisse, *Portraits*, Monte Carlo, 1954. The book was published posthumously on 20 December 1954.

2. See Escholier 1956, p. 193.

3. Though Matisse had remarked that ordinary portrait painters were being outdone by good photographers. See Text 28, above.

4. The precise date of this revelation is difficult to fix, but given Matisse's description of his method of working at the time, it would seem to be sometime around 1900. For an interesting psychological interpretation of this text, see Marcelin Pleynet, "Matisse's System," in *Painting and System*, Chicago and London, 1984, especially pp. 42–52.

5. For a fascinating description of Matisse's similar method in some of the "Themes and Variations" drawings of 1941–42, see the first-hand account of Lydia Delectorskaya in Stuttgart 1993, pp. 133–136.

6. The surgeon René Leriche, author of *Philosophie de la Chirurgie*, who operated on Matisse in 1941, and to whom Matisse in gratitude wrote, "I owe you these few years, since they are a bonus. . . ." (Escholier 1956, p. 207.)

7. Regarding this decisiveness, Matisse had told Aragon in 1942: "When you slap someone, you obviously don't do it with softness and uncertainty. No, there is an impulse. And this impulse is not decision, it is conviction. You slap someone with conviction . . ." Aragon 1943, p. 13.

Bibliography

GENERAL WORKS

The literature on Matisse is already vast and constantly growing. Extensive and useful general bibliographies appear in the following books, which also provide excellent illustrations of Matisse's works: Alfred H. Barr, Jr., *Matisse, His Art and His Public* (New York, 1951); Pierre Schneider, *Matisse* (Paris, 1984; New York, 1984); Jack Flam, *Matisse: The Man and His Art, 1869–1918* (Ithaca and London, 1986), which gives a narrative, historical overview of the Matisse literature; John Elderfield, *Henri Matisse: A Retrospective* (New York, 1992), which contains a similarly organized, updated bibliographical note.

Russell T. Clement, *Henri Matisse: A Bio-Bibliography* (Westport and London, 1993) presents the most comprehensive Matisse bibliography yet available, but unfortunately it is full of errors and must be used with caution.

Matisse's writings and statements on art are collected in French in Dominique Fourcade, ed., *Henri Matisse: Écrits et propos sur l'art* (Paris, 1972), where they are arranged thematically and thoroughly indexed; and in English in Jack D. Flam, *Matisse on Art* (London, 1973), the first edition of the present book, where they are arranged chronologically, with each text separately introduced and annotated. Additional texts are given in Dominique Fourcade, "Autres Propos de Henri Matisse," *Macula*, 1 (1976), pp. 92–115. Some of Matisse's writings, and the vast majority of his letters, remain uncollected. References to these are included in the "Bibliography of Writings, Statements, and Interviews by Matisse," below.

The most useful generally available books and exhibition catalogues published within the past twenty-five years include the following: Mario Luzi and Massimo Carra, *L'Opera de Matisse dalla rivolta "fauve" all'intimismo, 1904–1928* (Milan, 1971; French translation, *Tout l'oeuvre peint de Matisse, 1904–1928*, Paris, 1982; edited by Xavier Deryng, introduction by Pierre Schneider), a good compendium of small black-and-white photographs of Matisse's paintings, but neither so comprehensive as it appears nor altogether accurate; Louis Aragon, *Henri Matisse: Roman*, 2 vols. (Paris, 1971, published in English translation as *Henri Matisse: A Novel*, 2 vols., London, 1972; New York, 1972), personal, idiosyncratic, absorbing and especially valuable for its quotations of Matisse; *Henri Matisse: Paintings and Sculptures in Soviet Museums* (Leningrad, 1978), with an introduction by A. Izerghina; Lawrence Gowing, *Matisse* (London, 1979; New York and Toronto, 1979); Isabelle Monod-Fontaine, *Henri Matisse: oeuvres de Henri Matisse (1869–1954)* (Paris, 1979), catalogue of works by Matisse in the Musée National d'Art Moderne, Paris; Catherine C. Bock, *Henri Matisse and Neo-Impressionism, 1898–1908* (Ann Arbor, 1981), a detailed and original study; Michael Mezzatesta, *Henri Matisse: Sculptor/Painter, A Formal Analysis of Selected Works* (Fort Worth, 1984), exhibition catalogue, with informative text based on original research; Pierre Schneider, *Matisse* (Paris, 1984; English translation, New York, 1984; rev. French edition, 1992), with reproductions of numerous previously unpublished works and an insightful text; Roger Benjamin, *Matisse's "Notes of a Painter": Criticism, Theory, and Context, 1891–1908*, Ph.D. dissertation, Bryn Mawr, 1985 (Ann Arbor, 1987); Lydia Delectorskaya, *L'apparente facilité... Henri Matisse, Peintures de 1935–1939* (Paris, 1986; trans. Olga Tourkoff, *With Apparent Ease... Henri Matisse, Paintings from 1935–1939*, Paris, 1988), a first-hand account of Matisse's working procedure with numeorus quotations and comments on individual paintings; Jack Cowart and Dominique Fourcade, *Henri Matisse:*

The Early Years in Nice, 1916–1930 (New York, 1986), National Gallery of Art exhibition catalogue, with an essay by Margrit Hahloser-Ingold; Jack Flam, *Matisse: The Man and His Art, 1869–1918* (Ithaca, New York and London, 1986), a thorough study of Matisse's early career; Jack Flam, ed., *Matisse: A Retrospective* (New York, 1988), a useful compilation of excerpts from critical writings on Matisse from 1896 to 1957; Yve-Alain Bois, "Matisse and 'Arche-drawing,'" in *Painting as Model* (Cambridge, Mass., and London, 1990), pp. 3–63; John O'Brien, *Ruthless Hedonism: The Reception of Matisse in America, 1929–1954* (Ph.D. dissertation, Harvard University, 1990), an excellent study of an overlooked subject; John Elderfield, *Henri Matisse: A Retrospective* (New York, 1992), the catalogue of the largest ever Matisse exhibition, with an excellent chronology and much new documentary material; Musée National d'Art Moderne, Paris, *Henri Matisse, 1904–1917*, catalogue of the exhibition organized by Dominique Fourcade and Isabelle Monod-Fontaine, with excellent documentation, and an interesting introductory text by Yve-Alain Bois; Albert Kostenevich and Natalya Semyonova, *Matisse et la Russie*, (Paris, 1993; English trans. by Andrew Bromfield, *Collecting Matisse*, Paris, 1993), the most detailed study of Matisse's relationship to his Russian collectors; Jack Flam, *Matisse: The Dance* (Washington, D.C., 1993), a detailed study of the Barnes murals.

Since 1986 the Musée Matisse in Nice (Cimiez) has issued a useful series of publications on various aspects of the artist's life and work, "Cahiers Henri Matisse."

In addition to general works, a number of studies of Matisse's work in specific mediums are also of particular interest: Musée National d'Art Moderne, Paris, *Henri Matisse: Dessins et Sculpture* (Paris, 1975), introduction and catalogue by Dominique Fourcade; John Elderfield, *The Drawings of Henri Matisse* (New York and London, 1984), the most comprehensive book in English on Matisse's drawings; Staatsgalerie, Stuttgart, *Henri Matisse: Zeichnungen und Gouaches Découpées* (Stuttgart: Stuttgarter Galerieverein, 1993), exhibition catalogue with essays by Lydia Delectorskaya, Ortrud Dreyer, Jack Flam, Ulrike Gauss, Xavier Girard, Richard Hennessy, Andreas Stolzenburg; Marguerite Duthuit-Matisse and Claude Duthuit, with Françoise Garnaud, *Henri Matisse, Catalogue raisonné de l'oeuvre gravé*, 2 vols. (Paris, 1983), the standard reference work on Matisse's prints; Claude Duthuit, with Françoise Garnaud, *Henri Matisse: catalogue raisonné des ouvrages illustrés* (Paris, 1987), introduction by Jean Guichard-Meili, the standard work on the illustrated books; Albert E. Elsen, *The Sculpture of Matisse* (New York, 1972), the most comprehensive work on Matissse's sculpture; Isabelle Monod-Fontaine, *The Sculpture of Henri Matisse* (London, 1984); Jack Cowart, Jack D. Flam, Dominique Fourcade, and John Hallmark Neff, *Henri Matisse: Paper Cut-outs* (St. Louis and Detroit, 1977), the most comprehensive work on the cutouts; John Elderfield, *The Cut-outs of Henri Matisse* (New York, 1978).

∼

BIBLIOGRAPHY OF WRITINGS, STATEMENTS, AND INTERVIEWS BY MATISSE
(Arranged in Chronological Order, by Date of Publication)

Apollinaire, Guillaume. "Henri Matisse." *La Phalange*, II, 18, December 1907, pp. 481–485. (Text 1, above.)

Matisse, Henri. "Notes d'un peintre." *La Grande Revue*, LII, 24, 25 December 1908, pp. 731–745. (Text 2, above.)

Matisse, Henri. "George Besson Conducts Interviews on Pictorial Photography." *Camera Work*, No. 24, October 1908, p. 22. (Text 3, above.)

Caffin, Charles H. "Matisse and Isadora Duncan." *Camera Work*, No. 25, January 1909, pp. 17–20.

Estienne, Charles. "Des tendances de la peinture moderne: entretien avec M. Henri Matisse." *Les Nouvelles*, 12 April 1909, p. 4. (Text 5, above.)

Burgess, Gelett. "The Wild Men of Paris." *The Architectural Record*, May 1910, pp. 401–410. (Contains interview with Matisse done during the winter of 1908.)

Schmidt, Anna Seaton. "Henri Matisse: An Unbiased Account of the Eccentric Painter's Work." *Boston*

Evening Transcript, 29 January 1910, part 3, p. 4. (Reflects visit to Matisse at Issy; quotations based on "Notes of a Painter.")

Shevlyakov, M. V. "With Matisse." *Rannieie Utro*, 246, 26 October 1911; trans. in Albert Kostenevich and Natalya Semyonova, *Collecting Matisse*, Paris, 1993, p. 47. (Interview with Matisse while he was in Moscow.)

Goldschmidt, Ernst. "Strejtog i Kunsten: Henry Matisse." *Politiken*, 24 December 1911. (Text 7, above.)

Caffin, Charles H. *The Story of French Painting*. New York, 1911. (Relates attitudes Matisse expressed in recent conversation, pp. 211–216.)

MacChesney, Clara T. "A Talk with Matisse, Leader of Post-Impressionists." *New York Times Magazine*, 9 March 1913. (Text 8, above.)

Poore, Henry R. *The New Tendency in Art*. Garden City, N.Y., 1913. (Quotes conversation with Matisse, p. 27.)

Rey, Robert. "Une heure chez Matisse." *L'Opinion*, VII, 2, 10 January 1914, pp. 59–60. (Text 9, above.)

Severini, Gino. "La peinture d'avant-garde." *Mercure de France*, 14 June 1917. (Quotations about composition.)

Sacs, J. "Enric Matisse." *Vell i nou*, 1 November 1919. (Text 6, above.)

Purrmann, Hans. "Aus der Werkstatt Henri Matisses." *Kunst und Künstler*, XX, 5, February 1922, pp. 167–176. (Quotations related to Matisse's teaching.)

Harris, Frank. *Contemporary Portraits. Fourth Series*. London, 1924. (Conversations incorporated into "Henri Matisse and Renoir, Master Painters," pp. 133–141.)

Hoffmann, Finn. "Hos Henri Matisse." *Buen*, no. 2, December 1924, p. 6. (Brief quotations from interview with Matisse.)

Guenne, Jacques. "Entretien avec Henri Matisse." *L'Art vivant*, 18, 15 September 1925, pp. 1–6; also in *Portraits d'artistes*, Paris, 1925, pp. 123–127. (Text 11, above.)

Fels, Florent. *Propos d'Artistes*. Paris, 1925. (Some quotations, pp. 123–127.)

Fels, Florent. *Henri-Matisse*. Paris, 1929. (Numerous quotations from conversations with Matisse.)

Tériade, E. "Visite à Henri Matisse." *L'Intransigeant*, XXII, 14 January 1929; partially reprinted as "Propos de Henri Matisse àTériade," *Verve*, IV, 13, December 1945, p. 56. (Text 12, above.)

Tériade, E. "Entretien avec Tériade." *L'Intransigeant*, 20 and 27 October 1930. (Text 13, above.)

Matisse, Henri. "Notice biographique." *Formes*, I, 1, January 1930, p. 11. (Text 20, n. 2, above.)

Matisse, Henri. "Interview on Rembrandt and Modern Art." *Minneapolis Institute of Arts Bulletin*, 19, 29 March 1930, p. 62.

[Matisse, Henri.] "Study Art in America." *The Literary Digest*, 18 October, 1930, pp. 21–22. (Contains quotations about training young artists.)

Hoppe, Ragnar. "På visit hos Matisse." In *Städer och Konstnärer: Resebrev och essäer om konst*. Stockholm, 1931, pp. 193–199. (Text 10, above.)

Flint, Ralph. "Matisse Gives an Interview on Eve of Sailing." *Art News*, XXIX, 3 January 1931, p. 3. (Brief quotations.)

Courthion, Pierre. "Rencontre avec Matisse." *Les nouvelles littéraires*, 27 June 1931, p. 1. (Text 16, above.)

Tériade, E. "Autour d'une rétrospective, Henri-Matisse parle . . ." *L'Intransigeant*, 16 June 1931. (Text 14, above.)

Tériade, E. "Édouard Manet vu par Henri-Matisse." *L'Intransigeant*, 25 January 1932. (Matisse's comments on the importance of Manet; Text 38, n. 2, above.)

Jedlicka, Gotthard. "Begegnungen mit Henri Matisse." In *Begegnungen: Künstlernovellen*. Basle, 1933, pp. 102–126. (Text 15, above.)

[Matisse, Henri.] "Matisse Speaks." *Art News*, XXXI, 36, 3 June 1933, p. 8. (Quotations on art and the public; see Text 5, n. 2, above.)

Tériade, E. "Émancipation de la peinture." *Minotaure*, I, 3–4, 1933, pp. 9–20 (Matisse statement on p. 10). Reprinted in Verve, IV, 13 (December 1945), p. 20, where it is misdated to 1934. (Text 17, above.)

Courthion, Pierre. *Henri Matisse*. Paris, 1934. (Some quotations.)

Dudley, Dorothy. "The Matisse Fresco in Merion, Pennsylvania." *Hound and Horn*, VII, 2, January–March 1934, pp. 298–303. (Text 18, above.)

Matisse, Henri. "Dva pisma [Two letters to A. Romm]." *Iskusstvo*, 4, 1934, pp. 199–203. (Text 19, above.)

Matisse, Henri. *Testimony against Gertrude Stein*. The Hague, 1935 (supplement to *Transition* 23, 1934–35), pp. 3–8. (Rebuttal of Stein's statements concerning Matisse in *The Autobiography of Alice B. Toklas*.)

Matisse, Henri. "On Modernism and Tradition." *The Studio*, IX, 50, May 1935, pp. 236–239. (Text 20, above.)

Breeskin, Adelyn D. "Swans by Matisse." *American Magazine of Art*, XXVIII, 10, 9 October 1935, pp. 622–629. (Quotation on the Mallarmé swan.)

Tériade, E. "Constance du fauvisme." *Minotaure*, II, 9, 15 October 1936, p. 3; partially reprinted in *Verve*, IV, 13, December 1945, p. 13. (Text 21, above.)

Escholier, Raymond. *Henri Matisse*. Paris, 1937. (Recollections and statements, which were corrected in typescript by Matisse himself, pp. 30–31, 77–78, 88, 91–92, 97, 138, 141, 168.)

Huppert, Janine C. "Montherlant vu par Matisse." *Beaux-Arts*, 243, 27 August 1937. (Quotations on book illustration.)

Matisse, Henri. "Divagations." *Verve*, I, 1, December 1937, pp. 80–84. (Text 23, above.)

Montherlant, Henry de. "En écoutant Matisse." *L'Art et les Artistes*, XXXIII, 189, July 1938, pp. 336–339. (Text 24, above.)

Pach, Walter. *Queer Thing, Painting*. New York, 1938. (Some quotations.)

Matisse, Henri. "Notes d'un peintre sur son dessin." *Le Point*, 21, July 1939, pp. 104–110. (Text 25, above.)

Fels, Florent. "L'Atelier Matisse." *L'Art Vivant*, 16 August 1941.

Courthion, Pierre. *Le Visage de Matisse*. Lausanne, 1942. (Numerous quotations, many taken from Courthion's unpublished 1941 interviews with Matisse.)

Matisse, Henri. "In the Mail [extracts from 2 letters]." in *First Papers on Surrealism*. New York, 1942, pp. [25–26]. (One letter comprises Text 27, above.)

Diehl, Gaston. "Henri Matisse le méditerranéen nous dit." *Comoedia*, 7, February 1942, p. 1. (Quotations on color and light.)

Aragon, Louis. "Matisse-en-France." In Henri Matisse, *Dessins: thèmes et variations*. Paris, 1943; reprinted in *Henri Matisse, roman*. Paris, 1971. (Partially quoted in Text 29, above.)

Bouvier, Marguette. "Henri Matisse illustre Ronsard." *Comoedia*, 80, 9 January 1943, pp. 1, 6. (Quotations on Ronsard illustrations.)

Gillet, Louis. "L'Allongé. Une visite à Henri Matisse." *Candide*, 24 February 1943. (Quotation on vision.)

Diehl, Gaston. "Avec Matisse le classique." *Comoedia*, 102, 12 June 1943. pp. 1, 6. (Quotations on Cézanne's *Bathers*, book illustrations, and drawings.)

Matisse, Henri. "Témoignage recueilli par Gaston Diehl." in *Peintres d'aujourd'hui*. Collection Comoedia-Charpentier, Paris, June 1943. (Quotation on translation of emotion into formal means.)

Carco, Francis. "Souvenir d'atelier: conversation avec Matisse." *Die Kunst-Zeitung* (Zurich), 8, August 1943; also in *L'ami des peintres*. Paris, 1953, pp. 219–238. (Text 26, above.)

Diehl, Gaston. "Matisse, illustrateur et maître d'oeuvre." *Comoedia*, 132, 22 January 1944, pp. 1, 6. (Quotations on *Pasiphäe* illustrations.)

Diehl, Gaston. "La leçon de Matisse." *Comoedia*, 146–147, 29 April 1944, pp. 1 ff. (Quotations on *Jazz*.)

Bouvier, Marguette. "Henri-Matisse chez lui." *Labyrinthe*, 1, 15 October 1944, pp. 1–3. (Text 30, above.)

Grünewald, Isaac. *Matisse och Expressionismen*. Stockholm, 1944. (Some quotations.)

Swane, Leo. *Henri Matisse*. Stockholm, 1944. (Numerous quotations about Matisse's school from former students: Tor Bjurström, Edward Hald, Jean Heiberg, Einer Jolin, Per Krogh, Arthur Percy, Axel Revold, Henri Sörensen, Sigfrid Ullman.)

Matisse, Henri. "Rôle et modalités de la couleur." In Gaston Diehl, *Problèmes de la peinture*, Lyons, 1945, pp. 237–240. (Text 31, above.)

Diehl, Gaston. "Les nourritures terrestres de Matisse." *XXe Siècle*, 2, 18 October 1945, p. 1. (Quotations on art and nature.)

Matisse, Henri. [Observations on Painting] *Verve*, IV, 13, December 1945, pp. 9–10. (Text 32, above.)

Degand, Léon. "Matisse à Paris." *Les Lettres françaises*, 6 October 1945, pp. 1, 4. (Text 33, above.)

Matisse, Henri. "L'Art et le public—une grande enquête des Lettres Françaises." *Les Lettres Françaises*, 99, 15 March 1946.

Diehl, Gaston. "A la recherche d'un art mural." *Paris, les arts, les lettres*, 20, 19 April 1946, pp. 1–3. (Quotations on Barnes Murals.)

Purrman, Hans. "Über Henri Matisse." *Werk*, XXXIII, 6, June 1946, pp. 185–192. (Quotations.)

Matisse, Henri. "Comment j'ai fait mes livres." *Anthologie du livre illustré par les peintres et sculpteurs de l'École de Paris*. Geneva, 1946, pp. xxi–xxiii. (Text 35, above.)

Matisse, Henri. "Témoignages de peintres: Le noir est une couleur." *Derrière le miroir*, December 1946, pp. 2, 6, 7. (Text 34, above.)

Matisse, Henri. "Océanie: tenture murale." *Labyrinthe*, II, 3, December 1946, pp. 22–23. (Text 36, above.)

Marchand, André. "L'Œil." In Jacques Kober, ed., *Henri Matisse*. Paris, 1947, pp. 51–53. (Text 38, above.)

Matisse, Henri. *Jazz*. Paris, 1947. (Text 37, above.)

Matisse, Henri. "Le chemin de la couleur." *Art Présent*, 2, 1947, p. 23. (Text 39, above.)

Matisse, Henri. "L'exactitude n'est pas la vérité." in Galerie Maeght, *Henri Matisse: Dessins*, Paris, 1947; first trans. as "Exactitude is Not Truth," in Philadelphia Museum of Art, *Henri Matisse*. Philadelphia, 1948, pp. 33–34. (Text 40, above.)

Matisse, Henri. "Letter from Matisse [to Henry Clifford]." In Philadelphia Museum of Art, *Henri Matisse*. Philadelphia, 1948, pp. 15–16. (Text 41, above.)

Matisse, Henri. [Letter to Marc Vaux, 5 July 1948] *Carrefour des Arts*, 3, Summer 1948, p. 3. (Letter on "la nuit de Montparnasse.")

Grafly, D. "Matisse Speaks: With Commentary by D. Grafly." *American Artist*, 12, June 1948, pp. 50–51.

Barry, Joseph A. "Matisse Turns to Religious Art." *New York Times Magazine*, 26 December 1948, pp. 8, 24. (Brief quotations.)

Bernier, Rosamond. "Matisse Designs a New Church." *Vogue*, 15 February 1949, pp. 76, 131–132. (Statements by Matisse on drawing, Vence chapel, etc.)

Howe, Russell Warren. "Half-an-hour with Matisse." *Apollo*, XLIX, February 1949, p. 29. (Text 42, above.)

Matisse, Henri. [Statement on Art and the Public] *Transition Forty-Nine*, 5, 1949, p. 118. (Quoted in full, Text 5, n. 2, above.)

[Matisse, Henri.] "What I Want to Say; Work on the Dominican Chapel at Vence." *Time*, LIV, 17, 24 October 1949, p. 70. (Brief quotations.)

Peillex, Georges. "Et tout a commencé avec les Fauves . . ." in *Carreau I*, December 1949, pp. 1–2. (Quotations on Fauve painting.)

Bernheim de Villers, Gaston. *Petites histoires sur des grands artistes*. Paris, 1949; trans. *Little Tales of Great Artists*. New York, 1949. (Quotations.)

Buchanan, D. W. "Interview in Montparnasse." *Canadian Art*, VIII, 2, 1950, pp. 61–65. (Brief quotations; statement on Vence chapel.)

Duthuit, Georges. *Les Fauves*. Paris, 1949; trans. Ralph Manheim, *The Fauvist Painters*. New York, 1950. (Numerous quotations.)

Pernoud, Régine. "Nous manquions d'un portrait de Charles d'Orléans . . . Henri Matisse vient d'en composer un." *Le Figaro Littéraire*, 14 October 1950. (Interview on illustrations for the poems of Charles d'Orléans.)

Matisse, Henri. "Henri Matisse vous parle." *Traits*, 8, March 1950, p. 5. (Text 43, above.)

Barr, Alfred H., Jr. *Matisse: His Art and his Public*. New York, 1951. (Numerous quotations via questionnaires, correspondence, reminiscences, etc. Barr's questionnaires and other notes are now in the archives of the Museum of Modern Art, New York.)

Stein, Sarah. "A Great Artist Speaks to His Students 1908." In Alfred H. Barr, Jr., *Matisse: His Art and his Public*, New York, 1951, pp. 550–552. (Text 4, above.)

"Matisse's Radio Interviews, Winter, 1942." In Alfred H. Barr, Jr., *Matisse: His Art and his Public*. New York, 1951, pp. 562–563. (Barr publishes only excerpts; complete transcripts given in Text 28, above.)

Matisse, Henri. "Le Texte." In Tokyo National Museum, *Henri Matisse*. Tokyo, 1951, p. [2]. (Text 45, above.)

Matisse, Henri. "La Chapelle du Rosaire." In *Chapelle du Rosaire des Dominicaines de Vence*. Vence, 1951. (Text 46, above.)

Matisse, Henri. [Letter to the Bishop of Nice] *L'Art Sacré*, 11–12, July–August 1951, pp. 2–3. (Quoted in Text 46, n. 2, above.)

Lejard, André. "Propos de Henri Matisse." *Amis de l'Art*, n.s. 2, October 1951. (Interview with statement on the technique of the late cutouts.)

Tériade, E. "Matisse Speaks." *Art News*, November 1951, pp. 40–71; Art News Annual, 21, 1952, pp. 40–71. (Text 48, above.)

Matisse, Henri. "La Chapelle du rosaire des Dominicaines de Vence." *France Illustration*, 320, 1 December 1951, pp. [561–570]; reprinted as "La Chapelle de Vence, aboutissement d'une vie." *XXe Siècle*, special number (1970), pp. 71–73. (Text 47, above.)

Verdet, André. "Entretiens avec Henri Matisse." in *Prestiges de Matisse*. Paris, 1952, pp. 37–76. (Text 50, above.)

Luz, Maria. "Témoignages: Henri Matisse." *XXe Siècle*, n.s. 2, January 1952, pp. 55–57. (Text 49, above.)

Bridault, Yves. "J'ai passé un mauvais quart d'heure avec Matisse." *Arts*, 371, 7–13 August 1952, pp. 1, 8. (Includes statement on art and politics.)

Matisse, Henri. "Message à sa ville natale." In Musée Matisse, *Catalogue du Musée Matisse*, Le Cateau-Cambrésis, 1952.

Matisse, Henri. "Letter à Lancelle, 9 June 1896." *Arts*, 371, 7–13 August 1952, p. 1. (Letter to Matisse's cousin concerning Salon de la Nationale, 1896.)

Raymond, Marie. "Matisse contra de Abstracten," *Kroniek van Kunst en Kultur*, XIII, 6, July–Aug. 1953, pp. 227–229.

"Matisse Answers Twenty Questions." *Look*, XVII, 17, 25 August 1953, pp. 70–73. (Questionnaire with brief responses by Matisse.)

Matisse, Henri. "Il faut regarder toute la vie avec des yeux d'enfants." *Le Courrier de L'U.N.E.S.C.O*, VI, 10, October 1953; based on an interview by Régine Pernoud. Trans. as "Looking at Life with the Eyes of a Child," *Art News and Review*, London, 6 February 1954, p. 3. (Text 51, above.)

Diehl, Gaston. *Henri Matisse*. Paris, 1954. (Numerous quotations.)

Matisse, Henri. *Portraits*. Monte Carlo, 1954. (Text 52, above.)

Purrmann, Hans, ed. *Farbe und Gleichnis. Gesammelte Schriften*. Zurich, 1955. (Reprints fourteen of Matisse's writings, with introduction-memoir by Purrmann.)

Jedlicka, Gotthard. "Begegnung mit Henri Matisse." In *Die Matisse Kapelle in Vence*, Frankfurt, 1955, pp. 67–92.

Escholier, Raymond. Matisse, *ce vivant*. Paris, 1956; trans. Geraldine and H. M. Colvile, *Matisse, A Portrait of the Artist and the Man*. New York, 1960. (Many unpublished quotes, letters, etc.)

Matisse, Henri. *Propos de Matisse: propos notés par le père Couturier*. Paris, 1956. (Statements on faith; quoted Text 50, n. 8, above.)

Rouveyre, André. "Matisse évoqué." *La Revue des Arts*, VI, 2, June 1956. (Quotations.)

"Matisse dit au Père Couturier . . ." In *Le Figaro Littéraire*, 1 September 1956, pp. 1, 4.

Matisse, Henri. [Letter on Leda panel, 6 March 1946] *Derrière le miroir*, 107–109, 1958, pp. 14, 18.

Dauberville, J. and H. "Une visite à Matisse." In *Chefs-d'oeuvre de Matisse*, Paris, 1958. (Some quotations.)

Masson, André, "Conversations avec Henri Matisse." *Critique*, XXX, 324, 1958, pp. 393–399.

Charbonnier, Georges. "Entretien avec Henri Matisse." In *Le Monologue du peintre*, II, Paris, 1960, pp. 7–16. (Text 44, above.)

Couturier, Marie-Alain. *Se Garder Libre (Journal 1947–1954)*. Paris, 1962. (Various quotations, many on faith and on the Vence Chapel.)

Gilot, Françoise, and Carlton Lake. *Life with Picasso*. New York, 1964. (Quotations.)

Warnod, André. *Les peintres, mes amis*. Paris, 1965. (Quotation on African sculpture and early career, pp. 42–47.)

Brezianu, Barbu, ed. "Matisse-Pallady, Corespondenta inedita." *Secolul 20*, 6, 1965, pp. 161–172. (Letters to Pallady.)

Guichard-Meili, Jean. *Henri Matisse*. Paris, 1967. (Some unpublished quotations.)

Matisse, Henri. *Matiss. Zivopis, skul'ptura, grafika, pisma*. Leningrad, 1969. (Letters to Russian collectors, et al, including the Romm letters, Text 19, above.)

Schneider, Pierre. *Henri Matisse, exposition du centenaire*. Paris, 1970. (Quotations from unpublished letters.)

Brezianu, Barbu, ed. "O prietenie exemplara: Henri Matisse si Theodor Pallady." *Secolul 20*, 1970, pp. 155–178. (Letters to Pallady.)

Matisse, Henri, and Pierre Bonnard. "Correspondence Matisse-Bonnard, 1925–46." Ed. by Jean Clair, *La Nouvelle Revue Française*, XVIII, 211, 1 July 1970, pp. 82–100; XVIII, 212, 1 August 1970, pp. 53–70. (Includes some important letters about drawing and color; see Text 27, n. 2.)

Morris, George, L.K. "A Brief Encounter with Matisse." *Life* (Domestic Edition), 28 August 1970, pp. 43–46. (Account in Morris's journal of his 1931 meeting with Matisse.)

Giraudy, Danièle. "Correspondance Henri Matisse-Charles Camoin." *La Revue de l'Art*, 12, 1971, pp. 7–34.

Aragon, Louis. *Henri Matisse, roman*. Paris, 1971; trans. Jean Steward, *Henri Matisse: A Novel*, New York and London, 1971. (Numerous written notes and quotations.)

Fourcade, Dominique, ed. *Matisse: Écrits et propos sur l'art*. Paris, 1972. (Comprehensive collection of Matisse's writings, arranged thematically and thoroughly indexed.)

Flam, Jack D. *Matisse on Art*. London, 1973. (The first edition of the present book.)

Clay, Jean, ed. "Matisse explique Matisse." *Réalités*, 325, February 1973, pp. 82–89.

Fourcade, Dominique. "Autres propos de Henri Matisse." *Macula*, 1, 1976, pp. 92–115. (Texts that supplement Fourcade's 1972 collection.)

Cowart, Jack, and Jack D. Flam, Dominique Fourcade, and John Hallmark Neff. *Henri Matisse Paper Cut-Outs*. St. Louis and Detroit, 1977. (Quotations from unpublished letters, etc.)

Verdet, André. *Entretiens notes et écrits sur la peinture: Braque, Léger, Matisse, Picasso*. Paris, 1978, pp. 113–132. (Extended interviews with Matisse on various subjects, including Cubism, odalisques, and paper cutouts; excerpts cited in notes to Texts 10, 12, 37, 48, 49, 50, above.)

White, Barbara Erlich, ed. *Impressionism in Perspective*. Englewood Cliffs, N.J., 1978. (Matisse's reflections on Impressionism.)

"November 15, 1930. Matisse on American Art." *Art News*, 27, November 1980, p. 28. (Reprints a brief 1930 quotation of Matisse's views on American painting.)

Schneider, Pierre. *Matisse*. Paris, 1984; trans. Michael Taylor and Bridget Strevens Romer, *Matisse*. New York and London, 1984. (Numerous quotations from various sources, including unpublished letters and notebooks.)

Reze-Hure, Annette, ed. "Une lettre d'Henri Matisse à Pierre Gaut." *Cahiers du Musée National d'Art Moderne*, 13, 1984, pp. 26–29.

Matisse, Henri. "En malers optegnelser [a painter's notes]." *Louisiana Revy*, XXV, 2, January 1985, pp. 10–15.

Tériade, E. "Udtalaser af Matisse [sayings of Matisse]." *Louisiana Revy*, XXV, 2, January 1985, pp. 32–35.

Matisse, Henri. "Henri Matisse: l'or seul convient pour les cadres." *Domus International*, 661, May 1985, pp. 74–75.

Duhême, Jacqueline. *Line et les autres*. Paris, 1986. (Recounts conversations with Matisse, pp. 1–30.)

Delectorskaya, Lydia. *L'apparente facilité... Henri Matisse, Peintures de 1935–1939*. Paris, 1986; trans. Olga Tourkoff, *With Apparent Ease... Henri Matisse, Paintings from 1935–1939*. Paris, 1988.

Flam, Jack. *Matisse: The Man and His Art, 1869–1918*. Ithaca and London, 1986. (Previously unpublished letters and quotations.)

Bussy, Jane Simone. "A Great Man." *The Burlington Magazine*, CXXVIII, 995, February 1986, pp. 80–84. (Gives account of conversations with Matisse.)

Benjamin, Roger. *Matisse's "Notes of a Painter": Criticism, Theory and Context, 1891–1908*. Ann Arbor, Michigan, 1987.

Duthuit, Claude, with Françoise Garnaud. *Henri Matisse: catalogue raisonné des ouvrages illustrés*. Introduction by Jean Guichard-Meili. Paris, 1987.

Flam, Jack. "La Sculpture de Matisse." *Les Cahiers du Musée National d'Art Moderne*, 30, Winter 1989, pp. 23–40. (Quotations from unpublished documents related to Matisse's sculpture.)

Freeman, Judi, ed. *The Fauve Landscape*. Los Angeles and New York, 1990. (Quotations from letters.)

Gilot, Françoise. *Matisse and Picasso: A Friendship in Art*. New York, 1990. (Quotations.)

Bernier, Rosamond. *Matisse, Picasso, Miró As I Knew Them*. New York, 1991. (Conversations with Matisse.)

Matisse, Henri, and Pierre Bonnard. *Bonnard/Matisse, correspondance 1925–1946*. Jean Clair and Antoine Terrasse, eds. Paris, 1991; trans. Richard Howard, *Bonnard/Matisse: Letters Between Friends*. New York, 1992.

Duthuit, Georges. *Écrits sur Matisse*. Rémi Labrusse, ed. Paris, 1992. (Includes letters, pp. 206–274, and extensive notes from Duthuit's conversations with Matisse on diverse subjects, pp. 277–297.)

Jacques-Marie, Soeur (Monique Bourgeois). *Henri Matisse, La Chapelle de Vence*. Nice, 1993. (Conversations and documents related to the chapel at Vence.)

Kostenevich, Albert, and Natalya Semyonova. *Matisse et la Russie*. Paris, 1993; trans. Andrew Bromfield, *Collecting Matisse*. Paris, 1993. (Letters and quotations related to Matisse's 1911 trip to Russia.)

Couturier, M. A., and L. B. Rayssiguier. *La chapelle de Vence: Journal d'une Création*. Marcel Billot, ed. Paris, 1993. (Quotations and documents pertaining to the chapel at Vence.)

Flam, Jack. "Henri Matisse" catalogue entries. In *Great French Paintings from the Barnes Foundation: Impressionist, Post-impressionist, and Early Modern*. New York, 1993, pp. 226–293. (Quotations from unpublished letters.)

Flam, Jack. *Matisse: The Dance*. Washington, D.C., 1993; trans. Jeanne Bouniort in Musée d'Art Moderne de la Ville de Paris, *Autour d'un chef-d'oeuvre de Matisse: Les Trois Versions de la Danse Barnes (1930–1933)*. Paris, 1993, pp. 23–91. (Quotations from unpublished letters, mostly related to the Barnes Murals.)

\sim

In addition to published sources, a vast number of letters and papers are also in archives and private collections, access to many of which is highly limited, or closed. These include the Archives Henri Matisse, Paris, and the Pierre Matisse Archives, New York. An extensive list of archives is given in Russell T. Clement, *Henri Matisse: A Bio-Bibliography*, Westport and London, 1993, pp. 21–29. Among the more important public archives are the Alred H. Barr, Jr., papers at the Museum of Modern Art, New York; the Claribel and Etta Cone archives at the Baltimore Museum of Art, Maryland; Matisse's correspondence with Simon Bussy, originals in London, copies at the Center for Advanced Study in the Vi-

sual Arts, National Gallery of Art, Washington, D.C.; the Pierre Courthion papers (including the typescript of nine unpublished interviews with Matisse, done in 1941), at the Getty Center Center for the History of Art and the Humanities, Archives of the History of Art, Santa Monica, California; the Father Marie-Alain Couturier, O.P., papers, Couturier Collection at Yale University, Institute of Sacred Music, Worship and the Arts (to which there is a published guide, compiled by Joanna Weber, *Couturier Collection at Yale University: Archival Register*, New Haven, 1994); Matisse letters to various recipients (dating from 1904 to 1953) at the Getty Center for the History of Art and the Humanities, Archives of the History of Art, Santa Monica, California; the André Rouveyre-Henri Matisse correspondence (originals at Det Konglige Bibliotek, Copenhagen; copies at the Bibliothèque Littéraire Jacques Doucet, Universités de Paris).

Index

Abstract Expressionism, 297n3
Abstraction, 216–17, 265n43, 271n4, 286n14
Academic art, 46, 256n24
Aesthetics (Croce), 33
African art, 29, 35, 73, 159, 184, 204, 228, 260n3, 271n15, 300n14
Agutte, Georgette, 231, 270n6
Airplane, The, 172
Airplanes, 294n11
Algiers, 128
America, 90–93, 280n17
Angelico, Fra, 192
Annélies, 289n5
Antique art, 46, 55, 79
Apollinaire, Guillaume, 11, 16, 32, 34, 80, 133, 230, 260nn1,5, 262n11; Matisse's interview with, 3, 27, 52
Arabesque, 158, 167, 184, 194, 210–11, 302n2
Aragon, Louis, 14, 17, 148, 149, 234, 258nn46, 47, 286n11, 289n1, 298n9
Art Institute of Chicago, 64
Art school (Matisse's), 44–45, 81, 101, 203, 277n7
Art styles and periods, 83, 123, 126, 144, 196, 205
Artist, 129, 141, 150, 163, 294n17; material conditions of the, 80–81, 152, 186; and model, 131–32, 136, 267n7, 292n5; and public, 268n2; and work, 185, 270n4, 282n2; the young, 88, 147, 158, 173, 181, 186, 195, 253n7
Asia. *See* Oriental art
Astruc, Zacharie, 166, 291n3
Automne, Salon d', 31, 32, 53, 95, 121, 159, 202, 227, 234–35, 260n4, 265n47

Backs, The, 72, 267nn5,13
Badt, Kurt, 262n16, 287n38
Bakst, Léon, 178, 290n4
Balance. *See* Equilibrium
Balzac, Honoré, 142, 287n38

Barnes, Albert C., 108, 231–32, 276n7, 268n5, 281nn19,21
Barnes Foundation, 92, 232, 286n18
Barnes mural, 5, 11–12, 17, 95–96, 107, 109–16, 189–90
Barr, Alfred H., Jr., 8
Barrès, Maurice, 127, 284n3
Bas-relief, 72
Bathers by a River, 205, 268n6, 269n5, 300n16, *Fig. 36*
Bathers, The (Cézanne), 80 (see *Three Bathers*)
Benda, Julien, 163, 290n8
Benjamin, Roger, 32
Bergson, Henri, 33, 262n14, 263n18, 265nn36,39
Bernard, Émile, 37, 264n27
Besnard, Paul Albert, 68, 147, 270n9
Besson, George, 43, 230, 266n1
Biblical subjects: 86, 197, 198–99, 206. *See also* Christ
Birds, 135, 151
Black as color, 75, 165–66, 175, 291n4
Blanc, Joseph, 126
Blanche, Jacques-Émile, 37
Blue Nude, 64, 228, *Fig. 7*
Bonheur de Vivre, 116, 207, 227, *Fig. 2*
Bonnard, Pierre, 186, 230, 234–35, 288n2
Bonnat, Pierre, 126
Book illustration, 166–69, 194; of Mallarmé's poems, 96, 115, 166–67
Botanical metaphors, 182
Bouguereau, Adolphe William, 94, 200, 225, 297n3
Bouquet, The, 171–72
Bourgeat, Charles, 70, 79
Bouvier, Marguette, 151, 289n1
Braque, Georges, 3, 202
Bréal, Auguste, 19, 126
Bréal, Michel, 126, 284n7
Breton, André, 12–13
Bruegel, Pieter, The Elder, 126

Buffon, Georges Louis Leclerc, 138, 286n19
Burgess, Gelett, 270nn7,10
Burmese statues, 150
Bussy, Jane Simone, 253n3
Bussy, Simon, 226
Byzantine art, 178, 255n14, 273n22, 296n6

Caffin, Charles H., 271n15
Cambodian art, 29
Camera Work (journal), 43
Carracci, Annibale, 67, 201
Carco, Francis, 132, 133, 285n1
Carnegie Foundation, 93, 99, 276n10
Carrière, Eugène, 64, 227, 269n10, 286nn20–23
Cézanne, Paul, 24, 82, 188, 215, 226, 269n11; art
 of, 5, 33, 40, 52, 68, 80, 105, 109, 155, 157, 158,
 262n16; on art, 123, 158, 185, 189, 211, 282n6,
 290n6, 295n3, 297n4, 299n12; influence of,
 16, 32, 36, 78, 157, 255n14, 267n5; relation to
 cubism, 20, 21; works displayed by Matisse,
 64, 72, 124
Champaigne, Philippe de, 106, 201
Chance, 106
Chants du Maldoror, 15
Chapel at Vence. See Vence Chapel project
Charbonnier, Georges, 189, 236, 297n1
Chardin, Jean-Baptiste Siméon, 42, 68, 79, 105,
 106, 175, 226
Charles d'Orléans, 163
Chevreul, Michel Eugene, 84
Chinese art, 149, 155, 158, 289n2
Chinese Fish, 301n3
Christ, 41, 86, 106, 198, 199, 276n10
Cinema, 92, 145
Clarity of expression, 135, 202, 209
Clemenceau, Georges, 141
Clifford, Henry, 22, 181, 182, 235, 296n1
Color, 36, 62, 140, 206; brush technique and,
 117–18; drawing and, 155–56; and emotion,
 196–97; as force, 162, 219; and form, 51–52,
 84, 208; in music, 155; quantity and quality
 of, 85–86, 123; relations of, 38, 39, 40, 45,
 66, 95, 164
Composition, 38, 40, 66, 124, 196, 218
Consciousness, 32, 33, 161
"Constance du fauvisme" (Tériade), 14, 283n1
Construction, 45, 47, 50, 80, 84, 161, 175, 196,
 299n12
Content. See Subject matter
Contour, 254n13
Copying, 54, 176, 189, 193, 196, 213, 290n6
Cormon, Fernand, 227

Corot, Jean-Baptiste Camille, 68, 82, 151 226
Correggio, (Antonio Allegri), 183, 297n6
Corsica, 176, 226
Courbet, Gustave, 43, 274n25
Courthion, Pierre, 15, 22, 104, 232, 234, 257n42,
 298n11
Couturier, Philibert-Léon, 200, 272n3
Cowart, Jack, 287n30
Cranach, Lucas, 221
Creativity, 106–7, 211, 217–19
Crépons, 155, 289n3, 296n4
Croce, Benedetto, 33
Cross, Henri-Edmond, 84, 120, 201, 202, 275n4,
 283n9
Cubism, 3, 12, 20, 59, 94, 95, 142, 144, 184, 204;
 Cézanne and, 20, 21; criticism of, 184, 185,
 276n4, 299n13
Curves, 154, 172–73, 289n6
Cutouts, 15, 18–19, 169, 172, 206–7, 210, 212,
 256n18, 292n6, 293n10, 302n6

Dance, The, 137, 189, 297n2, 298n7; Barnes
 mural, 11–12, 17, 95–96, 107, 109–16,
 189–90, 264n31, 268n5, 269n5, 278n5,
 279nn12,13, 281nn5,6. Fig. 24; Moscow
 panel, 116–18, 190–91, 203, Fig. 21;
 Paris version, 281n6
D'Annunzio, Gabriele, 127
David, Jacques-Louis, 185
Death of the Toreador (Manet), 295n2
Decorativeness, 25, 38, 77, 82, 110, 151, 156,
 164–65, 268n6
Deformation, 34
Degand, Léon, 159, 290n1
Degas, Edgar Hilaire-Germain, 147, 154
Delacroix, Eugène, 79, 80, 105, 117, 150, 151, 155,
 164, 203, 273n12, 275n5
Delectorskaya, Lydia, 159, 232–34, 290n3, 303n5
Denis, Maurice, 37, 204, 261n2, 264n27
Density, 39, 124
Derain, André, 12–13, 95, 120, 141, 202, 227, 236,
 283n7
Desserte, La (copy after de Heem), 79, 105, Fig. 33
Dessins: Thèmes et variations, 148, 234, 258n47
Desvaillières, Georges, 30–31, 37, 53, 226,
 261nn3,5, 265n47
Detail, 78, 284n6
Diaghilev, Sergéi, 230
Diehl, Gaston, 8, 154, 235–36, 285n8, 289n1,
 291n4
Dinner Table, The, 226, 273n16, Fig. 18
Dissonance, 38, 45

"Divagations," 15, 125, 126, 233, 283n1
Divisionism, 21, 84, 196, 201–2
Drawing, 34, 46–49, 102–4, 125, 185, 210, 283n3,
 290n5; and color, 155–56; ink, 184, 187;
 painting compared with, 181, 182, 194, 208;
 preparatory studies, 106, 160, 253n7; purity
 in, 130–31
Dream, The, 160, 301n2
"Dream of the White Elephant," 15
Dreams, 15
Druet, Antoine, 56, 60, 82, 139, 269n4,
 274n28
Duccio di Buoninsegna, 29
Dudley, Dorothy, 107, 232, 273n22, 278nn1,4,5
Dufresne, Charles, 93
Dufy, Raoul, 202
Durand-Ruel, 157–58
Duration, 40
Dürer, Albrecht, 68, 154, 221
Duthuit, Georges, 8, 231

Easel painting, 211, 214
École des Beaux-Arts, 7, 10, 15, 35, 66, 78–79,
 86, 125, 126, 147–48, 196, 213, 225, 230
Egyptian art and influence, 29, 39, 188
El Greco, 85, 104, 193, 298n10
Emotion, 68, 106, 162; and color, 66, 67; desire
 or passion, 185, 217; expression of, 9, 78, 85,
 145, 208; and line, 130–31
Emptiness, 217
Ensemble, 28–29, 46, 49, 54, 123, 162, 180
Equilibrium, 34, 35, 39, 42, 55, 123, 152, 212
Ernst, Max, 257n41
Escholier, Raymond, 8, 122, 124, 160, 232–33
Essence, 18, 149, 156, 286n14
Essentialism, 20, 34
Essentials, 39, 46, 122–23, 156
Estienne, Charles, 3, 52, 148, 216, 268n1, 303n16
Evenepoël, Henri, 226
"Exactitude is not Truth," 179, 294n13
Exaggeration, 152
Exhibitions, 64, 82, 93, 94, 195, 227, 229
Expression, 36, 37–38, 42, 54, 130; art as personal,
 9, 32, 68; plastic or pictorial, 7, 17, 27, 29
Expressionist painting, 32
"Eye, The," 175, 295n1

Faces, 41, 172, 194, 220
Fauvism, 32, 43, 59, 94, 160, 196; the Fauve
 spirit, 14, 85–86, 122; naming of, 95, 121, 202;
 use of color in, 6, 12, 83, 84, 202, 204, 206
Feeling. See Emotion

Ferrier, Gabriel, 78, 225, 289n5
Fetishes, 135
Fig tree: as sign, 18, 179, 180
Film, 92, 145
Flandrin, 43
Flanner, Janet, 264n23
Floral or plant imagery, 17–18
Forain, Jean-Louis, 138
Forest at Fountainbleau, The, 265n41
Formalism, 68
Form and color, 51–52, 84, 208; and function,
 45, 46–48, 51; geometric, 120
Fragonard, Jean Honoré, 226
Framing art works, 82
Francesca (Piero della), 29
Free association, 283n5
Freedom, 6, 69, 101, 151, 158, 164, 186, 198
Frémiet, Emmannuel, 43
French art, 46, 164, 181
Fresco, 80, 108, 110
Friesz, Othon, 202, 208, 302n7
Fromentin, Eugène, 140, 287n35
Fry, Roger, 119
Futurists, 20, 258n53

Galleries and salons, 82, 93, 94, 133, 157, 179,
 260n4, 269n3, 274n28; Salon d'Automne,
 31, 32, 53, 95, 121, 159, 202
Garden on the Outskirts of Paris (Manet),
 295n2
Gardens, 135–36, 210, 215
Gauguin, Paul, 32, 90, 148, 155, 158, 212, 216,
 227; influence on Matisse, 84, 185–86,
 257n29
Gauss, Charles Edward, 32, 262n12
Gérôme, Jean-Léon, 126, 148
Giacometti, Alberto, 236
Giotto, 29, 40, 228
Girl Reading, 267n12
Glazes, 118
Gleizes, Albert, 20, 22
God, 163, 173, 294n18
Goethe, Johann Wolfgang, 21, 127, 128
Golberg, Mécislas, 34–35, 263nn19,20, 264n22
Goldfish and Sculpture, 65
Goldschmidt, Ernst, 1, 3, 60, 269n1
Goya y Lucientes, Francisco, 68, 104, 273n7
Greco, El, 85, 104, 193, 298n10
Greek art, 1, 29, 39, 58, 68, 188, 203
Guenne, Jacques, 78, 231, 272n1
Guérin, Charles, 37, 264n27
Guignon, 94, 200

Harmony, 38, 45, 66, 84–85, 121, 140
Harmony in Red, 8–9, *Fig. 8*
Harris, Frank, 139–40, 287n31
Heem, Davidsz de, 100, 105, *Fig. 33–34*
Hervé, Julian-Auguste, 32
Hindu art, 55
History, 21, 43, 123; the future, 212. *See also*
 Art styles and periods
Hokusai, 126
Holbein, Hans, 221
Hoppe, Ragnar, 5, 73, 74
Hourcade, Olivier-, 20
Howe, Russell Warren, 12, 184, 297n1
Hugo, Victor, 127, 289n2
Humanism, 41
Human subjects, 38–39, 54, 103, 118, 131–32,
 160, 266n1. *See also* Faces; Model; Nudes;
 Portraiture

Ideas, 263n18
Illness (of Matisse), 6, 22, 127–28, 225, 233–34
Illustration, 166–69, 194, 291n2; of Mallarmé's
 poetry, 96, 115, 166–67
Imitation, 54, 176, 189, 193, 196, 213, 290n6
Impressionism, 5, 6, 39, 75, 79, 100, 155; critique
 of, 32, 39, 101, 120
Improvisation. *See* Spontaneity
Indépendants, Salon des, 85, 148, 157, 227,
 260n4
Ingres, Jean Auguste Dominique, 49, 125, 126,
 157, 158, 164, 173, 289n2
Instinct, 59, 117, 185
Intelligence, 59, 145, 152
Intention, 86, 121
Interior space, 15, 130, 158, 192, 198
Interior vision, 7, 89, 218, 270n13, 292n6
Interior with Eggplants, 231, 269n8
Introduction to Metaphysics (Bergson), 33
Intuition, 32–33, 36
Islamic art, 229, 273nn21,22, 289n2, 296n5
Italian Primitives, 154, 303n12
Italian Woman, The, 267n6

Jacob, Max, 133
Jambon workshop, 133, 134, 285n2
Japanese art, 80, 155, 166, 174, 177, 178, 195,
 273n22. *See also* Crépons
Jazz, 15, 18, 21, 234, 289n7, 292nn1,2,6; designs
 for, 169–77, 171, 216
Jeannette series, 56, 71, 269n5, 270n9
Jedlicka, Gotthard, 6, 97, 232, 276n1
John, Augustus, 69

Joyce, James, 253n8
Joy of Life. See *Bonheur de vivre*

Kandinsky, Wassily, 2, 4, 254n12
Kean, Beverly, 264n24
Kempis, Thomas à, 294n16
Klee, Paul, 4
Kuniyoshi, 185

Lamotte, Angèle, 174
Laprade, Pierre, 138
Laurencin, Marie, 144
Lautréamont, Comte de, 13, 14
Lebasque, Henri, 138, 287n25
Le Corbusier, 188
Leda panel, 159, 161–62, 234
Léger, Fernand, 259nn54–56
Leonardo da Vinci, 15, 125, 126, 283n5
Le Point (journal), 129
Leriche, René, 223
Lettres Portugaises, 163, 235
Lhote, André, 22
Lieberman, William S., 285n4
Light, 206, 207, 213–14; creating effects of, 52,
 84, 102, 156, 267n17, 295n3; lighting, 190–91;
 natural, 89, 176, 201, 292
Line, 34, 48–49, 92, 154, 219; and emotion,
 130–31
Linoleum engraving, 168, 291n6
"Listening to Matisse" (Montherlant), 127,
 284n1
Literature, 289n1
"Looking at Life with the Eyes of a Child," 7,
 217, 236, 303n1
Lorraine, Claude, 149
Loti, Pierre, 203
Louvre museum, 68, 79, 105, 118, 178, 282n6,
 299nn5–6. *See also* Masters
Love, 173–74, 217
Luce, Maximilien, 139
Luminous space, 130
Luncheon in the Studio (Manet), 166, 291n2
Luxe, Calme et Volupté, 201, 267n12
Luz, Maria, 19, 207, 210, 301n1

MacChesney, Clara T., 3, 11, 64, 65, 229, 269n1
Maeterlinck, Maurice, 71, 140, 287n33
Maillol, Aristide, 163, 227, 230, 273n22
Mallarmé, Stéphane, 96, 115, 166–67
Manet, Édouard, 43, 68, 147, 175–76, 295n2
Manguin, Henri Charles, 95, 202, 226
Man Ray, 13, 14, 257n31

Mantegna, Andrea, 154

Marchand, André, 175, 295n1

Marinetti, 258n53

Marque, Albert, 95, 202

Marquet, Albert, 72, 79, 81, 135, 138–39, 186, 202, 226, 228, 230, 234–35, 269n3, 285n2

Marx, Roger, 201

Massine, Léonide, 230, 233

Masson, André, 14

Masters: 92, 120, 129, 154, 157. *See also* Leonardo da Vinci; Louvre museum; Michelangelo; Raphael

Matisse, Amélie, (Mme Henri), 134, 137; portrait of, 133, 226, 231–32, 234, 286n8, *Fig. 20*

Matisse, Henri, 3–4, 8, 23, 28, 61, 79–81, 112, 225; the art of, 4–6, 19–20, 30, 34; criticism of, 64, 255n16, 260n4; described by others, 66, 70, 75, 98–99, 104, 150, 152, 154, 184, 187, 279nn7–8; early life and education of, 1, 10–11, 79, 130, 133, 200, 225–26, 282n2, 287n30; illness of, 6, 22, 127–28, 225, 234; personality of, 10–11, 152, 154; studio and home of, 70, 71, 74, 77, 135–36, 147, 159–60, 165; as teacher, 46, 152–54; as writer, 1–4, 9–10, 19, 22, 23, 31, 35, 113, 284n6

Matisse, Pierre, 142, 143, 230, 231, 253n4

"Matisse Speaks," 12, 199, 200, 290n7, 299n1

Maturity, 88, 255n17

Means of expression, 122, 156, 160, 193, 206, 286n14, 288n3

Memory, 6, 99

Merion panel. *See* Barnes Mural

Metaphysics, 8, 22

Metzinger, Jean, 20

Michelangelo, 68, 129, 295n2

Minotaure (journal), 14, 15, 122

Miró, Joan, 258n43

Model, 47–48, 48–50, 51–52, 130, 185, 220; artist and, 131–32, 136, 267n7, 292n5

Modernity, 6, 21, 91

Modern painting, 64, 92, 121, 158, 165

Moll, Greta, 264n25

Mondrian, Piet, 4, 254n12

Monet, Claude, 39, 51, 68, 147, 226, 230, 294–95n2

Montherlant, Henry de, 127–28, 167, 284n1

Morale des Lignes, La (Golberg), 34

Moreau, Gustave, 79, 94, 105, 120, 144, 146, 157, 163, 201, 202, 225–26, 291n6

Morice, Charles, 31, 148, 262nn6,7

Morocco, 86, 139, 202–3, 299n11

Morosoff (Morosov), Ivan, 203–4, 228, 230

Morris, George L. K., 280n17

Moscow, 296n6

Mourlot, Fernand, 219

Movement, 39, 190

Mural painting, 110–11, 115–16, 90–92, 198

Museums, 91, 124, 204, 220; Louvre, 68, 79, 105, 118, 178, 282n6; Musée Matisse, 236, 256n25

Music, 56, 84–85, 117, 203, 268n6, 281n9

Music, 155, 161, 199, 208

Nasturtiums and "Dance", 270n5

Nature, perception and, 45, 182, 183, 95, 264n32, 271n12, 274n23; photographic reproductions of, 44, 72, 193; working from, 6–7, 11, 17, 35–36, 50, 286n14

Negro art, 29, 35, 73, 159, 184, 204

Neo-Fauvism, 206

Neo-Impressionism, 52, 82, 139, 283n8; and Fauvism, 83, 84–85, 275n5

New York, 90, 111

Nice, 20, 83, 88, 139, 205, 288n4

Nice period, 5, 255n15, 256n18, 300n17

Nietzsche, Friedrich Wilhelm, 13, 186

Non-figurative art, 184

"Notes of a Painter," 2, 4–5, 21, 30, 37, 46, 53, 118–19, 254n11, 260n1

"Notes of a Painter on his Drawing," 6, 15, 17, 125, 129, 130, 233

Nudes, 62, 72, 78, 86

Objects, 207–8, 211, 217, 218, 285n3, 290n5

"Observations on Painting," 157, 290n1

Oceania, 264n4; art of, 258n44, 260n3, 292n2, 294n19; *Oceania* panels, 15, 169, *Fig. 27*

Odalisques, 8, 86, 271n4, 275n9, 300n18

Olivier, Fernande, 7, 253n1, 260n2, 285n3

Olympia (Manet), 295n2

Olympiques (journal), 128

"On Modernism and Tradition," 6, 233, 282n1

Order, 40

Organization, 160

Oriental art, 150, 154; Chinese, 149, 155, 158; Japanese, 80, 155, 166, 174, 177, 178, 195

Pagnol, Marcel, 162, 290n7

Painting, 4, 50–51, 53, 181, 183, 205–6; drawing compared with, 181, 182, 194, 208; easel, 211, 214

Pallady, Théodore, 296n2

Parakeet and Mermaid, 15

Paris, 83–84, 119, 230

Pasiphäe (Montherlant), 167, 234, 284n2, 291n4

"Path of Color, The," 177
Pegurier, Auguste, 24, 138, 287n24
Péladan, Mérodack Joséphin, 43, 265n47,
 266nn48–49
Perception (visual), 36, 45
Peruvian art, 29
Photographs: paintings based on, 44, 277n3
Photography, 43–44, 54, 106, 145, 218; of the
 artist's oeuvre, 56, 60, 274n29; reproducing
 nature, 193
Piano Lesson, The, 18, 205, 230
Picasso, Pablo, 3, 15, 34, 93, 133–34, 141, 228, 230,
 233–35, 297n3; on Matisse, 259n64
Pink Marble Table, The, 302n4
Pissarro, Camille, 157, 175, 226
Planes, 84, 212, 273n22, 288n2
Planning, 267n15; preparatory studies, 106, 160,
 253n7
Plastic expression, 17, 27, 29
Plastic signs, 16–20, 40, 130, 132, 148, 149–51,
 178, 209
Plumb line, 172, 267n2
Poesies de Stéphane Mallarmé, 166–67, 232,
 281n7
Poetry, 7, 19, 54, 72, 89, 96; illustration of, 166–69
Politics, 216, 275n8
Portrait of Mme Matisse, 133, 286n8, Fig. 20
"Portraits," 7, 180, 219, 236, 303n1
Portraits (self-), 9, 179–80, Fig. 30, 32
Portraiture, 7, 76, 122, 134, 145, 218, 219–23
Post-Impressionism, 65, 119, 120
Poussin, Nicolas, 67, 149, 158, 188, 226
Preconception, 7
Pre-verbal expression, 7
Primitives: 29, 67, 73, 92, 150, 159, 178, 204, 227,
 296n6. See also African art
Primitivism, 27
Prints (lino), 168
Prix-de-Rome, 86, 147–48
Proportions, 68
Puget, Pierre, 39
Purity, 6, 35, 55, 107, 122, 206, 221; in drawing,
 130–31
Purrmann, Hans, 44, 45, 203, 228, 267nn14–17,
 Fig. 5
Puvis de Chavannes, Pierre, 55, 109, 110, 211,
 226, 279n10
Puy, Jean, 202

Racine, Jean, 43
Raphael, 58, 68, 79, 106, 115, 154, 164, 180, 212,
 221, 227

Raffäelli, Jean François, 68
Rastelli, 284n2
Ray, The (after Chardin), 79, 106–8, 270n4,
 273n14
Rayssiguier, L.-B., 13, 14, 235
Réalisation (of Cézanne), 33, 34
Realism, 54, 70, 88
Reality, 262n16, 265n35
Red Madras Headdress, 65, Fig. 6
Redon, Mme O., 139
Redon, Odilon, 57, 227
Red Still Life with a Magnolia, 140, 142, 160,
 218–219, 234, 287n34
Red Studio, The, 9, 17, 60, 229, 269nn6–7,
 Fig. 11
Relationships (pictorial), 89, 122, 145
Religion, 32, 173–74, 192, 212, 265n47,
 294nn16–20, 302n8
Rembrandt, H. van Rijn, 29, 68, 132, 180, 192,
 193
Renaissance painters. See Masters
Renoir, Pierre Auguste, 5, 43, 58, 78, 109, 118,
 127, 138, 147, 215, 230, 272n2, Fig. 14
Representation, 39, 45, 50, 66
Reverdy, Pierre, 163, 235, 291n5
Reverie, The, 269n7
Revue Hébdomadaire, 43
Rey, Robert, 3, 270n1
Rhythm, 121, 271n4
Rivière, Jacques, 20
Rodin, Auguste, 42, 43, 82, 126, 139, 227,
 284n6
Roger-Marx, Claude, 284n1, 285nn6,7, 299n5
"Role and Modalities of Color, The," 154–56,
 235
Romano, Giulio, 79
Romm, Alexander, 113, 281nn1,2
Ronsard, Pierre de, 163, 168, 235, 291n5
Rose de Sable, La (Montherlant), 127–28
Rouault, Georges, 273n17
Rousseau, Henri (Le Douanier), 92
Rouveyre, André, 19, 23, 34, 226, 289n3
Rubens, Peter Paul, 40
Ruysdael, Jacob, 100, 106

Sacs, J., 3, 56, 269n1
Sainsère, Olivier, 139
Salmon, André, 20, 34
Satie, Erik, 171
School (Matisse's), 44–45, 81, 101, 203, 277n7
School of Paris, 3
Schopenhauer, Arthur, 10

Scissors. *See* Cutouts

Sculpture, 49–50, 193, 298n11; sculptural quali-
ties, 267n8, 271n15; sculptural works, 29, 121

"Seeing," 7–8, 169, 218

Self-portraits, 9, 179–80

Sembat, Marcel, 230–31

Sensation, 16, 44, 56, 142; condensation or
translation of, 36, 38, 145, 285n5, 295n2

Sensuality, 6, 122, 181, 182

Sentiment. *See* Emotion

Serenity, 54, 55, 193, 198

Seurat, Georges, 84, 109, 120, 212, 275n5

Sexuality, 9, 253n9, 268n6, 282n9

Shchukin, Sergei Ivanovitch, 31, 35, 203, 228,
230, 254n10, 268n6, 282n9

Shiff, Richard, 258n50

Sienese primitives, 29

Signac, Paul, 20, 37, 84, 138, 185, 201, 226, 227,
264n27, 275n5

Signs ("plastic"), 16–20, 40, 130, 132, 148,
149–51, 178, 209, 295n2; defined, 265n37;
theory of, 148

Simplification, 120, 143, 295n2

Sincerity, 85, 158, 161, 295n2

Sisley, Alfred, 39, 265n33

Skyscrapers, 91

Snail, The, 166, 210

Sorrows of the King, The, 166

South Seas. *See* Oceania

Space, 21, 89, 130, 146, 153; interior, 15, 130, 158,
192, 198; luminous, 130; spiritual, 207

Spectator, 194

Spirituality, 58, 96, 181, 183, 192, 198, 254n12,
294n16, 297n5

Spiritual space, 207

Spontaneity, 67, 106, 107, 160–61

Stained glass windows, 198, 216

Standing Nude, 261n5, *Fig. 3*

Stein, Gertrude, 133, 134, 139, 142, 227,
285nn4,5,7, 287n37

Stein, Leo, 1, 253n2, 260n2

Stein, Michael, 44, *Fig. 5*

Stein, Sarah, 44–46, *Fig. 5*

Stendhal, 129

Stevens, Wallace, 7–8

Stieglitz, Alfred, 43

Still life, 57, 140, 142

Still Life After de Heem's "Desserte," 201, 299n6,
Fig. 34

Storm, The (Ruysdael), 106

Stravinsky, Igor, 230

Stschoukine. *See* Shchukin

Studies (preparatory), 106, 160, 253n7

Subject matter, 34, 170, 174, 205, 295n2

Surrealism, 12–16, 186, 283n5, 287n1, 289n1

Symbolism, 5, 8, 17, 22, 33

Sympathetic communication, 33

Tahiti, 83, 87, 88, 89–90, 91, 104, 105, 206,
213–14, 231. *See also* Oceania

Tanguy, Julien, 82, 274n27

Tériade, E., 5, 6, 11–12, 14–15, 16, 83, 87, 93, 106,
122, 174, 199, 200, 231–32, 235–36, 257n27,
275n2, 276nn1,2, 299n1

Terrace at St.-Tropez, The, 201

"Testimonial," 207

Tête d'expression, 32, *Fig. 6*

Theater, 129

Theory, 9, 33, 35, 261n2; absence or opposed to,
19, 21, 27, 132; of signs, 148

Three Bathers (Cézanne), 80, 124, 267n5,
287n32, *Fig. 19*

Tissot, James, 86, 206

Titian, 140

Tokyo exhibition, 195

Tonal value, 130, 196, 267n17, 273n22, 285n6

Toulouse-Lautrec, Henri de, 183, 213

Transformations, 142

Translation, 25–26

Transparency, 118

Trapp, Frank Anderson, 289n3

Travel, 88, 101, 206

Trompe l'oeil, 57

Truphème, Auguste Joseph, 94, 200, 276n3

Turner, J. M. W., 132

Tzara, Tristan, 14, 257n31

Ulysses (Joyce), 232, 253n8

Unconscious, 106, 107, 221–22

Utamaro, 185

Valtat, Louis, 215, 303n15

Value (tonal), 130, 196, 267n17, 273n22,
284–85n6

Van Dongen, Kees, 56–57, 137

Van Gogh, Vincent, 81, 82, 84, 155, 158, 212, 226,
227, 262n8

Vauxcelles, Louis, 95, 121, 202, 276n4

Velázquez (Diego Rodrigues de Silva y), 85

Vence Chapel project, 134, 151–52, 191–92,
196–99, 206–7, 212, 235, 236, 298nn1,9

Verdet, André, 184, 209, 271n4, 275n9, 292n6,
302nn1,6

Veronese, Paolo, 79

Verve (journal), 13, 235
Véry, Emile, 79, 273n15. See Wery
Vibrato, 84
Vision, 7, 217; interior, 7, 89, 218; "seeing," 7–8, 169, 218
Vlaminck, Maurice, 186, 202, 227
Voids, 217
Vollard, Ambroise, 139, 215–16, 274n29
Voyages, 294n11; Morocco, 86, 139, 202–3, 299n11; Tahiti, 83, 87, 88, 89–90, 91, 104, 105, 206, 213–14

Wasps Nest, The (Bouguereau), 94, 200
Watteau, Antoine, 226
Weill, Berthe, 82, 139, 226, 274n30, 287n29
Wéry, Emile, 79, 226, 273n15

Wilde, Oscar, 139
Will, 8, 255n17
Window at Tangiers, 204
Window on the Garden, 13, 160
Windows, 146, 197–98, 205
Woman in Yellow, 276n3
Woman with the Hat, 133, 134, 286n8, *Fig. 1*
Work ethic, 185, 272n4, 282n2
Writer (Matisse as), 1–4, 9–10, 19, 22, 23, 31, 35, 113, 284n6

Young artists, 88, 158, 173, 181, 186, 195, 253n7
Youth and Age, 273n7

Zborowska, Mme, 141
Zborowski, Leopold, 141, 287n36

Compositor:	Star Type, Berkeley
Text:	Adobe Garamond
Display:	Futura Book
Printer:	Malloy Lithographing, Inc.
Binder:	Malloy Lithographing, Inc.